M000311575

PEWTER OF THE WESTERN WORLD, 1600—1850

PEWTER OF THE WESTERN WORLD, 1600-1850

by Peter R.G. Hornsby

Schiffer Publishing Ltd

This book may be purchased from the publisher.
Please include $1.50 postage. Try your bookstore
first.

Schiffer Publishing Ltd.
Box E
Exton, Pennsylvania 19341

Designed by Ellen J. Taylor

Copyright 1983 © by Peter R.G. Hornsby
Library of Congress Catalog Number:
All rights reserved. No part of this work may be reproduced or used in
any forms or by any means—graphic, electronic or mechanical, includ-
ing photocopying or information storage and retrieval systems—without
written permission from the copyright holder.

Printed in the United States of America.
ISBN: 0-916838-83-8
Published by Schiffer Publishing Ltd.

Acknowledgments

The judgements and attributions that I have made are my responsibility but naturally I owe a very considerable debt to a number of people who have helped in the compilation of the book with advice, information and photographs. A glance at the acknowledgements under the photographs will show how widespread this support has been. It would be invidious to name individuals so suffice it for me to acknowledge the extensive help given by museums, collectors and my professional colleagues throughout the world.

Help was at hand, closer to home. My wife, Jen, took charge of the flood of illustrations that poured in, helped read the various drafts, calmed me as each inevitable set back or disaster occured and generally bore the burden of the books' preparation. Charles and Sue gave up many hours to reading the drafts and to the rehabilitation of my spelling.

To all those who helped I am most grateful.

Table of Contents

Introduction

The aim of this book is to present an overall, international, view of pewter made in the western world between 1600 and 1850. Such an attempt is bound to be both incomplete and selective.

It is bound to be incomplete because in spite of the sizeable literature on pewter, there are still many gaps in our knowledge. The historians have devoted little attention to the craft, apart from the excellent study by John Hatcher on British Pewter, and consequently hard evidence frequently does not exist.

It is bound to be selective for in a book of this dimension only a small part of what has been recorded can be included. Collectors and students of pewter have produced detailed studies on form and line. A general survey, such as this, can only summarize the mass of detailed knowledge contained in many different national studies.

In attempting to illustrate the leading forms of pewter between 1600 and 1850 it is impossible to eliminate some arbitrariness in selection. Inevitably there are many objects that could not be shown, and with those that are displayed there are many minor variations which also cannot be illustrated.

The story of pewter goes back before 1600 but there are few surviving pieces from the medieval period. The collector or student will not normally come across pewter made before the seventeenth century.

Pewter was made after 1850, but the story of the second half of the nineteenth century is the history not of pewter but of britannia metal, produced by powered machine in large factories and so dissimilar to the work of the traditional pewterer that it should certainly form the basis of a further, different, study.

It says much for the importance of pewter as an alloy in the service of man that it was able to hold its place over many hundreds of years, and still find for itself a role in two such different worlds as those of 1600 and 1850.

At the start of this study the first settlers from Britain were working to establish a viable colony in Virginia. Europe was divided into a multiplicity of small states. Within the Holy Roman Empire, for example, there were more than 300 separate principalities or dukedoms. The Islamic Ottoman Empire stretched as far north as Budapest and the Dneister River, including what we now know as Hungary, Bulgaria, Rumania, Albania, Greece and part of Russia.

Most people lived in the countryside. Serfdom and indentured service were widespread. Disease was rife and sanitation hardly existed. In the words of a contemporary philosopher life "was nasty, brutish, and short". Illiteracy was almost universal. Travel was difficult and costly. The total population of Europe, Britain and the North American Colonies was only around 100 million.

Contrast this picture of early seventeenth century life with that of the years around 1850.

By this time the total population of the same regions had risen to close to 300 million. The United States had grown to become one of the major states in the western world. The mass of principalities and small states had been concentrated into something akin to the system of national frontiers that we know today. The industrial revolution was already changing the face of society. Railways and canals offered speedy communications. Outside the United States, Russia and Cuba serfdom had been abolished.

It is important that in drawing these contrasts we do not fall into the trap of supposing that life in 1850 was similar to that which we live today.

Many differences existed. Europe was still largely rural, and although 65% of people in Holland lived in towns only 5% of Russians did so. Whilst levels of literacy had improved, 70% of Russians and 63% of Spaniards could not read or write.

Nor should the economic progress that had been made blind us to the vast development that was yet to take place. Industrial production which had risen two-fold in Britain, the first industrialised state, between 1801 and 1831, was to rise a further seven times by 1901. In 1850 only Britain and Belgium could truly be termed industrial states. Even in the United States in 1849, industry only accounted for 11% of the workforce.

The railways which had paved the way in Britain for the industrial revolution and which had opened up the United States were still in their infancy in much of Europe.

Thus while the development of the western world over the 250 years had been spectacular, the world of 1850 was far from being our world. For better or worse however, the society which had nurtured the pewter industry had gone forever.

CHAPTER 1

Background

What is Pewter?

Pewter is an alloy of tin. Pure tin is difficult to cast, brittle and hard to work. The addition of other elements such as lead, copper, bismuth and antimony made it malleable and easy to handle.

The essential nature of pewter is recognised in most languages, where the word for pewter is also the word for tin; Zinn (German), Etain (French), Olovo (Russian), Petro (Italian), Cyna (Polish), Tenn (Swedish) and On (Hungarian). Only in English has a special word been coined.

Roman pewter had a high lead content; up to 50% or more. High levels of lead were also used, for example, in eighteenth century baluster measures, but at nothing like such a dangerous level as that used by the Romans.

The amount of lead used was restricted because too high a lead content made objects soft and because lead was toxic.

Copper was widely added to pewter but the volume used was rarely higher than 10% and generally less than 3%. Antimony was used in Italy in the fifteenth century and probably also in the rest of Europe but did not reach Britain until the mid-seventeenth century. Antimony was used in small quantities until it was incorporated in what became known as "Hard Metal", when up to 10% antimony could be used. Bismuth was also frequently included but always in very small amounts, usually less than 1%.

A number of items of pewter have been chemically analysed to find their composition but the sample needed is large and the technique difficult.

Modern X-Ray fluorescent techniques require very small samples and work is being undertaken with such equipment into the composition of pewter at Winterthur Museum and at Lanchester Polytechnic in Coventry.

When these studies are complete we will know far more about the composition of pewter than we do today.

Early in the Middle Ages pewterers learnt that if pewter was to be useful the amount of lead added had to be restricted.

From this practical experience developed standards to which the pewterers had to work. Each standard was designed to produce pewter of a different but still acceptable grade.

Top quality pewter was used for plates, dishes, flagons, tankards, candlesticks and many other day to day items. Other standards were adopted for measures, spoons and smaller objects.

Over the centuries all standards were subject to change and none were ever universally accepted.

In France the top quality pewter termed "Fin" had to contain at least 90% tin, whereas the lower grade could include up to 26% lead. The lowest quality, "Claire Etoffe" was permitted to contain up to 40% lead.

In Holland the standards varied from town to town. In Zutphen, after 1639, 95% tin was required in fine pewter whilst in the eighteenth century most Dutch Guilds stipulated 94% tin for their best pewter. At Antwerp, after 1603, a high tin content of 97.5% was required.

English standards are more obscure. There are references in early documents which suggest that the top standard contained as much as 26 lbs. of copper to 112 lbs. of tin but this amount of copper could not be absorbed into the tin. Later references speak of adding as much copper to the tin "as of its own nature it will take"; probably not more than 10% and on average less than 3%. In the seventeenth century a little bismuth was also often added. The second quality pewter could contain 22 lbs. of lead to 112 lbs. of tin and in the late sixteenth century a third standard was created which lay somewhere between the first two, but which allowed for the use of old pewter as part of the mixture.

The use of antimony came to Britain from France in the seventeenth century, brought over by a Huguenot maker. Taudin's hard pewter was soon copied by other makers and the pewter they made was marked "Hard Metal" or "Superfine Hard Metal".

Just how successful were the Guilds in protecting their standards?

The Guilds faced a continuous struggle to maintain the quality of their pewter. Man's avarice encouraged the adulteration of the alloy whilst in the remoter areas the Guilds' writ was never fully accepted.

Searches for low quality pewter continued into the eighteenth century and many pewterers had their wares destroyed and were fined for such transgressions.

When analysed, pewter seldom conforms exactly to any of the national standards. This is perhaps not surprising as measurement was not an exact science and much was left to the individual Master provided that the minimum content of tin was met.

The proportion of lead in pewter could be judged visually by an experienced eye or crudely tested with a knife for softness. Less subjective tests were needed and pewterers evolved a method of assaying pewter to measure its lead content. A sample was taken of known size and its weight compared with a similar sample made to the guild standard. If the sample being tested was heavier then it contained more lead than was allowed.

Recent analyses have shown that there was a considerable variation in the tin content of pewter. The following table illustrates the range of tin found in samples of British eighteenth century pewter;

PEWTER	RANGE OF TIN
Plates, Dishes, Flagons & Tankards	91 — 97%
Balusters & Channel Island Pewter	64 — 72%
Scottish Measures	57 — 62%

Perhaps because second-hand pewter was widely used as a raw material American pewterers tended to make their plates and dishes with a lower tin content; as much as 10% less than in British plates.

James Vickers, working in Sheffield in the 1760's produced a hard lead-free alloy based on tin and antimony probably very similar to that made earlier and marked "Hard Metal". Vickers discovered that because of its hardness it could be cast much thinner, thus saving metal, and later he found that objects could be made up from thin sheets of the alloy.

The pewter that resulted was not very different at first from that made by casting but new methods were to revolutionize the industry and the resulting products became known as "Britannia Metal".

Britannia metal is sometimes defined in relation to the style of the objects which were made, other definitions relate to the composition of the alloy but the true meaning of the term derives from the methods of manufacture which developed in the nineteenth century.

Tin Resources

There were three main sources of tin in Europe in the seventeenth century; Saxony, Bohemia and Cornwall. Tin was mined elsewhere but other deposits were not of significance after 1600.

Cornwall had been the major producer of tin in Europe since the Middle Ages and a considerable proportion of its production was exported overseas to be made into pewter by foreign craftsmen. In 1700-09, for example 79% of cornish tin was sold overseas.

Throughout Europe tin from Cornwall was the main source of supply. Special marks were created by the Guilds for use on pewter made with this high quality Cornish tin.

Just how important Saxony and Bohemia were is not easy to establish but for much of the seventeenth century the output was low as a consequence of the ravages of the 30 Years War. It has been estimated that during the whole eighteenth century Bohemia and Saxony together produced about 30,000 tons of tin, less than one seventh of Cornish production over the same period.

Towards the end of the seventeenth century the Dutch started to import tin from Thailand. This "Banka" tin as it was called was always more costly than Cornish tin but became an important source of supply. Imports varied but over the ten years from 1760 to 1770 ranged from 60 tons to 457 but never exceeded 10% of Cornish production.

How was Pewter made?

All pewter was initially cast into molds or formed into sheets for subsequent hammering into plates and dishes. The vast majority of things made in pewter, however, were cast.

Pewter was simple to make. The hardening agents such as lead, copper, antimony or bismuth were added to the tin on the basis of established formulae and the mixture heated in iron vats or pots over a forge fire.

The melted alloy could then be poured into molds.

Molds were at first made of clay or stone and from the sixteenth century, of bronze. The molds were treated with such substances as ochre, egg white, pumice or carbon black, to improve the flow of the molten metal. Molds had to be heated to exactly the right temperature to ensure an even flow of the metal into all parts of the casting. A craftsman's experience, rather than instruments, told him when the moment was right.

After cooling, clay molds could be broken or permanent two-part molds opened, and the casting removed.

With one-piece objects such as plates, only one mold was needed. More complex forms with several parts had to have each section cast separately.

After the mold had been opened the first task was to remove the surplus metal where it had flowed into the mold. The edges of the casting had also to be cleaned. The resulting cast was dull gray, uneven and unfinished and now had to be cleaned, scraped and planished using hand tools and a wheel.

Flatware, with a few exceptions was then hammered to strengthen it round the "booge" (the part of the bowl between the rim and the base). According to English guild rules trenchers for export to Spain did not have to be hammered and

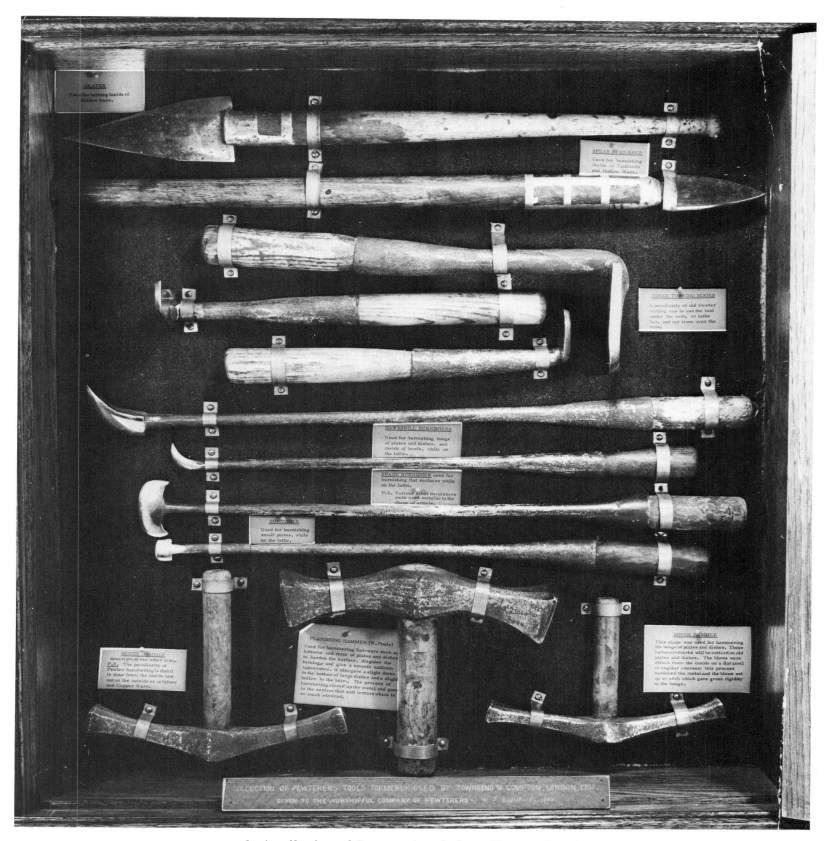

1. A collection of Pewterers' tools from Townsend and Compton, most originally from the early eighteenth century. The ubiquitous pewterers' hammer is in the centre at the bottom. (Courtesy of the Worshipful Company of Pewterers, London).

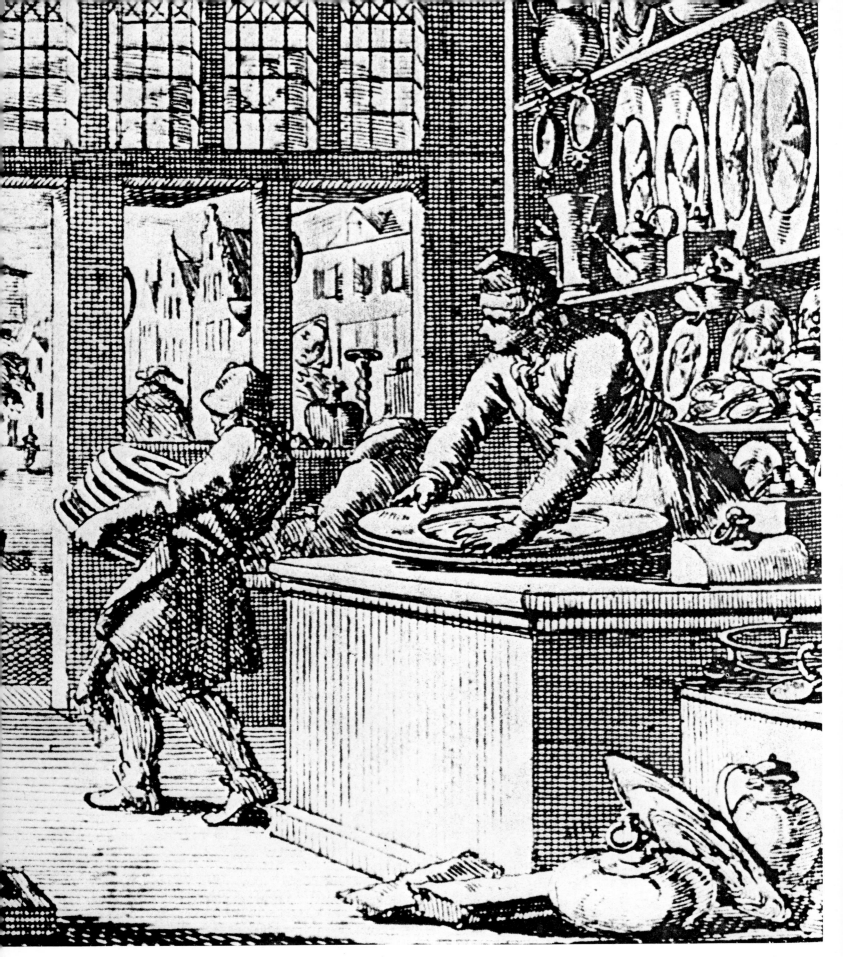

2. A french pewterers' shop circa 1600, showing goods for
sale. It is likely that most pewterers in larger cities had
establishments very similar to this.

after 1770 few American plates were worked this way.

When all the individual parts had been cleaned the pieces were soldered together.

Where clay molds were used, they had to be destroyed each time to extract the casting. This type of "one off" casting was a slow process and only suitable for a limited production.

The clay mold was soon abandoned in favour of molds made from stone. Stone molds could be made in two parts, the sections fitting neatly together. The surface of the resulting cast was often rather uneven and stone molds were fragile. They could only be made for simple one-piece objects such as plates and spoons and their use was limited.

There are occasional references to wooden molds but these must have been of little value.

Bronze molds appeared in the late fifteenth and sixteenth centuries. Bronze molds are difficult to make and costly but they were strong, gave excellent results and many identical objects could be cast from them.

The pewterer's hammer was often used as a symbol for the craft and it appears in many early makers' marks. The raising of pieces from sheet metal, the shaping of spoon bowls and the strengthening of plates by hammering, all involved the use of the hammer.

Pincers in steel or iron were used to remove excess metal from the casting. The scraping and finishing tools usually had wooden handles and steel heads.

The final "finish" was applied to the casting by turning it on a wheel and smoothing the surface by holding against it "planishing" tools of steel or agate.

The early form of wheel was a pole-lathe powered by the craftsman operating the lathe. In the sixteenth century a more efficient wheel of iron came into use which was turned for the pewterer by another workman. Its greater strength and speed much improved the finish on pewter. In London the city pewterers were protective of their newly acquired "Greate" wheels and instructions were issued for the wheels to be hidden away from the prying eyes of visiting rural craftsmen.

The methods used in the manufacture of pewter were basically unchanged over several hundred years until the early nineteenth century.

The industrial revolution encouraged craftsmen in other metalworking trades to seek more efficient methods of shaping and decorating their products. New techniques for pressing and stamping objects were soon applied in the brass industry. Pewterers were slow to adopt these new skills. A series of advances were made around 1825-30 when the technique of shaping objects out of thin metal sheet by pressing them round a pattern or master was evolved. This method, known as spinning, involved the use of powered machines, at first driven by water but later by

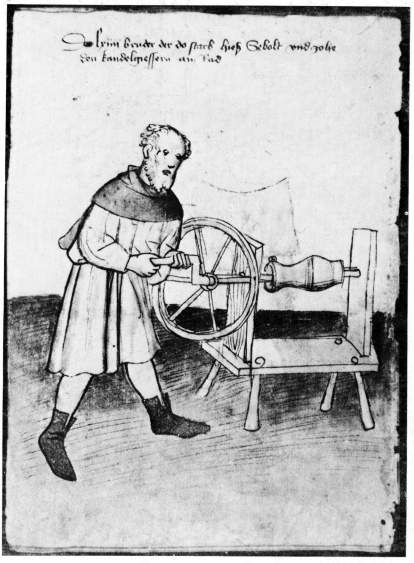

3. Turning a piece of pewter on an early lathe, a sixteenth century drawing.

steam. The thin sheet to be used was placed over the master and as the lathe turned it was pressed against the pattern by holding spinning tools against it, and in this way forced to take up the form of the design. Far less skill was needed and far greater levels of production could be achieved. The products of the britannia metal industry, as this process became known, were often partly cast and partly spun, the various sections being soldered together to make the complete object.

The Guilds

At 1600 in Britain and Europe the control of the many crafts and trades lay with the Craft Guilds.

These guilds developed during the Middle Ages. At first they mostly operated on a municipal basis bringing together local merchants, traders and craftsmen, for their mutual benefit. The Guilds provided a forum where problems could be tackled, business transacted and commerce regulated. These multi-craft unions generally developed into the Municipal Corporations and lost their commercial aspects. The steady rise in wealth and the diversification of trade lead to the

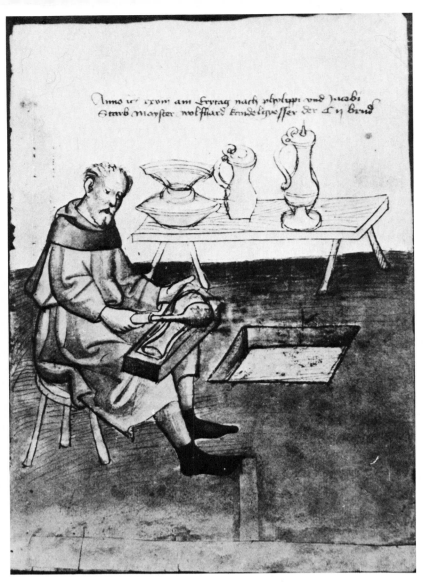

4. A sixteenth century drawing of a craftsman casting the body of a flagon. Typical of the kind of methods of manufacture used into the eighteenth century.

Although still powerful in 1600 their heyday had passed weakened by the breakdown of the medieval social order.

During the seventeenth century the general pattern was for the Guilds to exercise their powers actively but in some areas their decline was already apparent. In Holland the decay of the guilds was a gradual process. Poor quality pewter and fraudulent practice were common, the assaying (or testing to the guild standards) was abandoned in the sixteenth century in Rotterdam Delft, Haarlem and Gouda. New charters were given to several of these cities in the seventeenth century, but the decline of the guilds was never arrested.

In order to maintain their monopoly control of who should make pewter or practice any craft, each Guild controlled the entry into the trade through a system of training known as apprenticeships. No one could become a pewterer or indeed follow any other "Livery" trade without being

establishment of craft guilds, uniting men from a single trade or a group of allied trades.

At the peak of their power cities often had many guilds at work. London in 1422 had 111 different craft guilds while fifteenth century Cologne had 44. In most other towns there were many fewer.

Pewterers Guilds, or Guilds of Hammermen (usually metalworkers using the hammer as their principal tool) were formed from the thirteenth century onwards.

Although the Guilds were principally concerned with protecting the interests of their members they also acted to maintain the quality of pewter produced, controlling the apprenticeship system, regulating bargains, and in general smoothing the workings of the crafts for the benefit, in theory at least, of both public and pewterers.

The Guilds in Paris, Lubeck, Frankfurt and Nuremberg, were active in the thirteenth century. London, Augsburg, Hamburg, Strasbourg, Rouen and York date from the fourteenth century and during the next 100 years Guilds were established in many other cities.

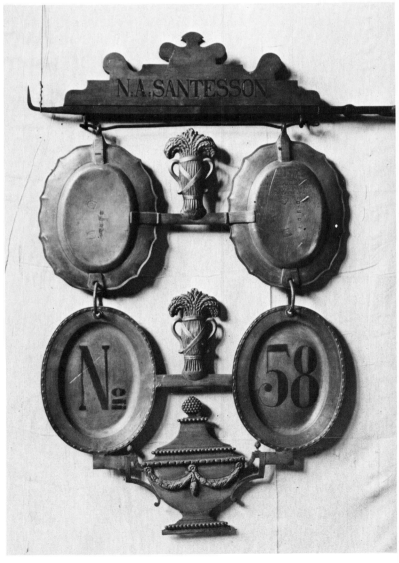

5. A pewterers trade sign, in pewter. From Sweden, the maker Nils A. Santesson of Stockholm, 1839. Thirty-nine inches high. (Courtesy of Nordiska Museet, Stockholm).

6. The first of the London Pewterers' Guild touch plates on which marks were struck after the Great Fire of London. The first to strike their touches were former masters of the company. Similar touch plates were widely used in Britain and Europe. (Courtesy of Worshipful Company of Pewterers).

17

7. Tin was bought in ingots which with English tin was "coined" in Cornwall; that is checked for quality and cast into suitable units. This is a nineteenth century ingot and the damage at the right is probably due to its being checked for purity. (Collection of Mr. William F. Kayhoe).

formally trained by an existing member. The length of training, during which the apprentice lived and worked with the master, varied between two and eight years. In Britain all apprentices had to serve seven years, in Louvain, Belgium the period was six years, at Haarlem and Ghent it was four years and in Antwerp and Utrecht it was two years.

Through the apprenticeship system the numbers entering the trade could be controlled, preference given to the sons of existing members, and high standards of professional skill be maintained. The number of apprentices that a master could have was always limited.

Life for the apprentice was hard; long hours of work, little or no pay and strict discipline.

When the period of the apprenticeship was up the young man or woman became a journeyman; that is a paid laborer, working for a master pewterer, sometimes for a short time to obtain experience before setting up on his own, in other cases for the rest of their working life. During the eighteenth century the difficulties of setting up on one's own became greater and fewer journeymen ever made the transition. In Germany it was common for artisans to marry widows twenty or thirty years their senior to obtain a Master's status.

The cost of setting up as a pewterer was considerable. Naturally it varied from country to country and over time. The potential Master needed premises to act as a workshop and retail outlet, expensive molds for casting, a wheel, tools and a supply of tin and other metals. In Britain it has been estimated that in the late seventeenth century it cost between £300 and £1000 to start a viable business in London.

Some idea of the value of tools and molds required for a small to medium-sized rural business can be obtained by looking at the inventories of pewterers at their deaths. Though it must be remembered that all the tools were, by defination, second hand and were being valued

for probate. From ten such inventories in Britain between 1667 and 1732 we find that on average the pewterer's tools and molds were valued at just over £20.

In the eighteenth and early nineteenth century these entry costs rose considerably as a group of American pewterer's inventories indicate. The inventory of Thomas Byles who died in 1771 shows that he had 1,371 pounds of molds valued at over £145, together with other tools worth £48. Three early nineteenth century pewterers, Austin, Eggleston and Melville owned an average of 383 pounds of molds valued on average at $139.

The high cost of molds is confirmed by the use of community molds. Most pewterers had their own molds for the things that they sold most frequently, such as flatware and spoons but the several molds needed to make more complex forms like tankards and flagons were often too costly for them to acquire. They had the choice of buying the finished pewter from other, better equipped, local pewterers or if they were fortunate making use of communally owned molds.

In Holland such community molds were common; pewterers at Nymegen and Utrecht

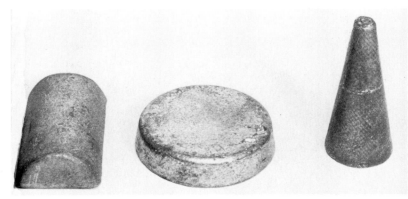

8. Three small ingots, from an American pewterer, nineteenth century. The cone is 3 1/8 inches high. (Collection of Mr. William F. Kayhoe).

9. Steel assaying tool with a bronze mold into which the pewter to be tested was cast. English, dated 1728, used by the London Guild. (Courtesy of the Worshipful Company of Pewterers. London).

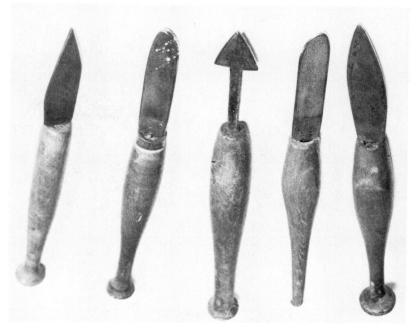

10. Scraping tools used in America by the Boardman family, nineteenth century. (Collection of Mr. William F. Kayhoe).

being amongst those owning communal molds. It appears very likely that the pewterers of Boston shared molds. This is the most likely explanation of the widespread use of the "Semper Eadem" mark which is found on the works of several pewterers.

American makers were also to the forefront in the economical use of molds. They found that one mold could serve for several parts in different objects. Thus Parks Boyd used the same mold for the lids of both pitchers and sugarbowls, William Will used the identical mold for parts of his cream jugs, salts and chalices, and the Sellews had a base mold which they used for both lamps and candlesticks. There are many other examples. Outside the United States such a multiple use of molds may have also taken place but it has proved difficult to find instances.

The Guild system never operated in the United States although there was an Association of Pewterers in New York City. The apprentices system provided however a useful way of training craftsmen.

The size of the Industry

Just how important was the pewtering industry?

Pewter was used everywhere but it was only an occasional purchase and would be regarded today as a consumer durable.

For this reason although the industry was of considerable significance it was overshadowed numerically by many other trades.

The relative insignificance of the pewterer's craft is shown by an examination of some of the studies on occupations. Several English sixteenth century studies show that only between 3% and 8% of people worked in all the metal trades. Pewtering was a minority within metalworkers, as a Norwich study confirms, where it was found that only four out of sixty-five metalworkers were pew-

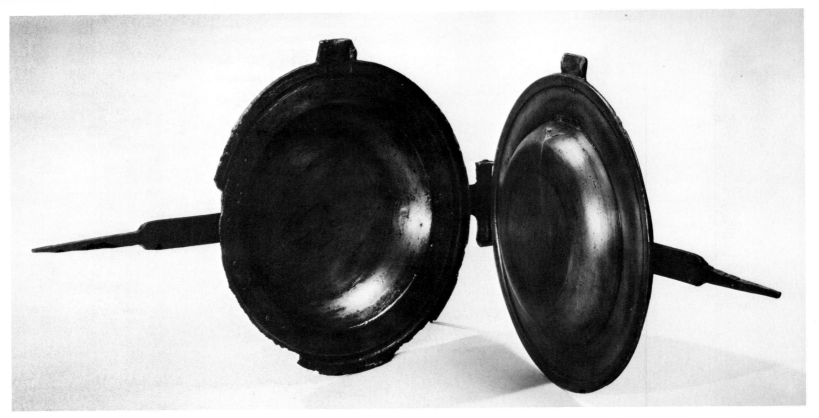

11. A bronze dish mold, either English or American. Eighteenth century. The mold is 22¼ inches in width and the dish to be cast would have been 12 3/8 inches diameter. (Courtesy of Colonial Williamsburg).

terers. In further studies in Worcester, Gloucester and Southampton only thirty-two out of 27,100 people were pewterers. In smaller studies in Frankfurt (1387), Florence (1552) and Venice (1660) the number of metal workers varied between 5% and 7% and it is again unlikely that pewterers formed more than a small fraction of these numbers.

Yet in some centres of the pewtering industry a hundred or more men were at work. In the seventeenth century in London there were 250 master pewterers at work as well as a considerable number of apprentices and journeymen. Amsterdam had more than 100 pewterers, Nuremberg 75, Bristol and Wigan over 60, Stockholm 25—30 and Geneva 10—15 to give but a few examples. Apart from a score of the major cities most towns would have had less than ten pewterers at work and in most smaller towns only an isolated pewterer would have plied his trade.

What kind of quantities of pewter were produced? We have already seen that most homes, by 1600, contained pewter, and Hatcher in his fine study of the history of the British pewtering industry estimates that in total there were between 18,000 and 29,000 tons of pewter in British homes in 1680. In Sweden Bruzelli has estimated, on the basis of assay records, that between 1754 and 1912, more than four million objects in pewter were made by the comparatively small Swedish pewtering industry. There is little other statistical evidence but it is clear from what we do know that many millions of items were made.

As a consequence of the lack of evidence any attempt to rank pewtering nations is risky, but it would appear that behind Britain in first place would have been France and Germany, to be followed by Austro-Hungary and the low countries, while Scandinavia and Switzerland would also have had significant industries. For the rest of Europe levels of production would have been less significant, whilst in the south the pewter industry was never of much importance. The pewter industry in the United States would have ranked, by the nineteenth century, below that of the leading European nations.

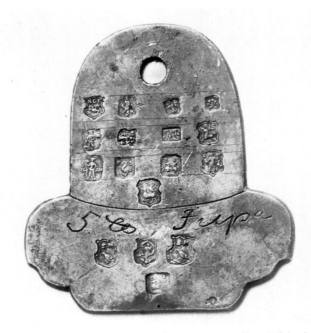

12. Molds were often owned communually. This is a tablet on which Stockholm masters struck their mark when they borrowed molds from the local guild. Four inches high. Eighteenth century. (Courtesy of Nordiska Museet, Stockholm).

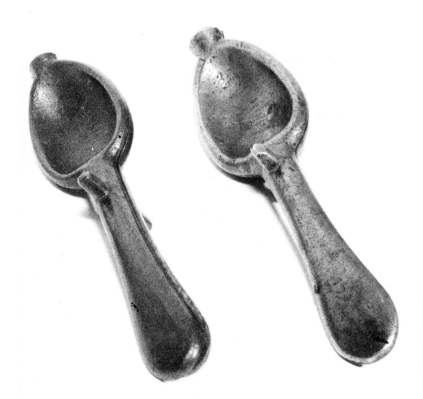

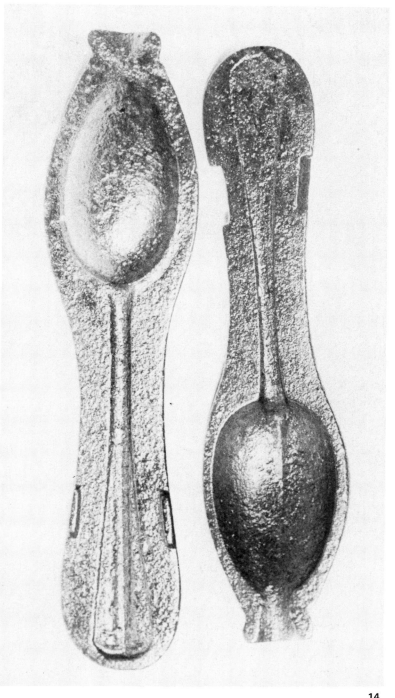

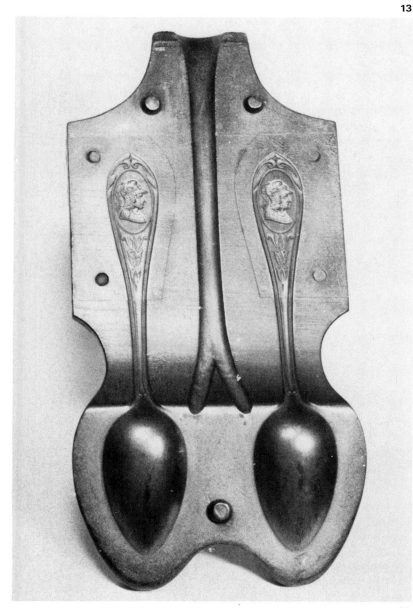

13. Two bronze spoon molds, American, eighteenth century. Each 8½ inches long. (Collection of Mr. William F. Kayhoe).

14. A rare cast iron spoon mold. English circa 1750. The spoon was in the old English pattern with a ridged stem. (Robin Bellamy Ltd).

15. Cast decorated double spoon mold from Boardman. Such a double mold enabled two spoons to be cast at once. Molds such as this are towards the middle and end of the nineteenth century. (Collection of Mr. William F. Kayhoe).

16

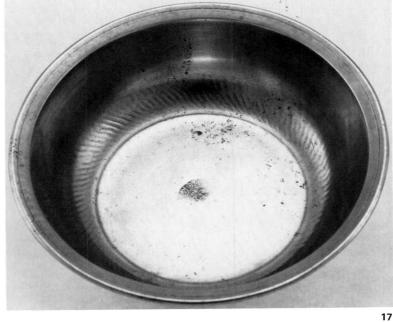

17

16. Widespread use was made by pewterers in all parts of the world of molds for parts of more than one object. The foot of one item might be the lid of another and so forth. In this illustration of three items by I. Trask, the cup on left comes from the same mold as the chalice bowl in the centre and the feet of the two chalices are again from the same mold. (Collection of Charles V. Swain).

17. Domestic basin or bowl by Sam Danforth, of Hartford, Connecticut, circa 1800. The "Chatter" marks, where the basin was turned off on the lathe are clearly visible. (Collection of Dr. and Mrs. Melvyn Wolf).

18. Handles, thumbpieces and other parts of an object were "bled" onto the piece by casting them against the partly completed object. In this case the porringer ear has been cast in situ against the bowl. Linen was used behind the casting to absorb the heat and prevent damage and the cloth marks can clearly be seen. (Collection of Dr. and Mrs. Melvyn Wolf).

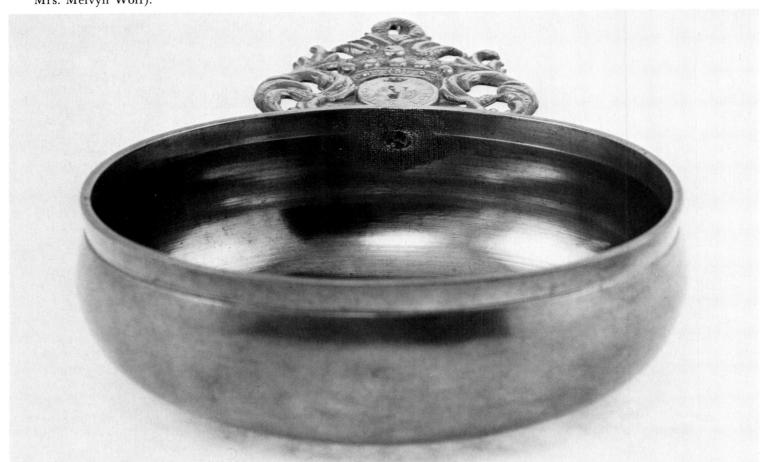

18

CHAPTER 2

History of the Pewter Industry

An Outline History of the Pewter Industry

Pewter has been used for several thousand years, certainly since the days of the Phoenicians.

The Romans used Cornish tin to make pewter and it is possible, though uncertain, that some pewter may have been made in Britain during the Dark Ages. A few rare examples of European pewter from before 1000 A.D. do exist.

The gradual development of a more ordered way of life, the drift to the towns, the growth of trade, and the erratic but generally upward movement of the standard of living in much of Europe led to a slow increase in the use of pewter during the Middle Ages.

At first pewter was used by the rich nobles and clergy but it slowly found its way into the homes of merchants and the middle classes.

Much medieval pewter was religious in character; sepulchral chalices, reliquaries and ampullae being the most frequently found survivors of this early age. In domestic pewter most frequent are plates, dishes, spoons, and flagons.

The years from 1500 onwards were to see a dramatic rise in personal consumption, felt at first in the expanding towns but gradually spreading into the countryside. New homes were built and the Spartan way of life that had dominated the Middle Ages was gradually replaced by a growing affluence and love of display.

After 1500 pewter was to be found in the homes of many merchants, artisans and yeomen. Harrison, an English commentator, wrote in 1576—77 on changes that had been seen in his lifetime; "The third thing they tell of is the exchange of vessel, as of treen (wooden) platters into pewter, and wooden spoons into silver or tin. For so common were all sorts of treen stuff in old time that a man should hardly find four pieces of pewter (of which one was a peradventure a salt) in a good farmer's house".

Statistical evidence is naturally scarce and unreliable. It is perhaps dangerous to generalise on the strength of the occasional glimpses that we are allowed, but there are two groups of inventories, one Dutch from the fifteenth century and a larger British group from the sixteenth century, which do help to illuminate the extent of pewter ownership at these times.

Inventories from Deventer in Holland, circa 1455—1495, showed that 41 out of 45 homes contained at least 30 items of pewter and in five cases there were more than 130 items listed.

Similar studies of English inventories confirm the expansion in the use of pewter within the home. A sample of 296 inventories from Devon, Oxfordshire and Worcestershire between 1575 and 1625 tell us that 83% of homes, other than those of the very poor, had pewter within them.

The Dutch inventories show that plates and dishes amounted to 65% of items listed, and that about 30% were flagons or drinking vessels. Flatware accounted for 57% of the pewter in the English homes and spoons, 11%.

Both groups of inventories come from the developed parts of Europe and probably do not reflect the position in much of Central and Southern Europe.

The Seventeenth Century

Pewter had already established itself in Western Europe and Britain in the homes of all but the poorest by 1600.

During the century the craft prospered although in much of Central Europe progress was retarded by the ravages of the 30 Years War (1618—48). In Germany some villages were sacked four times and it has been estimated that about 40% of the population was lost by war and epidemic. The Civil War in Britain also restricted growth.

It appears that in many parts of Britain and Europe the craft reached an apex in the 1680—1700 period. The growth of the trade in London in the seventeenth century is illustrated in the table below.

Period	Shopkeepers At Work	Average No. Apprentices Enrolled Annually
1591—1600	143	28
1651—1660	257	48
1691—1700	334	37

The absence of adequate statistical information for most of Europe means that we have to rely on the evidence that has been unearthed, mostly from Britain. Studies of personal inventories there show us that there was a considerable rise in the value of pewter in homes between 1575—1600 and 1651—1675. In money terms the value of domestic pewter more than doubled from £33 to £68, a 48% rise after allowing for the rise in the

price of pewter. The proportion of homes with pewter also grew but less significantly because of the already wide ownership in the first period.

Yet in spite of these developments other factors were at work which were to damage the long term viability of the craft.

From the middle of the seventeenth century pottery was extensively made in Europe, to compete with Chinese imports. The growth of the "delft" industry soon began to impinge on the pewter trade, for delft provided a colourful and cheap alternative to pewter.

The difficulties and high cost of transport hampered the economic growth of all trades. Pack horses and carts carried goods over the poor roads at a high cost; roads that were often impassable in winter. In Britain and those areas with easy access to the sea, coastal ships were a cheap and useful alternative to land transport. Where roads had to be relied upon, as in central Europe, the market for pewter was essentially a local one.

Tariffs also provided an additional burden to the free movement of goods. In 1671—1674, for example, on the 300 mile journey from Hamburg to Pirna there were more than 30 customs control posts en route.

It might be assumed that the increase in pewter production during the seventeenth century would have brought increased wealth to the pewterers. The rising demand for pewter was matched by a rise in wage rates, fluctuations in the price of tin and increased competition.

Higher prices for tin drove pewter prices upwards but not perhaps as high as might be supposed, as much of the metal used came into the pewterers' hands through part exchange.

The table at the foot of the page illustrates the movement in pewter, tin and second hand pewter prices in Britain during the first sixty years of the century.

The proportions of tin and old pewter used in the manufacture of pewter is not known, but profit margins were certainly reduced by the rise in tin prices.

The last 30 years of the century saw a sharp fall in tin prices, and pewter prices declined in sympathy but probably this had little effect on profits.

It would be wrong to think of all seventeenth century pewterers being of roughly the same importance. The trade was divided between a small group of major merchants who both made pewter and bought it finished from other craftsmen to sell. Such merchants were often in business in a substantial way using several "outworkers". The next category of pewterers was made up of those masters who made and sold their own pewter whilst the poorest group were those craftsmen who had no shop and worked for other masters.

Some pewterers were wealthy men. Peter C. Van Male of Rotterdam had, in 1631, more than 5,000 items of pewter in stock, and clearly was in a major way of business. Shrimpton of Boston, when he died in 1666, left over £12,000, although some of this wealth may have been due to other enterprises. In London in the early seventeenth century such men as Henry Duxell, Roger Glover and Richard Staple were very substantial merchants.

Not all pewterers were rich. Edmond Dolbeare, who had trained at Exeter in England before going to Boston, was described in 1700 as "Poor and Aged", and there are many examples in the London guild records of help being offered to indigent pewterers.

Pewterers in the smaller towns often earned part of their income from other activities. In Holland they bought and sold lead and English tin as well as renting out pewter for special occasions. In the American Colonies, in the eighteenth century, there are many instances of pewterers following other occupations. Gershom Jones sold stoneware, Edgell a variety of goods including nails and glass from his store, Leddel sold glass and acted as an engraver, George Coldwell sold tallow and Thomas Danforth advertised that he had a "quantity of onions" to sell. In Witney, England Henry Warde was also in business, with a relative, as a general retailer. There are many other similar instances.

Pewter was made in the seventeenth century where previously the craft had not operated.

There was virtually no pewter production in Russia prior to the setting up of an English factory there in 1629 but by 1650 there were four pewterers working in Moscow.

When the first settlers came to Virginia there was little time for the luxuries of life. Axes, nails, saws, weapons and gunpowder had a higher priority than pewter.

As people became more settled their attention slowly turned to a more commodious way of life.

There is evidence that at least 16 pewterers and probably several more were at work in Boston, Massachusetts Bay, and Philadelphia towards the end of the century.

Pewter was already being exported overseas from Britain during the Middle Ages and by the seventeenth century there was a steady movement from Britain to Europe, and later to the West Indies, the American Colonies and Africa.

Period	Estimated pewter price per pound	Estimated new tin price per pound	Estimated second hand pewter price per pound
1600—10	9.3d	6.4d	5.8d
1611—20	11.5d	9.6d	7.1d
1651—60	14.5d	12.8d	10.3d

Exports of pewter from Britain rose from around 50 tons per annum at 1600 to more than 250 tons a year by 1699—1701.

Holland was one of the principal European markets for British pewter and considerable quantities also went from London and Bristol to the American colonies in the last decades of the century. Local pewterers did not always welcome these imports. In 1661, for example, Antwerp pewterers protested over the levels of British exports.

Pewter could be bought from the shops of local craftsmen, ordered from nearby towns or cities or acquired during a visit to the local market or fair.

Fairs were still of considerable importance in the seventeenth century, although they had lost their pre-eminence as a vehicle for international trade. Daniel Defoe writing in the early eighteenth century about the Stourbridge Fair near Cambridge in England describes the scene vividly.".... the shops are placed in rows like streets...Scarce any trades are omitted; goldsmiths, toyshops, braziers, turners, milliners, haberdashers, hatters, mercers, drapers, pewterers, china-warehouses, and in a word all trades that can be named in London with coffee-houses, taverns, brandy-shops and eating-houses, innumerable, and all in tents, and booths..."

Pewter was usually offered for sale at local fairs in Britain and Europe. The large tents or wooden booths of the established pewterers being matched by pedlars hawking their wares on trays.

The Eighteenth Century

This was a century of mixed fortunes for the pewter industry. The growing population , the general increase in wealth and the spread of the craft into new areas such as Central Europe and the United States were favourable developments.

Yet as we have already seen, the fall in profits and the increased competition from pottery were casting shadows on the future of the craft.

The principal area of growth was the American colonies. Commentators have remarked on the slow development of the pewter industry in the United States. It was, at one time, believed that British colonial policy, restrictions on the export of tin and direct legislative discouragement of a local pewtering industry were responsible for this comparatively slow start.

Whilst British policies clearly did damp much local enterprise there now appears to be little weight in these arguments.

There were no legislative restrictions on the manufacture of pewter in the colonies. Even with trades where such restrictions did exist, as with the iron industry, they were largely ineffective. There were no special duties or rules to prevent the import of tin into the colonies. All tin sent overseas bore an equal duty and during the eighteenth century tin exports from Britain to other parts of the world rose steeply.

The reasons for the slow growth, which really did not gather speed until a few years after the War of Independence, probably lay in the low demand generated by the small and widely dispersed population, and in poor communications which made it easier to import from Britain than to move locally-made pewter within the colonies.

As Ben Franklin suggested, it was not until the 1740's that people had time to turn their attention to things other than the necessities of life. Local trade and industry was also beset with difficulties. Wages were high, uncontrolled by guilds and this made much industrial activity unprofitable. Men could easily earn a good living from the land and many indeed abandoned their crafts to do thia. As a commentator wrote in 1765 "Nothing does at present prevent...their growing into manufacturing except the proportionate dearness of labour". The same view was expressed three years later by Ben Franklin: "All speak of the dearness of labor that makes manufacturing impossible".

Nevertheless the following table indicates a steady growth in the number of pewterers known to be working in the colonies during the eighteenth century.

Period	Estimated number of pewterers at work
1700—25	49
1726—1776	123
1777—1800	105
1801—1850	450 x

These figures only include individual Master pewterers and companies and exclude all journeymen and employees.

x This figure includes britannia metal makers and is probably a more accurate assessment than that offered in the other period.

Pewterers were at work all along the Eastern sea board. Around 1750 there were at least 68 pewterers operating, based in Boston (21), New York City (15) and Philadelphia (7) as well as in New York State, Pennsylvania, Massachusetts, Maryland, Delaware, Virginia, Connecticut, Rhode Island and South Carolina.

The dramatic rise in the population in the eighteenth century, both natural and through migration from Europe, brought massive new demand for pewter. British pewterers continued to export in ever-greater quantities to the colonies with only a brief intermission following the years of conflict. With improved communications brought about by canals, better roads and later the railways, local pewterers began to win a greater proportion of the market. At the same time most American pewterers gained considerable profit from British exports which they sold in their shops. In general, margins on all imported goods were high and offered more profit than could easily be won for local products. The high price that could be obtained for imported pewter also helped to protect the local craft, which could

undercut the price of imported pewter and make a good profit at the same time. John Noseworthy advertising in 1771 offered his pewter "much cheaper than...can be imported from England".

The high levels of British imports also provided the colonial pewterers with a cheap source of the alloy. They had no great need to import tin when all the damaged pewter could be re-worked into new items and could be bought cheaply or traded in for newly-wrought work on advantageous terms. Many American pewterers advertised their willingness to take old for new, most offered one pound of newly-worked pewter for two pounds of old, a price below that which they would have had to pay for tin.

In Britain the demand for pewter continued to be strong but gradually the industry began to lean more and more on exports. In addition to the traditional markets in Europe where local production was becoming increasingly competitive, considerable quantities of pewter were exported to Africa, often in connection with the slave trade, to the plantations of the West Indies and to the American colonies. Between 1720—28 and 1760—68 the value of pewter sent to North America increased seven fold and amounted to over 300 tons per annum at the end of these periods, equivalent to over one million plates per year.

The importance of exports was recognised in Britain. As the Pewterer's Company expressed it, with some exaggeration, in 1703 "the greatest part of the world being served with pewter from this Kingdom". Without the fillip of pewter sold overseas the British industry would have been in decay even sooner than actually occurred.

In general the pattern of trade in pewter remained much the same as in the previous century. Both in Britain and Europe, better communications meant that local rural pewterers had to face increased competition from city craftsmen. Dutch records show for example that A.J. Coenen from Amsterdam sold massive amounts of pewter, both completed and unfinished, to other pewterers in the period 1754—1768. Such men were in a substantial way of business. J. Jackson of Boston who died in 1736 left over £30,000, while Jan Timmens of Rotterdam died worth 32,000 guilders.

Such wealth was not typical. In a study based on Holland in 1742 the incomes of 77 pewterers were examined. Fifty-one of these earned less than 800dfl and of the 17 pewterers who earned more than 1200dfl, 15 of these came from the city of Amsterdam. These returns are well below the average for other trades.

Margins certainly fell in the eighteenth century. For example the Oxford and Cambridge Colleges were able to dispose of their old pewter at between 7d and 9d per pound but on average had only paid 11d a pound for it; a price lower than in the mid-seventeenth century, and much lower in

relative terms considering the rise in prices and wage costs.

Increasingly there are, references in guild records in Britain and Europe to poor and indigent pewterers in Britain and Europe. A comment recorded in 1739 in London is typical of the times; "taking into consideration the severity of the season, ordered the sum of £50 to be distributed amongst the poor of the Company".

Another effect of the decline in profits in Britain and Europe was the increased sensitivity to competition by pedlars. These tin-pedlars operated all over Europe. In North America they were responsible for much of the distribution of pewter to remoter parts such as Canada. A contemporary commentator, Timothy Dwight reported that he had seen pedlars up to 300 miles from their bases in Connecticut.

The competition of unregistered craftsmen became increasingly irritating in Europe. These "Bonhasen" (Ground Rabbits) as they were called were often able to undercut skilled pewterers.

The eighteenth century saw sharply increased competition from two sources; pottery and brass and copper. In Britain the number of people working in the pottery trade had risen five-fold between 1680 and 1770 and the production from the potteries was enormous.

Pottery attacked pewter where it had been strongest; in the field of flatware. The fall in demand for pewter created problems elsewhere too. In 1776 hundreds of tinners "in a body went to Redruth (Cornwall) and broke all the Wares" (Earthenwares and Staffordware) and were only pacified when the local dignatories promised to take up their case and subsequently ordered new pewter from local makers.

The rise in production of copper and brass wares was also dramatic. Birmingham had become the world production centre for copper and brass.

The use of copper had risen fast. In 1725 an average of 400 tons per year was mined in Cornwall but by 1760 this had risen to 2,000 tons. In 1780 it had reached a peak at 5,000 tons but remained on an average of 3,000 tons in the early 1800's. Birmingham was using more than 20,000 tons of copper per year by 1865.

The eighteenth century saw considerable technical advances in industry. The British lead in the introduction of new machinery was the cause of several attempts to legally protect this advantage.

An act of 1696 had outlawed the export of machinery and after 1718 skilled craftsmen were not allowed to migrate abroad to work for competitors. In this restrictive spirit the London pewterers tried to prevent the export of pewtering molds and to increase the duty on tin so that more English pewter could be sold abroad. They were not successful in their attempts but that they tried is indicative of the pressures.

The guilds, where they survived, began to change character. By 1734 in Vienna only one third of the guild's members were Master Pewterers and in London by 1792 only 18 out of 43 members whose trades are known were pewterers.

In the seventeenth century more flatware and spoons had been bought than any other items, but by the eighteenth century competition from pottery and brass had forced the pewterers to seek new markets.

Two categories of goods increased in importance; implements for drinking tea and coffee, and beer mugs.

An analysis of two major export orders from Britain to the United States and the inventories of a group of four eighteenth century American makers, confirms this trend. The pewter sent to the United States by the British pewterers was dominated by flatware and spoons (92.5%), whereas the American inventories contained 77.8% spoons and flatware, but a sizeable proportion of coffee and tea pots, porringers and tankards.

The Nineteenth Century

In some countries the nineteenth century saw a rapid decline in the pewter industry, in others the decay was slower, but everywhere traditional pewterers were in difficulties.

It was often the traditional centres of the craft that were worst hit. A survey of a group of pewtering countries or regions as diverse as Norway, Sweden, Switzerland, Holland, Slovenia and Nuremberg indicates that of all the 2,800 pewterers who worked at any time between 1600 and 1850, an average 16% were at work during some part of the period 1800—1850. In Amsterdam and Rotterdam the equivalent figure was only 5%, compared with the rest of Holland at 16%.

A similar trend can be identified in other areas. In Switzerland new centres developed in Tessin and Schafthausen to the detriment of Geneva and Zurich and in Holland the two leading cities' loss was matched by the growth of the craft at Eindhoven, Gronigen, Hengelo and Maastricht.

Contemporary observers saw what was happening to the pewter trade. A Hungarian, writing in 1843, said of the trade "one gets the impression of a very old gentleman wearing a wig" and in the United States, another commentator wrote in 1820 "the trade in pewter had been a lucrative branch of manufacturing but about this time began to go out of fashion".

In Britain the census of 1841 only recorded 384 people in the trade (though this was certainly an underestimate), whilst in Holland in 1819 only 159 pewterers could be identified.

The rump of the pewter trade was sustained by the development of a few new markets. In Europe the rising tide of industrialisation meant that there was a brief rise in demand for pewter utensils for the home. As a consequence of metrication on the continent and the new Imperial standards in Britain, old measures had to be discarded and replaced with those of the new approved capacity.

Between 1800 and 1874 beer drinking in Britain rose four-fold and there was similar expansion in the United States. This dramatic rise in consumption created a new demand for mugs for use in taverns and bars. Without this new demand for drinking mugs and other tavern equipment the plight of the pewterers would have been even more severe.

Britannia metal production expanded rapidly. Factories replaced the small workshops and Sheffield became the British centre for britannia metal, although it was made in other centres also. Dr. Scott has identified 89 companies which worked in Sheffield between 1780 and 1850. There were 22 companies operating before 1800, 42 at work between 1800 and 1825 and at least 61 making Britannia metal between that year and 1850.

In the United States, the other main producing nation, it is possible to identify 238 companies or partnerships who worked in the trade at some time prior to 1850. The growth here too was significant. Between 1810 and 1820 some eight partnerships were operating, between 1821 and 1830 there were 46, from 1831 to 1840 over 100 and in the last decade to 1850 records can be found of at least 147 companies or groups.

Josiah Danforth was the first American to use antimony and Yales was probably the first to spin metal.

Some of the factories that emerged were large. That of James Dixon of Sheffield in 1846 employed over 400 men whilst in the United States Charles Parker, whose company went on to become the Meriden Britannia Metal Company, had 240 employees in 1850. Other partnerships or companies were more modest but generally they were larger than the old-style workshops. Luther Boardman employed 33 men in 1850, producing amongst many other items 12,000 gross of spoons in that year. Putnam had 18 employees (1855), Leonard Barton and Reed 12 (1835) and Sellew and Company 8 (1841).

The old limitations on where pewter could be sold had now gone for ever. It was available in all hardware and general stores, through braziers and blacksmiths, mail-order businesses and was also sold by pedlars, both in the United States and Europe. Timothy Bailey, himself a former pedlar, employed more than 16 pedlars in the 1830's to sell his britannia metal.

A considerable range of objects were made in britannia metal. Most important were tea and coffee pots, sugar bowls, jugs, candlesticks and snuff boxes. In the United States the production of oil lamps was significant.

The britannia industry was to continue at a peak for twenty years or more until its day was also done.

The last pewterers lingered on into the late nineteenth century, mending pewter and making a few items. The last active pewterer to be a member of the Worshipful Company of Pewterers was Englefield who died in 1927. In Edinburgh, Moyes worked on at the Grassmarket until 1870. In Germany the demand for Art Nouveau pewter kept several companies in business. At Zwolle, in Holland the Kamhoff family were making pewter this century and there are other examples of individual survival.

CHAPTER 3

Decoration on Pewter

Decoration

Pewter is lauded for its simplicity. Much is plain and unadorned but some was skillfully decorated in a variety of ways.

Most pewter forms are derived from the work of silver and goldsmiths but a few designs are unique to pewter including British baluster measures, Scottish tappit hens and French Pichets.

The shape and form an object possesses is central to the impression that it creates but there are many ways in which the basic form can be augmented.

The principal technique used to decorate pewter was to cast designs or patterns on to the surface. It was with this cast decoration that pewterers achieved their most spectacular effects.

Many other techniques of decoration were adopted including engraving, hammering the surface, painting, lacquering, silvering and gilding, fretting and the application of medallions or badges.

Cast Decoration

As most pewter is cast, the use of the term "cast decoration" can be misleading but it is used to describe those decorative features applied to the basic design in the mold.

Such features as knops, thumbpieces, handles and terminals are illustrated in the later chapters and brief studies of some leading features are included in appropriate sections.

In the sixteenth century, under the influence of Italian silversmiths, a vogue was created for flagons, ewers, tankards and dishes whose bodies were covered with intricately cast designs. This development moved European pewter dramatically away from the dominating simplicity of the medieval period. Over the next one hundred years there was a flowering of talent with many superb designs created by pewterers whose skill and craftsmanship was perhaps for the first and last time matched by their artistic talents.

These new cast designs first appeared in Lyon, France in the late sixteenth century and the technique was quickly adopted in other centres.

Superbly crafted objects flowed from the workshops of Briot (1560–1616), Enderlein (1586–1633), and the Nuremberg Masters including Jacob Koch II (1588–1619).

Although many of these craftsmen did work into the seventeenth century their skills more properly lie in the earlier period.

In the seventeenth century Nuremberg was the principal centre for this "Edelzinn" or relief cast pewter. Many highly successful masters were active including H. Spatz (1630–70) and the Ohams, father and son.

Most Nuremberg designs display religious, classical or political scenes or portraits. It was Paulus Oham, the younger, who created the famous series of "tellers" or plates with portraits of Ferdinand II and III. There was also another school of design in which flowers and naturalistic designs predominated.

Relief cast pewter was also worked in other German centres such as Regensberg, Marriensberg and Joachimsthal. The production of cast pewter continued in France and a fine school developed in Strasbourg which continued into the eighteenth century, under the leadership of Issac Faust. Relief cast pewter was also made in Switzerland. The "William Tell" plates and the thirteen lobed Canton plates, are outstanding examples of the Swiss school.

Cast decorated pewter was also made in Holland, Italy and in other European centres.

This form of decoration is also found in Britain. Several interesting wine cups and beakers are known, with cast decoration embodying royal symbols. The Grainger candlestick is another example of this school of work which appeared to flower briefly between 1580 and 1620.

The use of cast decoration reappears in Britain about 1660 and continued into the eighteenth century. Most frequently found are spoons with cast portraits, almost exclusively of the reigning sovereign, and porringers with royal or other portraits are also known.

British cast decoration is not of the same high quality as the work of the European masters.

Many of the European designs used were taken from old master drawings and prints. Some were freely interpreted, others drawn with great fidelity. Popular religious scenes include Susanna, Adam and Eva, Lot, Noah and the Apostles. Classical patterns include St. George and the Dragon and Diana and Octavius, whilst political representations are also common.

In addition to scenes or portraits extensive use was made of floral patterns. Dishes and plates were decorated with elaborate arabesque patterns

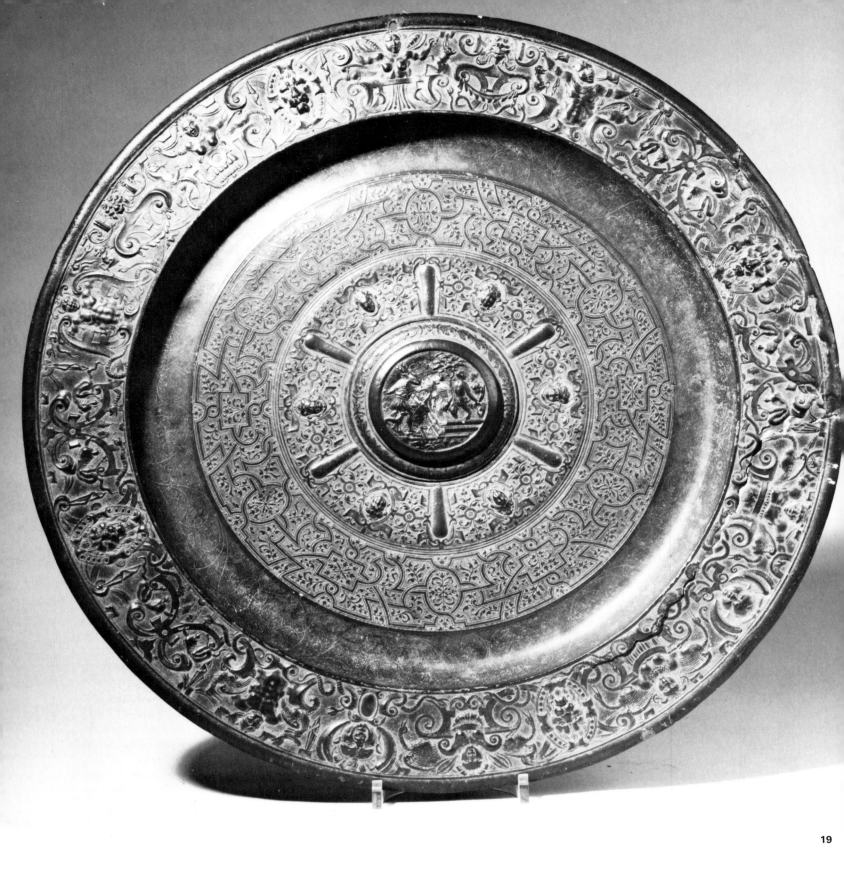

19. Superb French dish, circa 1560—1600, possibly from Lyon, 18 inches diameter. (Courtesy of Christies, London).

20. Relief cast Tankard from Strasbourg, circa 1680—90. (Courtesy of P. Boucaud).

21. German plate or saucer decorated in the Arabic manner, Nuremberg, circa 1600, 6¼ inches diameter. (Courtesy of the Kunstgewerbemuseum Cologne).

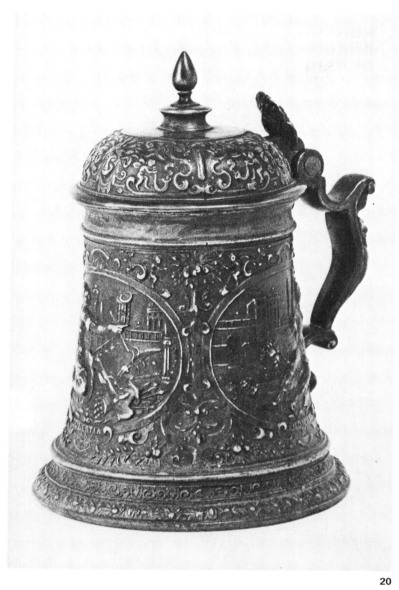

20

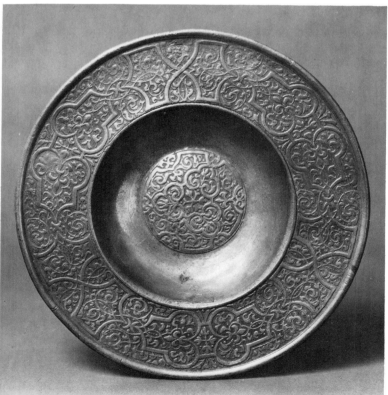

21

or closely worked designs of intertwined lines. Examples exist with a combination of several of these forms of decoration, linking the casting with engraving and punch work.

The workmanship is of an exceptionally fine quality. In some schools the casting was in substantial relief, in others flatter. In a few cases it appears as if the molds were made with acid etching as the relief is so fine and shallow.

Many examples of relief cast pewter bear the mark of the Master who made them, usually a very small mark cast into the design and difficult to find. By the mid-seventeenth century the makers marks are also sometimes placed on the back or underside of the object.

Molds passed from father to son, and were frequently used over several generations. At first the second owner would carefully add his own mark but towards the end of the seventeenth century pewterers became less disciplined and many unmarked examples exist. During the nineteenth century copies were once more made from the original molds, either without marks or with the false mark of the original owner of the mold.

It is not easy to tell copies or originals apart as the same molds were used to make both. Generally the workmanship on later casting is inferior, the patterns poorly finished and the plates do not show much sign of age or use. The turning on the back of plates also differs. Early turnings are spiral while later copies have concentric rings of turning.

Relief cast pewter was made in the eighteenth century although changing tastes produced new designs.

Popular were porringers or "ecuelles" with cast patterns on ears and lids. Fine examples occur in Switzerland and from Paris and Lyon in France.

Plates, ewers, flasks and candlesticks were also decorated with relief casting. Generally the designs are less detailed, simpler and less extensive, than in the seventeenth century.

In the eighteenth century a new form of cast decoration became popular. The shape of an object was altered by giving it movement.

With this form of decoration the lines of the design are twisted and turned to create a wrythen effect. This rococo style was widely adopted in Frankfurt, other parts of Germany, in Austro-Hungary and Scandinavia and was popular from around 1750 to the 1800's. The whole range of pewter production was treated in this fashion.

Engraving

Engraving was widely used in Europe but is less common in Britain and America. European engraving is usually more extensive and less restrained than engraving in the Anglo-Saxon tradition.

Most engraving was done without the aid of machines, the artist or craftsman cutting the surface with a hand-held tool. The shape of the cutting tool used and the way it was applied could

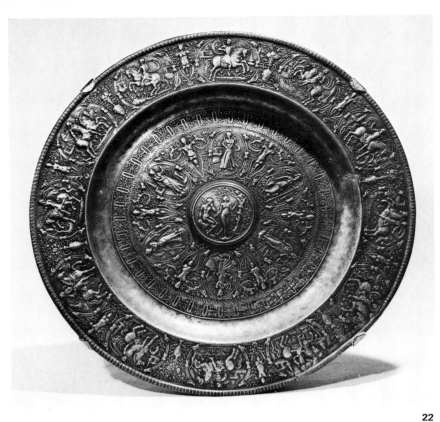

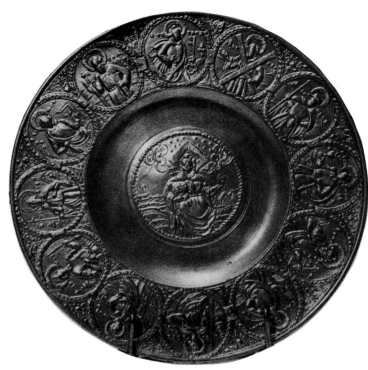

22

24

22. Large relief cast dish, French, circa 1600, 18½ inches with central motif of Adam and Eve, decorated with romantic figures and Sovereigns of the Holy Roman Empire. (Courtesy of Dr. Fritz Nagel).

23. LEFT: Heavily cast dish comprising high and low relief pattern, by N. Horchhaimer of Nuremberg, circa 1580. RIGHT: Plate with ornamental border by Hans Spatz II, Nuremberg, circa 1650, 8¾ inches diameter. (Courtesy of Kunstgewerbemuseum Cologne).

24. An Apostle plate or "teller", the central figure is Christ, with the Apostles round the rim. From Memmingen in Germany, circa 1629 by W. Locher, 7 inches diameter. (Courtesy of Dr. Fritz Nagel).

23

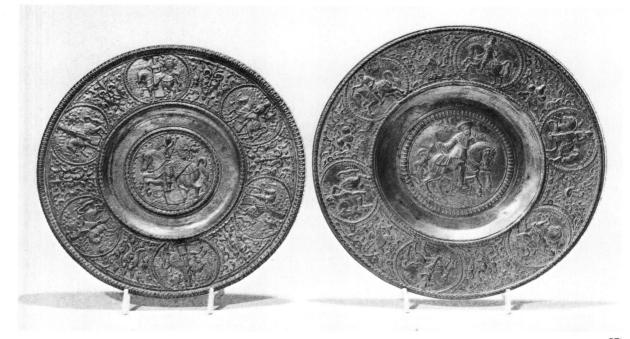

25

25. Two relief cast plates, both German from Nuremberg;
LEFT: Ferdinand III by A. Mergenthaler, seventeenth
century, 7¼ inches diameter. RIGHT: Gustav Adolphus
of Sweden by Paulus Oham the younger, seventeenth
century, 8 inches diamter. (Courtesy of Dr. Fritz Nagel).

26. Further religious motif plate, German, seventeenth
century. The Virgin with Apostles. (Courtesy of Sotheby
Parke Bernet, London).

27. LEFT: Swiss relief cast plate with Arms of Cantons, by
J. Schirmer of St. Gallen, circa 1680—90, 8½ inches
diameter. RIGHT: Flower decorated plate, German, by
H. Spatz II, Nuremberg, 7¼ inches diameter, circa 1650.
(Courtesy of Kunstgewerbemuseum Cologne).

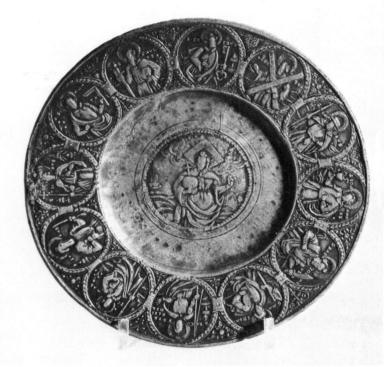
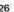

26

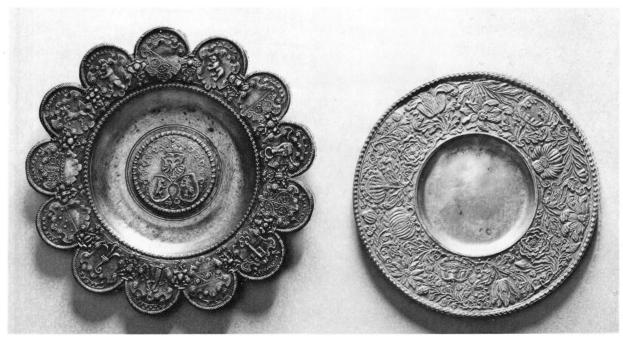

27

produce a variety of different cuts on the surface, each with its distinctive shape.

Some engraving tools left a small valley behind, others replaced the metal creating a series of furrows. Such engraving produced a continuous line. By cutting and then lifting the tool a broken line could be achieved that is known as "wrigglework".

The shape of the engraving tool would also change the shape of the cuts made in the pewter; some tools were rounded, others created square cuts and so on. A combination of different tools can sometimes be seen in engravings.

More detailed scenes were drawn on paper and the image produced on the surface by coating it with a thin film of wax and tracing the pattern into it. The lines thus made in the wax could then be engraved.

In Britain, Guild regulations forbade the use of artists for this work; the engraving and design had to be done by the craftsman who made the pewter. As a consequence British engraving is less well executed and more naive than the continental.

One pewterer, for example, Andrew Boyn, was twice reprimanded around 1580—1600 for allowing a "stranger to grave up on his pewter".

Roses, tulips, birds, beasts and other bucolic objects are widely employed in British wrigglework from around 1650 until about 1720. This work is found on flat-lidded tankards, plates, loving cups and many other items.

The form of engraving known as "Bright cutting" was occasionally used on pewter towards the end of the eighteenth century. The cut made by a beveled tool was burnished along one edge to give an impression of light and movement. A few examples of bright cutting are found on American pewter and in Britain and Europe.

Another form of engraving is lathe turning. Thin reeded lines are cut into the surface by turning the object on a lathe and applying a thin cutting tool as it spins around. Early triple-reeded plates have these incised lines and bands of similar incised decoration are found on the bodies of tankards and flagons.

In Oxford, England a few rare examples are found of plates decorated in this fashion by Quaker clockmakers who engraved their brass clock faces in the 1800's in a similar manner.

Very rarely the decoration was cut into the pewter not by a tool but by etching the surface with acid. It is probable that the process was similar to that used to prepare a printing plate; the parts to be kept plain were protected by a sheet of wax. Acid etching, some of fine, some of poor quality is found on pewter from Holland, Germany and Italy.

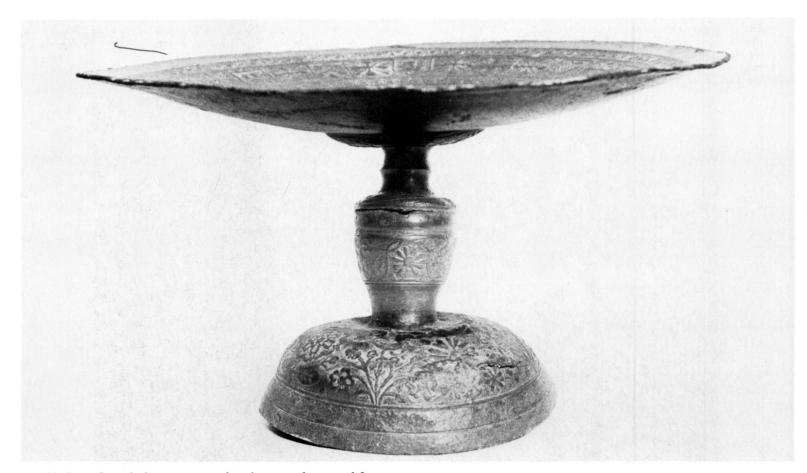

28. Rare footed plate or tazza, showing cast decorated foot and stem, English, circa 1616. From Great Shefford Church, Berkshire. (Courtesy of Rector of Great Shefford Church).

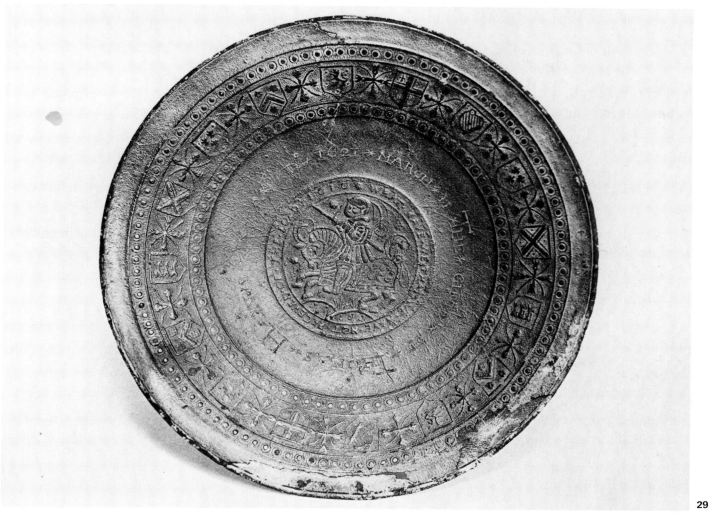

29

29. Top of the tazza, showing cast decoration and inscription. The first cast inscription reads "What have we that we have not received of the Lord 1616" and an engraved inscription "The gift of Thomas Harvie in Ano Do 1621 March 31st". (Courtesy of the Rector).

30. Fragment of cast decoration from Stanislaw Solkiewski's coffin at Lwow, circa 1620, 10¾ inches high. Polish. (Courtesy of Cracow Museum).

30

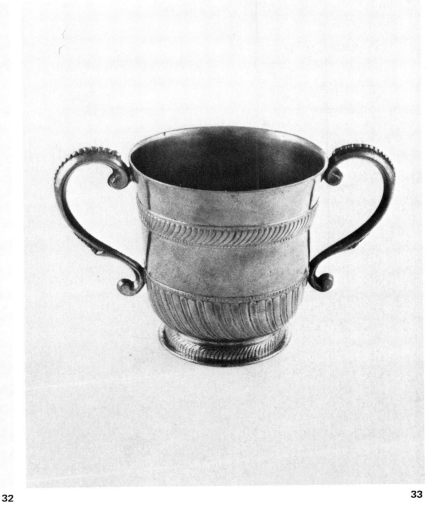

31 **32** **33**

35

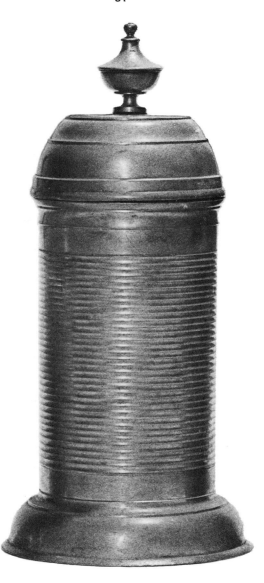

31. English portrait spoon, a caricature of George III as "Farmer George". Circa 1780. (From the Bishop-Vellacott Collection).

32. Decorated spoon back, English mid-eighteenth century showing shell pattern. (From the Bishop-Vellacott Collection).

33. Decorated body and cast handles, on a Bonyng, American two handled cup. (Collection of Dr. and Mrs. Melvyn Wolf).

34. German seventeenth century tankard with cast reeded body. Glatz, 1664, 7½ inches high. (Courtesy of Dr. Fritz Nagel).

35. Cast decorated porringer body, English, circa 1695. (Courtesy of Sotheby Parke Bernet).

34

36

Hammer Work

The basic pewterer's tool was the hammer.

Designs could be punched onto the surface of the pewter using a hammer and individual punches or the surface could be planished so as to leave a pattern of hammermarks upon it.

Hammering the booge of plates and dishes was part of their construction but hammering over the front surface was solely undertaken as decoration.

The hammer was also used, as in copper and brass working, to raise a pattern on the surface of the pewter. This style of decoration is termed "repousse".

Superb latten or brass dishes were made in this style in Dinant and Nuremberg but few examples are known in pewter. There are a few examples from the low countries made in the eighteenth century.

In Britain dishes are found with swirled decoration. Most are by Edward Leapidge or his brother-in-law, Samuel Smith. There is some discussion about whether they were decorated at the time of manufacture or later, but it is generally accepted that the decoration was contemporary.

There are also a group of French repousse dishes with fleur de lys or a coat of arms displayed upon the surface but there have been many late copies made of these designs, often by casting rather than through use of the hammer.

Repousse work is also to be found, in a more restrained form, on dishes, plates and other items. Small "pearles" or "prunts" are hammered onto the rim of dishes in Britain and Europe, frequently in conjunction with engraving or punch decoration.

Tankards and flagons from central Europe also have this form of decoration. In Britain the use appears to have been limited to the period 1560—1680 but it occurs in Europe into the eighteenth century.

By the nineteenth century small sheets of metal could be embossed or punched under machine presses to create a similar effect to repousse work and the designs were worked up into small objects, such as snuff boxes.

Originally used as a form of decoration in the late middle ages the use of hammering as a decorative form continued in Europe into the seventeenth century and in Britain until about 1700. It is a rare form of decoration, the surface of the plate or dish being hammered all over in a series of even lines to create a planished effect, sometimes mistaken for the hammered Britannia metal products of the twentieth century. This style of decoration seems to have been restricted to Germany, Holland, and Austro—Hungary though it is occasionally found on British plates and dishes of the late seventeenth century.

The use of punches to decorate the surface of pewter probably originated from decoration applied by leatherworkers in the middle ages.

They used a variety of stamps to produce patterns on belts, purses and costrels.

With pewter two, three, four or more different punches were used and by skillful use of these punches elaborate patterns could be created around the rim of dishes. The fleur de lys, rose and daisy pattern punches are those most often found.

In Europe the punched patterns were usually combined with other forms of decoration such as repousse work or with the use of cast patterns. In Britain it is only found on a group of saucers, dishes and plates from 1560 to about 1700 and there are less than 20 examples of British punch decoration known.

Gilding, Silvering, Painting and Lacquering

All these forms of decoration are uncommon.

The silvering or gilding of pewter first occurred on church pewter but few examples survive. For periods there were restrictions on the use of pewter in the communion service and whether the use of silvered and gilded pewter was a way of avoiding these restrictions or making the objects more pleasing can now never be ascertained.

Two forms of gilding were employed; mercury gilding and the use of gold leaf. For silvering, only silver leaf was used.

Gilding and silvering was used in Germany, France, and the low countries. In France there is some evidence that the techniques were briefly permitted on domestic pewter around 1730 but for other periods its use was restricted to Church pewter.

In Britain the use of gilding was outlawed. In 1622 for example, two pewterers were accused of "painting", the term then used for gilding their pewter. In the nineteenth century there are examples of silvering by the electro-plate process on britannia metal and examples are found stamped "EPBM" for electro plated britannia metal. Occasionally earlier pieces of pewter were also plated in the nineteenth century.

Painting was occasionally used as a form of decoration in early times but as with painted oak furniture, few examples have survived with their colours intact.

One important example is a Nuremberg bowl circa 1640 with a central cast portrait, the next section gilded and the outer rim of the broad rimmed dish being painted in the style frequently used on Scandinavian treen.

In Europe the only items of pewter likely to be found painted are those decorated in what we call lacquer-work.

This technique was particularly popular in Holland and Germany and was more rarely used elsewhere. The body of the object was painted with a lacquer, usually black, yellow or green and then decorated with colours in the Chinoiserie style. Coffee urns and Chestnut urns were most commonly lacquered, but salts, candlesticks and small boxes are also found. Yellow, green, red and

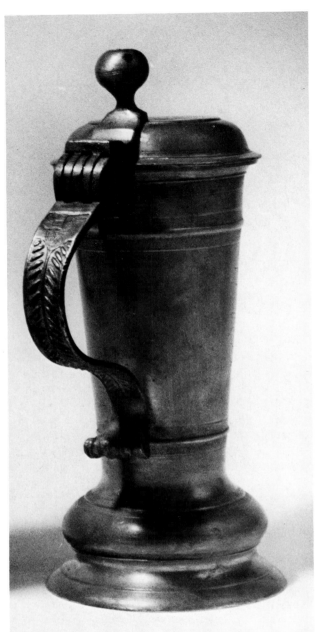

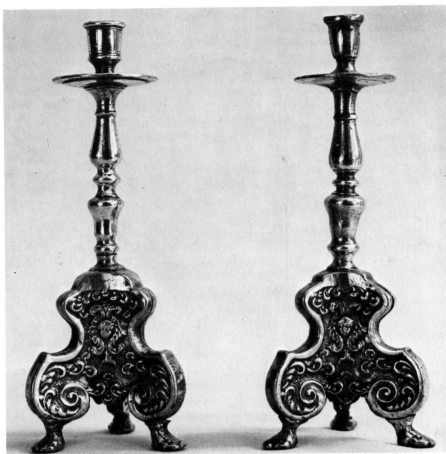

37

36. Cast handle on German tankard, circa 1745. (Courtesy of Kunsthandel Frieder Aichele).

37. Cast decorated candlestick bases. South German, circa 1770. (Courtesy of Bourgaux).

38. Cast handles and decorated foot on drinking cup or caudle cup, German, nineteenth century. (Courtesy of Dr. Fritz Nagel).

36

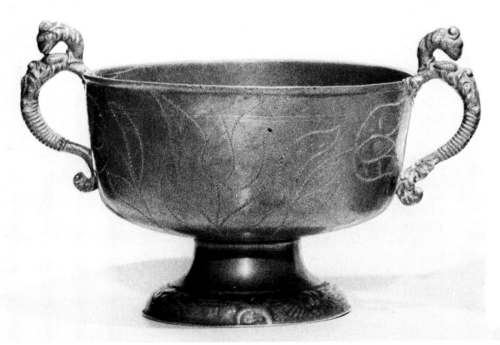

38

gold are the colours usually used to paint the patterns over the basic body colour.

Inlay and the Use of Other Metals

There are several instances of the use of brass to decorate pewter. A seventeenth century flagon from Nymegen in Holland has bands of brass and another flagon from the Bakers' Guild in the same town is inlaid with silver. There are other seventeenth century examples of the use of brass with pewter from Germany, Switzerland and Sweden.

In the late eighteenth and early nineteenth centuries brass-decorated guild flagons were popular in the north of Germany, especially from Kiel, Lubeck and Bremen.

The idea of combining brass and pewter also appears in Britain but in a very limited and specific field. Spoon makers from the fifteenth century had combined brass or latten knops on pewter spoons. In the sixteenth century there are examples of this technique signed I.G. for James God who was fined for this illegal practice by the guild in 1567.

In the United States a combination of brass and pewter is only found on lamps by R. Gleason in which the optical glass is mounted and shaded with brass.

Cutting and Fretting

Pewter was also decorated by cutting out patterns on the surface. From Holland, Germany and Switzerland come attractive cake dishes with fretted designs.

The punching of holes in cullenders or straining plates could also be turned into a decorative feature, placing the holes to create patterns.

Badges, Medallions and Rosettes

Pewter was sometimes decorated by adding medallions or badges to the surface. Many of these badges take the form of a coat of arms and were probably designed to have the owner's arms engraved upon them. Coats of arms are widely found on German, Austro-Hungarian and Swiss Guild flagons.

Medallions made in the form of a deep cast seal were applied for the same purpose to Nymegen and other Dutch flagons.

Seals or medallions are to be found upon the top of flagon or tankard lids. some are blank, perhaps never filled in by the first or subsequent owners, others have initials or coat of arms and still others have cast scenes or buildings amongst other patterns.

Coins were also used as seals and special commemorative medallions are found soldered to the lids of tankards especially those from Scandinavia. Portraits include Oscar (1844—59) and Charles XIV (1809—1819) from Sweden and Frederick IV (circa 1785) from Denmark.

There are a few British and American examples; a John Will tankard has a medal of Elijah and British tankards include examples with a medallion of John Wilkes.

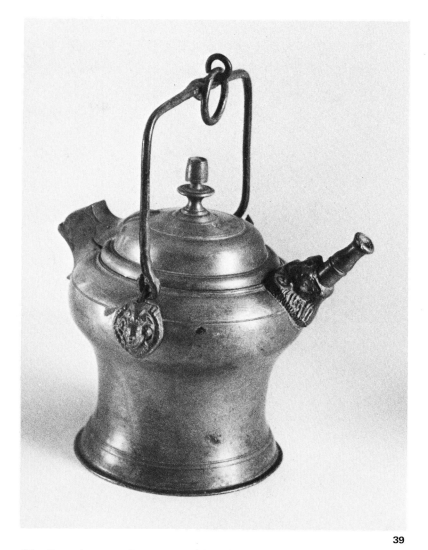

39. Cast decorated spout and mask on Swiss "Sugerli" eighteenth century. (Courtesy of Kunsthandel Frieder Aichele).

40 & 41. Two spoon handles with cast patterns. LEFT: English, circa 1660. RIGHT: Dutch, hoof knop, circa 1690. (Robin Bellamy Ltd).

 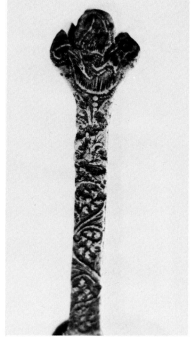

40 41

A few of these medallions have been enamelled. There is a reference circa 1630 to this practice in Holland and a number of British dishes have an enamelled badge in the centre. Some of these dishes are in churches but their exact purpose is not known. They may have been alms dishes or used for rose bowls. Several incorporate the royal arms of Charles I.

A considerable number of Swiss, German and Austro-Hungarian flagons and tankards are decorated inside the base with a cast badge or rosette. It is possible to identify some of the makers through the type of medallion they used. A study published in Germany in 1920 identified 54 different Austro-German examples, most of which incorporated an urn or flowers. A Swiss study found 92 badges, mostly roses but others with religious badges, birds or animals.

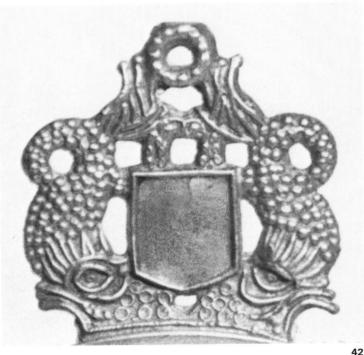

42. American Dolphin porringer handle, another example of the many cast features found on pewter.

43. Typical cast decorated handle from a German or Austrian tankard or flagon circa 1650—1780. (Art work by A. Cross).

44. Cast decoration on English porringer lid and handles, circa 1702. (Courtesy of Worshipful Company of Pewterers, London).

42

44

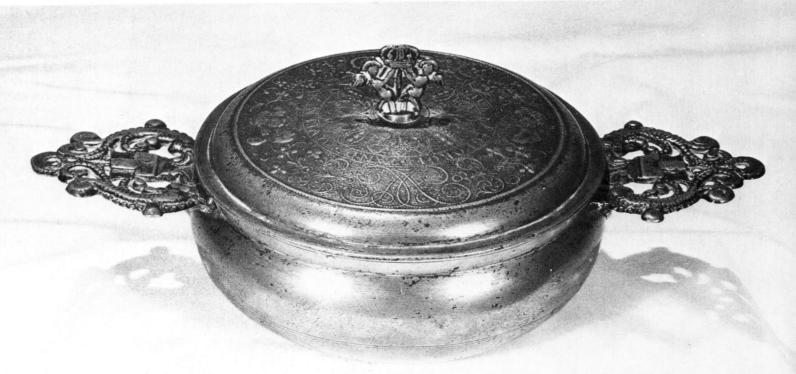

Pewter As a Decoration

Pewter has been used as an inlay and as a decoration on objects made in other materials.

Furniture has been inlaid with thin strips of pewter to form decorative patterns similar to those found in the early nineteenth century in brass. Examples are found of Scandinavian, German and British coffers and bureaux, and pewter has been used to decorate clock-cases and barometers.

Pewter inlay has also been added to wooded stave tankards known as "Pechkrugs". Examples are rare. They first appear in the seventeenth century in Thuringia in Germany and in the nineteenth century there are Scandinavian examples.

These wooden tankards also have pewter lids, thumbpieces and handles and are mounted at top and bottom with pewter. Bone, ivory, serpentine and pottery tankards are also found with similar pewter mounts, lids and handles. Pottery examples from all parts of Europe were mounted in this way from the sixteenth century onwards. Most stone, ivory or bone tankards are German.

ENGRAVING

Wrigglework

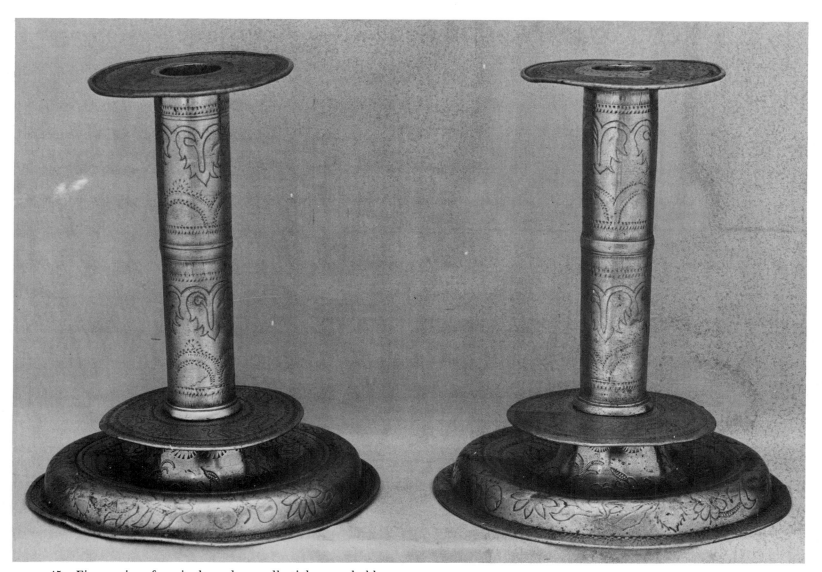

45. Fine pair of wrigglework candlesticks, probably Dutch, mid-seventeenth century. The wrigglework with its movement and well executed form is also typically Dutch. Rose and crown mark. (Courtesy of the Metropolitan Museum of Art, New York. Rogers Fund).

46. Dutch beaker with wrigglework decoration, 6¾ inches high, late seventeenth century. In addition to such floral patterns many beakers were decorated with portraits of William, Prince of Orange. (Courtesy of Christies).

47. Group of three English tankards with wrigglework decoration, the example in the centre being circa 1695, the other two circa 1680. (Courtesy of Sotheby Parke Bernet).

48. Superb wriggleworked plate with portrait of Charles II, English. (Courtesy of Sotheby Parke Bernet).

49. Fretted and wriggleworked cake plate of fine quality, German, seventeenth century. (Courtesy of P. Boucaud).

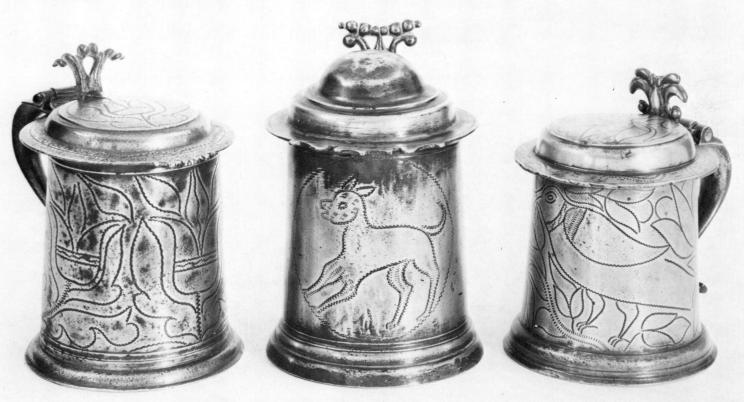

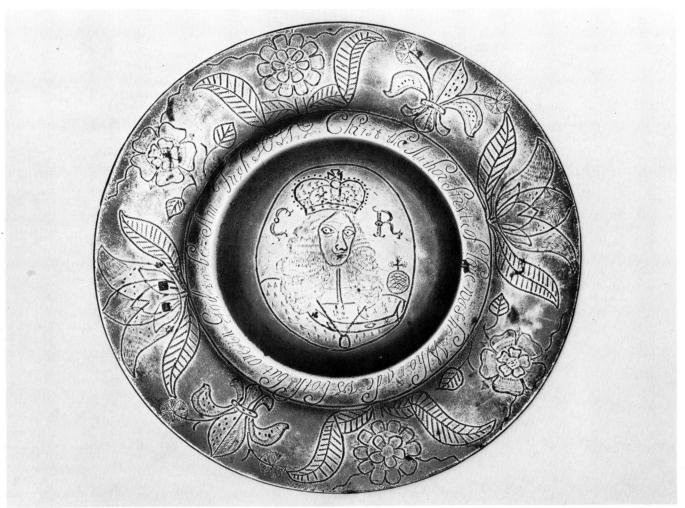

48

49

43

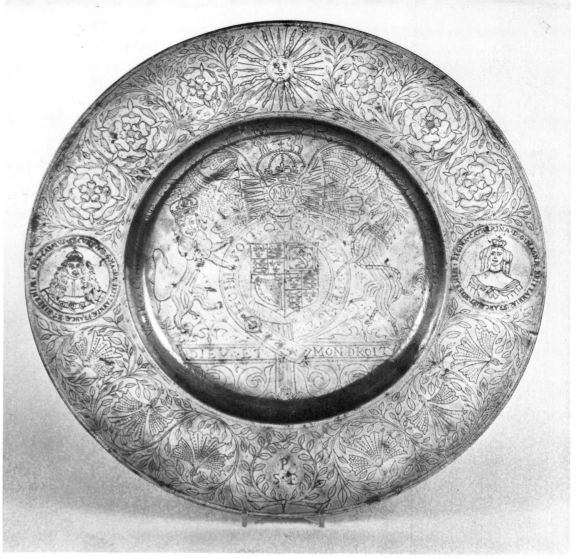

50

50. Fine Charles II marriage dish with royal portraits and heavily decorated surface. Twenty-two inches diameter, English, circa 1662. (Courtesy of Christies, London).

51. Rare Scottish flagon with wriggled portrait of a puritan, circa 1680. (Courtesy of the Parish Minister, Brechin Cathedral).

52. Royal portrait plate of William III, circa 1695, 8½ inches wide. (Courtesy of Sotheby Parke Bernet).

53. Many plates have rustic or floral patterns. This example displays the widely used Tulip, dated 1731 but made around 1700, 16¾ inches diameter dish. (Courtesy

51 of Mr. C. Minchin).

44

52

53

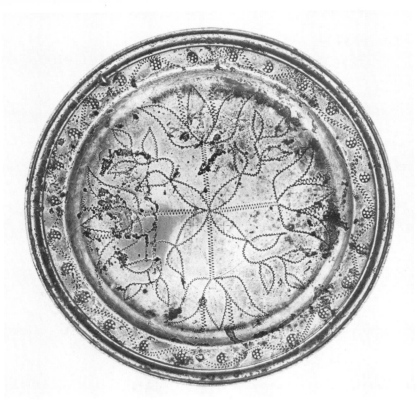

54. The tulip motif appears again in this plate, circa 1680—85. (Courtesy of Sotheby Parke Bernet).

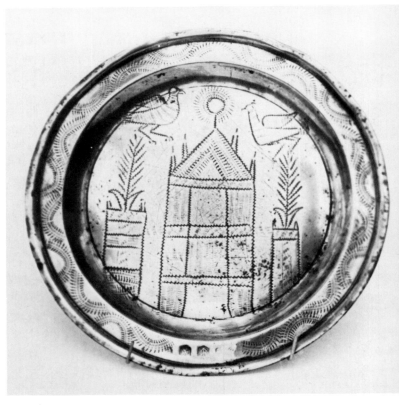

55. Physical structures like this castle are rare in English wrigglework, circa 1680. (Robin Bellamy Ltd).

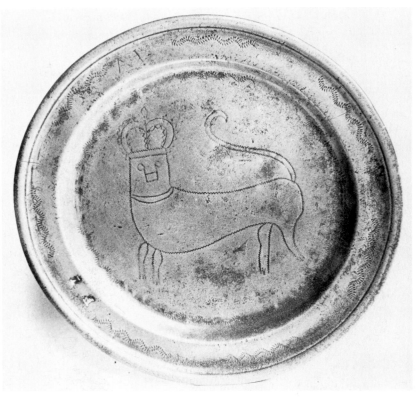

56. Some English wriggle work depicts birds and animals as with this rather coy lion, circa 1690. (From the Little Collection).

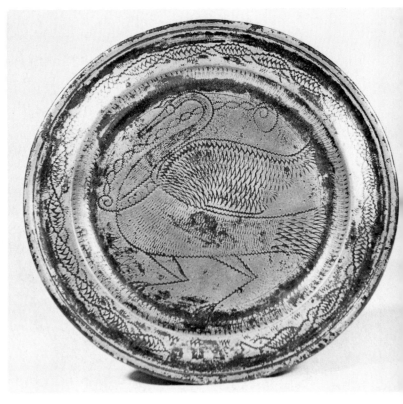

57. Swans are popular representations, circa 1670. (From the Minchin Collection).

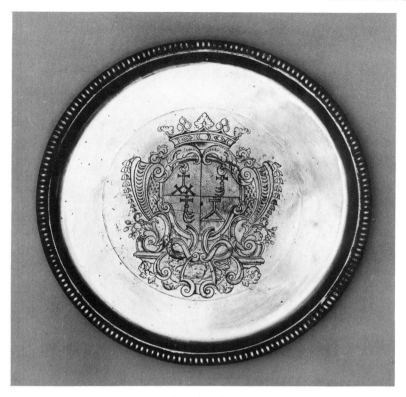

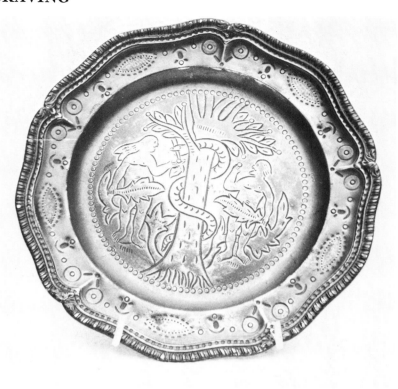

58. European engraving is often very fine. This superb example comes from a Swiss dish, eighteenth century. (Courtesy of P. Boucaud).

59. The lines are not always so fine or the patterns so well drawn as this rather rustic Adam and Eve scene confirms. On a German plate, mid-eighteenth century. (Courtesy of Robin Bellamy Ltd).

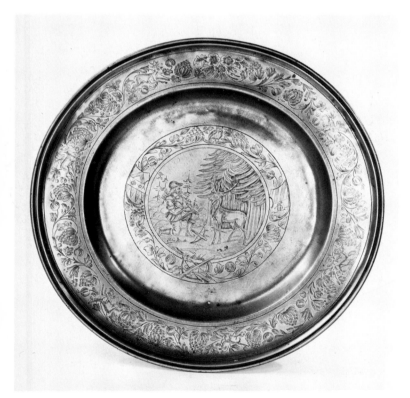

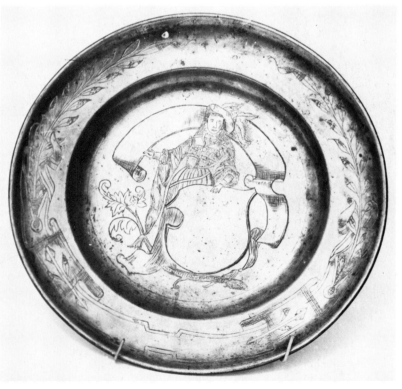

60. A typical Swiss engraved dish, late eighteenth century. (Courtesy of Christies, London).

61. A German late eighteenth century engraved dish. (Courtesy of Robin Bellamy Ltd).

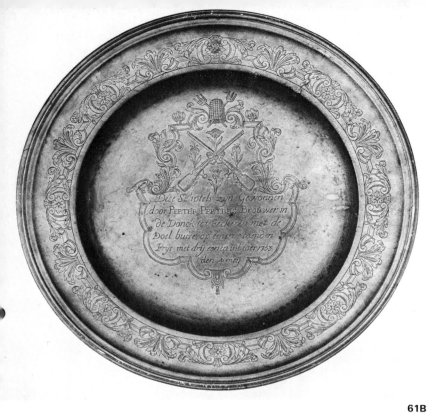

61B

62

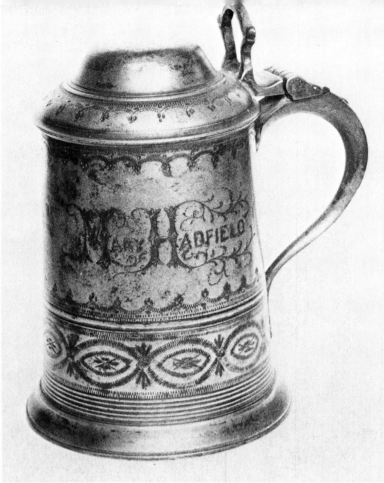

64

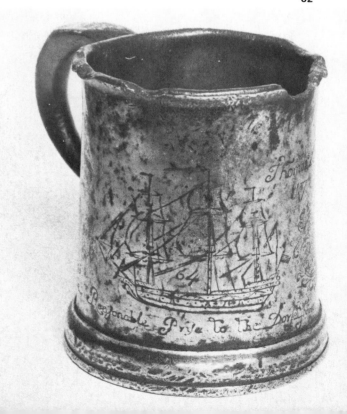

63

61B. Finely engraved German dish, circa 1755. Diameter 14½ inches. (Courtesy of Mr. Wolf Amelung).

62. A finely engraved English plain rimmed plated decorated with a Hogarth scene, mid-eighteenth century. (Courtesy of Robin Bellamy Ltd).

63. British engraving is often less well executed as compared with European examples as this most interesting tankard confirms. It is decorated with a ship and the name of a former owner. (Collection of Mr. K. Gordon).

64. This late eighteenth century domed tankard has heavy engraving in several styles, English. (Collection of Dr. Law).

65. This Stuart flat lidded tankard has a rare example of point engraving around the top and bottom of the body, circa 1660, English. (Courtesy of Mr. C. Minchin).

66. Engraving is rare on American pewter, but this sugar bowl by Whitlock of New York, circa 1830 is one example, 5¼ inches high. (Collection of Dr. and Mrs. Melvyn Wolf).

67. Another example of American engraving; on a tea pot by T. & S. Boardman, 7½ inches high. (Collection of Dr. and Mrs. Melvyn Wolf).

68. Inscriptions are commonplace on pewter and although they were not designed as decoration do often enhance an object. This English plate is dated 1718, 8 inches diameter. By John Savage. (Collection of Mr. K. Gordon).

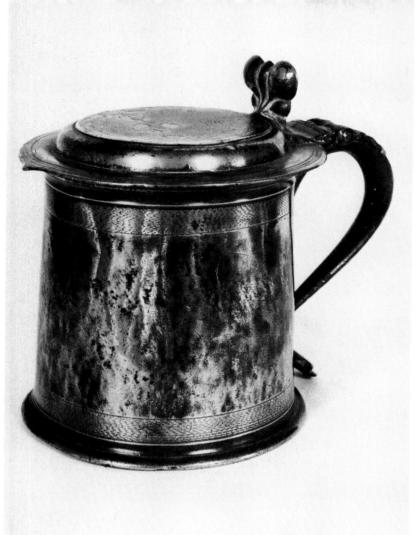

65

66

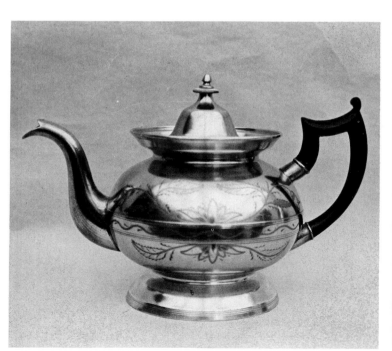

67

68

49

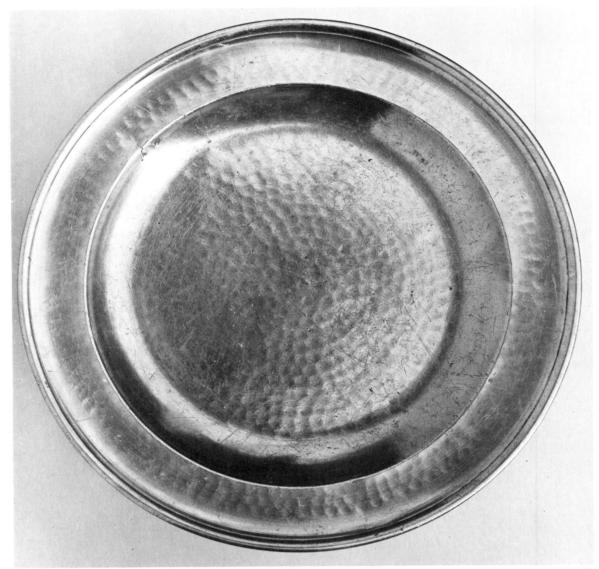

69

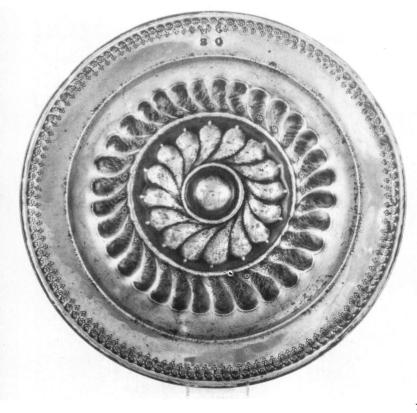

70

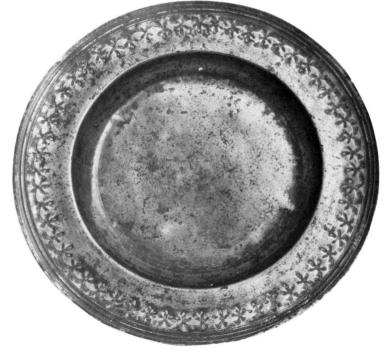

71

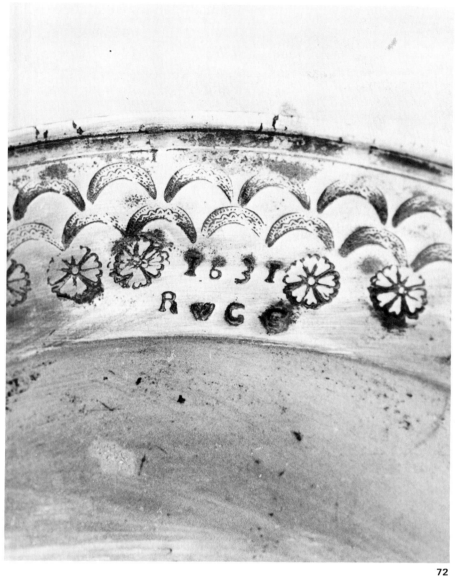

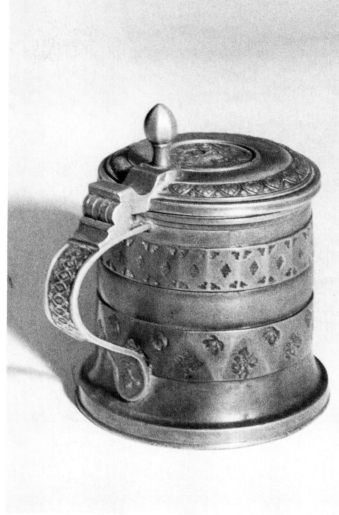

72

73

69. An excellent example of a hammered dish. Made by Simon Edgell of Philadelphia, first half of the eighteenth century. English plates are also occasionally found with the same work and from Germany even more finely hammered patterns are known from the seventeenth century. (Courtesy of the Metropolitan Museum of Art, New York. Gift of Joseph France).

70. Punch decoration is found on a considerable number of objects often combined with other forms of decoration such as cast relief and hammerwork. This English repousse dish, circa 1720 has both hammered designs and punch decoration. (From the Little Collection).

71. Punch decorated charger, English, late seventeenth century. The patterns are created by the use of two or more different punches. (Courtesy of Robin Bellamy Ltd).

72. An enlargment from another English punch decorated dish dated 1631 showing the two punches involved. (Courtesy of Robin Bellamy Ltd).

73. Here punch decoration is combined with a cast decorated handle and a medallion on a German tankard, circa 1850. (Courtesy of Kunsthandel Frieder Aichele).

74. A punch decorated dish from Northern Italy, late eighteenth century. (Courtesy of P. Boucaud).

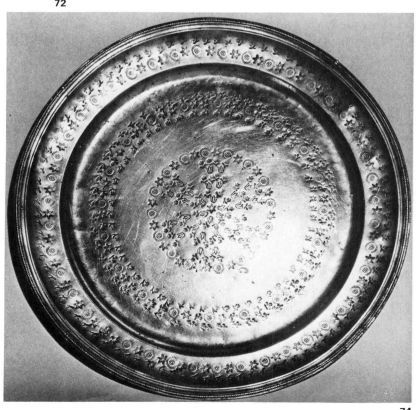

74

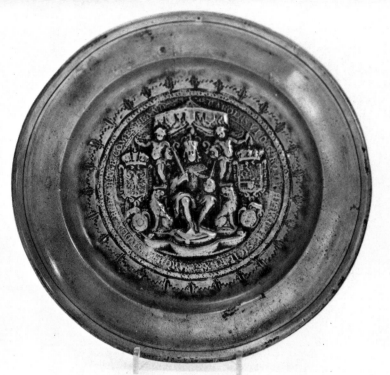

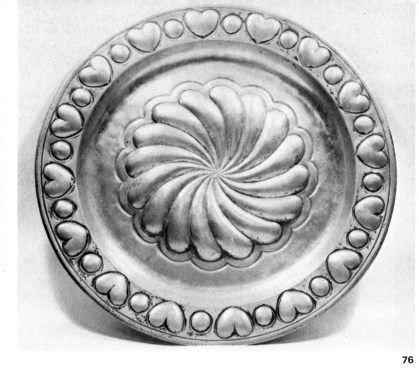

76

75

77

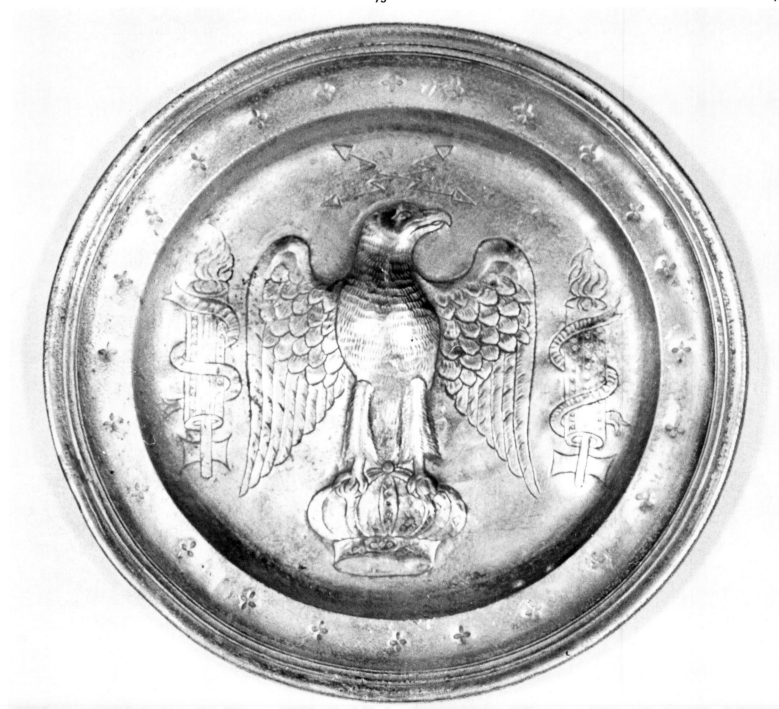

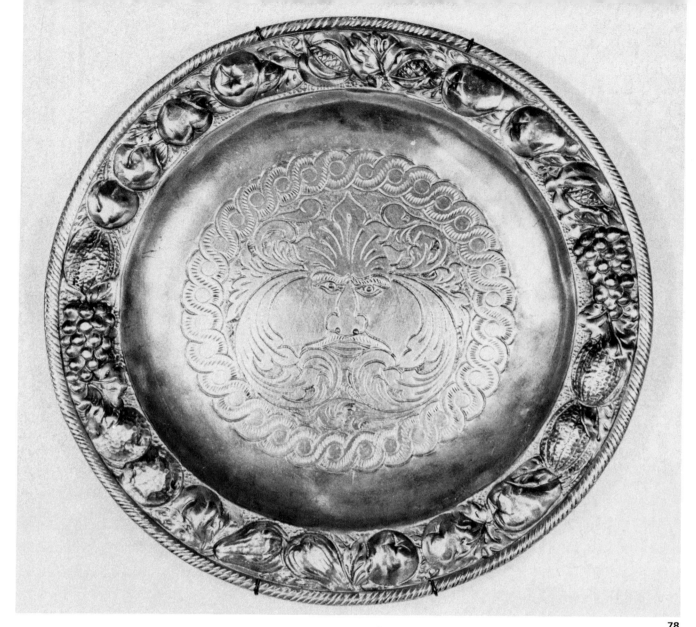

75. Cast relief decoration on a low countries plate combined with punched decoration. 9 inches, eighteenth century. (Courtesy of Sotheby Parke Bernet).

76. Embossed dish, German, from Frankfort last half of eighteenth century. Some of this type of work is undertaken by machine pressing, but some was hammer work. (Collection of Marianne & Albert Phiebig).

77. French plate decorated with Napoleonic Eagle, circa 1800. Many originally plain plates were later decorated

with such motifs and later still hundreds of cast copies were also made. (Collection of Marianne & Albert Phiebig).

78. Embossed and engraved Italian plate, 11½ inches diameter, circa 1800. (Collection of Marianne & Albert Phiebig).

79. A group of four German embossed dishes, from 1770 to around 1800, 9 to 11 inches diameter. (Courtesy of Dr. Fritz Nagel).

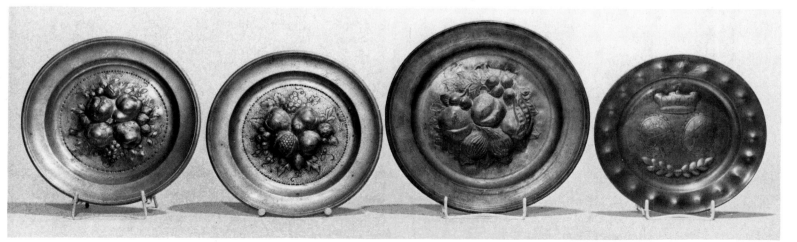

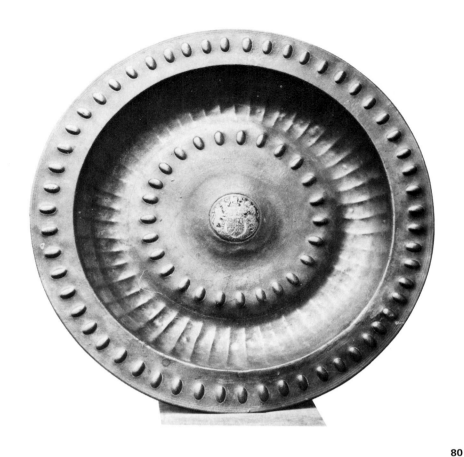

80

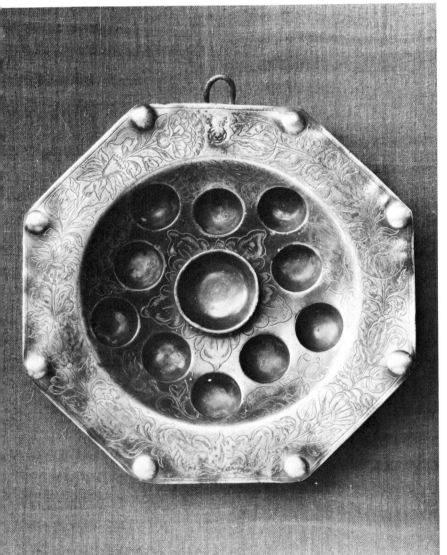

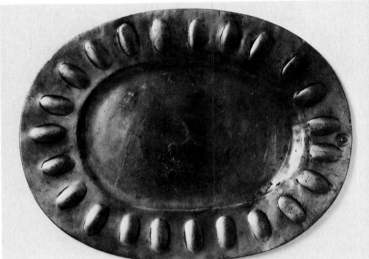

81

80. An English prunted dish, circa 1610—20, with a cast "surrey" enamel boss in centre. (See medallions in decoration). The "perles" or prunts were raised by a hammerman and this form of decoration was also employed in the late sixteenth century in Europe as well as Britain. (From the Little Collection).

81. Oval platter or dish by H.J. Etli, Swiss from Obwalden, mid-eighteenth century with prunts or perles, 11 inches wide. (Courtesy of the Swiss National Museum, Zurich).

82. Unusually shaped plate in which the basic purpose is reflected in the design. An egg plate with central depression for salt, the rim engraved. Danish seventeenth century. (Courtesy of the National Museum Copenhagen).

82

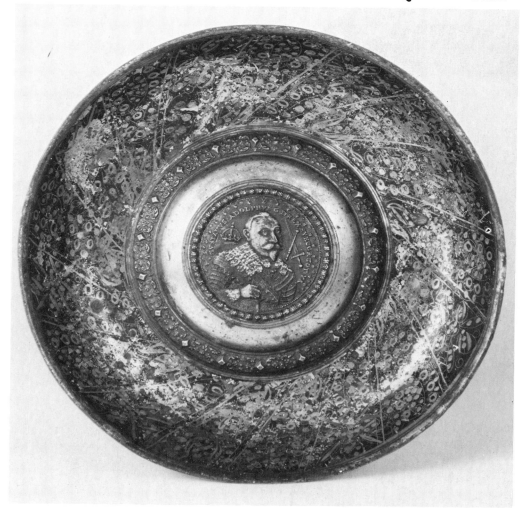

83

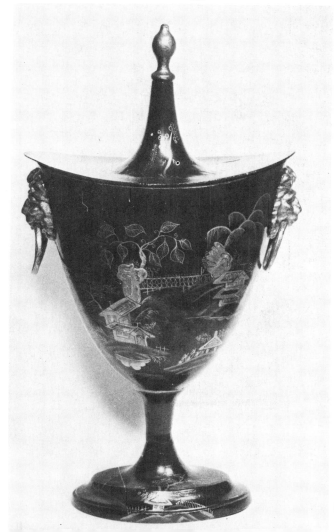

84

83. Bowl by "A.L.", Nuremberg, circa 1630, 9¾ inches diameter. The centre has a cast portrait of King Gustavus Adolphus. The background is black lacquer gilden with patterns. There is a gilded band round the portrait. (Courtesy of the Kunstgewerbemuseum Cologne).

84. One of a pair of lacquered chestnut urns, Dutch, circa 1800. The body painted with Chinoiserie decoration, 13 inches high. (Collection of William F. Kayhoe).

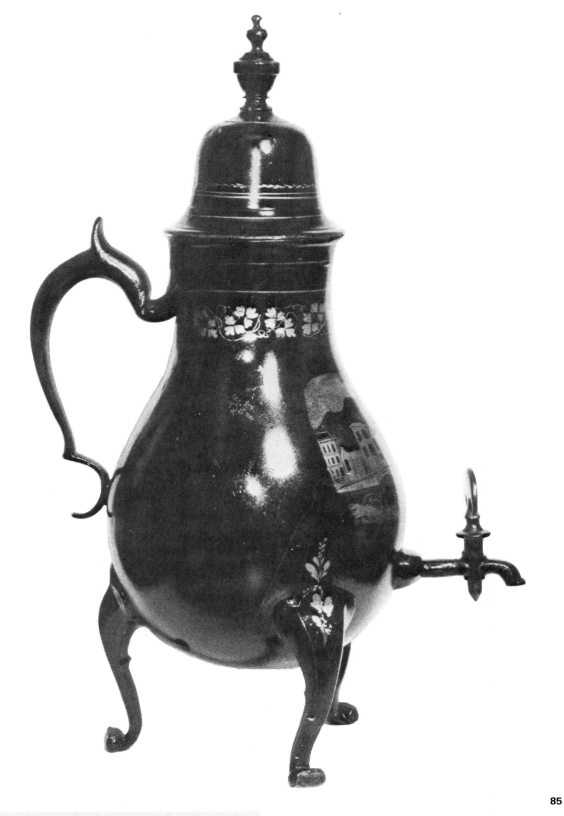

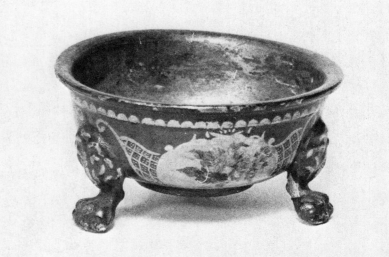

85. A Dutch coffee urn, 16 inches high, again with chinoiserie decoration, late eighteenth century. (Collection of William F. Kayhoe).

86. Green lacquer salt, with polychrome decoration, European, circa 1800, 3 inches wide. (Private collection).

87. North German late eighteenth century guild tankard with brass thumbpiece and body inlaid with brass. Dated 1799. (Courtesy of Sotheby Parke Bernet).

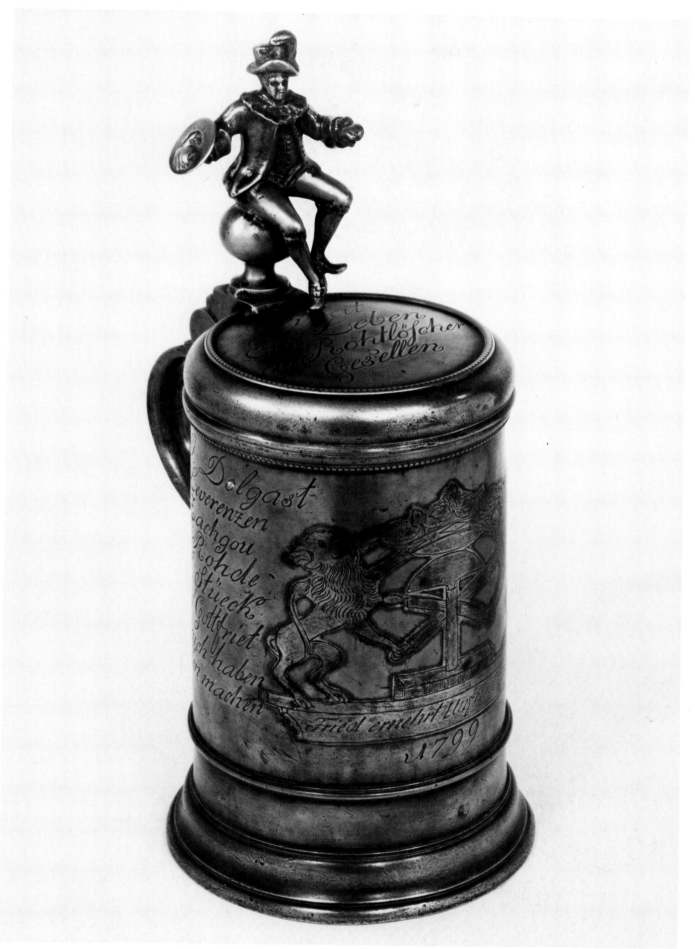

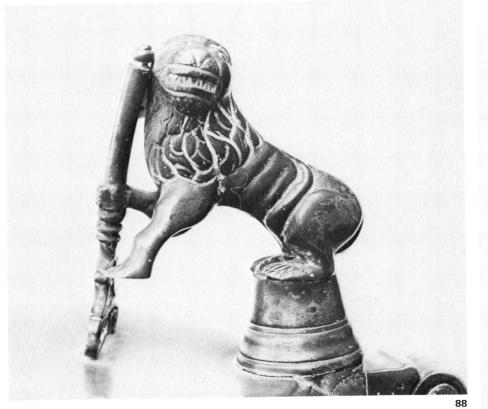

88

89

88. A bronze thumbpiece from another North German guild tankard, Kiel late eighteenth century. This example is probably from a medieval lattern tankard and was worked into a new guild tankard when it was made. The hinge is in brass. (Robin Bellamy Ltd).

89. An English mid-seventeenth century trumpet candlestick with a brass rim to base, 6¼ inches high, circa 1650. (From the Kydd Collection).

90. Copper inlay in a water fountain basin, Swiss mid-eighteenth century. (Courtesy of P. Boucaud).

91. Swiss flagon with bronze spout handles and mount. These "Bugelkanne" were made from the sixteenth to nineteenth century but more elaborate forms are earlier. (Courtesy of Dr. Fritz Nagel).

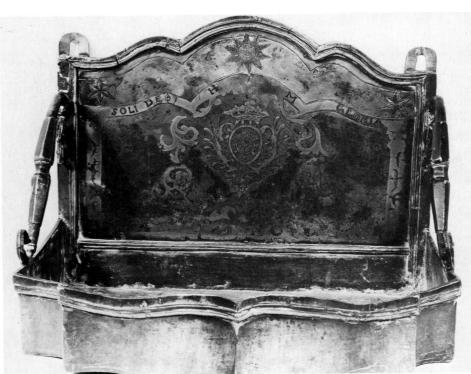

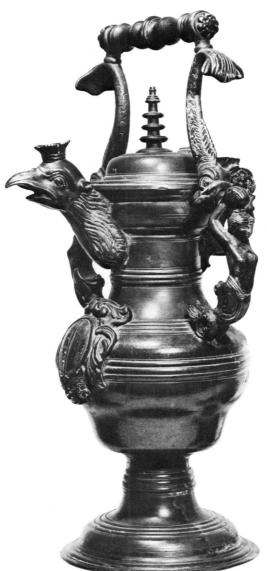

90

91

92

92. A central European cake plate of fretted form, the cut surfaces decorated with engraving and shaped into fishes. Eighteenth century. (Collection of Marianne & Albert Phiebig).

93. A rare English plate with decoration applied on a wheel. Similar to that used in Quaker clock workshops for clock faces towards the end of the eighteenth century. (Robin Bellamy Ltd).

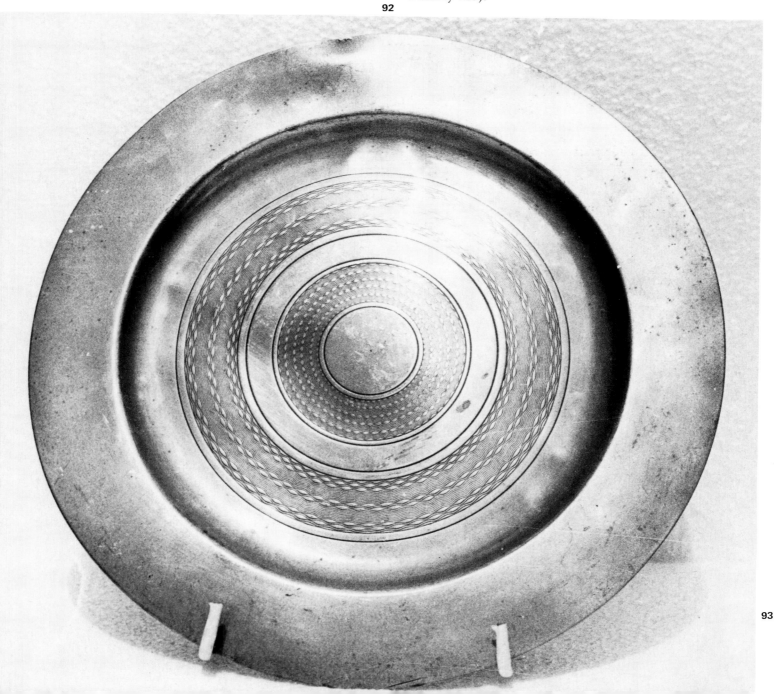

93

94

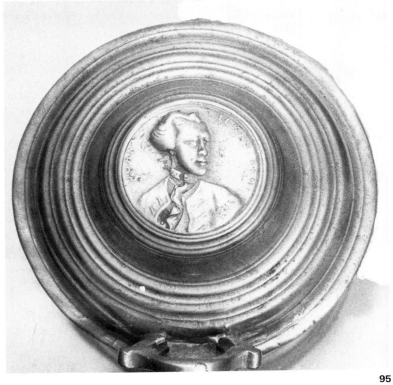

95

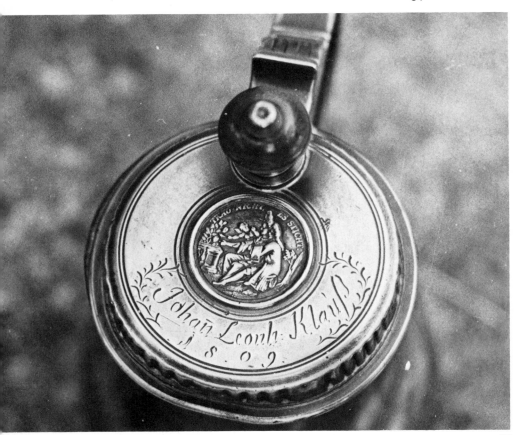

96

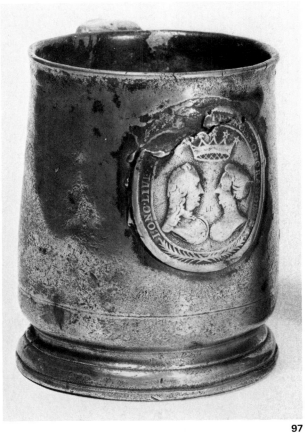

97

94. English dish with enameled central boss, 9¾ inches diameter with deep booge. The boss is a Royal Coat of Arms, circa 1600—20. One of a rare group of plates and dishes with such bosses. (Courtesy of Mr. C. Minchin).

95. A commemorative medallion of John Wilkes on an English domed tankard late eighteenth century. (Courtesy of Mr. Charles V. Swain).

96. A continental cast medallion on the lid of a tankard, early eighteenth century, German. (Robin Bellamy Ltd).

97. Mug with cast decorated portrait medallion applied, English, early eighteenth century. (Courtesy of Worshipful Company of Pewterers, London).

98. Rare mulberry bureau with pewter inlay. By Coxed and Woster, English eighteenth century. (Courtesy of Oasis Fine Arts Ltd., Liverpool).

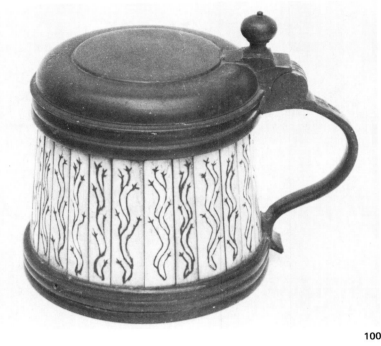

100

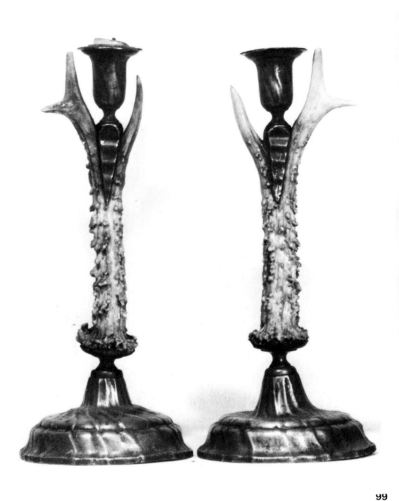

99

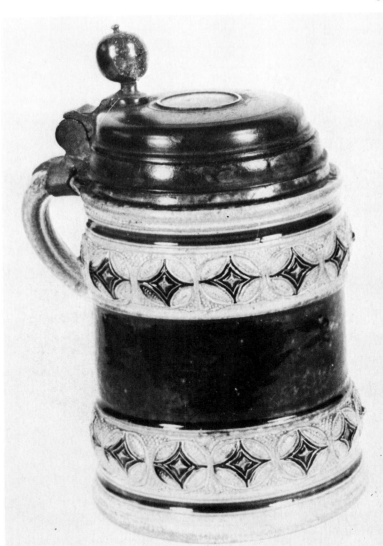

101

99. Pewter has been combined with many materials. This pair of candlesticks are made from stag horn mounted in pewter. From the Tirol, eighteenth century, 10 inches high. (Courtesy of Dr. Fritz Nagel).

100. A bone tankard with pewter mounts. Germany early eighteenth century. Pewter was also used to mount serpentine tankards from the seventeenth century onwards but all examples of these forms of work are rare. (Robin Bellamy Ltd).

101. A considerable variety of pottery tankards have pewter mounts. This example is from Zittau in Germany, circa 1700—10. 7 7/8 inches high. Similar pottery tankards and other vessels have pewter mounts and examples can be found from the earliest times in to the nineteenth century from all pottery manufacturing areas and countries. (Robin Bellamy Ltd).

102. Pottery tankard with pewter mounts, Central European or German, circa 1760. (Collection of Mr. and Mrs. Robert E. Asher).

103. Wooden stave tankards and other objects are found mounted in pewter and with pewter inlay. Early examples can date to the seventeenth century and this work was still being undertaken in the nineteenth century. This example is German, circa 1700—20. (Robin Bellamy Ltd).

104. Many of these pewter mounted treen vessels come from Germany. They are known as Lichtenhainer tankards or "Pechkrugs". This example is from Augsburg, circa 1730—50. (Courtesy of Kunsthaus Lempertz, Cologne).

105. Treen vessels were also mounted with pewter in Scandinavia and the Baltic states. This unusual flagon is however German, circa 1800, 10 1/8 inches high. (Courtesy of Dr. Fritz Nagel).

106. Wooden or treen bottle with pewter mounts from Germany, eighteenth century. (Courtesy of Hungarian National Museum, Budapest).

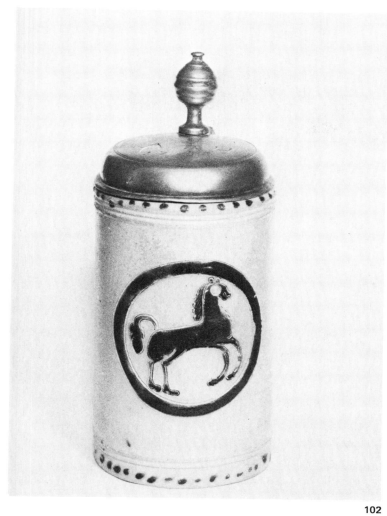

102

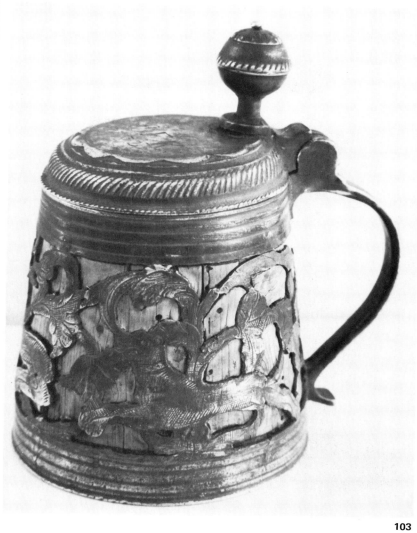

103

105

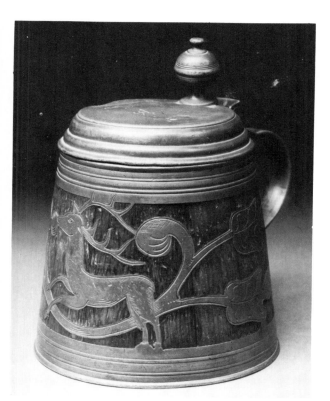

104

106

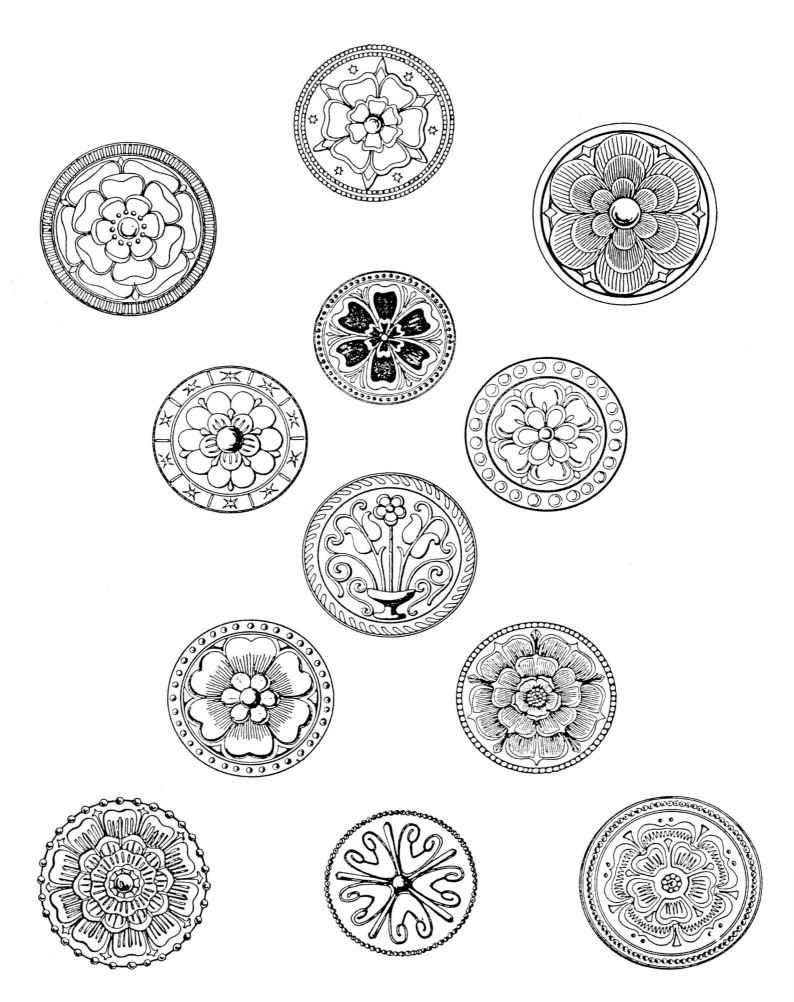

107. Group of typical Swiss, German and Austro-Hungarian "Rosettes" or bosses from flagons and flasks.

CHAPTER 4

Marks on Pewter

Marks

Most pewter bears a mark of some type or other. Marks found on pewter can be very useful in identifying the nationality or period of an object.

Marks to be found on pewter include;

Makers' Marks.	i
Quality Marks.	ii
Town and Corporation Marks.	iii
Capacity Marks.	iv
Ownership Marks.	v
Dates in Marks.	vi

There is much work to be done before the study of marks is complete. Although a familiarity with the way marks are used is helpful, the study has not yet made sufficient progress for it to offer a complete answer to the identification and dating of pewter by the marks struck upon it.

As we have seen there are several different standards of composition to which pewter had to be made, each with different proportions of tin. Each nation or region developed its own systems of marking the standards to which a piece of pewter had been made.

Most major national studies include details of maker's marks. In the Bibliography those books with extensive records of maker's marks are starred. In addition there are also a number of pocket books which may be useful and one general study on world marks which by its very nature is highly selective.

AMERICA	Jacobs	*Pocket Book of American Pewter.*
FRANCE	Tardy	*Poincons d'Etain.*
BRITAIN	Jackson	*English Pewter Touchmarks.*
WORLD	Stara	*Pewter Marks of the World.*

No brief list of marks can be of much service, but some general comments may be helpful.

Makers' marks of the late sixteenth and early seventeenth centuries tend to be smaller and simpler than later marks and are usually based on the initials of the maker. Later in the seventeenth century devices become more popular and marks often begin to incorporate the full name of the pewterer.

The whole story is made more complex by the use in Europe of combined touches in which quality, town and guild marks exist, often incorporating makers' initials.

Perhaps to simulate silver to unwary buyers or simply as an innovation to catch the eye, British pewterers placed "hall marks" on their pewter in the seventeenth century. False silver marks ape but do not follow exactly silversmiths' marks. A date letter is seldom used and even when it is it has no significance. Similar hallmarks are found on Dutch, German, Swedish and American pewter.

Far from all genuine antique pewter does bear a makers' mark. Students of pewter tend to rely too much on marks as a guarantee of age but although it is not quantifiable, I suspect that up to 30% of genuine pewter does not have a makers' mark. There are however many genuine makers' marks which have been struck on reproduction or fake pewter. All that glisters...!

Philippe Boucaud's book on false marks, *250 Poincons d'Etain Faux Copies Imitations Truguages"* although it concentrates on European marks, does include some of the marks commonly found on fake or reproduction British and American pewter.

Quality Marks

From the early middle ages the guilds established standards to which pewter had to be made. These standards were based on the proportion of tin in the alloy.

Each country had its own local or national standards.

In some countries, including Britain, broadly national standards were imposed by statute. In other areas the standards were local; monitored by the town or city guild as in the low countries, where the amount of lead allowed in pewter varied from town to town by a factor of five in the seventeenth century.

The guilds normally had the right of search and entry to maintain their standards. Suspected items were seized and tested to check on the tin content. In Britain the London Guild had the right to search throughout the "Realme of Englande" and they regularly exercised this right up to 1745. In Holland the abolition of the guilds in the nineteenth century ended such inspections, but guild control had been weakening for many years before then.

In Europe the most widely used quality system was based on three different grades. The highest standard was for "fine" pewter which had to have a high proportion of tin. Two lower standards were also common for pewter with a lesser tin content.

The three standard system was not universally adopted.

Each country or guild established a system of marking their pewter according to the standard or quality to which it had been made. If we know something about these marking systems it can help to identify where the pewter was made. For example in the Baltic States the top standard was identified by three town marks whilst the second quality had two makers' marks, and the lowest quality two town marks only. However the systems are complex, varied over time and not exclusive.

The table below records the marking system used for the top standard for the major producing areas, and the quality marks commonly used in that country.

COUNTRY	COMMON QUALITY MARKS	TOP QUALITY MARKING SYSTEM
AUSTRIA	Tudor Rose. Angel. "Feinzinn".	Master mark & Town mark (Except Vienna & Innsbruck.)
BOHEMIA, MORAVIA & SLOVAKIA	Angel. "Feinzinn". "Probzinn". "Schlagenwald".	Town, Master & Quality mark.
HUNGARY	"Probzinn". "Feinzinn".	As above.
POLAND	Eagle. Crowned Rose. St. John. Angel. Arms of Prussia. "Sonnant".	As above.
RUSSIA		Master mark. Guild mark & sometimes Town mark.
BALTIC STATES	Rosette	Three Town marks.
DENMARK	Angel	Town mark, Quality mark & makers' initials with date of membership of Guild.
NORWAY	Angel	Two Quality marks Town mark with initials & date of membership.
SWEDEN & FINLAND		Two Town and two Master marks.
HOLLAND	Hammer. Crowned Rose. Angel. Town Mark.	Varied from Guild to Guild.
FRANCE	Angel (Alsace & East). Crowned Rose (North & East). Town mark (rare). "Etain fin". "Sonnant".	Town mark, Makers' mark. Commune or control mark.
GERMANY (North & East)	Rose. Angel. Town mark. "Englisch Zinn". "Clarzinn".	Varied but often Town, Makers' & Quality mark.
(West & North)	Rose. Angel. "Blockzinn". "Englisch zinn". "F".	As above.
(South)	Angel. Rose. "Feinzinn". "Probzinn".	As above.
BELGIUM	Crowned Rose. St. Michael. "Engels tin".	Varied from town to town.
PORTUGAL		Makers' mark, Town, State or Local marks.
SWITZERLAND	Crowned Rose. Angel. "Finn Cristallin". Crowned "F". "Feinzinn". "Estain". "Blockzinn". "Englischzinn".	Considerable diversity according to Cantons.
BRITAIN	"Superfine Hard Metal". "X".	None.
USA	No Standard enforced.	

Symbols are shown without inverted commas, words used as marks are shown with inverted commas.

Town and Guild Marks

Many towns or guilds had their marks incorporated on pewter. These town marks were required by corporations as part of their quality marking systems or as an authentication of origin. The town mark is often based on the coat of arms born by the corporation but hundreds of other devices were adopted.

In Switzerland and France the marks are not of individual towns but of Cantons or Communes.

Town marks are found incorporating the first initial of the city or town involved (eg "B" for Bruges). In other cases an initial is used but one which does not correspond with the name of the town, as with "W" for Breslau. Castles and other architectural features appear on many town arms including Copenhagen, Budapest and Salzburg. Birds, animals and plants are also used.

In Britain the use of town arms is rare. Examples are known of the City of London, Oxford, Glasgow and Leeds as well as that of the Worshipful Company of Pewterers. British pewterers also incorporated into their makers' mark the name of the town in which they worked. London occurs regularly but was not only used by pewterers who lived and worked in the city. Birch and Villiers of Birmingham and Allen Bright of Bristol are two makers who made improper use of the London touch, and it is interesting to note that some Boston pewterers also took advantage of the high reputation of London by putting this mark on their pewter.

Amongst other centres whose names occur on more than one maker's work in Britain are Bristol, Barnstaple, Bideford, Birmingham, Falmouth, Newcastle, Liverpool, Tavistock, Tiverton, Edinburgh, Glasgow, Cork, Dublin, Limerick and Waterford.

In the United States coats of arms are not used as town marks but the names of 26 towns are incorporated into makers' marks, on ten occasions on the works of more than two pewterers; New York, Philadelphia, Boston, Norwich (Connecticut), Providence (Rhode Island), Middleton (Connecticut), Hartford, Baltimore, Salem and Albany.

Capacity Marks

Since the early middle ages the state has accepted the responsibility to see that when people bought in shops, fairs and markets that they received fair measure. Standards were widely established which had to be used in all transactions.

At first nearly all these standards were local and people were unconcerned with the effect that this had on trade between regions. Gradually national standards began to emerge.

Thus even in the middle ages there were a multiplicity of measures in use in Europe and Britain for wet and dry commodities and for length.

It was the practice for all measures used in the market situation to be "confirmed" by marking

REPRODUCING MAKERS MARKS

Marks can be reproduced in several ways. An artist can draw the mark, the technique used on page 69 for a representative group of makers marks. But inevitably there is some small element of selectivity or personal choice in such a method. Photographs can also be used but unless the mark is very clear they can often be unhelpful and the camera can obscure what the naked eye can sometimes see.

Two other methods are useful. A pressing or reverse mold can be made, in a rubber or acrylic substance, of the mark which can then be reproduced by printing it on paper. Another method is to cover the mark with carbon and take a pull of it on selotape, then placing the tape on white paper. Each system has its advantages and demerits.

In addition to the drawings of marks a few photographic examples of marks are also presented.

108

108. The American eagle often used in American pewter marks.

109. The mark of I.C. Heyne of Lancaster, Pennsylvania.

109

that they gave true measure. Local inspectors checked the measures against the "standard" measures that they carried.

In England the earliest marks that are found on pewter date from the reign of Henry VII when the initials HR or hR were used. To complicate matters these standards, and several later standards continued to be used long after the death of the Monarch. In the case of the HR or hR marks these can even be found on eighteenth century balusters.

In the seventeenth century progress was made in England towards a true national standard and from the end of the century the William III Wine and Ale standards were very widely accepted and

examples are often found with the "WR" mark. In the eighteenth century the initials "AR" and "GR" are occasionally used, although the William III standards continued to be accepted up to 1826.

Scotland had its own standards both before and after union with England in 1702 and these continued to be used even after the introduction of the Imperial Standards in 1826 throughout Britain.

Attempts in France in the fifteenth and sixteenth centuries to establish a standard pint had not met with permanent success. Many local standards continued to exist and even within areas local measures often changed. In the Basses Pyrenees for example, more than 25 local pints

had existed, the largest being twice the size of the smallest.

In Sweden the "Kanna" became the accepted standard from 1696 but in Germany the multiplicity of standards continued into the nineteenth century.

In Holland the "take" was the accepted standard from the middle ages and measures had to be checked that they conformed to this standard. Usually town marks were added to indicate this, sometimes struck by the guilds, on other occasions by local officials. By the end of the eighteenth century the system had become ineffective.

The French revolution and the subsequent gradual adoption of the metric system in most parts of Europe meant that for the first time in much of the continent a universal system was in use. Many countries, including Britain and the United States, ignored the new metric system, and in some parts of Europe its adoption was long delayed as in Italy (1845), Austria (1873), and Denmark and Poland (this century).

Even after metrication the systems of marks used frequently changed several times over a few years.

In France the marking systems changed seven times between 1801 and 1873. In Holland, where the metric system was compulsory after 1830—32, there were major changes in how it was marked. In Belgium, where it was adopted in 1801, there were five systems before 1877.

In each of these countries a scheme of date letters was adopted, not to indicate the year of manufacture, but the year the capacity of the measure was confirmed. In France the first system started with the letter "A" in 1801. The same system was then adopted in Belgium in that year. The French and Belgian systems separated in 1829 with Belgium starting a new series in 1831 with another letter "A". In Holland the system began in 1820 again with "A". Thus you can find measures from France and the low countries bearing many such date letters, the date indicated by each depending on where the capacity check was made. The date letter for 1837 for example might be indicated by either a "G", "K" or "S" depending on in which of the three countries the measure was marked.

In Britain in the nineteenth century the Imperial standard was adopted in 1826 and items of that period are marked GRIV for George IV. During the reign of Queen Victoria several changes occurred in the systems used for marking capacity, all based on the initials VR.

Until recently it was thought that no American pewter had been marked with any capacity check but it now seems certain that the date letters on baluster measures, mostly from the Boardman factory, are New York capacity marks. It is possible that other states may also have marked their measures in a similar fashion.

110. The touch of Peter Young of New York.

111. Perhaps the most famous American makers' mark of all, that of William Will.

112. A typical German makers' mark, used by Karl Finck of Mainz, circa 1835.

TOWN OR CITY MARKS

A. Hamburg B. Leipsig C. Munich D. Nuremberg E. Prague F. Rotterdam G. Amsterdam H. Antwerp

I. Augsburg J. Bern K. Bruges L. Budapest M. Copenhagen N. Dresden O. Edinburgh P. Salzburg

Q. Stockholm R. Zurich

CAPACITY OR STANDARD MARKS. SELECTED ENGLISH EXAMPLES.

A. Henry VIII, used into eighteenth century.
B. William III, used to 1826.
C. William IV.
D. George IV.
E. 1826 Portcullis mark for Imperial standard.
F. Victorian, after 1879.

 A B C D E F

OTHER CAPACITY MARKS.

G. From Dutch tankard late seventeenth and early eighteenth century capacity marks.
H. Capacity confirmation marks from AY, New York on a Boardman baluster.
I. Three "A" letter standard date marks from Holland, France and Belgium, each representing a different year.
J. Verification marks on a French measure from Arles in Southern France.
K. French capacity mark, metric system 1800—1807.
L. Another example 1825—30.
M. The metric system capacity mark under Louis Phillipe 1830—48.

G

H

I

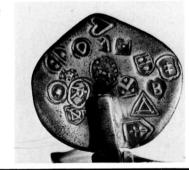

 K *L* *M*

J

QUALITY MARKS ON PEWTER

A. France and Poland.
B. Group of French pre-revolutionary Control marks.
C. German Probzinn mark.
D. German Feinzinn mark.
E. French quality mark. Also found on Swiss pewter.
F. English hard metal.
G. Prop zinn mark Central Europe.
H. Schlagenwald quality mark. Slovenian tin.
I. Crowned Rose, Holland and Germany for English tin.

 A *B* *C*

 ...

 D *E* *F* *G* *H* *I*

(Art Work by Andrew Cross)

George Coldwell and Francis Bassett II for example advertised "Sealed" measures and William Will offered measures "containing exact quantities as directed by law", all indicating that standards were both in use and enforced.

The study of capacity markings is thus still in its infancy and to identify marks it is necessary to consult one or other of the standard works on pewter.

Owners Marks

Owners frequently placed a mark on their pewter to identify it. Ownership marks include coats of arms, names, initials and housemarks.

It is seldom possible to identify a former owner of an item of pewter but just occasionally this can be achieved.

The system of Armorial bearings, or the use of coats of arms is a survival from the age of Chivalry; its origins go back into the early middle ages when knights used their shields, decorated with symbols, to distinguish them from their enemies.

Originally only those who had been "knighted" by their sovereign lord were entitled to a coat of arms but gradually, as the military meaning of arms diminished, their use became widespread and by the end of the seventeenth century many thousands of gentlemen were entitled to bear arms.

Identification of the ownership of any particular coat of arms is a skilled task. The laws of Heraldry, as the art is called, are complex. To complicate matters, those who engraved the arms on pewter were not always aware of the rules.

There are detailed records of coats of arms for Europe and Britain but none of these records are adequately indexed.

The manner in which coats of arms have been "emblazoned" or drawn has differed over the years, just as styles of handwriting vary. The way in which coats of arms are represented can help to date them. Seventeenth century arms are drawn with more movement and fluidity while nineteenth century coats are rigid and disciplined.

There are helpful differences too in the manner in which continental and British coats of arms are drawn. In French heraldry, for example, crests and mottos are less frequently used and there is more use of rounded shields than in British heraldry.

Although the thirteen American colonies were to form themselves into a republic, there was a considerable use of coats of arms on pewter. Although no examples of American pewter with a known coat of arms have survived we do know from documentary evidence that plates and dishes were engraved. George Washington in 1759 paid Richard Cleeve, a London pewterer, £1.4/- to engrave his crest on 96 items of pewter whilst in 1783, John Hancock ordered pewter from London and asked that his crest "be engraved on each dish and plate".

Many owners marked their pewter with a device of their own choosing or had their initials engraved. The Holyoke family crescent to give an example has been found in the United States on plain-rimmed plates. Various conventions developed over the way these initials were placed. On the continent initials, often four, were placed in a straight line whilst in Britain they were most frequently set to form a triangle; one above and two below.

The shape of the letters used in engraving can also help in identifying pewter. The use of a germanic script clearly indicates a German speaking area. The appearance of an "ij" for "y" means that it is Dutch. The "J" was written as an "I" into the 1700 and "U" often appears as a "V" during the seventeenth century.

Some owners used "housemarks" to identify their pewter, often a mark they also used in business. Many of these take the form of a "mystic" mark, a combination of symbols and initials unique, at least in the locality, to that owner.

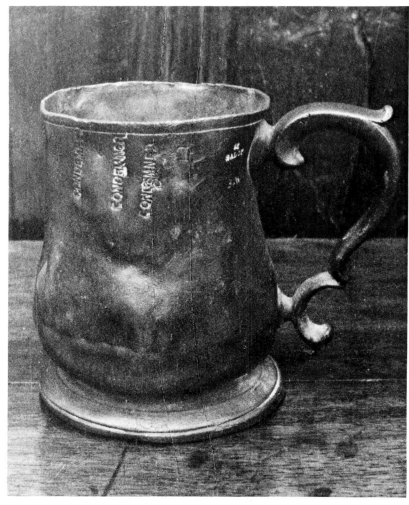

113. Unique example of a pre-Imperial English mug which was later rejected by a local weights and measures inspector, stamped several times with the word "Condemned" and stood on. The owner took the trouble to retrieve it, reshape it and it has survived to this day as a sole example of one that got away. (Courtesy of Robin Bellamy Ltd).

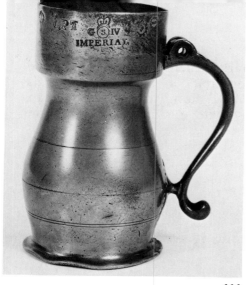

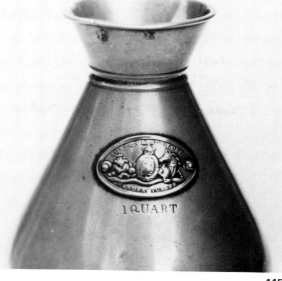

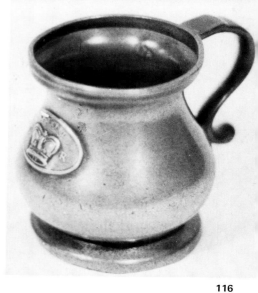

114

115

116

117

118

119

120

121

114. With the introduction of the Imperial standard in 1826 many measures had to be abandoned, but a few were specially extended to take the new standard. This is a lidded baluster which had its lid removed and a new neck built up so that its canny owner could continue to use it. Dated George IV, the join can be clearly seen. (Courtesy of Robin Bellamy Ltd).

115. Capacity medallion added to Irish quart measure, at time of manufacture. Circa 1826—30. (Courtesy of Robin Bellamy Ltd).

116. A similar George IV capacity seal added at manufacture on a Britannia mug, circa 1830, English. (Courtesy of Robin Bellamy Ltd).

117. Swiss Coat of Arms and crest from a broad rimmed plate, 1683. Note the "tighter" drawing of the arms. The use of three initials in a row, IVR is another indication of continental origin. (From a plate in a private collection).

118 & 119. Two Coats of Arms, each for the same person but drawn in the manner of the mid to late seventeenth century and the late eighteenth century. (Art work by Andrew Cross).

120. Early seventeenth century English "crest" from a coat of arms found on a broad rimmed plate formerly owned by the Drake family, circa 1610. The crest is the "Golden Hind". (From the Little Collection).

121. Coat of Arms, English, circa 1660—80, the feathering on the earlier example is now replaced by leaves. (Courtesy of Robin Bellamy Ltd).

Dates in Marks

Only in Scandinavia was there a system of marking pewter with the date of its manufacture. This system commenced in the Kingdom of Sweden in 1694. A single letter was at first used to denote the year an item was made and the style of the letter involved changed when the first cycle was exhausted. In 1759 in both Sweden and Finland a number was added to the date letter to make identification easier. In Sweden this method was used into the present century but in Finland it ended in 1817. You can find pewter marked with an "A" or "A4" or "A6", each mark denoting a different year.

Dates are also frequently found combined with makers' marks.

In Britain, Scandinavia, France and most of the rest of Europe such a date denotes either the year when the maker entered the guild or, less frequently, when he registered that particular mark.

In central Europe the date in the mark may be unconnected with the maker and be a reference to the date the guild regulations, under which the maker registered, came into force.

In Saxony the dates "13", "74" and "08" refer to the years 1613, 1674 and 1708, representing years when the Guild Charter was amended. Thus the date "13" could represent any year between 1613 and 1674, and the year "08" any time into the nineteenth century after 1708. The date 1708 appears in the mark of a Dresden pewterer, H.M. Herman as late as May 1855.

Among other cities which operated similar systems were;

Salzburg	86	(for 1486)
Wurzberg	86	(for 1686)
Breslau	66	(for 1766)
Geneva		1609 and 1719
Lubeck		1579 and 1633
Regensberg		1682

Some of these dated marks appear in makers' touches, other in Town or Guild marks.

Dated makers' touches are common in Scotland and England but confusion can be caused by the fact that the same makers' mark may appear with different dates. It appears likely that these changed dates either represent a change in the business circumstances of the pewterer or the adoption of a new touch. John Shorey (Cotterell 4262), for example, has marks dated 1683 and 1687. Examples also occur in Europe; Jacques Morel of Geneva has two dated touches; 1719 and 1743.

The two earlies known dated English touches are 1580 on a candlestick and 1599 on a bumpy-bottomed dish. The earliest Scottish dated mark is 1607 on a "Costrel" or flask.

In the United States dated touches are very uncommon. Copeland's touch includes the date 1675 and one of D. Melville's marks is found in association with the year 1788 but whether this has any significance is not clear.

Dates are also found in capacity marks; the year 1826 re-occurs often on British pewter and indicates the year the Imperial Standard was adopted. Some Dutch pewter is dated in a similar way.

The Illustrations

In each classification or category the leading styles are illustrated. Photographs are presented chronologically.

In some cases similar objects were made at different times in more than one country so that almost identical forms can appear twice. Flat-lidded tankards are an example of this duplication as they were made both in Britain between 1660 and 1700 and in the United States during the eighteenth century.

Only a few of even the most important forms can be shown. In most cases there are many small variations in design that occur. In flagons, for example, each main body form can occur with and without a knop on the lid, with any of several different thumbpieces and with varying handle forms.

Because a particular variety is not illustrated it does not mean that it is unrecorded or of doubtful authenticity.

In some cases with less significant categories there are many variations that exist although only the most common can be shown. For example in Swiss "messkanne" or small communion flagons, at least 16 styles are known, and with "seal-top" spoons at least 6 different "seal" forms are recorded.

122. Decorative inscription recording the gift of an item of pewter to a church, dated 1720, the cartouch is typical of this period in England. (Courtesy of Robin Bellamy Ltd).

123. A slightly earlier form of decoration dated 1710, English. (Courtesy of Robin Bellamy Ltd).

124. German Coat of Arms, dated 1737, with "shield" less coat and very different decoration or "mantling". (Courtesy of Robin Bellamy Ltd).

125. A set of donors marks, dated 1780 which are interesting in their own right as they record the gift of a flagon to the local church by the maker, Christopher Bankes, who was a pewterer at Bewdley, who was churchwarden in 1780. (Courtesy of Robin Bellamy Ltd).

126. Ownership initials of George IV found on the pewter made for his coronation dinner. (Courtesy of Robin Bellamy Ltd).

127. English ownership initials for a married couple. Perhaps John and Susan Smith, circa 1700. (Courtesy of Robin Bellamy Ltd).

128. Continental ownership initials and date 1786. (Courtesy of Robin Bellamy Ltd).

129. Later eighteenth century engraved ownership initials, English. (Courtesy of Robin Bellamy Ltd).

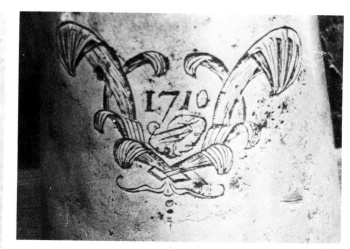

123

122

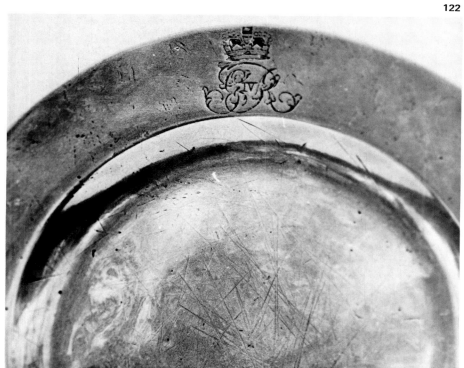

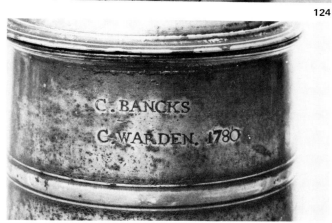

124

125

126

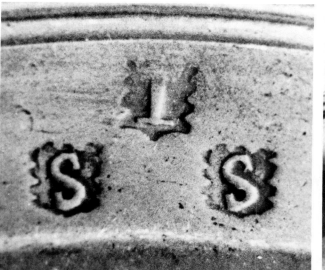

REPRESENTATIVE MAKERS' MARKS.
SEVENTEENTH CENTURY.
 A. English
 B. French
 C. Dutch
 D. Swiss
 E. English
 F. German
EIGHTEENTH CENTURY.
 G, H & I. American
 J. English
 K. French
 L. Dutch
 M. Swiss
NINETEENTH CENTURY.
 N. German
 O. American
 P. Dutch
 Q. French

A B C D E

F G, H & I J

K L M N O P Q

DATES AND MARKS.
A. Three City Marks.

B. Swedish date letters, A for 1718, O for 1731, H2 for 1790.
Similar letters were also used in other parts of Scandinavia
but imply different dates.

C. (1) Hallmarks, Dutch for N. Koch.
 (2) Austin of America.
 (3) English "I I".

A

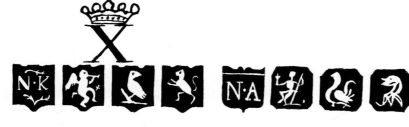

B

1 2 3

C

(Art Work by Andrew Cross)

74

CHAPTER 5

Religious Pewter

Religious Pewter

Ritual is universally associated with the exercise of religious belief. Pewter has been used extensively in the rituals of all branches of the Christian religion and in Judaism.

Some of the pewter was used in religious ceremonies, other items for the decoration or lighting of places of worship.

Religious ritual is seldom static; different times and attitudes bring changes. Thus the rituals of the Roman Catholic Church have altered over the centuries and the schisms of the fifteenth and sixteenth centuries which led to the development of the Protestant faith brought many changes of religious observance in their wake.

Many of the objects used in Churches are similar to those in domestic use. Chalices resemble drinking cups, while some baptismal bowls are similar to ordinary domestic bowls. Unless there is an established provenance or an inscription origins are often unclear.

After the synod of Rouen in 1074, pewter was not permitted to be used in the Communion in the Roman Catholic Church.

These and other restrictions were gradually withdrawn. In Britain the canons of 1602—03 permitted the use of pewter within the Communion and although there are earlier English pewter Communion flagons most date from that time onwards.

A considerable variety of objects were used with the Christian Communion but most common are flagons and chalices.

Much church pewter was ousted during the mid-nineteenth century. Many items were given away, discarded or destroyed.

In the United States complete Communion sets in pewter were popular from the mid-eighteenth century, with several makers offering standardised sets. Many items of Church pewter in the United States were bought from England through local pewterers. Some churches now have a mixed array of British and American pewter.

Flagons

A great variety of flagons have been used in the communion.

In the English tradition the most frequently found church flagons are those known as the "James I", the "Beefeater" and the "Spire" flagon. In Scotland the "Laver" was widely used.

In the United States the Spire flagon of both British or American manufacture vied with shaped flagons and large tankards which were also used as Communion vessels.

European communion flagons showed considerable regional variations and no one style was popular throughout Europe.

Chalices

In church ritual the chalice is used to hold the wine in the celebration of the Eucharist. It represents the chalice of the Last Supper referred to in the New Testament by the words "Take and drink ye all of it For this is the chalice of my blood..."

Chalices or vessels are used in all Christian churches where the Eucharist is celebrated.

Until the thirteenth century all participants in the communion drank from the chalice but gradually in the churches of the western Roman tradition the chalice was withdrawn from the laity and the wine was drunk only by the celebrating priest. In the eastern tradition the chalice continued to be offered to all communicants.

This restriction of the chalice to the priest continued in the Roman Catholic Church and as a consequence catholic chalices have smaller bowls than those used in Protestant churches.

Chalices differ in size and in the shape of the bowl, stem and foot. Similar forms are to be found in each area and if unmarked it can be difficult to identify their origins. Some chalices however take a purely local form. In Ireland for example there is a style unique to that country and the deep "U" bowled Scottish Reformed Church chalices are seldom found outside the homeland. Chalices in the gothic tradition with petal or cruciform bases are most likely to be from Europe.

It is possible to establish an elaborate classification of American chalices and footed cups. No fewer than 24 minor forms have been identified.

Other vessels were employed in the communion. In the Dutch Reformed Church beakers were used and footed cups served as chalices in the United States.

Pyx and Ciborium

These containers were used to hold the wafer for the communion. Early pyx were containers suspended on cords, but later small domed boxes were utilised. Ciboriums, similiar in appearance to lidded chalices were later used. Most ciboriums and pyx originate from countries with a strong Catholic tradition.

Holy Oil Containers

The use of sanctified oils in a variety of services is universal to the Catholic Church. There is a range of containers used to store these holy oils. Individual bottles, small burettes or baluster jugs are commonly employed and holy oils are also kept in small boxes or coffers.

These coffer-shaped containers, usually originating from the seventeenth and eighteenth centuries were widely used in France and Italy although examples do occur in other parts of Europe. The baluster burettes are mostly from Spain, Italy, Portugal and France. In Central Europe small lidded measures in the shape of flagons were used.

Travelling chrismatories were used for visiting the sick.

Holy oils containers were usually marked with the letters "SC", "OI" or "OS", the initials representing the Latin names of various holy oils.

Patens and Salvers

Communicants were offered the wafer from a pewter ciborium but in the Protestant tradition the wafer was sometimes presented on a paten or salver.

Patens are small plates, sometimes serving as chalice lids and generally similar in style to domestic saucers.

Salvers, or shaped dishes, were also used in Britain and the United States. Tazza or footed plates, similar to those used in the home, also served for this purpose.

Collecting Plates and Alms Dishes

Many objects have been used within the church for the collection of gifts and donations. Pewter plates often served this purpose in the eighteenth and nineteenth centuries.

Bowls and decorated alms dishes were also used for collections.

Reliquaries, Censers and Fonts

All are rare and were mostly made before 1600.

Reliquaries are used to display holy relics. Silver, gold or gilt-copper examples are more common than those in pewter.

Censers, used for the dispersal of incense are also more often found in other materials.

Fonts were also made in pewter but are rare and generally medieval.

RELIGIOUS PEWTER

Flagons

Many of the flagons illustrated in the chapter on flagons may well have been used in churches. This is particularly likely in the case of many of the American examples. The use of flagons is less common in Europe but the same position applies.

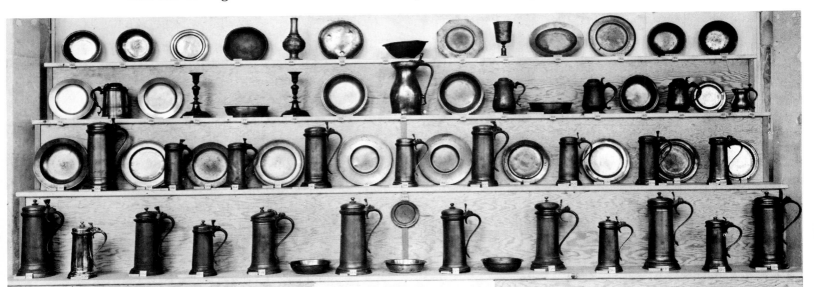

PEWTER FROM NORFOLK CHURCHES

Vases

Flowers were widely used to decorate churches and there are a variety of ecclesiastical vases some of which were used on the Altar. Examples were made in Holland, Belgium, Germany and Central Europe.

Holy Water Stoups

In Catholic countries it was common for Holy Water stoups to be hung from the walls at home. Pewter stoups occur from Belgium, France and southern Europe. Larger stoups were also used in churches. Early examples do exist but most are from the nineteenth century.

Baptismal Bowls

Baptismal bowls in pewter are found in the Reformed Churches of Scotland and American and much of Northern Europe. In Britain and Europe most bowls are quite large, but in the United States much smaller bowls, as little as six inches in diameter, were used.

It is not always easy to distinguish church from domestic bowls as few are marked or inscribed.

Most baptismal bowls are from the eighteenth or nineteenth century.

130. A group of church pewter from Norfolk churches, England brought together for an exhibition in 1934. The similarity of many of the flagons confirms that most parishes first adopted pewter flagons for use in the communion in the first half of the seventeenth century. (Courtesy of Mr. C. Minchin).

131. A rare flagon from a church in Leicestershire, England. Dated "35" in the touch it is almost certainly sixteenth century. But flagons such as this were still probably being made around 1600. Similar in style to Dutch flagons of the period, it is only recently that it has been appreciated that the same form was also made in England. (Courtesy of Robin Bellamy Ltd).

132. The "Werrington" flagon, one of the largest communion flagons, inscribed Ex Don Edmundo Penniye et Fraucissa uxoris eius ad usiem capella de werrington 1609. Fourteen inches high, English, 1609. (Courtesy of the Parish of Werrington).

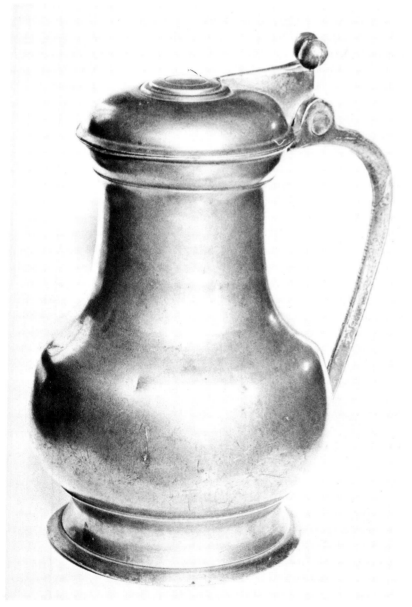

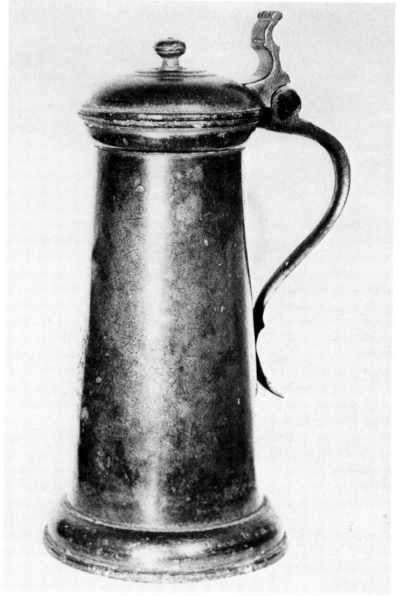

131

132

Lighting Devices

Churches had to be lit and this was mostly accomplished by the use of candles or lamps.

Hanging lamps were popular in Southern and Central Europe, but few pewter examples survive.

Pewter candlesticks were widely used. Most were similar to those in everyday domestic use but from southern and central Europe come a group of large candlesticks on triangular bases with baluster stems which were widely used in churches. Standing candelabra and hanging chandeliers were also employed.

Communion Tokens

In the reformed Protestant Churches admission to the communion was limited to "fit" persons to prevent, in the words of John Calvin, "the profanation of the table". One method used was to issue entry tickets or tokens to those felt to be suitable, the distribution usually resting with the church elders.

Many hundreds of such tokens were issued in Scotland from the seventeenth century onwards, often in pewter. Communion tokens were also used in the United States, Canada, New Zealand and in Calvinist Europe.

Jewish Pewter

The rites and traditions of the Jewish faith have included the use of several types of pewter objects in their ceremonies.

Most widely used were "Seder" dishes, used for the family meal taken on the first or second night of the Passover, in celebration of the Exodus from Egypt. These Seder dishes are inscribed in Hebrew, often with the addition of the names of the family. Most seder dishes are from the eighteenth century and examples can be found from all areas.

One month after the Passover is the Purim, commemorating the rescue of the Jews by Mordecai and Esther from the persecution of the Haman. There are some plates inscribed for use on this occasion.

133. Ewer or flagon, with medallion bearing the arms of Charles I, probably used in a church, with a similar decorated alms dish. 9½ inches high, circa 1620, English. (Courtesy of Ludlow Museum).

134. A superb flagon, one of a pair. By Samuel Billings of Coventry, they stand 12½ inches high. They were used at Queniborough and have the names of the church wardens inscribed on them with the date 1685. (From the Holt Collection).

135. Fine beefeater style flagon from Benington in Hertfordshire, England. Made by John Emes, circa 1680, 11¼ inches high. (Courtesy of Sotheby Parke Bernet).

136. Rare Scottish church flagons of the pot belly form. Inscribed and dated 1680. The communion dish is also of a most unusual form. (Courtesy of the Parish Minister, Brechin Cathedral).

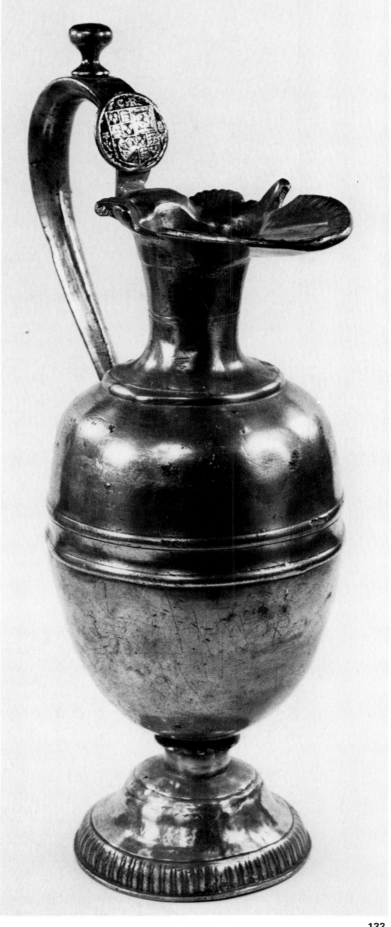

133

78

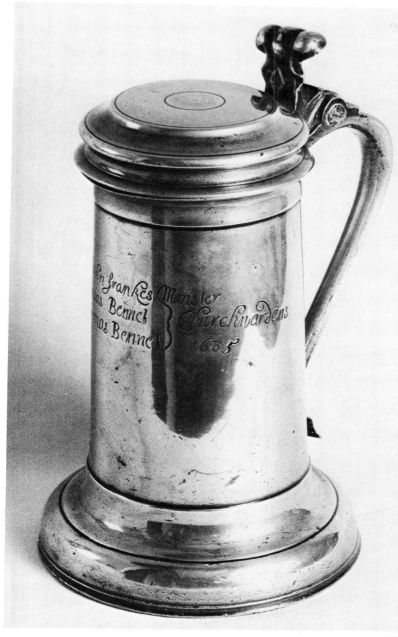

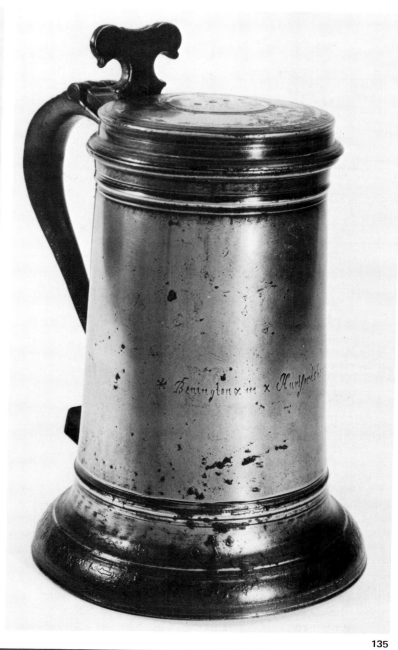

134

135

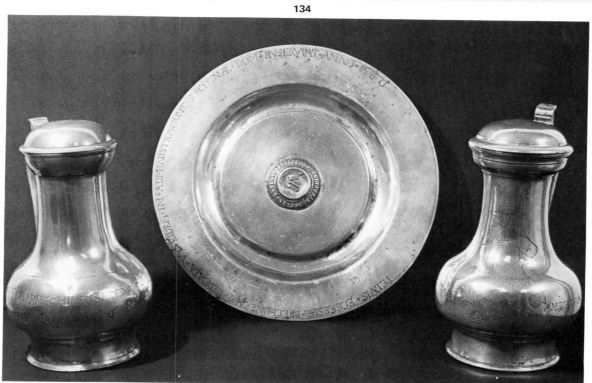

136

79

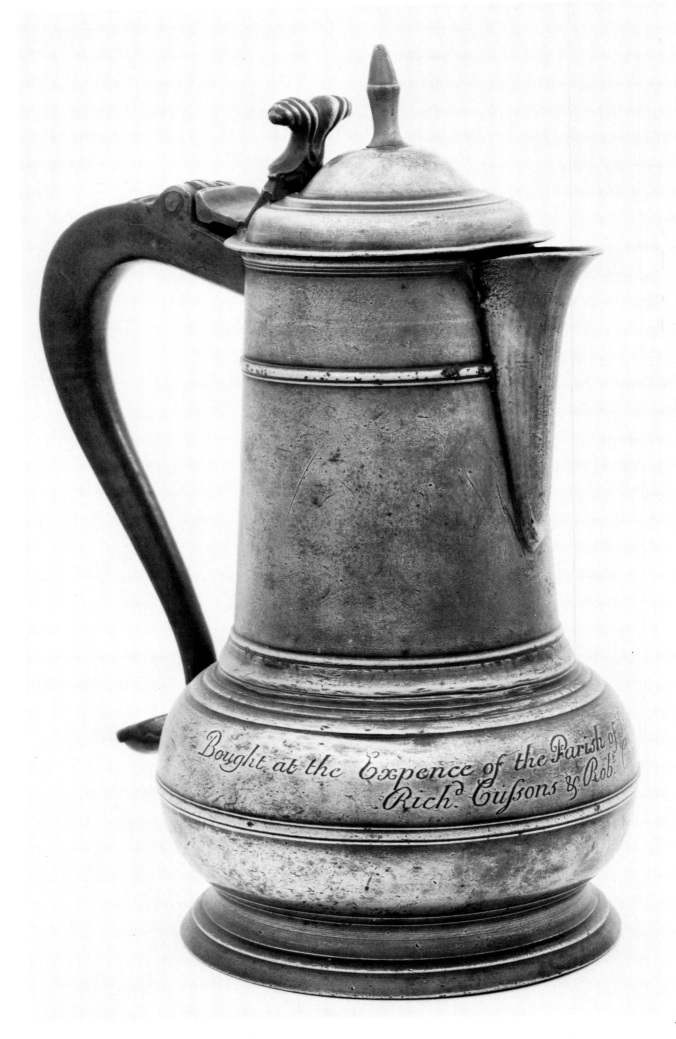

Bought at the Expence of the Parish of
Rich.ᵈ Cuſſons & Rob.ᵗ

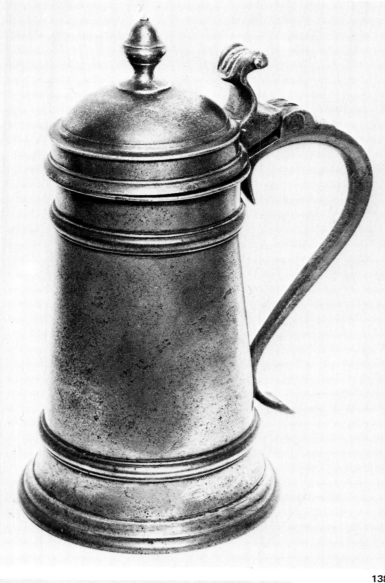

Hanouka Lamps also play an important part in Jewish ritual being used in the blessing and kindling of light. These lamps are mostly from Holland, Germany and central Europe and they date from the eighteenth and early nineteenth century.

Sabbath Lamps, hung from ceilings were also used and are similar in form to examples also found in christian churches. Pewter examples are uncommon.

Lavers or flagons were also used with the daily meal and during the Seder ceremonies.

Over much of Europe Jews were prohibited from membership of the guilds and thus there are no known examples of pewter made by Jews. The emancipation of the Jews in the nineteenth century came too late for the craft to open its doors to them but it is likely that some Jews did work for pewterers.

Seder dishes and other Jewish pewter could be bought in the fairs and markets. Their Hebrew inscriptions were generally engraved by local Jewish folk artists and the inscriptions completed with the family name where they were bought.

137. Fine York church flagon, 12¾ inches high, by "IH" probably John Harrison. Dated and inscribed 1750. From St. Saviours and St. Andrews Church, York. (Courtesy of Sotheby Parke Bernet, London).

138. Rounded flagon by Jonas Durand, inscribed to Church of Round Acton, in Shropshire, England, 1712. 11 inches high. (Private collection).

139. An unusual church flagon, possibly Welsh, inscribed with church wardens names and dated 1764, British, 12 3/8 inches high. (Courtesy of Sotheby Parke Bernet, London).

140. Scottish communion flagon and alms dish. Edinburgh and dated 1742. The alms dish is by an English maker, Richard Grunwin, the flagon is also English in manufacture by William Eddon. The flagon is 11 1/8 inches high, the dish has a diameter of 16 5/8 inches. (Courtesy of Mr. C. Minchin).

138

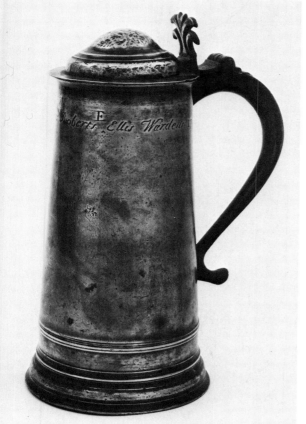

139

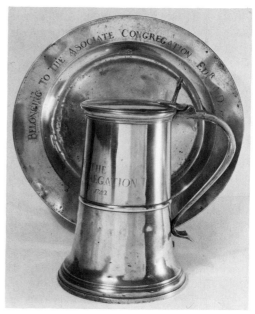

140

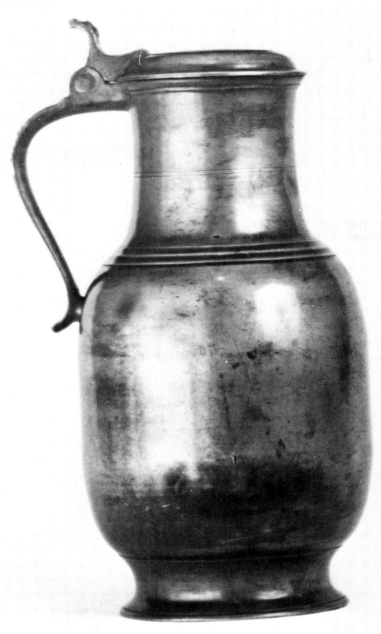

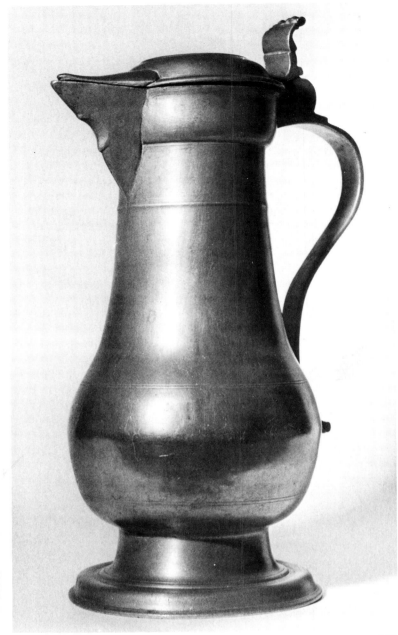

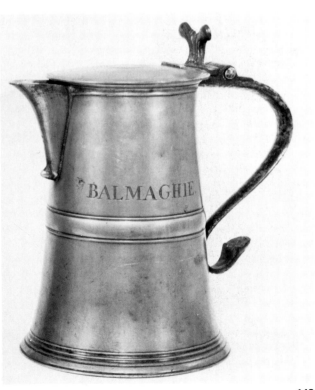

141. A Dutch church flagon, often termed the "Angels" flagon because of the mask on the thumbpiece. By Margman of Amsterdam, circa 1750, 13¾ inches high. (Courtesy of H. B. Havinga).

142. A communion flagon from Germany. By J.J. Tambornino, Ludwigsburg, circa 1750, 13 inches high. (Courtesy of Kunsthandel Frieder Aichele).

143. A Scottish flagon from Balmaghie, dated 1782. Made by Maxwell of Glasgow, 9 7/8 inches high. (Courtesy of Sotheby Parke Bernet).

144. American communion flagon attributed to William Will, 13 inches high. Inscribed in German to the Lutheran Zion Church at Pennstown, Northumberland and dated 1795. (Collection of Mr. Charles V. Swain).

145. English spire flagon inscribed as churchwarden by the pewterer who made it, C. Bankes, and dated 1780. (Courtesy of Robin Bellamy Ltd).

146. Communion set from Baptist Church, Bowdin, Maine by Israel Trask. The flagon is 13 inches high, the chalices are 7 inches. (Collection of Mr. Charles V. Swain).

147. Communion flagon from Stuttgart, Germany, end of the eighteenth century. By L. Pelargus, 14 inches high. (Courtesy of Kunsthandel Frieder Aichele).

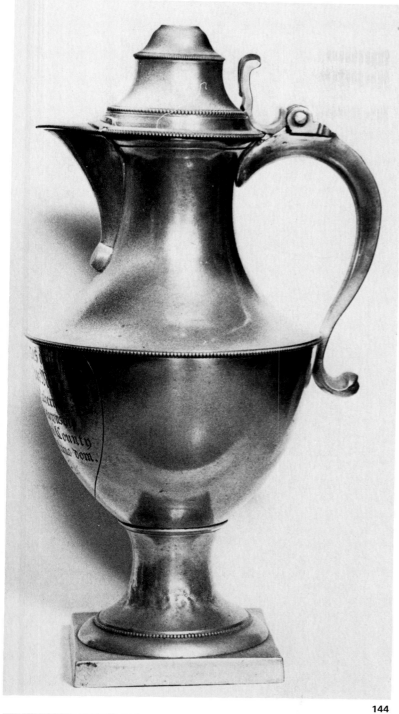

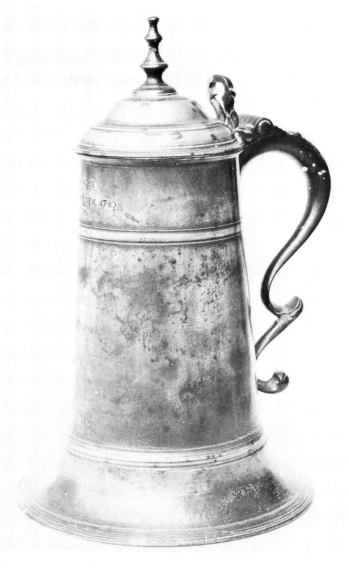

145

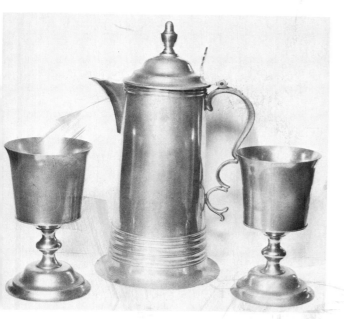

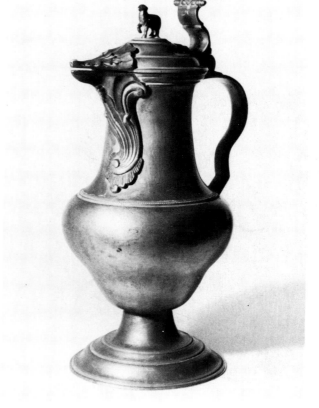

144

146

147

83

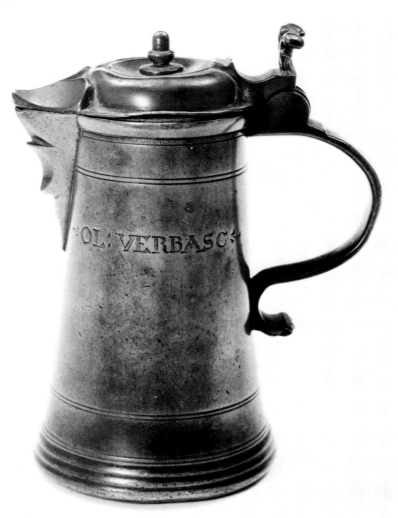

148

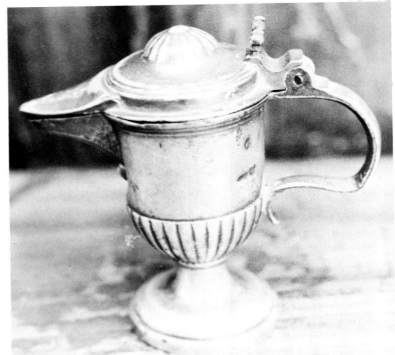

149

151

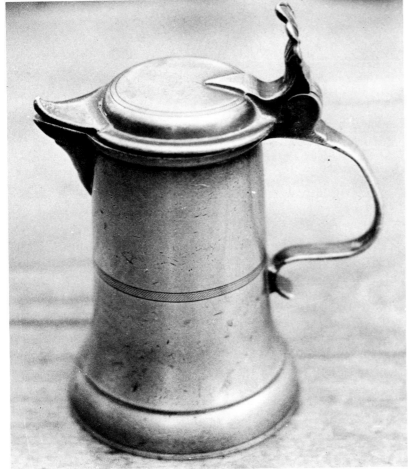

150

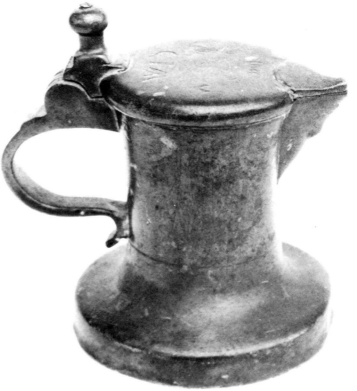

152

CHALICES

Small Bowled Chalices

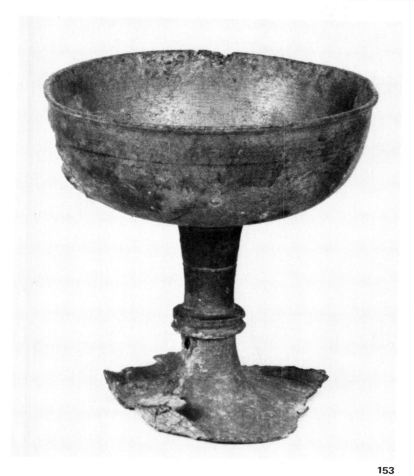

153

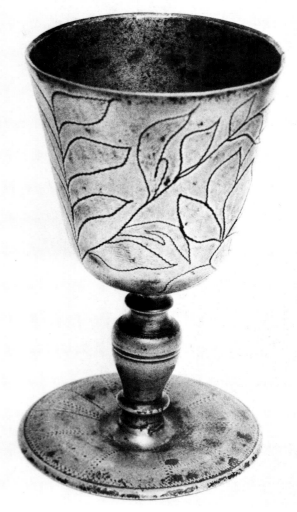

154

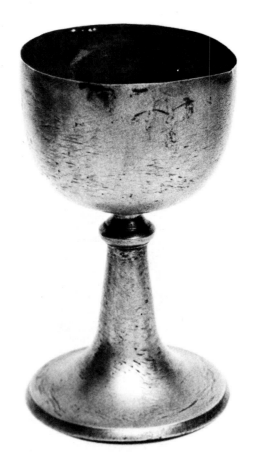

155

148. A cruet or small flagon by S. Bodmer from Bern, circa 1750, 5½ inches high. (Courtesy of Sotheby Parke Bernet, London).

149. Central European holy oil pitcher or small flagon, 3¾ inches high, circa 1780 — 1800. (Courtesy of Robin Bellamy Ltd).

150. Another small communion cruet, 4 inches high, German, eighteenth century. (Courtesy of Robin Bellamy Ltd).

151. A small flagon or cruet in form of a tankard, 4½ inches high, Germany, eighteenth century. (Courtesy of Robin Bellamy Ltd).

152. A cruet from Liegnitz by Buckhardt, circa 1750, German, 4¼ inches high. (Courtesy of Robin Bellamy Ltd).

153. A pre-Reformation chalice, excavated from a priest's grave, circa 1400. Although this style of chalice did not survive into the seventeenth century it illustrates the basic form used in the middle ages. English. (Private collection).

154. English chalice, circa 1640 — 50, with wrigglework bowl, 7¼ inches high. (From the collection of Mr. K. Bradshaw).

155. An early seventeenth century English chalice from a Somerset church, 5¼ inches high, circa 1630 — 40. (From the collection of Mr. K. Bradshaw).

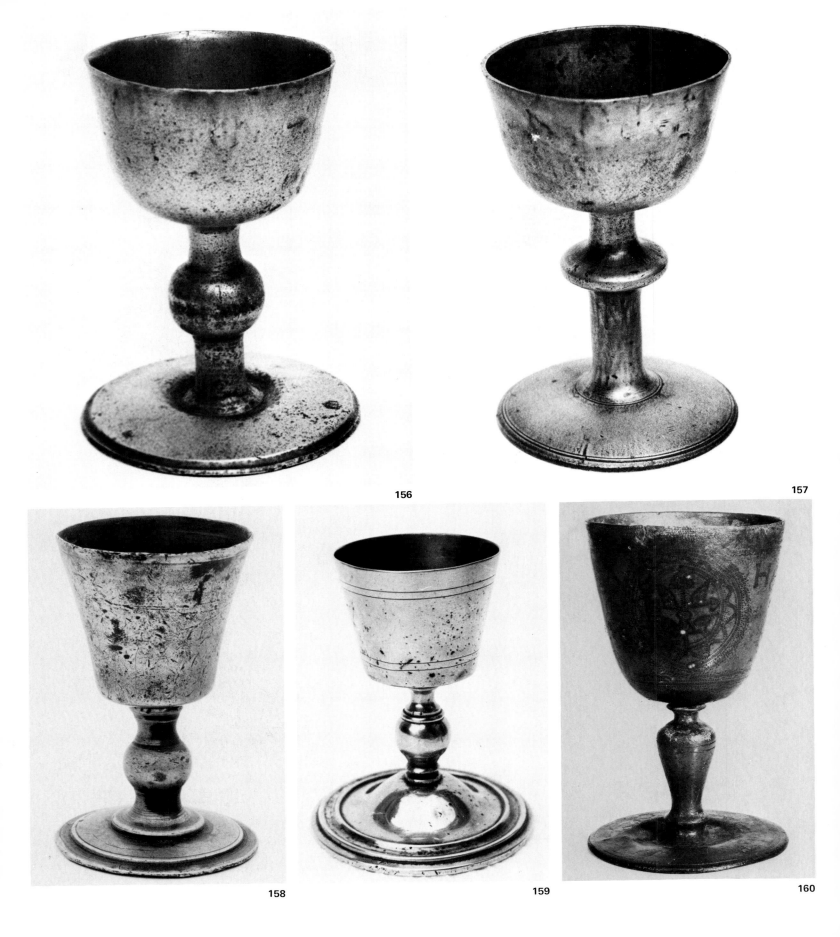

156

157

158

159

160

An interesting church cistern, English is shown at figure 1195. Attention is also drawn to numerous illustrations of beakers, goblets and footed cups which may well have been used in churches.

86

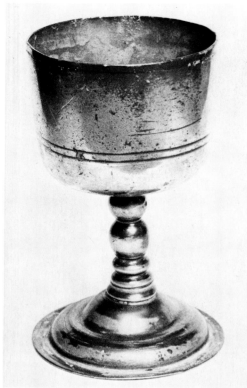

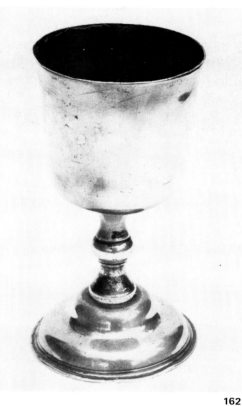

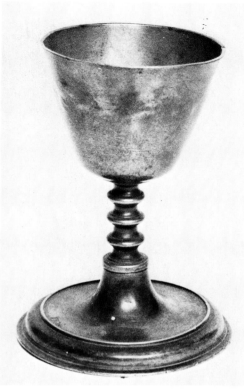

161

162

163

164

165

156. Knopped English chalice, circa 1650, 5 inches high. (From the collection of Mr. K. Bradshaw).

157. Knopped English chalice, circa 1640—60, 5½ inches high, West of England Church. (From the collection of Mr. K. Bradshaw).

158. Bucket shaped chalice, English, 3 1/8 inches high, circa 1630. (Courtesy of Sotheby Parke Bernet).

159. Chalice with bucket bowl, 4½ inches high, circa 1650, English. (Courtesy of Robin Bellamy Ltd).

160. A seventeenth century wrigglework chalice by W.M., English 6 5/8 inches high, circa 1680. (Courtesy of Sotheby Parke Bernet, London).

161. Knopped chalice, 6¼ inches high, English, seventeenth century. (From the Holt Collection).

162. Another short stemmed chalice from western Europe, 4 7/8 inches high, late seventeenth century. (Courtesy of Robin Bellamy Ltd).

163. A bladed knop chalice, with screw fitting, used for travelling. Unmarked, 5 inches high, circa 1700. Similar forms are found both in Europe and Britain. (From the Law Collection).

164. Flaired bowl with knopped stem, 5 inches high, Western Europe, late seventeenth century. (Courtesy of Robin Bellamy Ltd).

165. Dutch or German chalice with shaped base in Gothic style, 7¾ inches high, late seventeenth century. (Courtesy of Robin Bellamy Ltd).

166. Two further chalices with trefoil or shaped bases with knopped stems. European. The left hand example is probably German, circa 1700—30, the other mid-eighteenth century, both 8½ inches high. (Collection of Mr. Charles V. Swain).

167. An eighteenth century chalice from mid Europe, 7 1/8 inches high. (Collection of Mr. Charles V. Swain).

168. Another German or central European eighteenth century chalice, 8 inches high. (Collection of Mr. Charles V. Swain).

169. Bucket bowled chalice early eighteenth century, English, 4 7/8 inches high. (Courtesy of Robin Bellamy Ltd).

170. A similar American chalice, attributed to Henry Will, late eighteenth century, 10¾ inches high. (Collection of Mr. Charles V. Swain).

171. A multi-knopped covered chalice, probably American, 11½ inches high, late eighteenth century. (Collection of Mr. Charles V. Swain).

172. Two further American chalices, both attributed to William Will, 8 inches high, late eighteenth century. (Collection of Mr. Charles V. Swain).

170

171

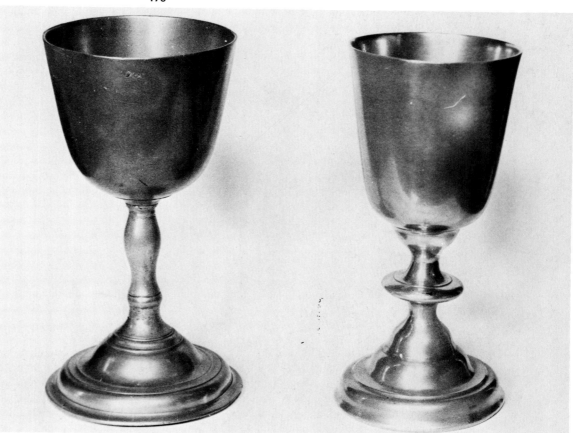

172

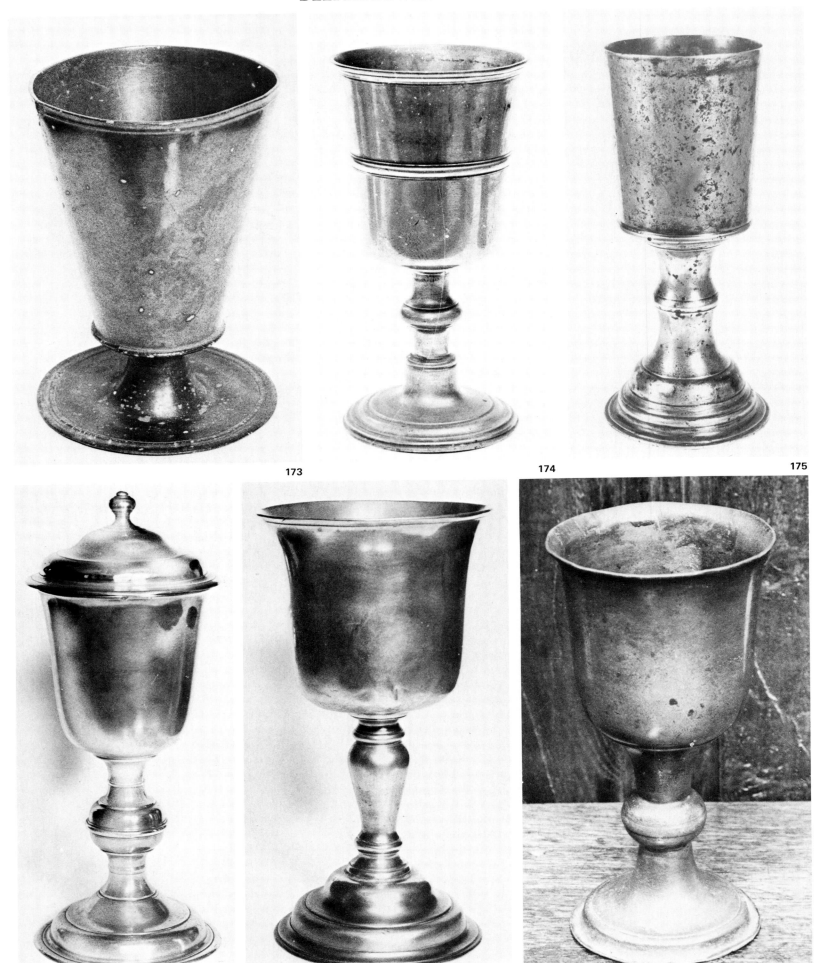

173

174

175

176

177

178

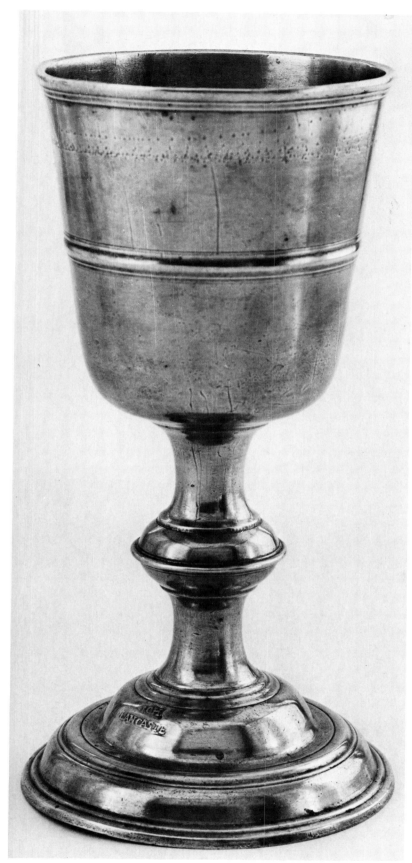

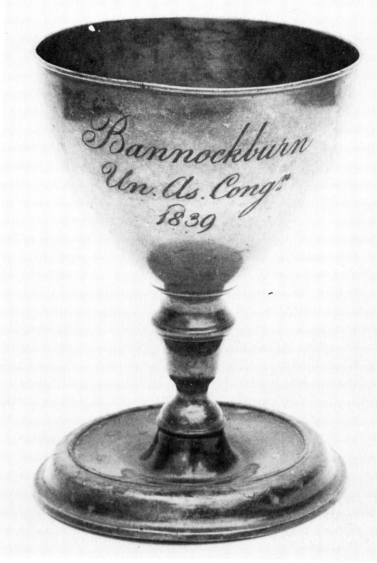

180

173. Rare "bucket" bowled English chalice, commonwealth period, 5¼ inches high, circa 1650. (Courtesy of the Rector Stratton Audley Oxfordshire).

174. English deep bowled chalice, 8 inches high, mid-eighteenth century. (Courtesy of Robin Bellamy Ltd).

175. Rare Irish chalice with thick stem. This form has only been recorded on chalices from Ireland. Early eighteenth century, 7¾ inches high. (Courtesy of Robin Bellamy Ltd).

176. Large knopped chalice with cover, attributed to J.C. Heyne, American, circa 1770—90, 10¾ inches high. (Collection of Mr. Charles V. Swain).

177. Scottish chalice by Wylie, 9¼ inches high, circa 1830. (Collection of Mr. and Mrs. Robert E. Asher).

178. Ball knopped chalice north of England or Scottish, circa 1700, 8 inches high. (Courtesy of Robin Bellamy Ltd).

179

179. Fine American chalice with similar knop, by J.C. Heyne, circa 1750, 8 7/8 inches high. (Courtesy of Metropolitan Museum of Art, New York. Gift of Joseph France).

180. Typical nineteenth century Scottish chalice with wide bowl. Dated 1839 from Bannockburn, 8¾ inches high. (Courtesy of Robin Bellamy Ltd).

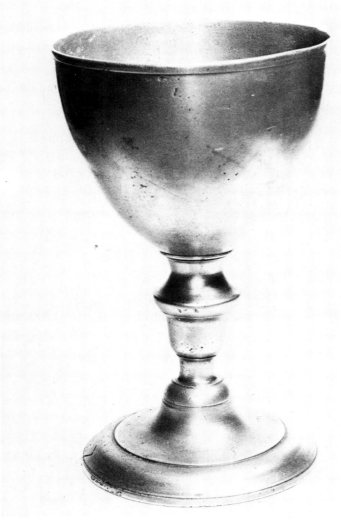

181

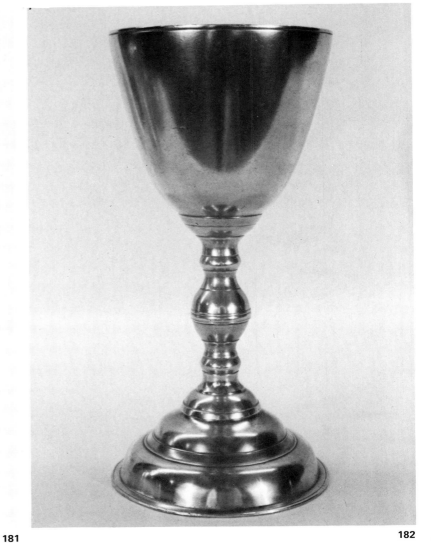

182

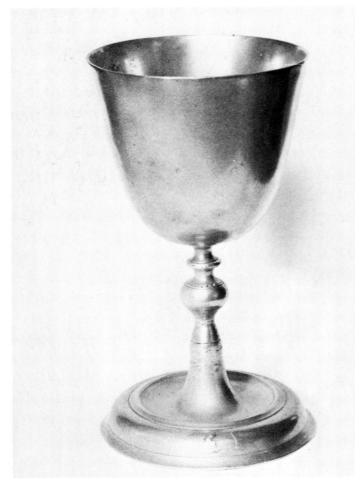

183

184

92

185

186

187

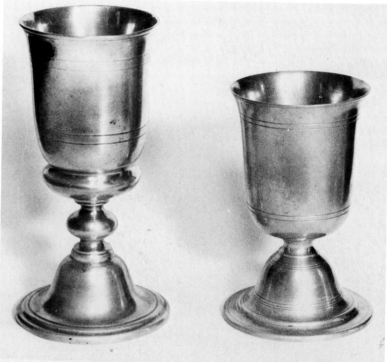

188

181. Similar uninscribed Scottish chalice, circa 1830, 7 7/8 inches high. (Courtesy of Robin Bellamy Ltd).

182. American chalice by P. Young of New York, 8½ inches high, circa 1790. (Collection of Dr. and Mrs. Melvyn Wolf).

183. Similar chalice, probably German, circa 1750, 7½ inches high. (Collection of Mr. Charles V. Swain).

184. Scottish chalice, late eighteenth century, 8¾ inches high. Inscribed "ASSote CONG MIDD CALDER. (Collection of Dr. D. Lamb).

185. American chalices attributed to Boardman, 7 inches, early nineteenth century. (Collection of Dr. and Mrs. Melvyn Wolf).

186. American chalices, attributed to Calder, 6 inches high, nineteenth century. (Collection of Dr. and Mrs. Melvyn Wolf).

187. American chalices attributed to Trask, nineteenth century, 6 1/8 inches high. (Collection of Dr. and Mrs. Melvyn Wolf).

188. Two chalices, American, attributed to Trask, showing similar bases, 7 inches and 5½ inches, nineteenth century. (Collection of Mr. Charles V. Swain).

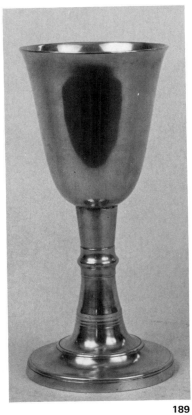
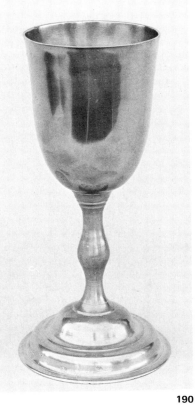
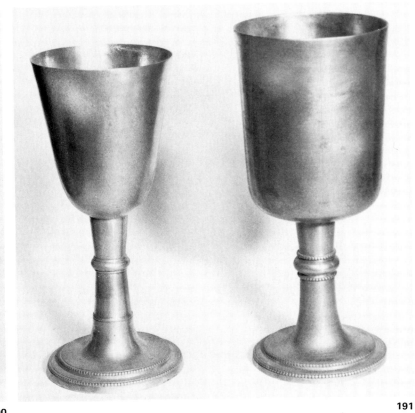

189　　　　**190**　　　　**191**

192

193

94

189. A Philadelphia chalice, circa 1800, 8 inches high. Examples are also found with beeding. American. (Collection of Dr. and Mrs. Melvyn Wolf).

190. Chalice attributed to William Will, eighteenth century, American, 9 inches high. (Collection of Dr. and Mrs. Melvyn Wolf).

191. Two further Philadelphia chalices, 7 inches and 8½ inches high, circa 1800, American. (Collection of Mr. Charles V. Swain).

192. American waisted chalice attributed to the Taunton Britannia Company, circa 1830, 6 1/8 inches high. (Collection of Dr. and Mrs. Melvyn Wolf).

193. Unusual American chalice, eastern shore, eighteenth century, 6¾ inches high. (Collection of Dr. and Mrs. Melvyn Wolf).

194. American chalice by Yale and Company, early nineteenth century, 7½ inches high. (Collection of Mr. Charles V. Swain).

195. Pair of slightly fluted chalices, American, attributed to Reed and Barton, 7 inches high, circa 1840—50. (Collection of Dr. and Mrs. Melvyn Wolf).

196. Rare chalice with cover, Scottish, eighteenth century. (Courtesy of Old St. Pauls Church, Edinburgh).

194

195

196

197

198

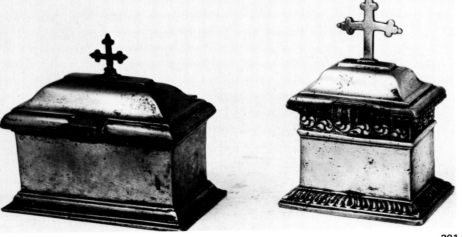

200

199

201

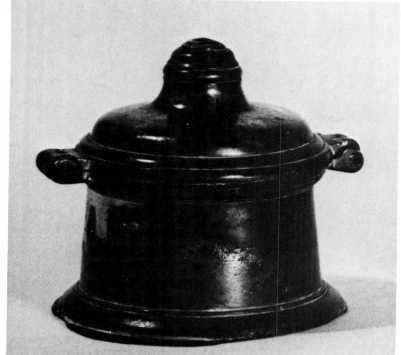

202

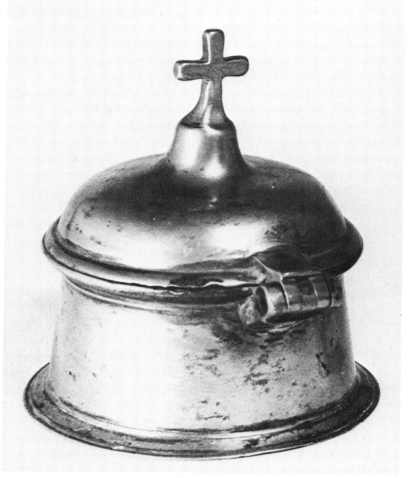

203

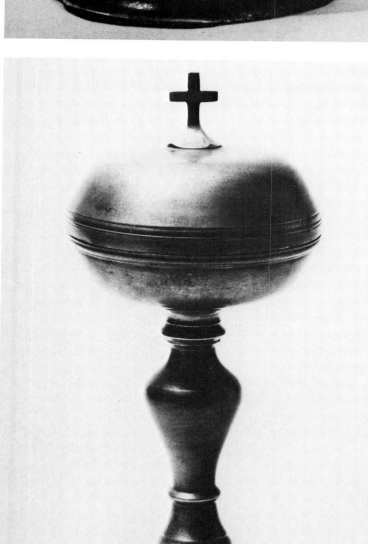

204

197. American chalice by P. Young, 8½ inches high, circa 1770—90. (Courtesy of Christies, New York).

198. A round holy oil container, Spanish, circa 1600. (Courtesy of Robin Bellamy Ltd).

199. Holy oil container, 4 inches high, French, circa 1700. (Courtesy of Robin Bellamy Ltd).

200. A seventeenth century holy oil box, French. The cross may well have been removed during the French Revolution when it was not wise to be an active churchman. (Courtesy of Robin Bellamy Ltd).

201. Two French holy oil containers of box form. Made over a long period, from the late seventeenth century to about 1800. (Courtesy of P. Boucaud).

202. Holy oil container, French, Toulouse, early eighteenth century. (Courtesy of P. Boucaud).

203. A French holy oil container, eighteenth century. (Courtesy of P. Boucaud).

204. French ciborium, by Simon Petit of Paris, second half of the eighteenth century. A typical form. (Courtesy of P. Boucaud).

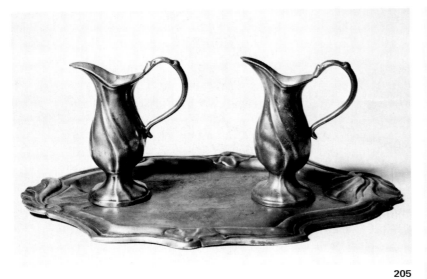

205

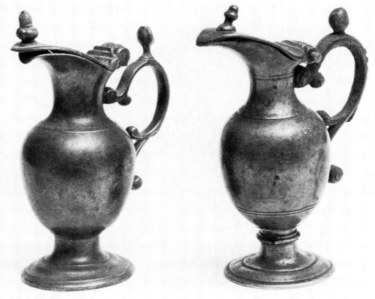

206

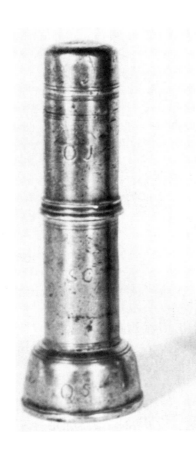

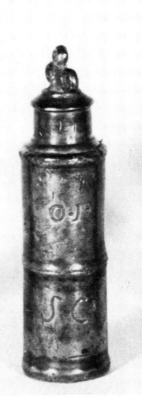

207

205. Two burettes or holy oil bottles. By F.L. Dittel of Cologne. The jugs are 4¼ inches high, dated 1767, German. Similar vessels were used in most parts of Europe. The dish is by the same maker. (Courtesy of Kunstgewerbemuseum Cologne).

206. Two lidded holy oil bottles, Paris, eighteenth century. (Courtesy of P. Boucaud).

207. A group of Holy oil bottles, French, from late eighteenth to early nineteenth century. (Courtesy of P. Boucaud).

208. A holy oil container in the shape of a cross, French, circa 1800. (Courtesy of H.B. Havinga).

209. Holy oil carafe, 6 inches high, European. (From the Gordon Collection).

210. Rare English semi-broad rimmed patten, Charles I period. (From the Little Collection).

211. Engraved plate with religious initials "IHS", similar to domestic cake plates. German, eighteenth century, 9¾ inches diameter. (Collection of Marianne & Albert Phiebig).

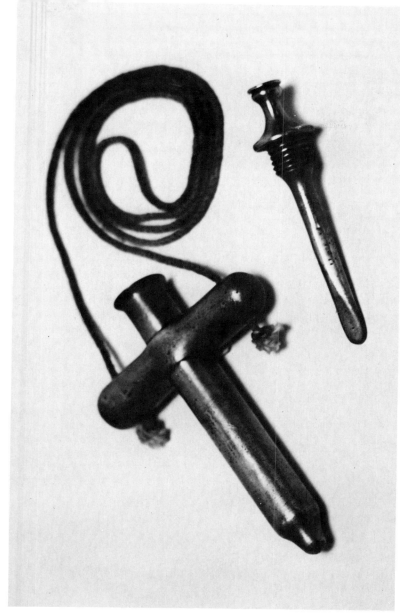

208

209

PATEN AND SALVERS

210

211

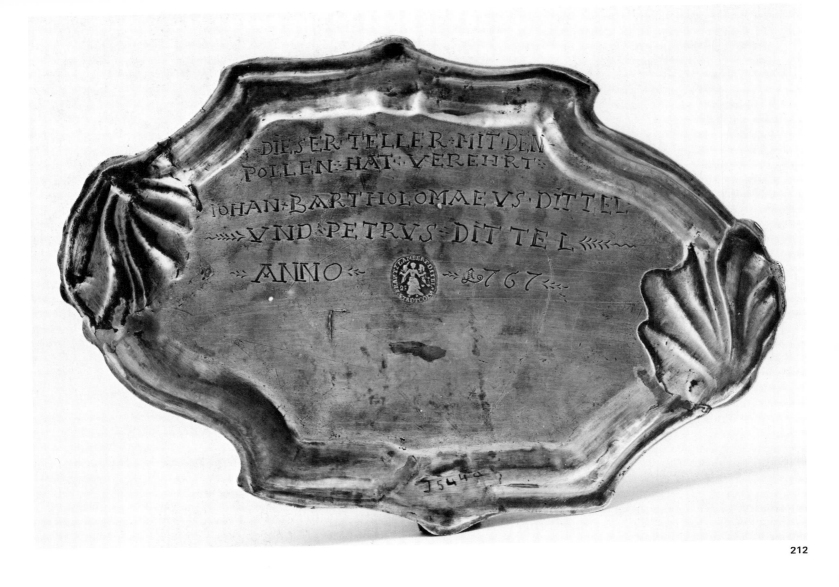

DIESER·TELLER·MIT·DEN·
POLLEN·HAT·VEREHRT·
iOHAN·BARTHOLOMAEVS·DITTEL·
VND·PETRVS·DITTEL
ANNO 1767

212

COLLECTING PLATES AND ALMS DISHES

213

BEEDON

214

HOLY WATER STOUPS

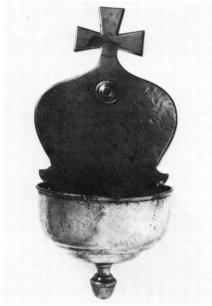

212. A tray or stand by F.L. Dittel, 1767 from Cologne and given to the church by the family. German. (Courtesy of Kunstgewerbemuseum Cologne).

213. An English triple reeded plate, 8 inches diameter, marked "S Nave" and used as collecting plate. Circa 1690—1710. (Courtesy of Robin Bellamy Ltd).

214. Alms plate, 10¾ inches diameter, from Beedon. Circa 1720—40. (From the Gordon Collection).

215. An English collecting plate with single reeded rim, 9 inches diameter, circa 1780—1800. (Courtesy of Robin Bellamy Ltd).

216. Another English early nineteenth century collecting plate. (Courtesy of Robin Bellamy Ltd).

217. Holy water stoup of early form, Dutch, seventeenth century. (Courtesy of Bourgaux).

218. Holy water stoup, Venice, Italy, eighteenth century. (Courtesy of P. Boucaud).

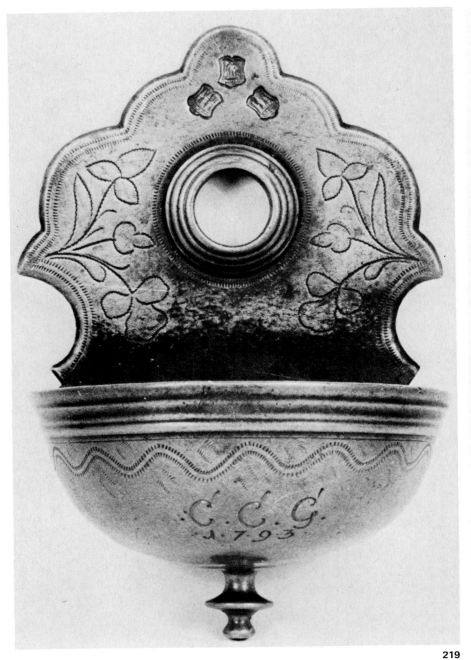

219

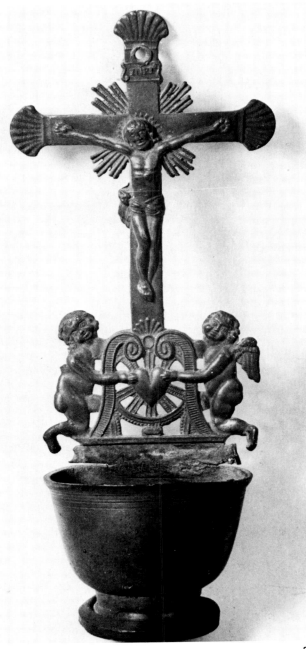

220

BAPTISMAL BOWLS

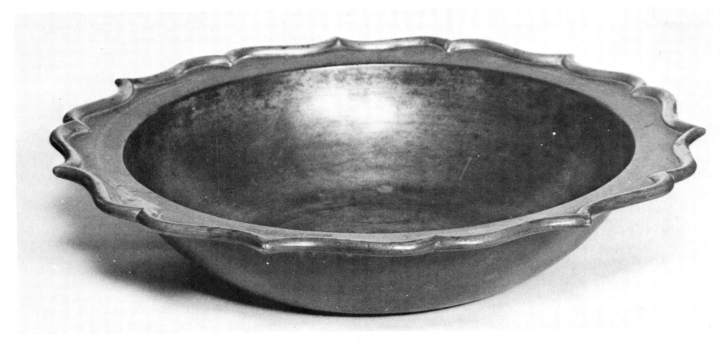

221

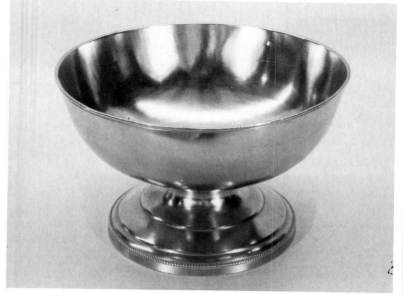

222

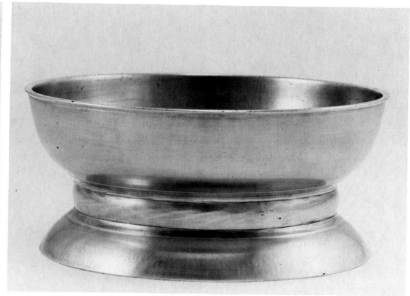

223

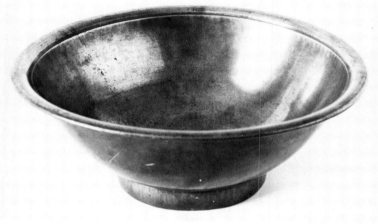

224

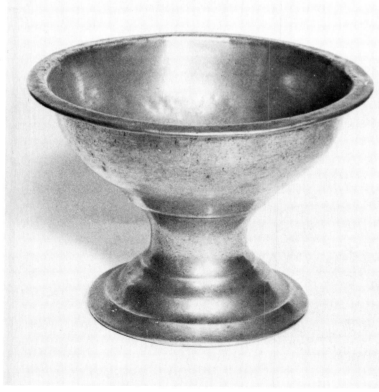

225

226

219. German holy water stoup, dated 1793, possibly used in a home. (Courtesy of Robin Bellamy Ltd).

220. This stoup is German, nineteenth century. Similar stoups were used in most of Europe. 7¼ inches high. (Courtesy of Kunstgewerbemuseum, Cologne).

221. Very rare baptismal bowl by Henry Will, circa 1760—90, 12½ inches wide, 2¾ inches high. (Collection of Mr. Charles V. Swain).

222. Baptismal bowl, American, attributed to Parks Boyde, eighteenth century, 7½ inches diameter. (Collection of Dr. and Mrs. Melvyn Wolf).

223. American baptismal bowl by Samuel Danforth, circa 1800, 7 5/8 inches diameter. (Collection of Dr. and Mrs. Melvyn Wolf).

224. Scottish baptismal bowl, early nineteenth century, 9½ inches diameter. (Collection of Dr. D. Lamb).

225. Fluted American baptismal bowl by the Taunton Britannia Company, 4½ inches high, circa 1830—35. (Collection of Mr. Charles V. Swain).

226. Baptismal bowl by Woodberry and Colton, American, circa 1835, 4 inches diameter. (Collection of Mr. Charles V. Swain).

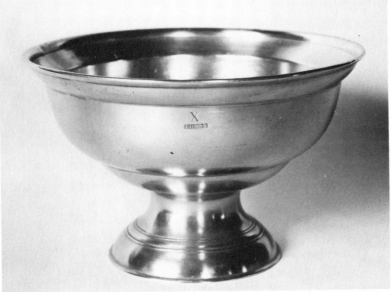

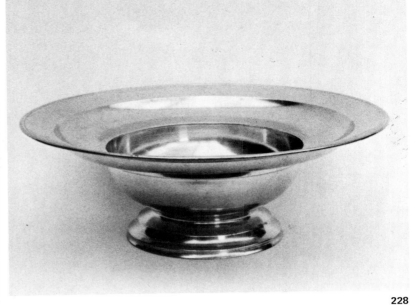

227

228

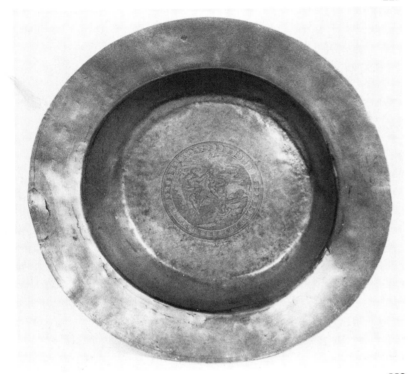

227. American baptismal bowl by Thomas and Sherman Boardman, circa 1810—25. (Collection of Gordon E. Perrin).

228. Baptismal bowl by Israel Trask, circa 1820—40, 10 3/8 inches wide, American. (Collection of Dr. and Mrs. Melvyn Wolf).

229. German baptismal dish or bowl with deep centre or well, circa 1620, Nuremberg. (Courtesy of H.B. Havinga).

230. An unusual baptismal bowl, German, circa 1600. (Courtesy of Metropolitan Museum of Art, New York. Rogers Fund).

231. Three seventeenth century Scottish communion tokens. (Courtesy of Robin Bellamy Ltd).

232. A group of seven eighteenth century Scottish communion tokens. (Courtesy of Robin Bellamy Ltd).

233. Three further Scottish eighteenth century tokens. (Courtesy of Robin Bellamy Ltd).

234. An interesting group of cast decorated Scottish communion tokens from the late eighteenth century onwards. (Courtesy of Robin Bellamy Ltd).

229

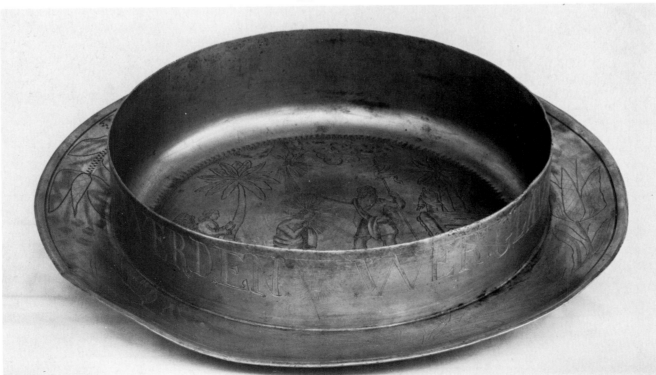

230

231

232

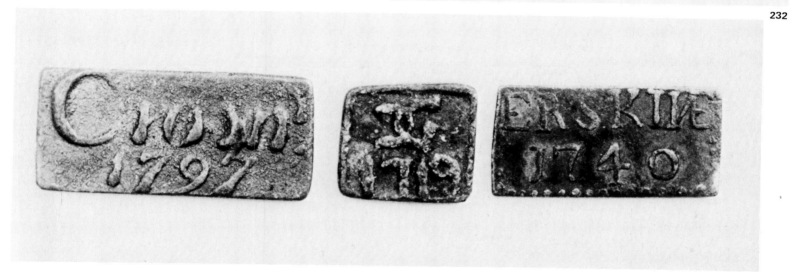

233

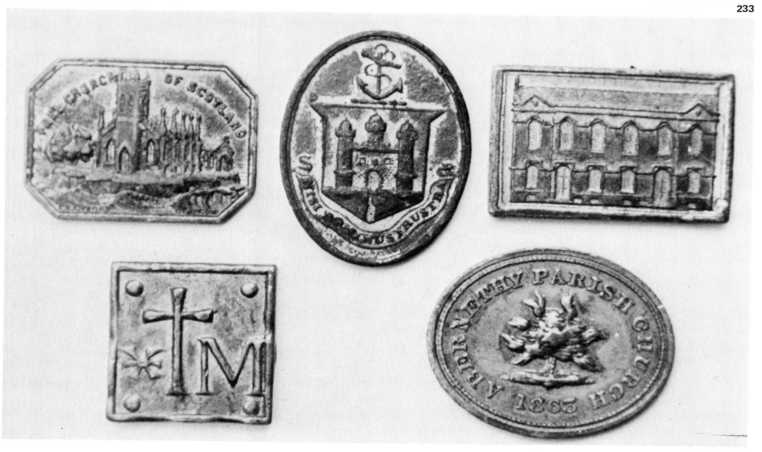

234

235

236

OTHER RELIGIOUS PEWTER

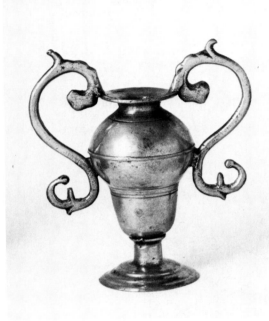

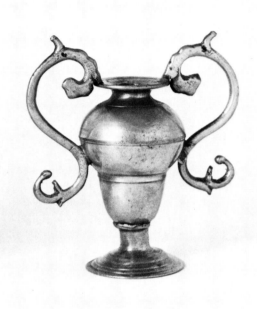

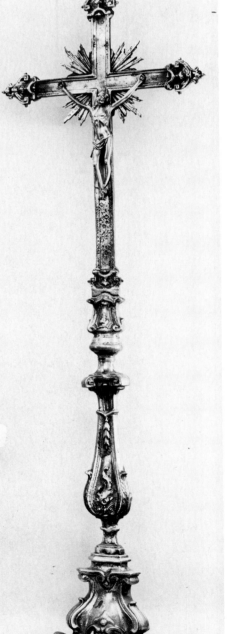

237

238

239

240

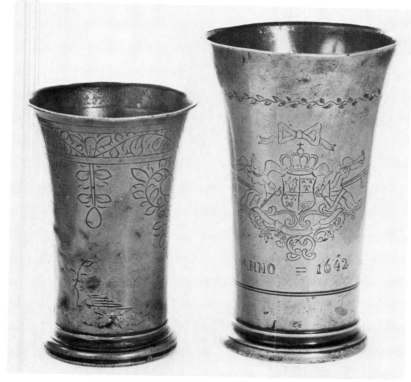

235. An American pewter communion token, showing front and back, dated 1807. (Courtesy of Christies, New York).

236. Two further American communion tokens. From left to right; From Schen-dy, New York, dated 1809. The example on the right carries a biblical reference. (Courtesy of Dementi Studio, Richmond, Virginia).

237. A pair of altar vases, Swiss, circa 1780. Similar vases were used in Holland, Germany and the rest of central Europe. (Courtesy of P. Boucaud).

238. A Portugese church cross, eighteenth century. (Courtesy of P. Boucaud).

239. A German candlestick. Most candlesticks of this form were probably used in churches as were many other forms illustrated in the section on candlesticks. This example is eighteenth century and stands 21 inches high. (Courtesy of Dr. Fritz Nagel).

240. A holy water sprinkler, American, nineteenth century, 10 7/8 inches. (Courtesy of Bowdoin College Museum of Art, Brunswick, Maine).

241

241. Two Dutch church beakers. That on the right dated 1642, both seventeenth century. (Courtesy of H.B. Havinga).

242. A rare pair of communion cups or beakers from Birse Kirk, Aboyne, Scotland. Inscribed "Cup H E for Breiss M I Keith Minr" dated 1660 and 1664. (Courtesy of the Minister Birse, Aboyne).

242

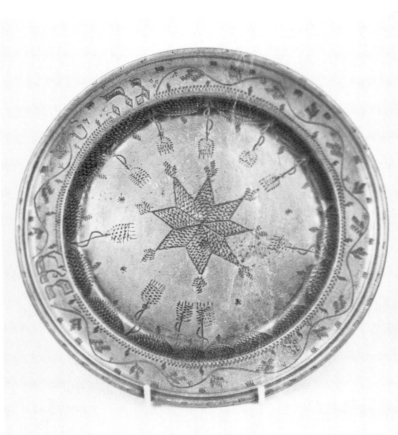

243

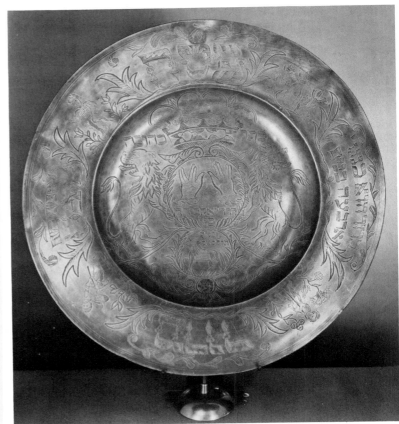

243A

243B

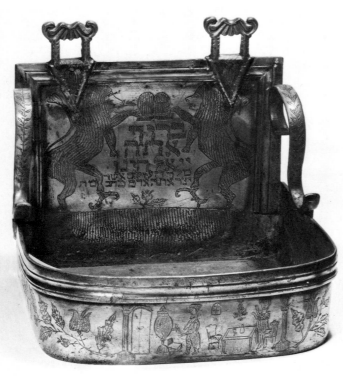

243C

243. German Seder plate, 9 inches diameter, eighteenth century. (Courtesy of Robin Bellamy Ltd).

243A. Passover dish, English from late seventeenth century possibly engraved later. 21 5/8 inches diameter. (Courtesy of the Warburg Institute, London).

243B. Hanukah lamp, made in Strasbourg, eighteenth century. 12½ inches by 10 inches. (Courtesy of the Warburg Institute, London).

243C. Laver. Engraved "Blessed Art Thou, O Lord King..." Possibly Swiss, 12 inches wide, late seventeenth or early eighteenth century. (Courtesy of the Jewish Museum, London).

CHAPTER 6

Institutional Pewter

Pewter was widely used by such public bodies as the trade and craft guilds, town corporations, schools and universities. Much of this pewter was acquired for ordinary domestic use by the people working or living within the institution, but there were a number of special items made for use by these bodies.

Schools, alms houses and other institutions in which people lived, frequently served the daily food on pewter plates or in porringers and most pupils, patients and inmates alike ate with a pewter spoon.

Many corporations had pewter plates and dishes but much was sold or thrown away in the nineteenth century. The pewter from the Borough of Newbury in England was sold in the local market in Victorian times.

The corporations whether composed of Burgess or craftsmen met frequently to conduct their business and pewter played a role in their ceremonies.

It was common for wine or ale to be offered to members in special guild flagons and many of these have survived.

Early guild flagons were tall, bellied and thin. Most corporations had acquired guild flagons prior to 1600 and seventeenth century examples are less common. After that date guild flagons are generally similar to domestic flagons although there are special styles used by particular corporations.

Most corporation flagons were lost or destroyed in the nineteenth century. The Nymegen Boatman's Guild alone lost thirty flagons.

Perhaps the commonest form of guild flagon are those from Germany and Austro-Hungary with straight sides standing on three feet. There are no American guild flagons.

One unique form of guild flagon found in Germany, Austro-Hungary and to a lesser extent in Scandinavia is the "Welcome" flagon. These large bulbous vessels, usually hung with shields, are each inscribed with the name of guild officers.

Some guild flagons or flasks were made to represent aspects of the guild's work; a shoe for the Cobbler's Guild for example. Pewter maces were used too and there are pewter guild signs. Individual tradesmen often displayed pewter trade signs outside their shops.

Guild pewter in Britain is rare. There are a few inscribed tankards mostly from the eighteenth and early nineteenth centuries.

Shooting associations in Switzerland and central Europe frequently gave inscribed plates and dishes as prizes.

Pewter has also been used as a medium for advertising messages. A famous lidless tankard from the seventeenth century bears the message inscribed on its side, "If sold, Stole" and "Att ye Horse and Jockey...in Reading...". Taverns often inscribed their pewter and other traders put their names on a variety of things to advertise their services.

Pewter with Royal associations also occurs. From Austria come an interesting series of water containers used by the Emperor to wash the feet of old men and women in Vienna each Easter as an act of humility.

The most famous Royal pewter is that used at the coronation of George IV. At the highly formal dinner held in honour of the king the table was laid with a new garnish of pewter made for the king by Sir George Alderson. Each piece was inscribed with the royal monogram "GR IV". At the end of the dinner the highly distinguished guests rose and stripped the tables, taking away with them the plates, dishes and tureens.

Pewter is also found with inscriptions of a military or naval nature. Regiments of Foot had their table-ware engraved. There are also a few genuine British naval broth bowls inscribed with the name of a ship of the line.

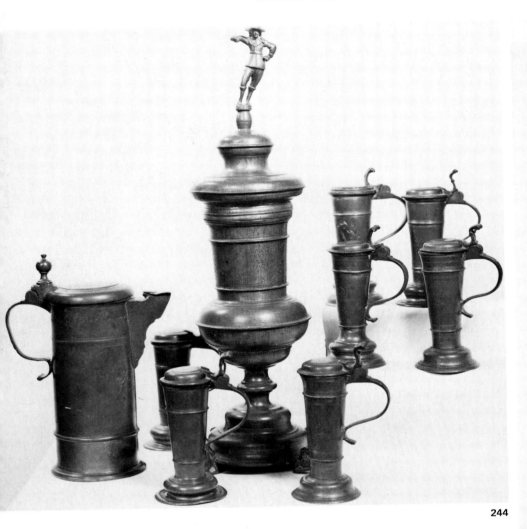

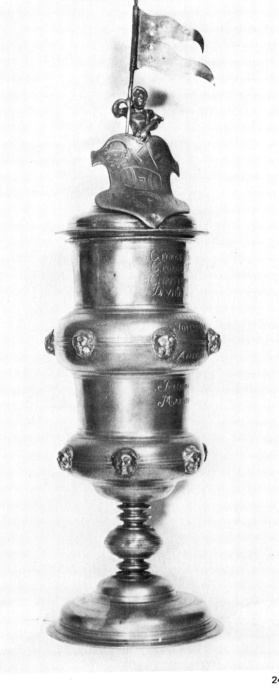

244

245

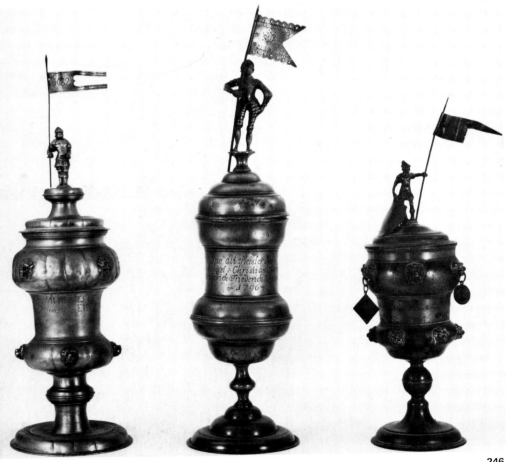

246

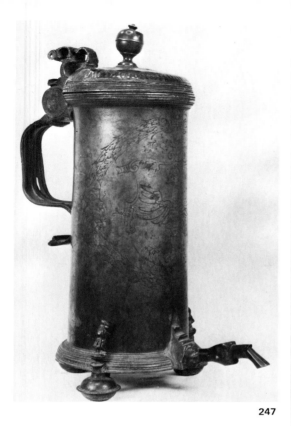

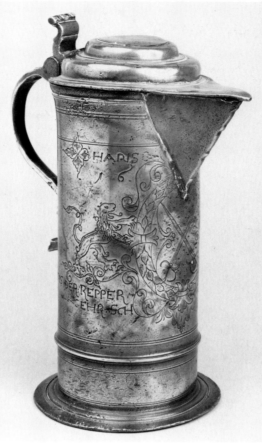

247

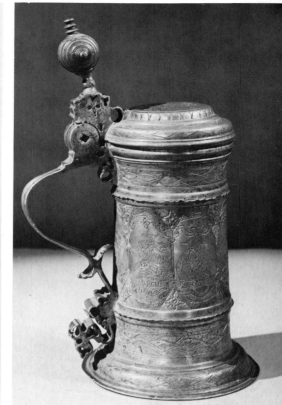

249

248

250

244. The Coopers Guild pewter Ratzeburg in Germany including the seventeenth century Welcome Cup, an eighteenth century guild flagon, and seventeenth and eighteenth century drinking tankards. The earliest tankard is dated 1687, the latest, 1832. (Courtesy of Robin Bellamy Ltd).

245. The most typical of all guild flagons or cups, widely used in Holland, Belgium, Scandinavia and central Europe. This is the Welcome Cup of a Brewers Guild, dated 1711. By "EW", German, 23 inches high. The flag is in brass (see chapter on Decoration for other examples of the combination of pewter and other metals). (Collection of Mr. and Mrs. Robert E. Asher).

246. Three further guild Welcome Cups. Left to right: German 1743, 22½ inches high. Bootmakers Guild, German, 1796, 24½ inches high. German cup, 19¾ inches high, mid-eighteenth century. (Courtesy of Sotheby Parke Bernet, London).

247. Fine guild flagon from the Cracow Bakers Guild, 1567, 25¾ inches high. Similar flagons were used and made throughout the seventeenth century. (Courtesy of Cracow Museum, Poland).

248. The spouted variety of guild flagon, this example is dated 1616, German. (Courtesy of Christies, London). &

249. Fine decorated German guild tankard from a potters guild, 11 inches high, north German or Saxon, seventeenth century. (Courtesy of Historical Museum Frankfurt).

250. A typical seventeenth century variety of the guild flagon, from the Fishermens Guild of Pest, Hungary, 1698. (Courtesy of Hungarian National Museum).

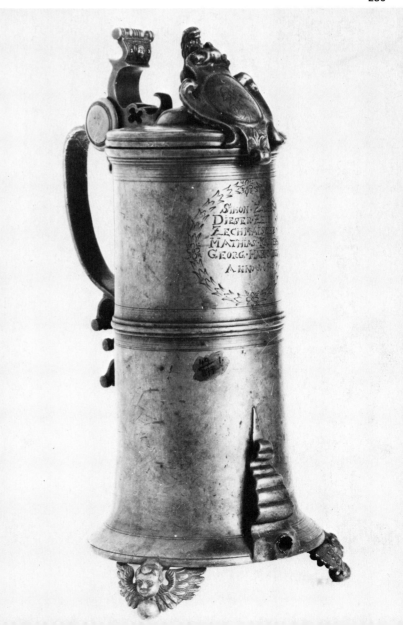

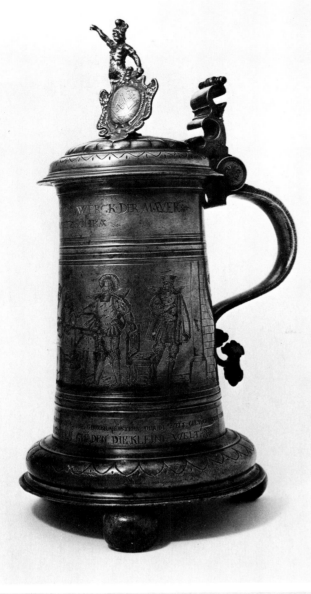

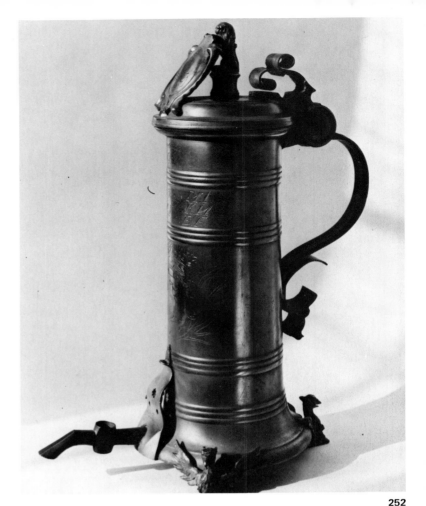

252

251. German guild tankard for a Masons Guild, seventeenth century. (Courtesy of P. Boucaud).

252. Eighteenth century flagon from Cluj, Roumania. Similar flagons are to be found from most of central Europe. (Courtesy of Museum of Applied Art, Budapest, Hungary).

253. A typical drinking tankard from Germany and northern Europe including the baltic states. From a Metalworkers Guild, 1668, by P.S. probably from Memmingen. (Courtesy of Sotheby Parke Bernet).

254. An unusual fluted guild tankard. North German, probably from Eberswalde, dated 1723, 8 7/8 inches high. (Courtesy of Sotheby Parke Bernet).

251

253

254

255

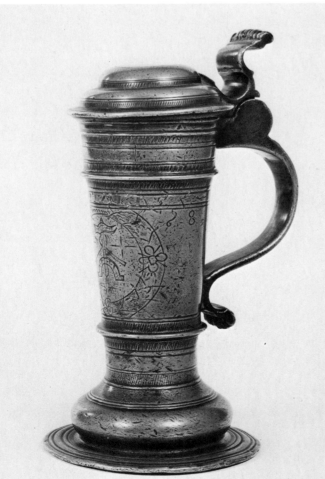

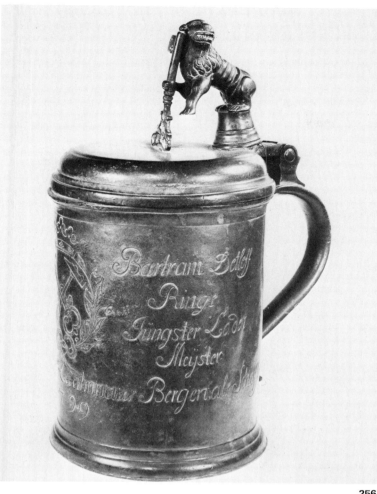

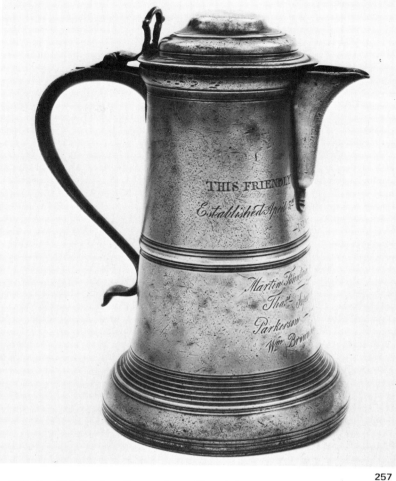

256

257

255. Most forms of European tankards have been used as guild drinking vessels. This is a typical ball knop tankard, from a Salzburg Guild, dated 1783. The lid is set with a copper gilt medallion, 9¼ inches high. (Courtesy of Sotheby Parke Bernet).

256. North German guild tankard. The knop is in brass. Dated 1799, made by F. Linde of Kiel. (Courtesy of Robin Bellamy Ltd).

257. English Society flagon from Norwich. Many "Friendly" Societies were formed for trade, convivial or trade union activities, circa 1819. (Courtesy of Sotheby Parke Bernet).

258. Mug or lidless tankard from the Cracow Bakers Guild, circa 1700—20, 8 1/8 inches high. (Courtesy of Cracow Museum, Poland).

259. Guild beaker or drinking cup for the Millers Guild, 1699, Hungarian. (Courtesy of Hungarian National Museum, Budapest).

258

259

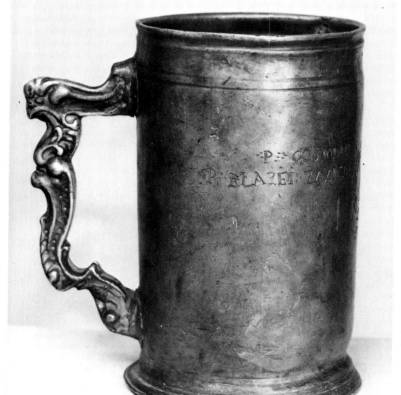

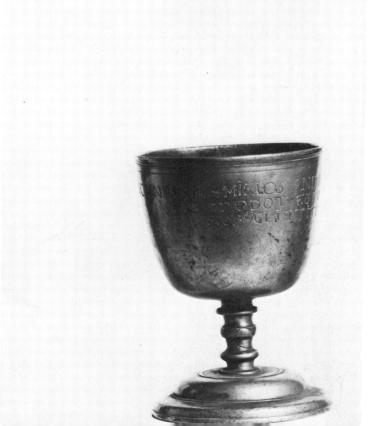

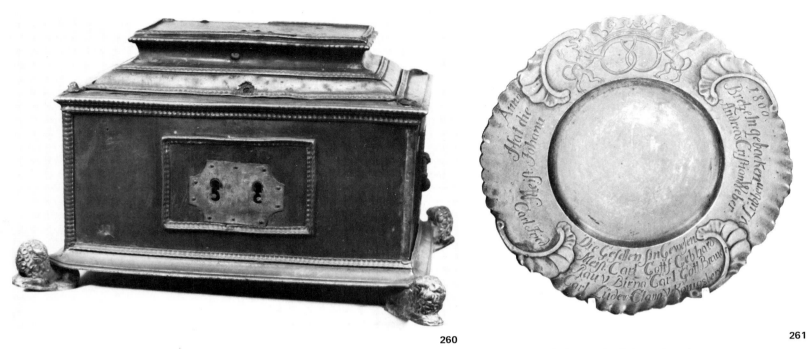

260

261

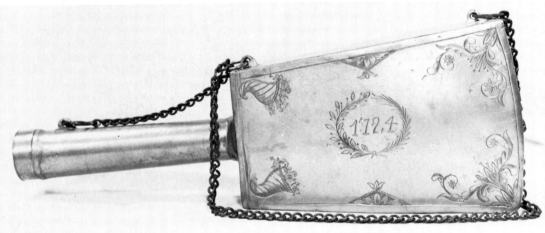

262

263

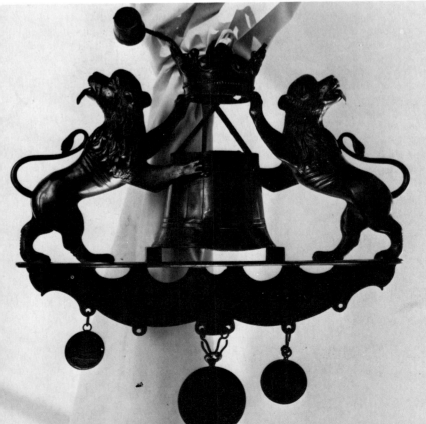

260. Guild chest from the Cracow Tailors Guild, 1668, 23½ inches wide. (Courtesy of Cracow Museum, Poland).

261. Rare guild dish, for the Pretzel Bakers Guild in Saxony. By D.G. Reinhard of Zittau, dated 1800, 9¾ inches diameter. (Courtesy of Sotheby Parke Bernet).

262. Guild flask from the Casket Makers in Dingolfing, in the shape of a mallet. 13½ inches long with screw thread to neck, dated 1724. (Collection of Marianne & Albert Phiebig).

263. Guild or trade sign, eighteenth century, from Sibia in Roumania, 16 inches square. (Courtesy of Museum of Applied Art, Budapest, Hungary).

264. Trade sign, Bayern, Germany, 1805, 12¾ inches wide. (Courtesy of Kunstgewerbemuseum, Cologne).

265. Guild drinking vessel in the shape of a shoe. Served also as a trade sign, German, circa 1710, 9¼ inches long. Similar vessels were made in a variety of shapes throughout central Europe. (Courtesy of Kunstgewerbemuseum Cologne).

266. A small spill holder for use in a tavern, advertised the service of a local pewterer in Ealing, London. Nineteenth century, English. (Courtesy of Robin Bellamy Ltd).

114

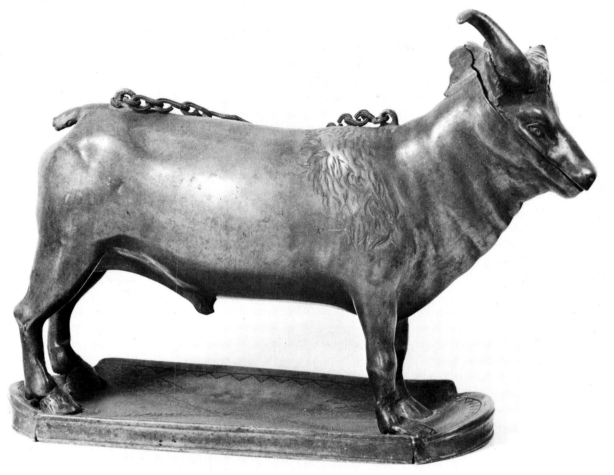

264

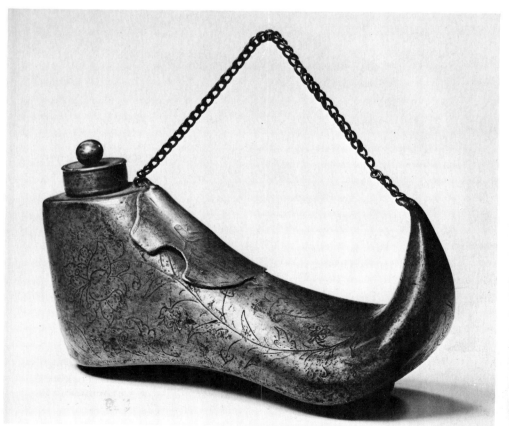

265

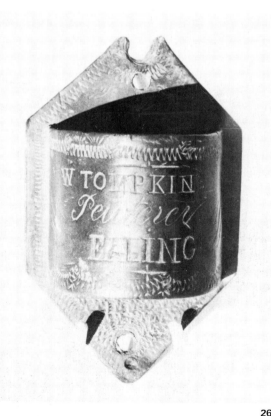

266

Further examples of Institutional pewter are illustrated at figures 436, 877, 913 & 1176.

CHAPTER 7

Medical Pewter

Pewter was used in hospitals. Many of the objects used were the same as those found in ordinary homes but other things were specifically designed for the treatment or comfort of the sick.

Only a few examples of domestic pewter with a hospital inscription have survived.

Three main categories of objects made for hospital use can be identified; things made to serve food to the sick, objects made as receptacles for the normal bodily functions and items made for use in the treatment of illness.

In the first category are a variety of feeding bowls, with long stems, or pouring lips.

Urinals, bed pans and pots were used in hospitals. In general these pots are the same as domestic examples. Bed pans and urinals were specially designed for their purpose. There are many forms and it is not easy to date or identify their origin.

One of the most frequent remedies for illness prescribed into the nineteenth century was to bleed the patient. Bowls designed to receive the blood were in widespread use. Termed "Barbers" bowls, because in the seventeenth century it was frequently the Barber—Surgeon, who bled the patient. These round or oval bowls have a small cut-out section to facilitate placing the bowl over the patient's arm. Many have gradations in the bowl to indicate how much blood has been taken. Porringers were also used for bleeding and a few also have gradation marks.

Medical instruments made in pewter are also found. Most common are a variety of syringes, most for treatment of urinary or rectal illness. Their considerable size and clumsiness provides an uncomfortable reminder of the standards of medical care even as late as the early nineteenth century.

Pewter accouchement trays, bidets and speculums, are amongst other medical equipment used.

Medicines were stored in pewter containers; ointments were kept in small pewter pots while larger containers held general remedies. Theriac, a medicine used for chest infections, was stored in vats in wards. Composed of up to 72 different ingredients, Theriac was an all purpose cough mixture. Chest infections were common and the treatment of coughs included the use of inhalers. Drugs were mixed with boiling water and inhaled through a tube. In the nineteenth century a group of containers with flat tight-fitting lids were made and used in Britain and America. Medicines were also given to the young and sick with "castor oil" spoons.

Bottles and Pap Boats

Babies and young children were fed from bottles of pewter, often provided with pewter "nipples". These bottles are all of a similar design although their lines do vary slightly. Made in all parts of Europe, Britain and the United States they date from 1600 to 1850. Few have makers' marks but amongst American pewterers known to have made them are William Bell circa 1764, and Deblois who advertised "Sucking bottles" in 1756.

Pap boats were also used to feed young children and the sick. Early pap boats in silver date from 1800 although there are references to pewter pap boats as early as 1631. Most pap boats found will be nineteenth century and many as late as 1900.

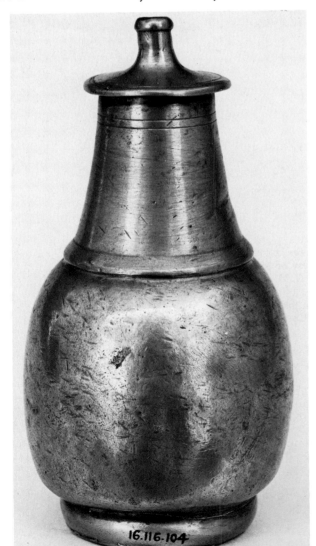

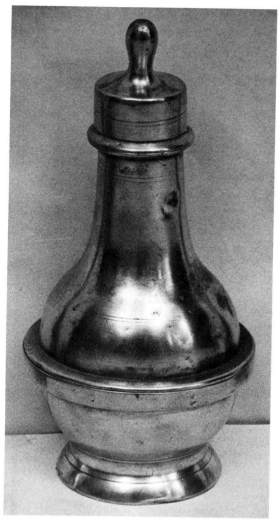

268

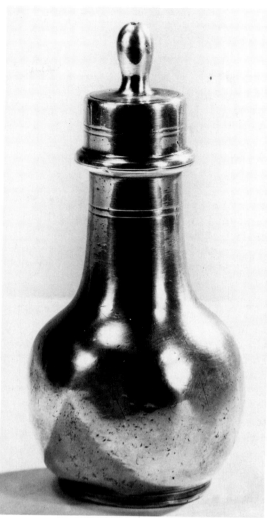

269

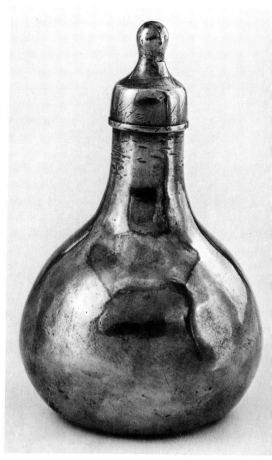

270

267. French feeding bottle, late seventeenth century. (Courtesy of Metropolitan Museum of Art, New York. Gift of Mr. R.M. Parmelee and Mrs. W.L. Parker).

268. English feeding bottle, circa 1780—1810, 6 3/8 inches high. (Courtesy of Colonial Williamsburg).

269. French biberon or feeding bottle, eighteenth century. (Courtesy of Bourgaux).

270. Baby's feeding bottle by T.D. Boardman, American nineteenth century. (Courtesy of the Metropolitan Museum of Art, New York. Gift of Joseph France).

271. More bulbous feeding bottle, American, 6½ inches high. By T. Boardman & Company, circa 1820. (From the Herr Collection).

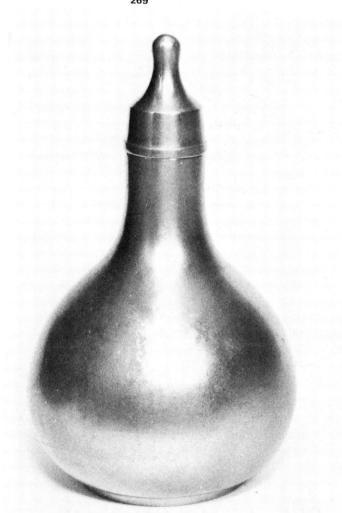

271

117

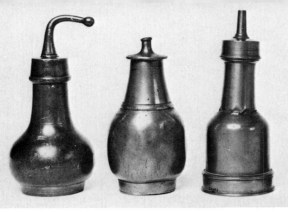

272

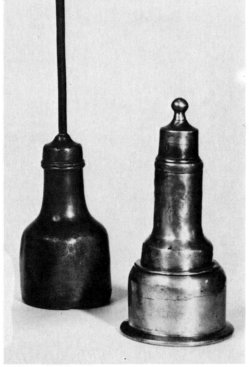

273

274

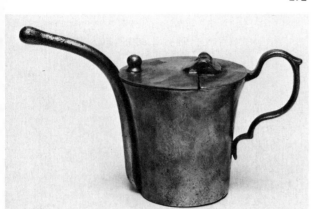

275

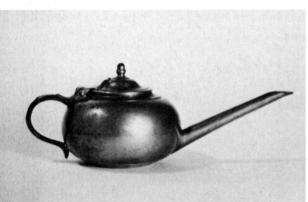

276

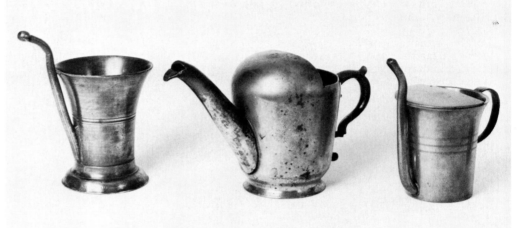

277

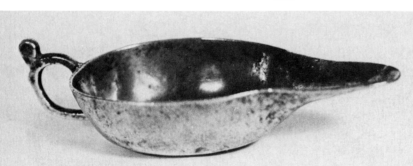

278

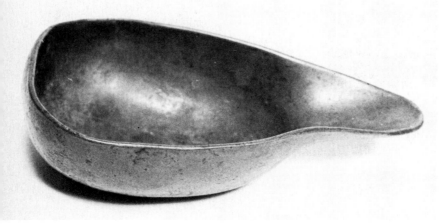

272. Group of three feeding bottles. Left to right; Dutch or French, 6½ inches high. French. French. All late eighteenth century. (Courtesy of Wellcome Institute Library, London).

273. Two further French feeding bottles, both nineteenth century. (Courtesy of H.B. Havinga).

274. Two feeding or invalid cups. Left: Dutch, eighteenth century. Right: French, nineteenth century. (Courtesy of H.B. Havinga).

275. "Bubby" or invalid feeding cup, English or Dutch eighteenth century. (Courtesy of Wellcome Institute Library, London).

276. Feeding bottle, French, of unusual form. Paris mid-eighteenth to nineteenth century. (Courtesy of P. Boucaud).

277. Three feeding cups, European, circa 1780—1820. (Courtesy of Wellcome Institute Library, London).

278. Pap boat, eastern France, nineteenth century. (Courtesy of P. Boucaud).

279. Pap boat, English, nineteenth century. (From the Dean Collection).

118

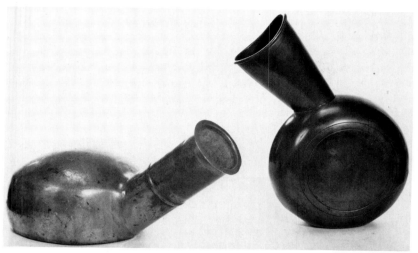

280. Two male urinals, Dutch, nineteenth century. (Courtesy of H.B. Havinga).

281. French urinal, male, made from eighteenth century into nineteenth century. (Courtesy of P. Boucaud).

282. Male urinal and in box a bourdelou, French, early nineteenth century. (Courtesy of Wellcome Institute Library, London).

283. A theriac container, used to provide an all-purpose cough mixture, Scandinavian, circa 1700. Such theriacs stood in many hospital wards throughout Europe, although the form often varied from hospital to hospital. 21¾ inches high. (Courtesy of National Museum, Stockholm).

284. Two pharmacy pots or jars, nineteenth century. Austro-Hungarian. (Courtesy of Hungarian National Museum, Budapest).

280

281

282

PEWTER FOR TREATMENT

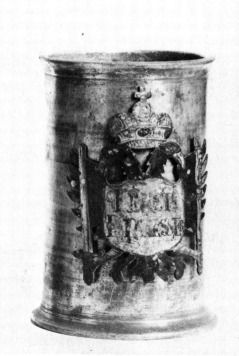

283

284

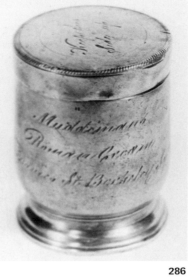

286

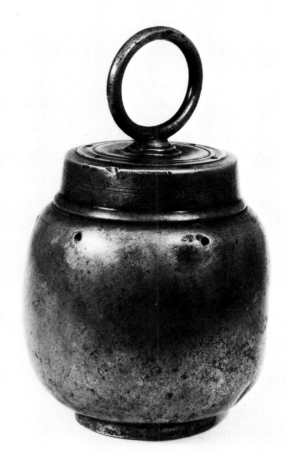

287

285

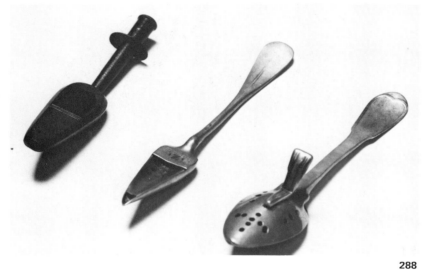

288

285. Small French theriac pot, Paris, eighteenth century. (Courtesy of P. Boucaud).

286. Small English ointment pot, early nineteenth century. (Courtesy of Robin Bellamy Ltd).

287. Leeches were used in bleeding. Common type of northern French leech pot, early nineteenth century, but similar pots made all over France and in other parts of Europe. (Courtesy of P. Boucaud).

288. A group of medicine spoons. Left to right: English, circa 1830; French, circa 1800; French, circa 1800. (Courtesy of H.B. Havinga).

289. Syringe with pistol handle with ivory inlay, English, early eighteenth century. (Courtesy of Wellcome Institute Library, London).

290. Nineteenth century French castor-oil spoon for serving medicine to young patients. (Courtesy of P. Boucaud).

289

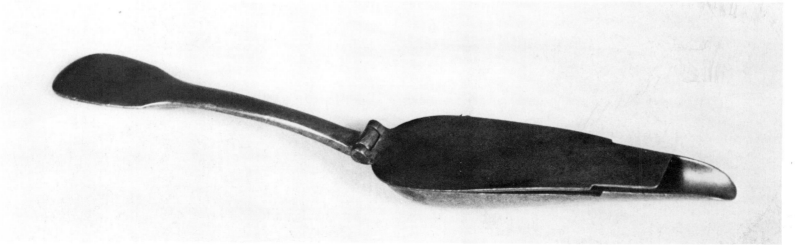

290

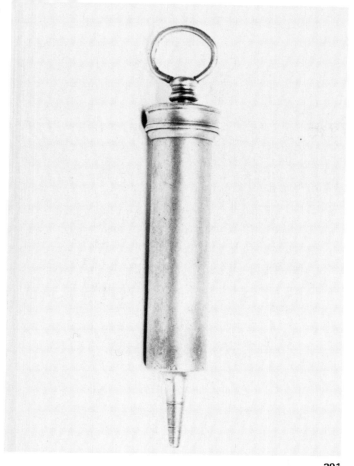

291

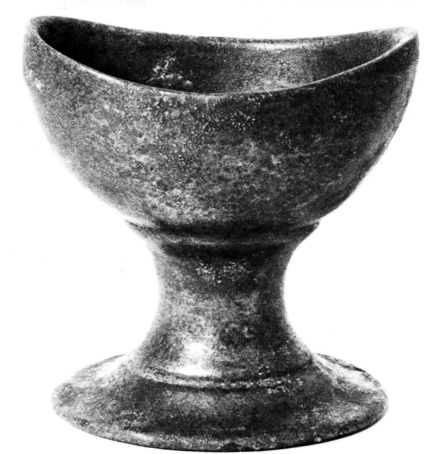

292

291. Small syringe, 5½ inches long, English or Dutch, circa 1820. (Courtesy of Robin Bellamy Ltd).

292. Pewter eye cup, origin unknown, but probably English or Dutch, eighteenth century. (Courtesy of Wellcome Institute Library, London).

293. A tisane pot, French, nineteenth century, Paris. (Courtesy of P. Boucaud).

294. An English inhaler used to treat chest infections. Nineteenth century, 5½ inches high. American examples were probably very similar. (From the Kydd Collection).

295. A suppository mold, American, nineteenth century, 5½ inches wide. (Courtesy of Bowdoin College Museum of Art, Brunswick, Maine).

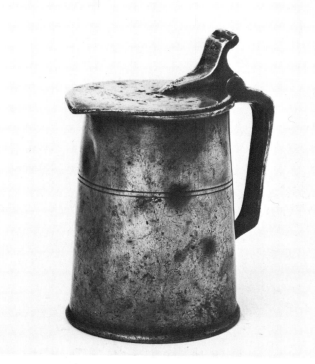

293

294

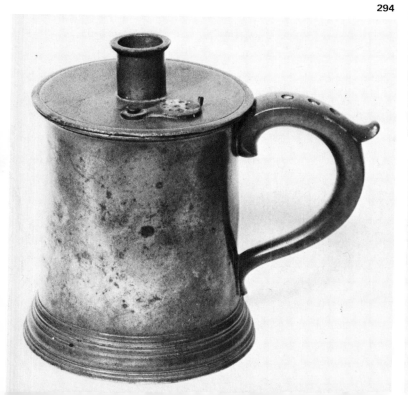

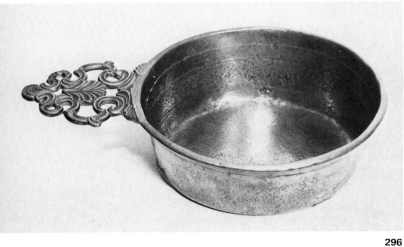

296

297

296. An English bleeding bowl in typical porringer form, gradated 12, 8 & 4. Circa 1800. (Private collection).

297. Bleeding bowl in porringer style, English, eighteenth century. (Courtesy of Wellcome Institute Library, London).

298. Bleeding bowl with straight handle, European, possibly from low countries, eighteenth century. (Courtesy of Robin Bellamy Ltd).

299. Ungradated French bleeding bowl, Chartres, second half of eighteenth century. (Courtesy of P. Boucaud).

300. Cup-like bleeding bowl, English eighteenth century, with 7 gradations, 4¾ inches high. (From the Kydd Collection).

301. Plain graduated bleeding bowl without handles, English, circa 1800. (Courtesy of Wellcome Institute Library, London).

298

299

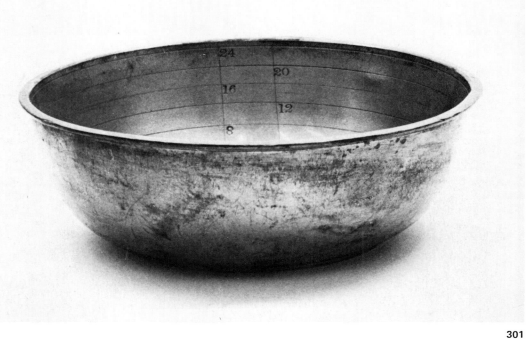

301

300

BARBERS BOWLS

Many of these were used for shaving but some by Barber—Surgeons for bleeding.

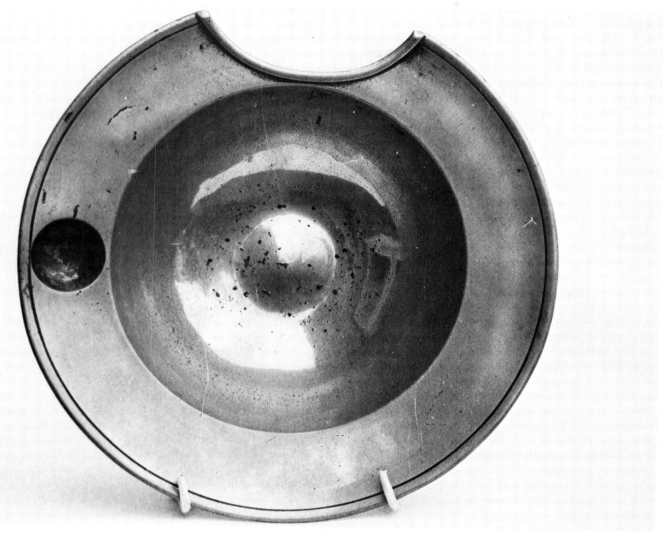

302. English eighteenth century barbers bowl, by Henry Joseph. (Courtesy of Robin Bellamy Ltd).

303. English barbers bowl, 10 5/8 inches, circa 1730—40. (From the Holt Collection).

304. Oval French barbers bowl. This form was made throughout the eighteenth and nineteenth century and similar oval bowls were also made in other parts of Europe. (Courtesy of P. Boucaud).

302

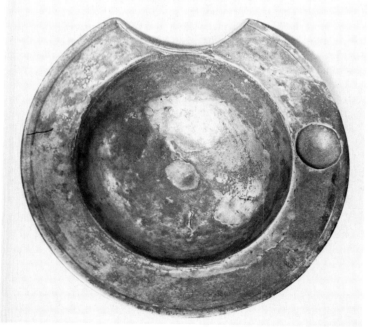

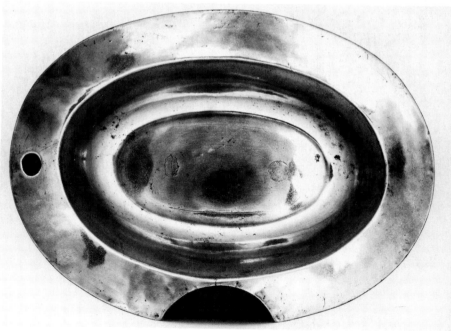

303

304

CHAPTER 8

Pewter for Eating: Flatware

More pewter plates, saucers, dishes and chargers were made than with any other group of objects. The term "flatware" being applied to all these objects, whatever their size.

Dutch and British inventories have shown that between 55% and 65% of all items of pewter listed in peoples' homes were flatware. From American pewterers' inventories we learn that flatware also accounted for a substantial proportion of their production.

Flatware was also called "Sadware" from an old English word meaning "solid" in contrast, to tankards and flagons which were termed "Hollow-ware".

For convenience we define "saucers" to mean small plates under five inches in diameter, while "plates" range from five inches to around twelve inches. The term "dish" refers to items between twelve and eighteen inches and the expression "charger" is reserved for dishes above eighteen inches.

In Medieval times flatware definitions were based not on diameter but on weight. Names were given to a variety of dishes and in some cases the meaning of the terms are now lost, eg Voyders, Salliers and Dobelers.

Until the advent of delft, pewter's only serious rival for plates and dishes was wood.

The development of flatware has been surprisingly uniform. Plates and dishes of similar form are found all over the western world although there were local forms and variations in the chronology and popularity of flatware, in general there was a similar pattern of development of Europe, the United States and Britain.

This general conformity of design arises from two causes. First, there was the need for a low cost durable product, and secondly the essentially simple nature of flatware did not encourage elaboration.

Most flatware was made for heavy daily use in the home or institution the exceptions being some decorated or cast dishes designed for display.

The dominating medieval form of flatware was a plate with a narrow rim, shallow sloping sides and a central boss. This form of plate was found throughout Britain and Europe and continued in use into the seventeenth century.

In Europe a new form of plate or dish with a much broader rim, more steeply-sloping bowl and flatter base became popular in the sixteenth century, and the style spread to Britain. These broad-rimmed dishes dominated the seventeenth century, their rims reaching relatively massive proportions around the middle of the century. Whilst they died out in Britain in the last decade they continued in production in other parts of Europe such as Switzerland into the early eighteenth century. Fine examples were made in France around 1650 called "Plat a Venaison" or Venison dishes. Towards the end of the seventeenth century the broad rim became less pronounced and in Britain, and later, in northern Europe, they were decorated with reeding, at first cut into the rim and then cast upon it.

Some broad rims of the mid-seventeenth century retained the central boss but after about 1650 or so most had flat bases.

Towards the end of the seventeenth century rims suddenly became much smaller and groups of very narrow rimmed plates were made in Britain and, less commonly, in other parts of Europe.

The late seventeenth century also saw a return to a plain-rimmed style without incising or reeding, but narrower than the broad rims. These plain-rimmed plates appeared in England circa 1690 and for 130 years dominated flatware production in that country. They were made in Europe and the United States in the eighteenth century but they were common in Britain.

The flatware discovered in the excavation of Port Royal in Jamaica (destroyed by an earthquake in 1692) has proved to be a form of time-capsule and provides an insight into the relative frequency with which various types of plates then in use occur. Sixty-four plates were recovered, of which 27 were narrow-rimmed, twenty had multiple reeding and seventeen were broad-rims.

In the early eighteenth century plates with a single cast-reed appeared. These "single-reeded plates" were made everywhere and were the dominating form in the United States and the most popular style in Europe.

The eighteenth century saw further changes. In the first half of the century plates were made with straight edges, with between four and ten sides, some plain, others decorated with beeding or gadrooning. Around the 1730's plates were

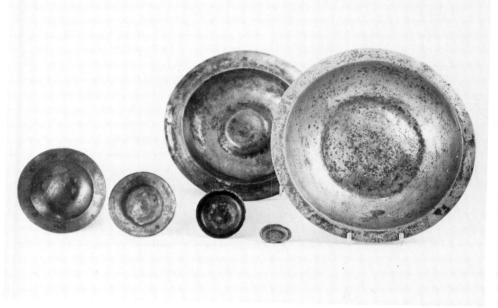

305

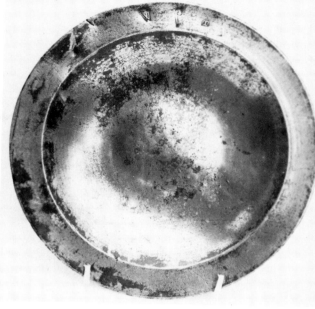

306

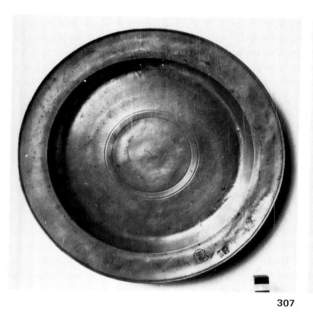

307

308

309

305. A group of typical Dutch fifteenth and sixteenth century dishes, plates and saucers. Similar flatware was used throughout Europe and the styles continued in manufacture up to around 1600. (Courtesy of H.B. Havinga).

306. An English sixteenth century plate with Rowel and Spur mark. Plates of this style were in use for a few years after 1600. (Courtesy of Robin Bellamy Ltd).

307. A Hungarian plate. This form had a flatter appearance than the sloping, bumpy bottomed plates, and was used throughout Europe and more occasionally in Britain. This example is sixteenth century. (Courtesy of the Hungarian National Museum).

308. An English flat plate of circa 1600—20. (Courtesy of Robin Bellamy Ltd).

309. Dishes and plates continued to be made and used with the gradually sloping sides and central boss until towards the end of the seventeenth century although they are much less common after 1630. This example is English, circa 1640. (Courtesy of Robin Bellamy Ltd).

310. The two early forms, the flat and bossed, gave way in the late sixteenth century to plates with flat broad rims. Broad rimmed plates were made and used throughout Europe and Britain and examples will have also been made in America. English, circa 1640. (Courtesy of Robin Bellamy Ltd).

310

produced in Europe and later in Britain with a "wavy" or scalloped edge. These edges can be plain, beeded or patterned.

Some wavy edged plates were made in the second half of the eighteenth century with the body of the plate as well as the rim shaped in wrythen or rococo form.

Deep-bowled plates did not appear until well into the eighteenth century.

In addition to wavy-edged and lobed dishes there are also oval examples, some with plain rims, others decorated, found in Britain and Europe.

A survey of more than 2,800 plates, dishes and chargers has shown the relative frequency with which the various forms are found in Europe, America and Britain.

In one sense the comparisons drawn are false as we are not comparing like with like; the time span involved for American production, in which most plates and dishes were made after 1760, is much shorter than that for Europe and Britain. The survey can also only reflect what has survived and thus must be weighted towards the styles that appeared on the scene later.

With these limitations in mind the survey shows that the singled reeded form dominated American production and that the singled reeded and wavy edges styles were far more popular on the continent than in Britain where plain rimmed plates and dishes dominate.

Flatware was made in a variety of sizes and the second part of the survey shows the frequency with which these sizes appear.

With dishes and chargers most American (90%) and European (83%) examples are fifteen inches in diameter or less, whereas a majority (57%) of British dishes are sixteen inches in diameter or larger.

The frequency with which dishes and plates have survived differs considerably. For every American dish there are 5.2 plates; for every European dish there are 3.9 plates whilst for every British dish there are only 2.1 plates. Thus dishes and chargers are much more frequent in Britain than elsewhere.

SPECIALIZED PLATES

Tazza

Footed plates or tazza were used in Britain and the United States for serving food. In Europe they are found less frequently. Rarer forms stand not on one foot but on three. Many footed plates have gadrooning around the rim and foot and most tazza date from 1680 to around 1730.

Hot Water Plates

Hot water plates had a period of popularity from the mid-eighteenth century. These rather utilitarian plates were made so that hot water could be poured into them to keep food on the plate hot during a meal.

311

312

311. A French broad rim, 9 inches diameter, circa 1660. (Courtesy of Robin Bellamy Ltd).

312. A Swiss example, by H.L. Cadenath of Chur, circa 1700, 11¼ inches. (Courtesy of Sotheby Parke Bernet).

313. Although broad rimmed plates are very similar wherever they come from, there are, by 1650 some small differences. British examples have plain rims, with a small ridge sometimes on the back, whereas European examples often have a lifted rim or ridge on the front as with this example, circa 1670. Excavated from a wreck off Panama. Probably Italian, 9½ inches diameter. (Courtesy of Robin Bellamy Ltd).

314. Broad rimmed dish by Edmond Dolbeare of Boston. American, circa 1690, 17 inches diameter. As the seventeenth century advanced the rims of such broad

313

314

315

316

rimmed plates and dishes gradually became smaller. (Collection of Dr. and Mrs. Melvyn Wolf).

315. Around 1650 another development in style occured with engraved ridges appearing on the rims of flatware. Later such reeding was cast in the mold. Reeded flatware was made in all regions. This charger is by John Donne, 23¼ inches diameter and has a cast multiple reeded rim, circa 1690, English. (Courtesy of Sotheby Parke Bernet).

316. Another fine reeded English charger with the hammering marks still clearly to be seen. 20 inches diameter, circa 1680. (Courtesy of Robin Bellamy Ltd).

317. Plates were also reeded. This 9 inch example is English and by Joseph Hopkins, circa 1780. (Courtesy of Robin Bellamy Ltd).

317

318

They were widely used in Britain, less extensively in the United States and rarely in Europe.

Cake Plates

In Europe decorated plates, which rest flat on the table were provided for serving cakes. These "Kuchenplatten" were popular in Germany, Switzerland and Alsace.

Serving Dishes and Food Containers

Until the eighteenth century food was mostly brought to the table on dishes or in domestic bowls. A range of special serving dishes gradually developed. Two trends can be identified. One in Germany and Austro-Hungary was for flat bottomed vessels usually with lids whilst everywhere, round dishes with feet and lids were popular. Some of these serving dishes are similar in style to tureens but are smaller. In Britain and the United States most use was made of ordinary domestic bowls.

A group of special containers were made in Europe to carry food to men working in the fields or forests. These had tight-fitting lids to keep the food warm but varied in style from country to country.

Bowls and Basins

Receptacles with deep sides were extensively used in the home, especially in the United States.

British and American bowls are similar in style; they are deep and have narrow rims. In the United States bowls varied from six inches to twelve inches in diameter but few bowls of above ten inches diameter are found in Britain. The booge of British but not American bowls are normally hammered. Where bowls are unmarked this is one of the few ways to identify their origins.

Domestic deep bowls were popular in Britain from 1680 into the nineteenth century but most American bowls were made after 1750.

A variety of names were applied to bowls including washbasins, slop bowls, barbers bowls, breakfast bowls and broth bowls, probably based on their size. They fulfilled a large range of domestic functions.

In Scotland a group of deep dishes were manufactured from the early eighteenth century and there are occasional examples found elsewhere.

European bowls are less common but examples can be found.

319

320

PLATES AND DISHES
FREQUENCY TABLE

Form	European %	British %	American %
Single Reed	45	20	86
Triple Reed	3	6	*
Broad Rims	10	2	*
Wavy Edges	22	6	*
Plain Rims	10	64	10
Narrow Rims	4	1	*
Other	6	1	4 (1)
	100	100	100

*Insufficient examples to be statistically significant.
(1)Includes triple reeded broad rim and all other forms.

PLATE SIZES

Size	European %	British %	American %
Under 7"	1	*	6
7"	5	*	15
8"	12	10	39
9"	64	82	20
10"	4	3	6
11"	4	2	6
12"	10	3	8
	100	100	100

DISH SIZES

Size	European %	British %	American %
13"	24	11	51
14"	33	12	28
15"	26	20	12
16"	6	29	2
17"	5	5	7
18"	3	14	*
19"	*	2	*
20"	2	3	*
21" or more	1	4	*
	100	100	100

*Insufficient data to be statistically significant.

318. Reeding was also found on dishes & plates with deeper bowls such as this example by Adam Bankes of Wigan. 9½ inches diameter, circa 1680, English. (From the Gordon Collection).

319. Fine decorated Swiss multiple reeded dish by G. Kruger of Geneva circa 1830, 16½ inches diameter. Reeded dishes were used in all parts of Europe and continued in production after they were out of fashion in Britain and the United States. (Collection of Mr. and Mrs. Robert E. Asher).

320. This bowl plate by "TW", 12½ inches diameter, has a central boss combined with the reeded rim, circa 1650—70, English. (Private collection).

321. Towards the end of the seventeenth century plates and dishes were made in Britain and less frequently in central Europe with very narrow rims or even without rims. Some of these narrow rimmed dishes had a single narrow reed on the rim, but most are multiple reeded. Here is an English plate, circa 1690, 8¾ inches diameter. (Courtesy of Robin Bellamy Ltd).

322. This triple reeded very narrow rimmed dish is by George Smith, circa 1680, 17 inches diameter, English. (Courtesy of Robin Bellamy Ltd).

323. Another dish by George Smith of London, but with plain very narrow rim. 16 inches diameter. (Courtesy of Robin Bellamy Ltd).

324. An American narrow rimmed plate by Thomas Danforth III, circa 1790, 9¼ inches diameter. (Courtesy of Christies, New York).

321

322

323

324

325

326

327

329

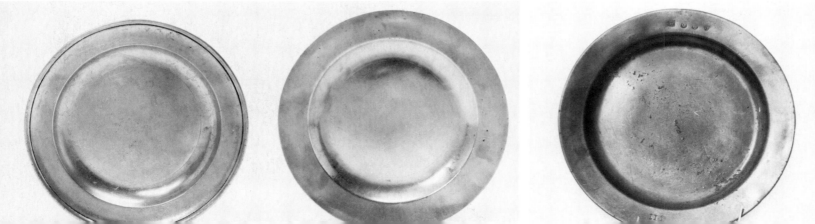

331

332

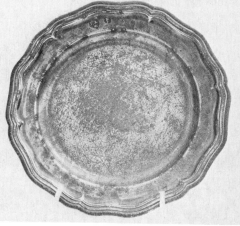

333

325. A complete garnish of English single-reeded plates and dishes. From 9 inches diameter to 16 inches diameter. The single reed was the dominant form in the eighteenth century in Europe and America and important in Britain. (Courtesy of Bourgaux).

326. A single reeded dish by Joseph Leddell of New York, circa 1730—40, 13½ inches diameter. (Courtesy of Christies, New York).

327. An important single reeded dish by William Will, circa 1770—80, 12 inches diameter. (Courtesy of Christies, New York).

328. Left: A 9 inch diameter plate by William Kirby of New York, circa 1770—80. Right: Important plain rimmed plate by John Dolbeare of Boston, circa 1720, 9¼ inches diameter. (Courtesy of Christies, New York).

329. Finely engraved French dish of a form made throughout the eighteenth and nineteenth century. (Courtesy of P. Boucaud).

330. The first plain rimmed plates since the early seventeenth century appear around 1690 and became the dominant form in Britain later in the eighteenth century. This 8½ inches diameter example is circa 1690. (Courtesy of Robin Bellamy Ltd).

331. English plain rimmed eighteenth century plate, typical of this style. (Courtesy of Robin Bellamy Ltd).

332. Belgian plain rimmed plate late eighteenth century. (Courtesy of Robin Bellamy Ltd).

333. Typical German wavy edged plate, circa 1770. (Courtesy of Robin Bellamy Ltd).

334. Wavy edged plates were also made with decorated rims. This fine English plate has a beeded rim. (Courtesy of Sotheby Parke Bernet).

335. A fine cast decorated English wavy edge plate, circa 1750, 9¾ inches diameter, by Thomas Chamberlain. (Courtesy of Robin Bellamy Ltd).

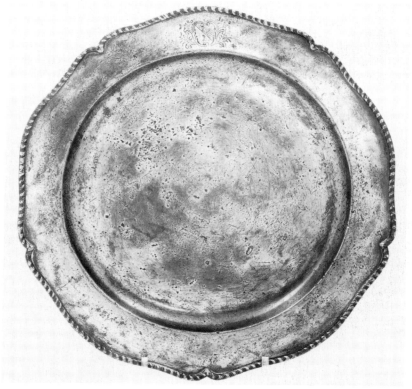

334

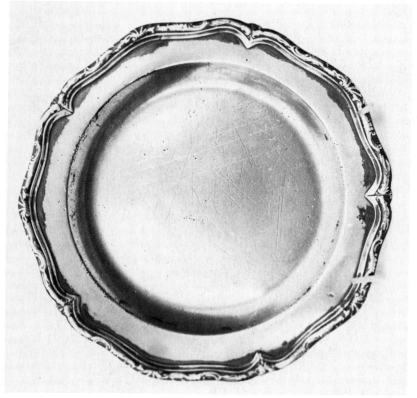

335

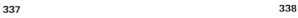

336 **337** **338**

339 **340**

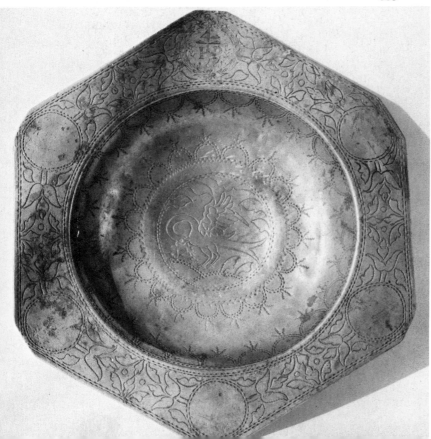

336. More rarely wavy edged plates were made with plain undecorated rims, English, circa 1740. (Courtesy of Robin Bellamy Ltd).

337. There are also rectangular wavy edged dishes, English in these instances, circa 1760, 12 inches wide. (Courtesy of Robin Bellamy Ltd).

338. Six, eight, and ten sided plates were made in Britain and western Europe from the early eighteenth century until the middle of the century. This is an English ten sided plate, 9 inches diameter. (Courtesy of Robin Bellamy Ltd).

339. Eight sided English plate, circa 1720—30, 9 inches diameter. (Courtesy of Robin Bellamy Ltd).

340. Twelve sided English dish by Jonas Durand, 16 inches diameter, circa 1750—60. (Courtesy of Sotheby Parke Bernet).

341. Six sided plate, Hungarian, circa 1660, 9 inches diameter. (Courtesy of the Museum of Applied Art, Budapest).

342. A French plate, 7¼ inches diameter with beeded rim, circa 1730. (Courtesy of Bourgaux).

341

132

342

343

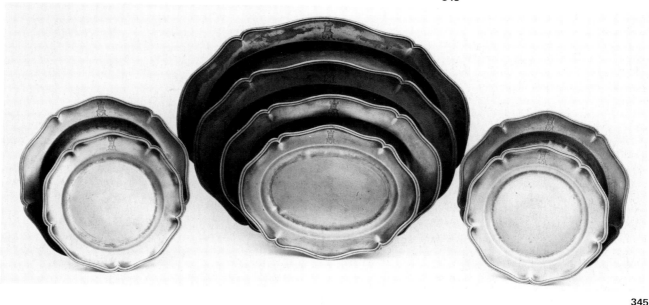

345

343. Some of the six to twelve sided plates were made with decorated rims. This eight sided plate is English by George Bacon, circa 1750—60, 9 1/8 inches diameter. (Courtesy of Sotheby Parke Bernet).

344. An English beeded plate, circa 1740, 9¼ inches diameter. (Courtesy of Robin Bellamy Ltd).

345. Plates and dishes with wavy edges were widely made in Europe and Britain. Some wavy edged flatware is round but oval examples are especially common in dishes, often as part of a garnish with round plates. This is an English garnish. (Courtesy of Sotheby Parke Bernet).

346. Multiple reeded French dish, Paris, circa 1680 with engraved coat of arms. (Courtesy of P. Boucaud).

347. Wavy edged French dish made in Lyon and central France. Mid-eighteenth century. (Courtesy of P. Boucaud).

348. Seventeenth century Rosewater dish, 17 inches diameter, no makers marks. (Courtesy of the Worshipful Company of Pewterers, London).

346

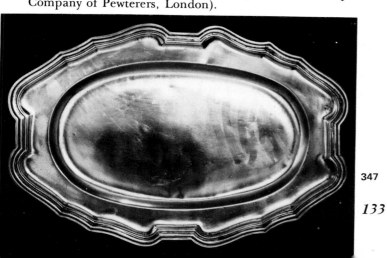

347

348

ON OTHER STYLES

There have been many other shapes of flatware made in Europe and Britain, some worked into elaborate forms. Many of these were used as serving dishes, salvers or for display but some were also probably used on the table for serving sweetmeats and other delicacies.

349

350

351

349. A Dutch salver on four shaped feet with cast decorated rim. By H. Hock, Rotterdam, circa 1740, 13 inches wide. (Courtesy of the Kunstgewerbemuseum, Cologne).

350. Salver, Dutch, eighteenth century, 11½ inches square. (Courtesy of the Lamb Collection).

351. Another unmarked but European salver with reeded edge, 10¾ inches wide, circa 1750. (Courtesy of Colonial Williamsburg).

352. A rare dish, French, with square cut corners. Southwest France, mid-eighteenth century. (Courtesy of P. Boucaud).

353. A serving dish from Austria by G.D. Apeller the younger, circa 1780. (Courtesy of the Metropolitan Museum of Art, New York).

353

352

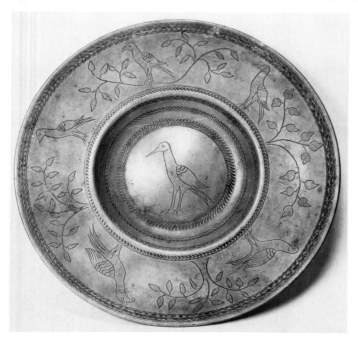

354

355

356

354. Unusual broad-rimmed plate from mid-eighteenth century. Lubin, Poland. (Courtesy of Warsaw Museum).

355. Slightly wrythen narrow rimmed dish, German, circa 1780. Marked "London", 13¼ inches diameter. (Courtesy of the Kunstgewerbemuseum, Cologne).

356. Gadrooned round plate or dish, Flemish, late eighteenth century. (Courtesy of P. Boucaud).

357. Strawberry dish by George Beeston, circa 1750—60, English, 8¾ inches diameter. (Courtesy of Sotheby Parke Bernet).

358. Another strawberry or sweetmeat dish, 5 inches diameter, English, circa 1720—30. (Courtesy of Sotheby Parke Bernet).

359. Small sweetmeat dish from Germany. Nuremberg mark, 4¼ inches wide, circa 1700—20. (From the Holt Collection).

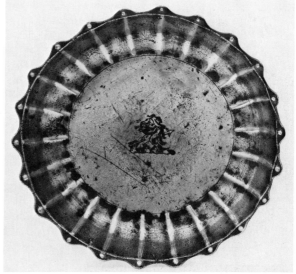

357

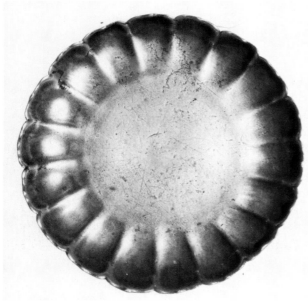

358

STRAINER PLATES AND DISHES

361

362

TAZZA AND FOOTED PLATES

360. Unusual rectangular dish probably used in the dairy. By Sam Levett of Barnstaple, circa 1700, 16 inches by 13 inches. (Courtesy of Robin Bellamy Ltd).

361. Unusual strainer plate by Richard Grunwin, circa 1725. English. Similar in form to a "scale" plate. (Courtesy of Robin Bellamy Ltd).

362. Complete dish with strainer plate by Thomas Reynolds, circa 1770. English. Dish-22½ inches wide, strainer-20 3/8 inches wide. (Courtesy of Colonial Williamsburg).

363. Seventeenth century wrigglework footed plate or Tazza. English. (Collection of Mr. Cyril Minchin).

364. Footed plate by Edward Leapidge. English, circa 1720, 10 inches diameter and standing 3 inches high. (Private collection).

365. Beeded English tazza, no makers marks, 9¾ inches diameter on decorated foot, circa 1690. (Courtesy of Robin Bellamy Ltd).

363

365

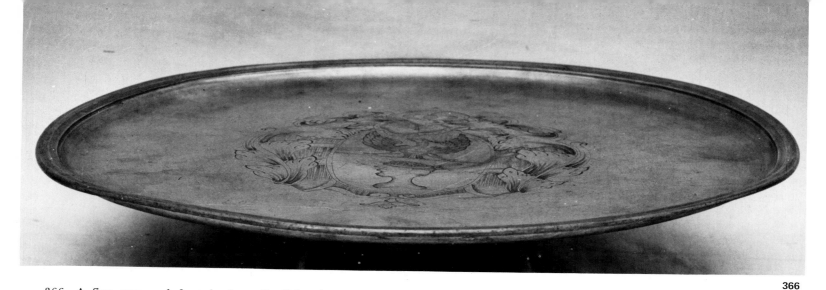

366

366. A fine engraved footed plate, English, circa 1700. (Courtesy of the Metropolitan Museum of Art, New York. Alice E. Parmelee Collection. Gift of Mrs. W.L. Parker and Mr. Robert E. Parmelee).

367. Less common are footed plates on ball or shaped feet. This fine example is circa 1665, English. (From the Gordon Collection).

368. Hot water plate, no makers marks, 8¾ inches diameter, English, circa 1770. (From the Kydd Collection).

369. A hot water plate by Henry Will of New York, late eighteenth century, 9½ inches diameter. (Courtesy of the Metropolitan Museum of Art, New York. Rogers Fund).

367

HOT WATER PLATES

368

369

CAKE PLATES

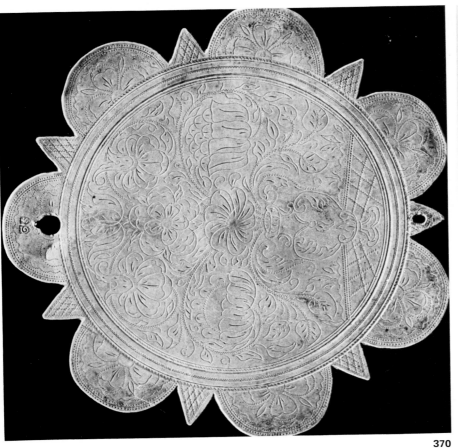

370

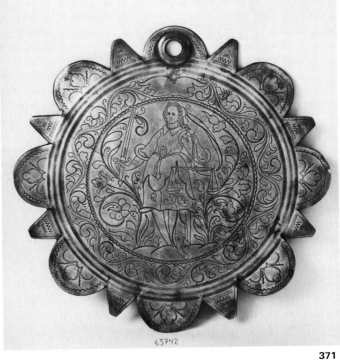

371

372

370. A cakeplate engraved with wrigglework by J. Shirmer of St. Gallen, Switzerland. 10 inches diameter, eighteenth century. Similar plates can be found from Germany and central Europe. (Courtesy of the Metropolitan Museum of Art, New York. Rogers Fund).

371. A lobed cake plate, Swiss, from Zurich, 11 inches diameter, second half of the seventeenth century. (Courtesy of Landesmuseum, Zurich).

372. English "scale" plate. Examples made around 1800—20 were made for use with pairs of scales but early examples such as this item, circa 1730, may well have been used on the table as cheese or cake plates as their size argues against their being scale plates. (Courtesy of Robin Bellamy Ltd).

BOWLS AND BASINS

373

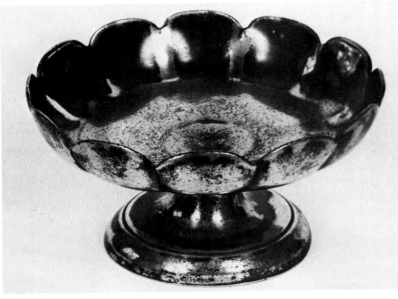

374

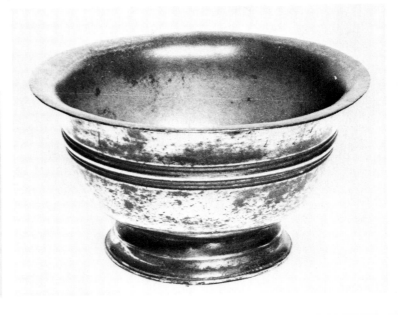

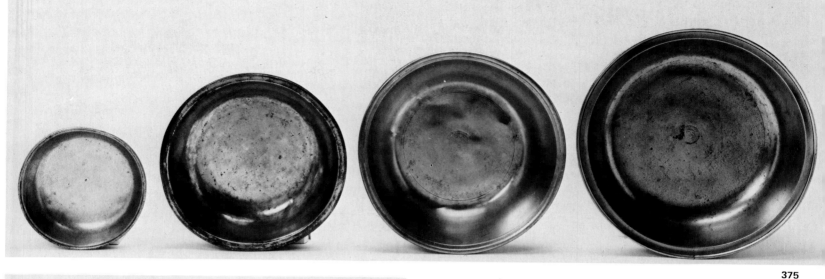

375

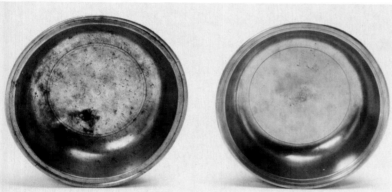

376

373. Small footed sweetmeat bowl. Similar bowls were made both in Britain and Europe, circa 1700—40. This example is 4¼ inches diameter, circa 1730. (Courtesy of Robin Bellamy Ltd).

374. A broth bowl, probably also used for most other domestic purposes. English, circa 1700, diameter of 5 inches. (Courtesy of Robin Bellamy Ltd).

375. Group of American basins from 6 3/8 inches to 11 5/8 inches diameter, all circa 1800—20. (Courtesy of Christies, New York).

376. Left: An American basin by Francis Bassett II of New York, circa 1770—80, 6 5/8 inches diameter. Right: Another by William Will of Philadelphia, circa 1770—90, 6 3/8 inches diameter. (Courtesy of Christies, New York).

377. Domestic or church bowl attributed to the Boardmans, 4½ inches diameter, circa 1800—30. Many similar bowls are to be found in churches used as baptisimal bowls but many similar bowls were probably also used domestically. (Collection of Dr. and Mrs. Melvyn Wolf).

378. American domestic bowl by Henry Will, 8 inches diameter, circa 1770—90. (Collection of Dr. and Mrs. Melvyn Wolf).

379. Typical European bowl or basin. Similar examples can be found from France, Germany, central Europe and the low countries. This basin is French and late eighteenth century, 10¾ inches diameter. (Courtesy of Christies, New York).

377

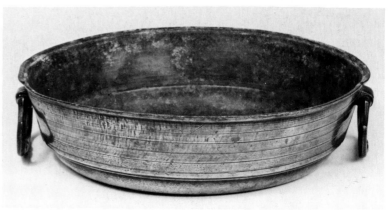

378
379

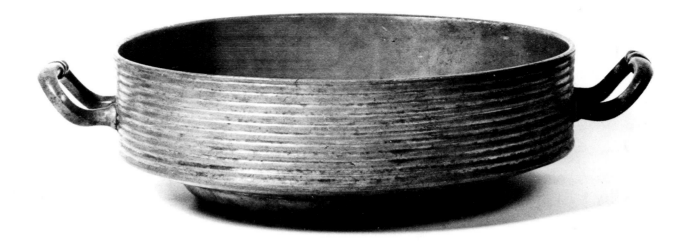

380

FOOD CONTAINERS

Used to carry food in institutions, to workers in the fields, workshops and about the home.

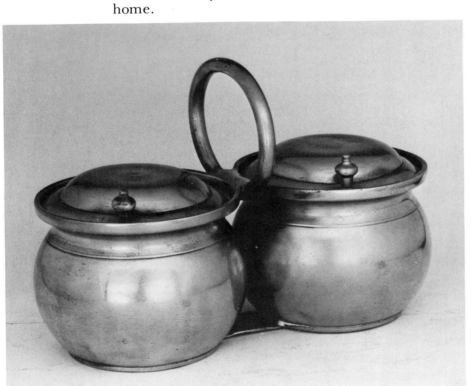

381

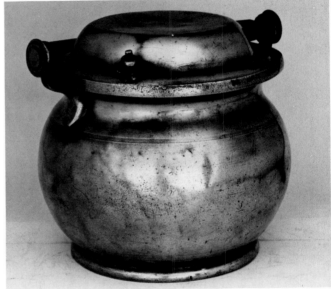

383

382

380. Another form of central European bowl, this example is German by G. Werbrum of Cologne, early nineteenth century, 9 1/8 inches diameter. (Courtesy of Kunstgewerbe-museum, Cologne).

381. Rare double porte-diner from Chartres in France, early nineteenth century. There are many varying forms used for this purpose, many with only a local significance. (Courtesy of P. Boucaud).

382. French from Paris and Champagne, late seventeenth century to end of the eighteenth century. (Courtesy of P. Boucaud).

383. Another more common porte-diner from France, Burgundy, from eighteenth century onwards. (Courtesy of P. Boucaud).

Hollow-Ware and Spoons

CONDIMENTS

Salts

Salt is an essential element of our diet.

In the home salt was usually stored in wooden barrels or pottery jars, but from central Europe come a range of wall-hanging salts, dating from the late seventeenth and eighteenth centuries.

Pewter table-salts were made in a great variety of sizes and shapes.

Salt was costly so that most seventeenth and eighteenth century salts were small.

There are a few triangular salts from Europe and other rarer examples with spouts on the lid but dominant is the "Capstan" style, so called because of its similarity to the dockside capstan. Capstan salts with octagonal bases first appeared about 1670, and those with round bases from about 1700. In Britain capstan salts went out of fashion around the turn of the century, but the style continued to be important in Europe well into the eighteenth century.

Some capstan salts had a shaped top and foot. The feet and rims of these salts were often decorated with cast patterns. Wrythen capstan salts appeared in the middle of the century.

The eighteenth century saw a multiplicity of styles of salts in Britain and many of these forms were also used in Europe.

British salts of the late seventeenth and early eighteenth centuries were without feet, standing on shaped bases with a small "saucer-like" salt container. By 1750 the Cup salt was becoming increasingly popular, at first with a short foot but in the nineteenth century with a much taller stem. Each main form has many variations and the late Percy Raymond identified more than 25 different forms of salts, ignoring minor variations.

In Europe the Cup salt was also popular and Oval salts are also found. European salts are seldom marked.

Salts were also extensively made in the United States, although few have survived. Advertisements confirm that several makers produced salts

and the inventories of Simon Edgell and Thomas Byles confirm this.

In Britain, Europe and the United States the nineteenth century saw the large scale production of britannia metal salts, many with three or four feet. Blue glass liners were also widely used to hold the salt which easily corrodes pewter.

Mustard and Spice Pots

Baluster shaped mustard pots, usually on a short stem and foot, were widely used in Europe from the late seventeenth century onwards. Early British and American examples however are unknown. Most baluster pots have a small cut-out on the lid to facilitate serving the mustard.

Nineteenth century mustards are open and flat. Examples with oval, round and shaped bodies occur, usually with blue glass liners. Most are in britannia metal and examples occur on both sides of the Atlantic.

Spices, prior to 1800, were used frequently at the table, for our forebears needed the pungent flavours to hide some of the less pleasant tastes of the salted or smoked meat and fish which for much of the year was all that was available. Ginger and cinnamon were the most popular spices.

In the eighteenth century small spice boxes were used on European tables while in the late eighteenth and nineteenth century baluster shaped lidded spice pots with loose fitting or screw lids were popular. Examples were made in Holland, Germany and Britain and also in other parts of Europe.

Sifters and Peppers

The use to which "sifters" were put is not always easy to determine. Where the holes are large the sifter was probably intended for sugar, small apertures implying spices or pepper. In early sifters the holes are roughly cut but after 1700—20 they are neatly drilled. Complete sets of three "casters" occasionally occur.

Most sifters derive their shape from silver forms. In Europe the baluster style appeared in pewter around 1670 and many fine large sifters were

made in Paris and Lyon in France at that time, often engraved or cast decorated.

There are a few straight-sided sifters.

Most early European sifters have "bayonet" fittings rather than screw threads.

Eighteenth century castors or sifters are uncommon although nineteenth century examples occur more frequently. Large quantities of small castors were made for pepper, many in britannia metal. A large variety of forms exist, but it is difficult to identify where most of them were made.

Oil Bottles and Condiment Stands

Condiment stands for holding oil, vinegar or "cayenne" bottles were made in pewter in Europe and the United States. The bottles are usually in glass though some have pewter mounts. Only in Portugal were pewter bottles used.

Some condiment stands hold a pair of bottles, others up to six containers. J. Danforth offered in 1842, stands with four, five or six bottles.

Oil and vinegar were also served in France and Italy in small burettes similar to those used for holy oils.

Porringers

The porringer was a most useful and popular utensil. Essentially a small, round and usually shallow bowl with one or two "ears" or handles, porringers were used throughout the western world.

For such a simple form there are a great number of variations. The shape of the bowl, the presence or absence of a boss in the base, the number and shape of the ears, the depth of the bowl, the existence of a lid and the method of construction used for joining the handles to the body can all create varieties as can the type of decoration.

British porringers have, for example, been classified into 22 basic body shapes, whilst the six main styles of ears found on American porringers have been developed into 25 sub-categories.

Early porringers were mostly shallow, flat-sided with flat bases, except in Holland and Scandinavia where deeper porringers were used.

During the seventeenth century porringers were made with rounded sides and a small central boss. In Europe most porringers had two ears but in Britain one-eared porringers predominate. The rounded form continued to be popular in Britain until 1700—1710. In America this style remained the most frequent shape into the nineteenth century. In "late" porringers from both countries the central boss disappears.

In Britain porringers are comparatively rare; in the United States they are quite common. Few British porringers were made after 1750, and it was at that time that American production was growing. However some British pewterers continued to make porringers, for export to the United States, into the nineteenth century.

384

385

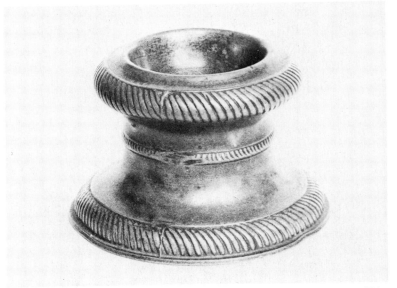

386

387

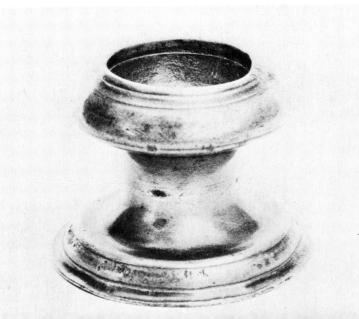

142

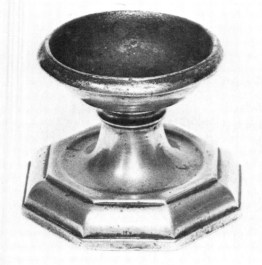

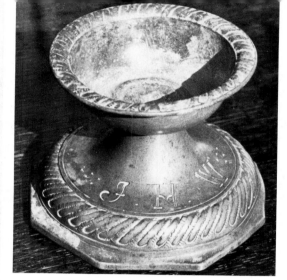

388

389

390

391

384. Salt or spice stand, south Germany, early seventeenth century, 2½ inches high. (Courtesy of Kunstgewerbemuseum, Cologne).

385. Three seventeenth century English salts. Left: William and Mary capstan with gadrooned bands, by TL, 2¾ inches high, circa 1690. Middle: An octagonal trencher salt, 1 5/8 inches high, circa 1700—20. Right: Rare spool salt by "AC", circa 1600. (Courtesy of Sotheby Parke Bernet).

386. A fine decorated capstan salt, late seventeenth century, English. (Courtesy of Robin Bellamy Ltd).

387. A similar salt with plain body also English, late seventeenth century. (Courtesy of Robin Bellamy Ltd).

388. A rare octagonal based capstan salt, English, circa 1680, 2 3/8 inches high. (From the Kydd Collection).

389. Continental decorated capstan salt, German, circa 1720. (Courtesy of Robin Bellamy Ltd).

390. Another plain capstan salt. Similar salts were made throughout Europe. Probably from central Europe. These salts were made into the nineteenth century unlike those of the same form from Britain. (Courtesy of Robin Bellamy Ltd).

391. A fine shaped and decorated French salt, eighteenth century. (Courtesy of P. Boucaud).

392. Trencher salt by Henry Quick, English, circa 1690. (Courtesy of Colonial Williamsburg).

393. Four English trencher salts from left to right: Salt with incised reeding, 1¾ inches high, circa 1700; Squat salt, 1 3/8 inches high, circa 1700; Cylindrical trencher by IH, 1½ inches high, circa 1700; Octagonal salt, 3 inches long, circa 1700—20. (Courtesy of Sotheby Parke Bernet).

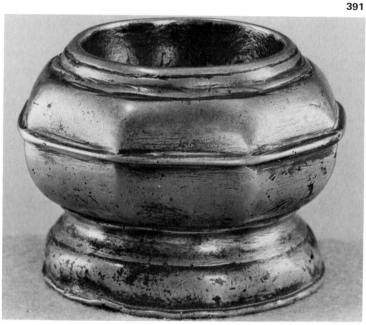

392

393

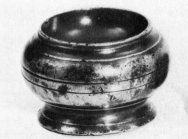

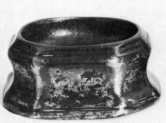

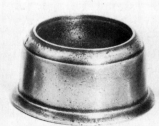

European eighteenth century porringers normally have two ears and straight sides although rounded examples do occur.

Towards the end of the seventeenth century porringers with cast decoration appear. In Britain and Holland there are several examples with royal portraits cast on base and lid. In the eighteenth century finely cast patterns were frequently worked onto the lids and ears of Swiss and French porringers.

Some lids are domed with a single knop, others flat with three small feet. Lids were probably far more common than we now appreciate as many have been lost.

Pewter for Use With Tea, Coffee and Chocolate

Pewterers were usually quick to respond to any new demand.

The spread of tea, coffee and chocolate drinking is an excellent example and from the early years of the eighteenth century many varieties of pots were made to hold these drinks.

Coffee had reached Europe via Turkey in the late sixteenth century, finding its way to France and Britain in the 1640's and 50's. Tea had come from China to Portugal and Spain in the early part of the seventeenth century and had reached Germany and France by 1630 and Britain in the 1650's. Chocolate, never as popular as the other two drinks, had come to Spain from Mexico in the sixteenth century. Coffee was to become popular everywhere, tea had a more limited appeal, being drunk especially in Britain, Holland, Russia and the United States.

Tea Pots

Early pewter tea pots are all copies of silver or chinese porcelain pots. There are no surviving examples in pewter known to have been made before 1700.

Even eighteenth century tea pots are uncommon. In the United States only 35 or so marked examples are recorded and British tea pots of the same period are nearly as rare. European examples too are found infrequently. Most British tea pots that have survived are to be found in the United States where they were originally exported in large numbers.

Early tea pots are of "bullet" form or are pear shaped. Examples of both these styles are found in Europe and the United States, but in Britain the bullet form is not known.

Some pear-shaped tea pots have cabriole legs and ball and claw feet. Others stand on a base.

Drum shaped tea pots are rare. Oval tea pots were made both in Britain and America, although they too are not common.

There were a number of other varieties made on both sides of the Atlantic in the nineteenth century, by the britannia metal process.

Oval, boat-shaped and other more elaborate designs were popular in the 1830's.

In the nineteenth century it is not always possible to tell whether a pot was intended for tea or coffee, and some coffee pots shown under that

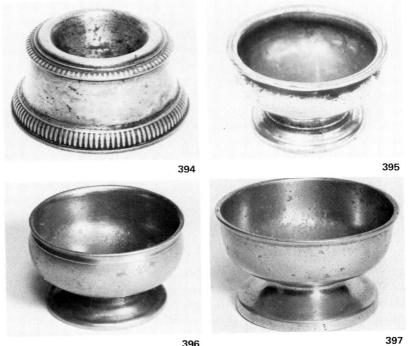

394 395

396 397

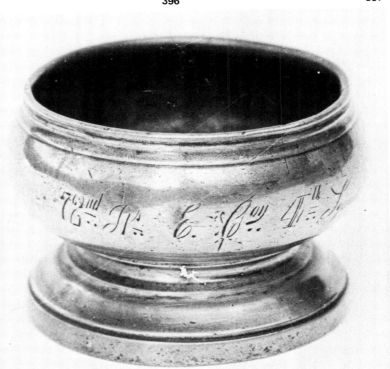

398

394. Cast decorated trencher salt by I.I., English late seventeenth century. (Private collection).

395. Cup salt, English, eighteenth century. (Courtesy of Robin Bellamy Ltd).

396. A similar salt, American, attributed to T. Boardman, 1800—30. (Collection of Dr. and Mrs. Melvyn Wolf).

397. A cup salt, probably European, but unmarked, 2 3/8 inches high, circa 1790—1820. (Collection of Mr. and Mrs. Robert E. Asher).

398. A regimental cup salt, with the mess details engraved on the side, English, circa 1800—20. (Courtesy of Robin Bellamy Ltd).

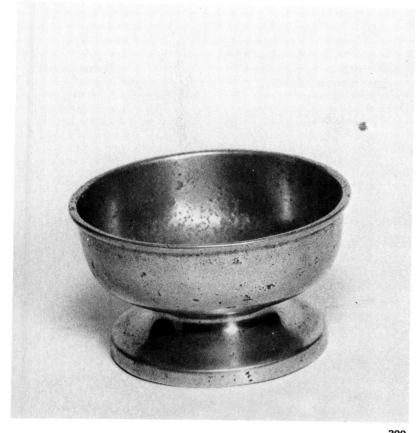

399

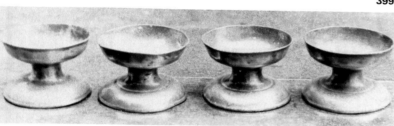

400

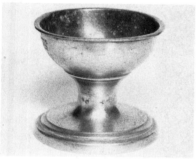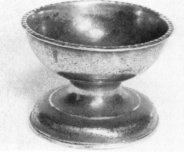

401 **402**

399. A cup salt, unmarked but typical of the form used in all areas, circa 1800. (Collection of Mr. and Mrs. Robert E. Asher).

400. Set of four cup salts with stems, English, circa 1800. (Courtesy of Robin Bellamy Ltd).

401. A cup salt with armorial on side, English, 3¼ inches high, circa 1790 – 1820. (Collection of Mr. and Mrs. Robert E. Asher).

402. A similar salt with beeded decoration at foot, 2 inches high, European or British, circa 1800. (Collection of Mr. and Mrs. Robert E. Asher).

section may well have been also intended for tea.

In Europe tea kettles were made in pewter, the tea being infused in them over a spirit lamp or low flame.

Tea urns, used for serving tea and coffee were popular in France, Holland, Germany and Scandinavia. Many were originally lacquered.

Coffee Pots

Coffee pots were extensively used in Europe from the 1740's onwards. Three distinct styles can be identified; those with baluster bodies, those with straight often tapering sides, and wrythen or rococo examples.

Coffee pots are rare in Britain. Only a handful of straight-sided tapering pots survive, apart from the large scale production of britannia metal pots in the nineteenth century.

In the United States many styles exist. Straight-sided pots by such makers as Porter and Yale are very similar to those used in Britain and Europe. There are two different groups of rounded pots, the simple single curved pots by makers like Gleason, Danforth and Putnam are similar to British "britannia" forms, but the complex curved variaties such as those made by Gleason, Boardman and Richards are seldom found in Britain.

Urns were also used to serve coffee and the main forms are illustrated under "Tea Pots".

Sugar Bowls

In America and Europe several styles of bowls exist, usually possessing domed lids.

Few bowls were used in Britain before the nineteenth century although some were made for export to America.

Cream Jugs

Cream or milk is widely used with tea, coffee and chocolate. Pewter cream jugs are frequently found in the United States, but are uncommon in Europe and scarce in Britain.

In Europe two main styles are found; the baluster and the wrythen jug. Most British and American eighteenth century jugs are in what is known in the United States as the "Queen Anne" style. In the nineteenth century a great variety of forms were made including many in britannia metal.

Tea Caddies

Oval tea caddies were popular in Britain in the eighteenth century, often decorated with bright cutting. Other forms are less frequently found but do occur in Europe.

Spoon Stands

In Switzerland and some other parts of central Europe two and three-tiered stands were made for offering sugar at the tea table and to provide stands for teaspoons. These date from the late eighteenth and early nineteenth centuries.

Spoons

Pewter spoons were easy to make, cheap to buy and universally used.

The shape that spoon bowls took can be a guide in dating them but it is from the terminal at the

end of handle that they take their names and it is these which provide the most useful classification.

Several types of spoons popular in Europe and Britain in the sixteenth century continued to be made and used in the seventeenth century. Early spoons that retained their popularity include the "seal top", "strawberry knop", and "stumpended" spoons from Holland and Britain. From the low countries and Italy come the "horses hoof" terminals, whilst apostle spoons were used in Germany, Holland and Britain. The most widely made spoon of all, the slip top is mostly found in Britain.

Spoons styles which appear for the first time in the seventeenth century include those with "puritan" ends, so called because of their unusual simplicity. These spoons first appeared about 1630 in Britain and Holland. Around the middle of the century flattened stems became fashionable, divided into three sections. These "tryfid" spoons were made in France, Holland and Britain as well in other parts of Europe and continued in production into the early eighteenth century. The "dog nose" is a derivative of the tryfid and was popular in Holland and Britain around 1690 — 1720. From France and Holland come a group of spoons with "shield-like" terminals.

In the 1690 — 1750 period, portrait spoons became popular and representations of most British sovereigns occur.

Eighteenth century spoons are relatively uncommon. Less than twenty marked American examples are known and European and British spoons occur less frequently than they did in the seventeenth century.

The round or oval spoon bowls of the previous century gradually became longer and extended, except in Holland where the round form continued into the 1800's. The flattened stem of the tryfid and puritan spoons gave way to a series of stems of rounded form. Many styles evolved including those known as "old english", "wavy", "fiddle", and "round". Spoons with ridges along the stem were also popular. Portrait spoons continued to be made and there are also examples of spoons with cast slogans. A range of spoons were made with cast patterns on the stem; frequently found are examples with flowers, fleur de lys, vines and shells. The "rat-tail" bowl was used both to decorate and to strengthen the spoon, but went out of fashion in 1720, except in the United States.

The importance of spoons is confirmed by the large number of spoon molds, from the United States especially, that have survived.

The production of spoons in the nineteenth century was enormous. One company alone, the Meriden Britannia Metal Company made more than 3,700,000 spoons in one year.

The nineteenth century saw several new techniques used in spoon making. Iron molds replaced bronze molds, and stems were made

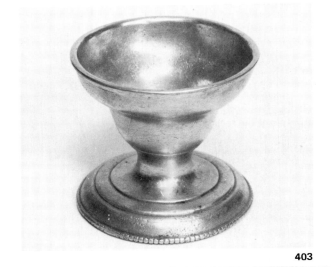

403

404

405

406

407

MUSTARDS AND SPICE POTS

409

403. Cup salt, 2½ inches high, attributed to William Will. The swell beneath the cup is not found normally on British salts, eighteenth century. (Collection of Mr. Charles V. Swain).

404. Another beeded salt, also attributed to William Will, 2½ inches high, eighteenth century. (Collection of Mr. Charles V. Swain).

405. An unmarked American cup salt, 2½ inches high, circa 1820—30. (Collection of Mr. Charles V. Swain).

406. A small bulbous salt, English late eighteenth century, 2¼ inches high. (From the Kydd Collection).

407. An unusual Swiss salt, reminiscent of a much earlier Dutch form, 3¾ inches high, early nineteenth century. (Courtesy of Swiss National Museum, Zurich).

408. Wall salt, German eighteenth century. Similar salts were found in central Europe from late seventeenth to nineteenth centuries. 8 5/8 inches high. (Courtesy of Christies, Amsterdam).

409. Rare French mustard, Paris, circa 1700. (Courtesy of P. Boucaud).

410. A Dutch baluster pot, 5½ inches high, circa 1720—40. (Collection of Mr. William F. Kayhoe).

411. A pair of wrythen mustard pots, Augsburg, Germany, eighteenth century. (Courtesy of Bourgaux).

412. Flemish baluster mustard pot, the body engraved with decoration, circa 1800, 6 inches high. Similar pots were made in France, Germany and Holland. (Courtesy of Robin Bellamy Ltd).

412

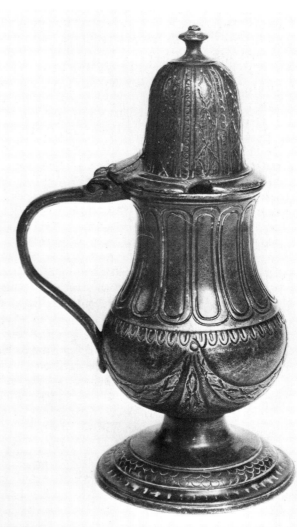

410

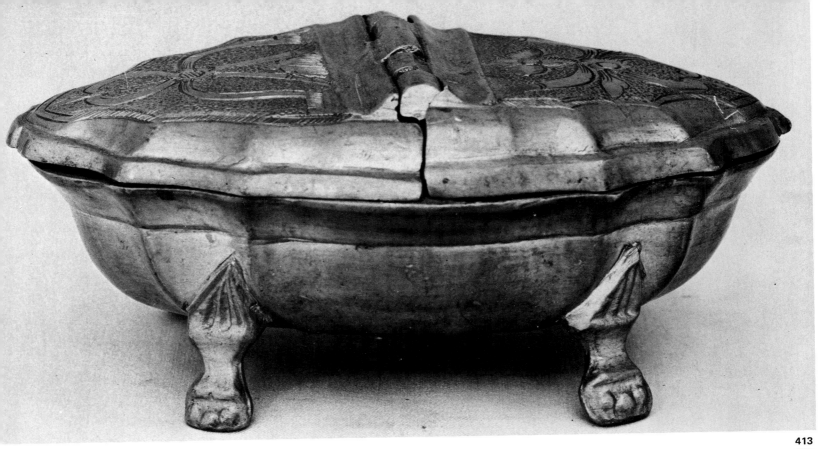

413

414

415

416

417

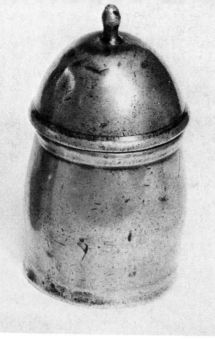

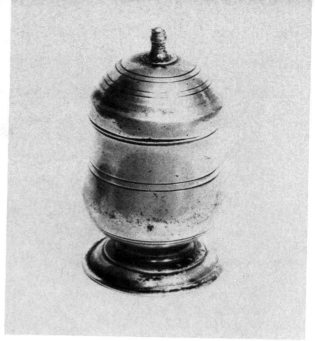

SIFTERS, SUGAR CASTORS AND PEPPERS

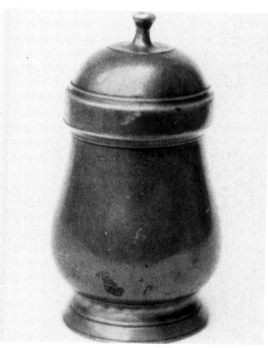

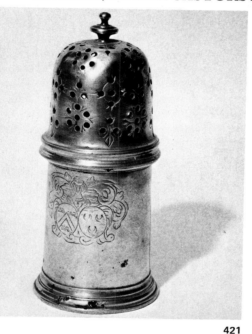

420

421

422

413. Spice box, Dutch or Flemish early eighteenth century. (Courtesy of Metropolitan Museum of Art, New York. Rogers Fund).

414. Spice server with three containers, German, 4¼ inches high, eighteenth century. (Collection of Marianne & Albert Phiebig).

415. Spice box, German, mid-eighteenth century, 2 7/8 inches high. (Courtesy of Colonial Williamsburg).

416. Two spice boxes, both late eighteenth century of a form found in France and Germany. (Courtesy of P. Boucaud).

417. English spice pot, late seventeenth century, 4 inches high. (From the Little Collection).

418. Two further spice pots, also 4 inches high. On the left, probably English, circa 1700—20. On the right, probably

Dutch although some spice pots in this form are likely to be English, eighteenth century. (From the Gordon Collection).

419. A spice pot, 4 inches high, Dutch or English, eighteenth century. The baluster form is the most frequently found. (From the Kydd Collection).

420. Plain baluster spice pot, probably Dutch, circa 1800. (Courtesy of Robin Bellamy Ltd).

421. A fine straight sided sugar castor, French made in Paris, circa 1680—1740. This example is probably late seventeenth century. (Courtesy of P. Boucaud).

422. A baluster sugar sifter or castor, Paris, France. Sifters of this form were made between 1680 and 1740. (Courtesy of P. Boucaud).

stronger by the addition of a wire core, a technique used in the sixteenth century but which had been abandoned. Multi-spoon molds were also used.

Until the nineteenth century most spoons made were of roughly the size of our "dessert" or "soup" spoons, although smaller and larger spoons were also constructed.

One group of smaller spoons made around 1660—1700 were small tryfids, used for chocolate or perhaps as children's spoons. Teaspoons were made from the eighteenth century onwards but are uncommon. Where they do exist they are similar in design to the larger spoons.

A few large spoons were made for serving food and there are a range of ladles found in most countries. Most ladles are nineteenth century. Some are made completely of pewter whilst others have wooden or bone handles.

Tureens

Tureens were used for serving soup, stews and ragouts.

Two basic shapes exist; round and oval examples of each can be found with a variety of feet and handles. Oval tureens were first made about 1730 and were used in Scandinavia, France and the German-speaking areas of Europe. In Britain oval tureens with ball feet did not appear until about 1780. The bodies of British tureens are usually plainer than those from Europe. Round tureens are usually European.

Funnels

Most funnels are eighteenth century. Few are marked and examples from each region are similar in style.

Confectionary Molds

Confections of sugar, jelly or later ice cream shaped in molds were popular from the eighteenth century onwards. These molds were mostly made in copper or brass but pewter examples do occur, generally from the mid-nineteenth century. Many different forms were created and unless they are marked it is difficult to tell the origin of a mold.

423

424 425

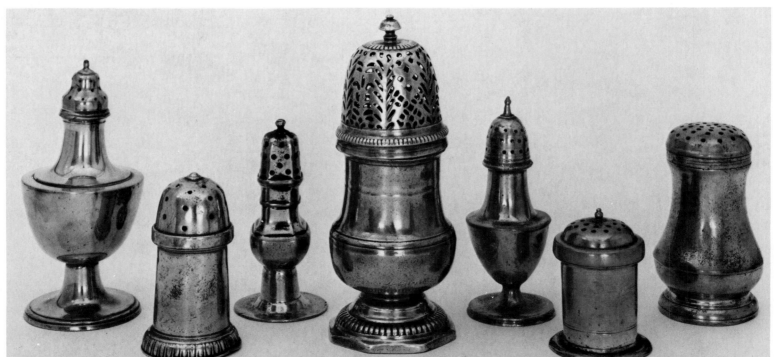

426

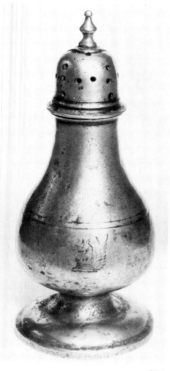
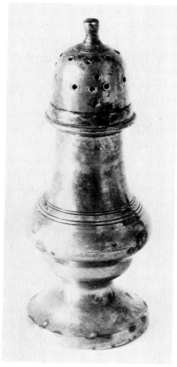

427 **428**

423. Baluster sugar castor with beeded foot, Paris, France, circa 1700. (Courtesy of P. Boucaud).

424. A castor of similar form. 5 3/8 inches high, possibly Dutch, eighteenth century. (From the Kydd Collection).

425. Another European sugar castor, 6 inches high, eighteenth century. (From the Gordon Collection).

426. A group of sugar sifters and pepper pots. Although the pepper on the left is of a form also found in England all are more likely from Europe, and are eighteenth century. (Courtesy of Sotheby Parke Bernet).

427. A baluster pepper with engraved coat of arms, 7 inches high, possibly also used for spices, English eighteenth century. (From the Gordon Collection).

428. A baluster pepper. Similar peppers are found both in Holland and Britain. From the mid-eighteenth century to around 1830. (Courtesy of Robin Bellamy Ltd).

429. A spice castor, of baluster form, English, circa 1780, 5¼ inches high. (Courtesy of Robin Bellamy Ltd).

430. A baluster pepper, 5 5/8 inches high, English or Dutch, late eighteenth century. (From the Kydd Collection).

431. Two further baluster peppers. Left; probably European, 4¼ inches high. Right; possibly American, 5¼ inches high. Neither have makers marks, both circa 1800. (Collection of Mr. Charles V. Swain).

432. A further group of peppers. From left to right: English or Dutch, circa 1800; English, circa 1780; English or European, early nineteenth century; English or Dutch, early nineteenth century; English or European, late eighteenth century. All are between 4 and 5 inches high. (From the Gordon Collection).

433. Few peppers from Britain are marked, but this pair is by Henry Joseph, circa 1780, 4 1/8 and 4¾ inches high. (Collection of Mr. Charles V. Swain).

429 **430**

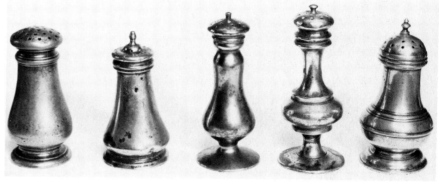

432

434 **435** **436**

434. An urn shaped sifter, English, 7 inches high, eighteenth century. (From the Gordon Collection).

435. Another urn sifter, 6 inches high, circa 1800. Similar sifters were also found in Europe. (From the Gordon Collection).

436. A regimental sifter, English, from the mess of the 43rd Regiment of the Line, circa 1800, 6¼ inches. (From the Gordon Collection).

437. Two sifters, probably American, no makers marks, 5½ and 5 inches high. (Collection of Mr. Charles V. Swain).

438. Pepper, English or Dutch, circa 1780—1820, 4 inches high. (Courtesy of Country Life Antiques).

439. A Philadelphia style American castor, 4½ inches high, early nineteenth century. (Collection of Dr. and Mrs. Melvyn Wolf).

440. An American castor, 5 7/8 inches high, early nineteenth century. (Collection of Dr. and Mrs. Melvyn Wolf).

438 **437** **439** **440**

A SMALL GROUP OF UNUSUALLY SHAPED SIFTERS. MANY OTHER FORMS HAVE BEEN RECORDED.

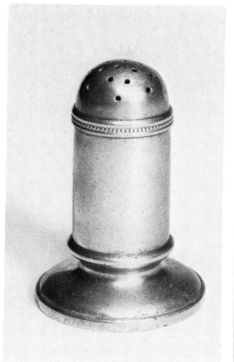

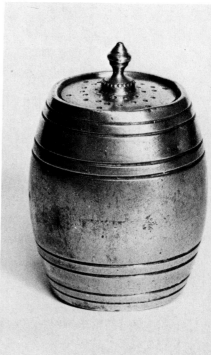

442 **443**

441. A tapering sifter next to a waisted baluster sifter, both nineteenth century. They are each 4½ inches high, English, but similar sifters were made in Europe. (From the Gordon Collection).

442. American small castor, 3 7/8 inches high, nineteenth century. (Collection of Dr. and Mrs. Melvyn Wolf).

443. A barrel shaped sifter or pepper, probably European, circa 1780—1800. (Collection of Mr. Charles V. Swain).

444. An American sifter or castor attributed to Thomas Danforth III, circa 1780—1810, 6 inches high. (Courtesy of Christies, New York).

445. In hard metal, this pepper in form of a lady is nineteenth century, probably English, 4 7/8 inches high. (From the Kydd Collection).

446. An unusual waisted sifter, 5 7/8 inches with screw in base, early nineteenth century. Origin uncertain. (From the Kydd Collection).

444 **445**

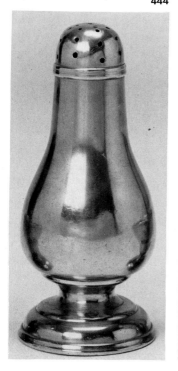

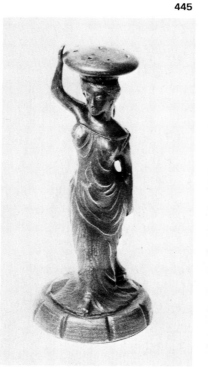

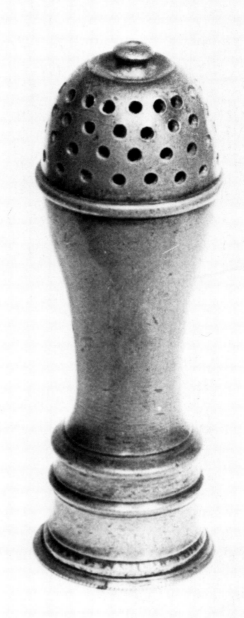

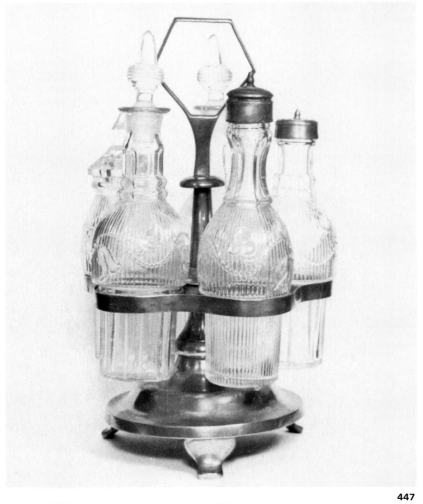

447

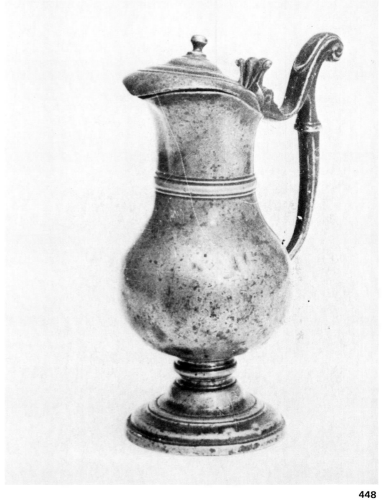

448

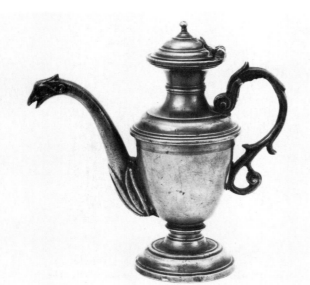

449

PORRINGERS

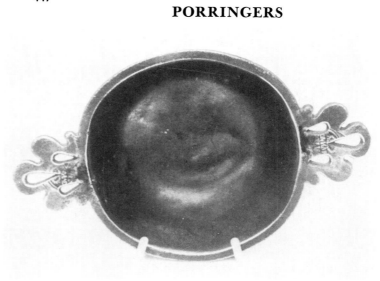

450

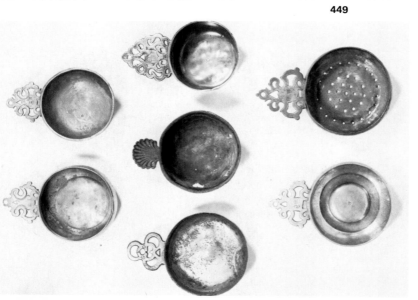

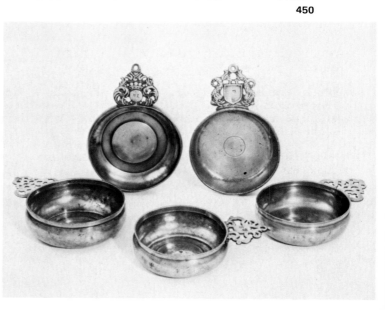

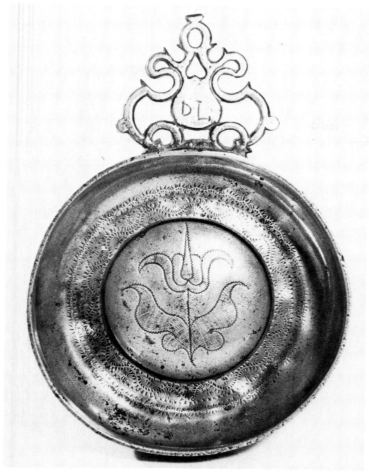

453

454

455

447. Condiment set by Gleason of Dorchester, Massachusetts. American, circa 1830−40, 10¼ inches high. (Collection of Mr. and Mrs. Merrill G. Beede).

448. Domestic cruet, Lyon, France, early eighteenth century. (Courtesy of P. Boucaud).

449. Table cruet, French, circa 1700−50, used for oil or sauces. (Courtesy of P. Boucaud).

450. Early seventeenth century porringer with flat base and triform ear. Probably French but similar porringers were also made in Britain and other parts of Europe. (Courtesy of Robin Bellamy Ltd).

451. Group of English seventeenth century porringers. The "shell" ear example in centre is circa 1600. Note too the interesting "strainer" porringer at bottom right. (Courtesy of the Worshipful Company of Pewterers, London).

452. Group of five English porringers. Top left; by John Langford, circa 1725, Crown ear, 7 5/8 inch maximum.

Top right; Dolphin ear, unmarked, circa 1700, 7 7/8 inch. Bottom left; by S.B., circa 1680, 7 1/8 inches maximum, flower ear. Bottom middle; by J. French, circa 1675, 7¼ inches maximum, old English ear. Bottom right; Charles II by "WI", circa 1670, 7 7/8 inches maximum width, flower ear. (Courtesy of Sotheby Parke Bernet).

453. Fine wrigglework English porringer with old English ear, circa 1680, bowl 5 inches. (Collection of Mr. C. Minchin).

454. Unique English porringer, the ear with initials of Queen Anne and crown, circa 1702. The bowl retains the central boss. (Courtesy of Worshipful Company of Pewterers, London).

455. Superb decorated porringer by John Quick, bowl 5 3/8 inches diameter, English, circa 1700. (Courtesy of Colonial Williamsburg).

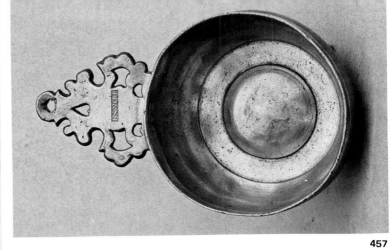

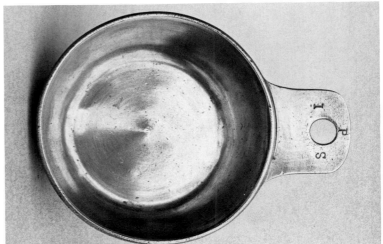

457

456

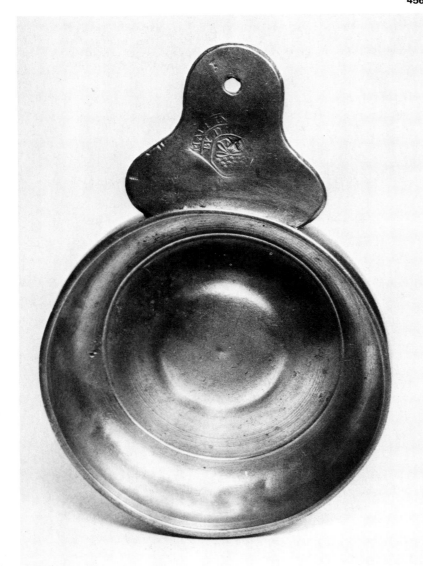

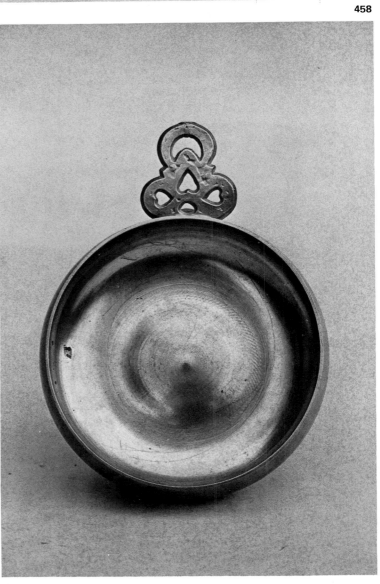

458

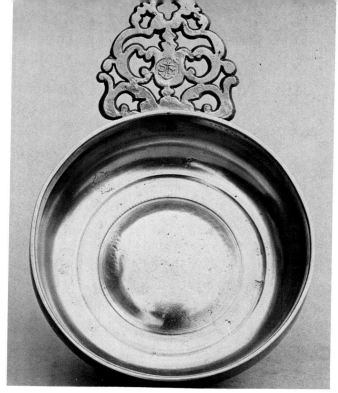

461

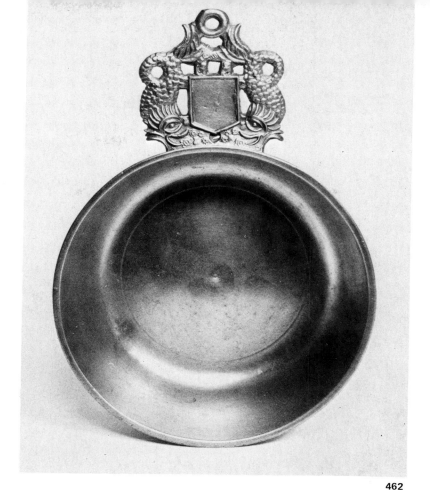

462

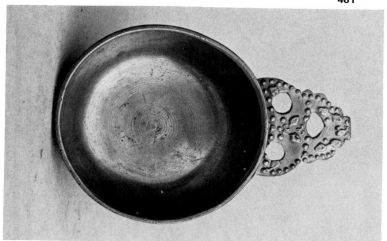

463

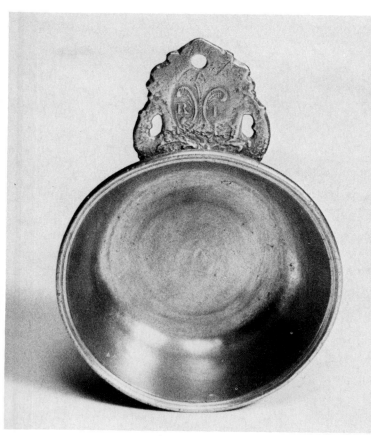

456. American porringers. Top left; by Thomas Danforth III, circa 1780—1810, bowl 4¼ inches diameter, old English ear. Top right; by J. Belcher, circa 1770—80, flower variant handle, 4 inches diameter bowl. Bottom left; crown handle, by S. Danforth, circa 1790, 5¼ inches diameter. Bottom right; by Frederick Bassett, late eighteenth century, old English handle, 4¼ inches diameter bowl. (Courtesy of Christies, New York).

457. American porringer with New England ear, 4¾ inch bowl by T.D. & S.B. Boardman, first half of nineteenth century. (Collection of Dr. and Mrs. Melvyn Wolf).

458. Tab handle porringer, American, attributed to Kirk, York, Pennsylvania, circa 1785. Cast in one section, 5½ inches diameter bowl. (Collection of Dr. and Mrs. Melvyn Wolf).

459. Plain tab handle porringer by Melville from Rhode Island. American, 7½ inches, circa 1770—80. (Collection of Mr. and Mrs. Merrill G. Beede).

460. Three hearts ear porringer, American with cast initial "R", 4 inches diameter bowl, nineteenth century. (Collection of Dr. and Mrs. Melvyn Wolf).

461. Flower handle porringer, American, by D. Melville, 5 3/8 inches bowl, circa 1770—80. (Collection of Dr. and Mrs. Melvyn Wolf).

462. Dolphin ear porringer, American, attributed to Danforth family, circa 1800, 8 inches maximum width. (Collection of Mr. and Mrs. Merrill G. Beede).

463. Small porringer or wine taster by I.C. Lewis, American, circa 1830—50, 2¼ inches diameter bowl. (Collection of Dr. and Mrs. Melvyn Wolf).

464. Another wine taster, by R. Lee, American, bowl 2 1/8 inches diameter, circa 1800. (Collection of Dr. and Mrs. Melvyn Wolf).

464

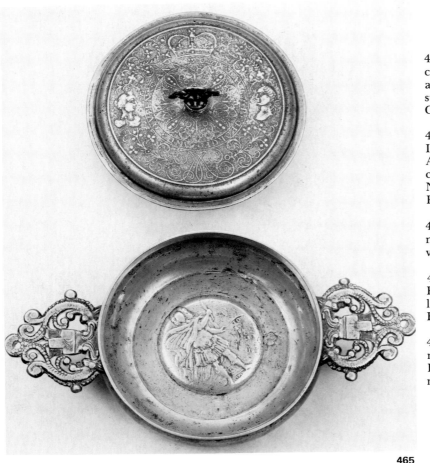

465. Fine cast decorated porringer with cover, by "AW", circa 1702. Decorated on cover with portrait of Queen Anne and her husband, George. The knop is two angels supporting a crown. English. (Courtesy of Worshipful Company of Pewterers, London).

466. Dutch two eared porringer, late seventeenth century. In general form it is very similar to British and later American examples except for the ears which are continental. (Courtesy of the Metropolitan Museum of Art, New York. Gift of Mr. R.M. Parmelee and Mrs. W.L. Parker).

467. Typical lidded Swiss or German, two eared porringer, mid-eighteenth century. The "knops" or "feet" on lid can vary considerably. (Courtesy of Christies, London).

468. A similar porringer with handles rather than ears. Porringers of this form are found in most parts of Europe, last quarter of eighteenth century. (Courtesy of Robin Bellamy Ltd).

469. A German lidded and decorated porringer with handle rather than knop on lid, mid-eighteenth century. By J.J. Pelargus or family of Stuttgart. (Courtesy of Kunstgewerbe-museum, Cologne).

465

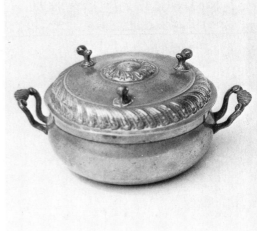

466

468

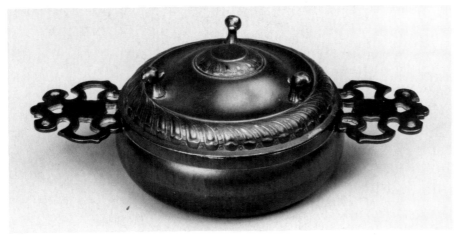

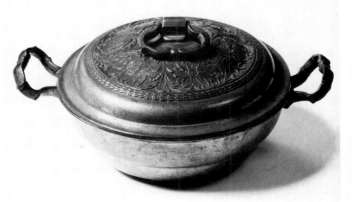

467

469

470. Typical wide, flat bottomed two eared porringer found in most parts of central Europe, including the low countries, France and Germany. Late eighteenth century. Examples with solid ears were made into the nineteenth century. (Courtesy of Robin Bellamy Ltd).

471. French porringer, Lyon. With rare salt cup on knop, first half of the eighteenth century. (Courtesy of P. Boucaud).

472. French porringer with cover of more common form. Paris, eighteenth century. (Courtesy of P. Boucaud).

473. French porringer from Bordeaux, late eighteenth century, with pineapple finial knop. (Courtesy of P. Boucaud).

474. Louis XV porringer, French, Paris, circa 1740, with solid engraved ears. 12¾ inches maximum width. (Courtesy of Sotheby Parke Bernet).

475. German porringer, Bremen, early nineteenth century, 10½ inches wide. (Courtesy of Sotheby Parke Bernet).

476. Small eighteenth century wine taster, Dutch, 4¼ inches diameter. (Private collection).

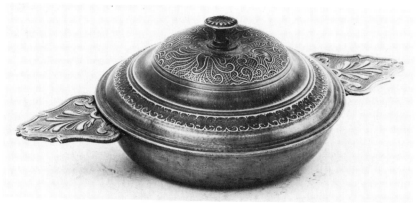

472

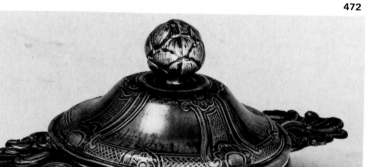

473

470

474

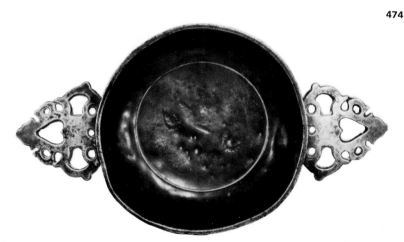

475

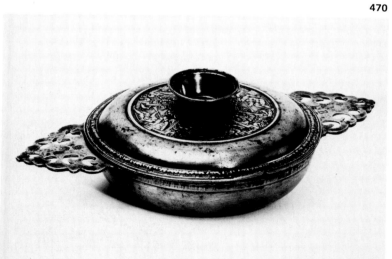

471

159

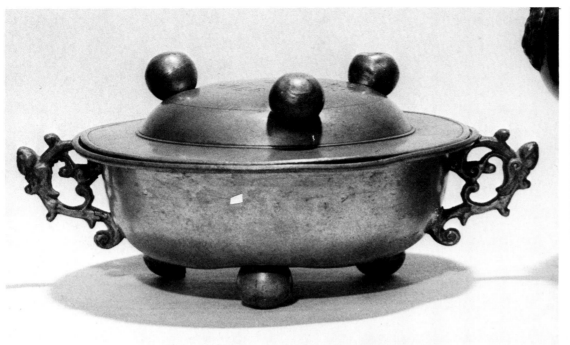

477

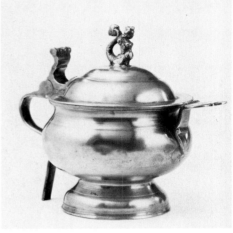

478

479

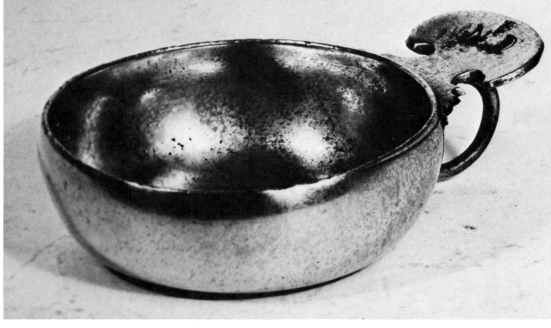

480

A *B* *C*

D *E* *F*

G *H* *I*

J *K*

L *M*

N *O*

P *Q*

477. A German porringer on feet. Similar porringers were made in Switzerland and in most of central Europe. By Hornung of Schordorf, circa 1730—40. (Courtesy of Dr. Fritz Nagel).

478. Scandinavian porringer with cover by H.C. Byssing of Bergen, Norway, circa 1745, 8 7/8 inches high. (Courtesy of Kunstindustrimuseet Oslo).

479. Deep bowled porringer from Low countries or northern France, eighteenth century, bowl diameter 5¾ inches. (Courtesy of the Metropolitan Museum of Art, New York. Gift of Mr. R.M. Parmelee and Mrs. W.L. Parker).

480. French handled feeding bowl form of porringer, circa 1800. (Courtesy of P. Boucaud).

PORRINGER EARS.
A. "Old English" style porringer handle found on both American and British porringers. 1680—1800.
B. New England style handle found on American porringers. 1800—30.
C. "Flower" handle found on British and American porringers, circa 1670—1820.
D. American "tab" handle, a more rounded version is also found on European porringers, America 1760—1830, Europe eighteenth century and early nineteenth century.
E. France and Switzerland, eighteenth century.
F. German, eighteenth century.
G. French, circa 1670—1800.
H. Plain handle, similar to American form. (See D)
I. Dolphin handle, found on British, European and American porringers, late seventeenth to eighteenth century.
J. Crown porringer ear, British and American from seventeenth century to 1820 or so.
K. "American ear, usually from Rhode Island, eighteenth century".
L. American porringer ear attributed to Bonynge, Boston mid-eighteenth century.
M. English or European early seventeenth century.
N. Rare shell handle, English seventeenth century and found in Europe in eighteenth century.
O. Ring handle, English early to mid-seventeenth century and also found occasionally in Europe in eighteenth century.
P. English seventeenth century form similar to examples found in Europe.
Q. American ear, the Pennsylvania style late eighteenth century.

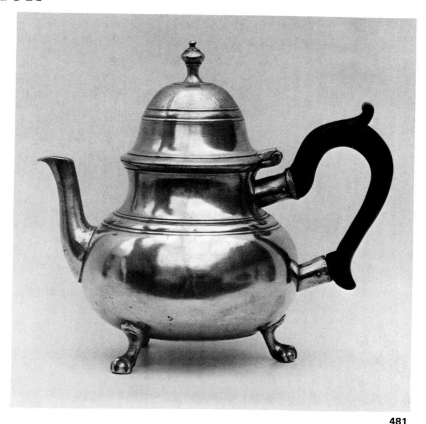

481

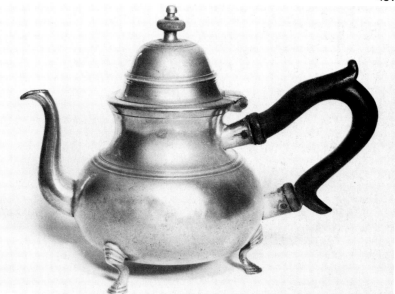

482

481. American tea pot on feet by W. Will, Philadelphia, circa 1760—1800, 8½ inches high. (Collection of Dr. and Mrs. Melvyn Wolf).

482. American tea pot by C. Bradford, 6 7/8 inches high, second half of the eighteenth century. (Collection of Mr. Charles V. Swain).

483. An English tea pot of identical style by John Townsend almost certainly a form only made for export to the United States, second half of the eighteenth century. (Courtesy of Mr. Garland Pass).

483

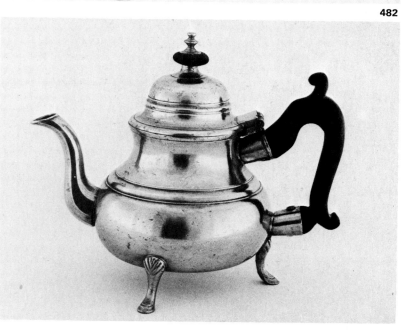

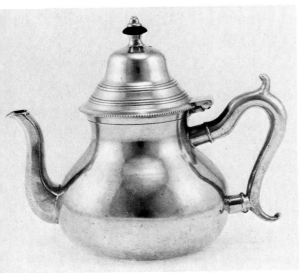

484

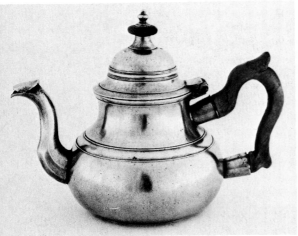

486

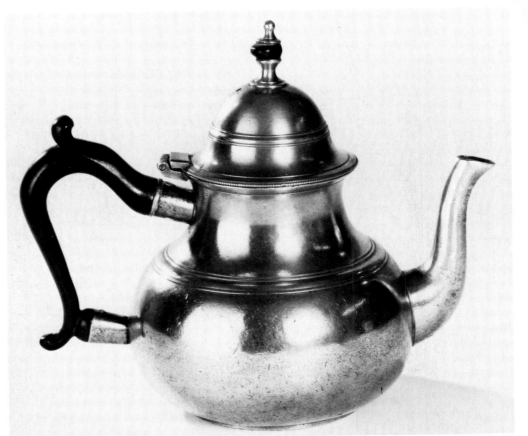

485

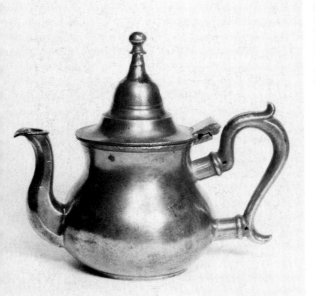

488

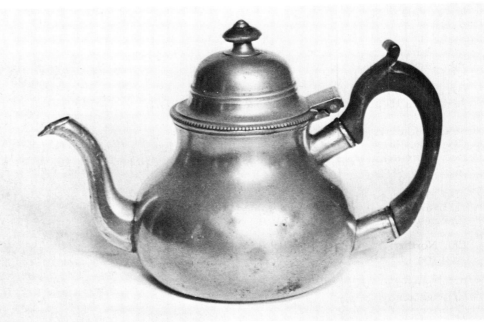

487

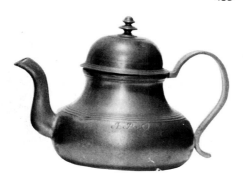

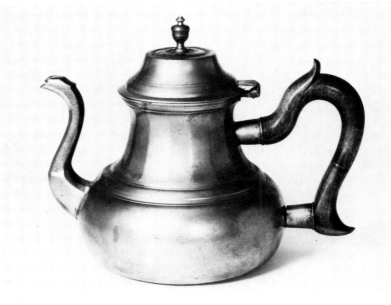

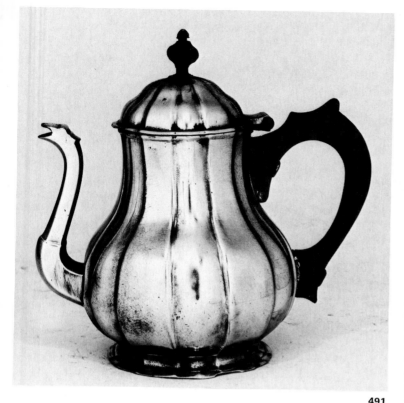

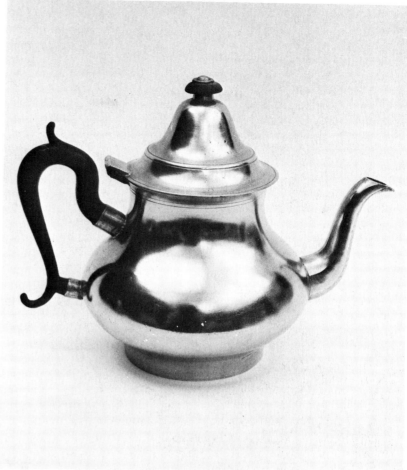

491

492

484. American tea pot by S. Danforth, circa 1790—1800, 7 1/8 inches high. (Collection of Dr. and Mrs. Melvyn Wolf).

485. American tea pot by Fred Bassett, 7½ inches high, circa 1760—1800. (Collection of Dr. and Mrs. Melvyn Wolf).

486. An English pot, by John Townsend, second half of eighteenth century. (Courtesy of Mr. Garland Pass).

487. English tea pot by Townsend and Compton, 5 inches high, circa 1800—10. (Collection of Mr. Charles V. Swain).

488. Another English pot but a form also found in Holland. 5½ inches high, nineteenth century. Copies of this form were being made this century. (Collection of Mr. and Mrs. Merrill G. Beede).

489. The nearest European equivalent form, by K.G. Friese of Lauban, Germany, circa 1780, 5 7/8 inches high. (Courtesy of Dr. Fritz Nagel).

490. Northern French tea pot made from 1750 to 1850. (Courtesy of P. Boucaud).

491. Interesting fluted tea pot, French from Lille, from mid-eighteenth century to early nineteenth century. (Courtesy of P. Boucaud).

492. American tea pot by Smith & Company of Boston, 7 inches high, circa 1850. (Collection of Dr. and Mrs. Melvyn Wolf).

493. Dutch decorated tea pot or perhaps kettle, early eighteenth century. (Courtesy of Robin Bellamy Ltd).

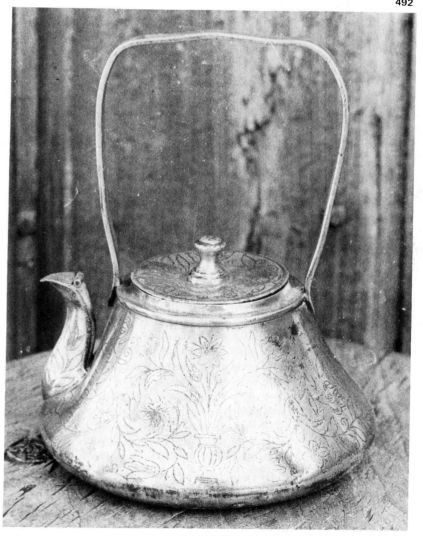

493

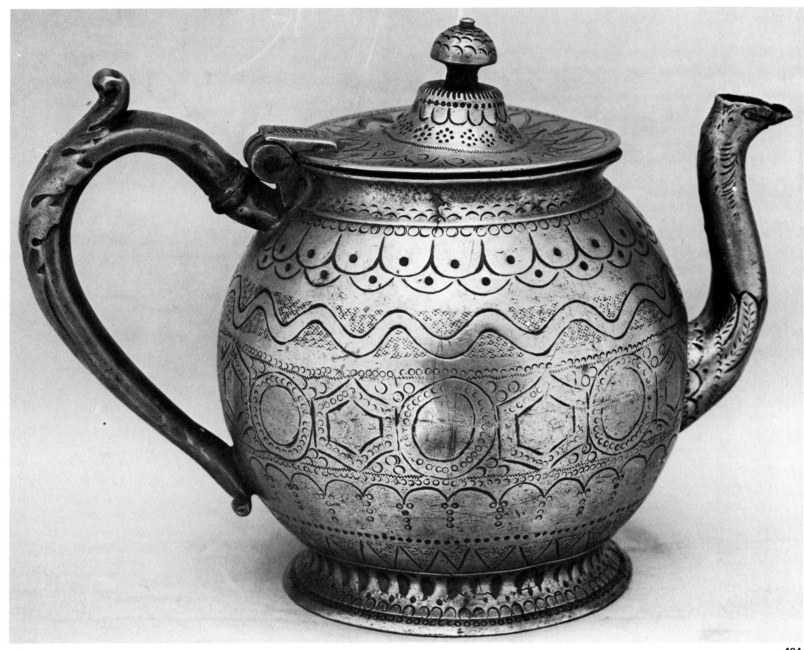

494

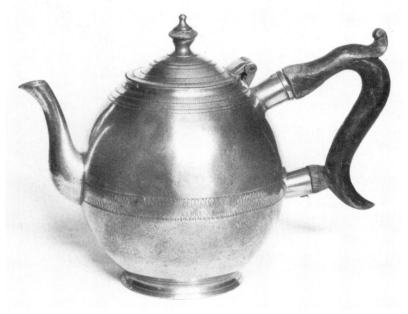

495

496

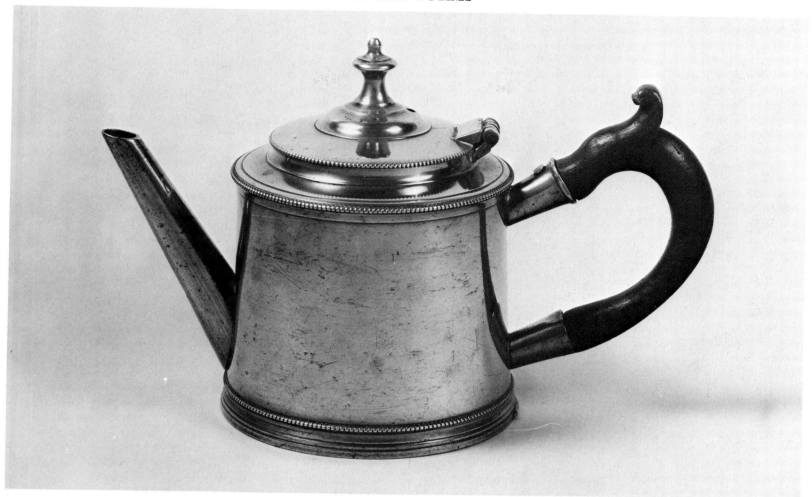

497

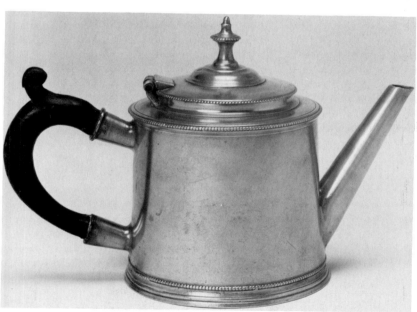

498

499

494. Flemish tea pot, mid-eighteenth century. (Courtesy of the Metropolitan Museum of Art, New York).

495. Melon tea pot by Fred Bassett, American, 6 inches high, second half of the eighteenth century. (Collection of Mr. Charles V. Swain).

496. Similar American tea pot, 6½ inches, soon after 1750. (Collection of Mr. Charles V. Swain).

497. Beautiful tea pot, American by William Will, eighteenth century, 6 1/8 inches high. (Courtesy of the

Metropolitan Museum of Art, New York. Gift of Mrs. Blair in memory of her husband J. Insley Blair).

498. American tea pot by William Will, circa 1780, 6 inches high. (Courtesy of Christies, New York).

499. English tea pot by Edgar Curtis & Son of Bristol, circa 1790—1800. (Courtesy of Mr. Garland Pass).

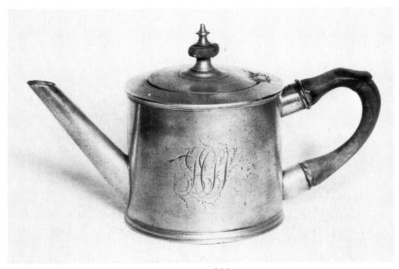

500

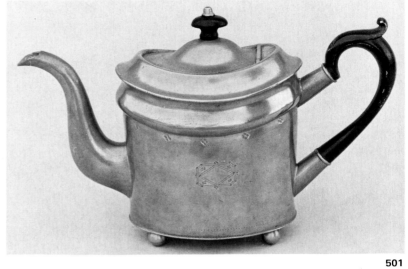

501

NINETEENTH CENTURY TEA POTS

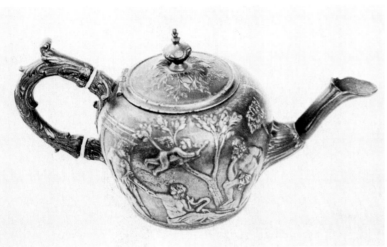

502

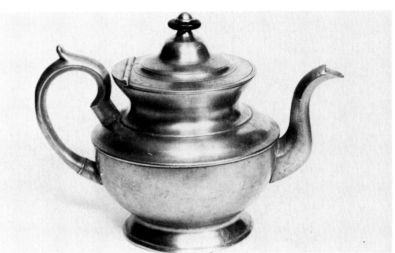

503

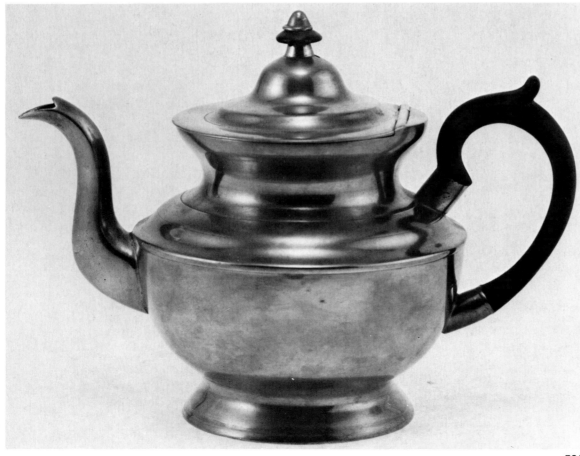

504

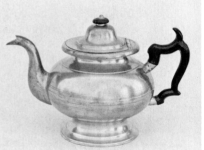

505

506

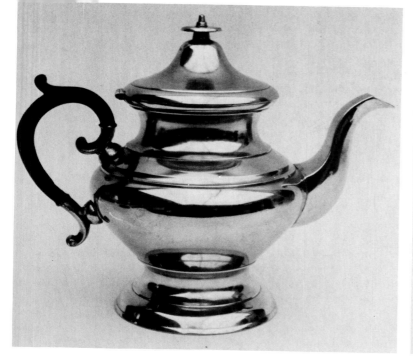

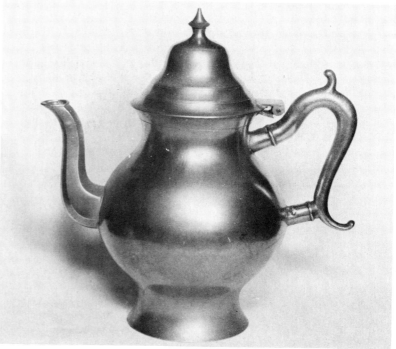

507

508

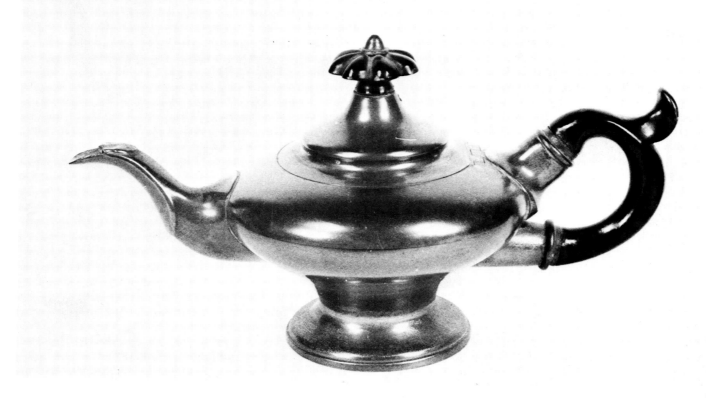

509

500. English tea pot by Pitt and Dadley, 4 7/8 inches high, circa 1780—1800. (Collection of Mr. Charles V. Swain).

501. American tea pot by Trask in the Federal style with ball feet, circa 1830, 7½ inches high. (Collection of Dr. and Mrs. Melvyn Wolf).

502. Cast decorated English tea pot decorated in style of Portland Vase, cast in a single operation in unusual mold, circa 1800—30. (Courtesy of Robin Bellamy Ltd).

503. American tea pot, early nineteenth century, 5¼ inches high. (Collection of Mr. and Mrs. Merrill G. Beede).

504. Another by Boardman and Hart, circa 1830. (Collection of Dr. and Mrs. Melvyn Wolf).

505. American tea pot by J.W. Cahill, circa 1830, 7½ inches high. (Collection of Dr. and Mrs. Melvyn Wolf).

506. Bulbous tea pot, American, 7 inches high, Smith and Company of Boston, circa 1850. (Collection of Dr. and Mrs. Melvyn Wolf).

507. American tea pot, by Putnam, circa 1830—35, 9 inches high. (Collection of Dr. and Mrs. Melvyn Wolf).

508. American tea pot by Kilborn of Baltimore, circa 1820—40, 8¾ inches high. (Collection of Mr. Charles V. Swain).

509. English Britania metal batchelors tea pot, one of many forms made 1790—1840, by Parkin of Sheffield, 8¾ inches wide. (Courtesy of Robin Bellamy Ltd).

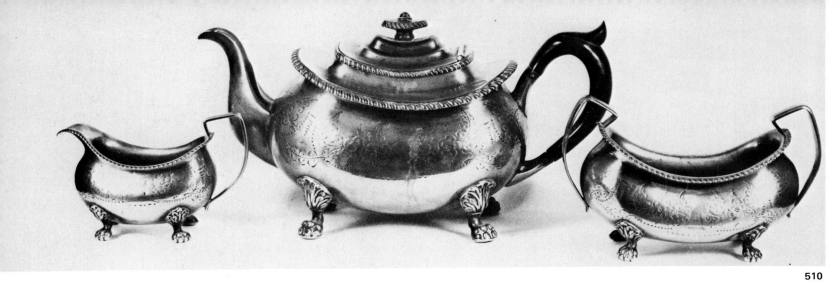

510

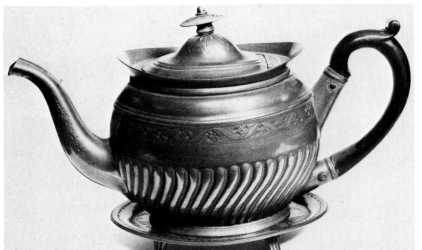

511

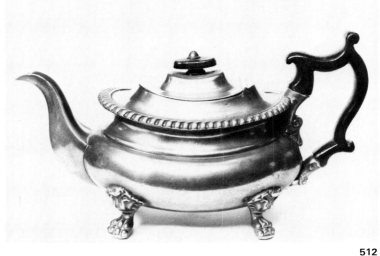

512

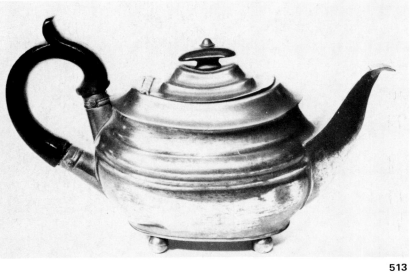

513

COFFEE POTS STRAIGHT SIDED

514

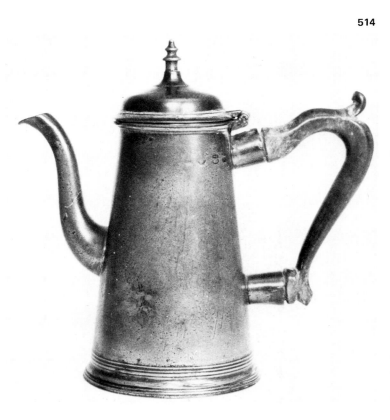

510. English tea pot, sugar bowl and cream jug in Britannia metal, by Dixon and Smith, circa 1810—20. Tea pot is 12 inches wide. (Courtesy of Robin Bellamy Ltd).

511. English Britannia metal tea pot on stand, by Vickers, circa 1800, 15 inches wide. (Courtesy of Robin Bellamy Ltd).

512. English tea pot in Britannia metal, by Smith and Dixon, circa 1815, 11 inches wide. (Courtesy of Robin Bellamy Ltd).

513. Tea pot, English, in Britannia metal, circa 1820, 8½ inches wide. (Courtesy of Robin Bellamy Ltd).

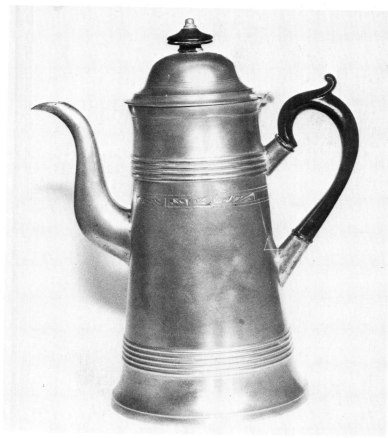

515

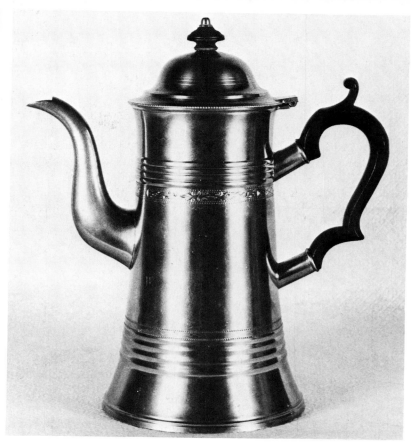

516

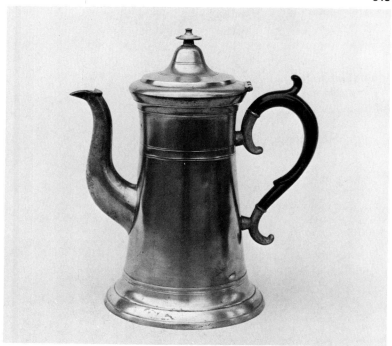

517

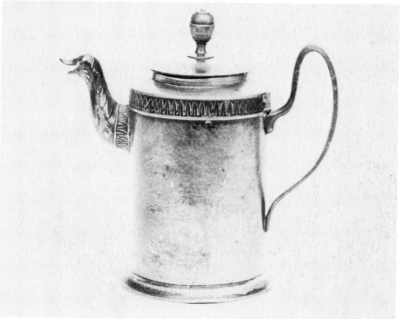

518

514. Very rare English coffee pot by B. Withers, 6 1/8 inches to lip, circa 1730. (Private collection).

515. American coffee pot by I. Trask, 11 inches high, nineteenth century. (Collection of Mr. and Mrs. Robert E. Asher).

516. American coffee pot by O. Trask, 11 inches, circa 1825—30. (Collection of Dr. and Mrs. Melvyn Wolf).

517. American pot by Ward of Wallingford, Connecticut, circa 1850. (Collection of Dr. and Mrs. Melvyn Wolf).

518. Typical German pot, circa 1820—40, with zoomorphic spout, 8 inches high. (Courtesy of Robin Bellamy Ltd).

519. Coffee pot in Britannia metal by James Dixon, circa 1850, 11 inches high. (Robin Bellamy Ltd).

519

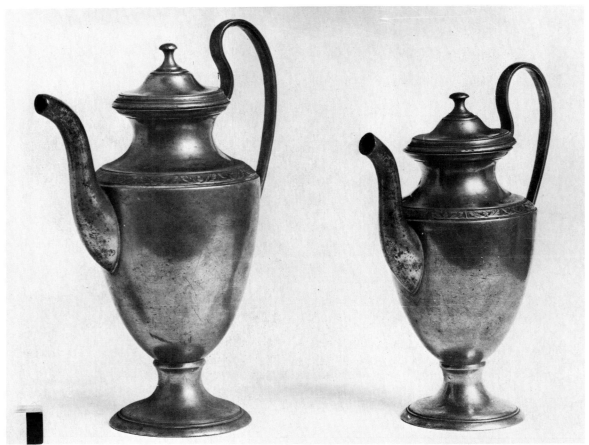

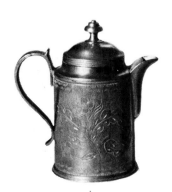

521A

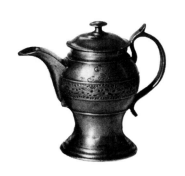

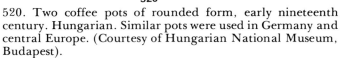

520

521B

520. Two coffee pots of rounded form, early nineteenth century. Hungarian. Similar pots were used in Germany and central Europe. (Courtesy of Hungarian National Museum, Budapest).

521A & 521B. Two coffee pots, German, circa 1800—50. Top: straight sided by C.W.H. Enke of Possneck, 6¼ inches high. Bottom: unmarked. (Courtesy of Kunsthandel Frieder Aichele).

522

522. Classical coffee pot, Germany & central Europe, 10 inches high, circa 1850. Cast decoration on body. (Courtesy of Country Life Antiques).

523. French coffee pot on feet, from Bescancon, circa 1760—80. (Courtesy of P. Boucaud).

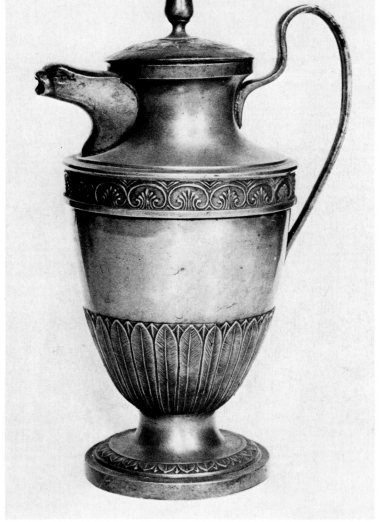

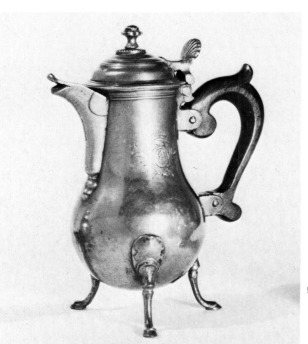

523

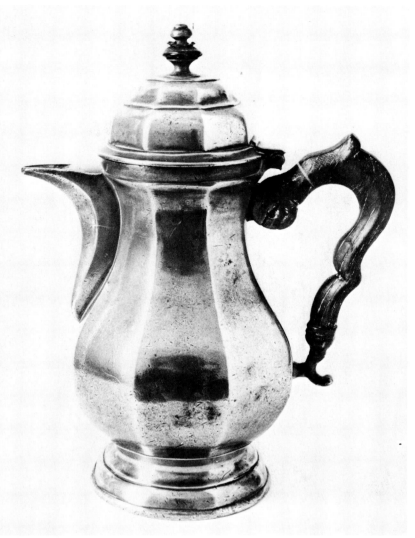

524. Baluster coffee pot, German, mid-eighteenth century, 6 inches high. (Courtesy of Robin Bellamy Ltd).

525. Coffee pot, octagonal form, eighteenth century, German or Austro-Hungarian, 7 inches high. (Collection of Dr. D. Lamb).

526. Two decorated coffee pots, German, mid-eighteenth century. Again a form found in other parts of central Europe as well as in the western parts of the continent, 9 7/8 and 7¾ inches high. (Courtesy of Historical Museum, Frankfurt).

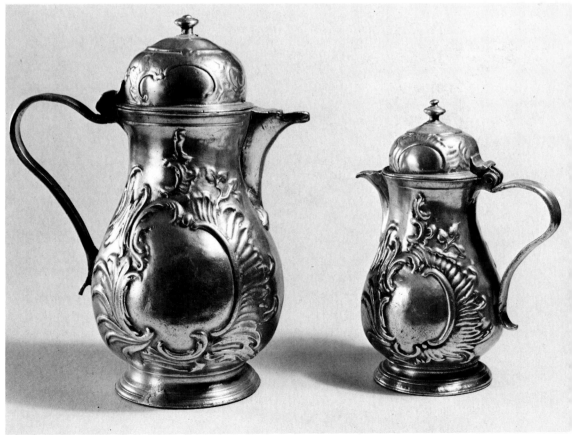

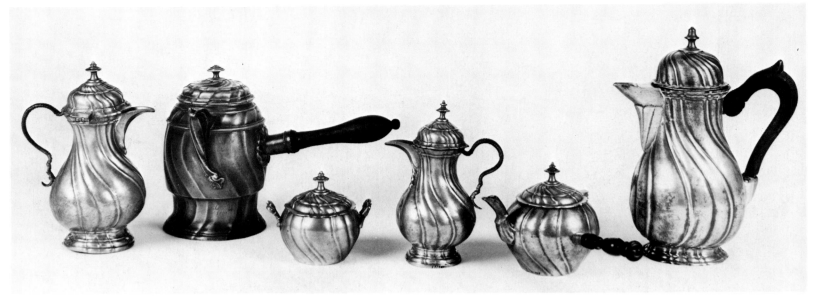

527

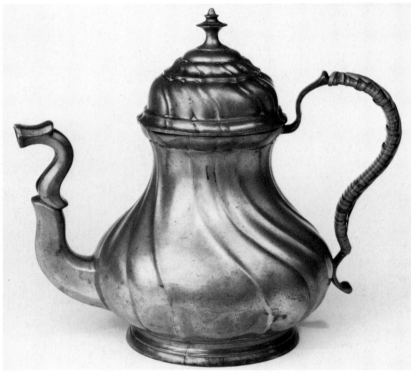

528

527. A group of Rococo wrythen pewter coffee pots including second from right a tea pot and third from left a sugar bowl. All German. From left to right: Coffee pot, eighteenth century, 8 1/8 inches high; Probably a chocolate pot but may also have been used for coffee, eighteenth century, 7½ inches; Sugar bowl, circa 1800, 3¾ inches high; Coffee pot, circa 1800—20, 6 7/8 inches; Tea or chocolate pot, late eighteenth century, 4¾ inches; And a coffee pot, circa 1780—1800, 9 7/8 inches. (Courtesy of Christies, Amsterdam).

528. Coffee or tea pot, Frankfurt, Germany, late eighteenth century. (Courtesy of Christies, London).

529. A small coffee pot with side handle, German, mid-eighteenth century, 5¼ inches. (Courtesy of Robin Bellamy Ltd).

530. English Britannia metal coffee pot with fluted body by Vickers, circa 1810, 9 inches. (Courtesy of Robin Bellamy Ltd).

531. A style unique to Sellew and Company, America, circa 1830—60, 11 inches high. (Collection of Dr. and Mrs. Melvyn Wolf).

532. Rare double bulbous pot, American, by Boardman and Hart, circa 1830—50, 11¾ inches high. (Collection of Dr. and Mrs. Melvyn Wolf).

533. Coffee pot, American, by Richardson, nineteenth century, 9½ inches high. (Collection of Dr. and Mrs. Melvyn Wolf).

534. American pot by Hall and Cotton, circa 1840—45, 11 inches high. (Collection of Dr. and Mrs. Melvyn Wolf).

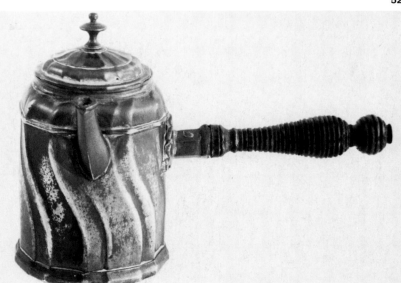

529

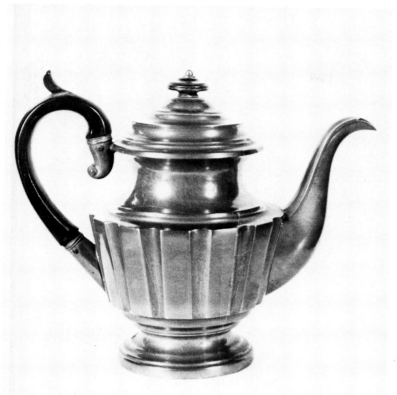

530

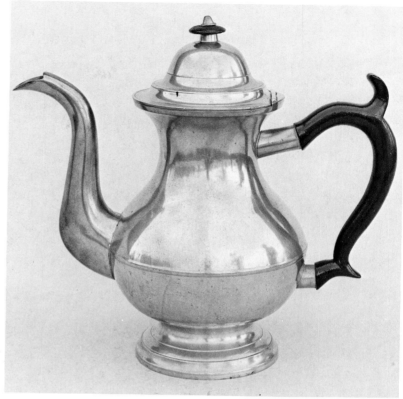

531

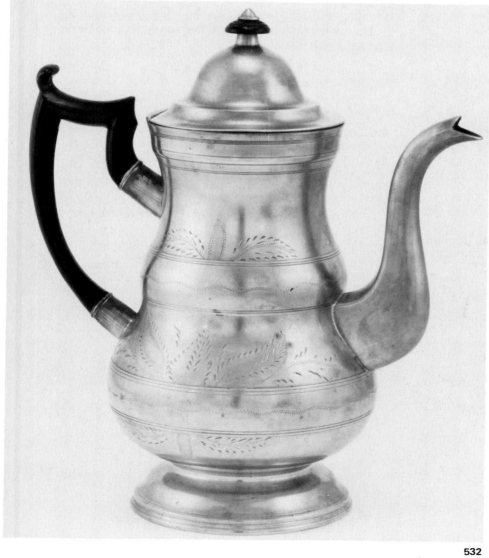

532

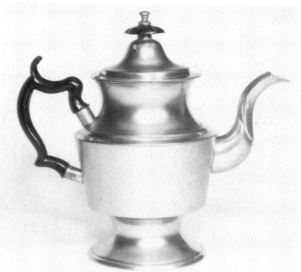

533

534

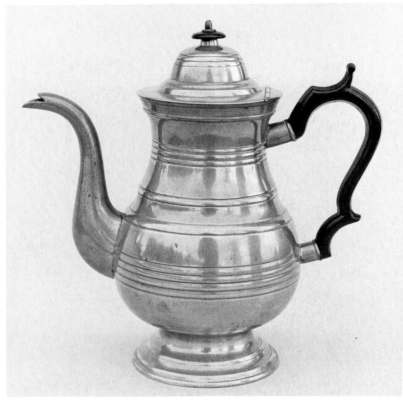

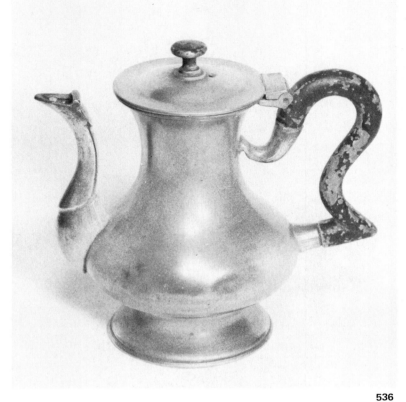

535

536

URNS

535. American coffee pot by A. Griswold, nineteenth century, 11 inches high. (Collection of Dr. and Mrs. Melvyn Wolf).

536. Small coffee pot, probably American, unmarked, 4½ inches high, mid-nineteenth century. (Collection of Mr. Charles V. Swain).

537. Two early eighteenth century wriggle work tea caddies, Dutch. (Courtesy of Robin Bellamy Ltd).

538. Two Dutch coffee urns. The one on left with original lacquer, the one on right in pewter, both with their stands. Similar urns were used in northern Holland and north Germany, eighteenth century. (Courtesy of H.B. Havinga).

539. Two urns, both German. Left: Augsburg, late eighteenth century, 14¼ inches high. Right: Angel mark, early nineteenth century, 17¼ inches high. (Courtesy of Dr. Fritz Nagel).

540. Coffee urn by R. Gleason, mid-nineteenth century, 15 7/8 inches high, American. (Courtesy of the Metropolitan Museum of Art, New York. Gift of George Labalme, Jr., Guy Labalme, and Mrs. Diane Brandauer).

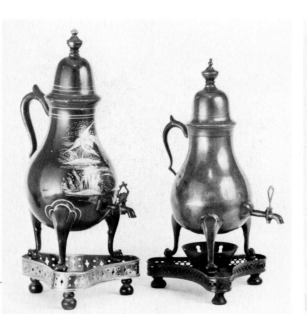

537

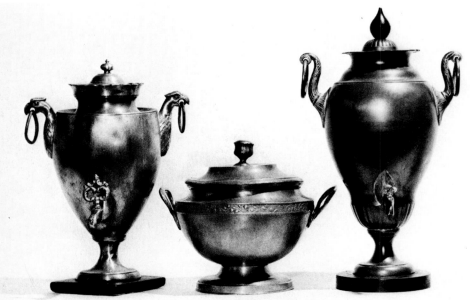

539

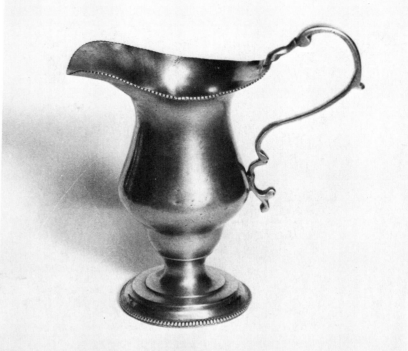

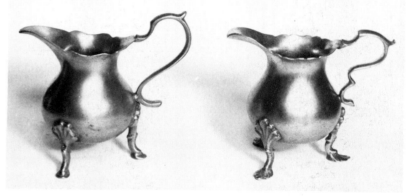

541

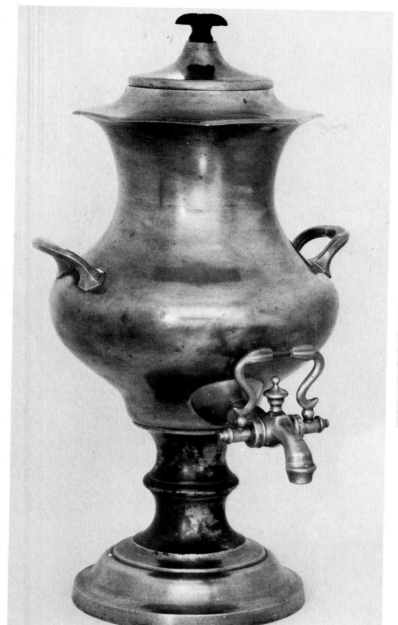

540

541. Cream jug by William Will, 5½ inches high, American late eighteenth century. (Collection of Mr. Charles V. Swain).

542. Two further cream jugs by William Will, 3½ inches high, late eighteenth century. (Collection of Mr. Charles V. Swain).

543. Three English cream jugs, late eighteenth century. That on left and right by Henry Joseph, 4 1/8, 4 1/8 and 4½ inches high. (Collection of Mr. Charles V. Swain).

542

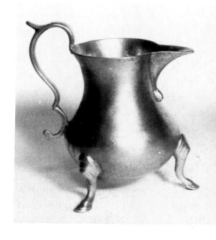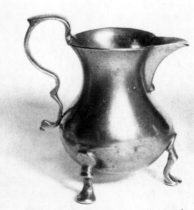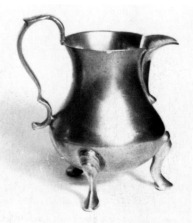

543

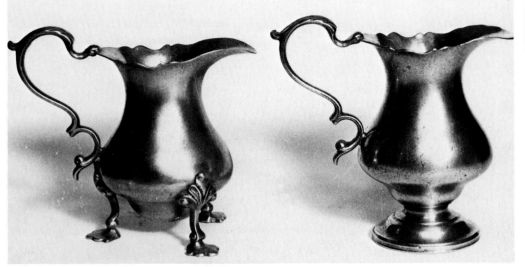

544

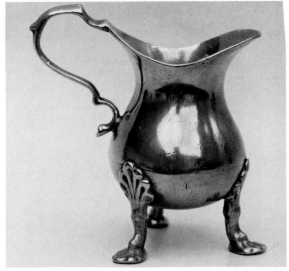

545

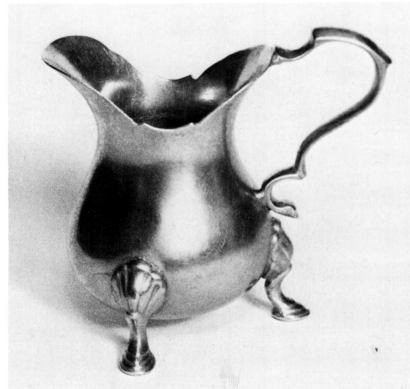

546

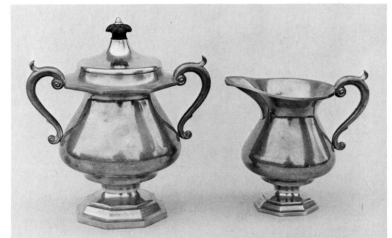

548

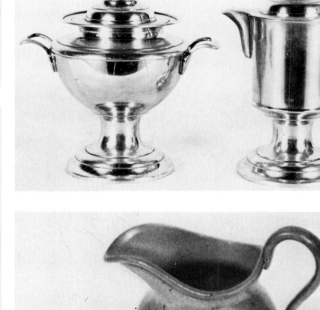

549

547

550

176

551

552

544. Two further English cream jugs by Henry Joseph who made this form particularly for export to the United States, 4 1/8 and 4¼ inches high. (Collection of Mr. Charles V. Swain).

545. Cream jug, American, by John Will, 4½ inches high, circa 1750—70. (Collection of Dr. and Mrs. Melvyn Wolf).

546. Another jug by the same maker, but of different form, 4¼ inches high. (Collection of Mr. Charles V. Swain).

547. An American cream jug attributed to the Boardmans, early nineteenth century, the body is engraved, 4 inches high. (Collection of Dr. and Mrs. Melvyn Wolf).

548. Cream jug and sugar bowl, American by Sheldon & Fettman, circa 1850, 8½ and 6 inches high. (Collection of Dr. and Mrs. Melvyn Wolf).

549. Another American sugar bowl and cream jug, early nineteenth century, 8 and 5 inches high. (Collection of Dr. and Mrs. Melvyn Wolf).

550. Small English hard metal cream jug, early nineteenth century, 2 inches high. (Courtesy of Robin Bellamy Ltd).

551. Spoon stand with sugar bowl, Swiss, circa 1800. (Collection of Marianne & Albert Phiebig).

552. Spoon stand with sugar bowl, Swiss or German, circa 1800. (Collection of Marianne & Albert Phiebig).

553. American sugar bowl, attributed to Parkes Boyde, Philadelphia, circa 1795—1820. (Collection of Mr. and Mrs. Merrill G. Beede).

553

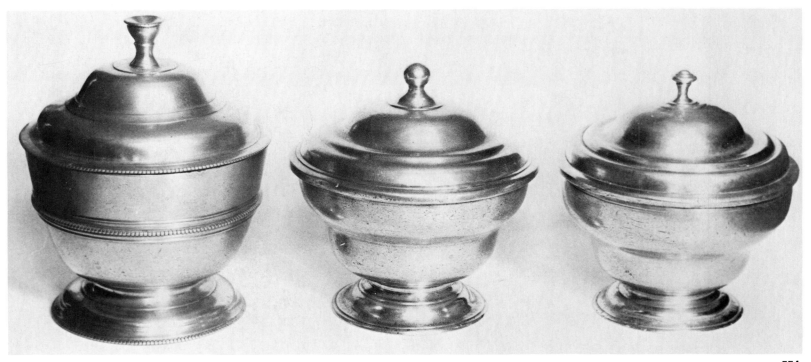

554

555

557

556

558

559

560

561

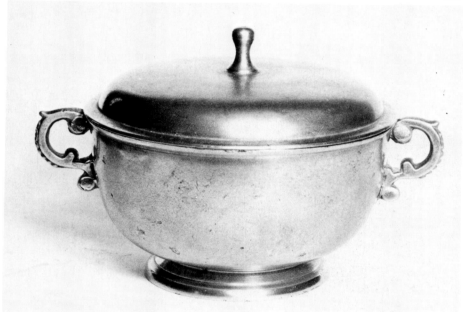

562

554. Three American lidded sugar bowls attributed to William Will, 5½, 5 and 5 inches high, late eighteenth century. (Collection of Mr. Charles V. Swain).

555. Austro-Hungarian sugar bowl, 4 inches high, Schlagenwald quality mark, late eighteenth century. (Courtesy of Country Life Antiques).

556. Swiss bowl, 7 inches high with cover, by Laccombe Brothers of Lausanne and Geneva early nineteenth century. (From the Gordon Collection).

557. Swiss bowl and cover, 3½ inches high, with fluted sides and wooden knop to lid, mid-eighteenth century. (Courtesy of Robin Bellamy Ltd).

558. Sugar bowl, American, by Thomas Danforth II, 4 inches high, circa 1755—80. (Collection of Mr. Charles V. Swain).

559. Sugar bowl by Cranston of Rhode Island, circa 1800—20, 5 inches high. (Courtesy of the Metropolitan Museum of Art, New York. Rogers Fund).

560. American sugar bowl by Richardon of Rhode Island, early nineteenth century, 5¼ inches high. (Courtesy of Christies, New York).

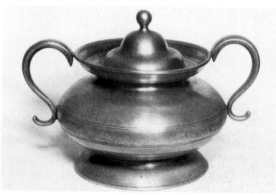

563

561. Sugar bowl by Thomas Danforth II, American, circa 1780—90, 3 7/8 inches high. (Courtesy of Christies, New York).

562. Rare English sugar bowl, made for export to the United States by Henry Joseph, late eighteenth century, 3½ inches high. (Collection of Mr. Charles V. Swain).

563. Sugar bowl, American, by Boardman, 5½ inches high, early nineteenth century. (Collection of Mr. Charles V. Swain).

Seventeenth Century Spoons

564

565

566

567

568

569

564. Slip top terminal, English, circa 1600. (From the Franklin Collection).

565. Seventeenth century slip top terminal with lines of inlaid brass, English. (From the Franklin Collection).

566, 567, 568, & 569. Group of four English "Seal top" terminals from the seventeenth century or slightly earlier in the case of 569 which has a brass terminal. (See Chapter 4). (From the Franklin Collection).

570. Apostle knop from an English seventeenth century spoon. (From the Franklin Collection).

571. Horses hoof knop from an English seventeenth century spoon. (From the Franklin Collection).

572. The slip top is the most common spoon terminal in the seventeenth century, found mainly in Britain but occasionally in Holland. (Courtesy of Robin Bellamy Ltd).

573. The stump end terminal spoon continued to be made into the seventeenth century in Britain, Holland and Germany. This is a Dutch spoon, circa 1660. (Private collection).

574. The Puritan spoon terminal developed in the mid-seventeenth century in England and Holland. Similar to the slip top but with a slightly widening handle. Dutch with a round bowl, circa 1700. (Collection of Mr. William F. Kayhoe).

575. Horses hoof spoon, Italian. (Courtesy of Robin Bellamy Ltd).

576. Another hoof terminal on a typical Dutch spiral stem, seventeenth century. (Courtesy of Robin Bellamy Ltd).

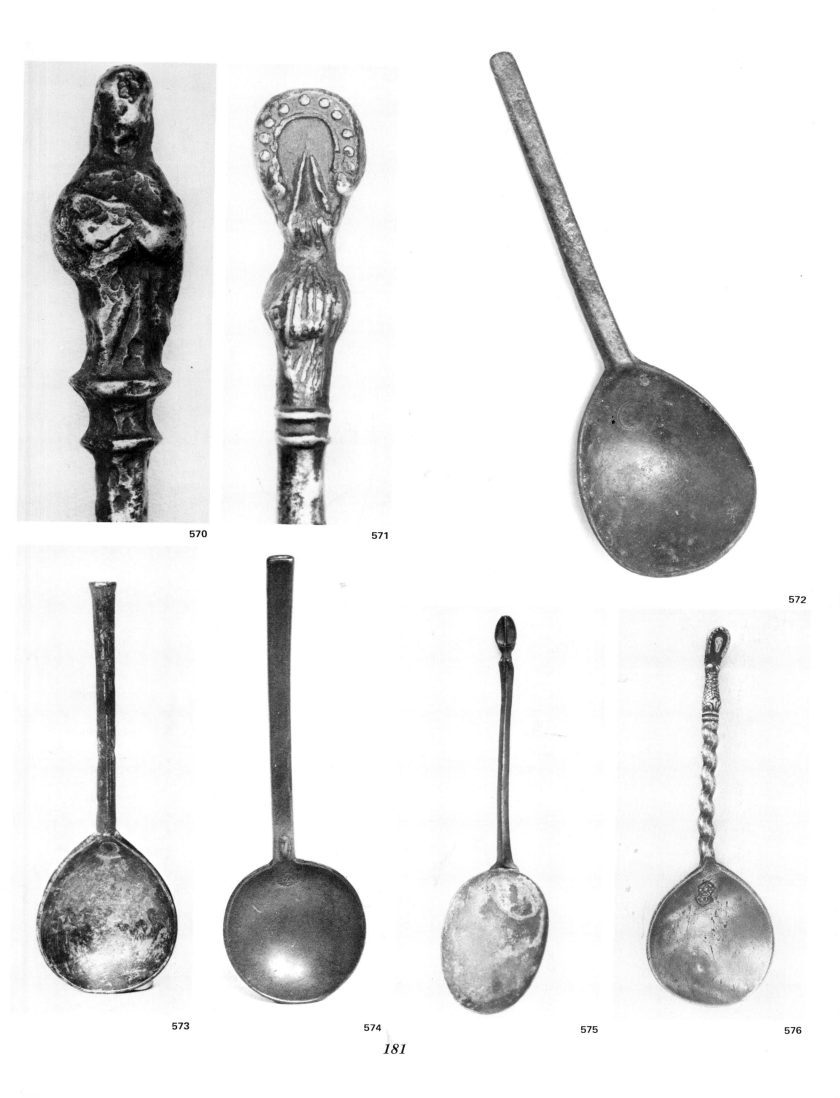

570

571

572

573

574

575

576

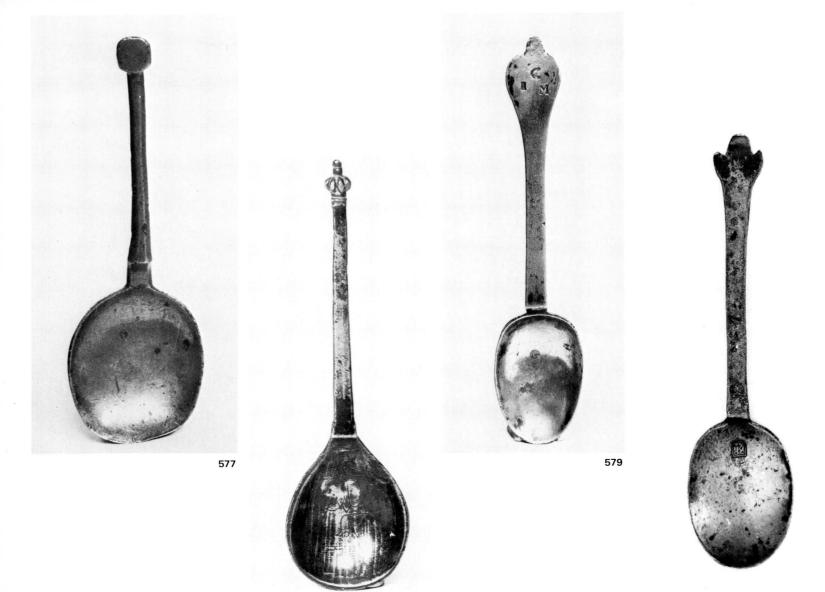

577

578

579

580

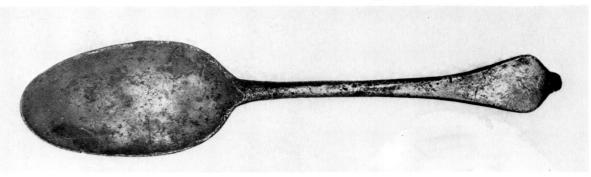

581

577. Less common "square" terminal spoon, Dutch late seventeenth century. (Collection of Mr. William F. Kayhoe).

578. Cast baluster knop spoon, with wriggle work in bowl. Dutch or German, mid-seventeenth century. Baluster knops in England are usually earlier. (Private collection).

579. English "tryfid" spoon, circa 1690. The two cuts which form the tryfid are less pronounced than on earlier tryfids. (Courtesy of Robin Bellamy Ltd).

580. Tryfid by "I.H.", English, circa 1680. (Courtesy of Robin Bellamy Ltd).

581. Dog nose spoon terminal, English, circa 1700. Similar spoons are also found in Holland. (Courtesy of Robin Bellamy Ltd).

582, 583, & 584. Spoons were often decorated with portraits or with ownership marks. 582. The "G.H." is for Greenwich Hospital, English, circa 1700. (Bishop-Vellacott Collection). 583. Portrait of George III and Queen Charlotte, English, circa 1770. (Bishop-Vellacott Collection). 584. Portrait of George I, English, circa 1720. (Courtesy of Robin Bellamy Ltd).

585. Cast decorated spoon by George Coldwell of New York, circa 1790—1800. (Courtesy of Colonial Williamsburg).

586. An unmarked spoon but probably from New England, circa 1780—1810. The elongated bowl would, if English, indicate a slightly earlier period, around 1710—50. (Courtesy of Colonial Williamsburg).

EIGHTEENTH AND NINETEENTH CENTURY SPOONS

While there were considerable styles made over this 150 years, national varieties tend to be very similar. Most of the major forms being made in America, Europe and Britain.

Spoons with cast decoration continued to be popular although portraits became rarer after 1780. There is a gradual development that can be discerned. The Old English terminal gives way to a more pointed form and a ridge is frequently added to the handle. Towards the end of the eighteenth century more elaborately shaped spoon handles became popular including the very widespread "fiddle and thread" style.

There are many dozens of variations and few examples are marked.

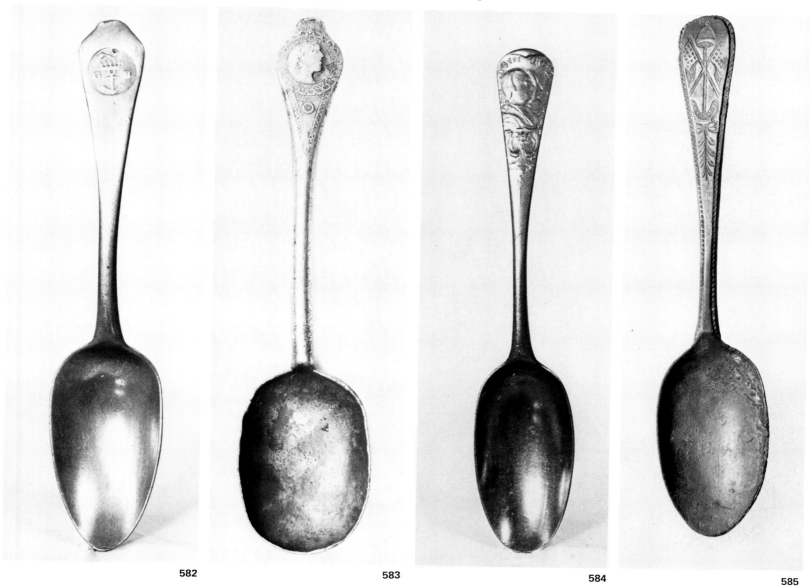

582 583 584 585

586

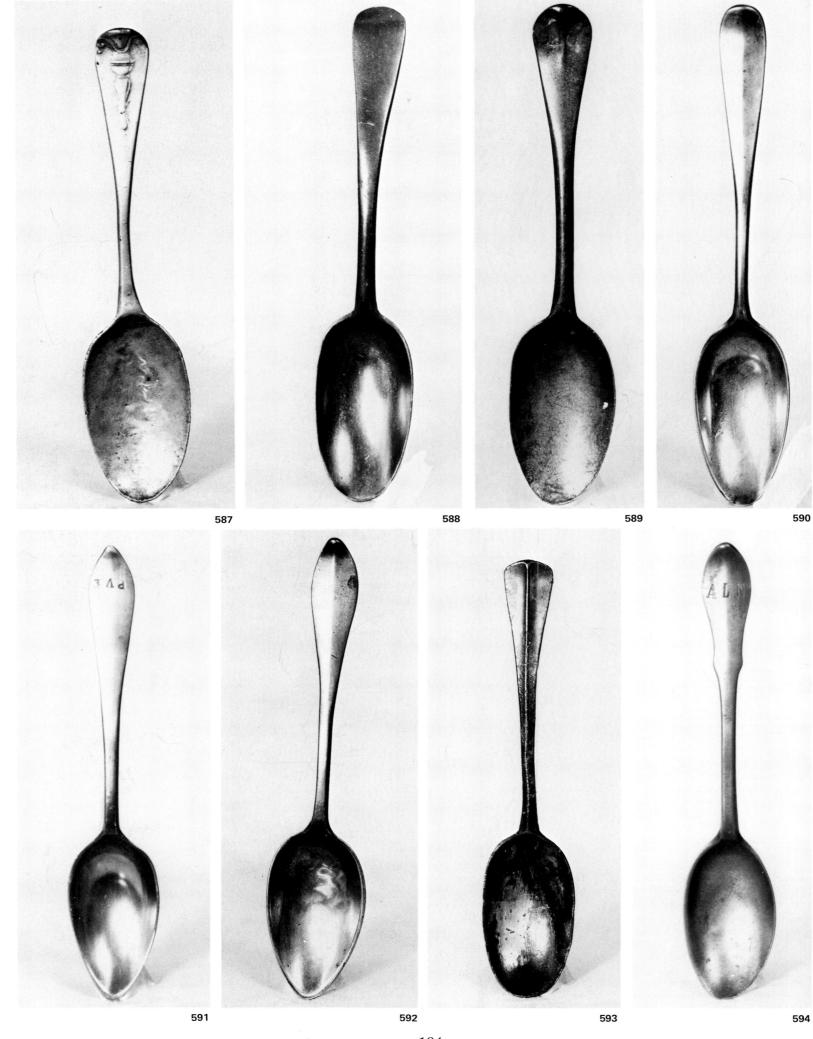

587 588 589 590

591 592 593 594

595 596 597 598

587. English spoon with cast "Urn" decoration, circa 1770. (Bishop-Vellacott Collection).

588. Typical old English handle. Spoons of this form were popular both in Britain and the United States. They continued to be made throughout the eighteenth century. (Bishop-Vellacott Collection).

589. The old English handle is slightly turned up here. Probably English, circa 1730—50. (Bishop-Vellacott Collection).

590. The old English terminal now has the ridge, second half of the eighteenth century. (Bishop-Vellacott Collection).

591. A popular form in America, Britain and in Europe. The more pointed bowl is a sign of nineteenth century production. (Bishop-Vellacott Collection).

592. This example of a pointed handle has the ridge. Nineteenth century, probably British or American. (Bishop-Vellacott Collection).

593. Another spoon form widely used in each area. This example is probably English and from the mid to late eighteenth century. (Bishop-Vellacott Collection).

594. A shield back spoon, probably European, circa 1800, but examples are also found in Britain and the United States. (Bishop-Vellacott Collection).

595. A rare shaped handle, probably European or British, circa 1830. (Bishop-Vellacott Collection).

596. An American spoon attributed to one of the Boardmans, circa 1830. (Collection of Mr. William F. Kayhoe).

597. Fiddle and thread spoon. Similar spoons were made in each region. Nineteenth century, American. (Collection of Mr. William F. Kayhoe).

598. An unusual American spoon, eighteenth century, showing European influence in the round bowl. (Collection of Mr. William F. Kayhoe).

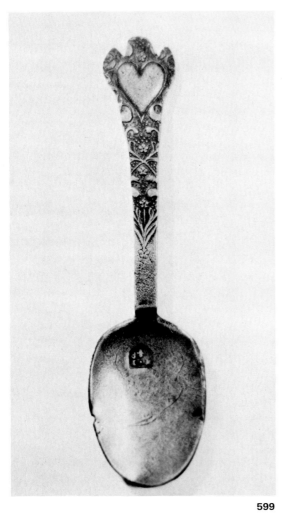

599

600

601

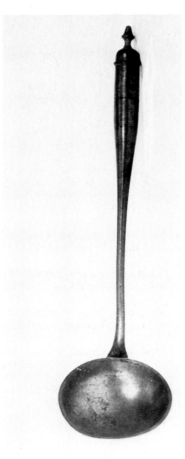

602

603

604

605

186

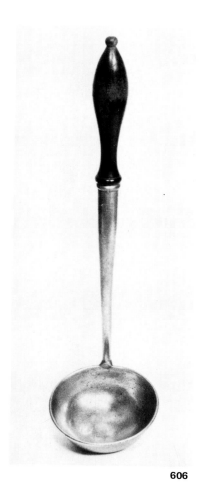

606

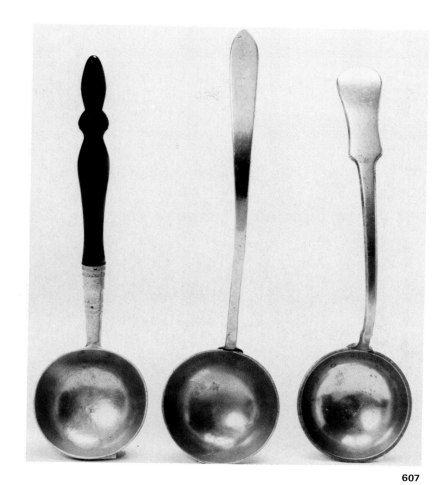

607

608

609

599. Tryfid chocolate spoon, English, circa 1670. Similar spoons of between 3½ and 4½ inches can be found compared with the average full spoon size of between 6 and 7 inches. (Courtesy of Robin Bellamy Ltd).

600. A rare American tea spoon by Richard Lee, circa 1800, 4 inches long. (Collection of Mr. William F. Kayhoe).

601. An American tea spoon attributed to the Boardmans, circa 1830. (Collection of Mr. William Kayhoe).

602. Unusual kitchen ladle, marked "Kings Coll Kit", English, perhaps circa 1820. (Bishop-Vellacott Collection).

603. Most uncommon double ended spoon by John Yates, English, 1840. (Bishop-Vellacott Collection).

604. Very rare Marrow spoon, by John Yates, circa 1840—50. (Bishop-Vellacott Collection).

605. Ladle with pewter handle, English. Made from mid-eighteenth century into the nineteenth century. (Bishop-Vellacott Collection).

606. Punch ladle with wooden handle. Ladles were made in most parts of the world and unless marked it is difficult to identify their origins. (Collection of Mr. and Mrs. Merrill G. Beede).

607. Three American ladles. Left to right: Ladle with wood handle by Richard Lee, circa 1800. Ladle by Thomas D. Boardman, circa 1830. Ladle by J.H. Palethorp, circa 1830—40. (Courtesy of Christies, New York).

608. Left to right: Typical bowl shape, circa 1700—20. Tryfid bowl shape, 1680—1700. Popular bowl shape, 1600—1670. (Art work by Andrew Cross).

609. Left to right: Bowl form widely used in eighteenth century. Nineteenth century bowl shape. Tryfid bowl shape, circa 1660—90. (Art work by Andrew Cross).

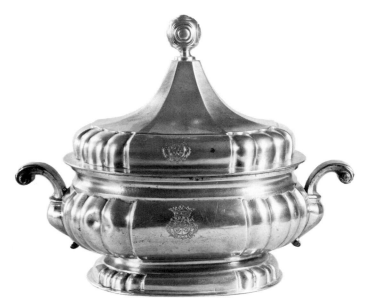

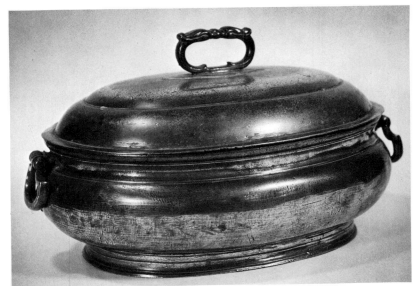

610

611

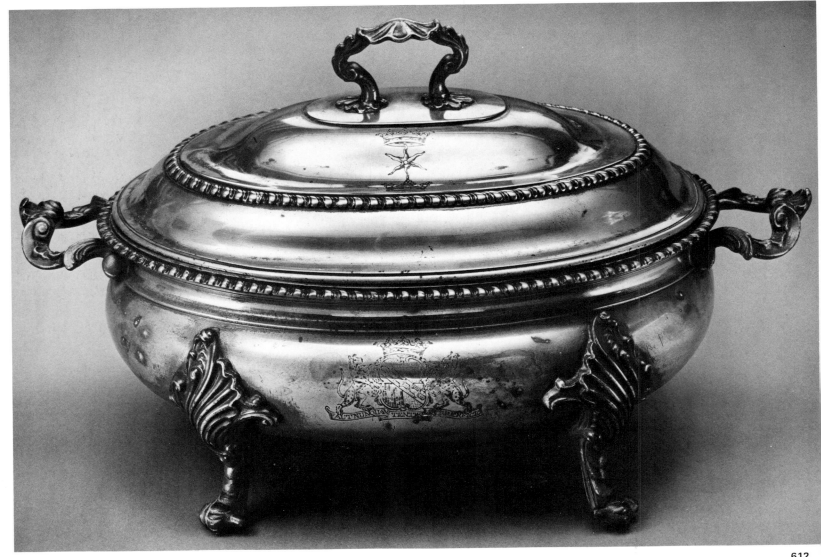

612

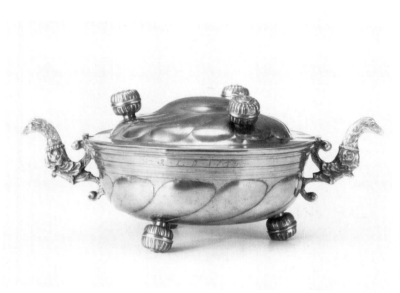

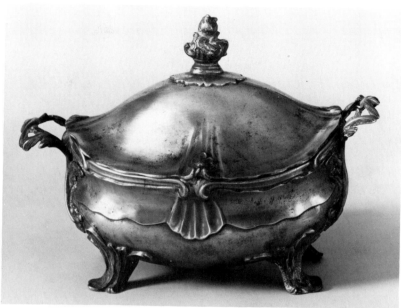

613

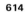

614

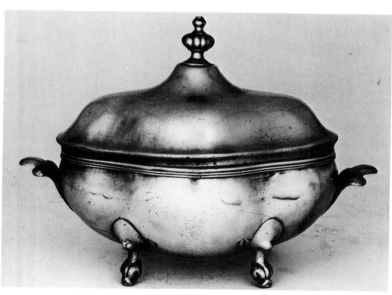

615

616

610. Fluted tureen by J.P. Heinicke of Frankfurt, circa 1735. German, but similar tureens are also found in the rest of central Europe. (Courtesy of Historical Museum, Frankfurt).

611. Tureen without feet, English, by William Green, circa 1740, 13¼ inches wide and 7 7/8 inches high. (Courtesy of Colonial Williamsburg).

612. Another fine English cast decorated tureen probably by Thomas Chamberlain, the arms are from the Sackville family, the Dukes of Dorset. 9¼ inches high, circa 1740—50. (Courtesy of Colonial Williamsburg).

613. Typical scandinavian smaller tureen similar in form to some brandy bowls. By S.A. Kaslew of Stromso, Norway, 13½ inches wide. (Courtesy of Kumstindustrimuseet, Oslo).

614. Oval tureen by G. Ostling of Vimmerby, Sweden, 1771, 10 7/8 inches high. (Courtesy of National Museum, Stockholm).

615. Italian tureen from Venice, 1750—1800. (Courtesy of P. Boucaud).

616. French tureen from Strasbourg, second half of the eighteenth century. (Courtesy of P. Boucaud).

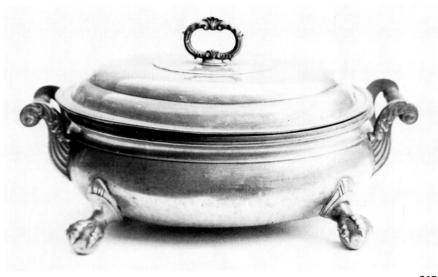

617

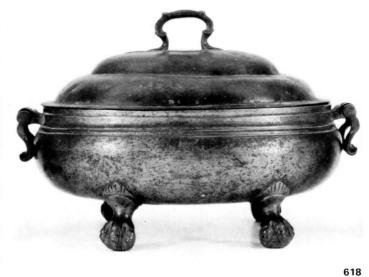

618

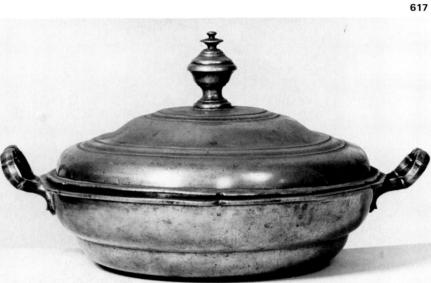

619

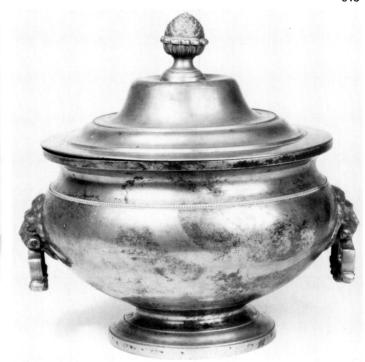

620

617. An English tureen with similar ball and claw feet but with fixed handles, circa 1770, 18 inches wide. (Courtesy of Robin Bellamy Ltd).

618. Oval tureen, no makers marks, 17¼ inches long. Similar tureens were made in most of Europe and Britain, mid-eighteenth century. (Courtesy of Sotheby Parke Bernet).

619. A German flat tureen with fixed handles, by J.J. Pelargus of Stuttgart, circa 1750, 7 1/8 inches high and 12½ inches wide. (Courtesy of the Kunstgewerbemuseum, Cologne).

620. A German round tureen with beeded decoration, 11 inches high, mid-eighteenth century. (Courtesy of Christies, London).

621. Typical rococo tureen, German, mid-eighteenth century. (Courtesy of Historical Museum, Frankfurt).

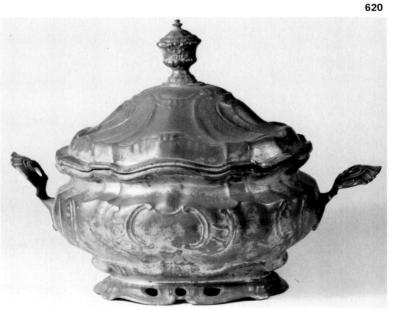

621

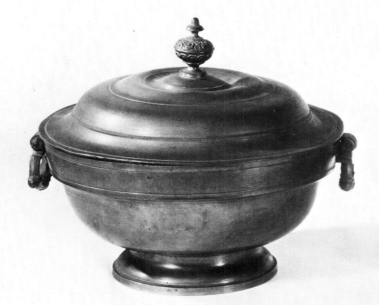

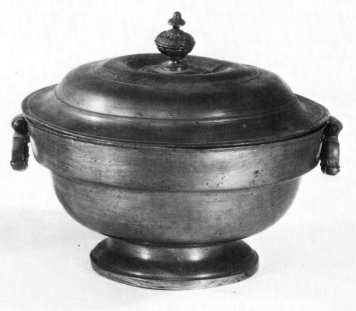

622

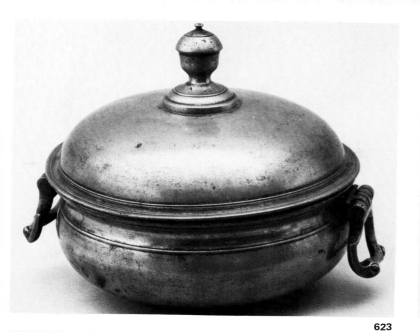

623

624

622. European, probably from central Europe, this pair of lidded dishes or tureens are late eighteenth century. Similar examples vary in size from a diameter of 8 inches to over 12 inches. (Courtesy of Christies, London).

623. A soup tureen from Sweden, mid-eighteenth century. (Courtesy of the Metropolitan Museum of Art, New York. Gift of Mrs. Russell Sage).

624. French tureen from northern France, circa 1800. (Courtesy of P. Boucaud).

625. Typical smaller German tureen, 1800–1840. (Courtesy of P. Boucaud).

625

626

627

628

629

FUNNELS

Funnels were made in Britain, America and most of Europe. Few are marked and all are very much alike. It is difficult to distinguish their origins.

630

631

632

633

634

636. A terrine by A. Heise of Reutlingen, Germany, dated 1832, 11¾ inches wide. Similar terrines were made in northern and central Europe. (Courtesy of Kunsthandel Frieder Aichele).

627. A flatter tureen or serving dish, English, made for the coronation banquet of George IV by Thomas Alderson. (Courtesy of the Worshipful Company of Pewterers, London).

628. Cast decorated terrine, German by F.D. Kellenberg of Ludwigsburg, circa 1820, 9 1/8 inches diameter. (Courtesy of Kunsthandel Frieder Aichele).

629. A similar dish with fixed handles, Swiss, circa 1850 by Charles Moriggi of Vervey. (Courtesy of Kunsthandel Frieder Aichele).

630. Funnel, possibly American, 6½ inches high, circa 1780 – 1820. (Collection of Mr. and Mrs. Merrill G. Beede).

631. Large English funnel, eighteenth century, 9½ inches high. (From the Kydd Collection).

632. Jelly mold, probably English nineteenth century. (Collection of Mr. and Mrs. James A. Taylor).

633. The same mold separated into its individual parts. (Collection of Mr. and Mrs. James A. Taylor).

634. Crown mold for marzipan or sugar confections, English early nineteenth century, 3½ inches wide. (Private collection).

635. The same mold when opened.

635

636

637

SAUCE BOATS

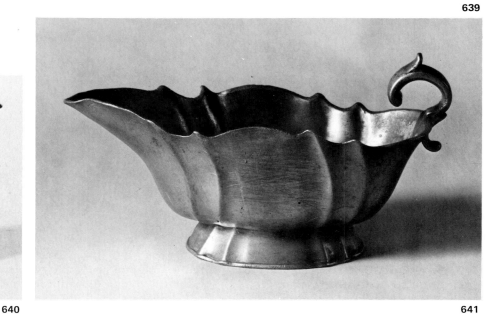

638

639

640

641

636. Two more typical nineteenth century molds, made in Britain and America. (Collection of Mr. and Mrs. James A. Taylor).

637. An unusual confectionary mold, probably European, circa 1800. (Collection of Mr. and Mrs. James A. Taylor).

638. An interesting melon mold with brass pins, made from "Best Pure Metal", 8¼ inches wide, nineteenth century, English. (Private collection).

639. Two English sauce boats with scalloped rims, by Henry Joseph, probably made for the export trade to the United

States as few are found in England, 4 inches and 3½ inches high. (Collection of Mr. Charles V. Swain).

640. Elaborate sauce boat from Belgium, plainer examples also occur in Holland and other parts of Europe, circa 1800. (Courtesy of P. Boucaud).

641. Swedish sauce boat, by G. Ostling, circa 1785. (Courtesy of Nationalmuseum, Stockholm).

CHAPTER 9

Pewter for Drinking

Flagons, Measures, Jugs and Flasks

There are a number of words in English used to describe pewter vessels used for the storage or provision of liquids such as "flagon", "tankard", "measure", "can", "flask" and "bottle" and the same is true in other languages. In French we have "pichet" "chop", "measure" "cimarre" and "gourde" whilst in German there are "krug" "stitze", "kanne" and "feldflasche".

The difficulty with all these terms is that they are seldom precisely defined and the terms are often interchanged.

In ordinary speech a flagon is a large lidded container, a measure is a container made to some capacity standard, a jug is used for pouring and so on. The difficulties arise from the fact that we try and fit a variety of forms and shapes into suitable categories for our own convenience.

When does a tall lidded vessel cease to be a flagon and become for example, a measure; just because it is made to a capacity and is so marked? And what if it is of a certain capacity but is not marked. Is it still a measure?

These are not theoretical questions but real practical difficulties. We know for example that many Channel Island vessels are made to local standards. Are they all measures therefore, even if their capacity is not shown?

No definition will take care of all the ambiguities or solve all the problems, for those who made this important variety of vessels or used them faced no restrictions on what purpose they could serve.

The following divisions will be used to present these vessels or containers;

Flagons; for lidded containers probably not made to a standard.

Measures, jugs and balusters; for lidded and unlidded containers, probably made to a standard or used for pouring.

Flasks; for that group of vessels with fitting tops used for the storage of liquids.

Flagons

Several methods of classifying flagons could be devised based, for example, on their body form, style of lids, thumbpieces, spouts and handles. In essence all such divisions are artificial and what is needed is a method of display which makes it easy for flagons to be identified.

Flagons are illustrated here in two main groups. Those with basically straight sided bodies and those with rounded or shouldered bodies. Both groups are presented chronologically.

The British and European traditions, differ. In Britain flagons generally have straight sides, although there are many variations in the lids, knops and thumbpieces used. In Europe the rounded form is found more frequently than in Britain and with both the rounded and straight sided flagons examples with feet and spouts are more common.

American flagons owe something to both traditions. Those, for example by William Will and Heyne, are continental in appearance whilst others follow the straight lines of contemporary British flagons. In a few examples both traditions are combined.

Measures, Jugs & Balusters

For convenience measures and jugs are presented in four categories;

i Measures made as capacity containers.

ii Baluster measures.

iii Jugs

iv Measures where lips or spouts have been added to other forms.

There is little similarity between the types of measures and jugs used in different countries. With a few exceptions each country or even each region has developed distinct forms. For example within the British Isles there are measures made only in Ireland, Scotland, the Channel Islands and the west of England.

One group of measures which were used across national boundaries are the straight sided metric measures of the nineteenth century from France, Holland and Belgium.

In Britain a unique form of measure, the baluster was popular over several hundred years. Balusters were made to both the ale and wine standards. Early examples were slim and less rounded, while later they became shorter and more bulbous. Help can be obtained in dating balusters by the thumbpieces used.

The baluster appeared in Scotland in the late eighteenth century onwards and developed its own varieties, which were used into the second half of the nineteenth century. The baluster was also used in America.

Lidless balusters were also made from the late eighteenth century onwards but are more common in the United States than in Britain.

Baluster shaped measures occur in Europe but are uncommon and are generally dissimilar from British and American examples.

There are many varieties of jugs, with pouring lips or spouts. Spouts are more frequently found in America and Europe than in Britain. Some of these jugs served for special purposes like dispensing oil and syrup.

The last group of measures' are those whose body shape is adapted from other forms, often mugs or drinking pots where a lip or spout has been added to facilitate pouring. These additions were done when the object was made but do not always sit well on the original design. They mostly come from Britain.

Flasks

This term is used to identify a series of different containers. These flasks, cans, or bottles are European and were used for carrying or storing liquids.

The first group, which we will term "cans" were used to carry liquids or foods such as porridge. They were mostly made in Germany, Poland, Switzerland, Russia and Scandinavia and come in many guises. Some are spouted, others not.

Round forms or those with six or eight sides are most frequent. Spouts are either plain or with a zoomorphic terminal.

The lids fasten in several ways. Some are hinged while others have screw or bayonet fittings. Cans continued to be made into the nineteenth century.

True flasks were either carried or hung about the person on leather cords. They were widely used in the middle ages but continued to be made into the eighteenth century. Some field flasks were also used for ceremonial purposes by corporations.

Bottles, the third sub-group, are simpler in style than flasks but do sometimes have carrying handles. Small flasks for drinking from or keeping in the pocket were also popular in Britain and the United States.

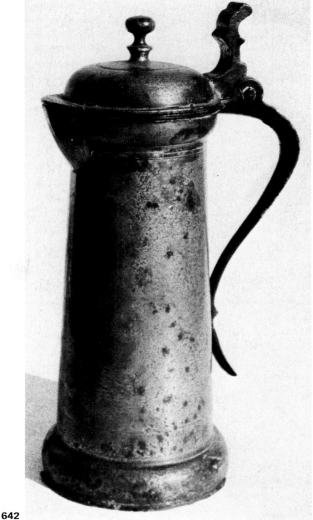

642

645

643

644

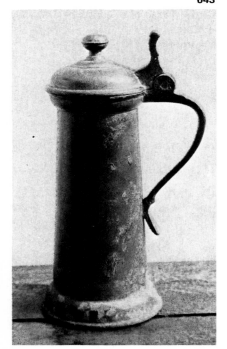

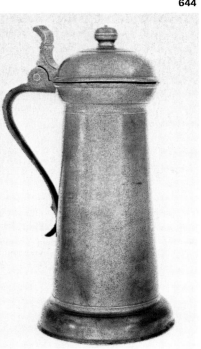

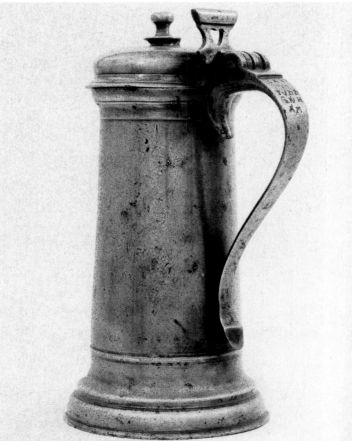

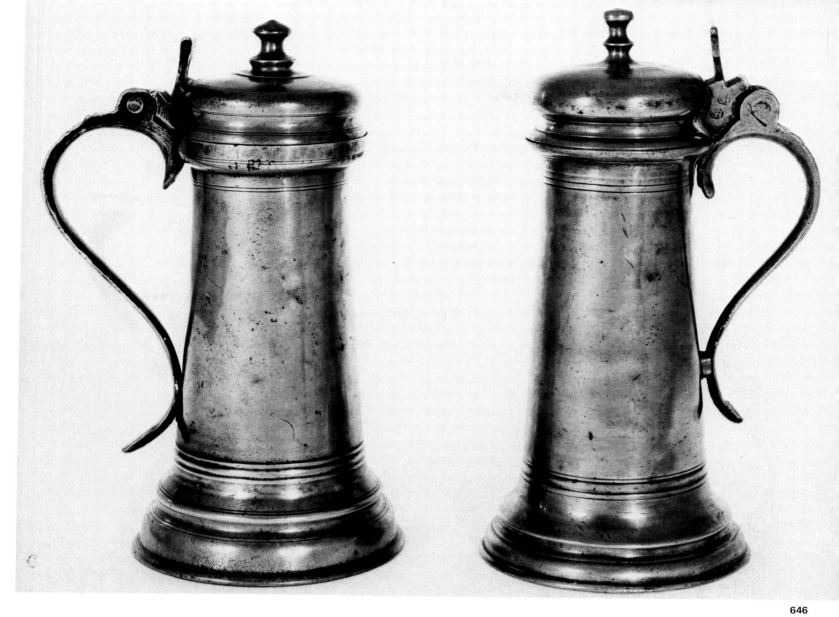

646

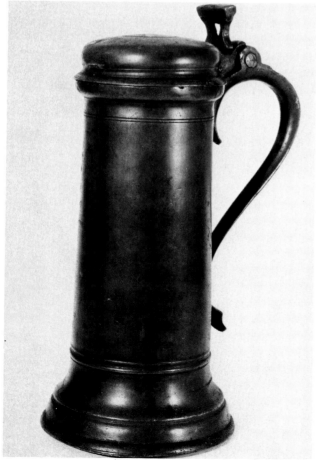

647

642. English flagon, of a form probably made from the 1580's but called the "James I". Examples with a spout are very rare. (Courtesy of Robin Bellamy Ltd).

643. Typical James I flagon with its erect thumbpiece and knopped lid. Most dated examples come from around 1609—20. (Courtesy of Robin Bellamy Ltd).

644. Another fine early English flagon by "EG & RA", 15 inches high, circa 1610—20. (Courtesy of Sotheby Parke Bernet).

645. Charles I flagon. The "East Tuddenham" flagon by "EG", circa 1630, English, 10 3/8 inches high. From East Tuddenham Church. (Courtesy of Sotheby Parke Bernet).

646. Two further knopped varieties of the Charles I flagon with varying reeding round base and different knops, circa 1630—40. (Private collection).

647. Fine English Charles I flagon without knop, 13½ inches high, circa 1630—40. (Courtesy of Sotheby Parke Bernet).

197

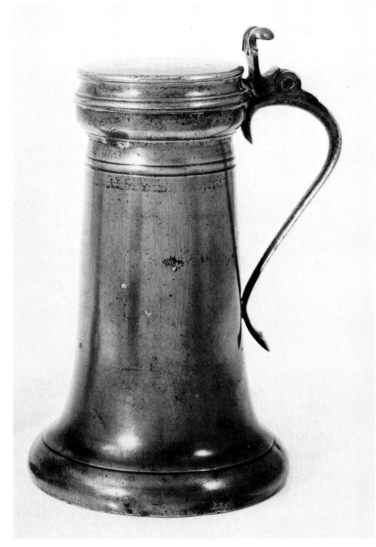

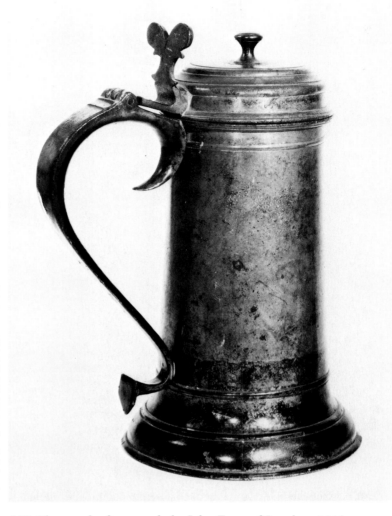

648. Different form of lid on an unknopped Charles I flagon, 11 7/8 inches high, circa 1640. (Courtesy of Sotheby Parke Bernet).

649. Flagon of a form made by John Emes of London, 11¼ inches high, circa 1700. (Courtesy of Sotheby Parke Bernet).

Thumbpieces

EXAMPLES FOUND ON BOTH FLAGONS AND TANKARDS.

A. Rams horn. Several forms of this important knop found in all three areas, especially on flat-lidded tankards. Seventeenth and eighteenth century use.

B. Twin Cusp, English on "beefeater" flagons and other forms.

C. Scroll, English, circa 1680—1720 and occasionally on European seventeenth century forms.

D. Another form of this style.

E. Spray, British late seventeenth century.

F. Plume, found in Britain and Europe, mostly circa 1680—1750.

G. Macaroon, a form of erect thumbpiece with mans face. European, seventeenth and eighteenth centuries.

A

B

C

D

E

F

G

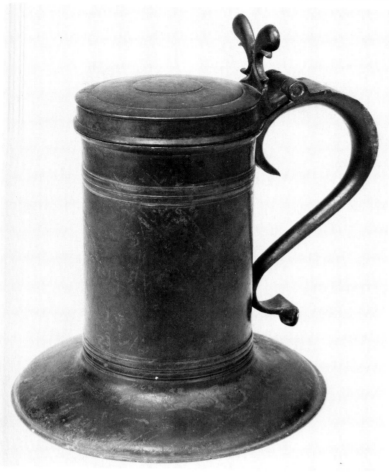

650

651

650. Cromwellian Beefeater flagon by TB, circa 1650, with rare very wide base. English. (Courtesy of Worshipful Company of Pewterers, London).

651. Rare flagon circa 1650—60, with unique thumbpiece illustrating that in addition to all the main varieties of thumbpieces one off productions were not uncommon. (Courtesy of Mr. C. Minchin).

652. Unusual flagon of similar form but with Palmette thumbpiece, 9 inches high, circa 1650—70. (Private collection).

653. More traditional beefeater with twin cusp thumbpiece by Francis Seagood of Kings Lynn, 9¾ inches high, circa 1660—1690. (Courtesy of Sotheby Parke Bernet).

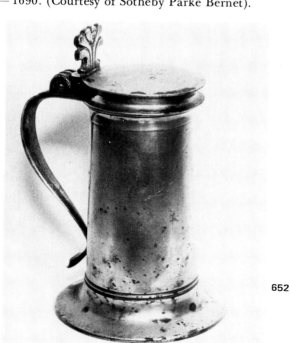

652

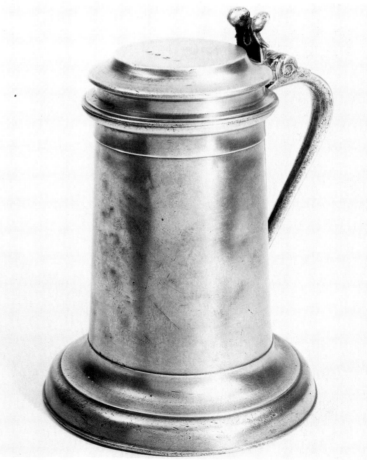

653

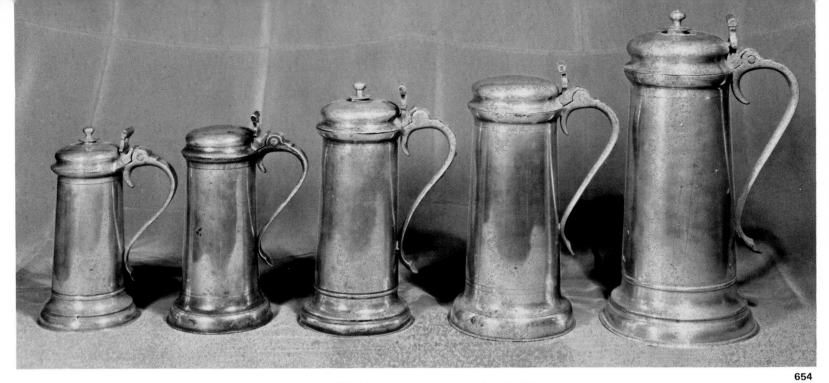

FLAT LIDDED FLAGONS

Of essentially the same body form as flat lidded tankards but which served as flagons.

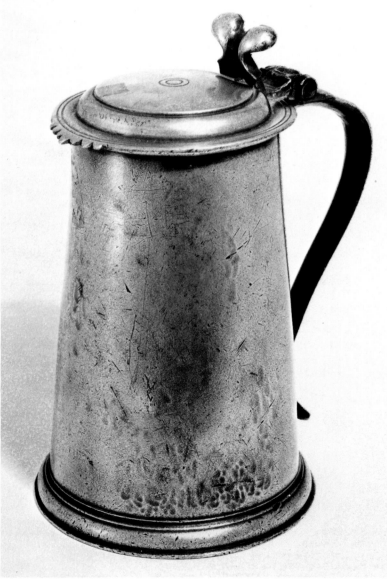

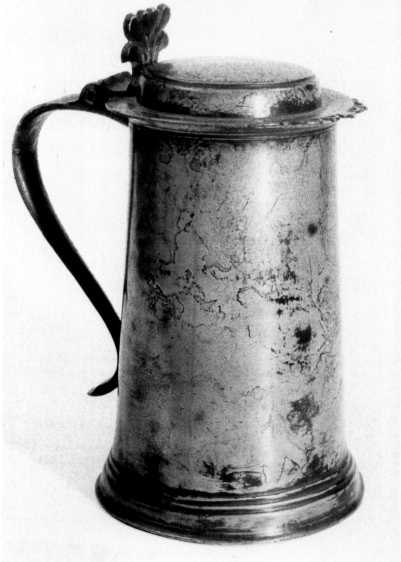

655

656

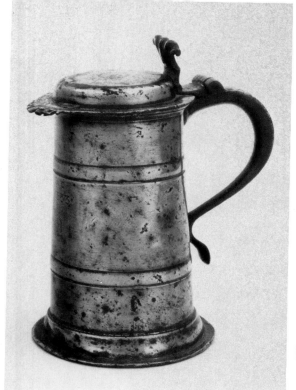

657

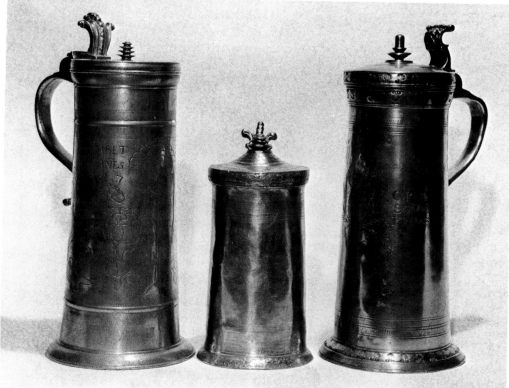

658

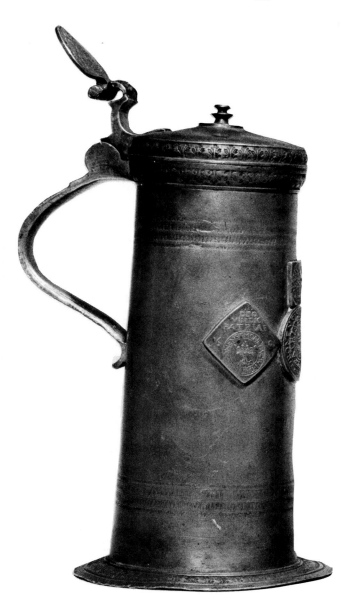

654. Group of Charles I English flagons of varying sizes, both knopped and plain lidded all by one maker "EG". Each will have been cast from different molds illustrating the great variety of seventeenth century forms found in flagons from Britain and Europe. (Courtesy of Mr. C. Minchin).

655. Fine Stuart English flat lidded flagon, 7¾ inches high, circa 1680—1710. (Courtesy of Sotheby Parke Bernet).

656. Another example with crenulated rim, 11 1/8 inches high, circa 1670—90. (Courtesy of Sotheby Parke Bernet).

657. A banded flat lidded flagon with rams horn thumbpiece, 8¾ inches high, circa 1680—1700. (Courtesy of Sotheby Parke Bernet).

658. In Europe straight sided flagons were less common than in Britain in the seventeenth century. Illustrated here are three typical German flagons of 1670—1720. Left to right: From Schassburg, circa 1680—1700, 11½ inches. Another from the same town, circa 1700, 7 7/8 inches. Another, circa 1680, 12 inches. (Courtesy of Dr. Fritz Nagel).

659. Another German flagon with unusual thumbpiece, circa 1680, 9 1/8 inches high. (Courtesy of Dr. Fritz Nagel).

659

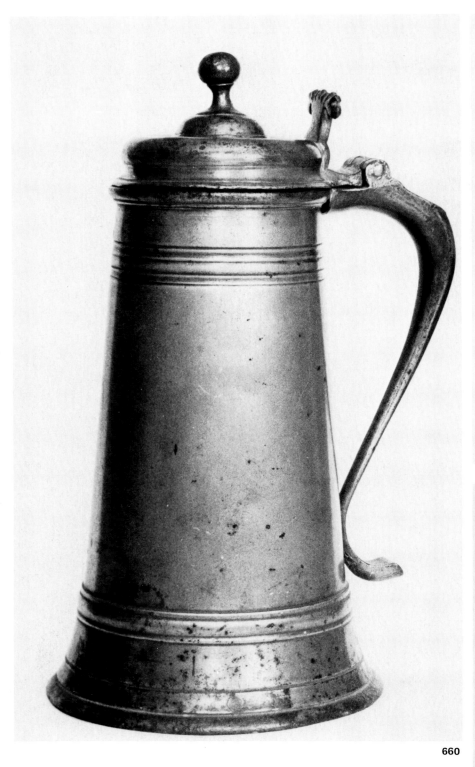

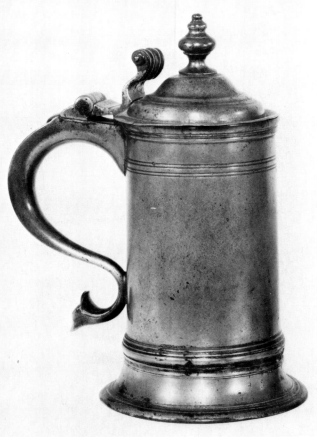

661

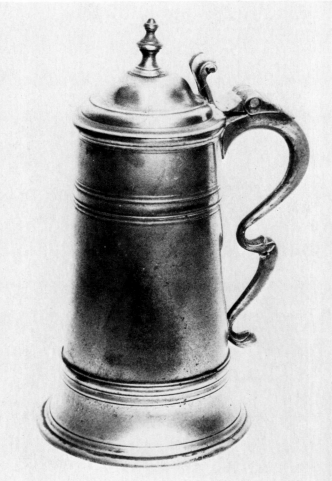

660

660. Early form of "Spire" flagon, English, circa 1700–20 with plain strap handle. (Private collection).

661. Another form with plain handle, George II period, English, 9 1/8 inches high, circa 1730. (Courtesy of Sotheby Parke Bernet).

662. More typical English spire flagon of a form made between 1730 and 1770, 10½ inches high. (Private collection).

663. Two further spire flagons. That on the right by A. Bright of Bristol, 12½ inches high. Left is unmarked, 12 inches high. Mid-eighteenth century. (Private collection).

662

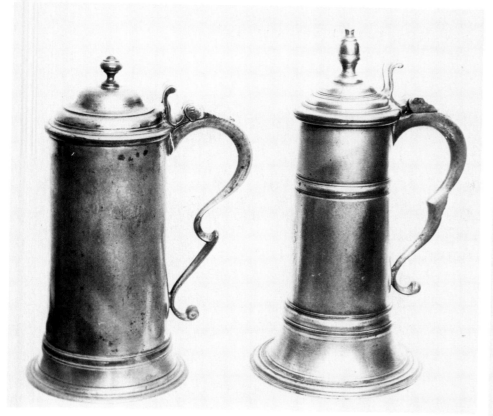

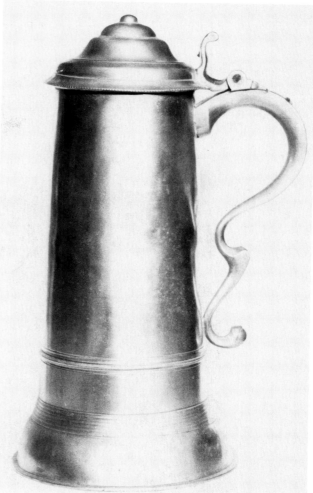

663

664

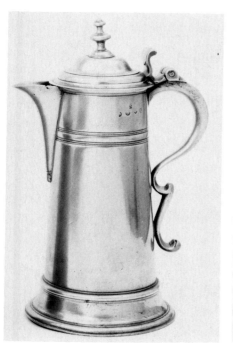

665

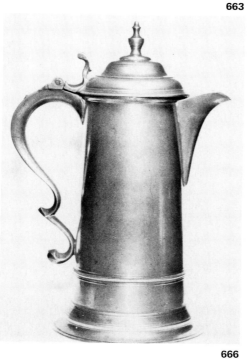

666

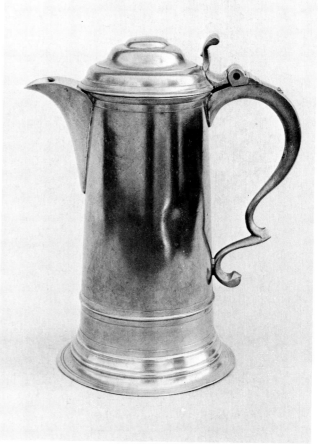

664. American spire flagon with small knop, by Samuel Danforth, 12¾ inches high. The form circa 1780—1820. (Collection of Charles V. Swain).

665. English spouted spire flagon by Thomas Carpenter, 13¼ inches high. The example is circa 1750 but spouted spires were made from then up to 1800. (Courtesy of Sotheby Parke Bernet).

666. American spouted spire flagon, 12¾ inches high by T & S Boardman, early nineteenth century. (From the Herr Collection).

667. Two quart American flagon by Boardman & Company, circa 1820, 11½ inches high. (Collection of Dr. and Mrs. Melvyn Wolf).

667

668

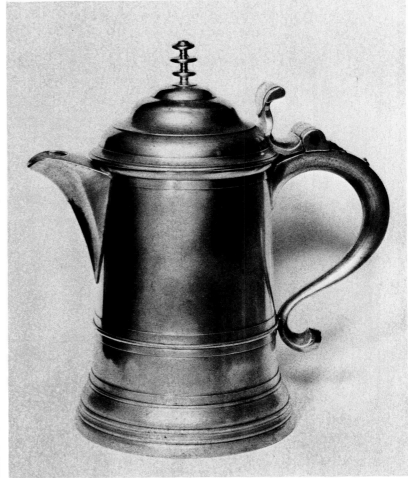

669

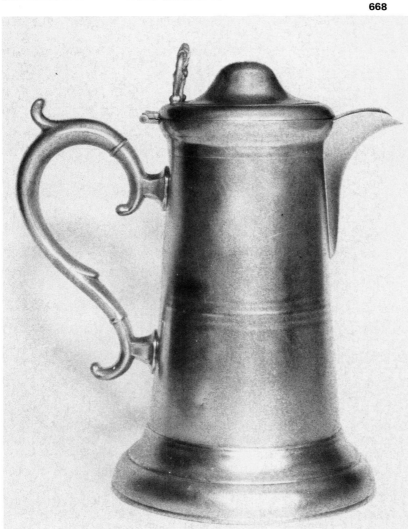

668. A similar flagon with tall knop, American by Boardman & Company, circa 1820, 12½ inches high. (Collection of Charles V. Swain).

669. A more squat example from the same company, 8 7/8 inches high, early nineteenth century. (Collection of Charles V. Swain).

670. American spire flagon attributed by the Sellews, with open chair thumbpiece, 10¾ inches high, circa 1840. (Collection of Dr. and Mrs. Melvyn Wolf).

671. Another similar flagon, American by W. Calder, circa 1830—50, 11 inches high. (Collection of Dr. and Mrs. Melvyn Wolf).

672. Queen Anne flagon with domed lid and spout, 10 inches high, by I.B. The form was popular from 1690 to perhaps 1720. (Collection of Mr. P. Kydd).

673. Rare York straight sided flagon with typical York spout. This style of flagon dates from around 1710 to perhaps 1740. Very rare. (Collection of Mr. F. Holt).

674. Domed flagon with crenulated lip, 10¾ inches high, circa 1710—25, English. (Private collection).

670

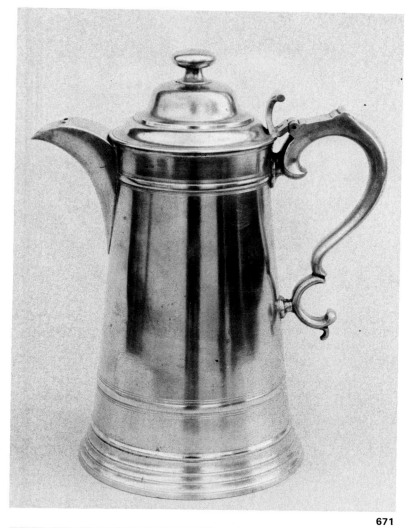

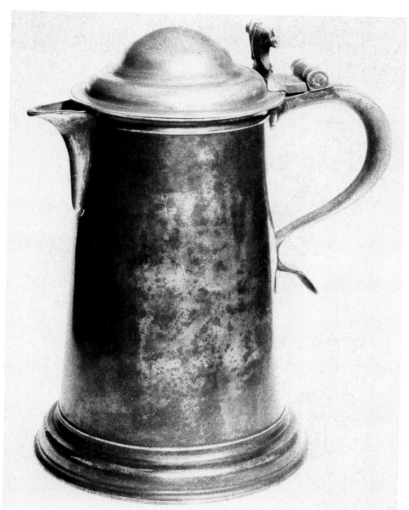

671

672

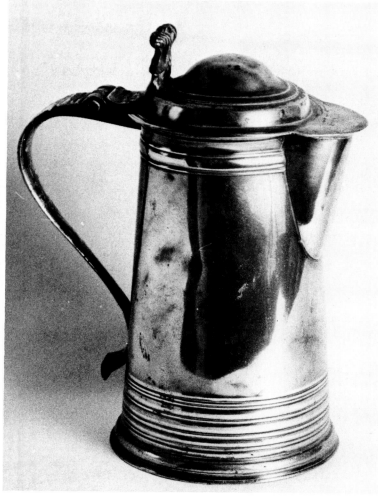

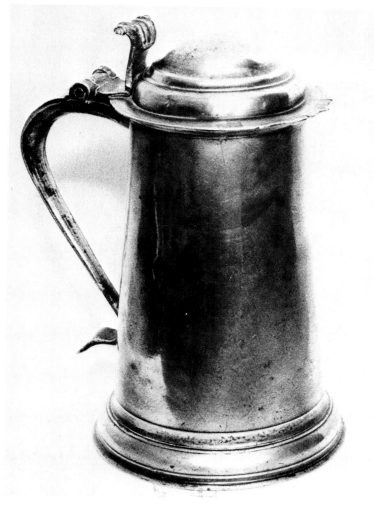

673

674

205

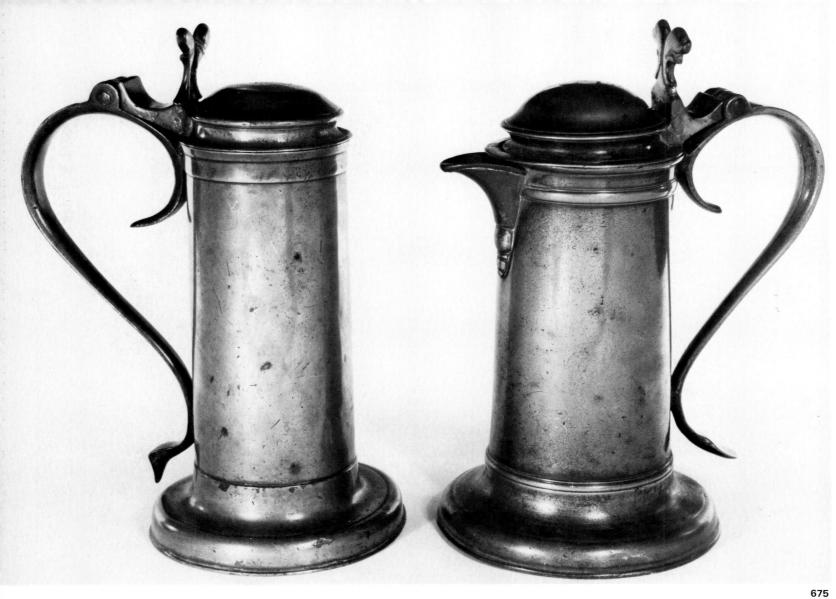

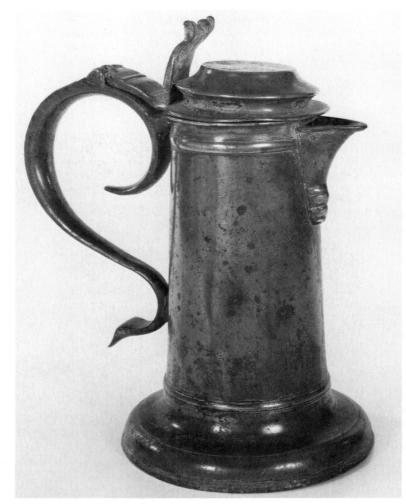

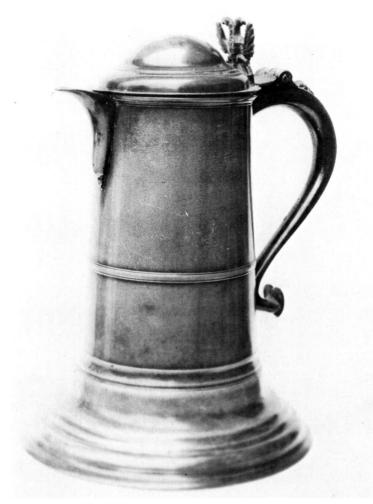

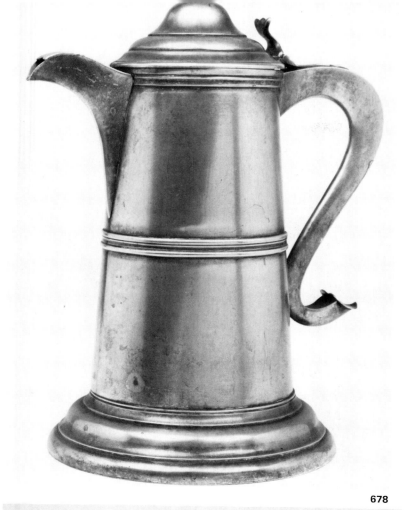

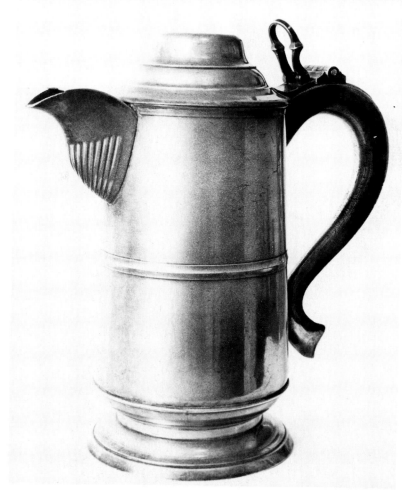

678

679

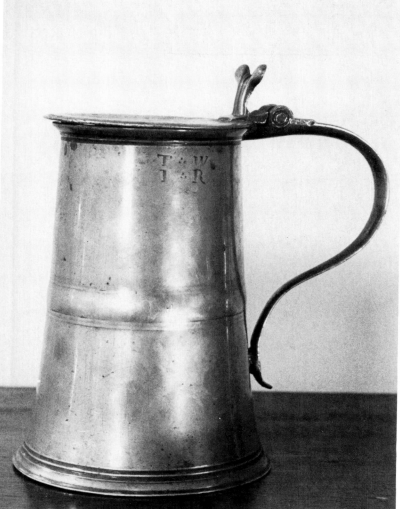

675. Two Irish flagons from the eighteenth century. The example on the right has a typical Irish spout, and both have an unusual rounded lid. (Courtesy of Worshipful Company of Pewterers, London).

676. Another slightly later spouted Irish flagon by R. Palmer, Dublin, mid-eighteenth century. (Courtesy of Sotheby Parke Bernet).

677. Regional English flagon of a body form made at Wigan. This example is circa 1770 but the style existed from 1720 or so. The double headed eagle thumbpiece is another example of rare thumbpieces. (Courtesy of Robin Bellamy Ltd).

678. English nineteenth century domed flagon, circa 1830—50. (Courtesy of Christies, London).

679. Scottish church flagon by Ramage of Edinburgh, circa 1810, 12¼ inches high. (Collection of Dr. D. Lamb).

680. Typical Scottish flat lidded flagon often used in Scottish reformed churches, but also domestic in purpose. Made from 1730's into the nineteenth century. (Courtesy of Robin Bellamy Ltd).

680

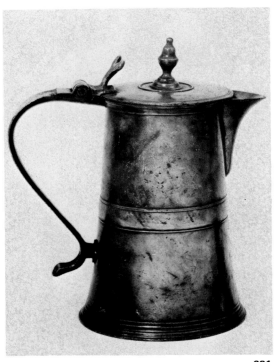

681

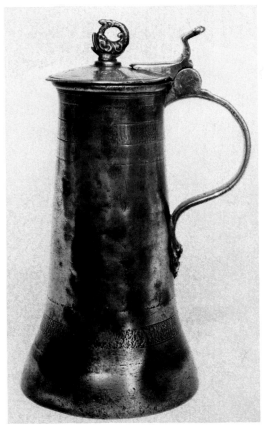

682

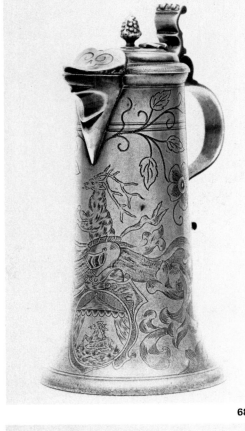

683

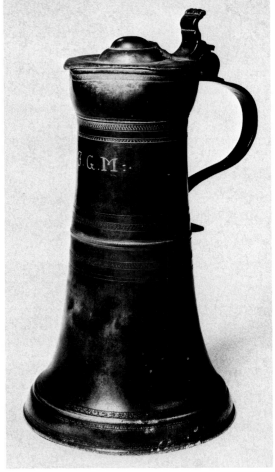

684

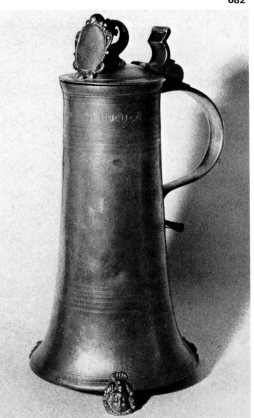

685

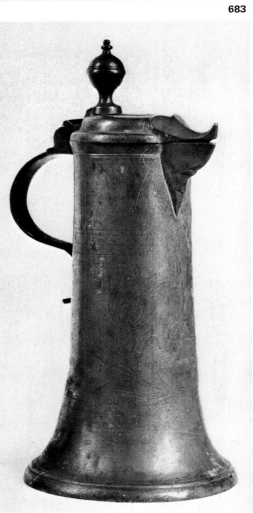

686

687

208

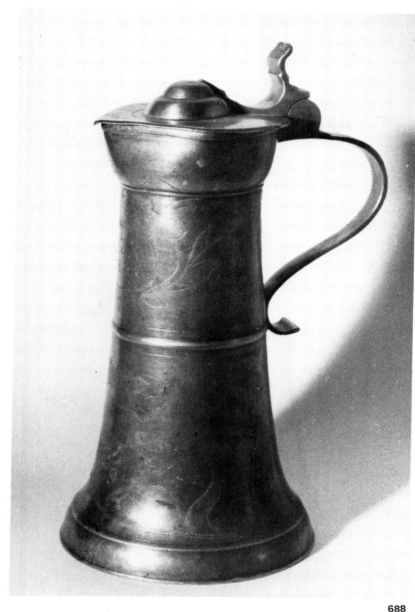

681. A spouted Scottish laver or flagon of nineteenth century form. Marked Graham and Wardrop, "Success to the USA", circa 1790, 10¼ inches high. (Courtesy of Sotheby Parke Bernet).

682. Slightly tapering German flagon, typical of German and Austro-Hungarian forms. The dolphin knop is less common. 11 inches high, circa 1680—1750. (Courtesy of Robin Bellamy Ltd).

683. Swiss spouted flagon with engraved decoration, by Uebelin of Basle, 11½ inches, circa 1700. This form was made into the late eighteenth century. (Courtesy of M. & G. Segal).

684. Another similar flagon, Hungarian, seventeenth century example. (Courtesy of Hungarian National Museum, Budapest).

685. German flagon with feet and shield knop, by IK, circa 1700, 12 1/8 inches high. The form was also used in Austro-Hungary into the late eighteenth century. (Courtesy of Kunsthandel Frieder Aichele).

686. A mid-eighteenth century flagon, German or Austro-Hungarian. Dated 1768, 9 1/8 inches high. (Courtesy of Kunsthandel Frieder Aiechele).

687. German flagons, of a form also found from Strasbourg, eighteenth century, circa 1750. (Courtesy of Kunsthandel Frieder Aichele).

688. Another similar German flagon circa 1800". (Courtesy of Kunsthandel Frieder Aichele).

689. French Pichet or Flagon in the German style from Strasbourg, eighteenth century into nineteenth century. (Courtesy of P. Boucaud).

690. Three German flagons from 1830 to 1850. (Courtesy of Dr. Fritz Nagel).

688

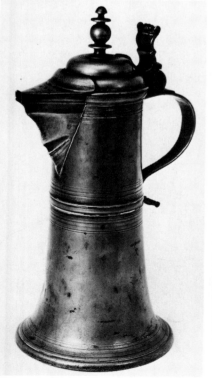

689

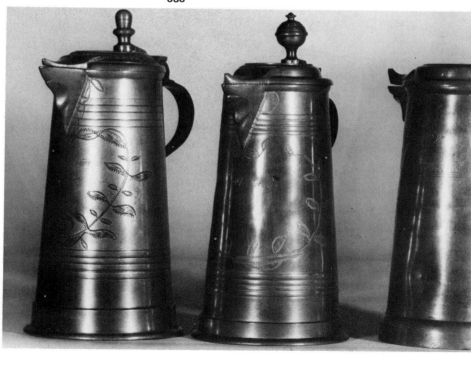

690

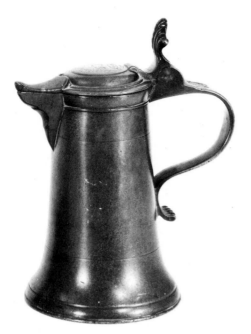

691

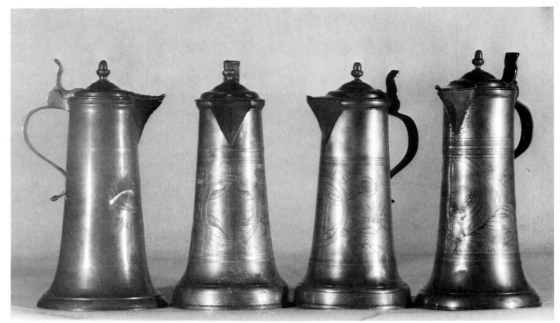

692

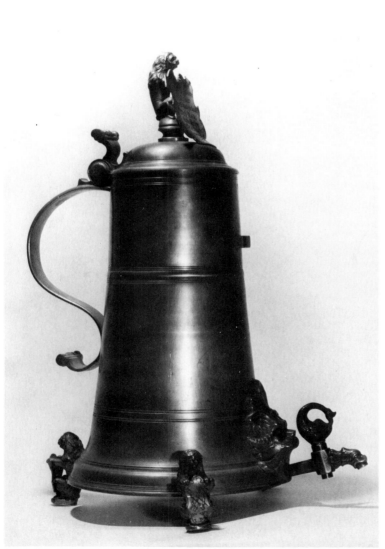

693

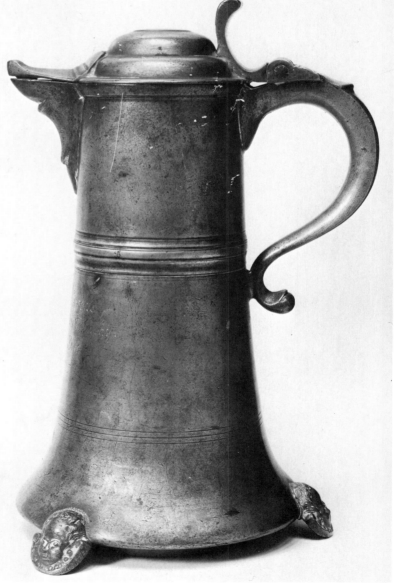

694

210

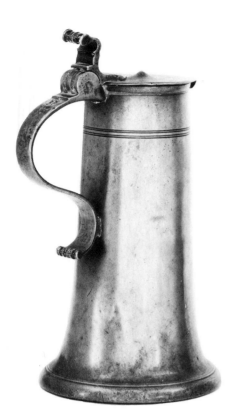

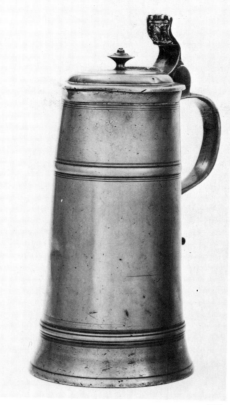

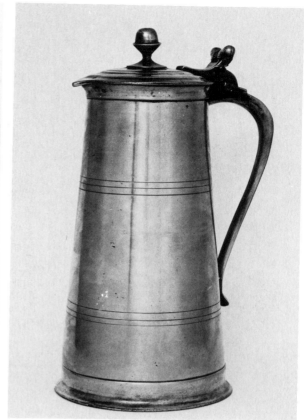

695

696

697

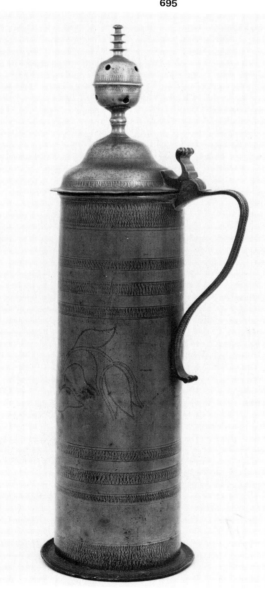

691. Austrian flagon, eighteenth century. (Courtesy of Sotheby Parke Bernet).

692. Four German nineteenth century spouted flagons. The late form. (Courtesy of Dr. Fritz Nagel).

693. Fine footed flagon with spout by Roos from Lindauer, Germany, circa 1770—80. Reminiscent of an early form favoured by guilds. (Courtesy of Dr. Fritz Nagel).

694. Rare and important American flagon by I.C. Heyne of Lancaster of typical German form, circa 1760—80. (Courtesy of Dr. Herr).

695. Swiss flagon from Basle, first half of eighteenth century, 11¼ inches high. (Courtesy of Sotheby Parke Bernet).

696. Another flagon also probably Swiss, mid-eighteenth century, 10½ inches high. (Courtesy of Sotheby Parke Bernet).

697. French straight sided flagon from Abbeville, eighteenth and early nineteenth century style. (Courtesy of P. Boucaud).

698. Rare north German flagon of elongated form, 25½ inches high, circa 1820—30. (Courtesy of Sotheby Parke Bernet).

698

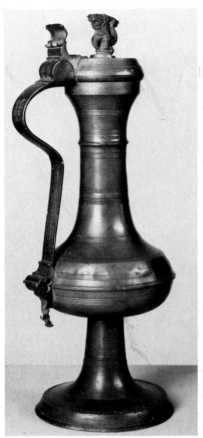

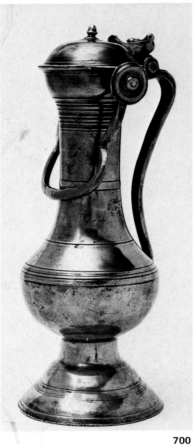

699

700

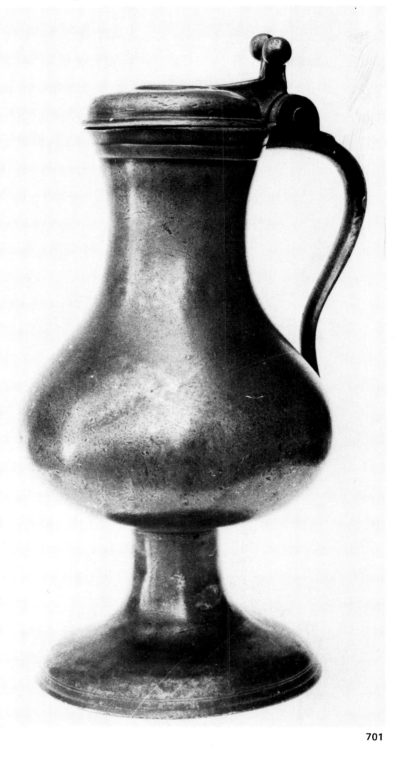

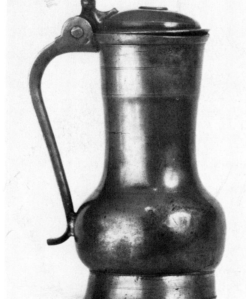

702

701

699. Tall rounded flagon of early form, German, from Eger, 20½ inches high. This example is early seventeenth century. (Courtesy of Kunstgewerbemuseum, Cologne).

700. French Cimarre or flagon. Examples are known from the seventeenth century but eighteenth century cimarres are more common. (Courtesy of P. Boucaud).

701. Bellied flagon circa 1580–1620. Examples are recorded from Holland and may well also have been made in England. On the continent similar flagons were in use in the middle ages. (Courtesy of Robin Bellamy Ltd).

702. Dutch Rembrandt flagon, circa 1600, with acorn thumbpiece, 11 inches high. (Courtesy of H.B. Havinga).

703. Dutch wine flagon, 7½ inches high, circa 1650. (Courtesy of H.B. Havinga).

704. Amsterdam flagon, Dutch seventeenth century. (Courtesy of H.B. Havinga).

705. Two further Dutch Rembrandt flagons each circa 1700. (Courtesy of Sotheby Parke Bernet).

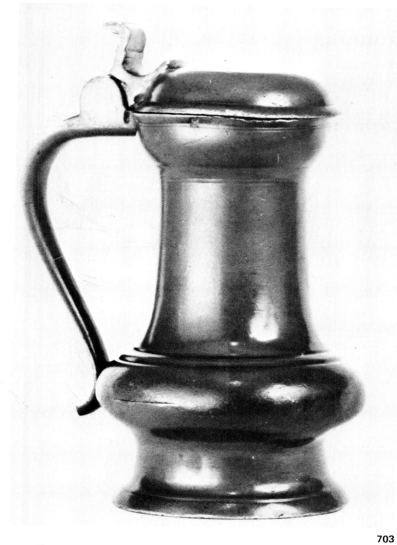

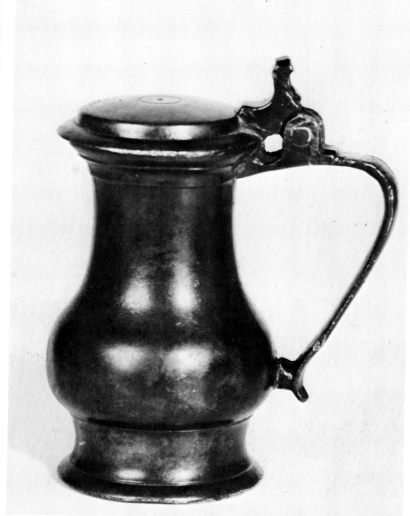

703

704

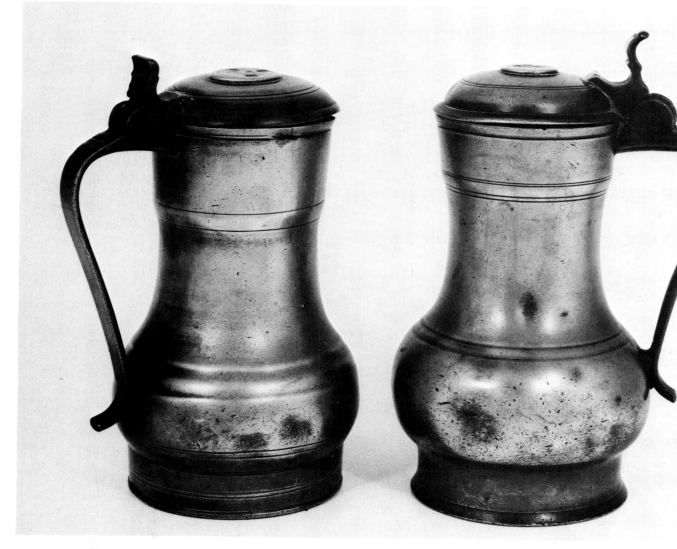

705

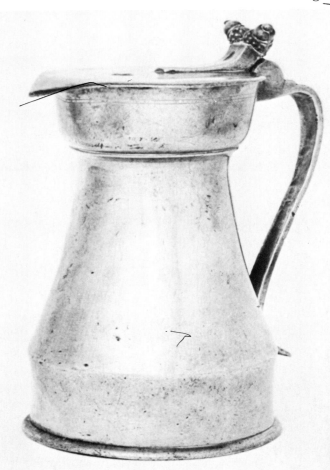

706. Rare French flagon from Lyon, 1680 — 1800. (Courtesy of P. Boucaud).

707. Cologne flagon, German from late seventeenth century to late eighteenth century. (Courtesy of Kunstgewerbemuseum, Cologne).

708. English York "Acorn" flagon. The style appeared between 1680 and 1740 both with and without spout or lip. (Courtesy of Robin Bellamy Ltd).

709. French flagon from Chartres. From eighteenth to early nineteenth century. (Courtesy of P. Boucaud).

710. Belgian wine flagon, circa 1750. (Courtesy of H.B. Havinga).

711. French flagon, the Falaise form from Normandy. Made from eighteenth century onwards. (Courtesy of P. Boucaud).

712. Swiss flagon, the "Kurbiskanne" form, from Bern, eighteenth century. (Courtesy of Kunsthandel Frieder Aichele).

706

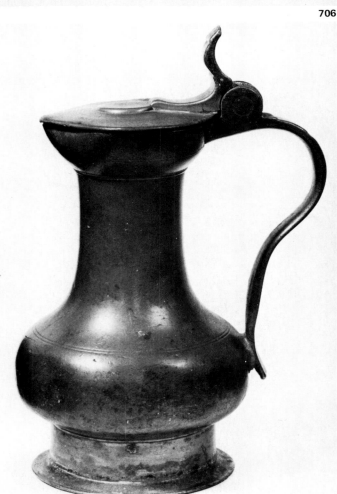

707

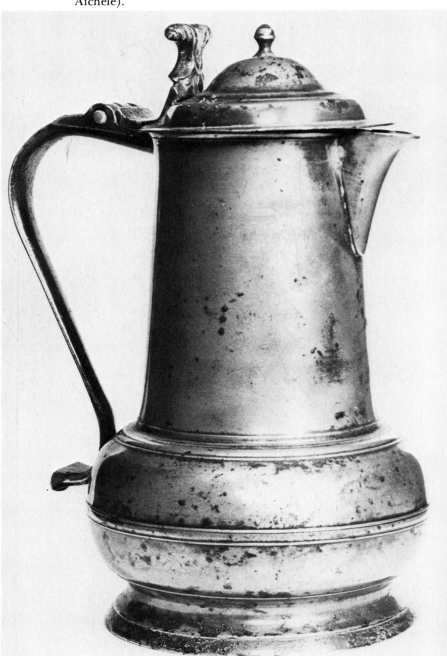

708

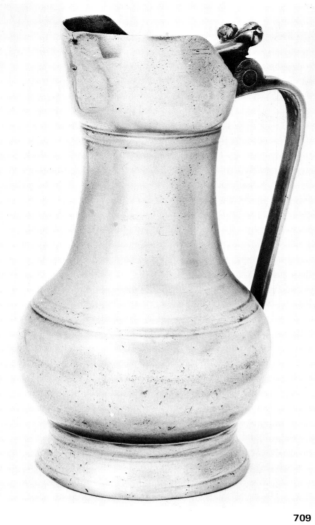

709

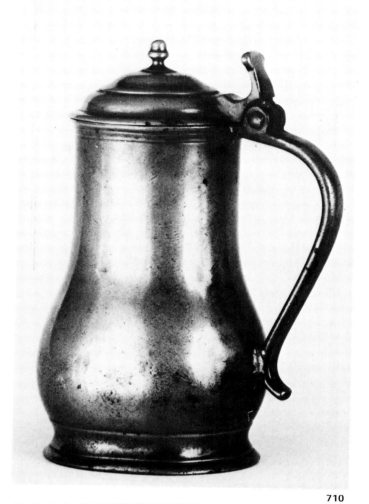

710

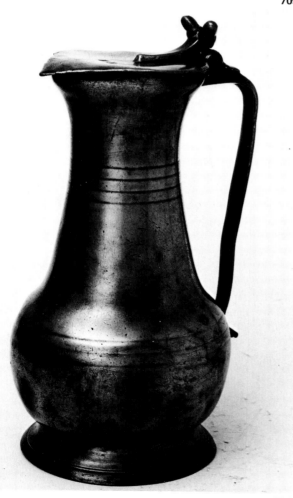

711

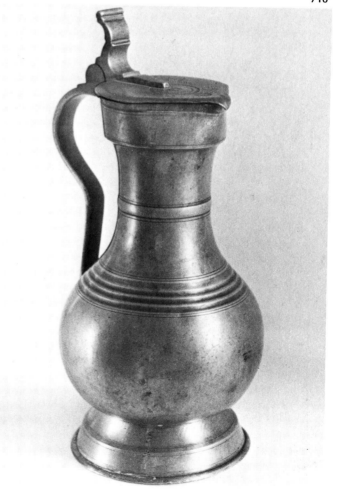

712

215

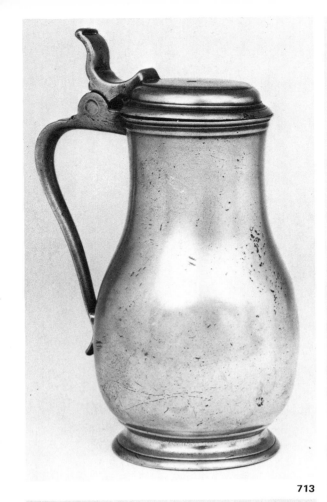

713

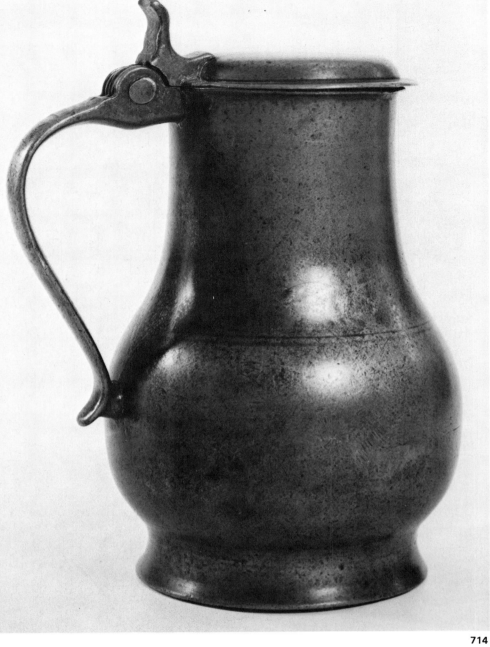

714

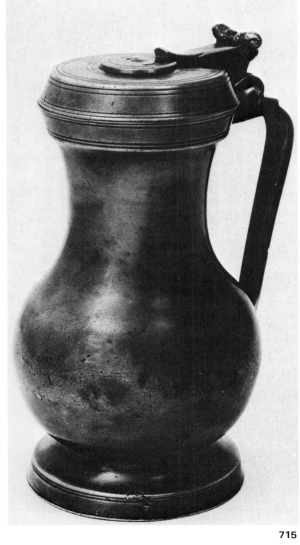

715

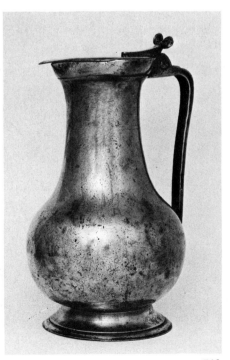

716

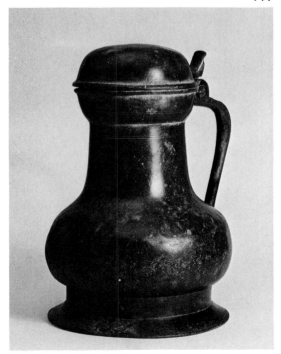

717

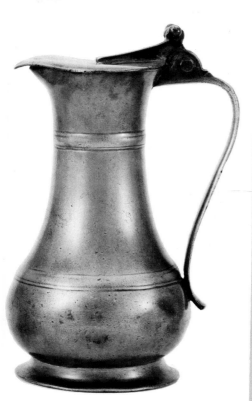
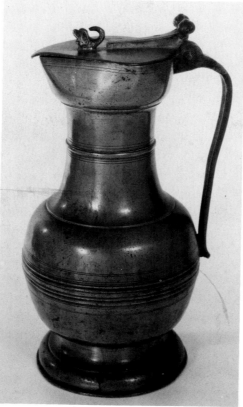
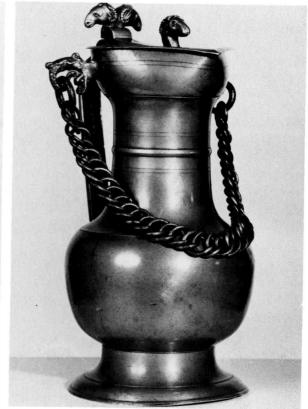

718

719

720

713. Amsterdam flagon from Holland, eighteenth century, 9¾ inches high. (Courtesy of Christies, London).

714. Dutch flagon, mid-eighteenth century, 8 inches high. (Courtesy of Sotheby Parke Bernet).

715. French flagon from Toulouse, mid-eighteenth century. (Courtesy of P. Boucaud).

716. French flagon from Besancon, eighteenth century. (Courtesy of P. Boucaud).

717. Portugese flagon, eighteenth century. (Courtesy of P. Boucaud).

718. French Normandy flagon, eighteenth century example, 10¾ inches high. (Courtesy of Sotheby Parke Bernet).

719. Swiss flagon a "Bauchkanne" by Utin of Vevey, 14 inches high, circa 1750. Made from mid-eighteenth century into nineteenth century. (Courtesy of Sotheby Parke Bernet).

720. A similar flagon with chain, rams head knop and rams head thumbpiece, circa 1800. (Courtesy of H.B. Havinga).

721. A Swiss "Schenkanne" by G. Maciago, Brig, 8¾ inches high. Nineteenth century, but examples are known from eighteenth century. (Courtesy of Christies, London).

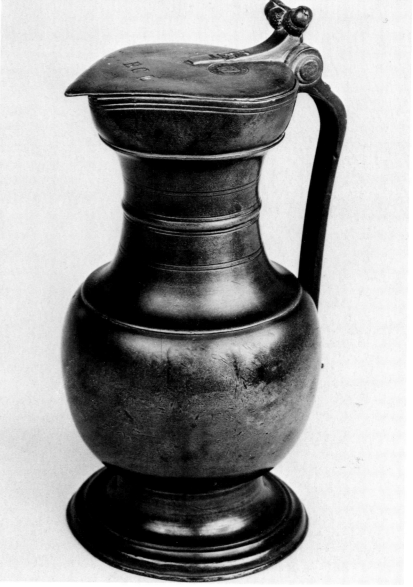

721

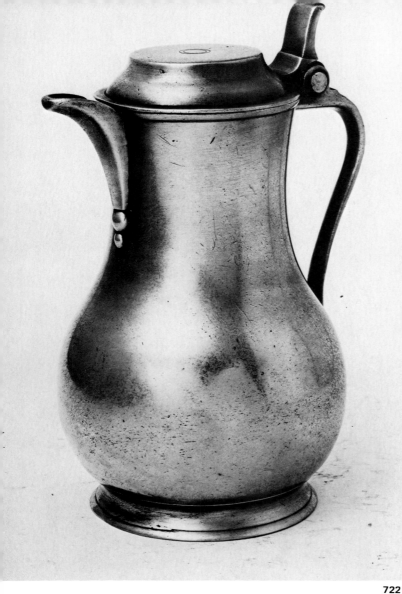

722

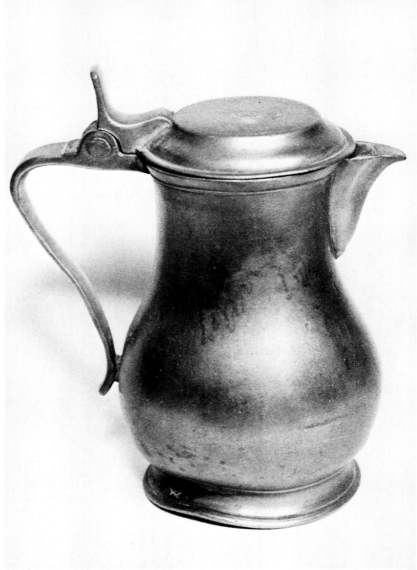

723

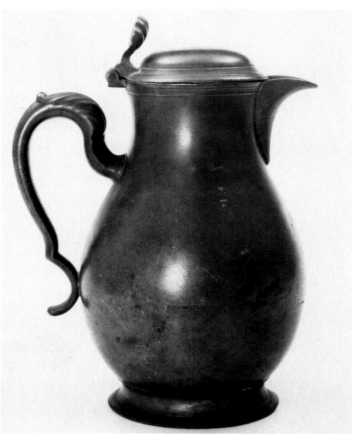

724

722. Flemish rounded flagon or measure late eighteenth century. Examples are also found of similar flagons from Germany and this form was made into nineteenth century. (Courtesy of P. Boucaud).

723. A French flagon from Lille, of a style also made in Belgium, 6½ inches high, circa 1800—50. (Collection of William F. Kayhoe).

724. Dutch or Belgian flagon, 10 inches high, early nineteenth century form. (Courtesy of Sotheby Parke Bernet).

725. Fine flagon by William Will, late eighteenth century, 8¼ inches high. (Collection of Dr. and Mrs. Melvyn Wolf).

726. Bulbous spouted flagon, German, mid-eighteenth century. (Courtesy of Kunsthandel Frieder Aichele).

727. German wine flagon with heavy spout, Hesse, circa 1741, 15½ inches high. (Courtesy of Dr. Fritz Nagel).

728. Superb Ewer or flagon attributed to William Will, American late eighteenth century, 14 inches high. (Collection of Dr. and Mrs. Melvyn Wolf).

729. A fine American flagon by John Will, circa 1750, 12 inches high. (Collection of Dr. and Mrs. Melvyn Wolf).

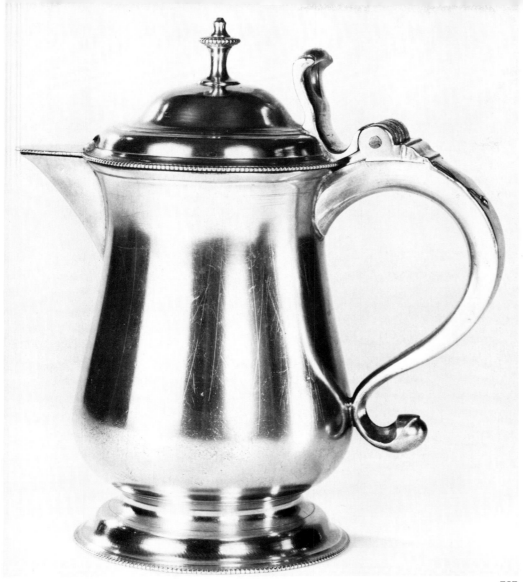

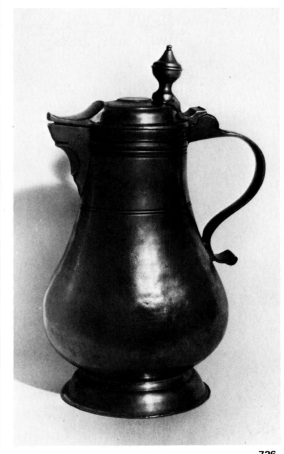

726

725

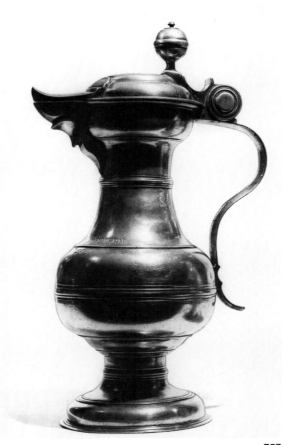

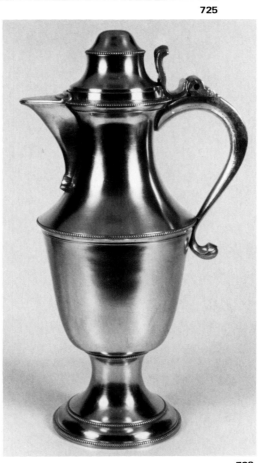

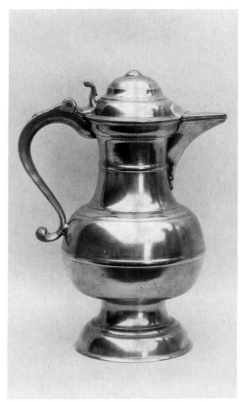

729

727

728

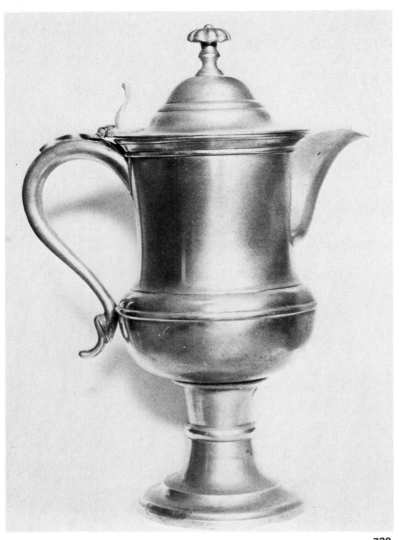

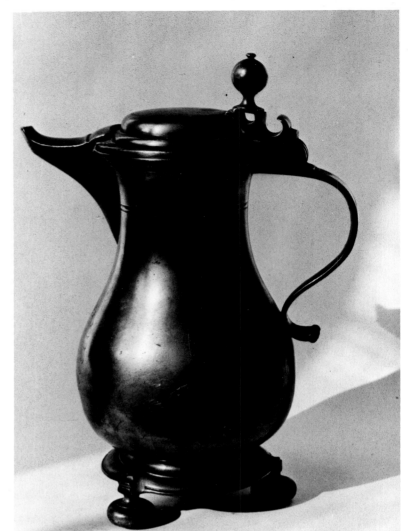

730

731

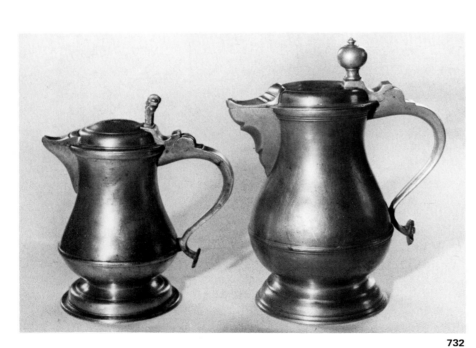

732

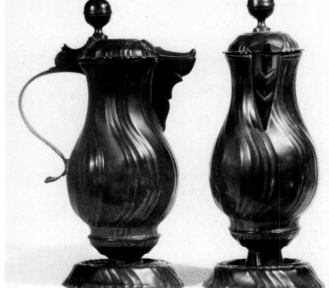

733

730. Another American flagon by Yale of Wallingford, 14½ inches high, circa 1820–30. (Collection of Charles V. Swain).

731. Austrian flagon with ball feet, eighteenth century, Vienna. (Courtesy of Museum of Applied Art, Budapest).

732. Two German flagons, from Danzig, eighteenth century. (Courtesy of Kunsthandel Frieder Aichele).

733. Wrythen German flagon, south German, eighteenth century, circa 1770, 15 inches high. (Courtesy of Dr. Fritz Nagel).

734. Early French flagon attributed to Normandy, circa 1600. (Courtesy of P. Boucaud).

735. Uncommon French flagon from Amiens, circa 1700. (Courtesy of H.B. Havinga).

FLAGONS WITH "SHOULDERED" FORM

Attention is drawn to several measures including the Scottish "Tappit Hen" series which have a shouldered form.

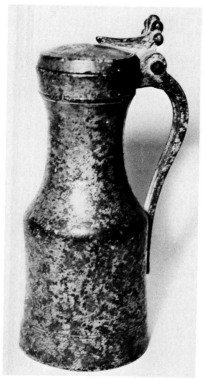

734

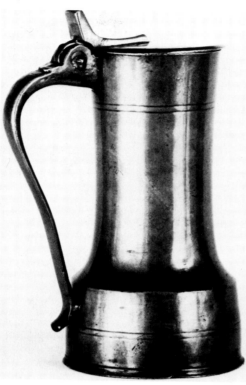

735

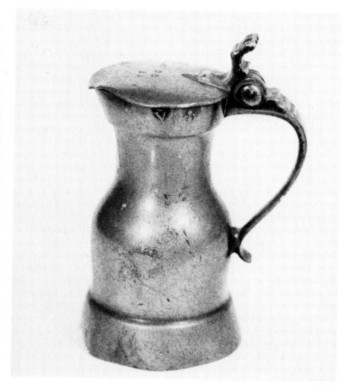

736

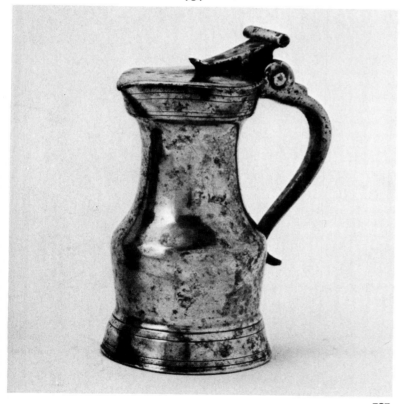

737

738

736. Eighteenth century French flagon from Paris. (Courtesy of Robin Bellamy Ltd).

737. Seventeenth century French Pichet, Paris. (Courtesy of P. Boucaud).

738. French flagon, Normandy, from Caudebec, early eighteenth century. (Courtesy of Robin Bellamy Ltd).

739

740

741

742

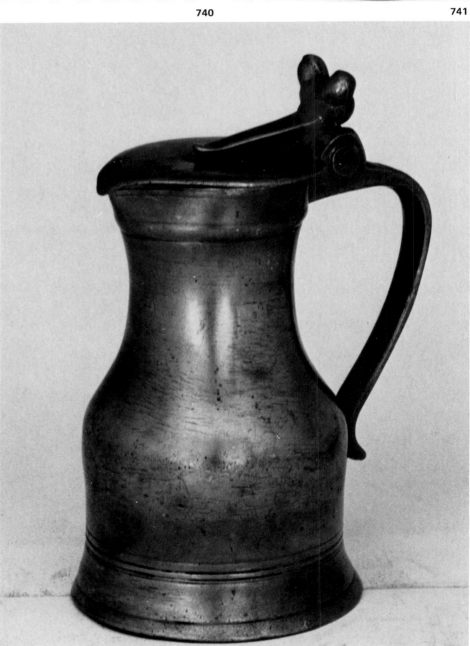

743

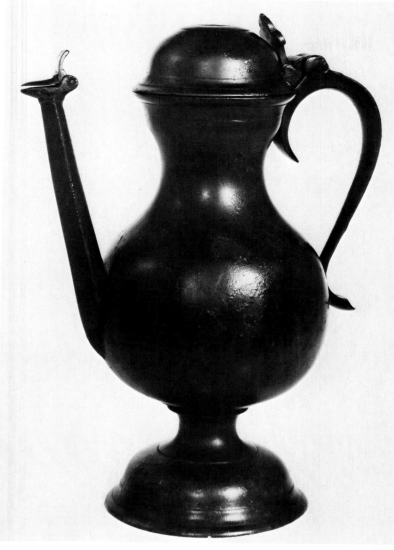

744

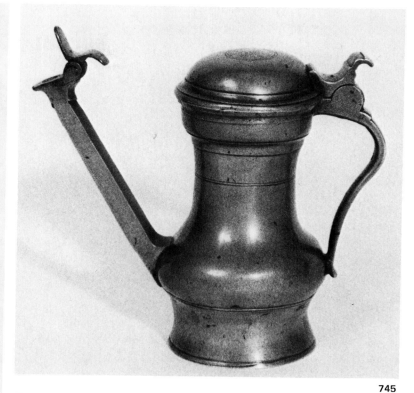

745

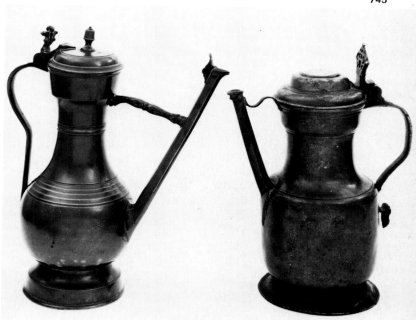

746

739. French flagon from Lille. Found in eighteenth century but more common in nineteenth century. (Courtesy of P. Boucaud).

740. Typical nineteenth century French Normandy "measure". (Courtesy of Christies, London).

741. French flagon from Versailles, circa 1750, 9 inches high. (Courtesy of Sotheby Parke Bernet).

742. Swiss Kelchkanne or flagon. By Utin of Vevey, eighteenth century, 10¾ inches high. Made into the nineteenth century. (Courtesy of Sotheby Parke Bernet).

743. French Normandy flagon of style found both in eighteenth and nineteenth century. (Courtesy of P. Boucaud).

744. Rare and important English flagon with long pouring spout, circa 1580—1620. (Collection of Mr. D. Little).

745. A Dutch "Jan Steen" flagon, circa 1650. Dutch, less than 10 examples are known of this form of Dutch flagon. Most are between 7½ and 8¼ inches high. (Courtesy of H.B. Havinga).

746. Two spouted flagons. Left: Swiss "Stegkanne" by Nattzger of Thun, circa 1750—90, 13½ inches high. Right: German spouted flagon, circa 1650—80, Saxon, 13 inches high. (Courtesy of Sotheby Parke Bernet).

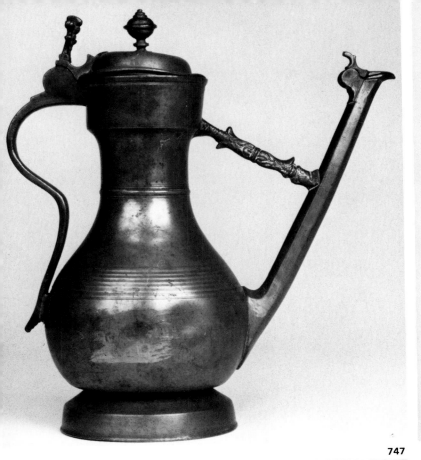

747

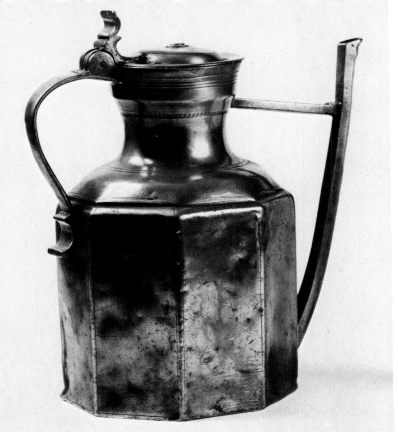

748

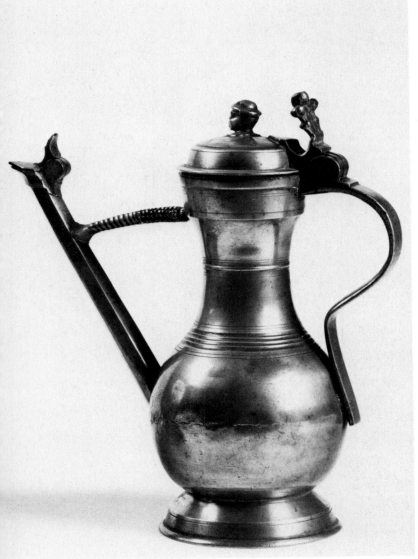

749

Spouts

A B C D E

F G H I

J K L M

224

MEASURES INCLUDING BALUSTERS AND JUGS

It is often difficult to separate measures from flagons. Many flagons may well have been made to a standard now lost but not so marked. Often in the home a flagon or measure would have been direct alternatives for most purposes. Many lipped or spouted flagons would have been used for exactly the same purposes as jugs and measures made to local standards and the reader is referred to illustrations of many forms in the earlier section on flagons.

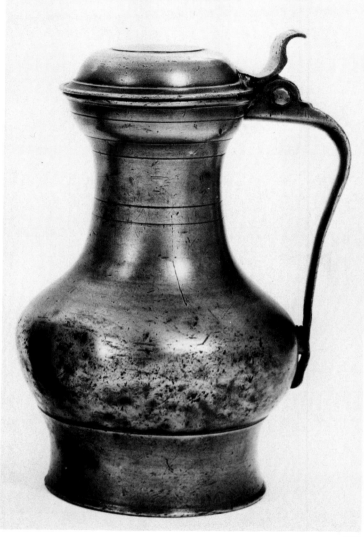

750

751

747. Swiss Stegkanne or flagon, eighteenth century. (Courtesy of Christies, London).

748. Spouted Swiss eighteenth century flagon. (Courtesy of Christies, Amsterdam).

749. Swiss stegkanne, circa 1800–50. Blackamore knop, 10 5/8 inches high. (Courtesy of Christies, Amsterdam).

750. Scottish pot belly measure made to Scottish standards, circa 1680–1720. The origins of these measures are clearly both Dutch and Tudor English, 10 inches high, Scottish pint capacity. (Courtesy of Sotheby Parke Bernet).

751. A lidless example of the same type of measure, perhaps 1700–30. (Collection of Mr. D. Little).

SPOUTS.
A. Spout or pouring lip found on York flagons, English circa 1680–1730.
B. Lip from Irish flagons and measures, eighteenth century.
C. Typical Scottish lip from Lavers and jugs.
D. Russian spout, eighteenth century.
E. Typical American spout found for example on Boardman and Gleason flagons, nineteenth century.
F. Spout from American flagons by William Will.
G. Widely used spout found on American, British and European forms.
H. Spout frequently found on American pitchers and British later Ale jugs and other measures, nineteenth century.

I. Very common form of spout on British and European jugs, generally eighteenth century or later.
J. Late form of spout found in all areas, generally mid-nineteenth century.
K. Austro-Hungarian or German spout but also found on Heyne American pewter, from seventeenth to nineteeth centuries.
L. Another form of Central European spout, from 1650 onwards.
M. Central European spout, seventeenth and eighteenth centuries.

(Art Work by Andrew Cross)

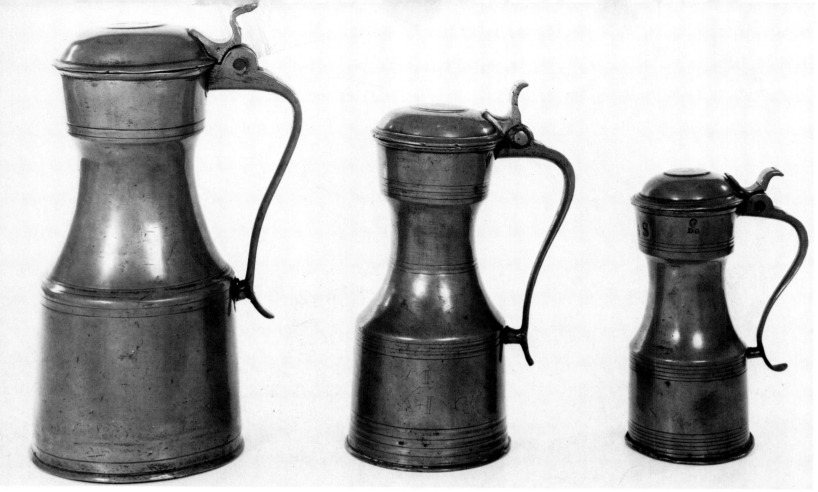

752

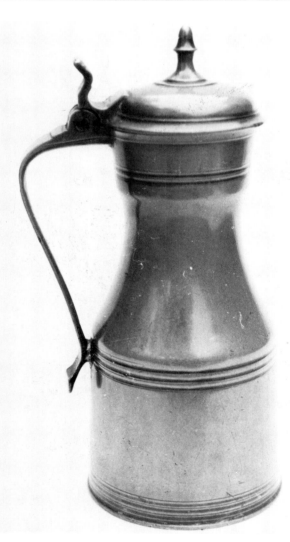

753

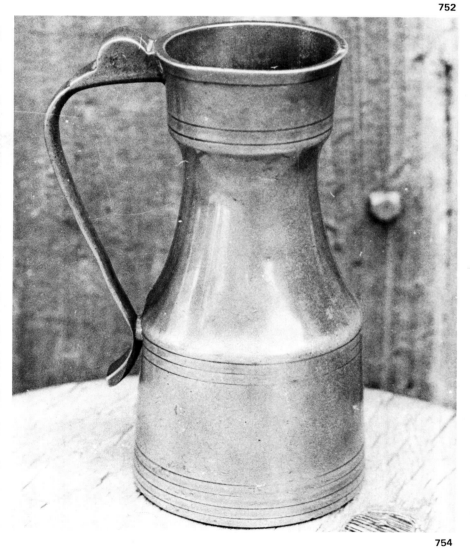

754

226

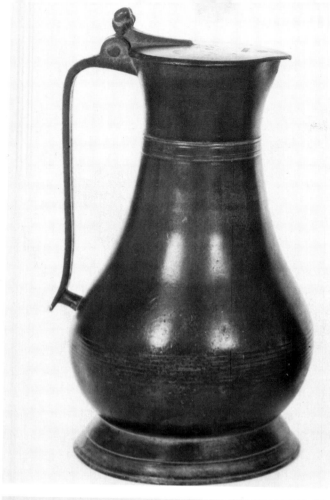
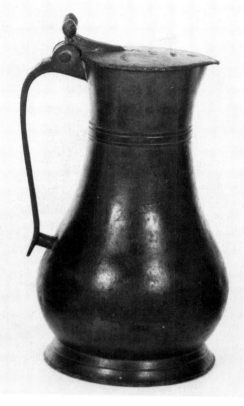
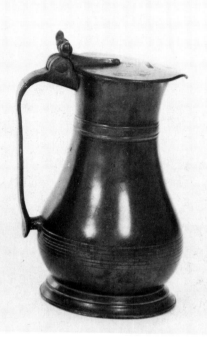

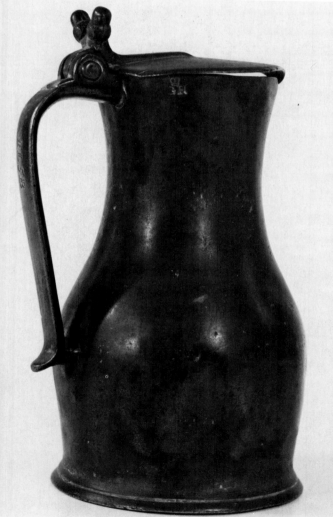

752. The famous Scottish Tappit Hen series, from full pint down to quarter pint, known as "Tappit Hen", "Chopin" and "Mutchkin". Earliest examples are from late seventeenth century but this form went on being made into the nineteenth century and in addition to these Scottish capacities a series of these measures can be found in Imperial Capacities. (Courtesy of Sotheby Parke Bernet).

753. The exact chronology is unclear but until recently it has been assumed that the crested Tappit hen, only found in Scottish capacities, post dated the plain examples. Mostly eighteenth century. (Courtesy of Robin Bellamy Ltd).

754. Rare lidless Tappit hen. Most of this form appear to have come from Aberdeen. Early nineteenth century. (Courtesy of Robin Bellamy Ltd).

755. A set of three Guernsey measures in that Channel Islands' capacities, eighteenth century. Some examples are reeded, others have plain bodies. Most Guernsey measures appear to have been made in England. (Courtesy of Sotheby Parke Bernet).

756. Another Channel Islands measure, a Jersey made to that islands' local standards, eighteenth century. This example made in England by Jerseyman John de St. Croix, 8¾ inches high. (Courtesy of Sotheby Parke Bernet).

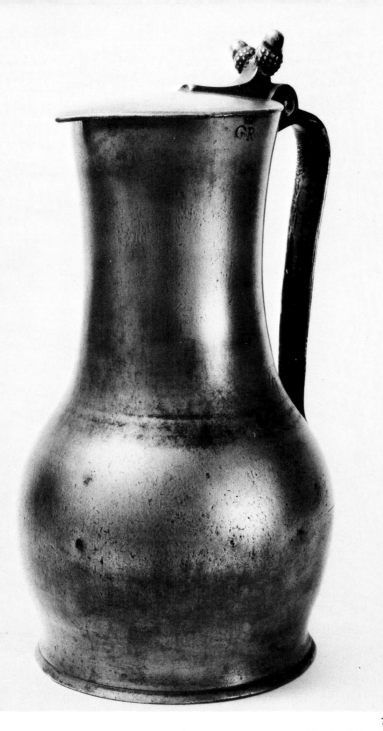

757. Another variety of Jersey measure, eighteenth century. (Courtesy of Sotheby Parke Bernet).

758. Jersey measures are also made in lidless form although no similar Guernseys are known. Mostly found in smaller Jersey sizes. Late eighteenth and early nineteenth centuries. (Courtesy of Robin Bellamy Ltd).

759. Rare English measure of gallon capacity, William III standard, circa 1720—40 with flat lid, the form generally similar to the Scottish "Laver" style of vessel, 13 inches high. (Courtesy of Robin Bellamy Ltd).

760. Typical ale jug with domed lid and straight sides, English, circa 1770—1830. (Courtesy of Robin Bellamy Ltd).

761. An English gallon ale jug inscribed "Victoria Benefit Society" and dated 1837. Circa 1830. (Courtesy of Bourgaux).

762. The most common form of a group of rare west of England lidless measures often used in taverns and breweries. This style can be found from gallon downwards. This example is a half gill, circa 1830—60. (Courtesy of Robin Bellamy Ltd).

763. A variety of the west of England measures made only by one company, Fothergill of Bristol, circa 1830—40. Found rarely but quarts to half pint are more common than other capacities. (Courtesy of Robin Bellamy Ltd).

764. Rare tapering west of England measure, mid-nineteenth century. (Courtesy of Robin Bellamy Ltd).

765. The least common of all four forms of west of England measures, circa 1800—40. (Courtesy of Robin Bellamy Ltd).

766. The famous Irish Haystack measures mostly by Austen of Cork or the Munster Iron Company, made from 1820 to 1900. Found from gallon downwards. (Courtesy of Sotheby Parke Bernet).

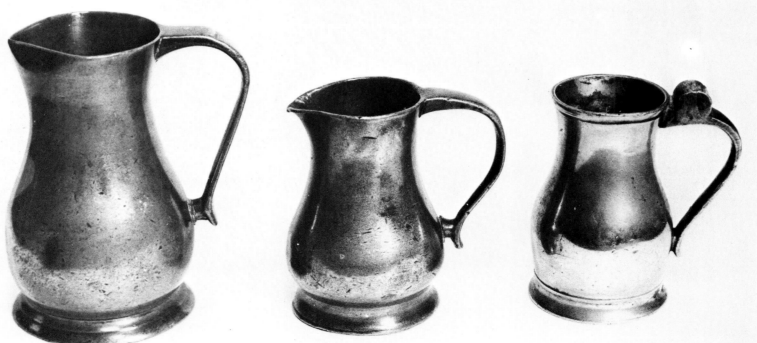

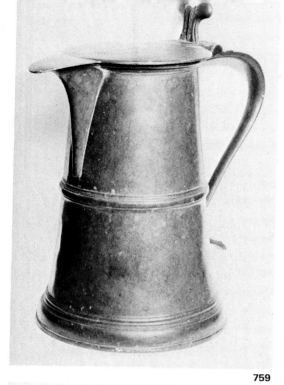

759

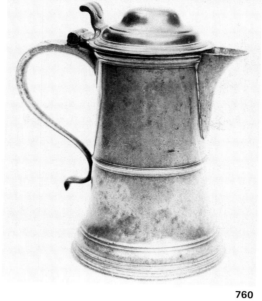

760

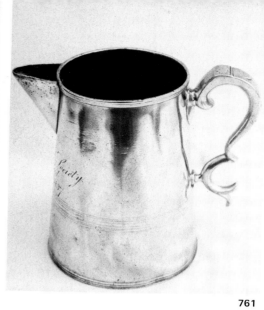

761

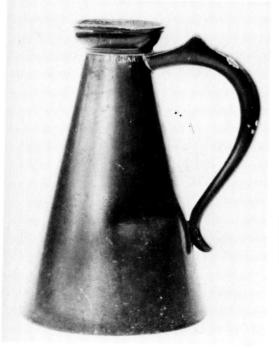

762

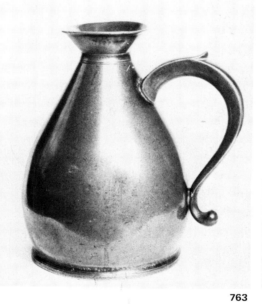

763

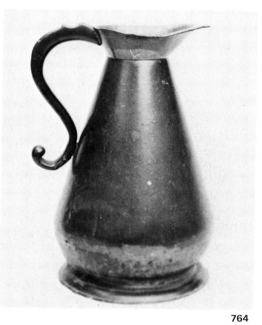

764

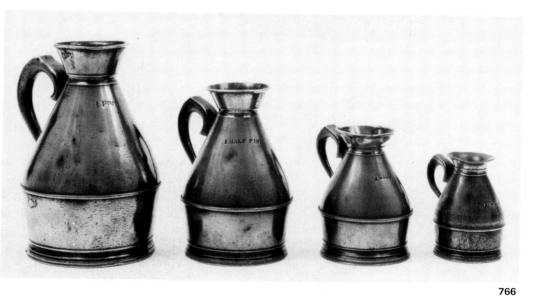

765

766

Thumbpieces

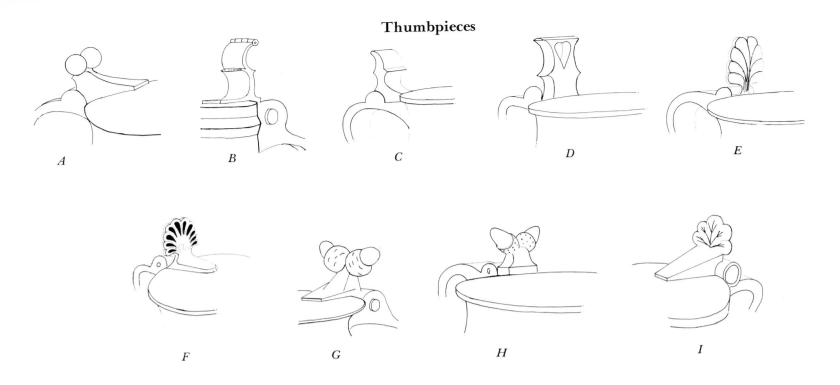

A B C D E

F G H I

JUGS

INCLUDING LIDDED AND UNLIDDED SPOUTED TANKARDS

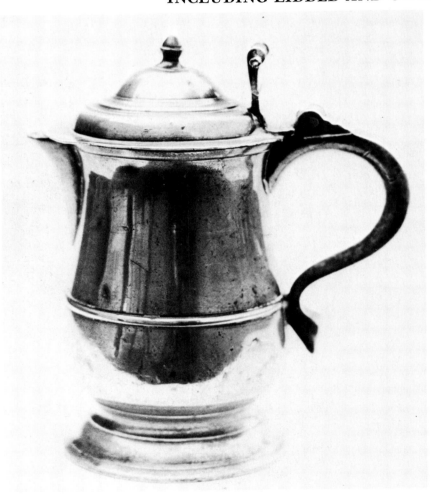

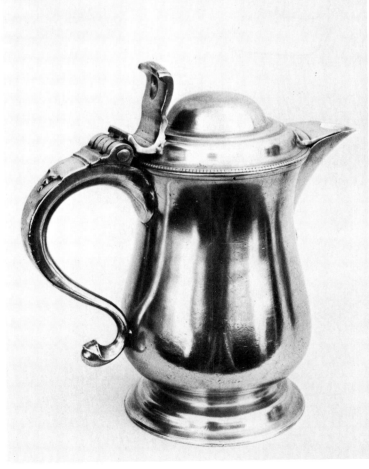

767. Fine lipped and lidded tankard or measure, English, circa 1710–30. (Courtesy of Robin Bellamy Ltd).

768. A similar lipped American tankard, attributed to William Will, 8½ inches, last quarter of eighteenth century. Exactly where these two objects should be displayed is a matter of conjecture as both are very rare and may have served either as tankards, communion flagons or measures. (Collection of Dr. and Mrs. Melvyn Wolf).

J *K*

FLAGON MEASURE AND TANKARD THUMBPIECES.
FOUND MOSTLY ON FLAGONS.
A. Twin Ball, sixteenth and early seventeenth century form.
B. Erect, European form with decoration and movement. Seventeenth and eighteenth centuries.
C. Erect, British, on James I flagons.
D. Decorated erect from British Charles I flagons.
E. Spray, a similar thumbpiece occurs occasionally on British flagons circa 1680—1700 and in Europe into late eighteenth century.
F. Another version of this form. European, 1700—1800.
G. Acorn, European form found for example on French and Swiss flagons basically an eighteenth and nineteenth century style.
H. Acorn from Channel Island pewter, eighteenth century and also on some European examples.
I. Leaf, found in Europe circa 1600—1750.
J. Shell, European style, late eighteenth and early nineteenth century. Occasionally also on late British Ale jugs.
K. Rams Horn, either twin or triple, Swiss circa 1800.

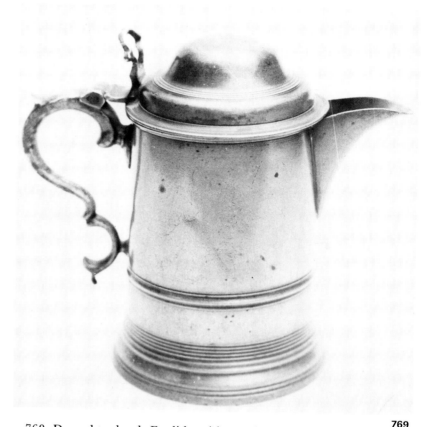

769

769. Domed tankard, English, with pouring lip, open chair thumbpiece and "broken" handle, circa 1780, quart capacity. (Courtesy of Robin Bellamy Ltd).

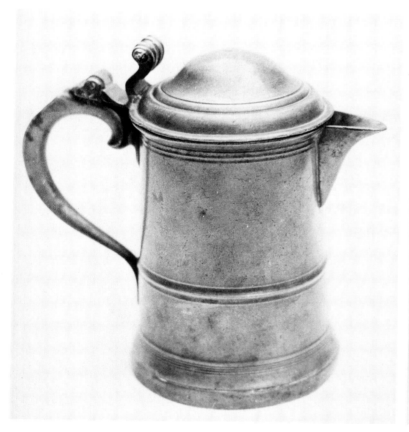

770. Similar English lipped tankard of quart capacity. Circa 1770 with rams horn thumbpiece unusually late for an English item. Exeter. (Courtesy of Robin Bellamy Ltd).

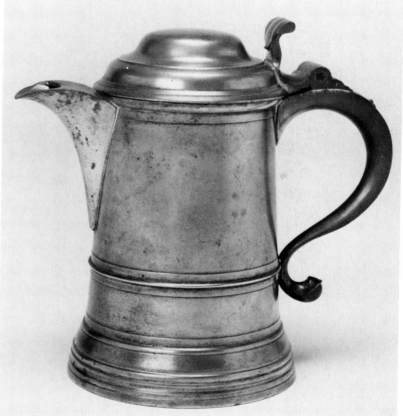

771. American quart tankard or flagon with lip, by Boardman and Company, circa 1820, 8 inches high. (Courtesy of Christies, New York).

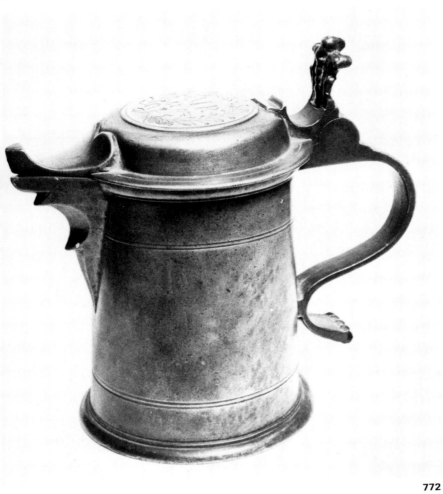

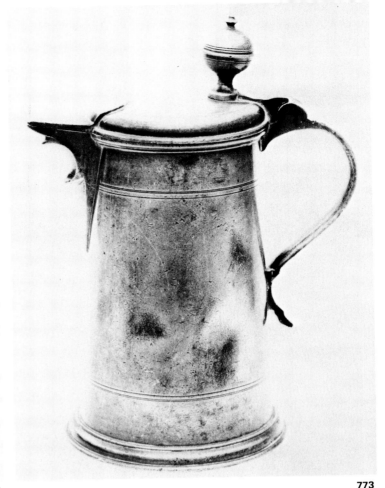

772

773

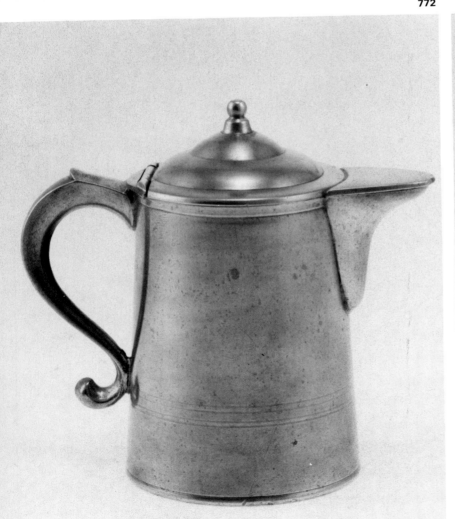

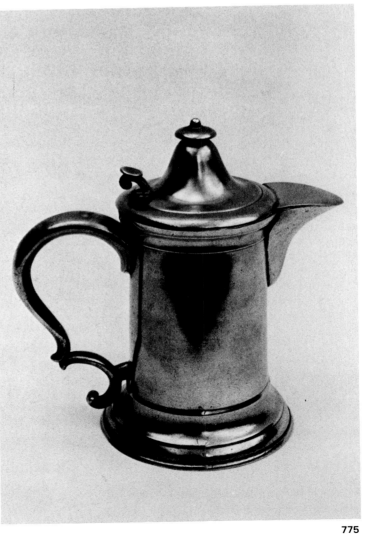

774

775

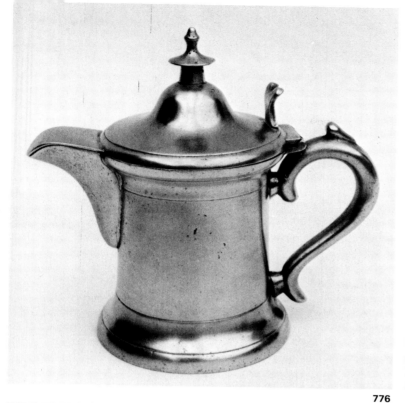

776

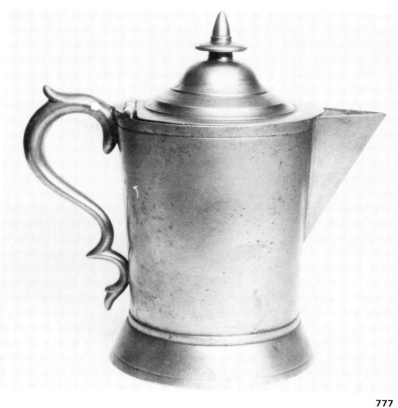

777

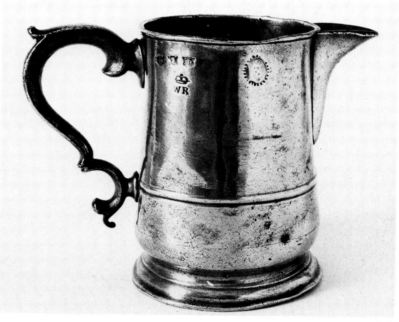

778

779

772. Austro-Hungarian small lipped flagon or measure, circa 1702, with plume thumbpiece. Many similar spouted measures or flagons are to be found in Germany and central Europe. (Courtesy of Robin Bellamy Ltd).

773. A straight sided German tankard with spout and ball thumbpiece, circa 1800. (Courtesy of Robin Bellamy Ltd).

774. A specialised American jug for "syrup" by Boardman and Hart, circa 1830, 5 inches high. (Collection of Dr. and Mrs. Melvyn Wolf).

775. American syrup jug by Simpson of New York, 6¼ inches high, circa 1845. (Collection of Dr. and Mrs. Melvyn Wolf).

776. An American syrup jug by the Sellews of Cincinatti, 5¼ inches high, mid-nineteenth century. (Collection of Dr. and Mrs. Melvyn Wolf).

777. Another example of an American syrup jug. These can take many forms. By Gleason, 6½ inches high, circa 1850. (Collection of Mr. and Mrs. Merrill G. Beede).

778. English pint mug with original pouring lip by Birch & Villiers, circa 1820. (From the Law Collection).

779. Ale jug by I.C. Crane Bewdley, English, circa 1820, 5 7/8 inches high. (Collection of Dr. D. Lamb).

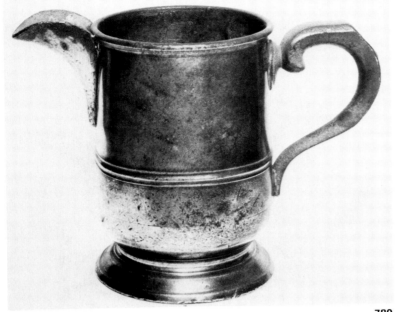

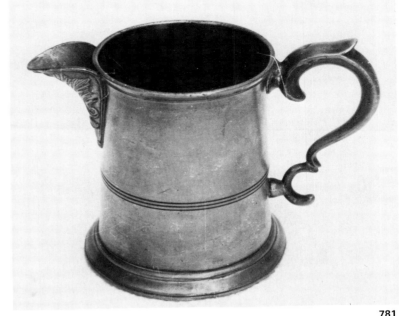

780

781

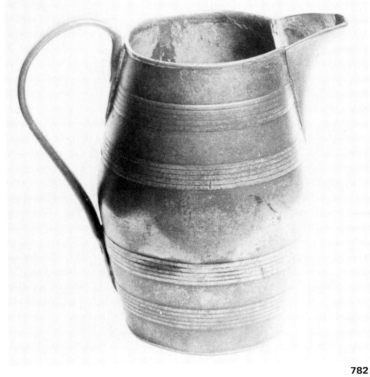

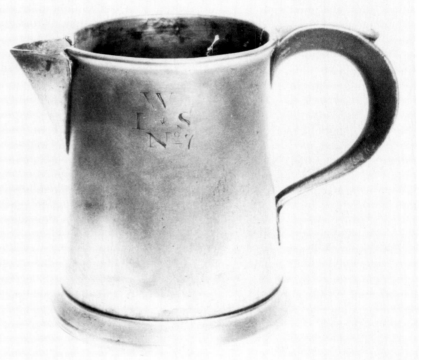

782

783

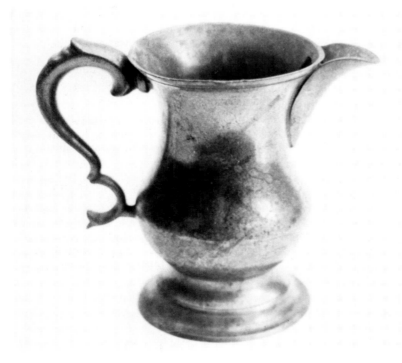

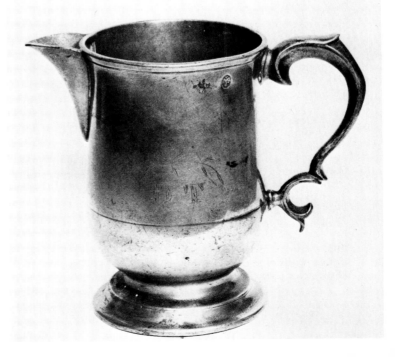

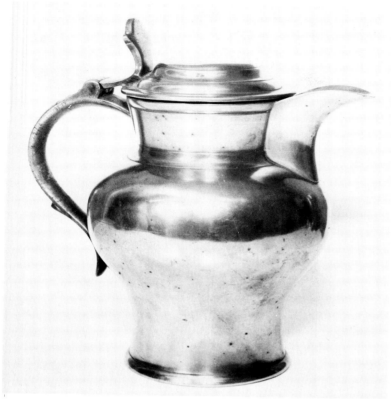

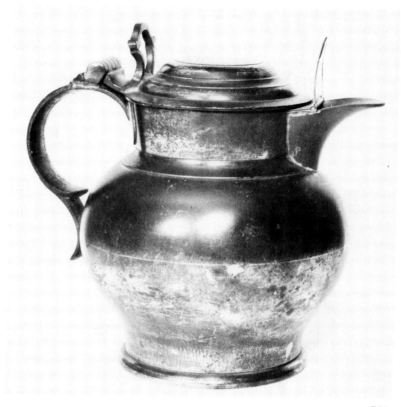

786

787

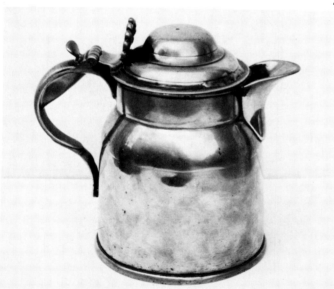

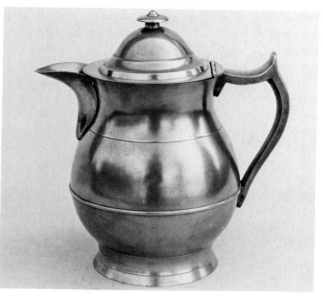

788

789

780. Another similar English mug but with different lip, by "RG" west of England, circa 1820. (From the Law Collection).

781. Rare cast decorated spout on English mug, circa 1830. (Courtesy of Robin Bellamy Ltd).

782. Rare barrel shaped mug with lip possibly by Alderson of London, circa 1820—30, 6¼ inches high. (From the Kydd Collection).

783. Spouted quart by Ingram and Hunt, early nineteenth century. (From the Law Collection).

784. Typical Galbraith, Scottish jug or lipped measure, circa 1820—40. (Courtesy of Robin Bellamy Ltd).

785. Scottish lipped pint possibly by Scoular who made many of this type of vessel, circa 1830—50, 5¼ inches high. (From the Law Collection).

786. There are several different forms of what was called the "Oxford" ale measure. Actually used for cider, ale and even wine. This example is English ale standard by C. Bentley, early nineteenth century, 8 inches high. (Courtesy of Country Life Antiques).

787. Another typical ale measure of the form made between 1780 and 1900. This example circa 1790. Unusual to have a hinged lid to spout, 8 inches high. (Courtesy of Country Life Antiques).

788. More uncommon flat based ale jug, sometimes suggested to have been made for use on ships, circa 1840, English. (Courtesy of Robin Bellamy Ltd).

789. The American equivalent is usually slightly more elongated. Attributed to Boardman, this example is of 3 quart capacity, 10¼ inches high, early nineteenth century. (Collection of Dr. and Mrs. Melvyn Wolf).

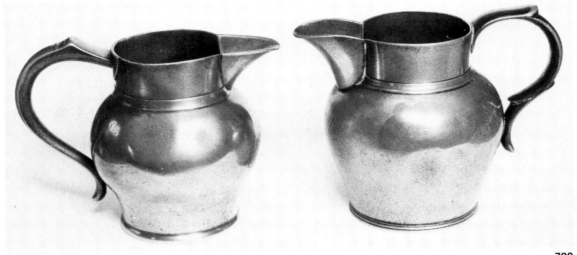

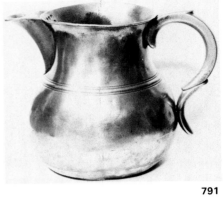

790

791

792

793

WATER JUGS
INCLUDING SOME BASINS

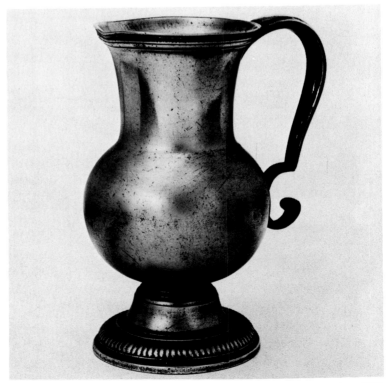

794

795

236

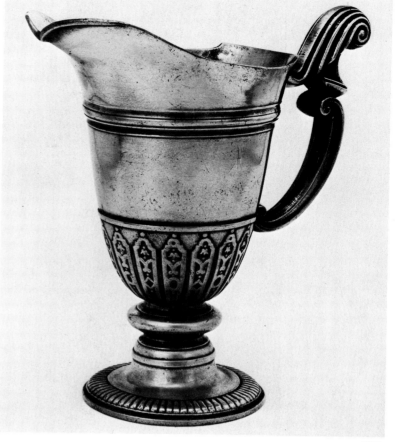

797

796

790. Lidless examples of similar ale jugs are less common in England than lidded examples. These two English ale jugs are of half pint capacity, 5 inches and 4 7/8 inches high, circa 1800. (Collection of Mr. K. Gordon).

791. A less common form with flat base and more rounded form, just one of the many styles that these jugs can take. Made unusually to wine standard gallon capacity, 8¼ inches high, circa 1800. (From the Kydd Collection).

792. American "Pitcher" by R. Dunham, circa 1840—60, 6¾ inches high. (Courtesy of Christies, New York).

793. A similar jug or pitcher typical of several makers of the early nineteenth century. This example is unmarked and holds 48 fluid ounces. (Collection of Dr. and Mrs. Melvyn Wolf).

794. In France and to a lesser extent Switzerland and Germany special jugs were often provided for use at the table. Often with a matching basin. This "Aiguiere" or ewer is French, seventeenth century from Paris. (Courtesy of Bourgaux).

795. This is another form of water jug, French from Paris made from the late seventeenth century until around 1750. (Courtesy of P. Boucaud).

796. Another French example from Metz, circa 1700. (Courtesy of P. Boucaud).

797. A French jug from Toulouse, circa 1709. (Courtesy of P. Boucaud).

798. This fine example of ewer and basin is by Klingling of Frankfurt, eighteenth century. The bowl is 12½ inches in diameter, the ewer 7 7/8 inches high, German. (Courtesy of Sotheby Parke Bernet).

798

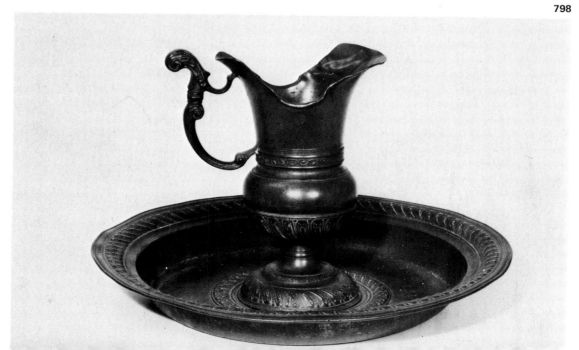

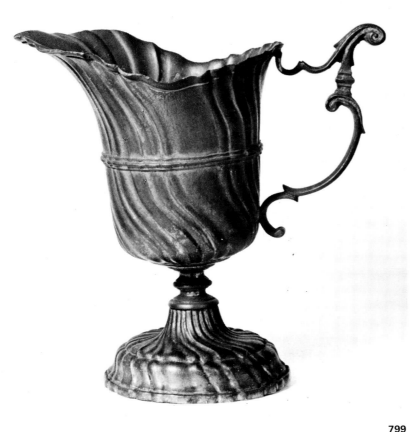

799. Another German ewer, mid-eighteenth century. (Courtesy of Kunstgewerbemuseum, Cologne).

800. North Italian ewer and basin possibly Venetian mid-eighteenth century. The basin is 15 inches wide, the ewer is 8¼ inches high. (Courtesy of Sotheby Parke Bernet).

801. Common form of French jug, circa 1750 to 1880. (Courtesy of P. Boucaud).

802. Two further typical French eighteenth century water jugs. (Courtesy of P. Boucaud).

803. Lidless French metric measure. A very rare eighteenth century example made soon after the Revolution. See Fleur de Lys mark. (Courtesy of P. Boucaud).

804. Group of Norwegian measures. Left to right: By Smidt, Trondheim, circa 1820. The rest are by Bergen pewterers of the eighteenth century. (Courtesy of Kunstindustrimuseet, Oslo).

805. Typical northern French metric measure, early nineteenth century. Similar forms were also used in Belgium. (Courtesy of P. Boucaud).

806. French straight sided measure from Caen in Normandy, nineteenth century. (Courtesy of P. Boucaud).

807. Spouted French measure from Lille, nineteenth century. (Courtesy of P. Boucaud).

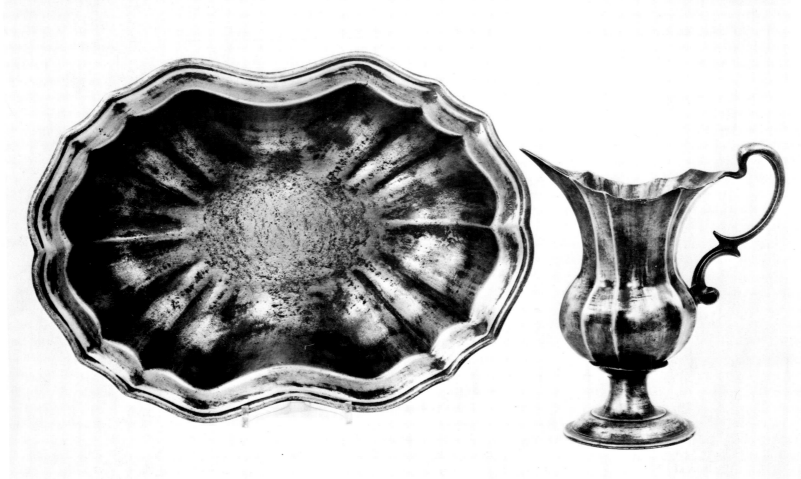

800

238

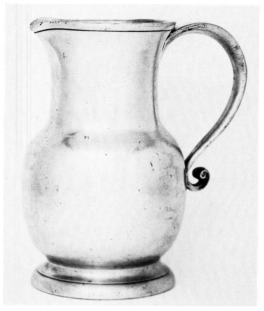

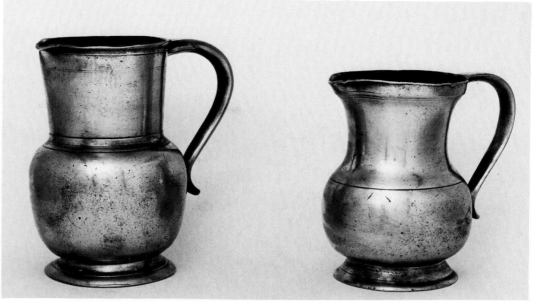

801

MEASURES MADE TO THE METRIC STANDARD

802

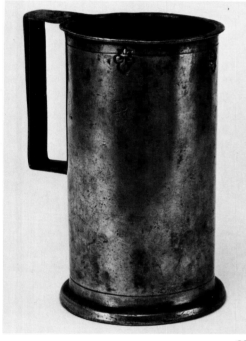

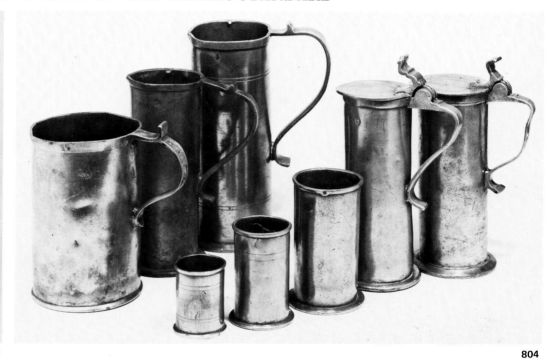

803

804

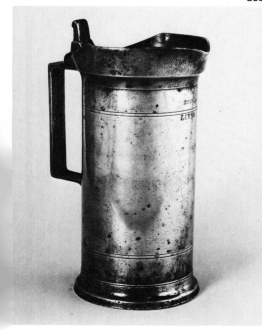

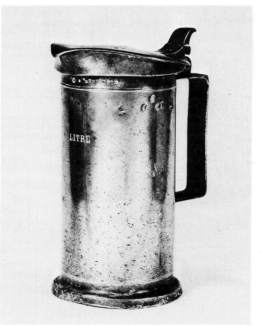

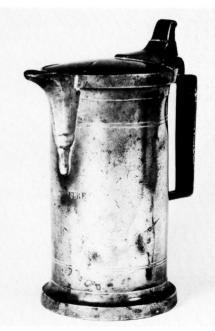

805

806

807

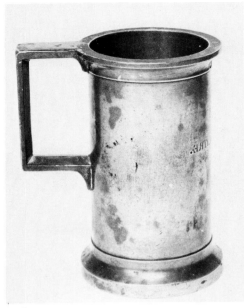

808

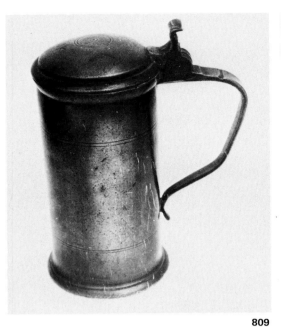

809

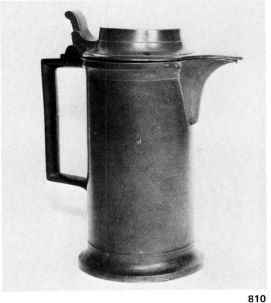

810

BALUSTERS

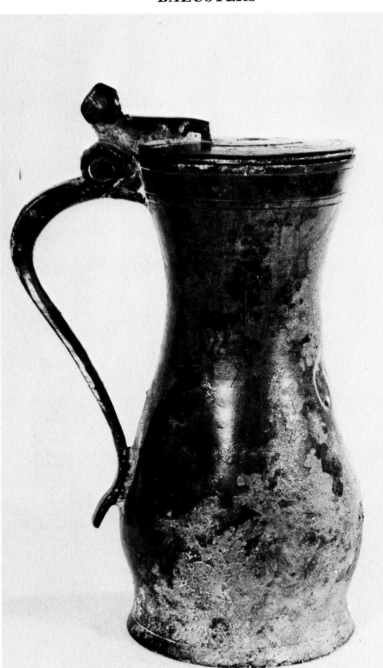

811

808. French straight sided measure by C.L., circa 1850. (Courtesy of Country Life Antiques).

809. Flemish metric measure, circa 1800. (Courtesy of Robin Bellamy Ltd).

810. A Flemish measure from Ghent, 8 inches high, circa 1800. (Courtesy of Country Life Antiques).

811. Early English slim baluster. The lines are typical of those few rare fifteenth and sixteenth century balusters which were probably made into the start of the seventeenth century. Hammerhead thumbpiece. (Courtesy of Mr. C. Minchin).

812. Two seventeenth century English hammerhead balusters with typical form. Probably towards the end of the century. (Courtesy of Sotheby Parke Bernet).

813. A rare matched set of English ball balusters of the late seventeenth century. From pint to half gill capacity. (Courtesy of Sotheby Parke Bernet).

814. The most frequently found English baluster form, the "bud". From late seventeenth century into early nineteenth century though most examples are circa 1700—70. (Courtesy of Robin Bellamy Ltd).

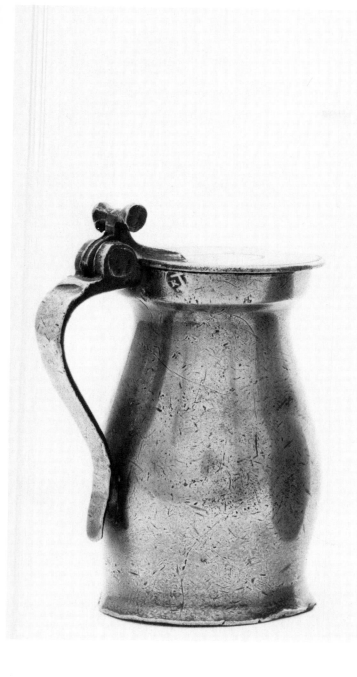

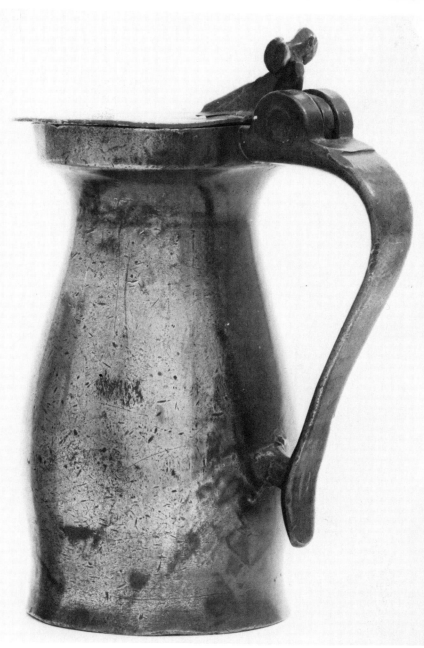

812

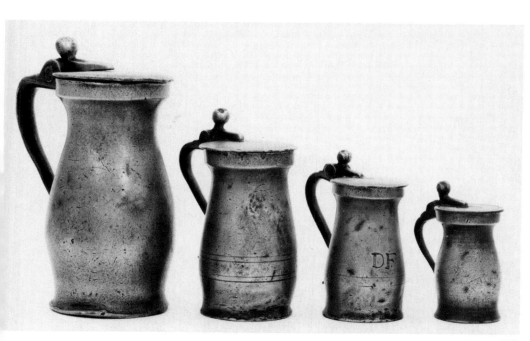

813

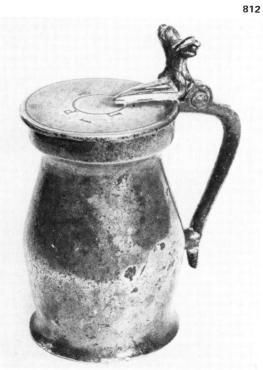

814

241

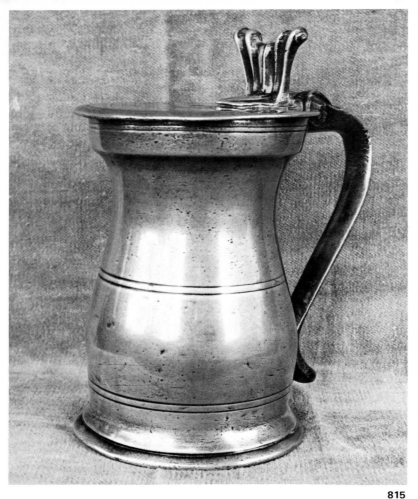

815

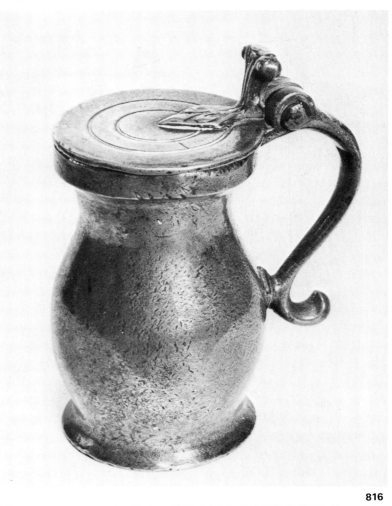

816

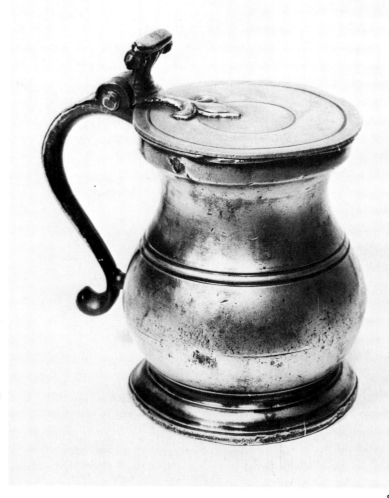

817

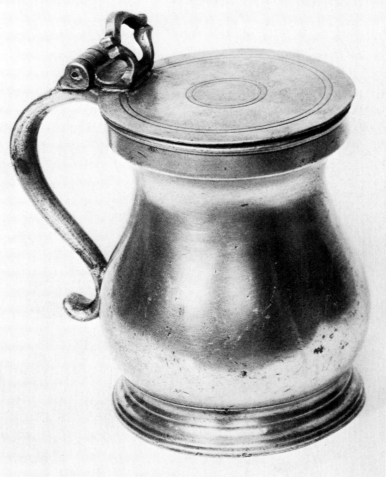

818

242

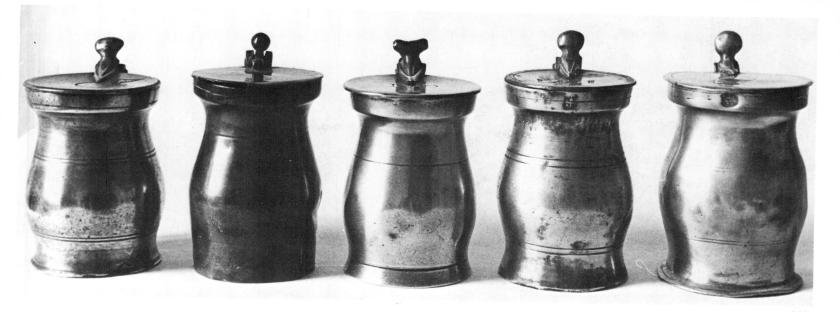

819

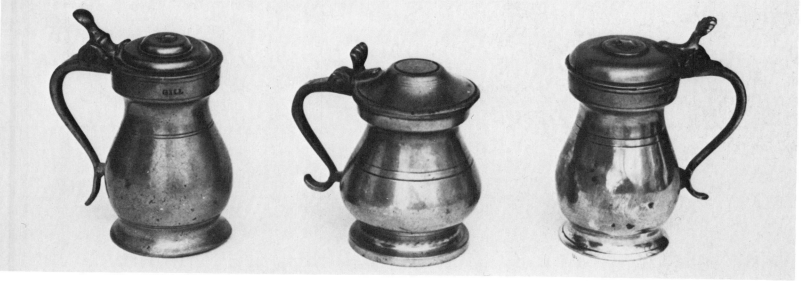

820

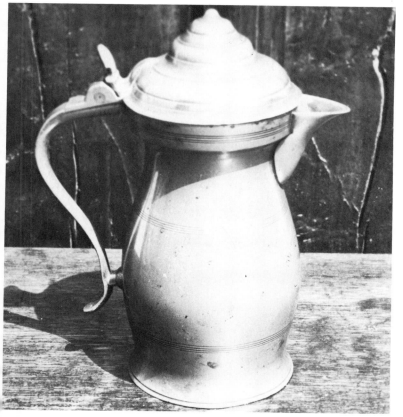

815. The rare north of England "Spray or plume" baluster. One pint capacity, 6 3/8 inches high, by "RB", early eighteenth century. (Collection of Mr. J.H. Myrtle).

816. The "Double Volute" baluster made during the eighteenth century, English. (Courtesy of Robin Bellamy Ltd).

817. Towards the end of the eighteenth century the baluster body began to change to a more bulbous form, similar to the "pot belly" lidless mugs found later. Circa 1820—30, English, 6 inches high. (From the Kydd Collection).

818. Another rare late baluster of bulbous form with an open chair thumbpiece, 5½ inches high, circa 1800—20, English. (From the Kydd Collection).

819. A group of Scottish balusters of late eighteenth to early nineteenth century form. Left to right: Shell, ball, bud, shell, and shell. (Collection of Dr. Lamb).

820. Three Scottish balusters, 1826—1880. Left to right: Glasgow double domed form. Edinburgh type. Glasgow domed form. (Courtesy of Robin Bellamy Ltd).

821. Rare multi-domed "More Majorum" baluster wine measure. Edinburgh. So named from the inscription found on several examples. Late eighteenth century. Wine standard. (Courtesy of Robin Bellamy Ltd).

821

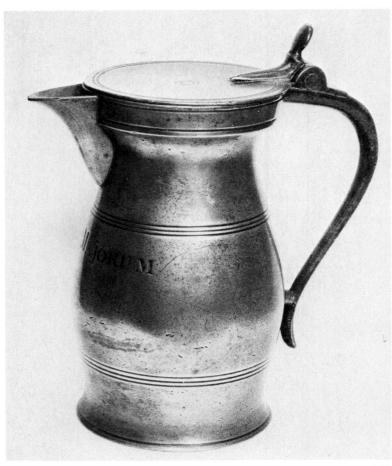

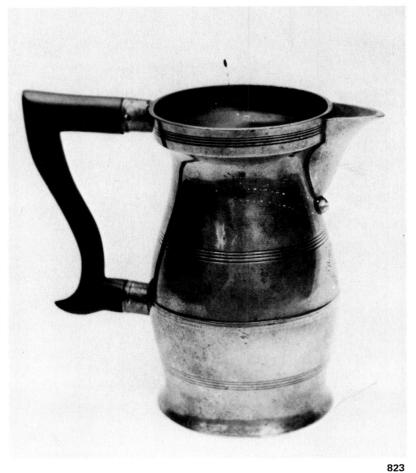

822

823

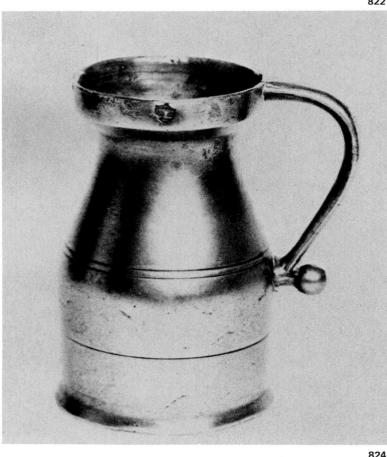

824

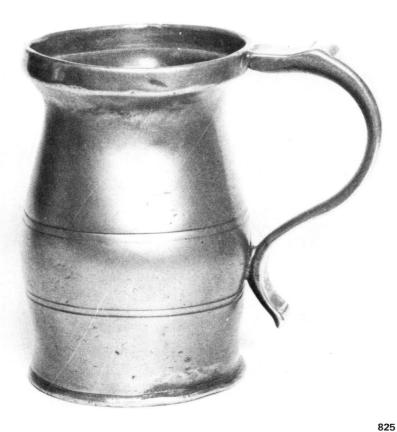

825

822. A more typical baluster lidded example, circa 1780—1800, Scottish, 7¾ inches high. (From the Law Collection).

823. A rare lidless example, with wooden handle, circa 1800—20, Scottish. (Courtesy of Robin Bellamy Ltd).

824. North of England or Scottish lidless baluster with ball at terminal to handle, circa 1800, 3½ inches high. (Collection of Mr. and Mrs. Robert E. Asher).

825. Typical English lidless baluster, circa 1780—1820, ½ pint capacity, 4 inches high. (Collection of Mr. and Mrs. Robert E. Asher).

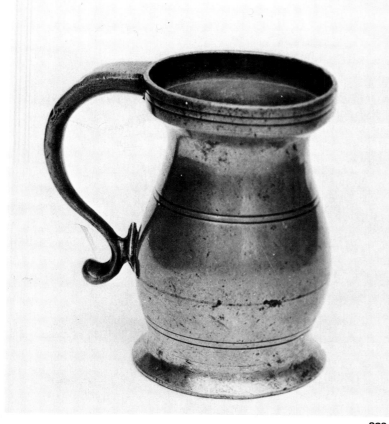

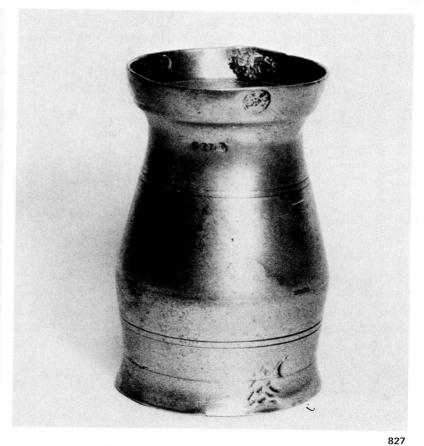

826

827

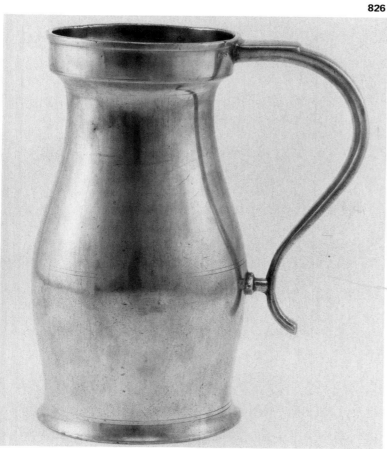

828

826. Another English form, circa 1780—1820. (Courtesy of Robin Bellamy Ltd).

827. Irish measure of baluster form without handle. Nineteenth century, this example is a noggin or gill, 3½ inches high. (Collection of Mr. and Mrs. Robert E. Asher).

828. American half gallon baluster by T. Boardman and Company, 1822, 9 inches high. (Collection of Dr. and Mrs. Melvyn Wolf).

BALUSTER THUMBPIECES.
A. Hammerhead, sixteenth century and again at end of seventeenth century.
B. Ball, again a style which endured from sixteenth century into the early eighteenth century.
C. Bud, seventeenth and eighteenth century.
D. Double Volute, the eighteenth century style.
E. Spade, Scottish eighteenth and early nineteenth century.
F. Embryo shell, Scottish from about 1800.

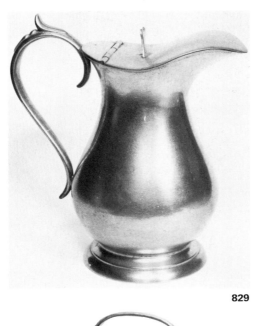

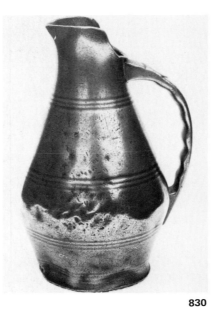

829

830

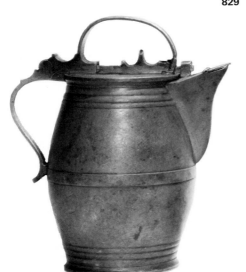

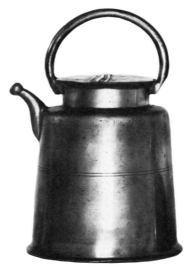

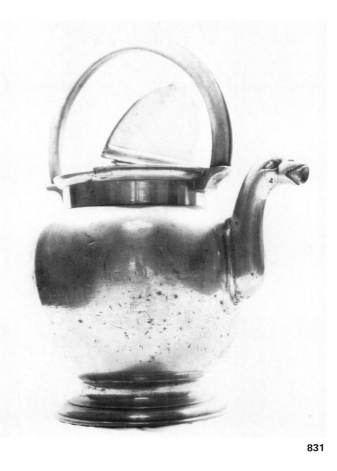

831

832

833

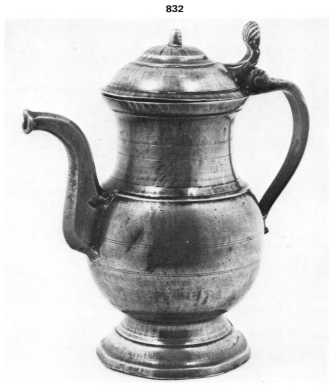

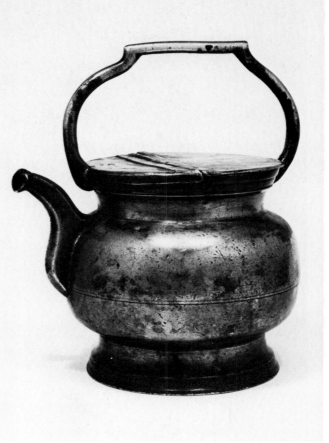

834

835

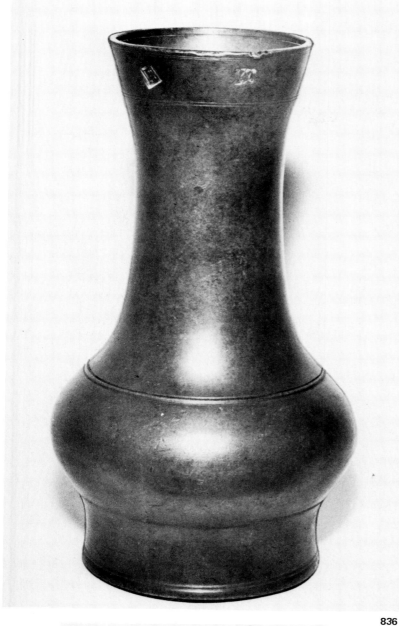

836

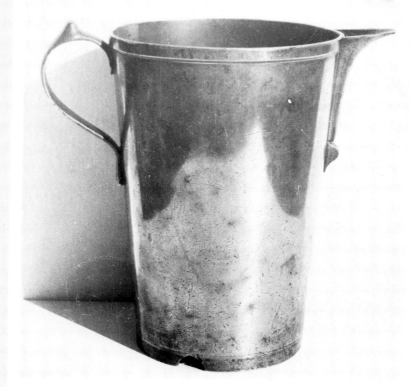

837

829. Hot water jug. Typical of examples made both in Britain and America. This is American made by the Sellews, 6¼ inches high, circa 1850. (Collection of Mr. and Mrs. Merrill G. Beede).

830. "Broc au vin", used in France for collecting wine. Nineteenth century. A small plug like lid fitted into the neck. (Courtesy of Robin Bellamy Ltd).

831. French milk bottle or vessel, Lyon, circa 1810—40, 12¼ inches high. (Collection of Marianne & Albert Phiebig).

832. German measure, Bohemian, circa 1800—50, 12 1/8 inches high. (Courtesy of Dr. Fritz Nagel).

833. Another French milk jug, nineteenth century. (Courtesy of Bourgaux).

834. Oil measure southern France. Very common French form. Made from late eighteenth century into the nineteenth century. (Courtesy of P. Boucaud).

835. Another oil container French, from the Rhone valley, circa 1680—1850. (Courtesy of P. Boucaud).

836. Rare German measure, from Dinekelsbuhl, circa 1680—1700, 9¼ inches high. (Courtesy of Kunsthandel Frieder Aichele).

837. Lipped measure, probably Swiss, circa 1780—1800. (Courtesy of Robin Bellamy Ltd).

838. Flask, measure or demijohn, American by J.H. Putnam, circa 1850. (Courtesy of the Metropolitan Museum of Art, New York. Gift of Mrs. Blair in memory of her husband J. Insley Blair).

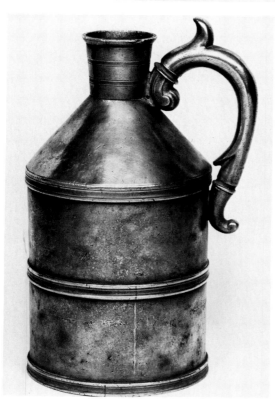

838

FLASKS

Fine examples are mostly from corporations or guilds but simple examples were sometimes used in the fields.

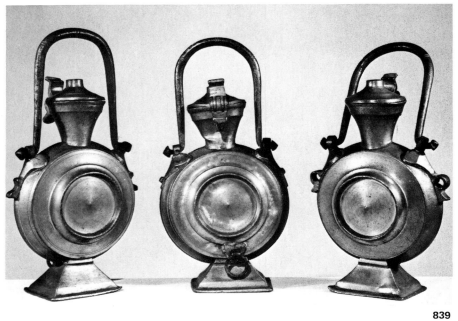

839

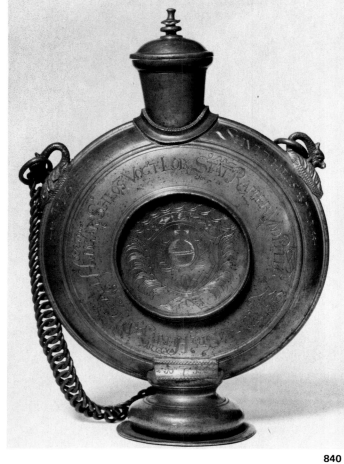

840

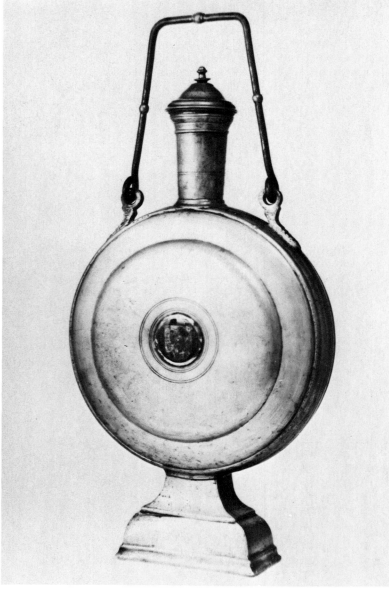

841

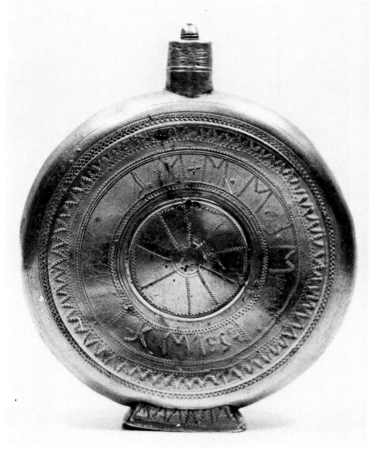

842

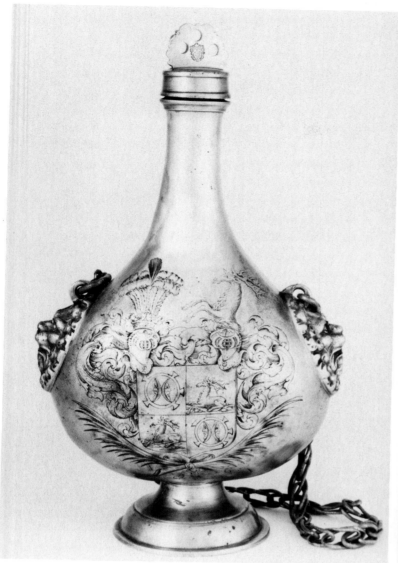

843

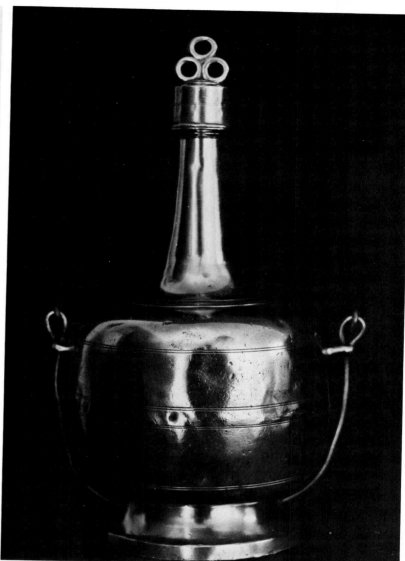

844

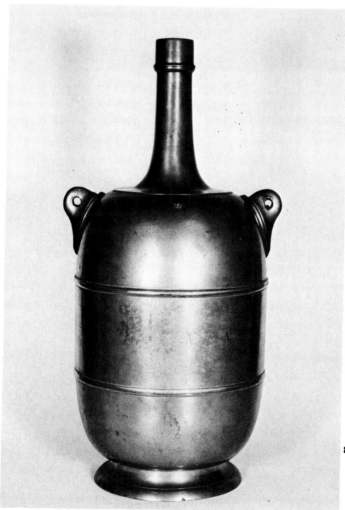

845

839. Three municipal flasks, part of a set of 12 with iron carrying handles, Germany, circa 1600. (Courtesy of the Historical Museum, Frankfurt).

840. Another German flask from Rapperswill, circa 1710, 14 inches high. (Courtesy of the Kunstgewerbemuseum, Cologne).

841. Fine decorated Swiss flask by Frans Xavier Etli from Obwalden, circa 1800, 16½ inches high. (Courtesy of the Swiss National Museum, Zurich).

842. Footed bottle with screw top, 7 1/8 inches high. Probably Greek or from Balkans, circa 1800. (Collection of Marianne & Albert Phiebig).

843. Superb field flask by Hans Jakob Steiner of Zurich, second half of the seventeenth century, 14½ inches high. (Courtesy of the Swiss National Museum, Zurich).

844. Large wine bottle, southern French, eighteenth century. (Courtesy of Bourgaux).

845. French bottle, Toulouse, from end of eighteenth century. (Courtesy of P. Boucaud).

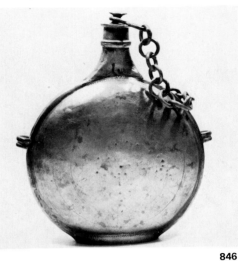

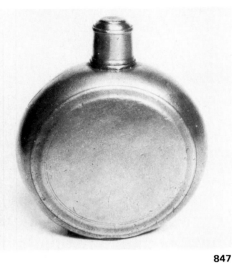

846

847

848

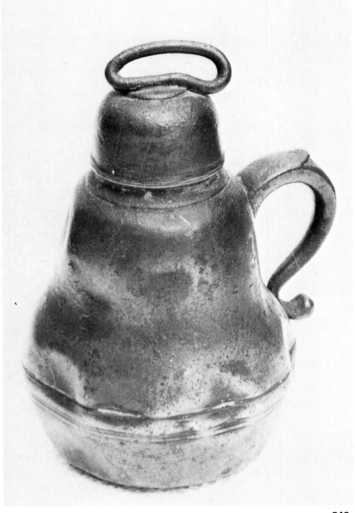

849

850

846. Swiss bottle, 7½ inches high, eighteenth century. (Collection of Marianne & Albert Phiebig).

847. Flask from America. Attributed to J.C. Heyne of Lancaster, late eighteenth century, 4¼ inches high. (Collection of Mr. and Mrs. Merrill G. Beede).

848. A small English nineteenth century flask. (From the Kydd Collection).

849. Food bottle, English late seventeenth century. (Courtesy of Robin Bellamy Ltd).

850. Large wine or storage flagon, now without its lid. Found in an Irish castle. Twelve inches high, circa 1700. (Collection of K. Gordon).

851. Fine wine can, Frankfurt, eighteenth century. (Courtesy of the Historical Museum, Frankfurt).

852. Wine can or "Bugelkanne" from Switzerland. By Felix Schmid of Stein am Rhein, mid-seventeenth century, 16 inches high. (Courtesy of the Swiss National Museum, Zurich).

853. Left: Southern German wine can or flask, dated 1593, 17 inches high. Right: Large flask, German, eighteenth century, 13¾ inches high. (Courtesy of Dr. Fritz Nagel).

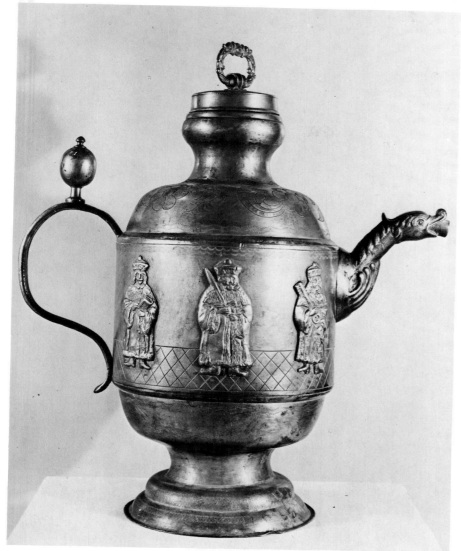

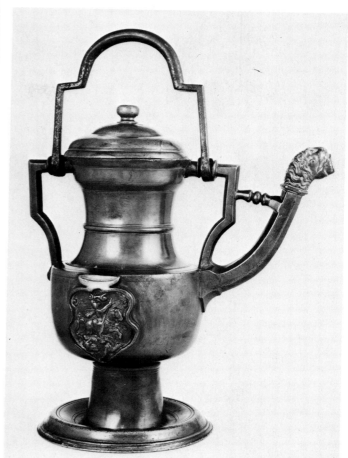

852

851

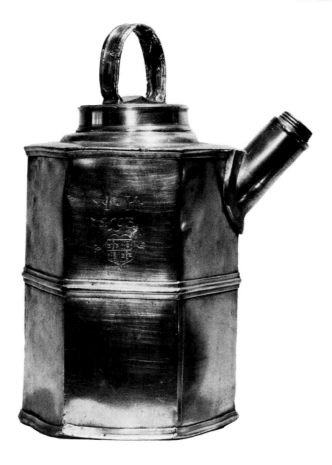

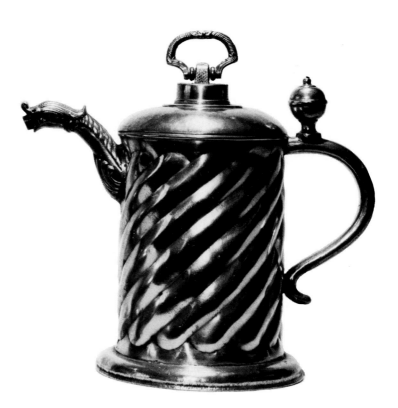

853

251

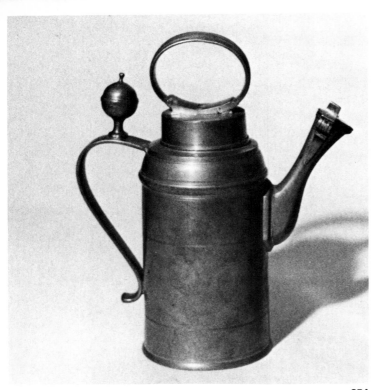

854

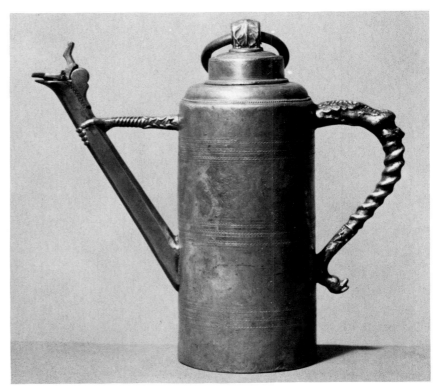

855

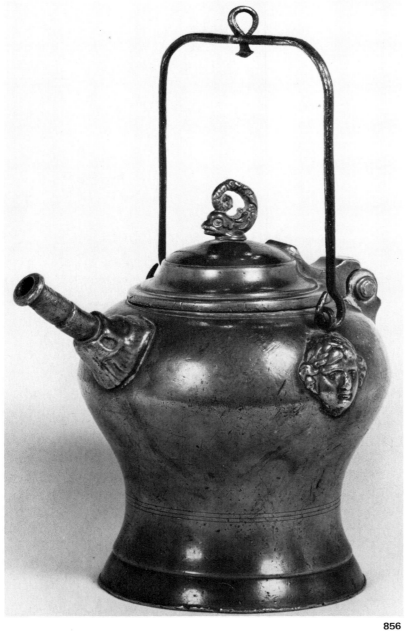

856

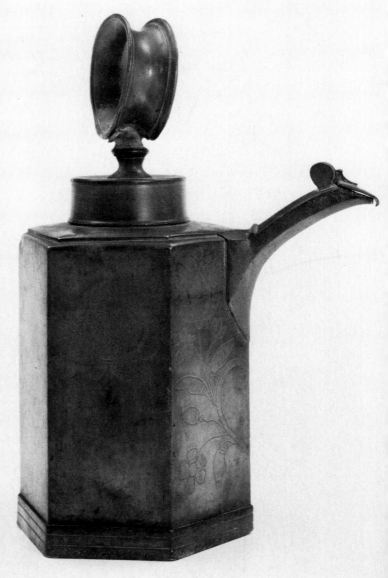

85

252

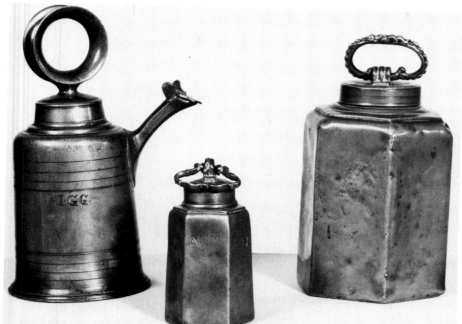

858

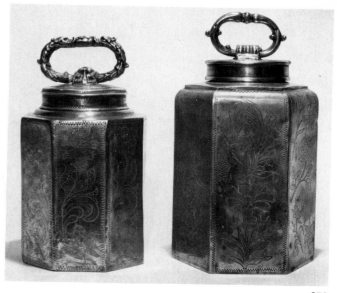

859

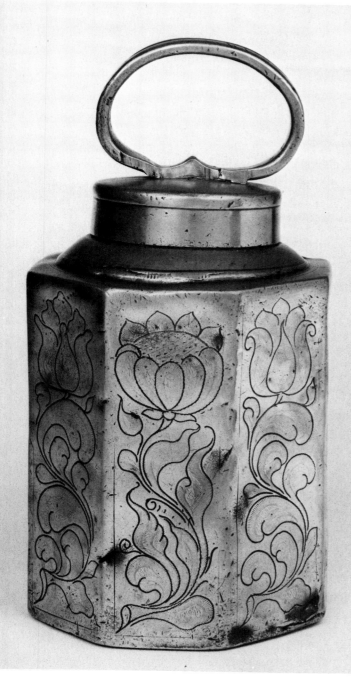

860

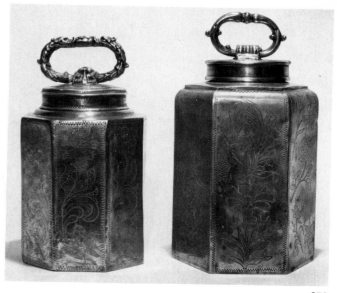

861

854. Flask or "Schraubkanne", 11¼ inches high, circa 1820—50, German. (Courtesy of Kunsthandel Frieder Aichele).

855. Similar flask by Heinrich Feller of Reutlingen, circa 1850, 9 inches high. (Courtesy of Kunstgewerbemuseum, Cologne).

856. Typical Swiss "Sugerli". The handles are usually of iron and there are several variations in knop, spout and masks. Mostly from the eighteenth and nineteenth century. (Courtesy of M. & G. Segal).

857. Hexagonal prisemkann by F. Cane of Appenzall in Switzerland, early nineteenth century, 14 inches high. There are several variations on spout form, spout lid and ring. (Courtesy of Sotheby Parke Bernet, London).

858. Group of three flasks. From left to right: Glockenkann of rounded form. Straight sided and shaped examples are also found from Germany, Swiss, circa 1800; Flask without spout; and larger six sided flask. Again similar flasks can be found from Switzerland, Germany and other parts of central Europe from the eighteenth century onwards. (Courtesy of H.B. Havinga).

859. Two further decorated flasks with eight sides, both German, late seventeenth century. (Courtesy of Dr. Fritz Nagel).

860. Swiss decorated flask, circa 1800. (Courtesy of Christies, London).

861. Shaped and waisted flask, central Europe, eighteenth century. (Collection of Mr. and Mrs. James A. Taylor).

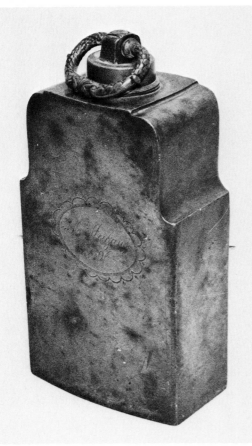

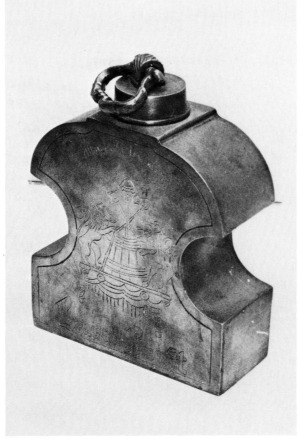

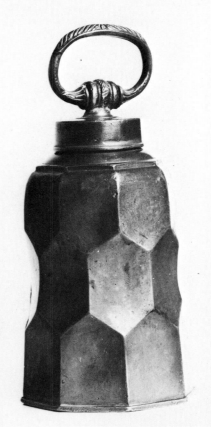

862

863

864

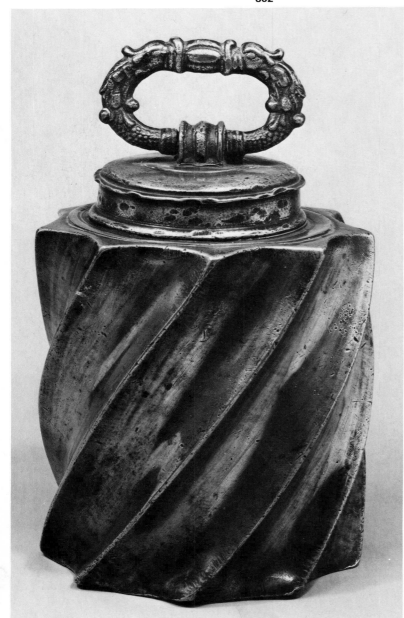

862. Shaped flask, Germany, circa 1800. (Collection of Mr. and Mrs. James A. Taylor).

863. Rare waisted flask, central European, eighteenth century. (Collection of Mr. and Mrs. James A. Taylor).

864. Rare flask with slightly concave patterns on its sides. Hungarian, but examples are also found from Germany and other parts of central Europe, circa 1800. (Courtesy of the Hungarian National Museum).

865. Uncommon wrythen flask, central Europe, early eighteenth century. (Courtesy of Christies, London).

865

254

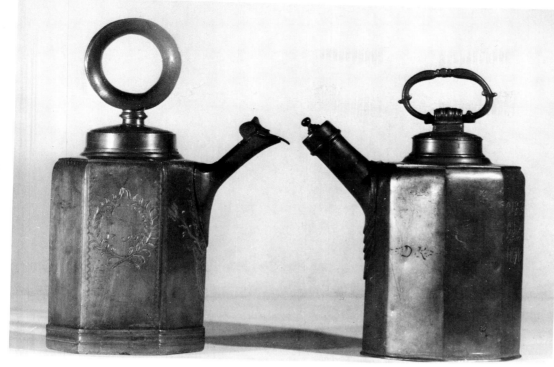

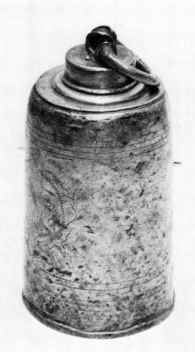

866. Flasks with six and eight sides are also found with spouts similar to those on the round "Glockenkannes". The example on the left is Swiss, circa 1796, 14 inches high. On the right is a German flask, circa 1789, 11¾ inches high. (Courtesy of Dr. Fritz Nagel).

867. Round flask, circa 1800. Examples are to be found from all of central Europe. (Collection of Mr. and Mrs. James A. Taylor).

868. Group of unusual round flasks, probably food bottles, Dutch, circa 1750—1800. (Courtesy of the Zuiderzee Museum, Enkhuisen).

869. Flask, probably from the Balkans. Six inches high, decorated with St. George and the Dragon. Similar flasks appear to have been made over a considerable period but most are nineteenth century. (Collection of Marianne & Albert Phiebig).

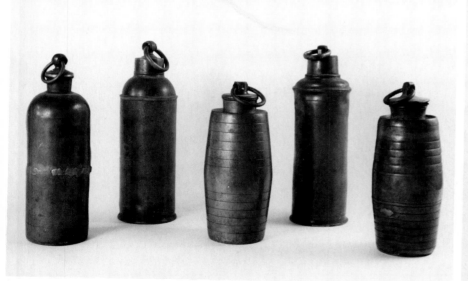

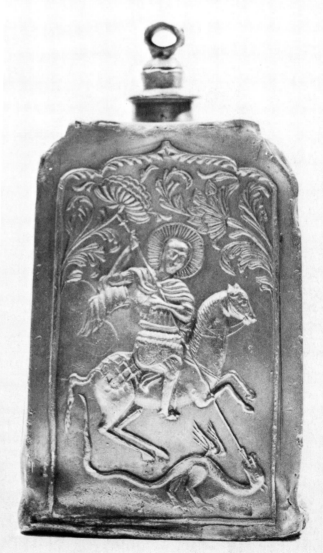

Pewter for Drinking

Tankards

The term "Tankards" is reserved in this book, to those lidded vessels used for drinking.

Tankards were extensively used in the seventeenth and eighteenth centuries but went out of fashion after 1800.

Tankards are presented here in two groups; those with essentially straight lines and those with a rounded form; both shown in chronological order.

Seventeenth century British tankards had straight sides and until the last years of the century, flat lids. Around 1680—90 examples are found with domed lids and it was this domed fashion that dominated the eighteenth century. Most flat-lidded tankards and some of the early domed examples were made with a crenulation at the lip also known as a "Serrated" lip. Many of the seventeenth century flat-lidded tankards are decorated with wrigglework.

In the eighteenth century there were variations in the height of the dome, and in the nature of both the thumbpiece and the terminal to the handle. About 1730 a new form, with rounded sides known as the "Tulip" became popular. These tankards retained the domed lid used on other eighteenth century forms.

In America tankards followed the three basic forms found in Britain, the flat-lidded variety, domed straight-sided tankards and tulip tankards. Examples which have survived are all eighteenth century and it has not been possible to establish any chronology between these various forms. Around 250 American tankards have been recorded and from them a survey of 100 has been made. The survey found that 24 were flat-lidded, 66 had domed lids, and ten tulip-shaped examples were found.

Crenulations were present on fourteen out of 24 flat-lidded examples and on sixteen domed tankards with plain bodies. Of the domed examples, 46 had some banding around the body, generally low down. Most frequently found thumbpieces are the ram's horn and scroll (92 out of 100) and the ball terminal appears on 60 out of 100 handles.

The flat-lidded tankard is also found in France, Holland and Germany.

Several distinct varieties of central European tankards can be identified. There are those with straight sides and flat lids, usually with a pronounced "Ball" thumbpiece. These come particularly from north and central Germany. A variety of this form is found with a much taller body. The second main group are the "Roerkens" mostly from the Baltic Coast areas. These unusual tankards, often used by guilds, taper outwards as they rise. Interesting examples occur with dice set in the base, probably for use in a tavern.

The third major category are those with rounded forms, the Birnkrugs from central Germany, Silesia, Saxony and Thuringia, often with the ubiquitous ball knop.

Several other forms of tankards can be identified, including interesting examples from Scandinavia, France and Holland.

Mugs, Cans or Pots

A variety of names, such as mugs, pots and cans, have been given to that group of lidless drinking tankards so popular in American and British taverns. Originally these different terms may each have had a distinct meaning but today they are synonymous.

Mugs were used in Europe but they were never common.

Although most mugs were used in taverns, bars and saloons some would have been used in the home. Most were made to the current local standard and a majority of British examples have a capacity check mark to confirm this.

The first "pots" that we know of appear in English taverns around 1650; the early examples are tall with heavy banding, but about 1690—1700 pots with plain bodies appeared.

Eighteenth century tavern mugs are uncommon. The tall early form gave way to squat tankards, usually with a ball terminal to their strap handles. Examples before about 1750 tend to differ from maker to maker. About the middle of the eighteenth century, mugs with a "tulip" shape or with "U" shaped body were introduced.

From 1800 onwards the production of mugs rose steeply and the introduction of the Imperial Standard of capacity in 1826 led to the replacement of most examples then in public use.

Up to 1826 mugs were mostly made to the ale standard but, particularly in the eighteenth century, rarer examples conformed to the wine standard.

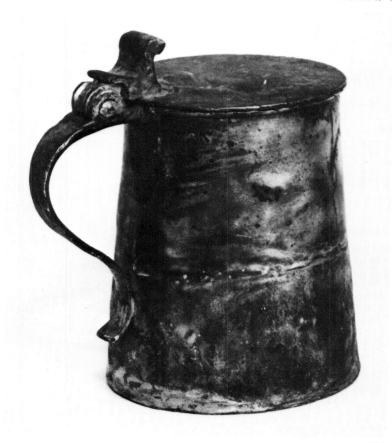

870

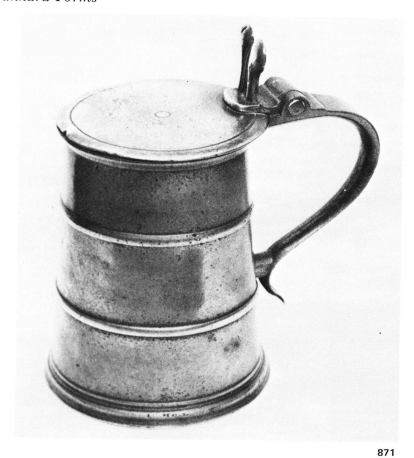

871

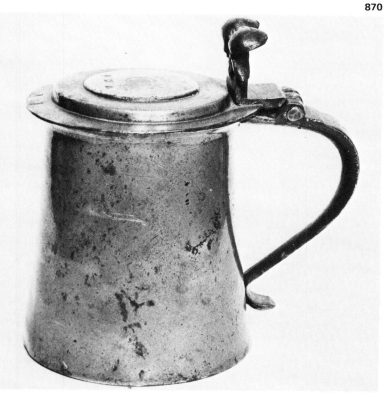

872

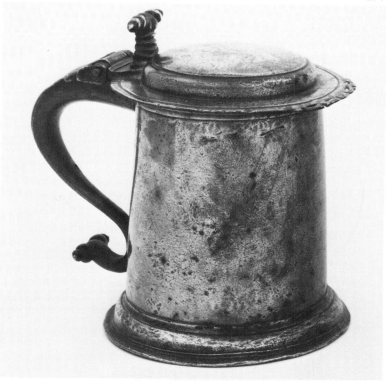

873

870. A rare early English tankard excavated from the Thames, 5¾ inches high, by ¨EH¨, circa 1600—30. (Courtesy of Sotheby Parke Bernet).

871. A flat lidded "thurendel" with bands, similar in form to mid-seventeenth century lidless tankards. This holds an ale quart, 6 1/8 inches high, English second half of the seventeenth century. (Private collection).

872. One of the earliest Stuart flat-lidded tankards with twin cusp thumbpiece, pint capacity, circa 1650—70. (From the Law Collection).

873. The more traditional Stuart flat-lidded form with rams horn thumbpiece, 6 3/8 inches high by "WW", circa 1690. (Courtesy of Sotheby Parke Bernet, London).

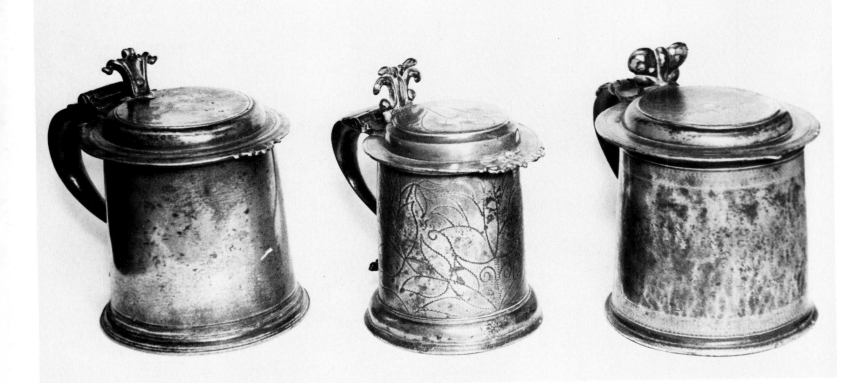

874

The nineteenth century saw the rise of a popular shape variously known as the "pear", "belly" or "bulbous" form. More mugs of this type were made than of any other form and they continued to be popular up to the beginning of this century. The smallest capacity made prior to 1850 was the half gill and most common are the quart, pint, half pint and gill, although gallons and half gallons are known. The smaller fractions only appear after 1850.

Many local or regional varieties of mug were made in the nineteenth century and there is a range of tavern mugs made to the Scottish Standard that was only used north of the border.

Glass-bottomed mugs began to appear in the 1790's, some with clear bases, others with coloured glass, and they continued to be used throughout the nineteenth century.

At some point in the mid-nineteenth century makers developed a range of mugs with thickened lips or rims. These were made with brass, pewter or copper lips or rims, the thickening presumably intended to strengthen them for the heavy wear they received. These rims are found on both straight-sided and "belly" forms.

Many tavern mugs have an inscription on their sides or under their bases showing the "pub" where they were used. Quarts are slightly more common in Britain than pints and the larger and smaller sizes are all less frequently found.

Until the 1840's two forms of handles predominated; the plain strap and the "broken" handle or "double C" curve, as it is called in the United States. A range of new mugs with rectangular or oval handles and with different body forms were gradually introduced into English pubs and many of these forms were still popular in 1900.

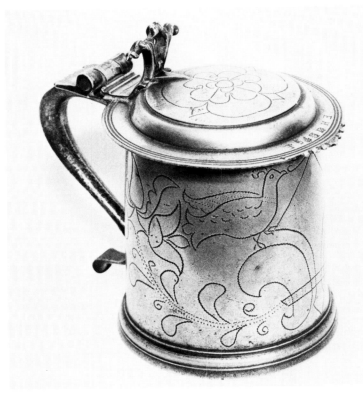

875

874. A group of three English flat-lidded Stuart tankards. From left to right: By Francis Seagood of Norwich, 6½ inches; Unmarked, 6 inches; Rare triple cusp thumbpiece, no marks, 6½ inches with small "blip" crenulation. (Private collection).

875. Fine Stuart wrigglework flat-lidded tankard, English, 6 3/8 inches high. Two sets of ownership initials on lip, circa 1670. (Private collection).

876. Very fine flat-lidded tankard by John Donne, circa 1686—88, 6 7/8 inches high. With portrait of James I wriggled on the body. English. (Courtesy of Colonial Williamsburg).

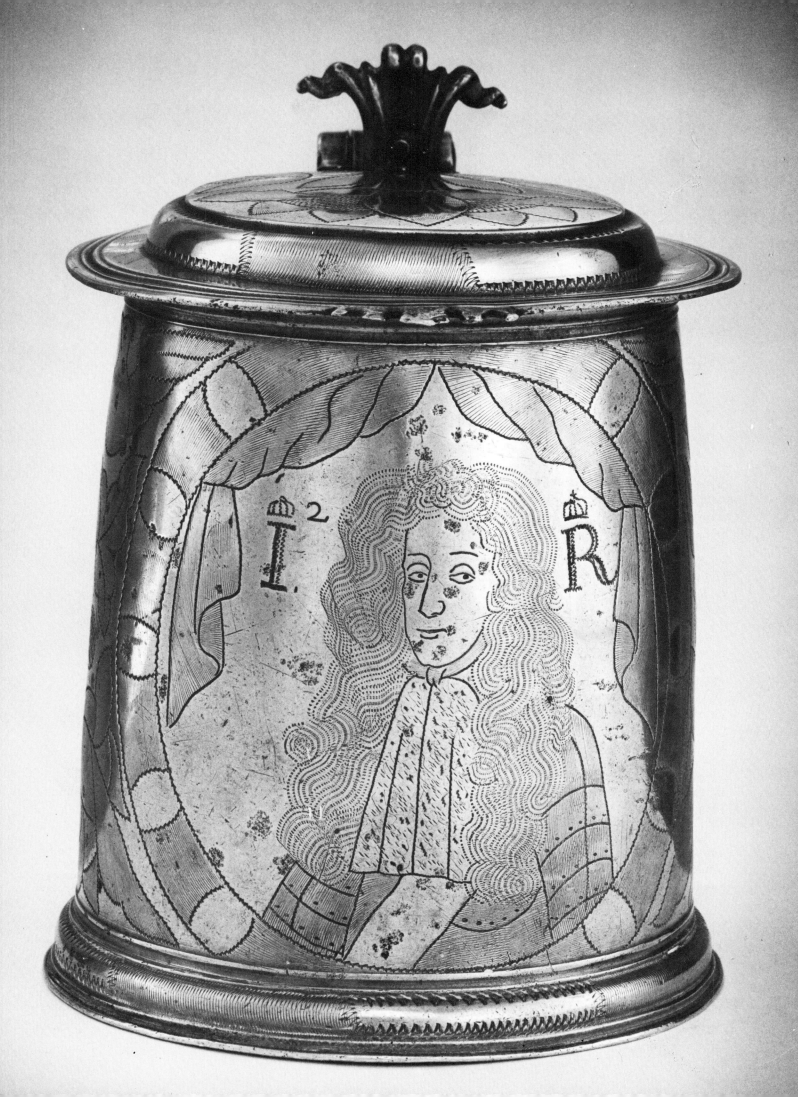

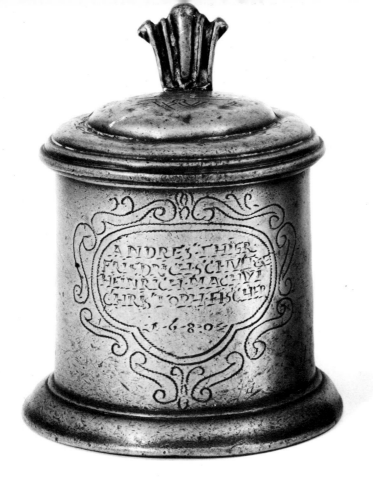

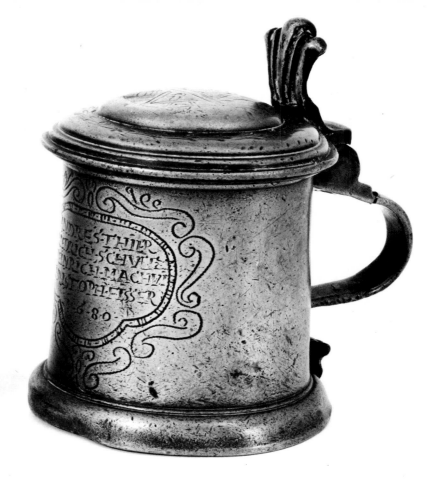

877

In the United States the straight-sided mug is the dominant form. A number of varieties occur, some with plain bodies, others banded. Examples with broad bands are probably from New York or Pennsylvania, while those with narrow bands may be from New England.

Strap handles are more common than those with the "double C" scroll. More pints exist than other capacities but mugs were made in several sizes; Boardman and Danforth, for example, manufactured five capacities. Most were made to the ale standard but examples, some by S. Hamlin and Boardman and Hart, were constructed to the wine standard.

Tall tapering mugs reminiscent of the early form in England were made by New England pewterers, each often adding a distinct terminal to the handle.

Tulip-shaped mugs were popular with Philadelphia makers and all but one example have strap handles. There is some evidence that the term "cans" may have been reserved in the United States for this shape of mug.

Several other forms of mugs were made in the nineteenth century, some unique to America, others reflecting English styles.

Other Drinking Vessels

In addition to tankards and tavern mugs several other forms were used for drinking. Any classification of these forms must unfortunately be

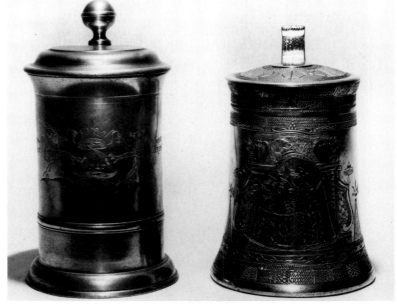

878

arbitrary, as can be shown by reference to the 1867 Meriden Britannia Metal Company's catalogue which illustrates what we would term goblets, footed cups and beakers, all as tumblers.

For simplicity the following categories are used;
1. Two-handled cups
2. Drinking cups (with one handle)
3. Beakers (with straight sides and no handles)
4. Goblets (with curved sides and no handles)
5. Wine cups
6. Punch bowls, Monteiths and wine coolers

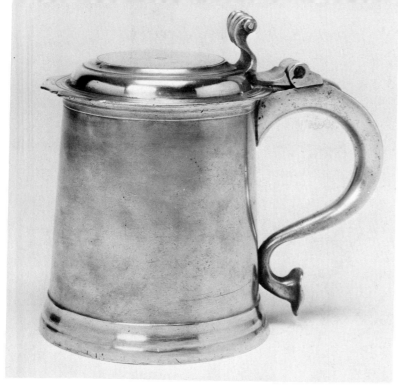

879

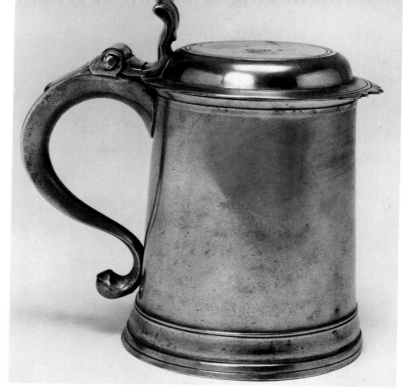

880

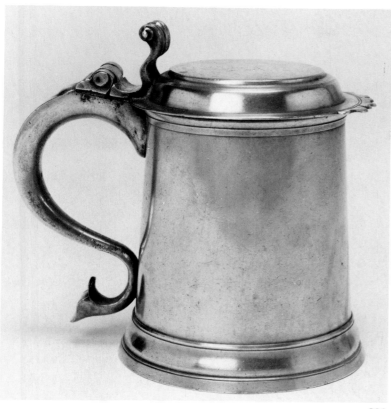

881

882

877. Pair of German tankards, engraved with the arms of a Mason's Guild, circa 1680, 6 1/8 inches high. This is the nearest equivalent form in Europe to the Anglo-Saxon flat lid. (Courtesy of Sotheby Parke Bernet, London).

878. Two German tankards. Left: Mid-eighteenth century ball knop. Right: Decorated tankard, circa 1680. (Courtesy of Dr. Fritz Nagel).

879. Quart American tankard by William Bradford, New York, circa 1720—60, 7 1/8 inches high. (Courtesy of Christies, New York).

880. American flat-lidded tankard by John Will of New York City, third quarter of eighteenth century, 7 inches high. (Courtesy of Christies, New York).

881. Another excellent American flat-lidded tankard of quart size by Francis Bassett II, New York City, circa 1770—80, 6 7/8 inches high. (Courtesy of Christies, New York).

882. American flat lid without crenulation on lip by Peter Young, last quarter of eighteenth century, 6¾ inches high. (Courtesy of Christies, New York).

Two-handled Cups

Two-handled cups are found in several sizes.

The most common European form is the small shallow brandy bowl, from Holland, Germany, Scandinavia and France. Brandy bowls usually have decorated handles and they were popular from the 1680's to around 1800.

One version, the Friesian brandy bowl, is similar in appearance to a small group of bowls made in Britain toward the end of the seventeenth century.

In Britain there are a few large two-handled bowls known as "Loving Cups". Some of these may have been "Wassail" cups; that is, passed from hand to hand on convivial occasions, but it is more likely that they were gifts upon betrothal or marriage. Loving cups of this style appear about 1650 and go out of fashion around 1730.

Later in the eighteenth century smaller cups appear. Some may have been used as chalices in Britain and the United States, but most were for ordinary domestic use.

Two-handled cups from the mid-eighteenth century onwards are found in a number of varieties.

Drinking Cups

Small single-handled cups were used everywhere. From the seventeenth century come small concave-sided cups used in Britain and Holland, but most examples date from the eighteenth century and have straight, slightly tapering or rounded sides.

Some rather exalted names are given to these cups including "possett" and "caudle", but in reality they were probably used for drinking almost any liquid. Most American examples date from the nineteenth century.

Beakers

The term "beaker" is used to describe drinking cups with straight bodies and without handles. Beakers were used in the Middle Ages but few have survived. In the seventeenth century we find a small group of cast decorated beakers found in Britain dating from around 1610. Later in the seventeenth century similar tall beakers were popular in Holland and Britain, many decorated with wrigglework.

The tall beaker went out of fashion in Great Britain and Holland around 1720, but continued to be made in the United States and Scandinavia into the nineteenth century.

In the eighteenth century beakers were made in several styles. In Britain shorter examples were popular, first appearing about 1720. Flared beakers were made in France and Switzerland towards the end of the eighteenth century. Beakers are found with plain, decorated and reeded bodies. Most British beakers are half pints but American examples vary from under two inches to over six inches in height.

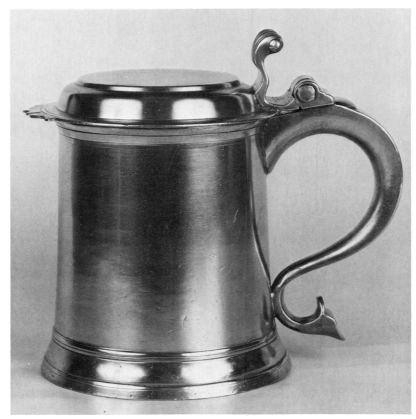

883

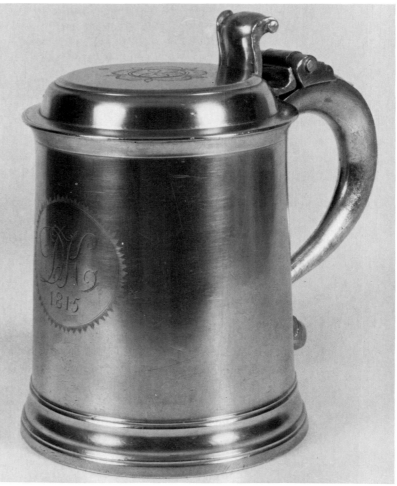

884

883. American flat-lidded tankard by Frederick Bassett, circa 1760—90, 7 inches high. (Collection of Dr. and Mrs. Melvyn Wolf).

884. An excellent flat-lidded tankard by William Will, with later engraving and dated 1815. Late eighteenth century, 7 1/8 inches high. (Collection of Dr. and Mrs. Melvyn Wolf).

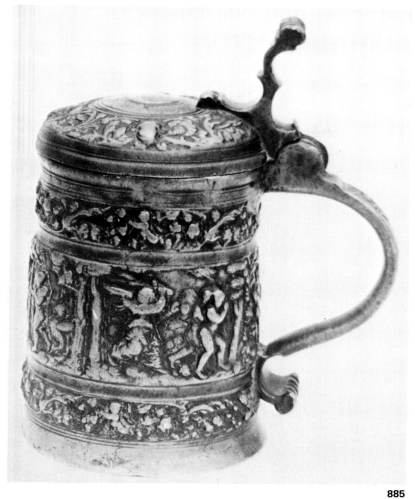

885

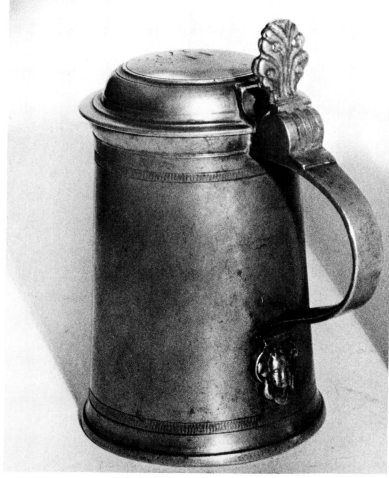

887

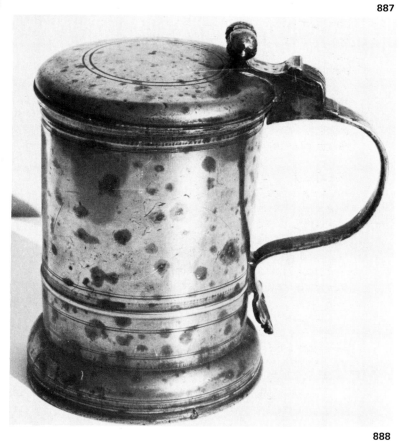

886

888

885. Cast decorated German tankard with flat lid. This example has lost its skirt but comes from the early seventeenth century. (Courtesy of Robin Bellamy Ltd).

886. Engraved German tankard, end of the seventeenth century, 10¼ inches high. It has an erect thumbpiece more often found on flagons. (Courtesy of Christies).

887. More tapering flat-lidded tankard from Amberg in Germany, early eighteenth century, 7¼ inches high. (Courtesy of Kunsthandel Frieder Aichele).

888. A Scandinavian flat-lidded tankard, Danish, circa 1700, with twin ball thumbpiece. (Courtesy of Robin Bellamy Ltd).

Goblets

Goblets are defined here as cups similar to beakers, but with curved sides and a small stem or foot.

Examples with decorated sides were popular in France and Switzerland around 1750. British and American goblets however are usually plain and are predominantly nineteenth century.

Wine Cups

Wine cups were used from an early period for drinking wine or "strong" ale. They resemble chalices and are often mistaken for them.

The main differences are that wine cups tend to be shorter and usually have simple, plain stems without knops. They graced the tables of many homes from the seventeenth century onwards, until they went out of fashion around 1730. Examples from Britain and northern Europe predominate.

Punch Bowls, Monteiths and Wine Coolers

Punch, warmed or spiced brandy or rum, was served in bowls, and poured into individual glasses or containers, usually with a ladle. The punch bowls are of round or oval form, usually standing on a foot.

One particularly rare group of punch bowls are those known as "Monteiths". These have notches round the rim reminiscent of castellation, into which glasses could be set. Monteiths are normally Dutch or (less commonly), English.

Punch bowls appear to go out of fashion about 1775.

Wine coolers were made in pewter from the 1680's into the eighteenth century. They were used to cool the squat bottles of wine.

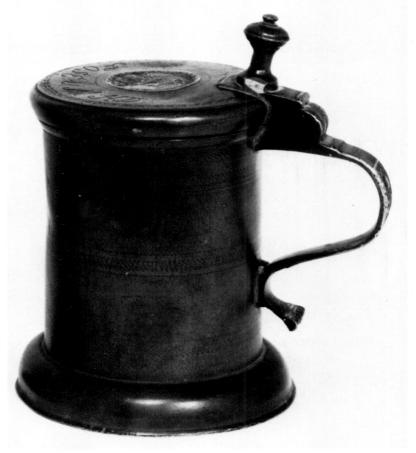

889

889. A Norwegian tankard. Such tankards often have pegs on the inside to mark where each participant should drink to of an evening. By P.M. Vahl of Bergen, with a medallion of Christian V on the lid, second half eighteenth century, 7½ inches high. (Courtesy of Sotheby Parke Bernet, London).

890. A large drinking tankard, this example has ball and claw feet. Norwegian from Oslo, third quarter eighteenth century, 7½ inches high. (Collection of Marianne & Albert Phiebig).

891. An unusually fine Swedish footed tankard dated 1765 by P. Noren of Hedemora, 8¾ inches high. (Courtesy of Nordiska Museet, Stockholm).

892. German tankard with ball thumbpiece and short handle. By J.G. Rothe, circa 1755, Leipsig, 10 1/8 inches high. (Courtesy of Dr. Fritz Nagel).

893. Slightly tapering Dutch tankard, circa 1700. (Courtesy of H.B. Havinga).

894. German tankard, Bohemian, mid-eighteenth century. Typical of a large range of eighteenth century tankards of this form with ball knop. (Courtesy of Kunsthandel Frieder Aichele).

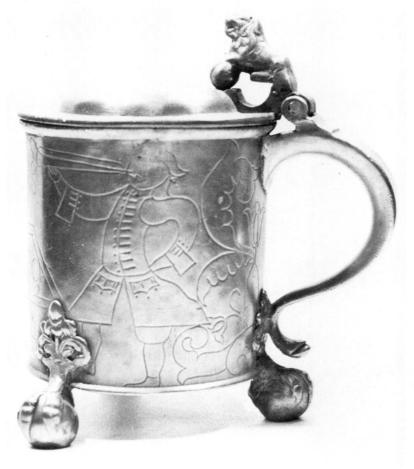

890

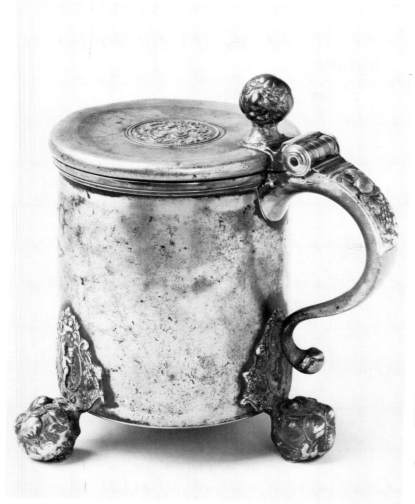

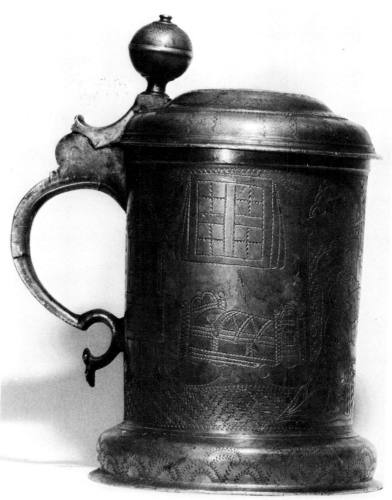

891

892

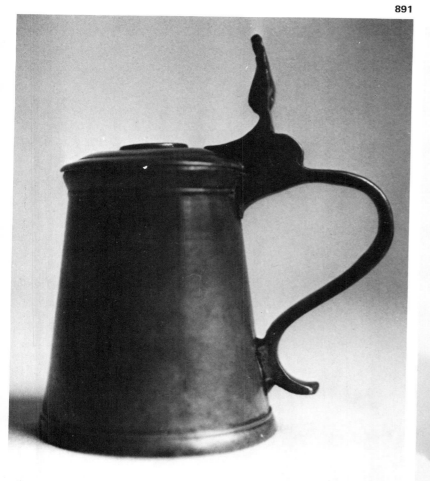

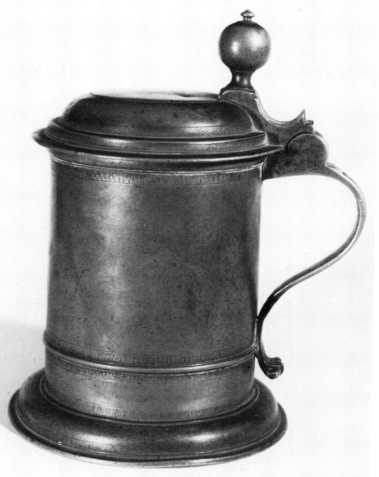

893

894

265

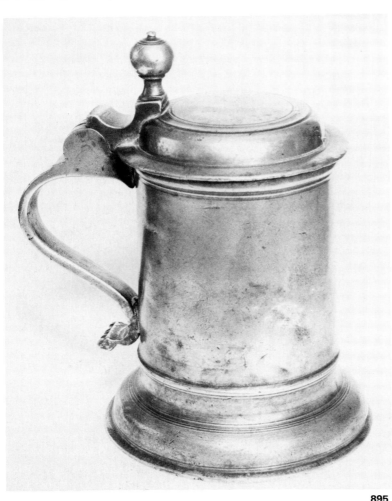

895

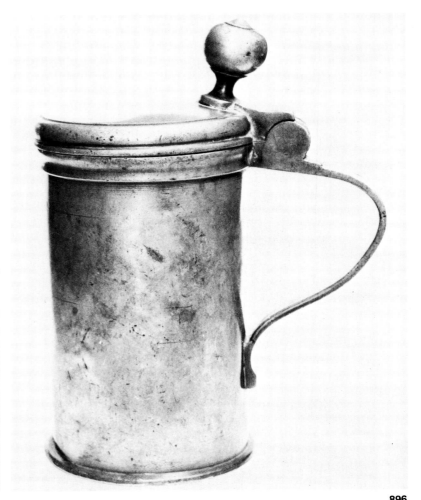

896

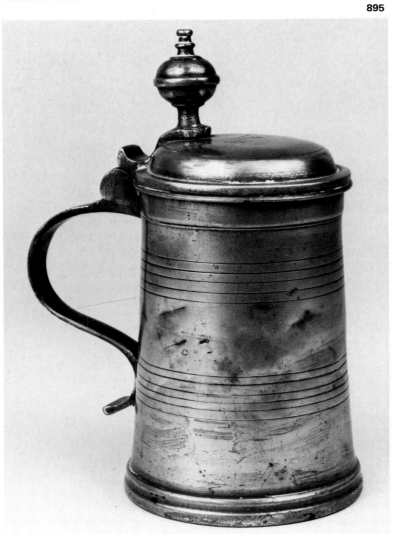

897

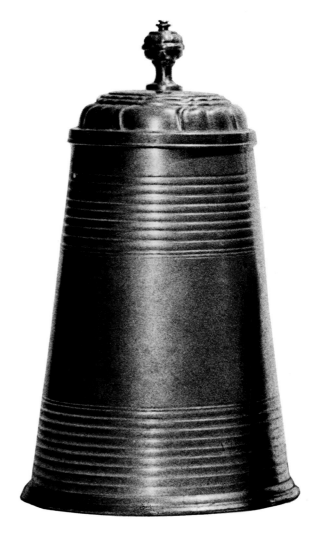

898

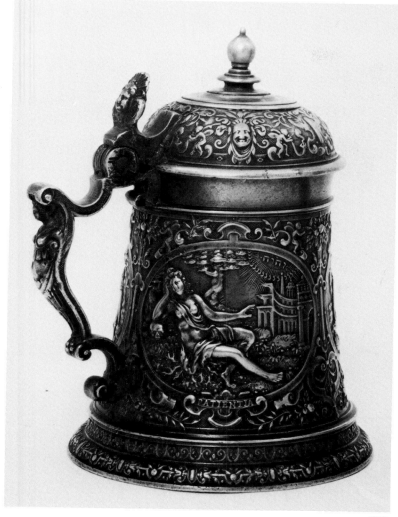

899

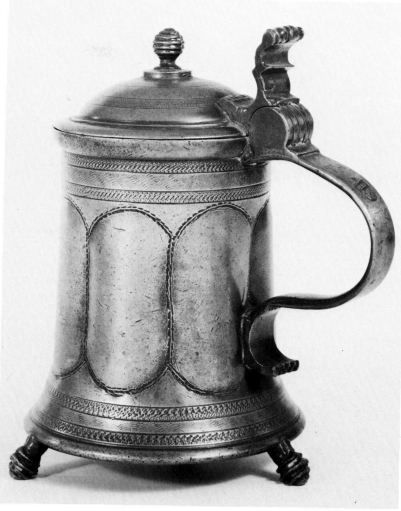

900

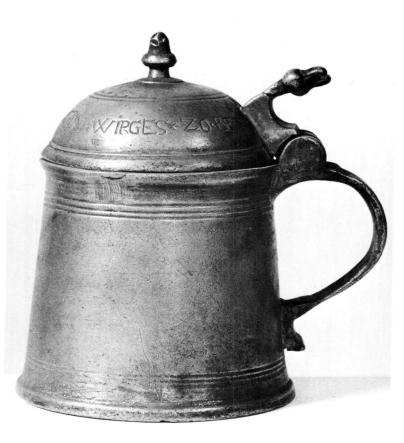

901

895. Similar tankard but from Poland. By J.A. Doerffal from Nysa, second quarter eighteenth century. Similar tankards are found in all parts of the old Austro-Hungarian empire, 8 inches high. (Collection of Mr. K. Gordon).

896. Slightly later version of the ball thumbpiece tankard, late eighteenth century. (Courtesy of Robin Bellamy Ltd).

897. Decorated ball knop tankard with incised decoration. Late eighteenth century, German or Austro-Hungarian. (Courtesy of Christies, London).

898. German tapering tankard, Augsburg, circa 1820, 9½ inches high. (Courtesy of Dr. Fritz Nagel).

899. Fine relief cast tankard with knop by Isaac Faust, Strasbourg, mid-seventeenth century, 7 inches high. (Courtesy of Sotheby Parke Bernet, London).

900. German tankard with pannelled sides by H.J. Seifertold of Wurtemberg, seventeenth century, 7¼ inches high, on decorated feet. (Courtesy of Sotheby Parke Bernet).

901. German mid-seventeenth century krug or tankard, 5 3/8 inches high. (Courtesy of Kunstgewerbemuseum, Cologne).

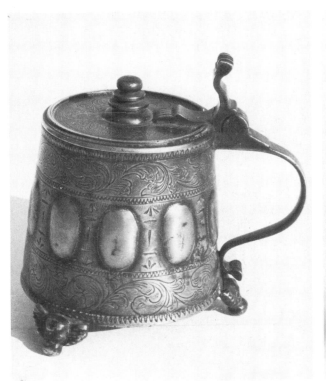

902

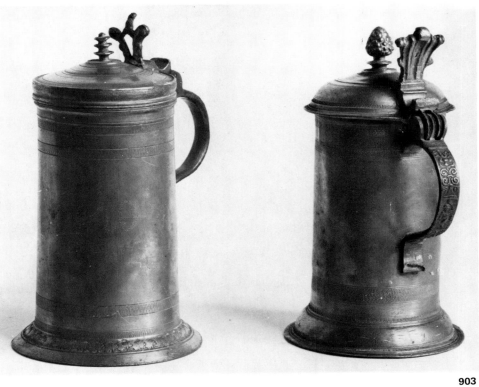

903

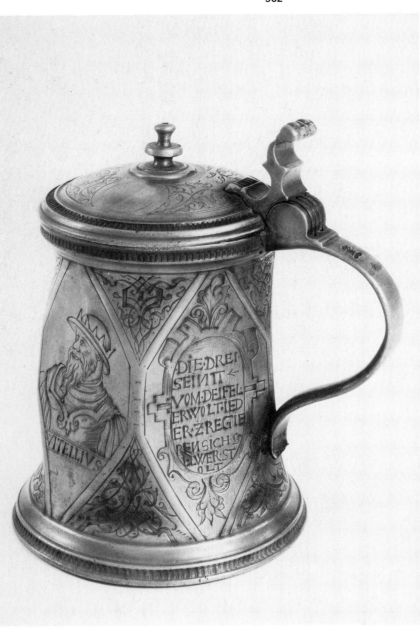

904

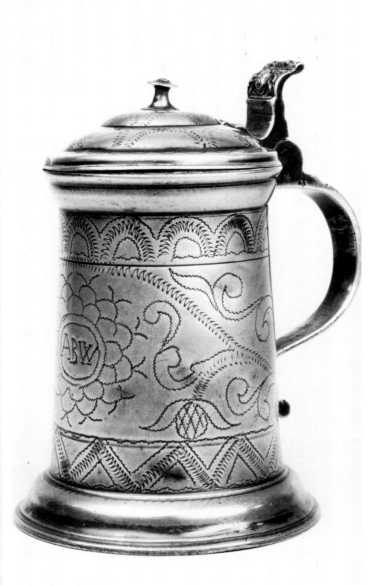

905

268

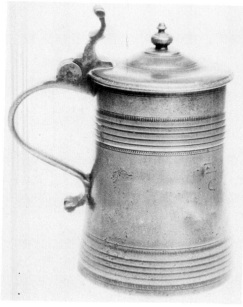

906

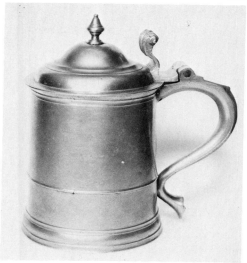

908

909

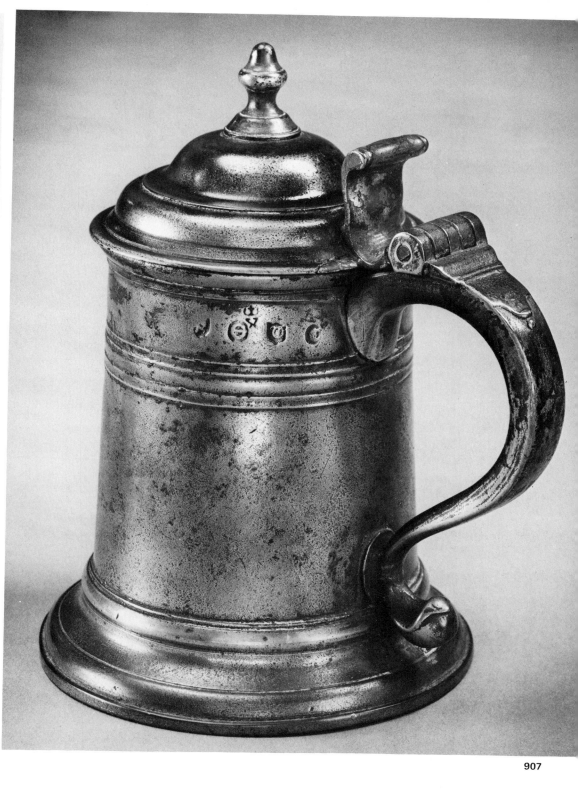

907

902. Austrian tankard of tapering form, Salzburg early eighteenth century, 7¼ inches high. (Courtesy of Kunsthandel Frieder Aichele).

903. Two Hungarian tankards. Left: Circa 1620. Right: Early eighteenth century. (Courtesy of Hungarian National Museum, Budapest).

904. Fine tankard, German probably Munich, seventeenth century, 6½ inches high with engraved pannelled sides. (Courtesy of Sotheby Parke Bernet, London).

905. Fine decorated Swiss tankard, mid-eighteenth century. (Courtesy of Christies, London).

906. A similar Austro-Hungarian or German tankard, again mid-eighteenth century. (Courtesy of Robin Bellamy Ltd).

907. Rare tankard in the form of a spire flagon, by John Carpenter, circa 1725—40, 6 5/8 inches high. (Courtesy of Colonial Williamsburg).

908. American knopped lid tankard, New England, 6½ inches high, circa 1750—70. (Collection of Mr. and Mrs. Merrill G. Beede).

909. Another similar tankard, American with "Semper Eadem" mark, circa 1750—70, 7½ inches high. (Collection of Dr. and Mrs. Melvyn Wolf).

269

TANKARDS WITH TAPERING FORMS

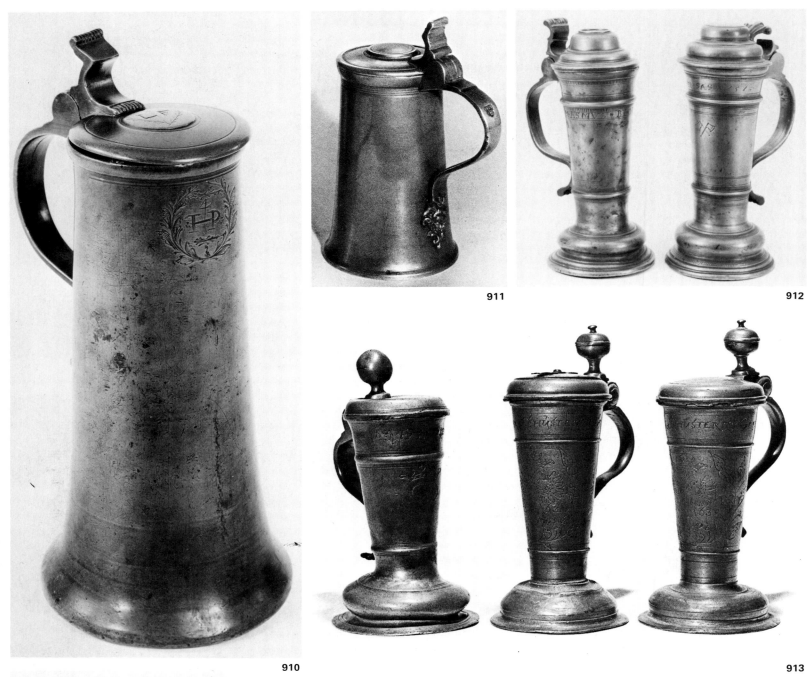

910

911

912

913

914

915

STRAIGHT SIDED TANKARDS WITH DOMED LIDS

916

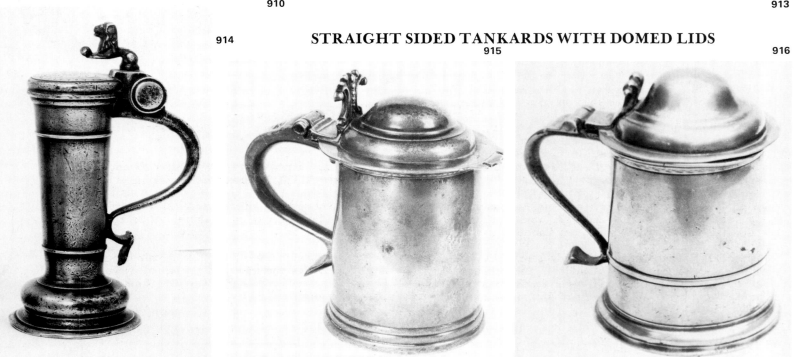

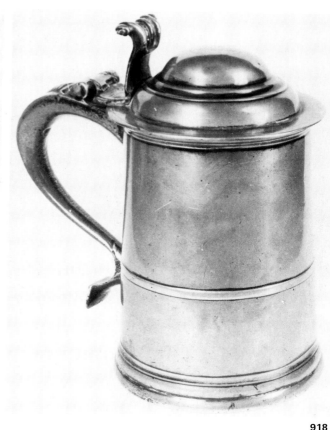

918

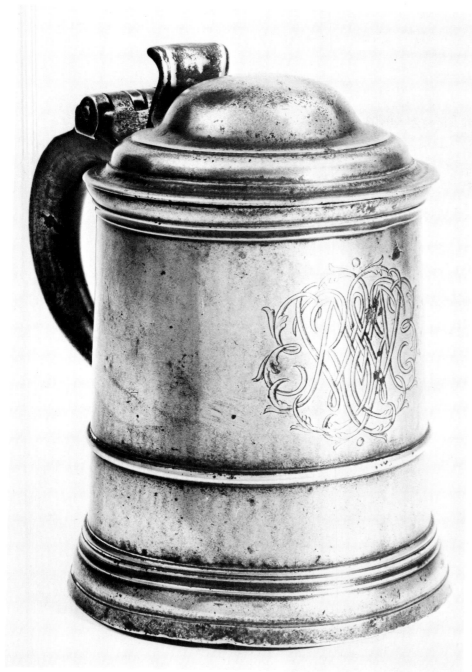

917

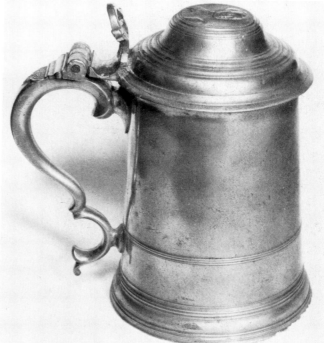

919

910. Taller German tankard of a form also found in Austro-Hungary, Munich, 10 inches high, circa 1730. (Courtesy of Sotheby Parke Bernet).

911. Another small footed tankard with decorated panels, and engraving, mid-seventeenth century. Austro-Hungarian. (Courtesy of Robin Bellamy Ltd).

912. Two fine tapering tankards or "Roerken". Left: By H. Helmcke of Lubeck, dated 1653 on body, 8½ inches high. Right: By H. Helmcke again and inscribed to 1656, 8¼ inches high. (Courtesy of Sotheby Parke Bernet).

913. Three further roerkens, German eighteenth century, from 7½ to 8¼ inches high. All used as guild drinking tankards. (Courtesy of Dr. Fritz Nagel).

914. Mid-eighteenth century north German tankard by Otto of Lubeck, 9 inches high. Note the unusual thumbpiece. (Courtesy of Sotheby Parke Bernet, London).

915. Early dome lidded tankards sometimes had the crenulated lip found on flat-lidded Stuart tankards and often similar thumbpieces. This is an English domed lidded tankard of circa 1690. (Courtesy of Robin Bellamy Ltd).

916. Another version of the domed lidded English tankard, circa 1700–20 with high dome. (Courtesy of Robin Bellamy Ltd).

917. A fine domed tankard by Spicer, 7 inches high, English, circa 1720. (Courtesy of Sotheby Parke Bernet).

918. As the eighteenth century progressed domed tankards became taller. This is an example of circa 1730–40. English. (Courtesy of Robin Bellamy Ltd).

919. A rare domed tankard with cast medallion on lid. This is of John Wilkes, the reformer, English by Townsend and Griffin, 7 inches high, circa 1777–1800. (Collection of Mr. Charles V. Swain).

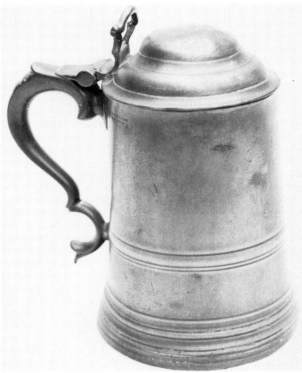

920

921

922

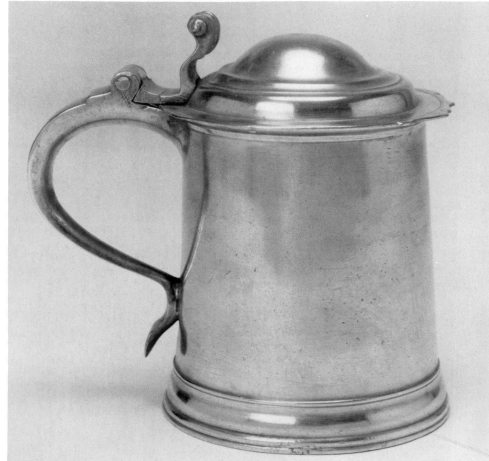

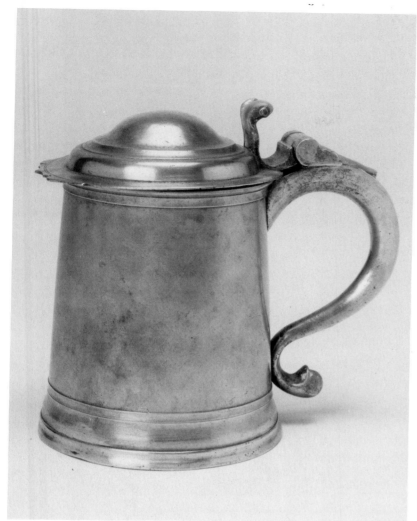

925

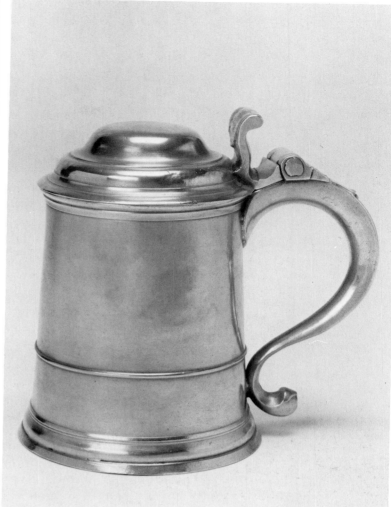

926

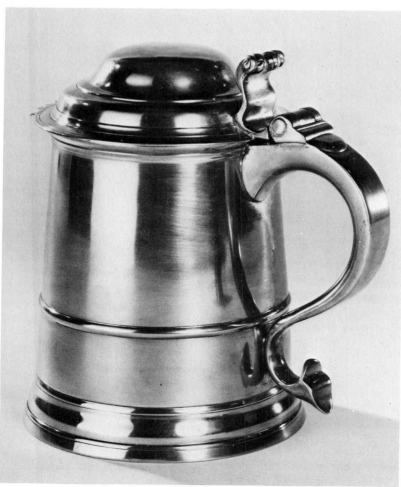

927

920. A late eighteenth century domed tankard with open chair thumbpiece and tall body, 8½ inches high, circa 1780. English. (Courtesy of Robin Bellamy Ltd).

921. A fine tankard by John Will, American, circa 1750—60, the body decorated with wrigglework. (Courtesy of the Metropolitan Museum of Art, New York. Gift of Mrs. Blair in memory of her husband J. Insley Blair).

922. The crenulated lip appears on American flat-lidded tankards during the eighteenth century although it has disappeared on British examples by 1710. Another tankard by John Will, 6 7/8 inches high, circa 1750—60. (Courtesy of Christies, New York).

923. Plain bodied domed tankard, American, by Henry Will, circa 1760—80, 6 7/8 inches high. (Collection of Dr. and Mrs. Melvyn Wolf).

924. Another American example by William Bradford, New York City, first half of the eighteenth century, 7 inches high. (Courtesy of Christies, New York).

925. The plain body with crenulation, on an American tankard by Cornelius Bradford, 1750—80, 6 7/8 inches high. (Courtesy of Christies, New York).

926. Fine American quart tankard, by Francis Bassett II, circa 1760—1780, 6½ inches high. (Courtesy of Christies, New York).

927. Three and half pint tankard by Frederick Bassett, 7¾ inches high, American circa 1760—90. (Collection of Dr. and Mrs. Melvyn Wolf).

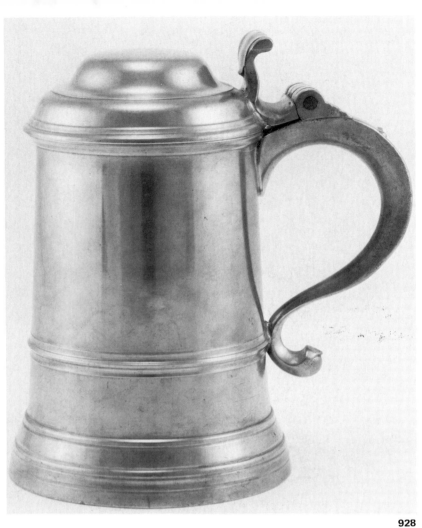

928. Taller American double domed tankard by T.D. & S. Boardman, circa 1820, 8 inches high. Later American tankards still retain ball terminal and thumbpieces found on early examples. (Collection of Dr. and Mrs. Melvyn Wolf).

929. Two Philadelphia tankards. Left: By Parkes Boyde, 7½ inches high, circa 1800. Right: By Robert Palethorp, 7 3/8 inches high, circa 1820. The flat top domed lid and reeded body are typical of Philadelphia tankards and come from a popular form found in Scandinavia. (Courtesy of Christies, New York).

930. Another example of this type of American tankard, with "Love" marks, probably circa 1780—1800. (Collection of Dr. and Mrs. Melvyn Wolf).

931. Pint tankard by Bonynge, Boston, circa 1730—50, 5½ inches high. American. (Collection of Dr. and Mrs. Melvyn Wolf).

932. Late American tankard by Wildes of New York, 7½ inches high, circa 1830—40. (Collection of Mr. Charles V. Swain).

933. English Tulip tankard with domed lid, 8½ inches high, circa 1730—50. (Courtesy of Robin Bellamy Ltd).

928

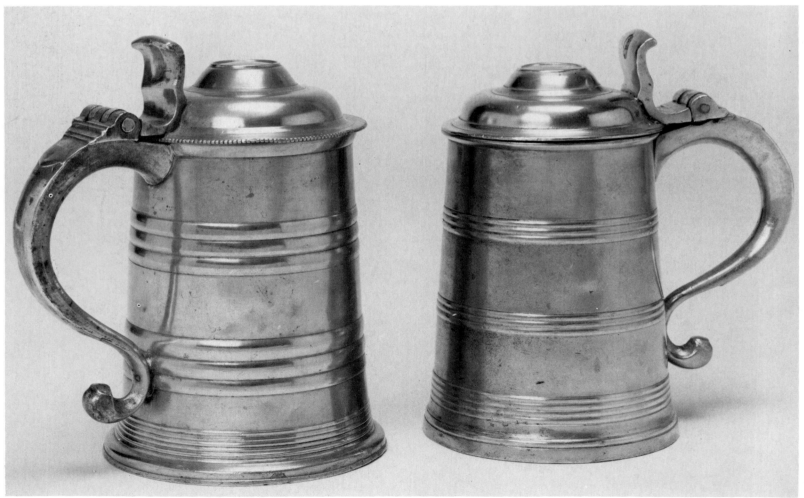

929

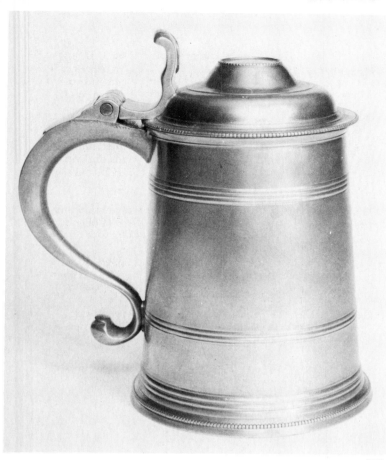

930

931

ROUNDED TANKARD FORMS

932

933

275

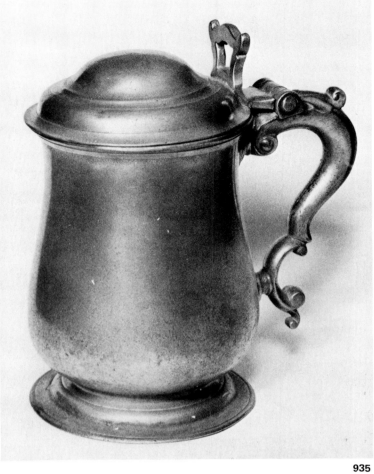

934

935

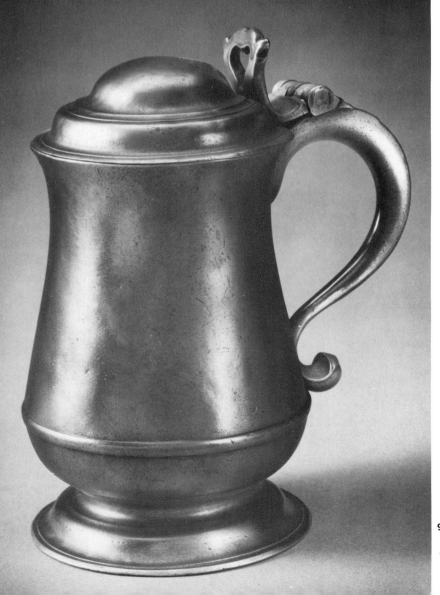

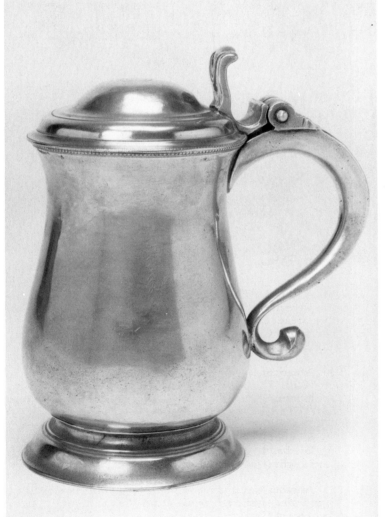

936

937

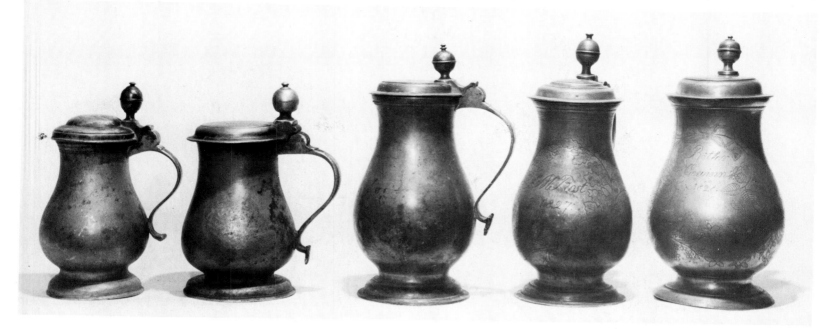

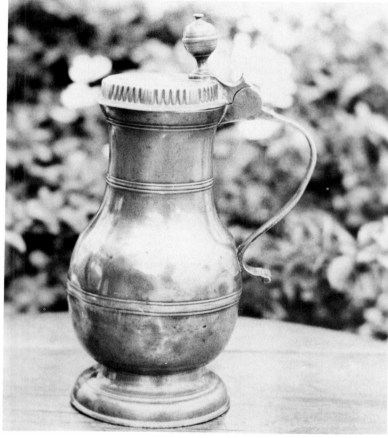

939

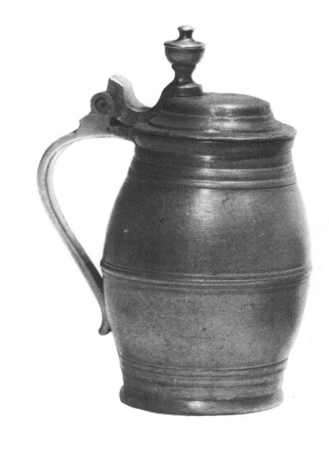

940

934. A later English tulip tankard. Many examples of this form were made in Bristol but they are also found from all other areas. Open chair thumbpiece and less pronounced body form. Circa 1770—90. (Courtesy of Robin Bellamy Ltd).

935. American "open" chair thumbpiece tulip tankard by John Will, 7 inches high, circa 1750—70. The broken handle form is seldom seen on British examples. (Collection of Mr. Charles V. Swain).

936. Another American tulip with more elongated body and with low band, by William Will, circa 1760—1800, 7 7/8 inches high. (Courtesy of Colonial Williamsburg).

937. Another tankard by William Will, with fine beeding around rim, late eighteenth century, 7 7/8 inches high. (Courtesy of Christies, New York).

938. A group of typical German and Austro-Hungarian pear shaped tankards. Most examples have the ball thumbpiece shown here. From left to right: Circa 1768, 10¼ inches high. Breslau, circa 1712, 10¼ inches high. Circa 1800, 12½ inches high. Circa 1820, 12¾ inches high. Circa 1820, 12¾ inches high. (Courtesy of Dr. Fritz Nagel).

939. Taller German tankard with decorated lid, 13 inches high, circa 1750. (Courtesy of Robin Bellamy Ltd).

940. Barrel shaped tankard, Bohemia, Germany early nineteenth century, 6¼ inches high. (Courtesy of Dr. Fritz Nagel).

Thumbpieces

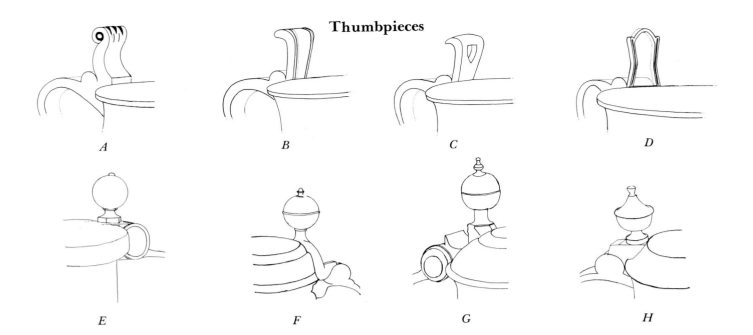

A

B

C

D

E

F

G

H

MOSTLY FOUND ON TANKARDS.

A. Decorated scroll, often similar to less well worked rams horn. English 1680—1750.

B. Scroll, found on domed tankards especially, British and American eighteenth century.

C. Cut or decorated scroll, British and American, eighteenth century.

D. Open chair thumbpiece, British and American late eighteenth century particularly.

E. Plain ball, European eighteenth and nineteenth centuries.

F. Ball with slight knop, Europe eighteenth and nineteenth centuries.

G. Knopped ball, Europe eighteenth and nineteenth centuries.

H. Shaped "ball", Europe, mostly eighteenth century.

LIDLESS TAVERN MUGS

Seventeenth and Early Eighteenth Century

Lidless Tankards

941. English Stuart lidless tankard with heavy banded body, William III capacity mark on rim, 5½ inches high, circa 1689—1700. (Courtesy of Sotheby Parke Bernet).

942. Queen Anne Tavern Pot, English circa 1705 and with very rare Queen Anne capacity mark on side. By "E.M." 6 5/8 inches high. (Courtesy of Worshipful Company of Pewterers, London).

943. Unique tavern mug, inscribed "John Little at ye Horse and Jockey in Reading. 99" and "If Sold Stole". Made by Henry Frewin of Reading, 6 3/8 inches high, circa 1690—99. English. (Collection of Mr. C. Minchin).

944. High fillet on tall straight sided early eighteenth century tavern pot, English circa 1720. (From the Law Collection).

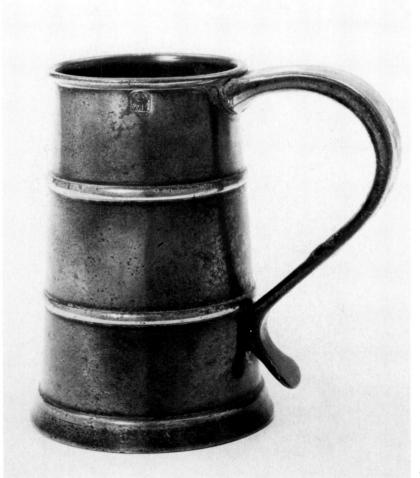

941

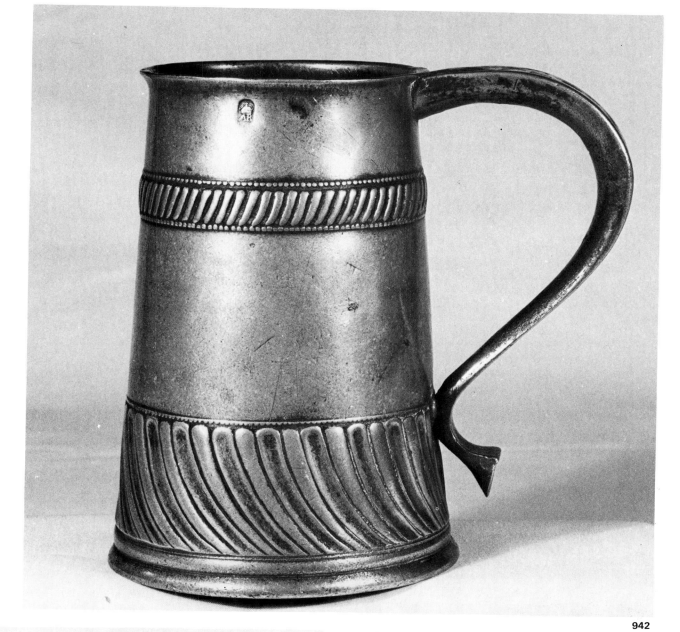

942

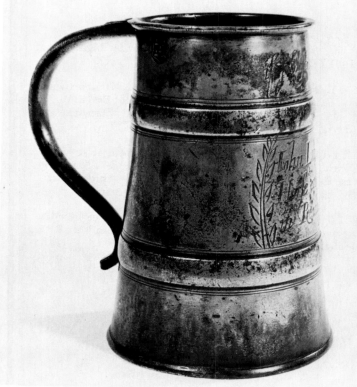

943

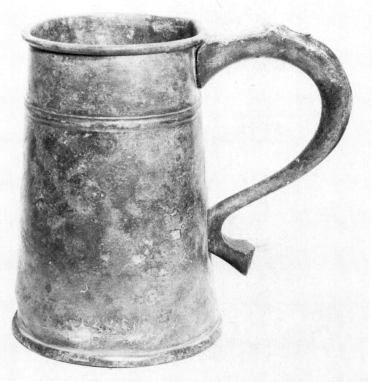

944

279

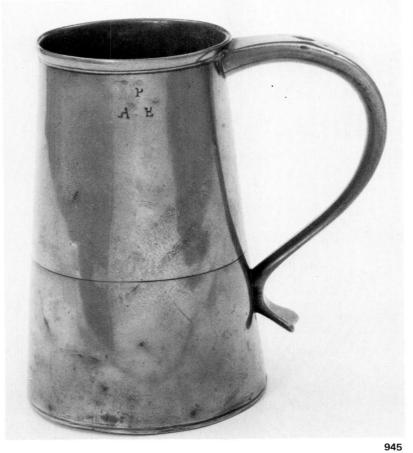
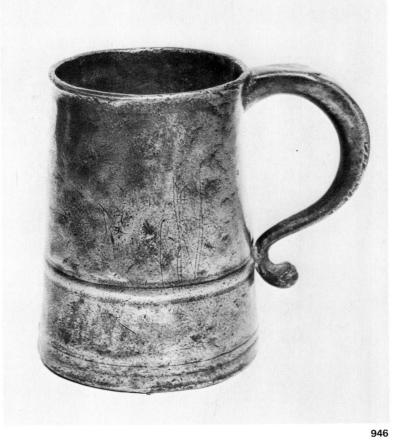

945

946

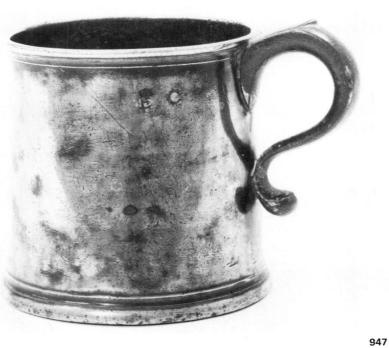
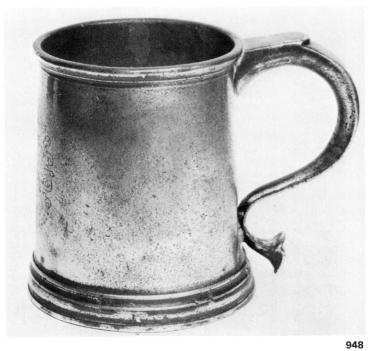

947

948

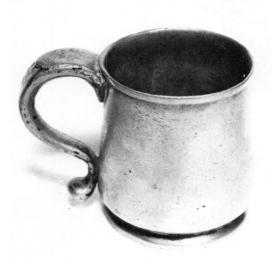
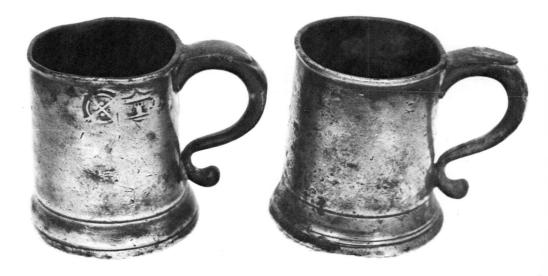

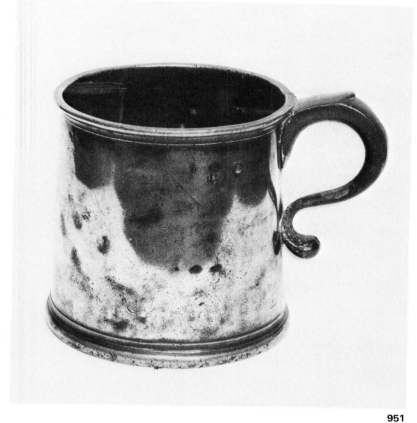

945. English ale standard quart tavern pot, circa 1680—1700. (Courtesy of Sotheby Parke Bernet).

946. Low fillet English pot by "IG", circa 1720. Pint capacity. (From the Law Collection).

947. Rare squat English mug, 3 5/8 inches high, of Winchester wine standard, circa 1720. (Courtesy of Sotheby Parke Bernet).

948. Early eighteenth century straight sided pint by William Eddon, circa 1720—30. (Collection of Dr. Law).

949. Ball terminal half pint English mug, 3 inches high, second half of eighteenth century. (Collection of Mr. R. Dean).

950. Two straight sided half pint mugs, the one on the left with Newcastle capacity check mark. Late eighteenth century. (Courtesy of Robin Bellamy Ltd).

951. Squat late eighteenth century English mug". (From the collection of Dr. Law).

952. Two banded pint by T. Phillips, circa 1790. (Collection of Dr. Law).

953. A variety of pint form, Yorkshire, 4¾ inches high, circa 1820. (Collection of Mr. R. Dean).

951

STRAIGHT SIDED MUGS

From the mid-eighteenth century into the nineteenth century straight sided mugs tended to predominate. They are found in a variety of forms, with plain and banded bodies, with different handles and terminals.

All eighteenth century examples are rare but there are probably more American examples than British.

English Examples

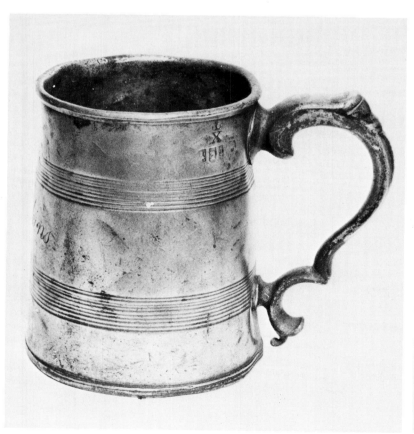

952

281

953

954

955

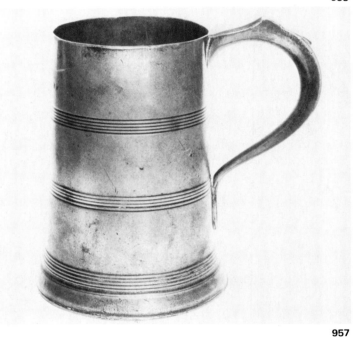

956

957

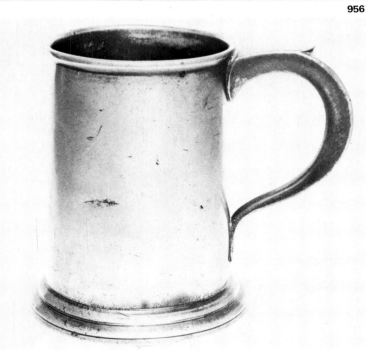

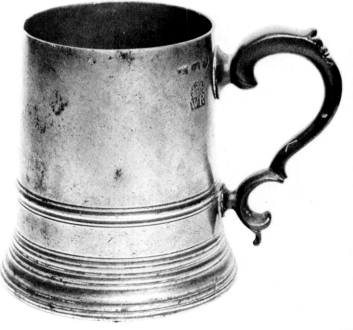

958

959

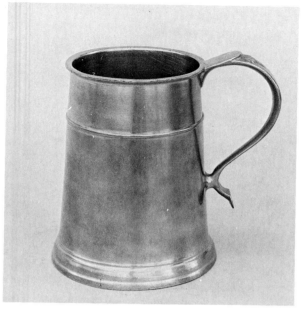

960

961

962

954. Quart mug by R. Stanton, presumably holding 6d of wine or strong ale, circa 1820—40. (Collection of Dr. Law).

955. Two further examples of typical English mugs circa 1820, with early form of handle to body joint. (Collection of Dr. Law).

956. Straight sided quart with banding at base, circa 1830. (Courtesy of Robin Bellamy Ltd).

957. Quart with three sets of banding, attention handle join at base of handle. By Ingram and Hart. Has glass bottom. The earliest forms of glass bottomed mugs are circa 1770—90 but few examples date before 1830. Early nineteenth century. Wine standard. (Collection of Dr. Law).

958. A variety found in Newcastle, or north of England, circa 1800—30. (Collection of Dr. Law).

959. Another glass bottomed pint, by Sam Cocks with William III capacity marks, early nineteenth century. (Collection of Dr. Law).

960. American straight sided mug by Robert Bonynge or Bonning, Boston, circa 1740—50. (Collection of Dr. and Mrs. Melvyn Wolf).

961. Two further mugs. Left: By Peter Young, New York, last quarter of eighteenth century, 4 1/8 inches high. Right: By William Will, late eighteenth century, 4¼ inches high. (Courtesy of Christies, New York).

962. Two mugs, both American. Left: Attributed to Robert Bonynge, circa 1740—50, 6 1/8 inches high, with "heel" terminal. Right: By Samuel Hamlin, late eighteenth century, 6 inches high. (Courtesy of Christies, New York).

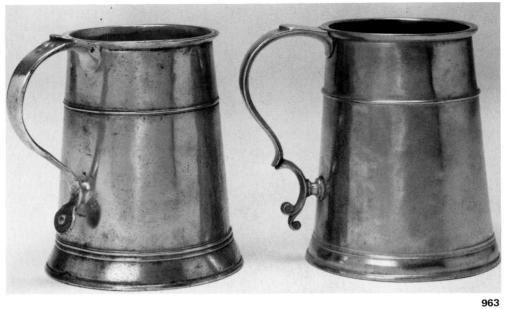
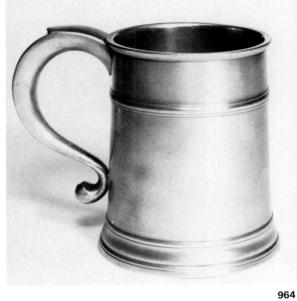

963

964

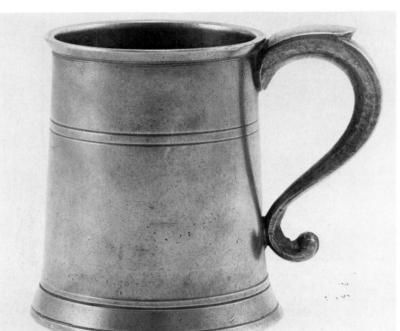
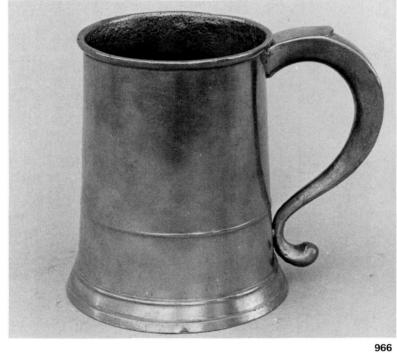

965

966

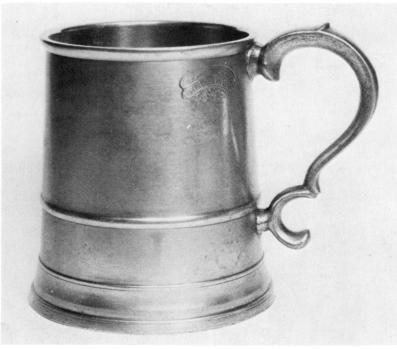
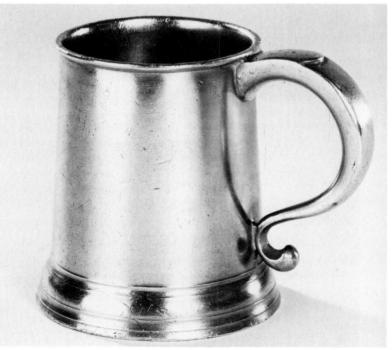

967

968

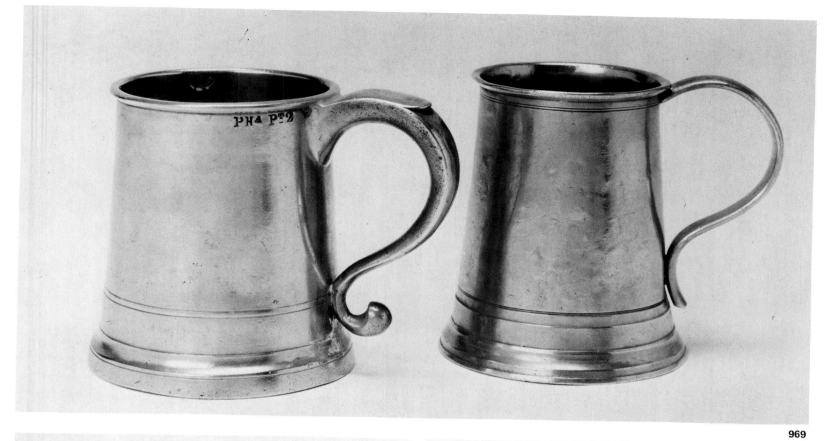

969

970

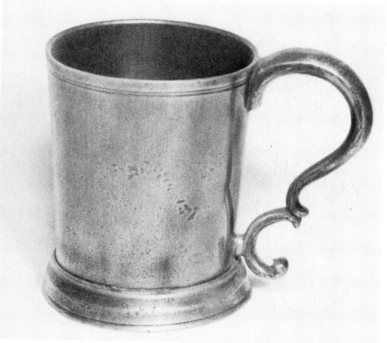

971

963. Two interesting mugs, quart capacity. Left: By Nathanial Austin, with typical terminal to handle, 6 inches high, late eighteenth century. Right: New England mug and rare "broken" or "double C scroll" handle, circa 1780—1800. (Courtesy of Christies, New York).

964. Pint mug by Fred Bassett, 4 5/8 inches high, American, circa 1780. (Collection of Dr. and Mrs. Melvyn Wolf).

965. Another mug, by S. Danforth, circa 1800, pint, 4½ inches high. (Collection of Dr. and Mrs. Melvyn Wolf).

966. Mug by Joseph Danforth, 5 7/8 inches high, American, circa 1780. (Collection of Dr. and Mrs. Melvyn Wolf).

967. Mug by S. Hamlin, American, circa 1780—1800. (Collection of Mr. and Mrs. Merrill G. Beede).

968. Pint mug by George Caldwell, American, 4 3/8 inches high, circa 1790. (Collection of Dr. and Mrs. Melvyn Wolf).

969. Two mugs. Left: Tapered drum with reeding by R. Palethorp, early nineteenth century, 4¼ inches high. Right: By William McQuilkin, circa 1840, 4¼ inches high. (Courtesy of Christies, New York).

970. Small mug, 3¾ inches high by J. Weekes, circa 1830—40. (Collection of Dr. and Mrs. Melvyn Wolf).

971. Slightly tapering mug by Hall and Cotton, 4¼ inches high, circa 1840. (Collection of Charles V. Swain).

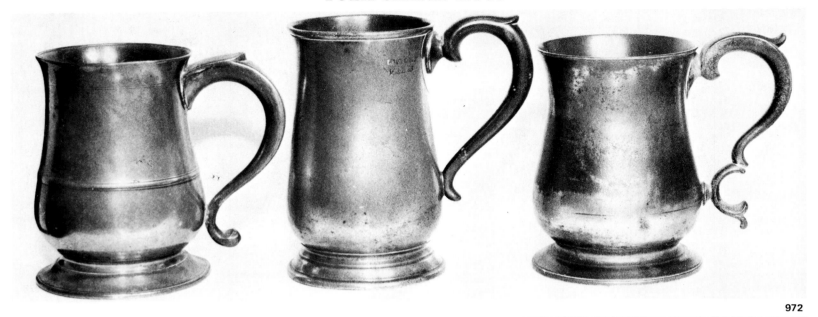

972

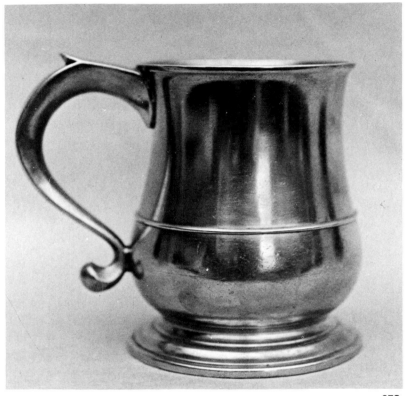

973

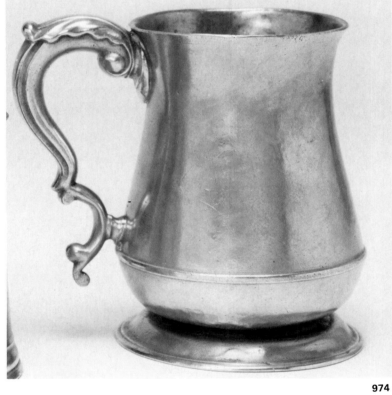

974

975

976

977

978

MAINLY NINETEENTH CENTURY FORMS

The Rounded or Belly Style

Perhaps the most popular shape of tavern mug. Pre-Imperial (prior to 1826) examples do exist but most mugs of this form are mid to late nineteenth century. They can be found from gallon downwards and in the smaller sizes below half a gill there are a variety of fractional capacities. It is possible to construct a dating sequence of styles within this form, with the plain bodied examples with ball terminal being the earliest but not too much reliance must be placed on style differences as many are not chronological changes but stem from the maker who often had small individual quirks of form that they established.

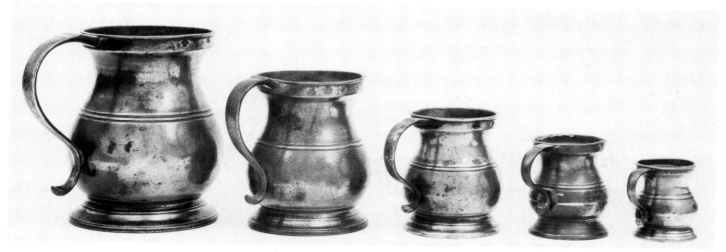

979

972. Three English tulip quarts. Left: Circa 1750. Middle: By Charles Bentley, early nineteenth century. Right: By Schofield of Birmingham, circa 1840. (Collection of Dr. Law).

973. American tulip of pint capacity, by Bonyng (Bonning) of Boston, 5 inches high, circa 1730 – 60. (Collection of Dr. and Mrs. Melvyn Wolf).

974. Fine tulip, American, with cast decorated handle, by William Will, last quarter eighteenth century, 6 inches high. (Courtesy of Christies, New York).

975. English banded tulip pot, half pint capacity, circa 1760. (Courtesy of Robin Bellamy Ltd).

976. Rare tulip mug with wooden handle, English, probably circa 1780 although the form appears earlier. (Courtesy of Robin Bellamy Ltd).

977. Scottish mug, of broadly similar style to the tulip. By Galbraith, 5 inches high, circa 1830. (Collection of Dr. Law).

978. The proof that James Dixon & Son did make cast pewter. This tulip shaped quart, 6 7/8 inches high is by this company, early nineteenth century. (Courtesy of Country Life Antiques).

979. A set of fine English "belly" measures from quart to half gill, mid-nineteenth century. (Courtesy of Sotheby Parke Bernet).

287

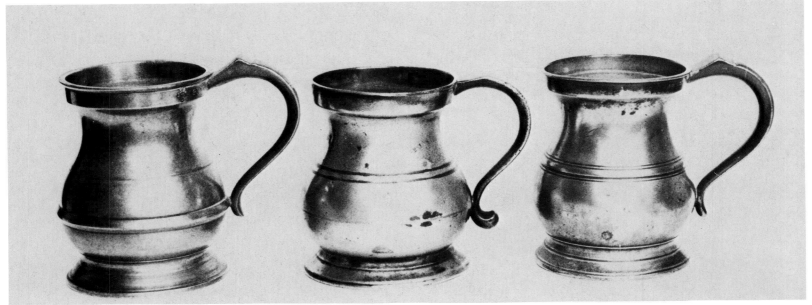

980

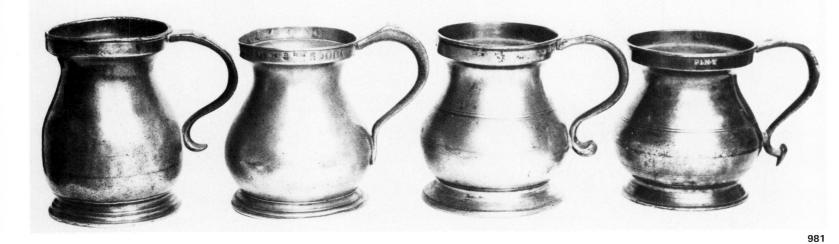

981

OTHER BASICALLY NINETEENTH CENTURY FORMS

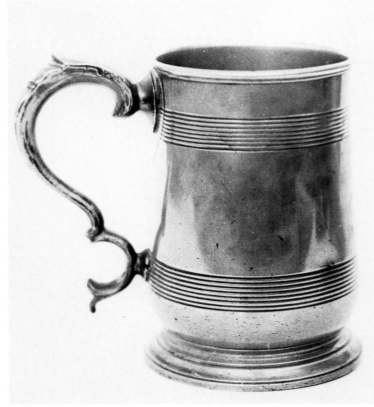

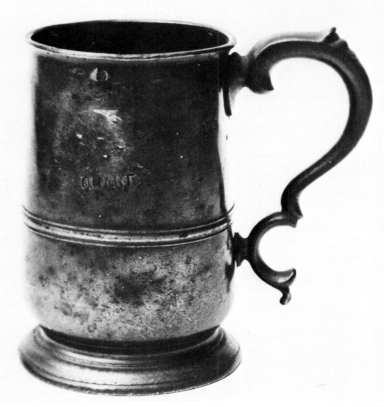

982

983

Thrill at the many secrets
you'll discover at the History Center

And while you're here, be sure and take some secret
treasures home with you from our gift shops:

❖ The Center Shop
❖ The River Bend Trading Post
❖ Carriage House Book Store

$1.⁰⁰ OFF ADMISSIO

Copshaholm,
The Oliver Mansion

THE NORTHERN INDIANA
CENTER FOR HISTORY

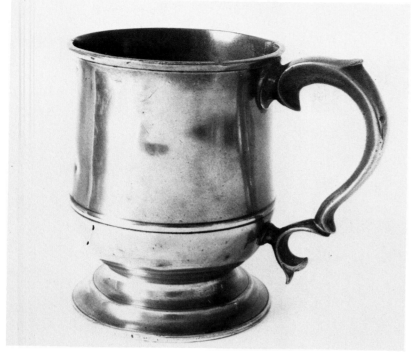

984

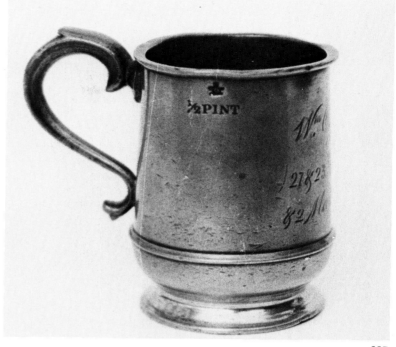
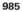

985

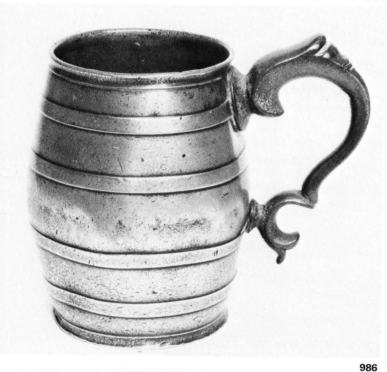

986

987

980. Three further varieties of this major form. All English and circa 1840—60. All are pints. (Collection of Dr. Law).

981. A group of four further examples, English, pint capacity. Left to right: London. Wigan. Unknown. Bristol or west of England. All mid-nineteenth century. (Collection of Dr. Law).

982. "U" shaped quart, English, first half of the nineteenth century. (Courtesy of Robin Bellamy Ltd).

983. Most "U" shaped mugs are post Imperial as is this example. English, circa 1840. (Courtesy of Robin Bellamy Ltd).

984. A Scottish ale measure, or mug, circa 1800, pint capacity, OEWS or Mutchkin, 4 5/8 inches high. (Collection of Dr. D. Lamb).

985. "U" shaped mug with waisted foot, circa 1830, English. (Courtesy of Robin Bellamy Ltd).

986. Rare barrel shaped mug by Gerardin & Watson, circa 1830, English. (From the Law Collection).

987. Rare mug in the "bottle" capacity series. This is a half "bottle", 3 3/8 inches high, nineteenth century. Probably post Imperial. (Collection of Mr. P. Kydd).

988. Waisted straight sided Scottish mug by mid-nineteenth century maker, 6 7/8 inches. Typical widely made form. (Collection of Dr. Law).

988

LATE TAVERN MUGS

A group of forms used in the last half of the nineteenth century. Some of these forms first appeared by the 1840's but many were still in production around 1900.

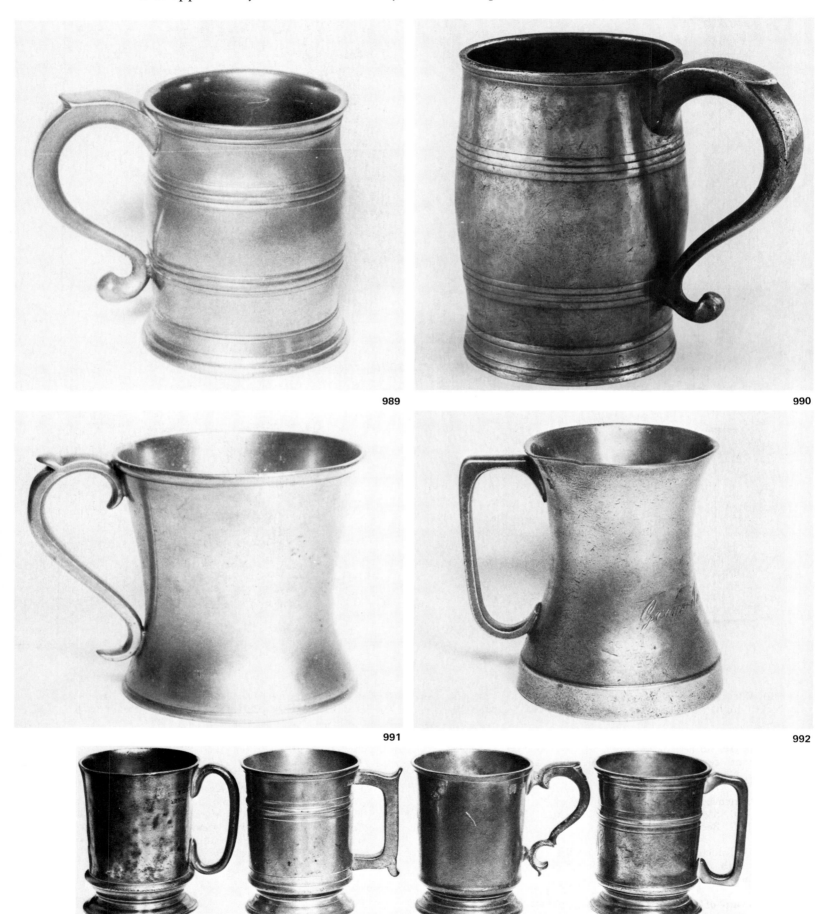

989

990

991

992

993

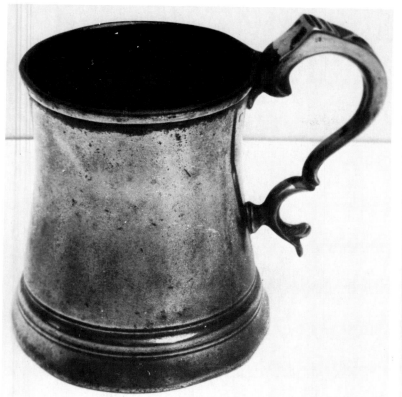

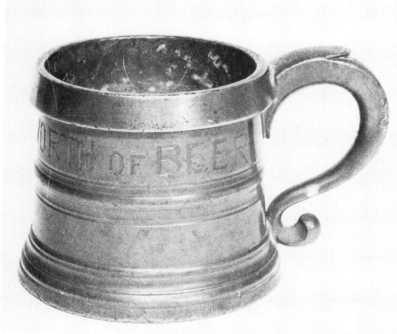

994

995

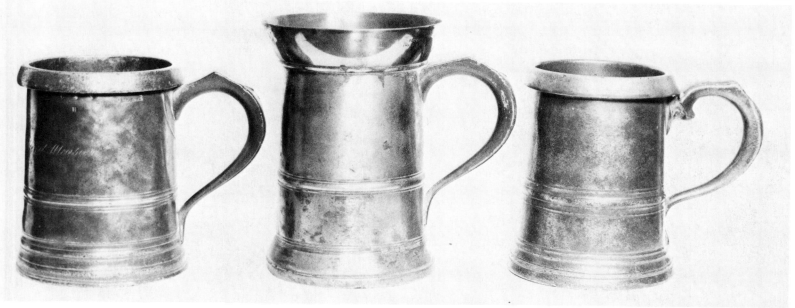

996

989. Barrel shaped mug, American, by Parkes Boyd, 4¼ inches high, circa 1800—20. (Collection of Charles V. Swain).

990. Barrel shaped mug, American, by Parkes Boyd, early nineteenth century. (Courtesy of the Metropolitan Museum of Art, New York. Gift of Joseph France).

991. Concave sided mug, American, by R. Gleason, circa 1840—50, 3½ inches high. (Collection of Mr. and Mrs. Merrill G. Beede).

992. English concave sided mug from the Grove Tavern, 4¾ inches high. After 1840. (Collection of Mr. and Mrs. Robert E. Asher).

993. Group of four straight sided pints all English circa 1850—1900. Made left to right; by Bentley, Acton, Heath, and Loftus. (From the Law Collection).

994. More restrained concave mug, with "broken" handle, circa 1840—50, English. (Courtesy of Robin Bellamy Ltd).

995. A small brass rimmed measure, English, 2 7/8 inches high, circa 1850 onwards, interestingly inscribed "One Penny worth of Beer". (Private collection).

996. Three English mugs each with an extended rim, made at time of manufacture to take the froth on the ale. Probably a "selling" point during the mid to late nineteenth century for pewterers with their customers the publicans. From left to right the rims are extended with pewter, copper and brass. (From the Law Collection).

OTHER DRINKING VESSELS

Two Handled Loving Cups

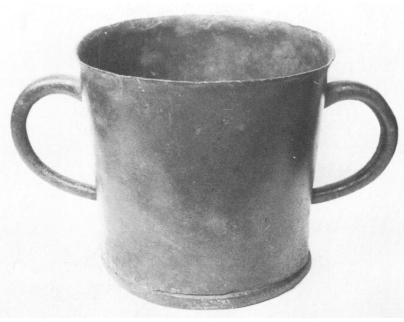

997

997. Straight sided two handled loving cup, late seventeenth century. English, 5¾ inches high. Such cups are also known as posset cups. Wrigglework examples are also recorded and cups with fish tail handles are known. (Collection of Mr. P. Kydd).

998. Two handled cup by "IL" circa 1690—1710. English, 5 7/8 inches high. (Courtesy of Colonial Williamsburg).

999. A similar English loving cup but with more elaborate handles. Fleur de lys mark, 5½ inches high, circa 1700. (From the Law Collection).

1000. A loving cup of pint size by William Hux, circa 1700, English. (From the Law Collection).

1001. A two handled loving cup by Robert Bonynge of Boston, circa 1740. See two drinking cups with the same body form. Numbers 1054 and 1055. American. (Collection of Dr. and Mrs. Melvyn Wolf).

1002. Two handled cup, 4 7/8 inches high, possibly by Richard Meddom, English, circa 1685—1700. The two handles are reminiscent of those also found on the continent. (Collection of Mr. C. Minchin).

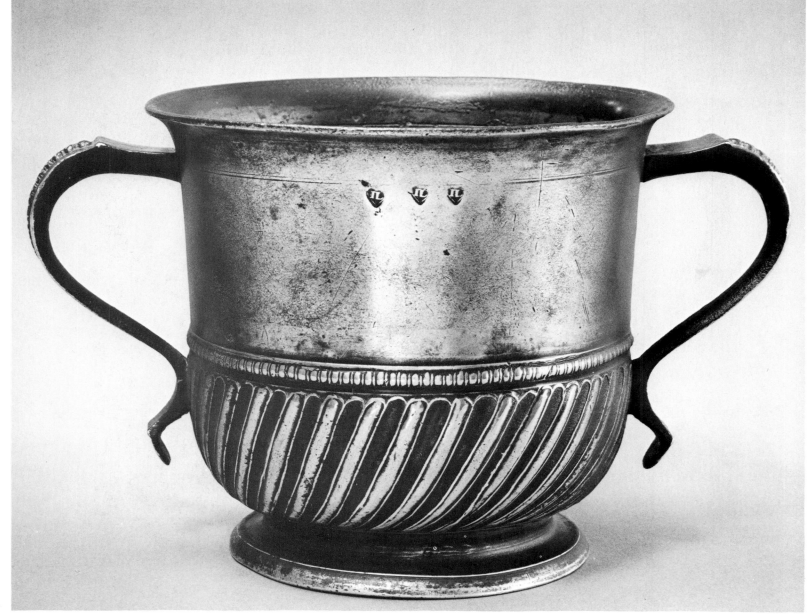

998

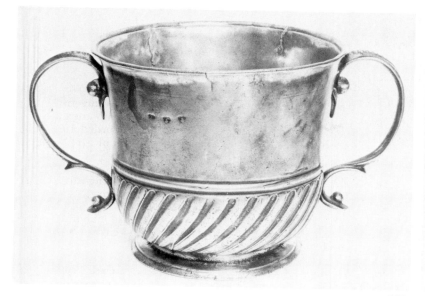

999

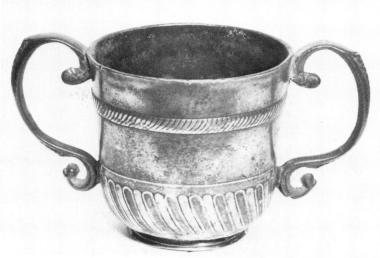

1000

1001

1002

1003. Two handled cup, English, possibly by Charles Tough of London, circa 1700, 4 5/8 inches high. (Courtesy of Colonial Williamsburg).

293

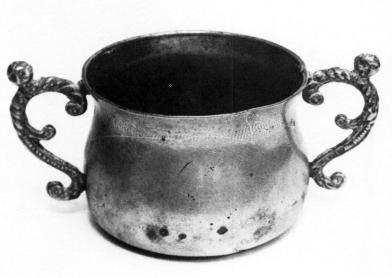

1004

1005

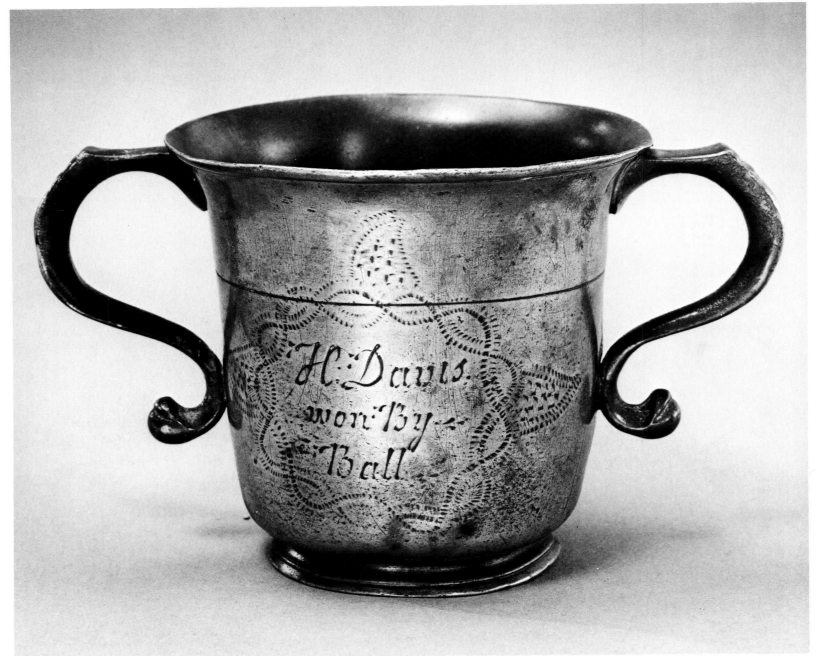

1006

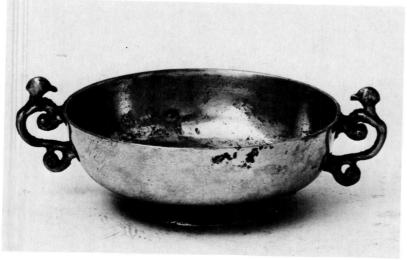

1007

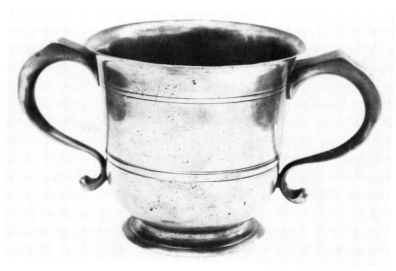

1008

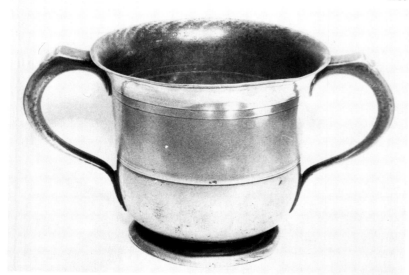

1009

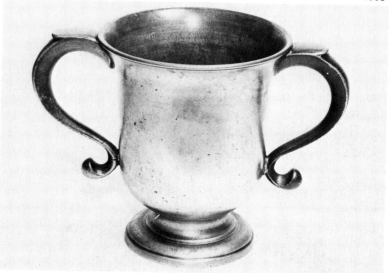

1010

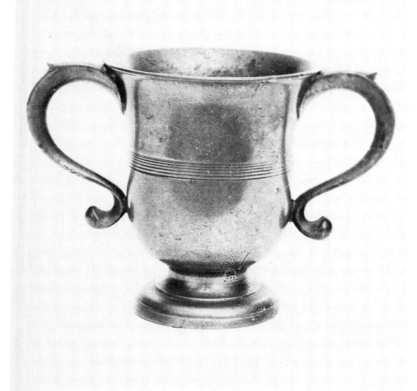

1011

1004. Very similar cup early eighteenth century from Hungary. Almost identical cups are also recorded from Scandinavia and attributed to other areas of Europe. (Courtesy of Hungarian National museum, Budapest).

1005. Rare two handled cup by WI, circa 1660, 6½ inches maximum width. (From the Bradshaw Collection).

1006. Loving cup, English, around 1725, 4 inches high. Attributed to Wigan. (Courtesy of Colonial Williamsburg).

1007. French loving cup, first half of eighteenth century. (Courtesy of P. Boucaud).

1008. Another similar cup, circa 1750, also English. This form appears only to have been made in Britain. (Courtesy of Robin Bellamy Ltd).

1009. A slightly later version, second half of the eighteenth century, 5½ inches high. (Private collection).

1010. Late eighteenth century baluster shaped two handled cup. English, 5½ inches high. (Courtesy of Robin Bellamy Ltd).

1011. A similar cup with incising, circa 1800, English. (Courtesy of Robin Bellamy Ltd).

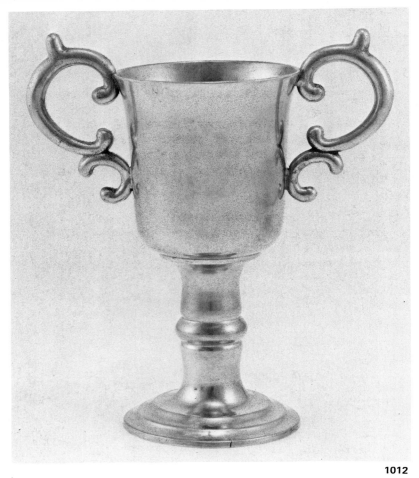

1012

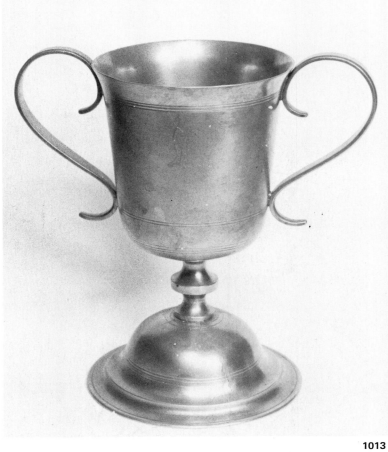

1013

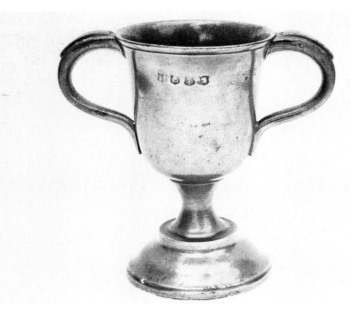

1014

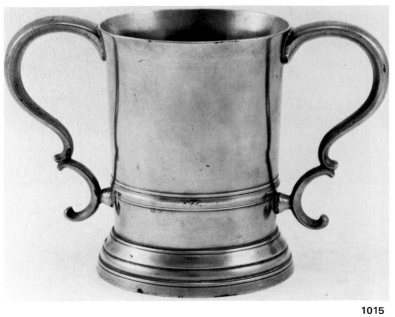

1015

1016

1017

DRINKING CUPS WITH ONE HANDLE

1018

1019

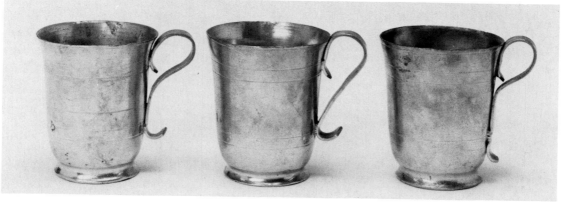

1020

1012. A two handled cup, perhaps used as a chalice. Attributed to the Boardmans. American, early nineteenth century, 8½ inches high. (Collection of Dr. and Mrs. Melvyn Wolf).

1013. A two handled loving cup attributed to Trask, American, circa 1800—40, 6½ inches high. (Collection of Mr. and Mrs. Merrill G. Beede).

1014. A very similar two handled cup, English, circa 1800, 6 inches high. (Courtesy of Robin Bellamy Ltd).

1015. Two handled cup, probably used in a church, by Thomas Danforth Boardman, nineteenth century, 5 inches high, American. (Collection of Dr. and Mrs. Melvyn Wolf).

1016. Small flat two handled cup or bowl, English but examples also occur in the low countries. Eighteenth century. (Courtesy of Robin Bellamy Ltd).

1017. A two handled cup or bowl, similar in form to broth bowls from England, circa 1700—40, English, 4 inches high. (Courtesy of Robin Bellamy Ltd).

1018. Group of three small drinking cups, also sometimes called caudle cups. From left to right: Wine cup, circa 1680. Wrythen wine cup, circa 1700. Wine cup, late seventeenth century. (Courtesy of Worshipful Company of Pewterers, London).

1019. Group of four English footed cups, nineteenth century. From left to right: By Morgan; "R.B."; Crane; and unmarked example. (From the Law Collection).

1020. Three American footed cups, nineteenth century, 3½ inches high. (Courtesy of Christies, New York).

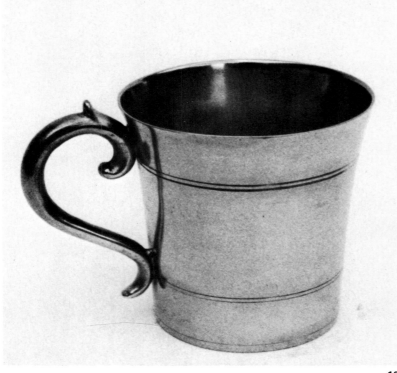

1021

1021. Another American footed cup or handled beaker, by Thomas Weekes, 2 7/8 inches high, circa 1820—40. (Collection of Dr. and Mrs. Melvyn Wolf).

1022. Rare cast decorated English beaker, with Prince of Wales feathers, circa 1600—10. (Courtesy of Robin Bellamy Ltd).

1023. Early eighteenth century Dutch wrigglework beaker, 5½ inches high. Most seventeenth century and early eighteenth century beakers have a tall flaired appearance. (Courtesy of Sotheby Parke Bernet, London).

1024. Similar engraved beaker from Germany, early eighteenth century. (Courtesy Historical Museum, Frankfurt).

1025. Two Dutch late seventeenth century beakers with wrigglework decoration, 8¾ inches high. (Courtesy of Bourgaux).

1026. Beaker, possibly American or European, eighteenth century. No marks, 5¼ inches high. (Collection of Mr. and Mrs. Merrill G. Beede).

BEAKERS

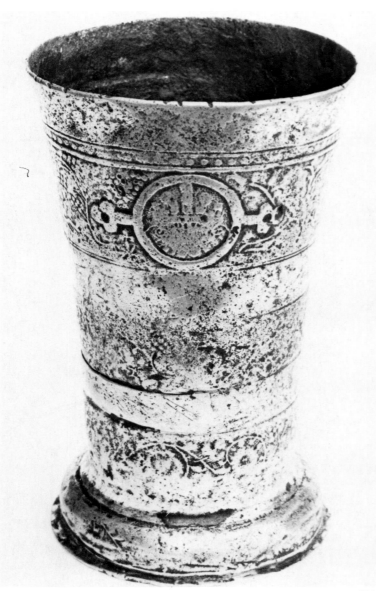

1022

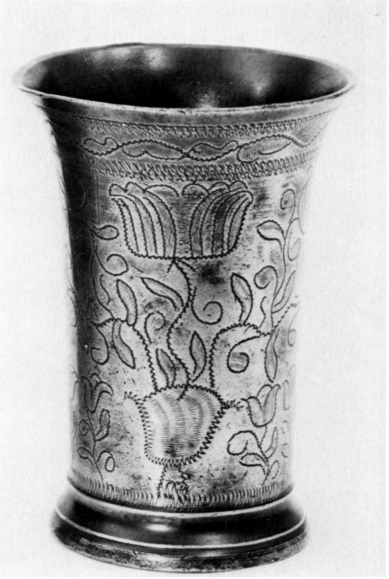

1023

1025 →

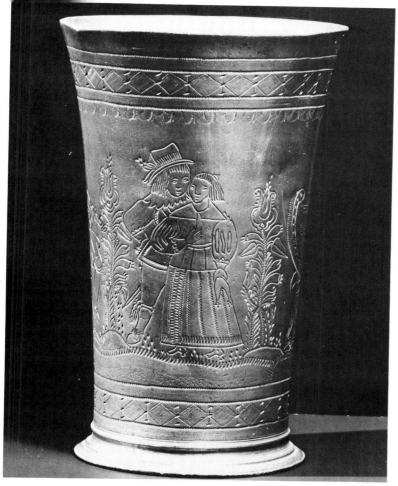

1024

1026

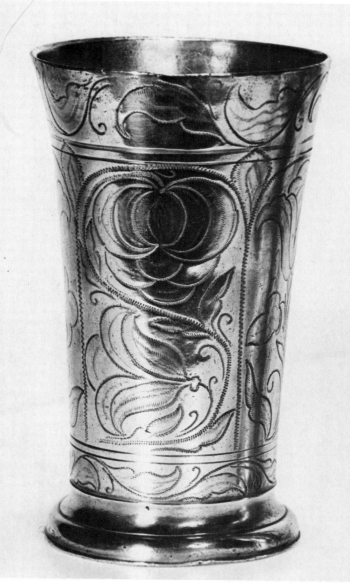
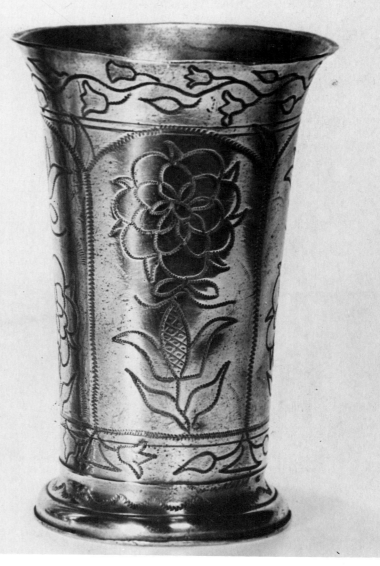

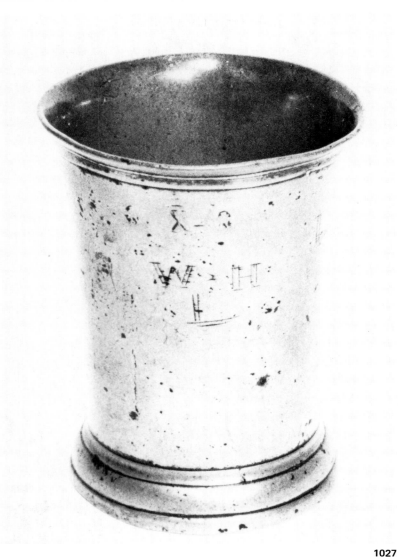

1027

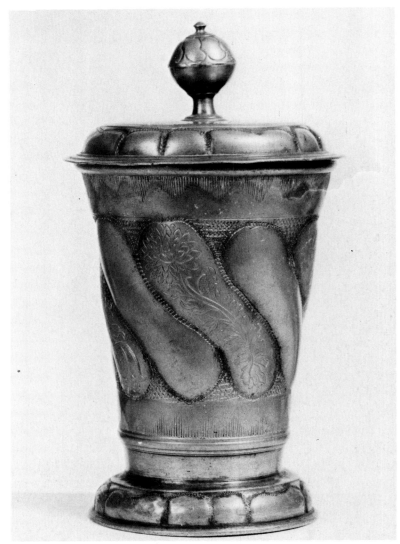

1027B

1028

1027. European beaker, no makers marks, 4 inches high, eighteenth century. (From the Law Collection).

1027B. Wrythen, lidded Polish beaker, circa 1751. (Courtesy of Narodwe Museum, Warsaw).

1028. French beaker, early nineteenth century, 4 1/8 inches high. (Courtesy of the Kunstgewerbemuseum, Cologne).

1029. Pair of tall beakers, by Timothy Boardman & Company, circa 1822—25. (Collection of Dr. and Mrs. Melvyn Wolf).

1030. Beaker by Thomas and Sherman Boardman, 5 1/8 inches hich, circa 1820—30. (Courtesy of the Metropolitan Museum of Art, New York. Gift of Mrs. Blair, in memory of her husband, J. Insley Blair).

1031. Fine beaker, perhaps used as a chalice, by J.C. Heyne of Lancaster, Pennsylvania, circa 1760, 4¼ inches high. (From the Herr Collection).

1032. Beaker by Frederick Bassett of New York, circa 1780—90, 4 5/8 inches high. (Collection of Dr. and Mrs. Melvyn Wolf).

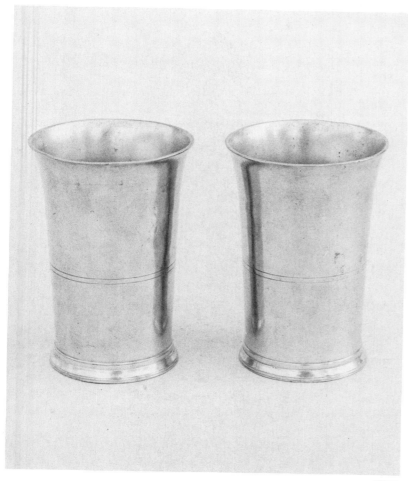

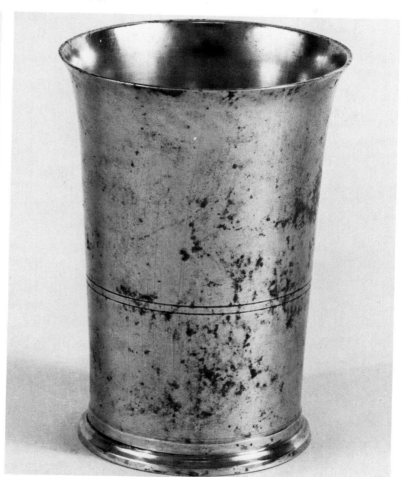

1029

1030

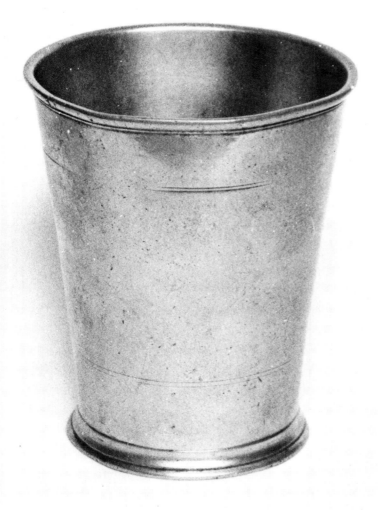

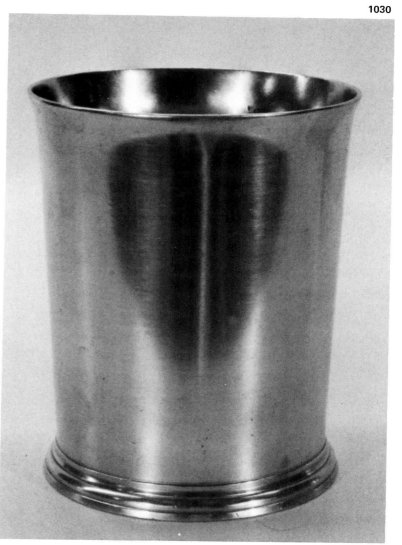

1031

1032

301

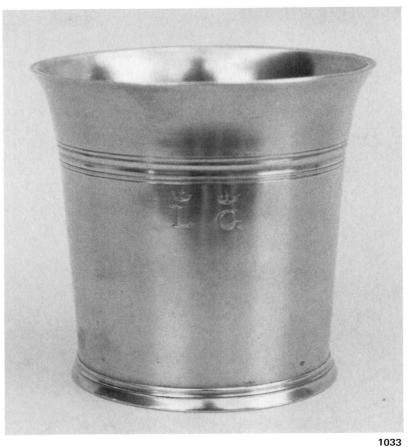

1033

1034

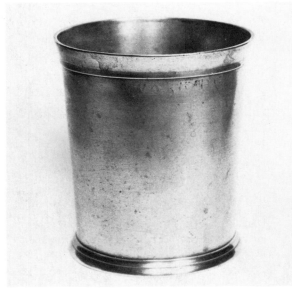

1035

1033. Beaker by Joseph Danforth, circa 1780—88, 3½ inches high. (Collection of Dr. and Mrs. Melvyn Wolf).

1034. Beaker, 3½ inches high by Samuel Danforth, circa 1800. (Collection of Mr. and Mrs. Merrill G. Beede).

1035. American beaker by GC with Eagle mark, 4½ inches high, circa 1800. (Collection of Mr. and Mrs. Merrill G. Beede).

1036. Three typical New England beakers, 2 7/8 inches high, 3 inches high & 3 1/8 inches high, circa 1800. (Courtesy of Christies, New York).

1037. British "squat" beakers; half pint capacity. Left to right: By R. Whyte, Edinburgh, circa 1820—20. Richard Yates of London, circa 1800. And with worn beaded circle mark, circa 1720. (From the Law Collection).

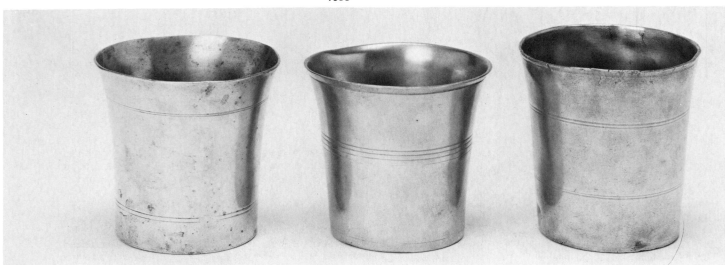

1036

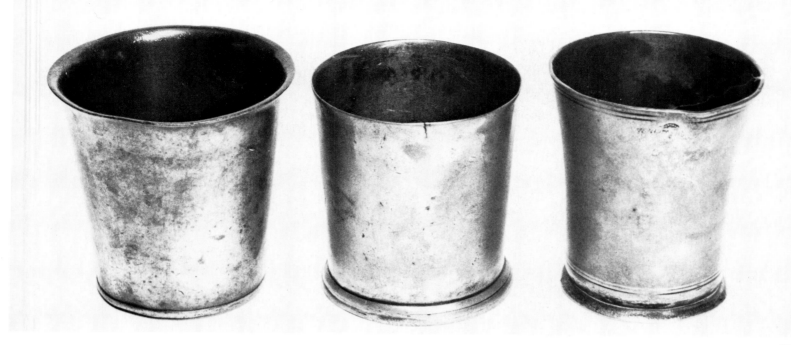

1037

1038

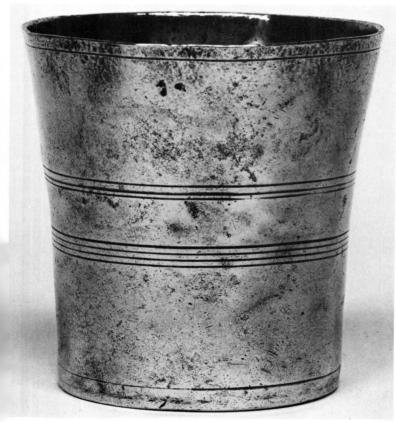

1040

1038. Further British beakers showing some of the variety of slight modifications which exist. Left to right: By Thomas Phillips of London, circa 1790—1800. Unmarked but with George IV capacity mark, circa 1826. By Stanton of Shoe Lane, London, circa 1820. By C. Watkins, circa 1830. By Francis Gerradin, circa 1820. By J. Brown, circa 1830. (From the Law Collection).

1039. Interesting beaker by Ashbil Griswold, 3 inches high, circa 1820—30. (Courtesy of the Metropolitan Museum of Art, New York. Gift of Mrs. J. Insley Blair in memory of her husband, J. Insley Blair).

1040. Group of English beakers, with short feet. All of half pint capacity. Left to right: By John Warne, circa 1830. Unmarked, circa 1840. By Loftus, circa 1850. Unmarked but probably late eighteenth century. And by Samuel Orford, circa 1820. (From the Law Collection).

1039

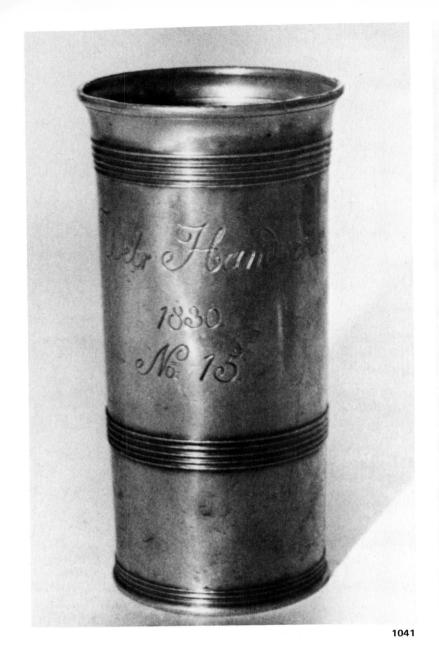

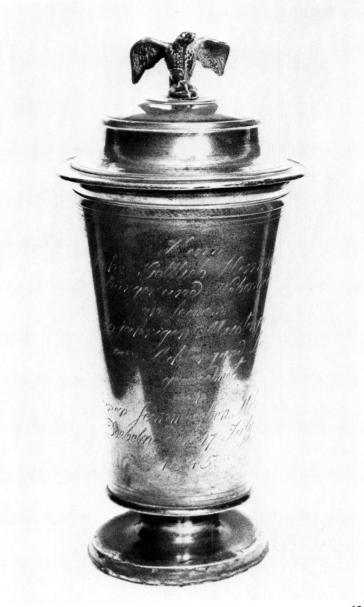

1041

1042

GOBLETS

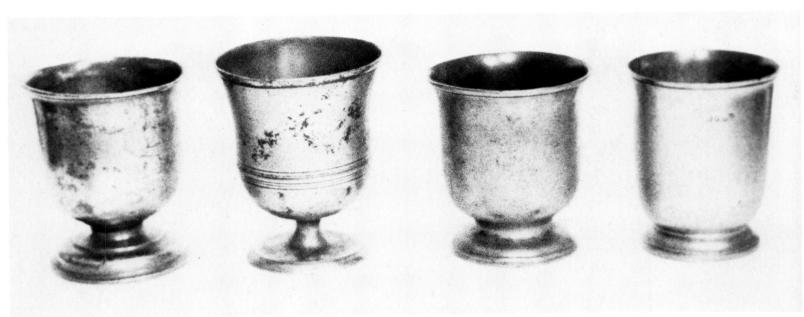

1043

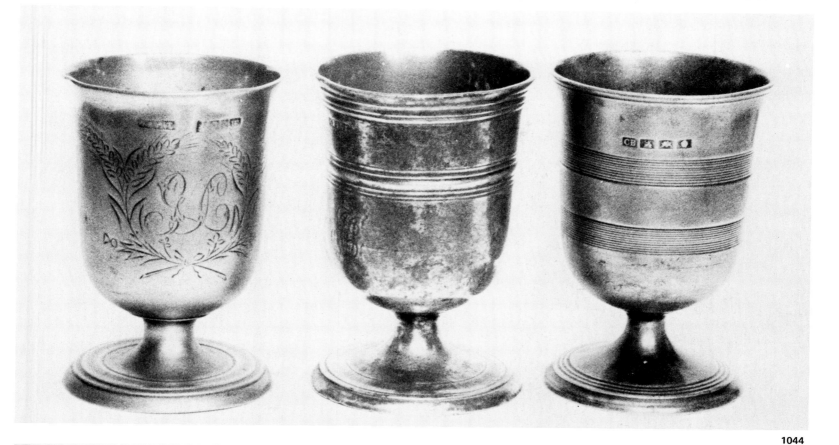

1044

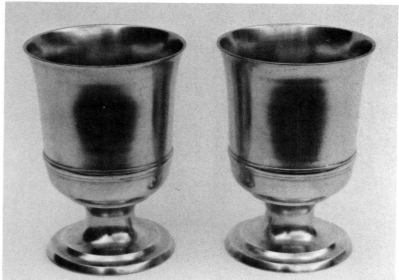

1046

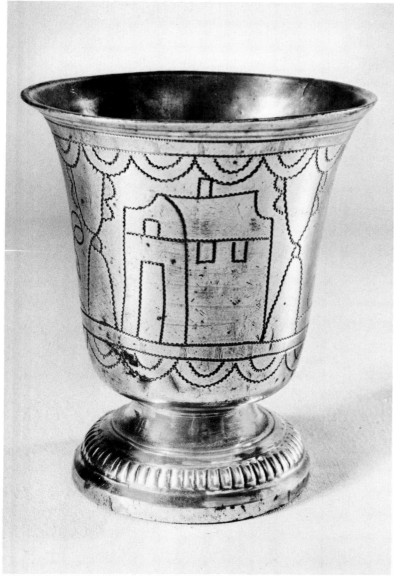

1041. Tall straight sided beaker by C.A. Gramer, circa 1830, Chemnitz, Germany, 8½ inches high. (Courtesy of Kunsthandel Frieder Aichele).

1042. Rare lidded beaker, German, dated 1845, 10½ inches high. (From the Law Collection).

1043. Four English half pint footed beakers. Left to right: By Watts and Harton, circa 1840. Unmarked, circa 1830. By King of Liverpool, circa 1830. And Townsend & Compton, circa 1800—10. (From the Law Collection).

1044. Three English footed beakers. Left to right: By James Edwards, circa 1830. Unmarked. And by Charles Bentley, circa 1840. (From the Law Collection).

1045. Fine engraved footed beaker, Paris, circa 1760. (Courtesy of Florin Dragu and Phillip Boucaud of Paris).

1046. Pair of American footed beakers, 5¼ inches high, by Boardman, circa 1820's, and 4¾ inches high. (Collection of Dr. and Mrs. Melvyn Wolf).

1045

1047

1048

1049

1050

1047. Pair of thistle shaped footed beakers attributed to Gleason, circa 1830—50, 6½ inches high. (Collection of Dr. and Mrs. Melvyn Wolf).

1048. Plain footed beaker attributed to the Boardmans, circa 1830, 4¾ inches high. (Collection of Dr. and Mrs. Melvyn Wolf).

1049. A pair of cups, possibly used as communion cups, American, attributed to Boardman, 3¾ inches high, nineteenth century. (Collection of Dr. and Mrs. Melvyn Wolf).

1050. Another small cup, possibly a travelling communion cup, unmarked American, 2 1/8 inches high, nineteenth century. (Collection of Mr. and Mrs. Merrill G. Beede).

1051. James I relief cast wine cup inscribed "Though wine be good too much of that wil make one lean though he be fat", circa 1616, 5 7/8 inches high. (Courtesy of Sotheby Parke Bernet).

WINE OR DRINKING CUPS

The difficulty of distinguishing between chalices and wine or drinking cups has already been discussed. Some of the chalices illustrated in the chapter on religious pewter may have been used domestically and it is also possible that a few of the cups shown in this chapter might have been used as chalices. That wine cups were used domestically is well established.

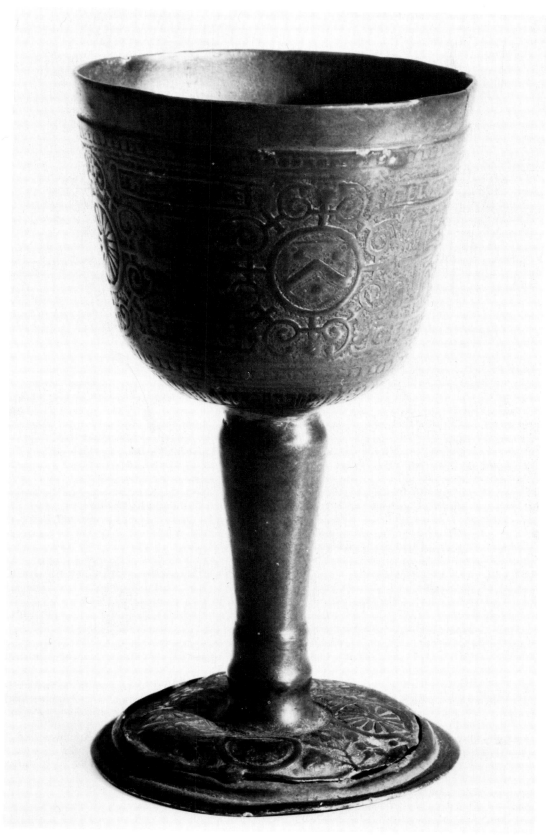

1051

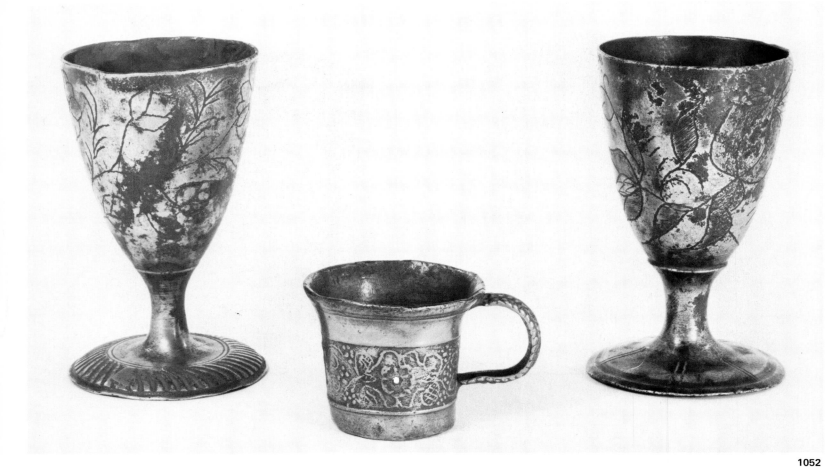

1052

1053

1052. Wine cups and a caudle cup. The wine cups are unmarked but early seventeenth century, English. The caudle cup dates from the same period and is also English although similar cups were made in Holland. (Courtesy of the Worshipful Company of Pewterers, London).

1053. A small wine cup, circa 1700, European, 3¼ inches high. (Courtesy of Robin Bellamy Ltd).

1054. Small drinking cups or possibly chalices with swirled body, very similar in style to a number of late seventeenth century caudle cups or loving cups. Probably American and early eighteenth century, 2½ inches high. (Collection of Dr. Herr).

1055. A very similar cup, but with cast swirls less well pronounced. Probably American, mid-eighteenth century, 2½ inches high. (Collection of Mr. Charles V. Swain).

1056. Small plain seventeenth century drinking cup, 2 1/8 inches high, origin uncertain but probably Dutch or English. (Courtesy of Colonial Williamsburg).

1057. Oval wine bowl, German, circa 1820. By J.C. Hohenner, from Kulmbach, 16½ inches wide. (Courtesy of Kunsthandel Frieder Aichele).

1058. Flemish wine cooler or punch bowl, late seventeenth century. Similar vessels were also made in most of Europe. (Courtesy of Bourgaux).

1054

1055

PUNCH BOWLS AND MONTEITHS

1056

1057

1058

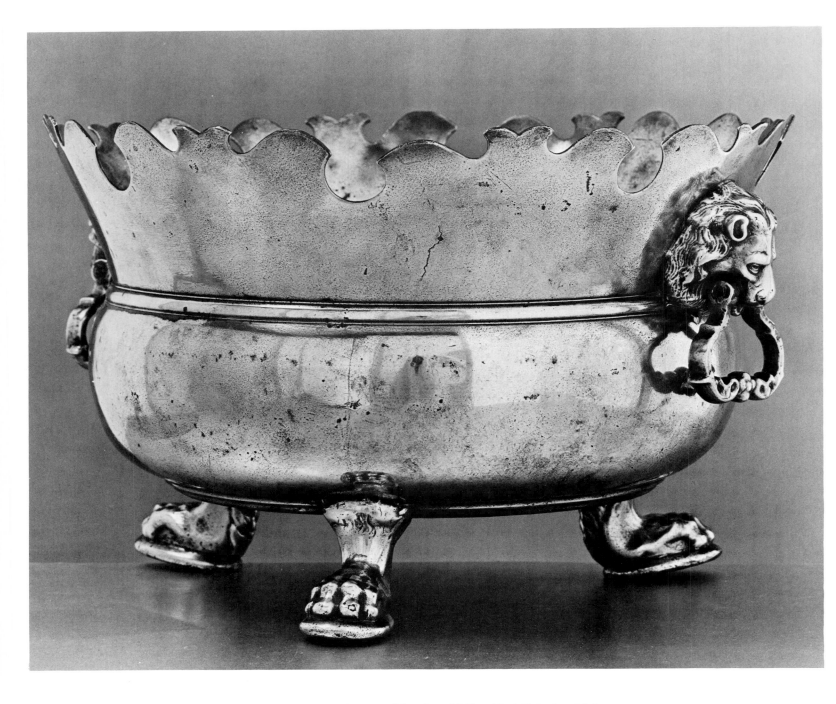

1059. A Dutch Monteith, circa 1720—40, 8¾ inches high,
unmarked. (Courtesy of Colonial Williamsburg).

CHAPTER 10

Domestic Pewter

Lighting

In the western world we are accustomed to instant and brilliant light, but such facilities are of recent origin. Domestic electricity and gas date only from the last two decades of the nineteenth century, and the widespread use of oil lamps did not develop until after the discovery of mineral oil in the 1860's. Lighting, before 1850, was thus scarce, expensive and of poor quality.

Probably the cheapest illumination was provided by rush lights.

Small oil lamps using animal or vegetable oils were popular in southern Europe and, later in the nineteenth century, wherever whale oil was easily available. Most extensively used of all were candles, of animal fats, beeswax or bayberry. These were all costly but sperm or wax candles cost three or four times those made with animal fat or tallow.

As a result most homes before 1850 were poorly lit and only in those of the well-to-do did lighting extend the hours of activity into the night.

Candlesticks

All but the late nineteenth century candlesticks made in pewter are now rare.

The rarity with which early examples occur creates problems when it comes to classification. In many cases only one or two examples of a particular form have survived and it is thus difficult to know which examples reflect major trends and which were isolated examples of only local or regional significance. Because of the very high level of losses there may well be other seventeenth century styles now wholly unknown to us.

Candlesticks of what is known as the "Heemskirk" form were widely used in the sixteenth century in Europe and they continued in use into the seventeenth century. These candlesticks had central drip pans, round bases and knopped stems. Other examples of candlesticks from this period have bases similar in outline to a bell and are thus named "bellbased" candlesticks. Rare British and European examples exist.

In the late sixteenth and early seventeenth centuries squarebased candlesticks with square stems were made in France, Scandinavia, Russia, the Baltic states and Britain.

The first uniquely seventeenth century candlestick, with a trumpet-shaped base, appeared in the 1640's. Examples with and without drip-trays were made in Britain, Holland, France and probably elsewhere.

In the 1640's a group of candlesticks with square or octagonal bases became popular. The drip-pan was placed much lower on these candlesticks than formerly and a considerable variety of stems were made.

The "ball" knop candlesticks probably appeared first in the 1630's. These candlesticks have round or shaped bases, with a substantial ball knop on the stem. They do not possess drip-trays.

There are a number of local forms which do not follow this general pattern of development.

British and American pewter candlesticks virtually disappear in the eighteenth century and examples from Europe are uncommon. Why this should have occured is far from clear. The most likely explanation is that the great popularity of brass or latten candlesticks simply drove pewter out, and time has destroyed the survivors.

In the eighteenth century bases were much flatter and were usually round, square or rectangular, while the stems were usually of baluster form. Such candlesticks were made in France, Holland, Germany and, very occasionally, in Britain.

From Sweden, Germany, central Europe and Holland come candlesticks in the wrythen form.

In the late eighteenth century candlesticks began to reappear in greater quantities. The dominant style has a round base and baluster stem, often made in Britannia metal.

In the nineteenth century candlesticks in pewter were made with oval, rectangular, square and round bases, and with plain, knopped and straight stems. It is not easy to tell where a particular candlestick may have been made due to the similarities of design used in all three areas.

There are also several interesting varieties of candlesticks found only in one particular country.

Pewter wall sconces; candleholders which are fastened to the wall, are very rare.

Chandeliers are also very uncommon in pewter and there are no known British or American examples.

Oil Lamps

Lamps burning vegetable oil were widely used in southern Europe and France, and the availability of whale oil led to the widespread use of lamps in Scandinavia and north Germany in the nineteenth century. Oil lamps do not appear to have been made in Britain although we know that whale oil was imported.

The basic European design comprises a reservoir in glass or pewter and a long stem. In some cases the fuel is supplied by capillary action, in others through gravity. Shorter, perhaps more stable, lamps are also known.

A few of these lamps have their reservoirs marked with gradations so that the passage of time could be recorded.

In the United States far more varieties of lamps are found than in Europe. Examples of the work of more than 70 makers are recorded and many made several versions, creating several hundred different forms. Only about one in five American lamps are marked.

Lamps were probably first made in America in the 1820's but lost popularity after the 1870's, when the mineral oil or "hurricane" lamp was introduced.

At first lamps were fuelled by whale oil and were provided with short burners. Later the necks are threaded and burners screwed into place. Early lamps were cast but most later ones were spun from Britannia metal.

For a time in the 1830's and 40's lamps were fuelled by solid lard oil but these were replaced by lamps lit by campharene; a mixture of turpentine and alcohol. This mixture evaporated speedily so that lamps using it had small caps to keep the gas from escaping.

American makers did make tall lamps in the European style. The other principal American forms are known as "Bull's eyes", "Bell" lamps, "Spillholder" lamps, "Swing" or hanging lamps and "nursing", "sparking" or "tavern" lamps. Six main types of reservoirs have been identified and there are variations on the type of stems used, so that there are many different forms to be found.

Inkstands

In these days of fibre-tipped and ball-point pens we are accustomed to having ready access to the means of writing. We forget the difficulties which faced our forbears.

The scribe needed ink, which he made up from a powder and his pen was a quill cut from a goose feather. Even the Victorian clerk had to have a bottle of ink at hand for use with his new steel nib.

Over the years a variety of containers were used to store ink, quills, nibs and materials for blotting the wet ink. Most desks would have possessed a "Standish" or "Inkstand".

Popular in Britain and the United States during the eighteenth century were flat desk-sets, often on ball feet, with two lifting flaps which when raised revealed two containers, one for the storage of equipment, the other for the ink and pumice or

1060. Rare bell based candlestick, English, 8½ inches high, circa 1600. (From the Little Collection).

1061. Pair of trumpet based English pewter candlesticks, by Charles Sweeting, circa 1650—60. (Courtesy of the Worshipful Company of Pewterers, London).

1062. Plain stemmed English trumpet based candlestick, mid-seventeenth century. (From the Little Collection).

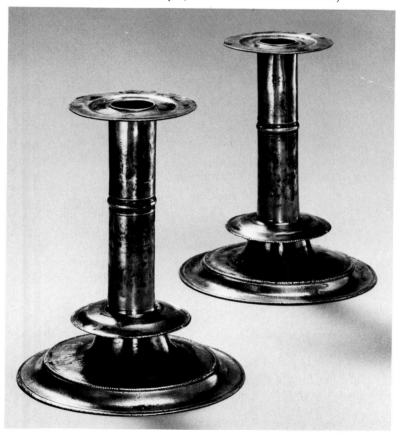

1063. Pair of fine candlesticks, with plain stems and low drip trays, 10¾ inches high, circa 1650. Probably Dutch, but with English coat of arms engraved on foot. (Courtesy of Colonial Williamsburg).

sand for blotting. These are often called "Treasury" ink stands.

Square or rectangular box ink pots were made in Britain, Ireland, the United States and in northern Europe. These eighteenth century boxes usually had two small drawers beneath the space provided for the bottle of ink.

A group of oblong boxes with lifting flaps and drawers beneath were also made in Britain and Europe from the late eighteenth century onwards.

Most British and American inkstands are plain and undecorated but in Europe shaped and cast decorated boxes were common.

Popular in the nineteenth century and reproduced in this century are a variety of round inkstands. These were made in both Britain and the United States throughout this period, those with very large bases being the most recent in origin.

Commodes

We are used to the "water closet" and the speedy and easy disposal of our bodies excreta. In earlier times this was a difficult and dirty task. Until the eighteenth century waste was thrown directly into the street, added as "night soil" to a local tip or taken away by men employed for this purpose.

Widespread use was thus made at all levels of society of "Pots" or "Commodes".

The French had a pleasant name for these utensils, calling them "Vases de Nuit" or night vases.

We tend to use the terms "Pot" and "Commode" interchangeably but more properly, a pot was used by itself and a commode hidden in a piece of furniture.

Two forms are most frequently found; the traditional rounded pot with handle, and the "Welsh Hat" style. Most European examples are of the first type and although some British pieces are similar, all American and most British pots or commodes are of the "Welsh Hat" style. William Will is recorded as offering his "Chair Pans" at $1.50 each whilst Simon Edgell's were priced at 10/-s.

The earliest rounded pots can be sixteenth century but the Welsh Hat form does not appear until about 1700.

Water Cisterns

Our forefathers' only running water came from a nearby stream. Water was seldom on tap before the early nineteenth century and the well, local river or water-cart provided what was needed.

Water had to be kept ready for use and water cisterns or fountains were popular in Europe for this purpose.

Examples from France, the low countries, Switzerland and central Europe are most frequently seen. Simple forms were popular in the nineteenth century but many interesting shapes were created in earlier periods. Only one British example is known.

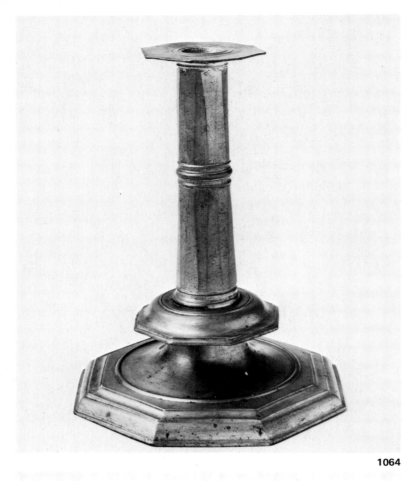

1064

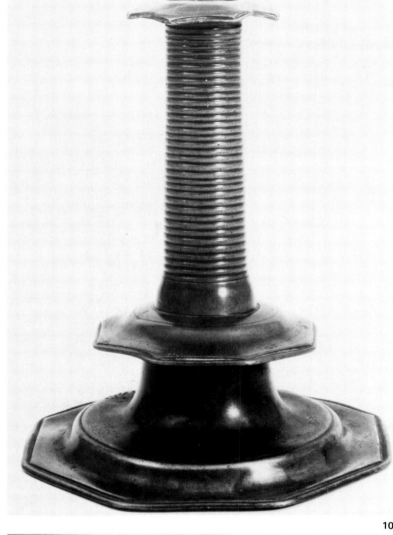

1065

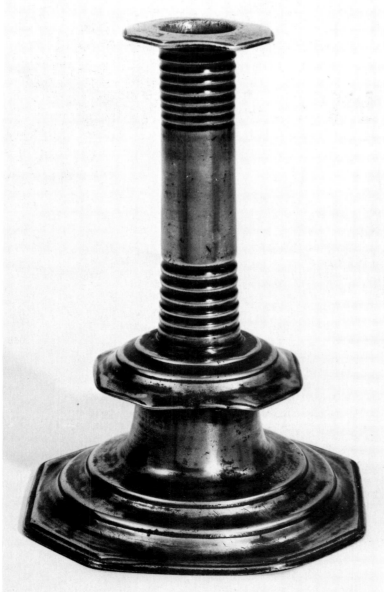

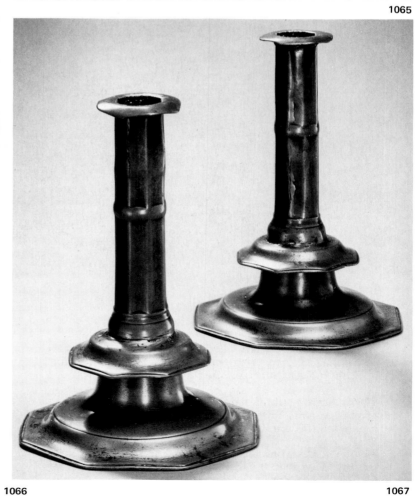

1066

1067

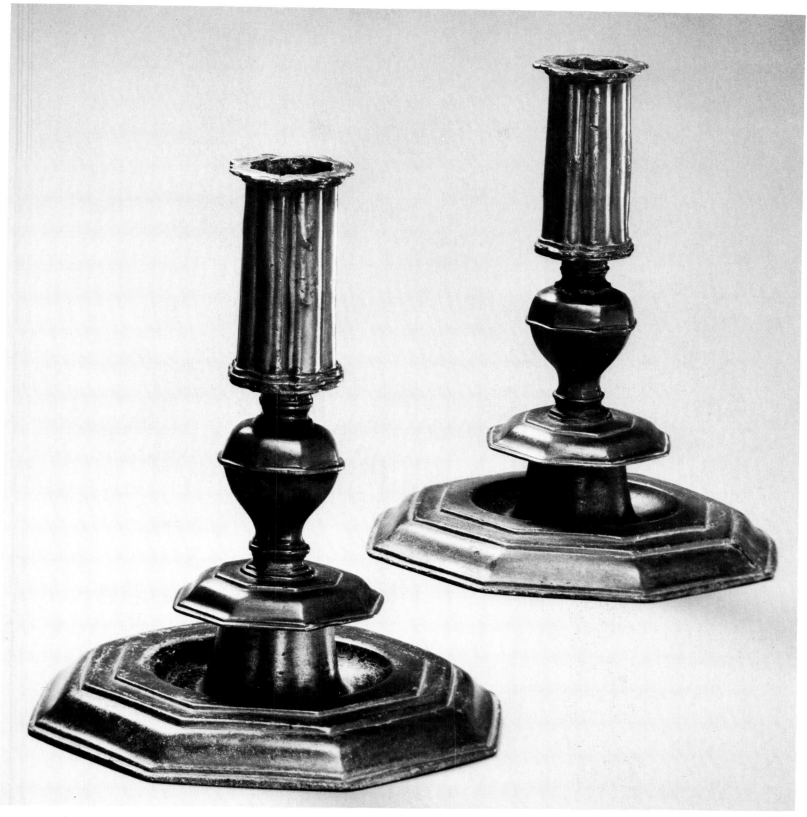

1068

1064. Scandinavian eight sided low drip pan candlestick. By M. Jonson of Stockholm, circa 1680, 10¾ inches high. (Courtesy of the Nordiska Museum, Stockholm).

1065. Narrow ribbing on Charles II English octagonal candlestick with low drip tray, by "CB" dated 1670, 7 3/8 inches high. (Courtesy of Sotheby Parke Bernet, London).

1066. Another similar candlestick but with only partial ribbing, circa 1675, English, 7 5/8 inches high. (Courtesy of Sotheby Parke Bernet).

1067. A pair of English candlesticks of similar broad form but with fluted stems. By W. Allen, circa 1680, 9 inches high. (Courtesy of Colonial Williamsburg).

1068. A rare pair of candlesticks with ball knop stem and fluted candleholder, English by Henry Quick, circa 1675, 9½ inches high. (Courtesy of Colonial Williamsburg).

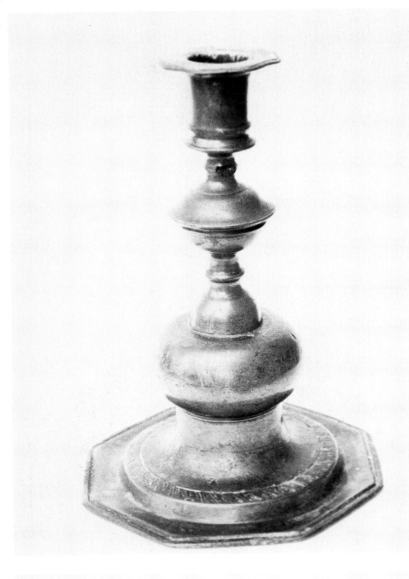

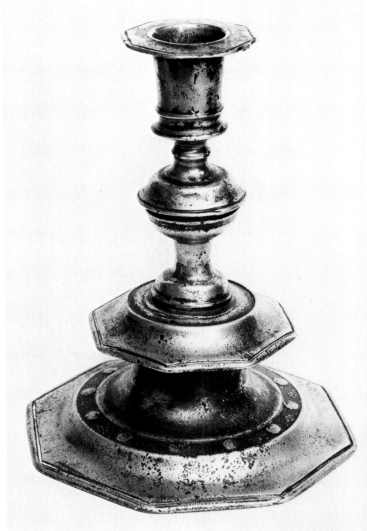

1069

1070

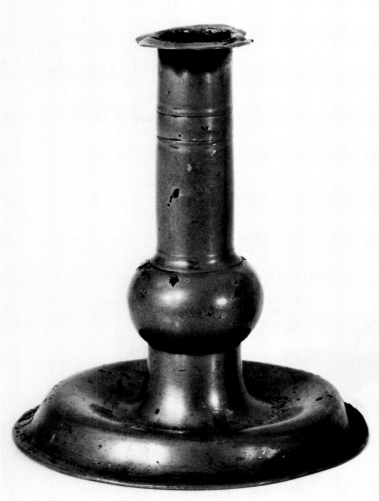

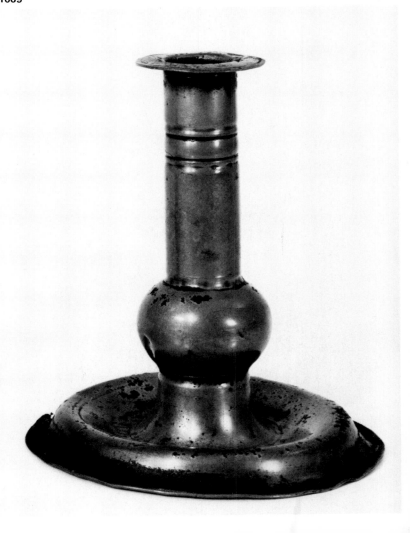

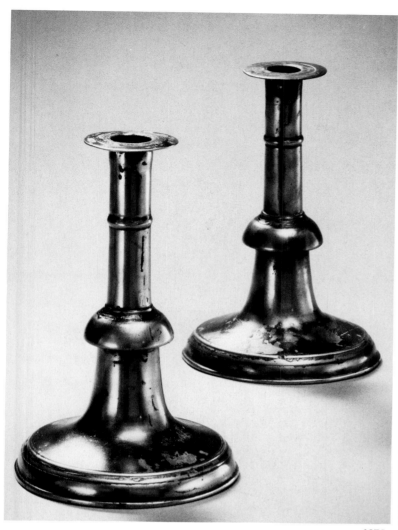

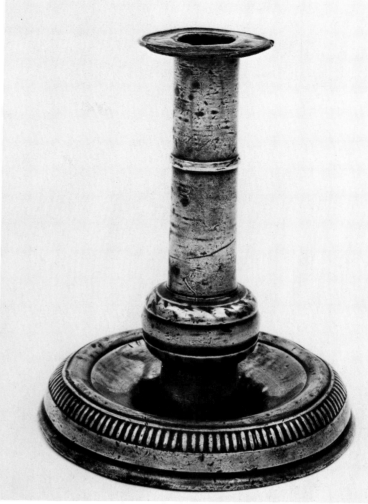

1072

1073

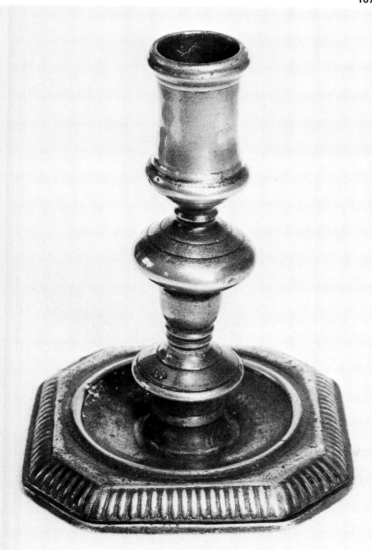

1069. A large ball knop on English candlestick, circa 1650. (Courtesy of Robin Bellamy Ltd).

1070. Eight sided base, low drip pan with ball knop, English, circa 1650—50. (From the Bradshaw Collection).

1071. Plain stemmed candlesticks with ball knops, English, circa 1670—80, 6 inches high. (From the Little Collection).

1072. Pair of English candlesticks with half ball knops, late seventeenth century, 7 inches high. (Courtesy of Colonial Williamsburg).

1073. Round based candlestick with low ball knop, English, circa 1690. Low ball knops are also found on Dutch candlesticks of the same period, 6 inches high. (Courtesy of Sotheby Parke Bernet, London).

1074. Candlestick with cast decorated base, shaped knop, English, circa 1680, by Hugh Quick, 5¾ inches high. (Collection of Mr. K. Gordon).

1074

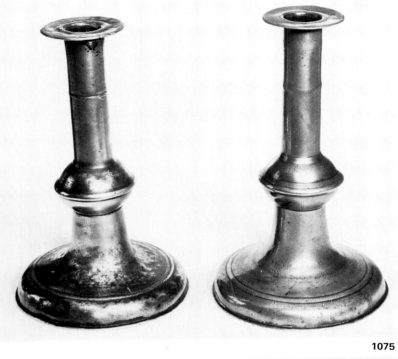

1075

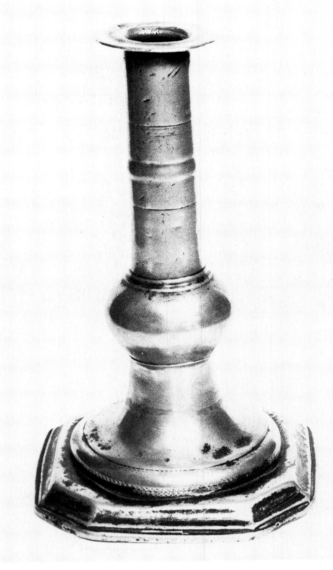

1076

1077

1075. Two round-based ball knop candlesticks, circa 1690–1710, both English, 7 7/8 inches high. (Collection of Mr. K. Gordon).

1076. Similar candlestick with square base with "cut" corners, circa 1690–1700, English, 6 inches high. (From the Kydd Collection).

1077. Pair of German tall plain stemmed candlesticks on round bases with central knop on stem, circa 1670. (Courtesy of P. Boucaud).

1078. Pair of German pricket candlesticks on round bases with knopped stems, circa 1550–1600. (Courtesy of Sotheby Parke Bernet).

1079. Group of German candlesticks. Left and extreme right: Pair, dated 1657, 17¾ inches high. Second left (with other from pair): Dated 1611, 14½ inches high. Centre: Circa 1600, 21 inches high. (Courtesy of Dr. Fritz Nagel).

1080. German seventeenth century candlesticks on ball feet. (Courtesy of Christies, London).

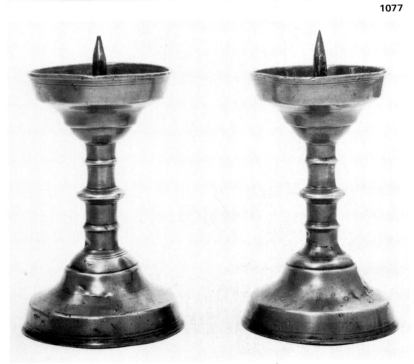

1078

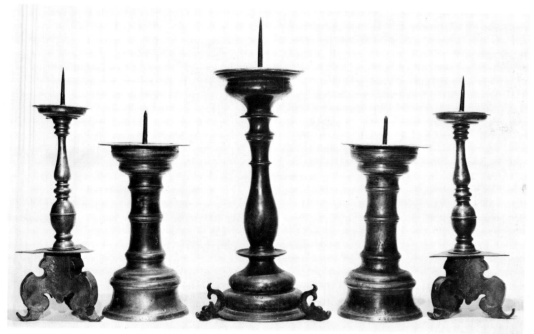

1079

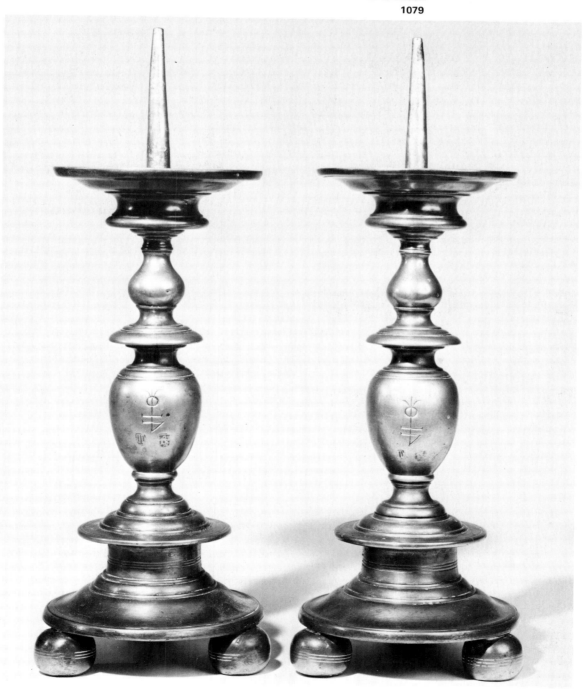

1080

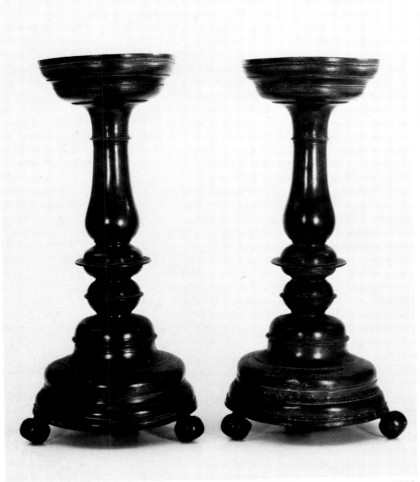

1081

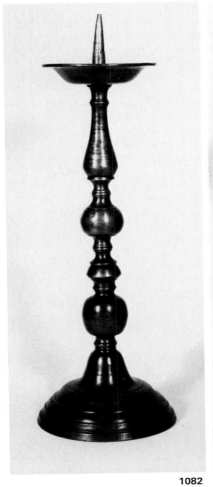

1082

1083

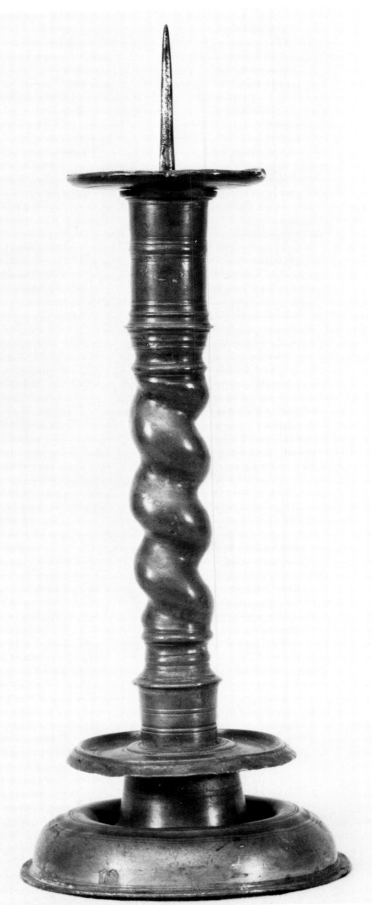

1081B

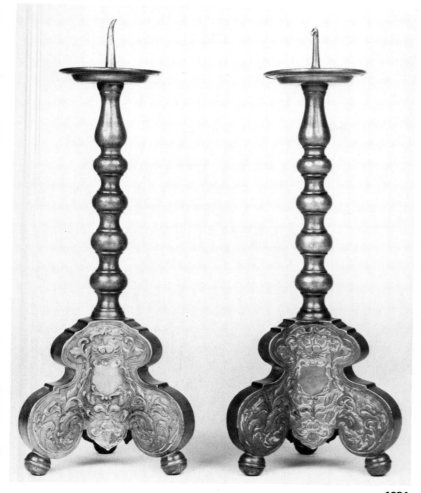

1084

1085

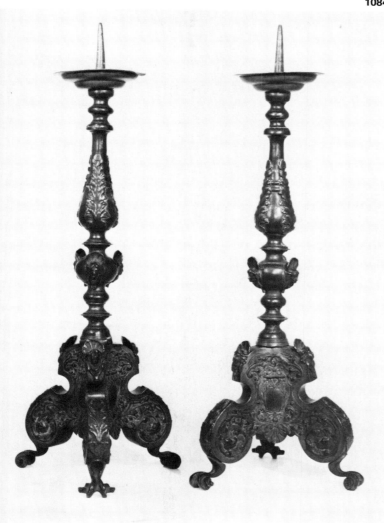

1086

1081. A similar pair of knopped candlesticks on ball feet, dated 1654, German, 20¼ inches high. (Courtesy of Sotheby Parke Bernet).

1081B. Unusual "wrythen" stemmed German candlestick, Regensberg, circa 1650—90, 14 inches high. (Courtesy of Mr. Wolf Amelung).

1082. French baluster knop pricket candlestick, made from seventeenth century to around 1800. (Courtesy of P. Boucaud).

1083. Similar candlestick, probably French, circa 1720, 15 inches high. (Collection of William F. Kayhoe).

1084. Typical European form with triangular bases. This pair have baluster knops, German, seventeenth century, 15½ inches high. (Courtesy of Christies, London).

1085. A similar pair of German candlesticks but with plainer feet, German, circa 1700. By F.L. Dittel, 22 inches high. (Courtesy of Kunsthaus Lempertz).

1086. An elaborate pair of triangular based candlesticks, again German, circa 1700—30, 22 inches high. Similar examples were also found in Austro-Hungary and Italy. (Courtesy of Sotheby Parke Bernet).

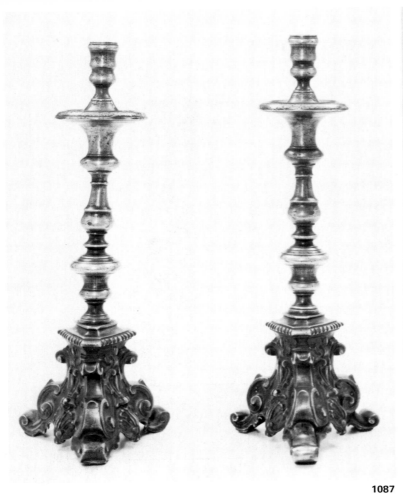

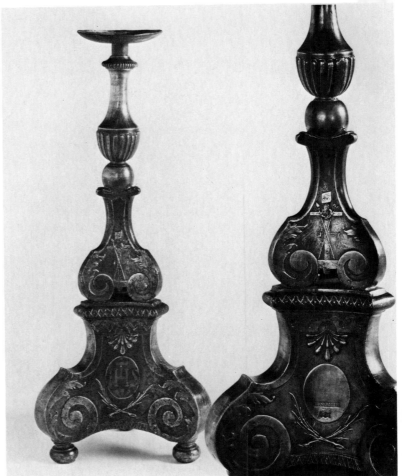

1087

1088

1089

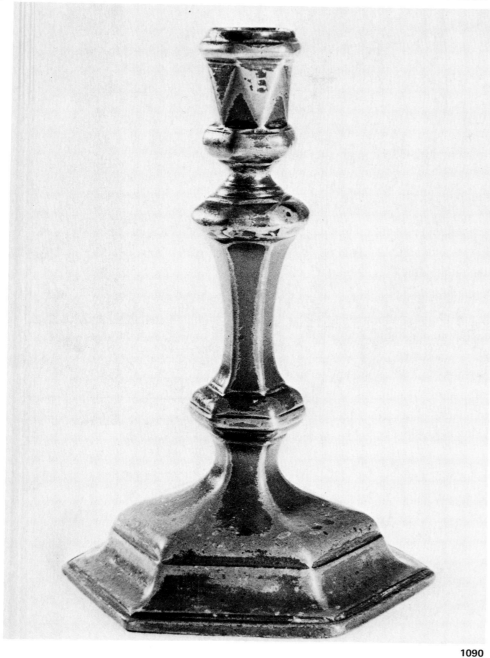

1090

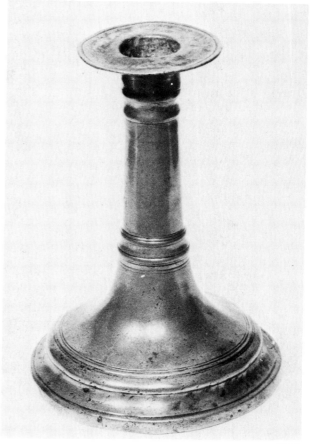

1091

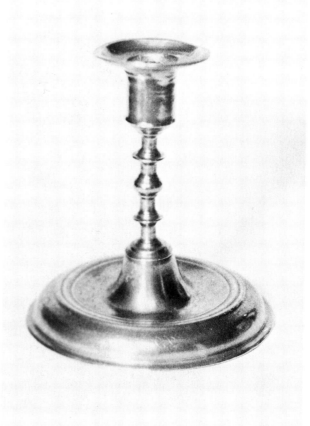

1092

1087. A pair of candlesticks, the prickets now replaced with candleholders, circa 1750—1800, Austro-Hungarian, 13½ inches high. (Courtesy of Sotheby Parke Bernet).

1088. Pair of American candlesticks after the European style, by J.C. Heyne, circa 1750—80. Marked with makers name and Lancaster, and with IHS indicating that they were, like many similar candlesticks in Europe, made for church use. Just over 21 inches high. (Courtesy of the Henry Francis du Pont Winterthur Museum).

1089. Pair of Portugese candlesticks of a form made from 1600 into the last century, 7¼ inches high. (Courtesy of Dr. Fritz Nagel).

1090. A very rare English candlestick with six sided base, circa 1690—1720. (Collection of Mr. C. Minchin).

1091. A plain "trumpet" based candlestick, English, circa 1880—1720, 6 inches high. (Collection of Mr. P. Kydd).

1092. Multi-knopped candlestick, German or central European, early eighteenth century. A typical European form, 5½ inches high. (Collection of Mr. Charles V. Swain).

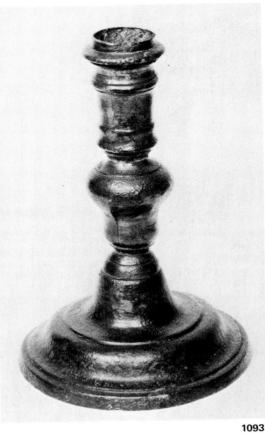

1093

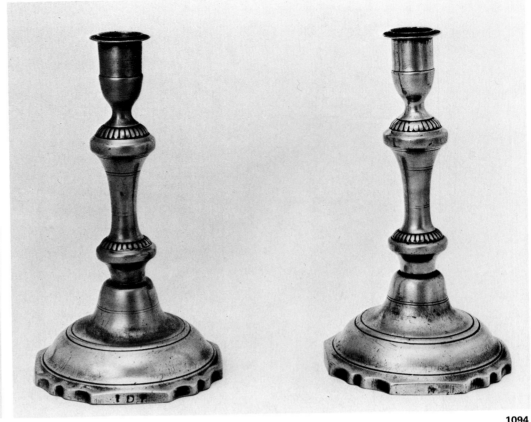

1094

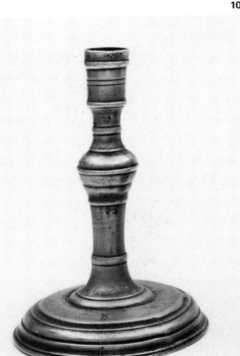

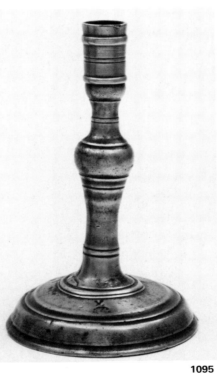

1095

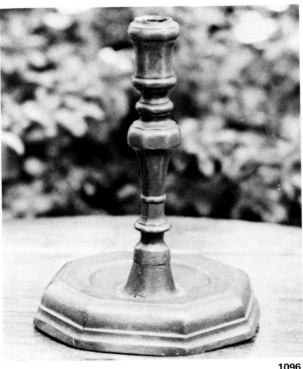

1096

1093. An English candlestick, with round base and single knop, first half of the eighteenth century, 6 1/3 inches high. (Collection of Mr. P. Kydd).

1094. French candlesticks with typical high domed bases. Made in Rouen, circa 1700—60. (Courtesy of P. Boucaud).

1095. English candlesticks from Newcastle, by George Lowes, 6½ inches high, circa 1720. (Courtesy of Sotheby Parke Bernet, London).

1096. French or Dutch knopped candlestick, circa 1720—50. (Courtesy of Robin Bellamy Ltd).

1097. German knopped candlestick, Hamburg, circa 1764. (Courtesy of Bourgaux).

1098. Candlestick with knopped stem and shaped base, European, probably Swiss or German, 8½ inches high, circa 1750. (Collection of Mr. Charles V. Swain).

1099. Fine pair of European candlesticks, a form found in France, Switzerland and Germany, circa 1730—50. (Courtesy of Christies, London).

1100. Wrythen German candlestick, mid-eighteenth century. (Courtesy of the Kunstgewerbemuseum, Cologne).

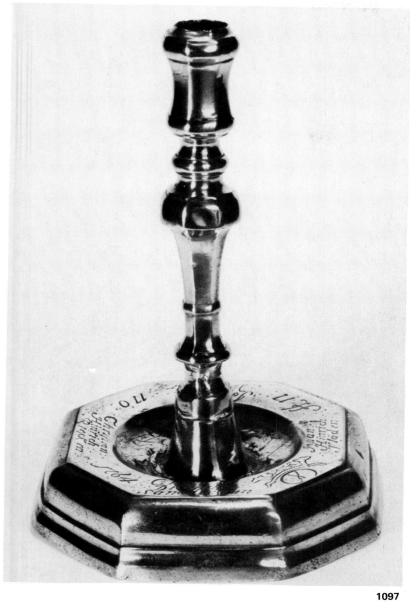

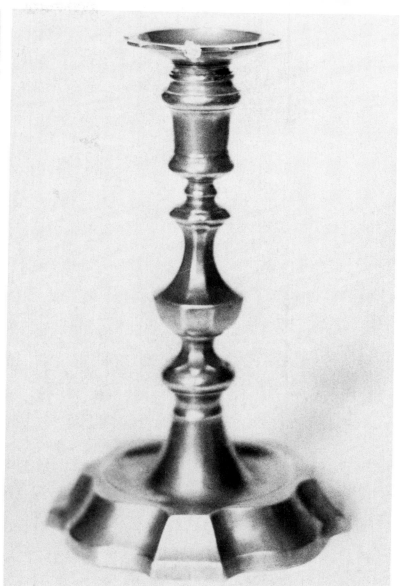

1097

1098

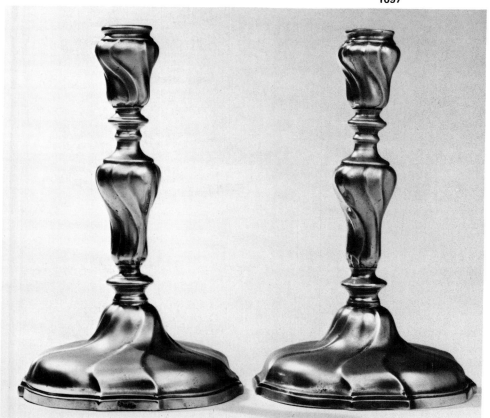

1099

1100

325

1101. Another pair of rococo candlesticks with high domed base, French, eighteenth century from Bourdeaux. (Courtesy of P. Boucaud).

1102. Telescopic candlestick, stem extended, English, circa 1800—30, 9½ inches when extended, 7 inches high when not extended. (Private collection).

1103. Similar shaped candlestick but not extending and with square base, 5¼ inches high, circa 1800—50, English. (From the Kydd Collection).

1104. Plain tall candlestick, German, nineteenth century, 9 inches high. (Courtesy of Robin Bellamy Ltd).

1105. Straight stemmed candlestick with cast decoration, dated 1824, but form made in late eighteenth century onwards, 8 inches high, probably Swiss or German. (Private collection).

1106. Pair of classical corinthian column candlesticks, German, circa 1800, 11¾ inches high. (Courtesy of Kunstgewerbemuseum, Cologne).

1101

PLAIN STEMMED CANDLESTICKS

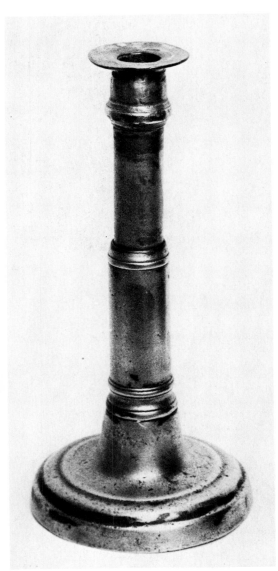

1102

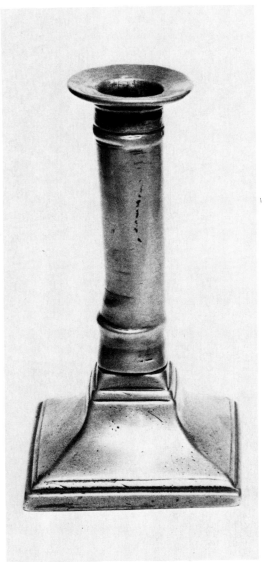

1103

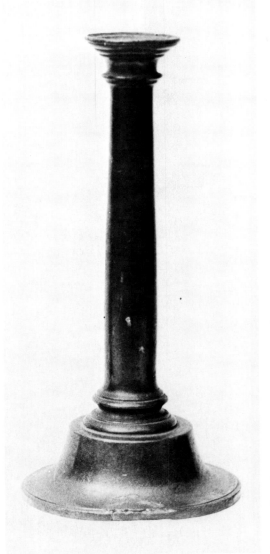

1104

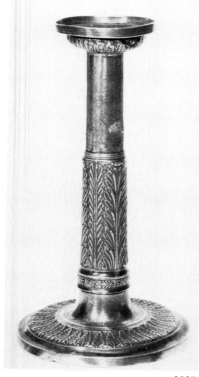

1105

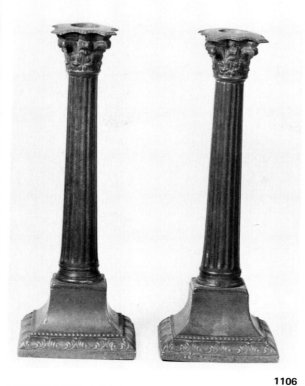

1106

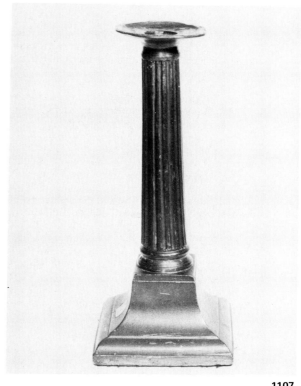

1107

1108

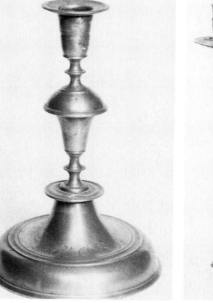

1109

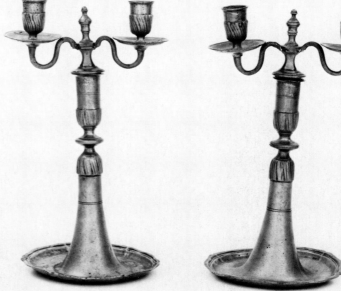

1110

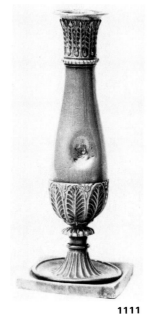

1111

1112

1107. A similar probably English candlestick, 9 1/3 inches high, circa 1800—20. (From the Kydd Collection).

1108. Plain stemmed candlestick, German, circa 1800—30. (Courtesy of Robin Bellamy Ltd).

1109. A German or central European candlestick, 7½ inches high, dated 1793. (Collection of Mr. Charles V. Swain).

1110. Pair of Swiss candlesticks with double detachable candleholders, 11¾ inches high, circa 1770—1800. (Courtesy of Sotheby Parke Bernet, London).

1111. Dutch candlestick with decorated stem, circa 1790—1820. (Courtesy of Robin Bellamy Ltd).

1112. Classical stem candlestick, 7 inches high, western European, circa 1800. (Courtesy of Christies, New York).

KNOPPED CANDLESTICKS FROM EIGHTEENTH AND NINETEENTH CENTURIES

Few examples are marked and identification is therefore difficult. Many baluster and urn forms were made both in the Anglo-Saxon communities and in Europe. Similar candlesticks were also being made throughout the period and it is far from easy to distinguish late eighteenth century examples from those made a hundred years later.

1113 1114 1115 1116

1113. Knopped candlestick, 9½ inches high, circa 1800—40, English. (From the Kydd Collection).

1114. Attenuated baluster knop, German, circa 1800. (Courtesy of Robin Bellamy Ltd).

1115. Knopped candlestick, European, circa 1840, 7½ inches high. (Courtesy of Christies, New York).

1116. Baluster knop candlestick, probably English, 9½ inches high, made between 1790 and 1850. (From the Kydd Collection).

1117. Baluster candlestick with removable bobeche or candleholder, 8½ inches high, nineteenth century, English. (From the Kydd Collection).

1118. Baluster knop with two disks, 8½ inches high, nineteenth century, possibly European. (From the Kydd Collection).

1119. Knopped candlestick with beeded decoration, 7 inches high, circa 1800, English. (From the Kydd Collection).

1120. Two knopped candlesticks. Left: American by Gleason, 8½ inches high, circa 1830—50. Right: British or American, square based, 9 inches high, circa 1850. (Collection of Mr. Charles V. Swain).

1117 1118

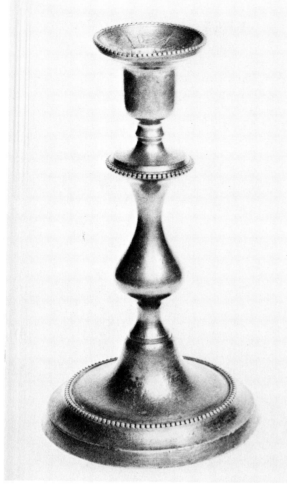
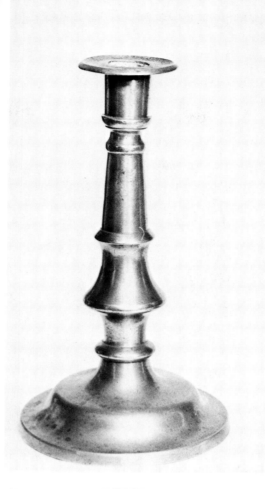
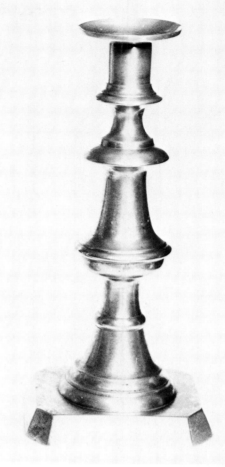

1119

1120

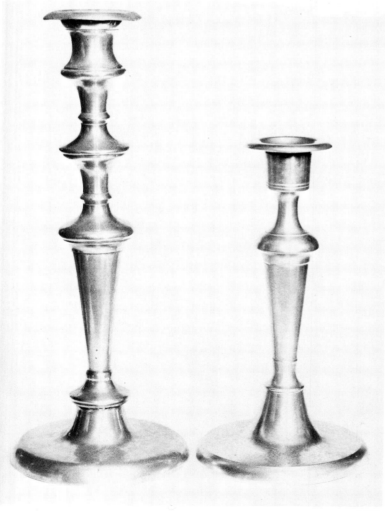

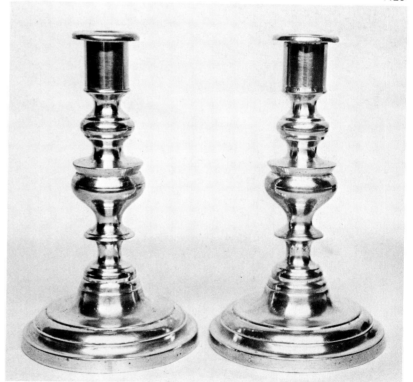

1122

1121. Two candlesticks both American. Left: By Harper, 12 inches high, circa 1850. Right: By Fuller & Smith, 8½ inches high, circa 1850. (Collection of Mr. Charles V. Swain).

1122. Heavy urn knops, attributed to the Taunton Britannian Metal Company, American, circa 1830—35, 8 inches high. (Collection of Dr. and Mrs. Melvyn Wolf).

1121

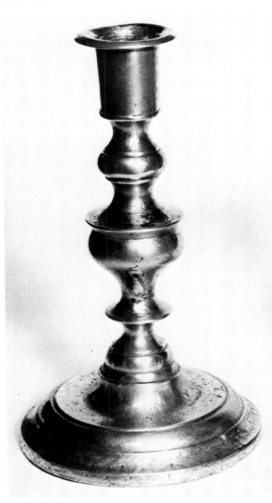
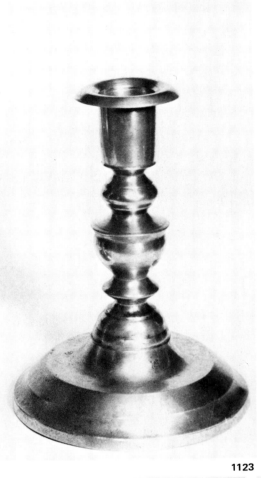

1123

1124

1125

1126

1127

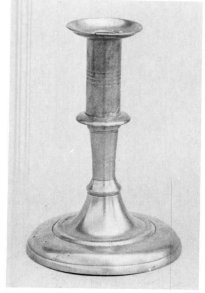

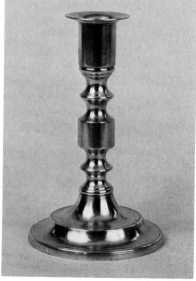

1128

1129

CHAMBER CANDLESTICKS

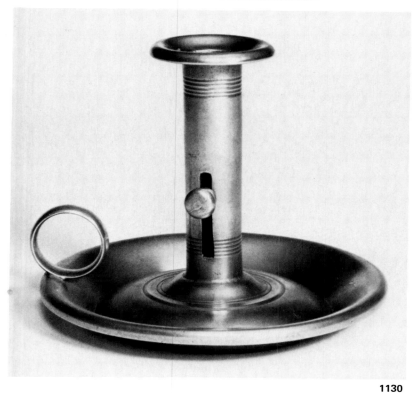

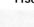

1130

1123. Two American candlesticks. Left: By J. Weekes, 7½ inches high, circa 1820—40. Right: By Dunham, 6 inches high, circa 1850. (Collection of Mr. Charles V. Swain).

1124. Knopped candlestick, American, by J. & H. Graves, circa 1850, 9½ inches high. (Collection of Dr. and Mrs. Melvyn Wolf).

1125. American candlestick with urn knop, by Ostrander and Norris, circa 1850, 10 inches high. (Collection of Dr. and Mrs. Melvyn Wolf).

1126. Knopped candlestick, English, circa 1820, 9 inches high. (From the Kydd Collection).

1127. Heavily knopped candlestick, with pusher in base, 8¾ inches high, nineteenth century, English. (Private collection).

1128. Unusual knopped candlestick, by R. Gleason, American, 6½ inches high, circa 1830—50. (Collection of Dr. and Mrs. Melvyn Wolf).

1129. An uncommon two part candlestick with telescopic action, American, New England circa 1830—40, 8 inches high. (Collection of Dr. and Mrs. Melvyn Wolf).

1130. American by Lewis & Cowles, 4¾ inches high, circa 1830. (Collection of Dr. and Mrs. Melvyn Wolf).

1131. An English chamber stick with beeding, unmarked, circa 1820—40, 5 inches high. (From the Kydd Collection).

1132. A chamber stick with snuffer, 6½ inches diameter, 4½ inches high, circa 1820—40, English. (Collection of Mr. R. Dean).

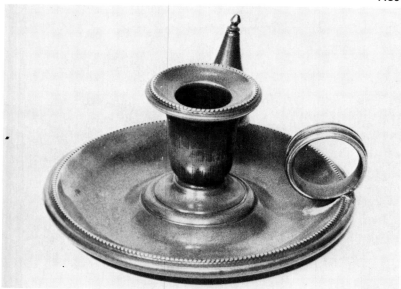

1131

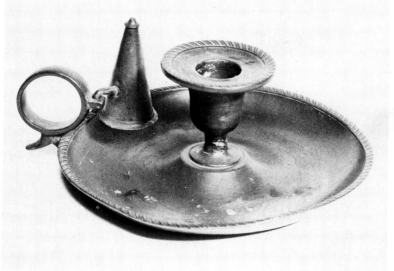

1132

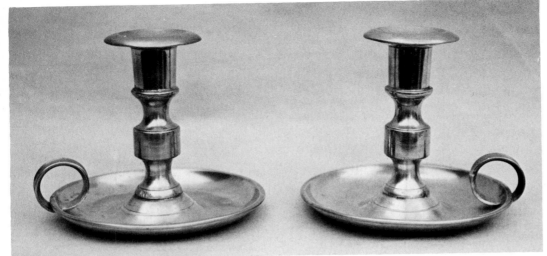

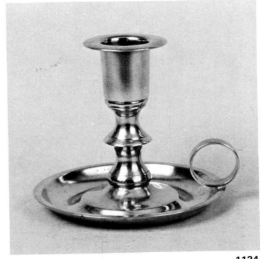

1133

1134

OIL LAMPS
Tall Style

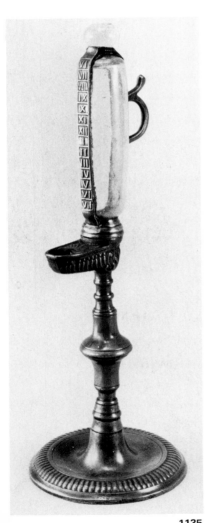

1135

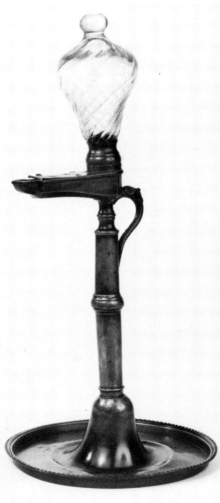

1136

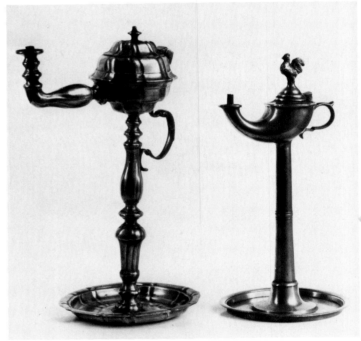

1137

1133. An American chamber candlestick with taller stem, by R. Gleason, mid-nineteenth century, 3¼ inches high. (Collection of Dr. and Mrs. Melvyn Wolf).

1134. Pair of American candleholders, with knopped stems, by Ostrander & Norris, circa 1850, 4½ inches high. (Collection of Dr. and Mrs. Melvyn Wolf).

1135. Fine French hour lamp, early eighteenth century. (Courtesy of Phillip Boucaud of Paris).

1136. German oil lamp with glass container for the oil, circa 1780–1800, 14½ inches high. (Courtesy of Christies, London).

1137. Two lamps. Left: A rococo lamp with unusual spout, circa 1780, Eger, Hungary. Right: Lamp with cockerel finial, Hungarian, circa 1800. (Courtesy of Hungarian National Museum, Budapest).

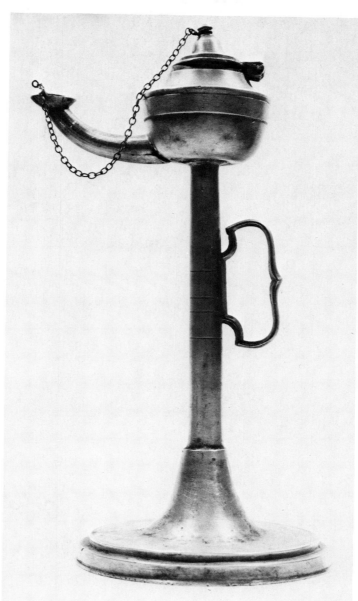

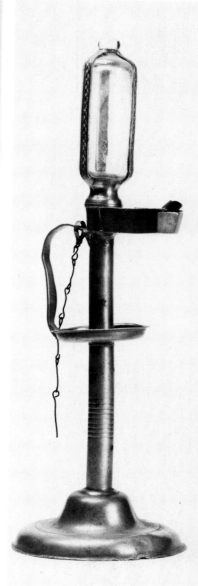

1138

1139

1140

AMERICAN LAMP FORMS

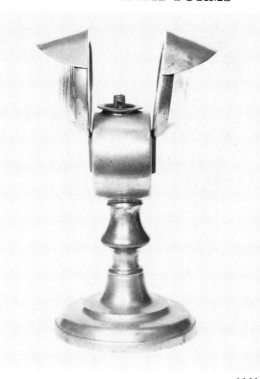

1138. A similar lamp but without the cover by G.H. Thoma. German, 9½ inches high, circa 1800. (Collection of Marianne & Albert Phiebig).

1139. Whale oil lamp, German, early nineteenth century, 9 inches high. (Collection of Marianne & Albert Phiebig).

1140. German early nineteenth century lamp with glass resevoir, which is marked to indicate the passage of time, 16½ inches high. (Courtesy of Christies, Amsterdam).

1141. Double bulls-eye lamp, 8 inches high, American, attributed to Gleason, circa 1850. (Collection of Mr. and Mrs. Merrill G. Beede).

1141

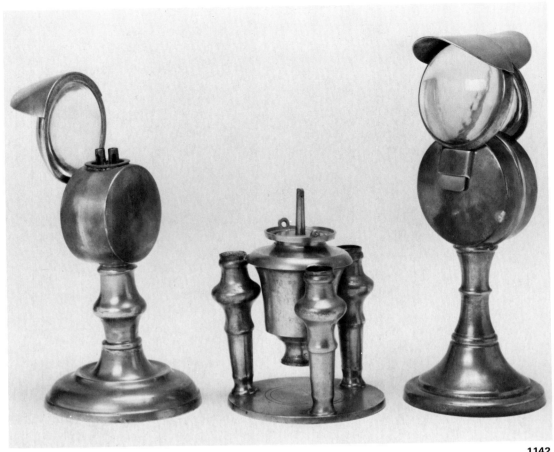

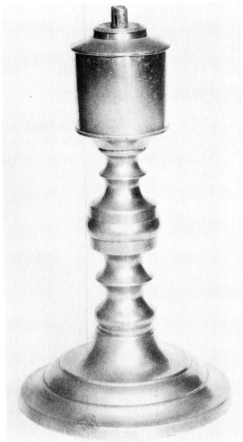

1142

1143

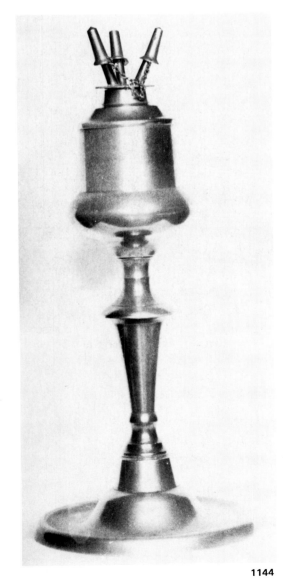

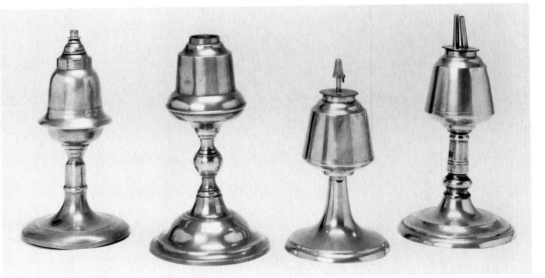

1145

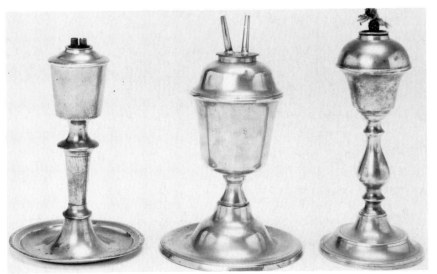

1144

1146

334

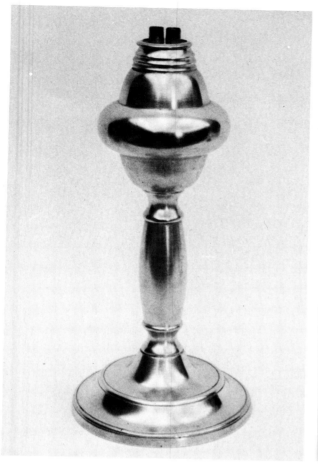

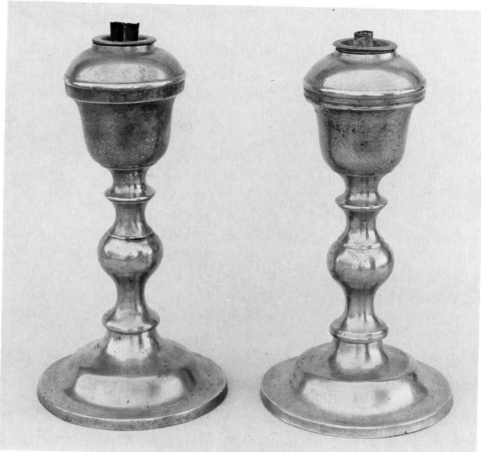

1147

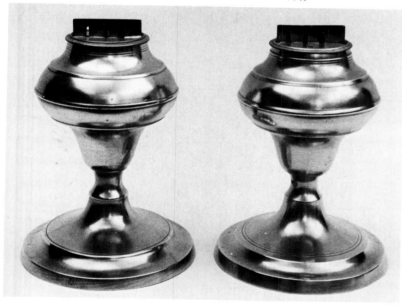

1149

1150

1148

1142. Left to right: American unmarked whale oil lamp, 8¾ inches high. Patent American oil lamp, 5½ inches high. Another whale oil lamp, 9¾ inches high. All mid-nineteenth century. (Courtesy of Christies, New York).

1143. A knopped lamp by A. Porter, circa 1830, 8½ inches high, American. (Collection of Charles V. Swain).

1144. Baluster bladed lamp, American, by Martin Hyde of New York, circa 1850. (From the Herr Collection).

1145. Group of lamps, American mid-nineteenth century. Between 8 and 9¾ inches high, no makers marks. (Courtesy of Christies, New York).

1146. Three further American nineteenth century lamps, that on the right by Smith & Company of Boston, 1847—49. (Courtesy of Christies, New York).

1147. An American lamp by R. Gleason, first half of the nineteenth century, 8½ inches high. (Courtesy of Dr. and Mrs. Melvyn Wolf).

1148. Two similar American lamps with acorn font, by Selew and Company of Cincinatti, circa 1830—60, 9¼ inches high. (Collection of Dr. and Mrs. Melvyn Wolf).

1149. A rare pair of American lard lamps, 6½ inches high, first half of the nineteenth century. (Collection of Dr. and Mrs. Melvyn Wolf).

1150. Pair of tall knopped lamps with carrying handles, by Henry Hopper of New York, American, 1842—47, 8 inches high. (Collection of Dr. and Mrs. Melvyn Wolf).

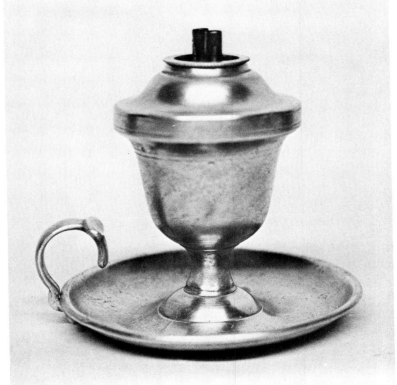

1151

1152

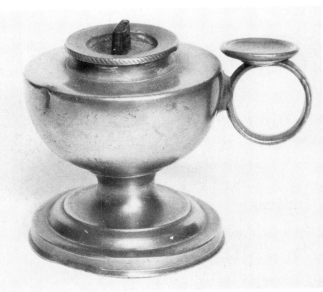

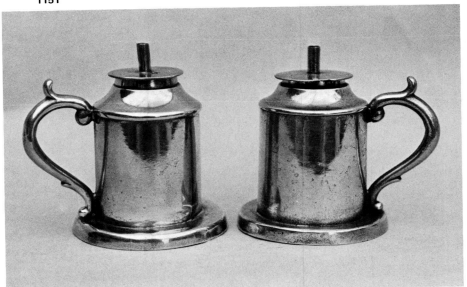

1153

1154

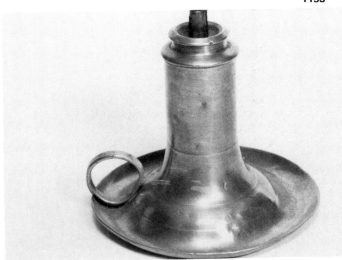

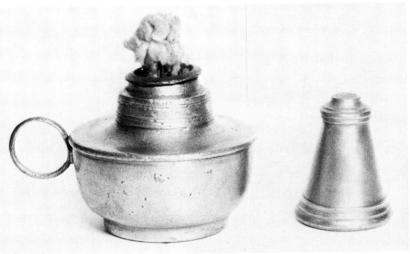

1155

1156

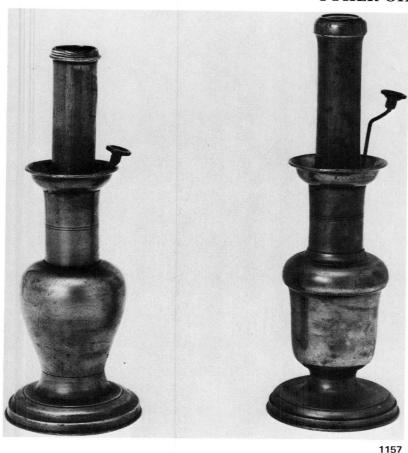

1157

1151. A gimbel whale oil lamp, by Yale and Curtis, American, nineteenth century, 5 inches high. (Collection of Dr. and Mrs. Melvyn Wolf).

1152. Lamp by Henry Hopper of New York, American, 1842—47, 4½ inches high. (Collection of Dr. and Mrs. Melvyn Wolf).

1153. Whale oil lamp, American, circa 1850, 2½ inches high. (Collection of Mr. and Mrs. Robert E. Asher).

1154. A pair of American lamps, 6½ inches high, by Cooper & Martineaux, New York, 1848—54. (Collection of Dr. and Mrs. Melvyn Wolf).

1155. An unmarked American lamp, 3½ inches high, nineteenth century. (Collection of Mr. and Mrs. Merrill G. Beede).

1156. Small unmarked American oil lamp, 3½ inches with cover, nineteenth century. (Collection of Mr. and Mrs. Merrill G. Beede).

1157. Typical French oil lamps from Provence, these examples were actually made in Dijon, 1800 to end of century. (Courtesy of Mr. P. Boucaud).

1158. Early nineteenth century Swiss oil lamp, 8¾ inches high. Similar lamps were also made in central Europe. (Courtesy of Swiss National Museum, Zurich).

1159. Uncommon oil lamp with pump, European, early nineteenth century. (Collection of Mr. and Mrs. James A. Taylor).

1160. Rare travelling lamp, 2½ inches high, American, nineteenth century. (Collection of Mr. Hill Sandidge).

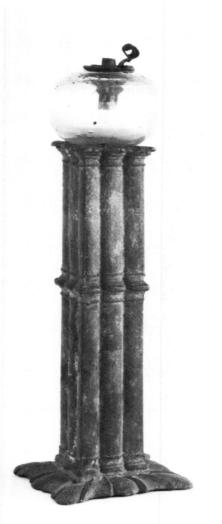

1158

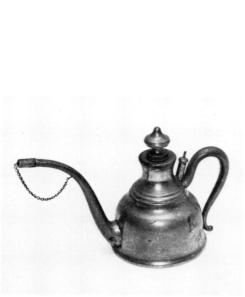

1159

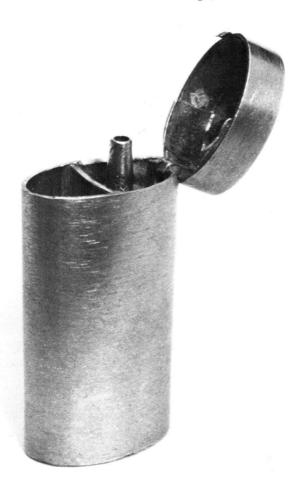

1160

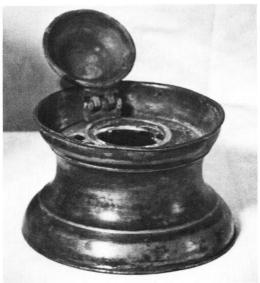

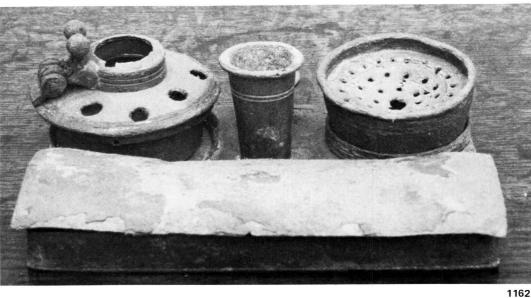

1161

1162

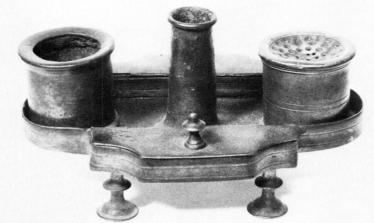

1163

1164

1165

1166

1161. Early Dutch ink pot, reminiscent of the popular nineteenth century form found in Britain and the United States. Circa 1600, 2 inches high. (Courtesy of Colonial Williamsburg).

1162. Standish, English seventeenth century by a member of the Quick family. (Courtesy of Robin Bellamy Ltd).

1163. Standish with two flaps. English but examples are known from Europe, 7½ inches wide, 1680—1720. (Collection of Mr. P. Kydd).

1164. Dutch ink stand, Rotterdam, circa 1800, 9¾ inches wide. (Courtesy of Christies, Amsterdam).

1165. A very similar standish, English, circa 1790, 11¼ inches wide. (Courtesy of Robin Bellamy Ltd).

1166. Group of ink stands, Dutch, all from around 1800. Top left: Ink box with twin ink wells. Top right: Round ink pot. Bottom left: Standish. Bottom right: Round ink pot with handle. (Courtesy of H.B. Havinga).

1167. Oval ink stand by N. Tysoe, 5½ inches wide, English, circa 1780—1820. There is a copper handle and a japanned base. (Collection of Mr. P. Kydd).

1168. Swiss standish, by J.L. Keiser, Zug, from late eighteenth century, 6¼ inches wide. (Courtesy of Swiss National Museum, Zurich).

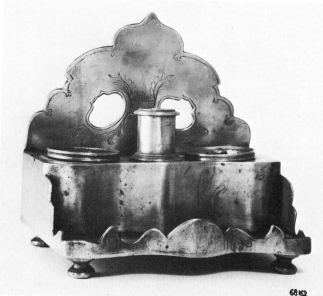

1167

1168

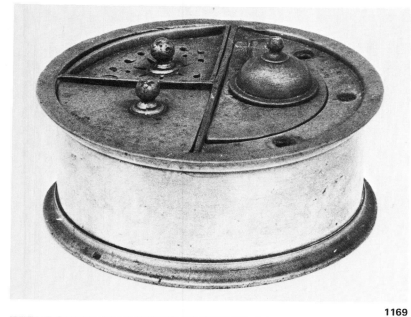

1169

1170

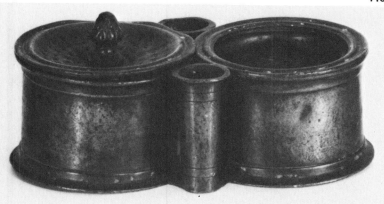

1171

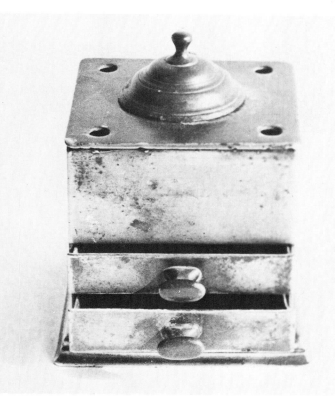

1169. Typical Dutch late eighteenth century ink pot. (Courtesy of Robin Bellamy Ltd).

1170. Another form of the same kind of pot, Dutch, circa 1790. (Courtesy of Robin Bellamy Ltd).

1171. Shaped ink stand, Swiss, by F. Cane or Canis of Appenzell, circa 1800, 5 inches wide. (Courtesy of Sotheby Parke Bernet).

1172. English ink box, very similar to Dutch examples. A few examples are also found with Irish marks, circa 1780—1800. (Courtesy of Robin Bellamy Ltd).

1172

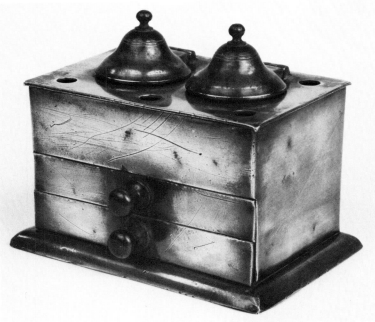

1173

1174

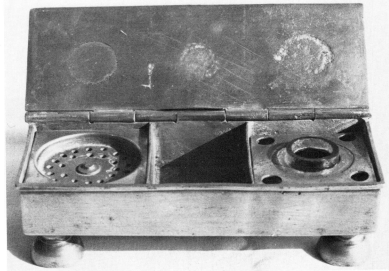

1175

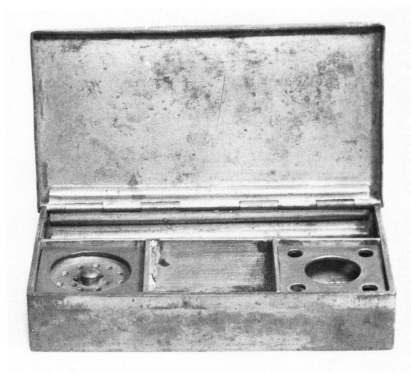

1176

1173. A double size ink pot, English, circa 1800. (Courtesy of Christies).

1174. Another form of standish with space for pens under top lid. English, circa 1770. (Courtesy of Robin Bellamy Ltd).

1175. A standish of rectangular form open to show paunce pot and ink well, English, circa 1780–1820. (Courtesy of Robin Bellamy Ltd).

1176. A similar box or stand, closed, with the marks of H.M. Customs and Excise. Circa 1800, English. (Courtesy of Robin Bellamy Ltd).

1177. A rectangular standish, circa 1800–30, English, 5¼ inches wide. (Collection of Mr. P. Kydd).

1178. Ink pot with drawer, American after 1820, 3½ inches high. (Courtesy of Christies, New York).

1179. Ink well by James Putnam, American, circa 1830–50, 2 inches high. (Collection of Dr. and Mrs. Melvyn Wolf).

1180. Three American nineteenth century ink wells, the centre example is of unusual form. The round ink wells on right and left are also found in Britain. (Courtesy of Christies, New York).

1181. Fine ink well by Danforth and Sherman Boardman, nineteenth century. (Courtesy of the Metropolitan Museum of Art, New York. Gift of Mrs. Blair in memory of her husband, J. Insley Blair).

1177

1178

1179

1180

1181

1182

1183

1184

342

COMMODES

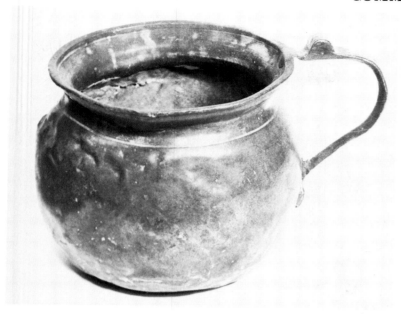

1185

1186

1187

1188

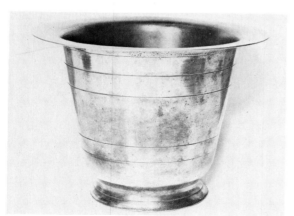

1189

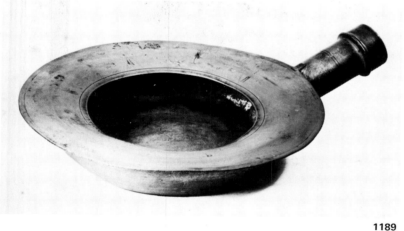

1182. American ink well by the Fenns, circa 1830—40. (Courtesy of the Metropolitan Museum of Art, New York. The Sylmaris Collection, gift of George Coe Graves).

1183. English round ink well of the early nineteenth century, 2½ inches high. Copies of this form were widely made in this century. (Courtesy of Country Life Antiques).

1184. Typical ink stand of the mid to late nineteenth century with wide base, British and American. (Courtesy of Christies, New York).

Commodes

1185. Dutch round commode, circa 1600—50, 7 inches wide. (Collection of Mr. R. Dean).

1186. English commode, by I.C. Crane of Bewdley, circa 1800—20, 5¾ inches high. (Courtesy of Colonial Williamsburg).

1187. Dutch lidded commode, on left. On right a Dutch commode without handle. Both nineteenth century. (Courtesy of Hans Havinga).

1188. Typical French pan made from late eighteenth to nineteenth centuries. (Courtesy of P. Boucaud).

1189. French commode, the most common form, early nineteenth century. (Courtesy of P. Boucaud).

1190. Tall "Welsh hat" type of commode. English by Ingram and Hart, 8½ inches high, late eighteenth century, but similar commodes were being made in the late seventeenth century. (Private collection).

1190

343

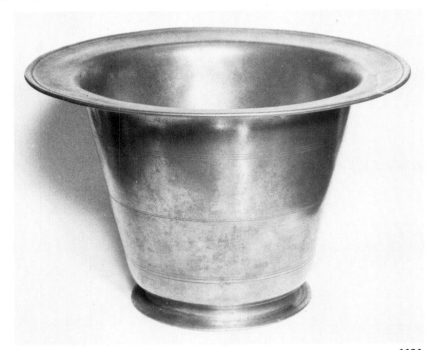

1191

1191. American "Welsh Hat" by Fred Bassett, 8¾ inches high, late eighteenth century. (Collection of Mr. Charles V. Swain).

1192. Acorn shaped water fountain, by H.K. Hottinger, circa 1650, Swiss, 11 1/8 inches high. (Courtesy of National Museum, Zurich).

1193. French water fountain, Lyon, circa 1680. (Courtesy of P. Boucaud).

1194. Swiss water cistern, by K.B. Studelin, circa 1700. (Courtesy of National Museum, Zurich).

1195. Rare English wall cistern, dated 1716, from a church. (Collection of Mr. C. Minchin).

1196. Complete mounted wall cistern, with tray. Built into a piece of furniture. From Basle in Switzerland, late eighteenth century. (Courtesy of P. Boucaud).

1197. Wall cistern with twin dolphin knops, the body decorated. Swiss or German, eighteenth century. (Courtesy of Christies, London).

WATER CISTERNS OR FOUNTAINS

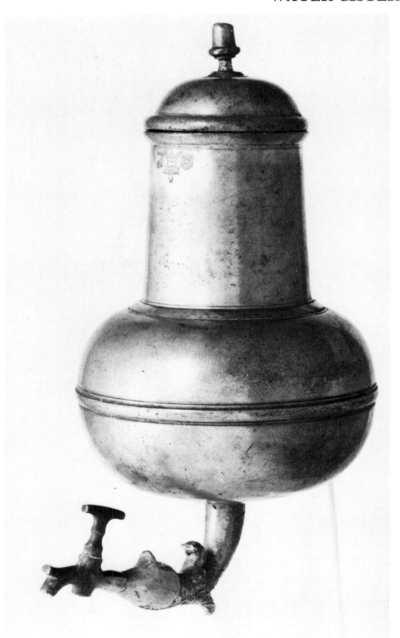

1192

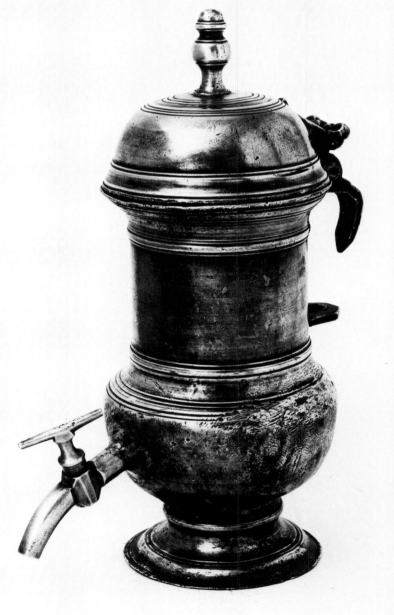

1193

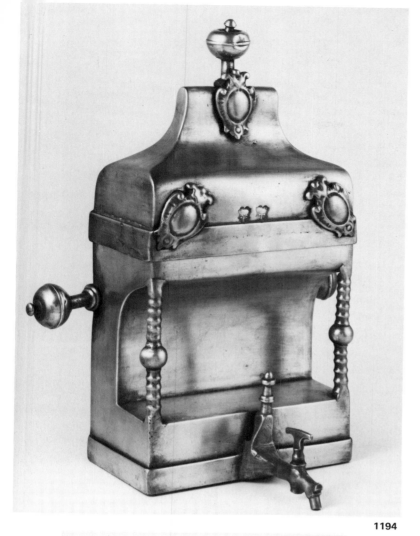

1194

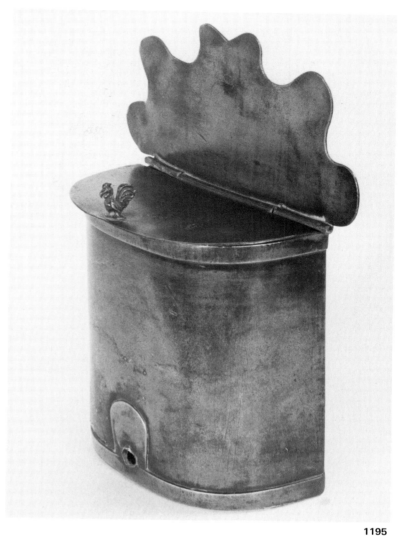

1195

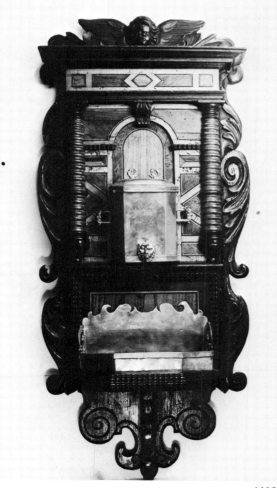

1196

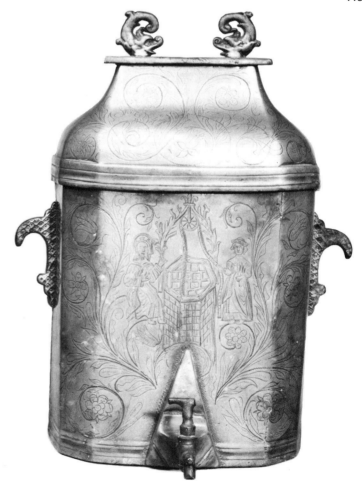

1197

1198

1199

1200

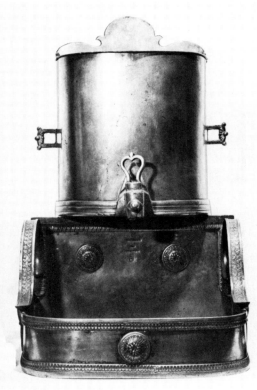

1201

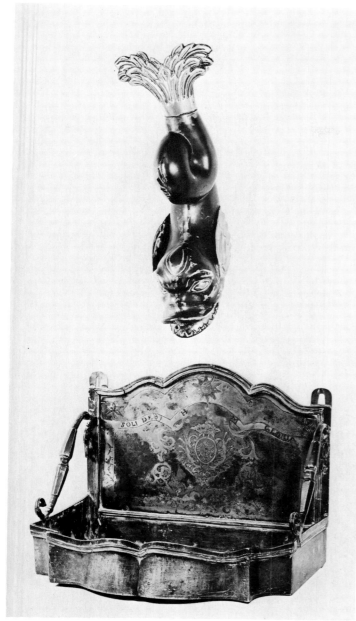

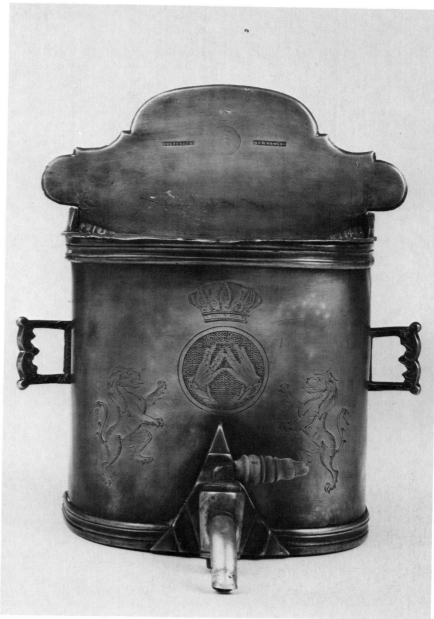

1202

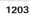

1203

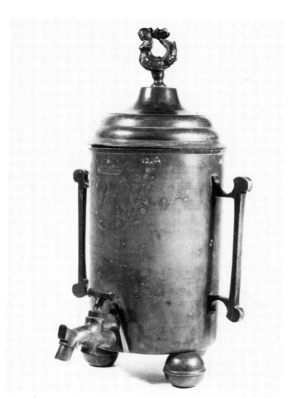

1203B

1198. Wall cistern and tray, French, typical of examples from the Rhone Valley and south west France, circa 1740—1850. (Courtesy of P. Boucaud).

1199. German water cistern from Nuremberg, eighteenth century, 12½ inches high. (Courtesy of Christies, London).

1200. Wall cistern and basin, French eighteenth century. (Courtesy of Bourgaux).

1201. Wall cistern with basin from Memingen, circa 1770. (Courtesy of Dr. Fritz Nagel).

1202. Swiss wall cistern with basin, the dolphin with copper tail, the basin inlaid with copper, mid-eighteenth century. (Courtesy of P. Boucaud).

1203. German wall fountain with basin, eighteenth century, 12½ inches high. (Courtesy of Christies, London).

1203B. Nineteenth century footed water cistern from Warsaw, Poland. (Courtesy of Narodwe Museum, Warsaw).

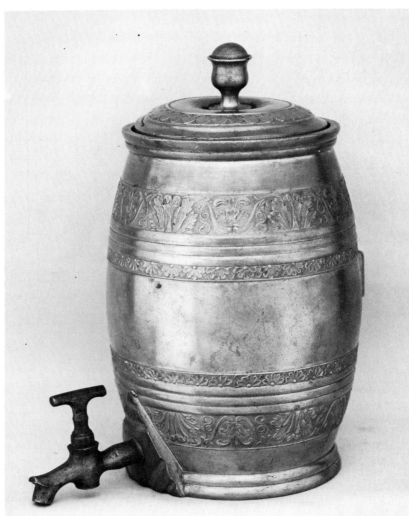

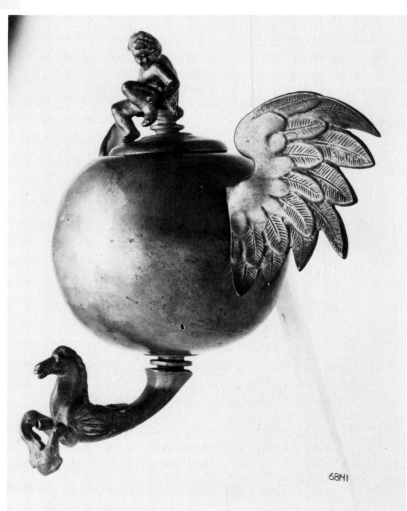

1204. Standing cistern, Flemish, eighteenth century. (Courtesy of the Metropolitan Museum of Art, New York. Rogers Fund).

1205. Round cistern with wings, Swiss, first half of the nineteenth century, 10 1/8 inches. (Courtesy of Swiss National Museum, Zurich).

348

CHAPTER 11

Miscellaneous Pewter

Miscellaneous Pewter

Hundreds of different things were made in pewter during the 250 years of this study. In some cases the fashion for pewter examples was short-lived, in others the alloy did not prove really suitable as a medium.

In many cases only a few examples now exist and it is usually difficult to identify their origins or date them, unless they are marked.

Examples of some of this multiplicity of items are illustrated here. This list can never be complete and new objects made in pewter are still being identified or discovered.

The extensive list of pewter still being made at Townsend and Compton's in 1850 is a salutory reminder for any who think they have "seen it all". Amongst pewter items still being produced by that company were; alembics, balneums, child boats, brandy bottlers, butter basins, club pots, cranes, feet-warmers, hashdishes, kettles, nipple-shields, oleos, sauce-boats, shaving-pots, side-warmers, soap-boats, tart-warmers and water-stands.

Boxes

All shapes and sizes of boxes were made. In many cases their original purpose has been lost.

Coins and Medallions

A few rare coins have been struck in pewter. During the English Civil War a crown was minted at Oxford in 1644 and pewter farthings were also made for Charles II, James II and William and Mary. Medallions were also made in the nineteenth century generally either commemorating persons or events.

Buttons

The first pewter button appeared in the sixteenth century, but production was limited until the early eighteenth century. Plain and cast decorated buttons were then made in considerable quantities, usually by makers specialising in this field.

Sun-Dials

A few pewter sun-dials are to be found, mostly from the United States. American examples are mostly between two and five inches square, smaller than sun-dials usually used out of doors. It is likely that they were for use on window-sills. Examples marked IM or NM have been attributed to Josiah Miller, 1725—1775.

Tobacco

The attitude adopted towards tobacco and smoking appears to be turning full circle. Originally greeted with hostility it then enjoyed several hundred years of popularity only to be regarded with growing suspicion over the last decades.

What is certain is that for many millions tobacco provided considerable pleasure from the time that the first Virginian leaf reached the Court of Elizabeth I to the present day.

Until the 1890's tobacco was smoked in pipes or as cigars, chewed or inhaled. Cigarettes are of recent origin.

Tobacco was kept in boxes. Larger boxes were used for storing it in the home, smaller boxes for carrying about the person.

Pewter tobacco boxes are found from all regions, mostly dating from the mid-eighteenth century onwards. Most personal tobacco boxes are in other materials but a few in pewter have survived.

Snuff, a mixture of tobacco and spices was inhaled. It was carried about the person in small boxes or kept at home in larger boxes or containers.

Many hundreds of different designs were created. Snuff boxes were made everywhere although British examples are the most numerous. Few snuff boxes exist prior to 1750. Most are in Britannia metal and date from the early nineteenth century. They are seldom marked.

VARIOUS BOXES

Many varieties of boxes were made. Some such as spice boxes are illustrated in other chapters. In some cases the original purpose of boxes has now been lost. There are many individual examples and many forms.

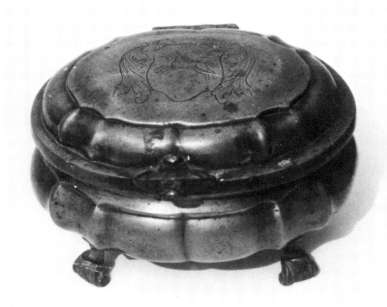

1206

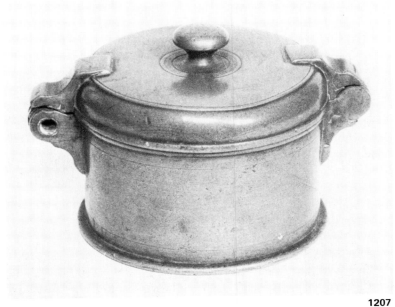

1207

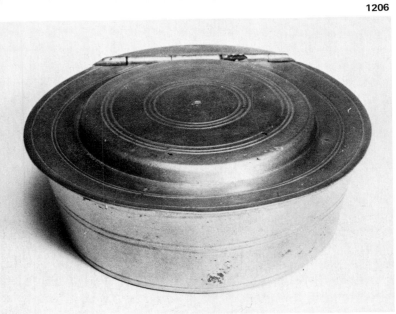

1208

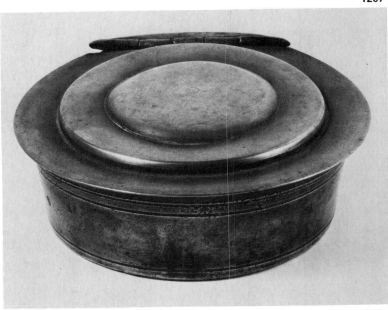

1209

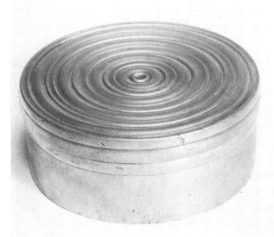

1210

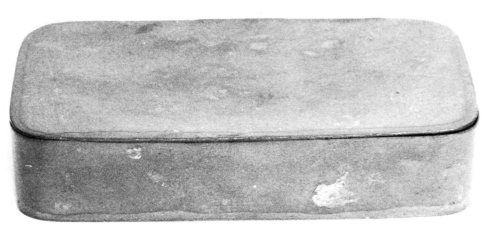

1211

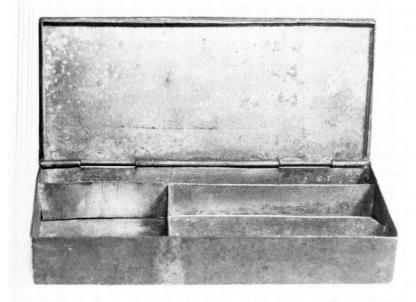

1206. Small round box, Dutch or German, eighteenth century, 4 7/8 inches wide. (Courtesy of Robin Bellamy Ltd).

1207. Another form of box, German or central European, eighteenth century, 3 inches wide. (Collection of Mr. William F. Kayhoe).

1208. Box with lifting hinged lid, possibly for soap, by A. Griswold, American, circa 1820, 3½ inches wide. (Collection of Dr. and Mrs. Melvyn Wolf).

1209. Early nineteenth century American box, 4 3/8 inches wide. (Courtesy of Bowdoin College Museum of Art, Brunswick, Maine).

1210. American box, 4 inches diameter, circa 1800. (Collection of Dr. and Mrs. Melvyn Wolf).

1211. Hard metal rectangular box, purpose unknown, nineteenth century. Similar boxes were made both in America and Britain, 6 3/8 inches wide. (Collection of Mr. P. Kydd).

1212

COINS AND MEDALLIONS

1212. Instrument box, English nineteenth century, 7 inches wide. (Collection of Mr. P. Kydd).

1213. English, seventeenth century. James II (top left), William and Mary (top right), commonwealth farthing circa 1650 (bottom left), Charles II (bottom right). (Courtesy of Worshipful Company of Pewterers, London).

1214. Medallion of Sir Robert Peel, English, circa 1850. Peel was the founder of the Metropolitan Police and a notable politician. (Collection of Mr. K. Gordon).

1215. Five French eighteenth century medallions with a horn mold, all in classical form. (Courtesy of P. Boucaud of Paris).

1213

1214

1215

1216

1217

SUNDIALS

1218

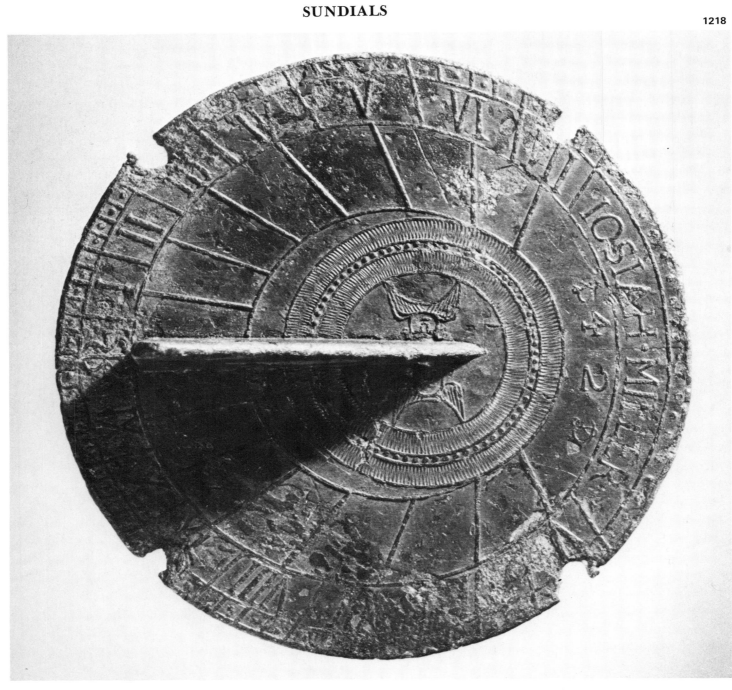

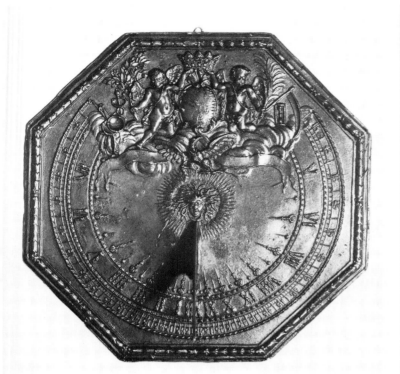

1219

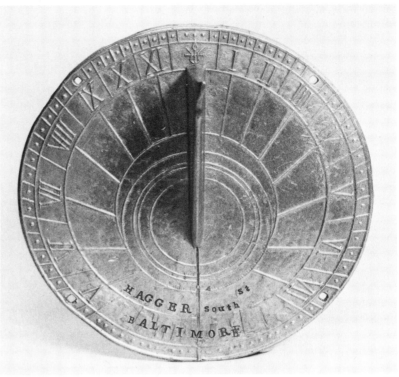

1220

TOBACCO AND SNUFF BOXES

1221

1216. English commemorative medallion, commemorating Queen Victoria and Prince Alberts' visit to Liverpool and Manchester, 1851. (Courtesy of Robin Bellamy Ltd).

1217. Lincoln commemorative medal, circa 1850—60, 1 5/8 inches diameter. (Courtesy of Bowdoin College Museum of Art, Brunswick, Maine).

1218. American sundial by Josiah Miller, circa 1750—75, 4 3/8 inches diameter. (Courtesy of the Metropolitan Museum of Art, New York. Gift of Mrs. Stephen S. Fitzgerald).

1219. French pewter sundial, circa 1700, with cast decoration. (Courtesy of P. Boucaud).

1220. American pewter sundial engraved with Hagger South Street, Baltimore, 4 inches diameter, late eighteenth century. (Collection of Mr. and Mrs. Merrill G. Beede).

1221. Pocket tobacco box, English, unmarked, circa 1760—90, 4 3/8 inches wide. (Courtesy of Colonial Williamsburg).

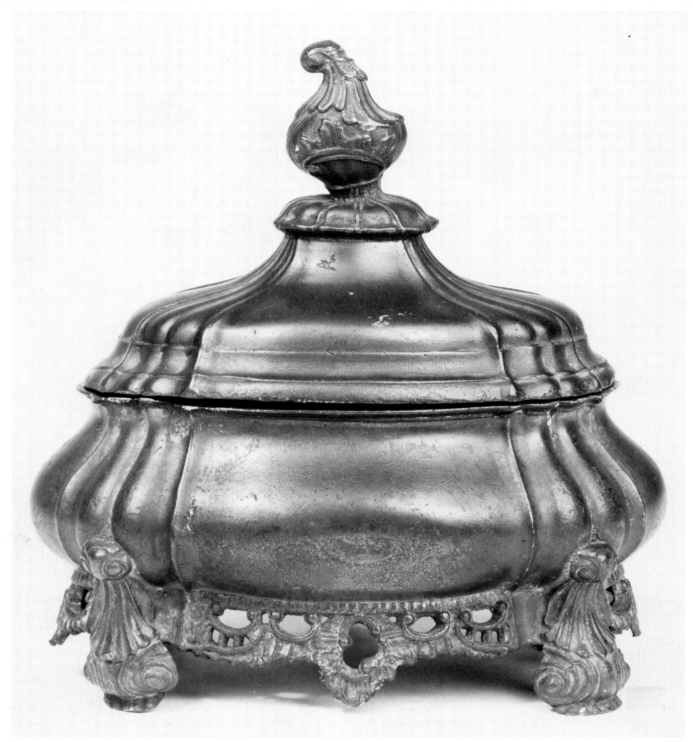

1222

1222. Rococo tobacco box for table use. Dutch by M. Kraun of Amsterdam, mid-eighteenth century, 6¼ inches wide. Similar boxes were made in Germany and much of central Europe. The decoration varies from box to box. (Courtesy of Christies).

1223. Nineteenth century plain tobacco box, with brass knop, 6 inches high, English or European. (Collection of Mr. William F. Kayhoe).

1224. Typical round tobacco box from late eighteenth century. Similar boxes were made in France, Germany, Holland and Britain. (Collection of Mr. and Mrs. James A. Taylor).

1225. Round tobacco box, English early nineteenth century, 6¼ inches high. (Collection of Dr. D. Lamb).

1226. Nineteenth century decorated box, from Saxony, Germany, 8 5/8 inches high. (Courtesy of Dr. Fritz Nagel).

1227. Box of rounded form, English, circa 1820, 2¾ inches wide. (Courtesy of Robin Bellamy Ltd).

1228. Cast decorated snuff box by Shaw and Fisher of Sheffield, circa 1845, English, 2 7/8 inches wide. (Courtesy of Robin Bellamy Ltd).

1229. Pistol snuff box, English, circa 1800. (Courtesy of Robin Bellamy Ltd).

1230. Cast decorated box with horse racing scene, circa 1830, English. (Courtesy of Robin Bellamy Ltd).

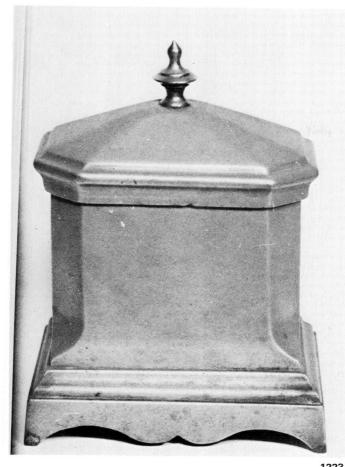

1223

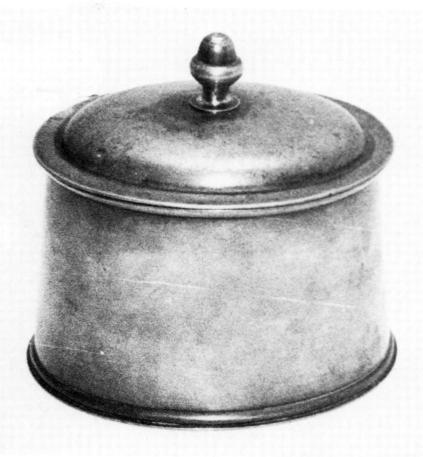

1224

1225

1226

1227

1228

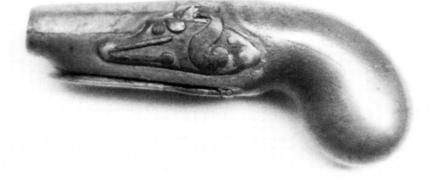

1229

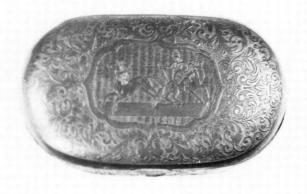

1230

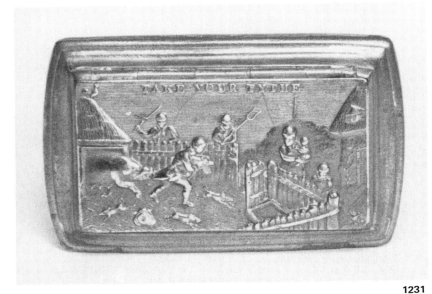

1231. Cast decorated snuff box, "Take Your Tythe", English early nineteenth century, 2¾ inches wide. (Collection of Mr. and Mrs. Robert E. Asher).

1232. Three Scottish snuff boxes. From left to right: Deers foot box. Deer's foot box by Durie. Cowrie box mounted in pewter. All circa 1800. (Collection of Dr. Lamb).

1233. Large deers foot snuff box, mounted in pewter with pewter inside, circa 1800—20, 3 inches long, Scottish. (Courtesy of Robin Bellamy Ltd).

1234. Group of five snuff boxes or mulls. The mull in pewter shaped like a rams horn. All British, early nineteenth century. (Courtesy of Robin Bellamy Ltd).

1235. A group of European snuff boxes, early nineteenth century. (Courtesy of P. Boucaud).

1231

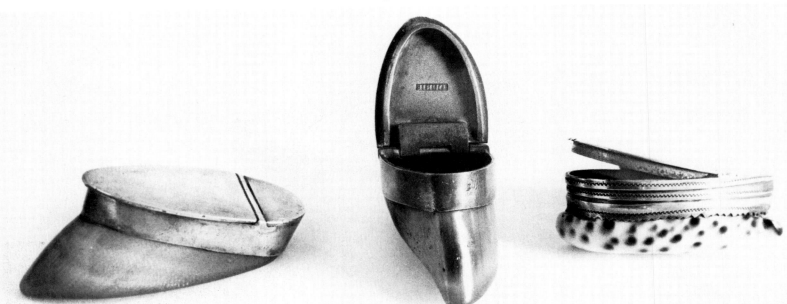

1232

1233

356

1234

1235

357

1236

1237

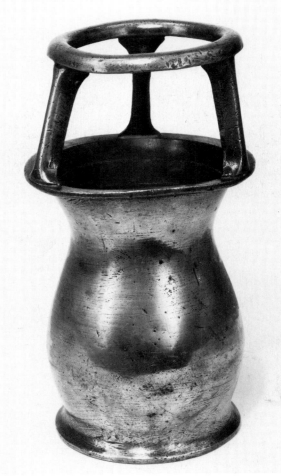

1238

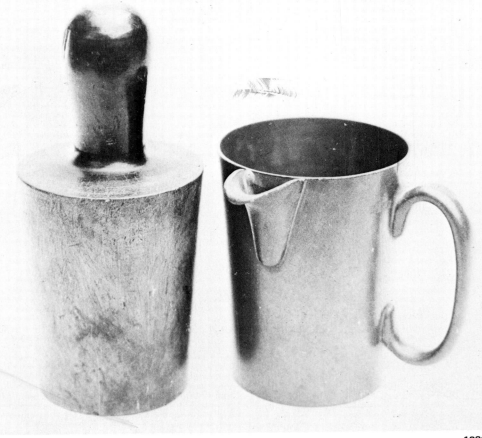

1239

1240

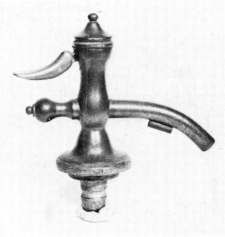

1241

1236. An American cuspidor, by William Savage, circa 1830, 8¼ inches diameter. (Courtesy of the Metropolitan Museum of Art, New York. Gift of Mrs. Stephen S. Fitzgerald).

1237. An English nineteenth century cribbage board, engraved "Barton Tavern". (Courtesy of Robin Bellamy Ltd).

1238. English baluster shaped bottle dryer. The bottle was stood upside down after washing, circa 1770. (Courtesy of the Worshipful Company of Pewterers, London).

1239. Wood forms were used to keep pewter mugs in the right shape. They were driven into the mug to remove small dents and bruising. English, circa 1850. (Courtesy of Robin Bellamy Ltd).

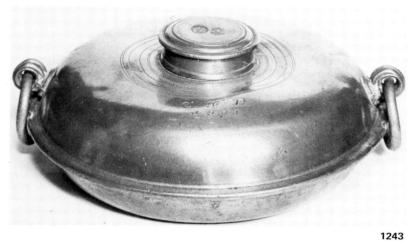

1243

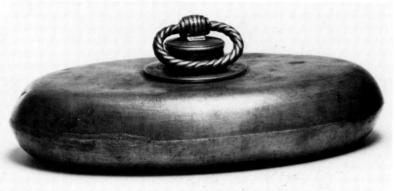

1242

1244

1240. A tap or spiggot, English nineteenth century, used for barrels of ale. (Courtesy of Robin Bellamy Ltd).

1241. A similar tap, possibly American, 4¾ inches maximum length, circa 1840—50. (Collection of Mr. William F. Kayhoe).

1242. Rectangular hot water container, possibly for use in a coach, circa 1800, European. (Courtesy of Robin Bellamy Ltd).

1243. Bed or perhaps foot warmer, German dated 1808. (Collection of Mr. and Mrs. Robert E. Asher).

1244. French footwarmer or bed warmer, nineteenth century, 30 inches long. (Courtesy of Christies, Amsterdam).

1245. Bed warmer, possibly American, with brass ring and cap, nineteenth century, 11 1/8 inches wide. (Courtesy of Bowdoin College Museum of Art, Brunswick, Maine).

1245

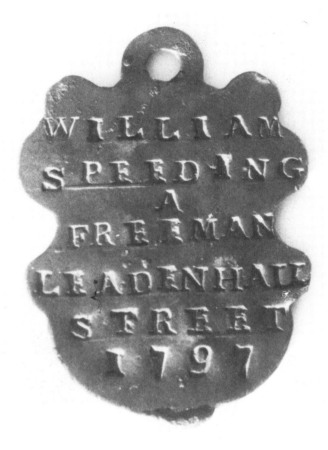

1246

1247

1248

1249

1246. An English pewter badge, from London. Carried by a porter. Dated 1797. (Courtesy of Robin Bellamy Ltd).

1247. Bottle in green glass with pewter mounts, circa 1820, European. (Courtesy of P. Boucaud).

1248. Eighteenth century American shoe buckle by "IT", 3 inches by 2½ inches. (Collection of Dr. and Mrs. Melvyn Wolf).

1249. American shoe buckle, early nineteenth century, 2¾ inches wide. (Courtesy of Bowdoin College Museum of Art, Brunswick, Maine).

1250. Hanging bulb pot, Swiss, circa 1680—1700, 6 3/8 inches high. (Courtesy of Swiss National Museum, Zurich).

1251. French butter dish or pot au beurre, from Burgundy, circa 1780—1810. (Courtesy of P. Boucaud).

1252. A group of five English eighteenth century pewter buttons, all excavated in Oxfordshire. (Courtesy of Robin Bellamy Ltd).

1253. Candle mold, for three candles, late eighteenth century. Similar molds were certainly used in all areas. (Collection of Mr. James Taylor).

1254. French candlemold, circa 1840, 12 inches high. (Courtesy of Country Life Antiques).

1250

1251

1252

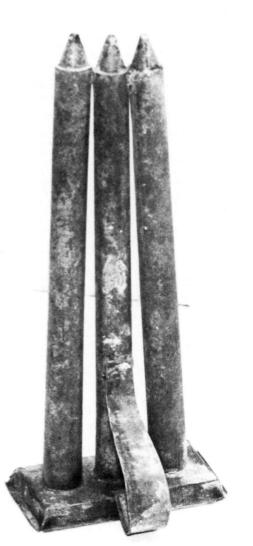

1253

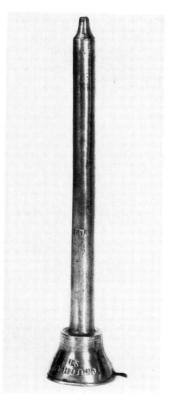

1254

361

1255

1256

1257

1255. A royal coat of arms in pewter, English, 10 inches high, early nineteenth century. (Courtesy of Robin Bellamy Ltd).

1256. A cigar mold, American, nineteenth century, 6 1/8 inches long. (Courtesy of Bowdoin College Museum of Art, Brunswick, Maine).

1257. Interesting wine bottle or decanter coaster, American by O. Trask, probably circa 1800. (Courtesy of the Metropolitan Museum of Art, New York. Gift of Mrs. Blair in memory of her husband, J. Insley Blair).

1258. Dutch dish ring stand, 3½ inches high and 8 1/8 inches diameter, circa 1780—1820. (Collection of Mr. and Mrs. Merrill G. Beede).

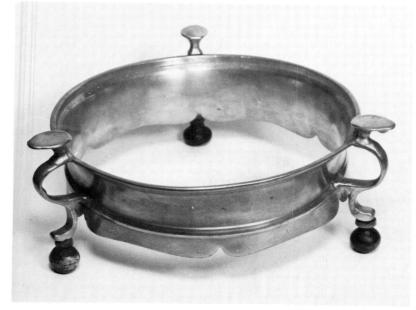

1258

1259

1260

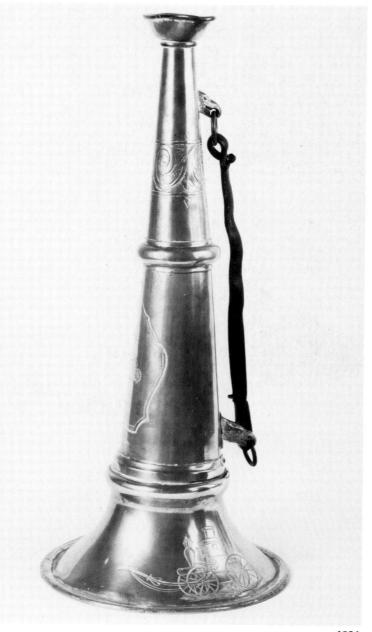

1259. A most unusual footed container with lifting lid, with a fitted partition, 8 inches high, American, nineteenth century. Possibly for tea or other dry goods. (Collection of Mr. and Mrs. Merrill G. Beede).

1260. A rare English egg cup, circa 1800, 2¼ inches high. (From the Kydd Collection).

1261. Fireman's speaking trumpet, American, mid-nineteenth century, 16 7/8 inches long. (Courtesy of Bowdoin College Museum of Art, Brunswick, Maine).

1261

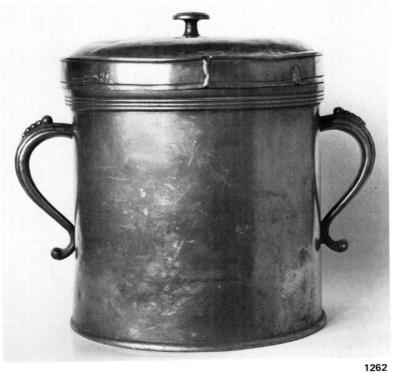

1262

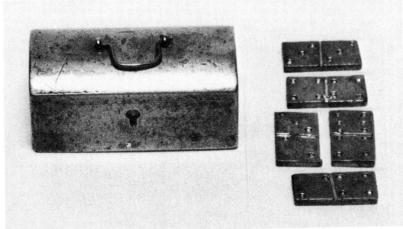

1263

1265

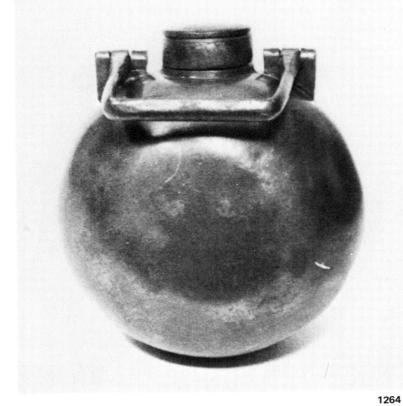

1264

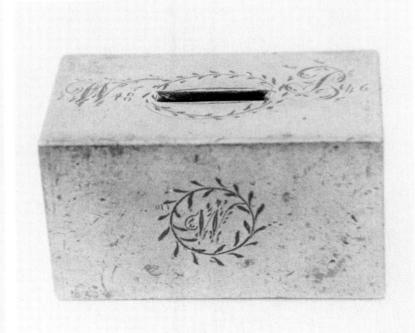

1266

1267

1268

1269

364

1270

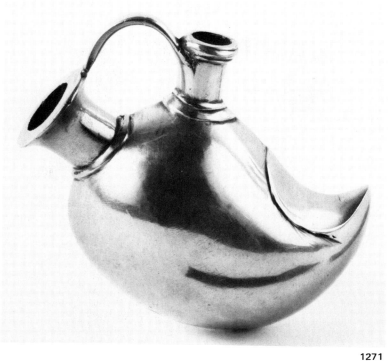

1271

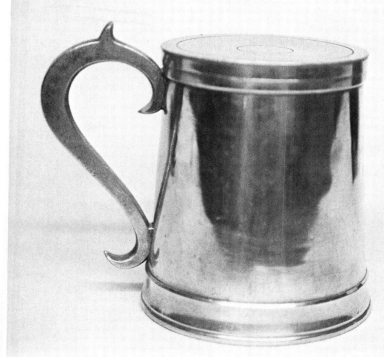

1272

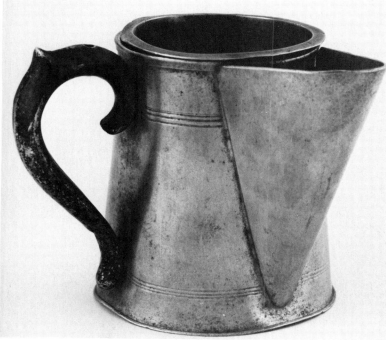

1273

1262. Swiss container or canister possibly used for flour or other domestic commodities. Early eighteenth century. (Courtesy of the Metropolitan Museum of Art, New York. Rogers Fund).

1263. Box of Dominoes, 1½ inches wide, nineteenth century, possibly American. (Collection of Mr. and Mrs. Merrill G. Beede).

1264. A small handwarmer, which was filled with hot water and used in a muff on cold days, 2½ inches high, circa 1800. (Private collection).

1265. A pair of nineteenth century horse harness decorations, English. (Courtesy of Country Life Antiques).

1266. English money box with engraved decoration. Dated April 1846, 2¾ inches wide. (Courtesy of Robin Bellamy Ltd).

1267. An American pewter picture frame on a miniature painting, 2½ inches diameter, early nineteenth century. (Collection of Dr. and Mrs. Melvyn Wolf).

1268. Silhouette frame, American, nineteenth century, 3 3/8 inches diameter. (Courtesy of Bowdoin College Museum of Art, Brunswick, Miane).

1269. American pewter pipe, 10 7/8 inches long, probably eighteenth century. (Collection of Mr. William F. Kayhoe).

1270. Ceramic plate stand with pewter mounts and feet. The tile and stand are American, the pewter by Dunham and Sons of Portland, Maine, circa 1850−60. (Collection of Mr. and Mrs. Merrill G. Beede).

1271. A rare powder horn, probably American and nineteenth century, 4 7/8 inches high. (Courtesy of Bowdoin College Museum of Art, Brunswick, Maine).

1272. An unusual mug with screw top lid, possibly a communion vessel for traveling, or for some other purpose which required a close fitting lid. American by Gleason, 5 1/8 inches high, circa 1830−60. (Collection of Dr. and Mrs. Melvyn Wolf).

1273. American shaving mug by George Richardson, early nineteenth century. (Courtesy of the Metropolitan Museum of Art, New York. Gift of Joseph France).

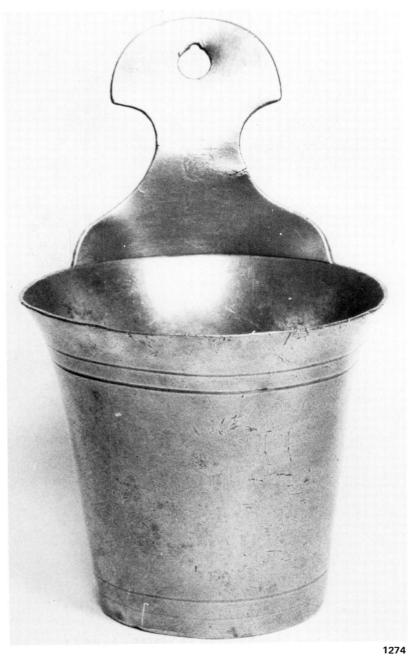

1274

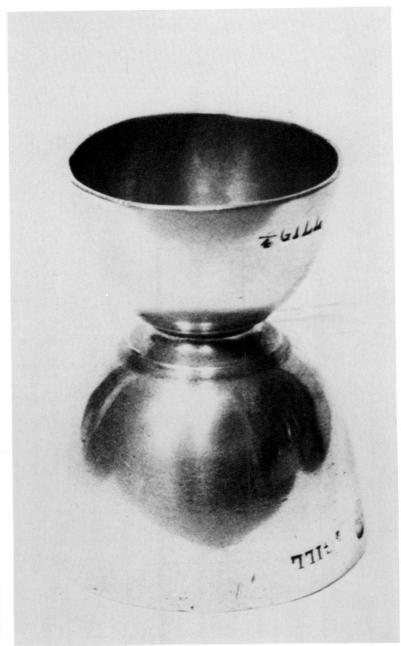

1275

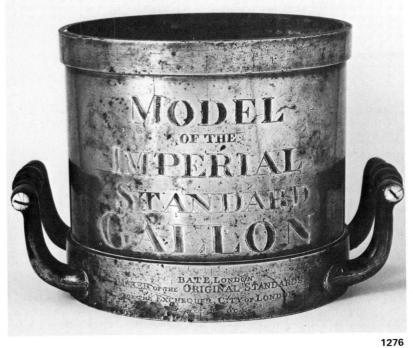

1276

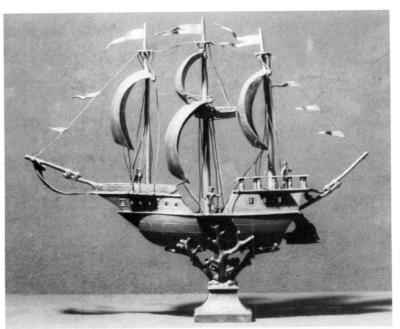

1277

1278

1279

1280

1274. Dutch soap dish or stand, circa 1800, 7¼ inches high. (Collection of Mr. and Mrs. Merrill G. Beede).

1275. An Irish egg cup spirit measure, each end offers a different capacity. Also made in England, circa 1780—1850. This example is for half and quarter gill. Victorian, 3 inches high. (Collection of Mr. P. Kydd).

1276. A rare model or pattern of an Imperial English Standard measure in pewter. For Bate of London, gallon capacity, circa 1826. (Courtesy of P. Boucaud).

1277. A table decoration or "Nef", Dutch or German, eighteenth century. (Courtesy of Dr. Fritz Nagel).

1278. Hard metal English toast rack, early nineteenth century. (Courtesy of Robin Bellamy Ltd).

1279. Two French Napoleonic silhouette soldiers, circa 1800—20, possibly from Strasbourg. (Courtesy of P. Boucaud).

1280. Pocket watch case, American, nineteenth century. Maximum dimension 3¼ inches. (Courtesy of Bowdoin College Museum of Art, Brunswick, Maine).

1281. Small pewter whistle, 2 inches long, English, early nineteenth century. (Collection of Mr. R. Dean).

1281

Appendix

A Guide to Dating Pewter

The dating of pewter and other antiques is not yet, and probably never will be, an exact science.

Throughout this study references have been made to a number of considerations all of which can play their part in suggesting a date at which an item of pewter may have been made.

In first place is the style or form of the object. Can it be identified with any other group of similar objects? Features of its design such as lids, knops and thumbpieces can help in suggesting a period of origin. Marks and decoration can both be useful in dating.

These features should suggest a possible date at which the object may have been made. Such an hypothesis must be tested against other evidence; for example was such an object in use at the time suggested?

Are there any other methods of testing such hypothesis?

The first, often overlooked, is a close physical examination of the object. Nothing that has been used for over several decades in house, church or place of work will have escaped some damage. Examine the wear around the hinge, the marks on the surface and the dents and bumps found on the body. Are these consistent with it being antique? It is always possible that an old object can have survived in a pristine, undamaged condition but it is very unlikely. Seek confirmation by examination and handling that the object truly shows signs of age.

There are two further tests that can sometimes be helpful. The composition of an object can be discovered through chemical or X-Ray fluorescent analysis. We do not yet know enough about the composition of pewter throughout its long history to establish firm criteria against which we can judge any results. Nor do we have enough information on the composition of fakes or reproductions. Even when sufficient data is available and when the remaining technical difficulties have been eliminated, analysis can never say with certainty whether an object is old or not. Analysis can only tell us that an object has a composition consistent with the composition of other genuine items. Evidence that its composition is very different will alert us to an inconsistency and make us question our hypothesis.

With measures that may have been made to local or national standards their capacity can occasionally help to date the item. By measuring the amount of liquid that a measure will hold and comparing this with the standards to which it might conform, it is sometimes possible to identify the standard used and thus help to date the piece.

Measure, for example, the capacity of a British mug and you might find that it holds 16 fluid ounces of water. This suggests that it conforms to the Wine standard used between 1689 and 1826. Likewise tests with Scottish Tappit Hens can confirm whether an example is of true Scottish capacity and therefore before 1826 or if it is perhaps of Imperial Standard.

But there are many difficulties. Firstly some containers are dented by use and this will reduce the amount of liquid that can be held. It is also unclear to what level the container should be filled before weighing. Where there is a "plouk" or mark there is no problem but with a jug or measure just how far from the top was it practical to fill it?

The tolerances to which it was possible to make pewter measures is also important. We know that makers of bronze standard measures were able to construct them to within 1% of the standard. Makers of pewter measures and mugs were permitted to work to much larger tolerances. British law permits measures to be made within 5.5% above and 2.5% below the standard, a spread of 8%. Tests of 65 American porringers and mugs showed that only 26 conformed to these limits and the evidence is that pewterers were not able to work to close tolerances.

So what is the position with measures which only differ by a small amount? For example the Queen Anne Ale standard and the Imperial Ale standard vary by less than 2%, well within the tolerances permitted.

Capacity can probably do little more than confirm an indication of date even when the standard to which it was made to is known.

The attempt to date pewter rests essentially on judgment. Where all the criteria are united in suggesting a certain date then the judgment that results is probably well-founded but where inconsistent answers result from these examinations any hypothesis must be treated with caution.

Fakes and Reproductions

It is important to make a distinction between fakes and reproductions.

Fakes are objects made to deceive an unwary buyer into thinking that they are antique and desirable because of their age. Reproductions are copies openly made and sold as such.

The faker attempts to recreate on his copy such evidence of age as would be found on an original.

Fakes are made to command a premium price, reproductions to sell at what ever the market value might be.

The two separate strands can become intertwined. Reproduction pewter can be treated to give it a false appearance of age. Darkened and stained pewter is to be seen on sale in many parts of France and batches of similarly "treated" pewter have been appearing in British sale-rooms over the last ten years.

The work of the faker is not easy to spot. he took time and care to match the appearance of the genuine example. Oxide can be faked in several ways and a "false" repair was often added to reassure the unwary. True fakes, however are rare.

There is no profit in faking anything unless it is valuable. Thus it is only the really rare items that are faked. In Britain, Stuart candlesticks and flat-lidded tankards were especially vulnerable.

Pewter in Britain or America had little value before 1910 so fakes from these countries were mostly made after the first world war. In Europe the interest in all things "Gothic" had created a demand for pewter from the 1880's and the faker was quick to move in. Early fakes are now genuine antiques in their own right!

The faker has also turned his attention to "improving" genuine pewter by adding decoration or false maker's marks to augment its value. Narrow-rimmed plates by Hitchman have been wriggled over the last twenty years and genuine Alderson plates engraved with the initials "GRIV" to copy the monogram found on the Coronation pewter of George IV. In America false marks have been struck on genuine but unmarked plates to substantially increase their value.

Reproductions were made in Europe from 1880 and after the first world war elsewhere. Almost every major form has been copied. Not strictly copies however, are a group of objects made by the reproduction companies loosely based on earlier forms but never actually made historically. These acts of the imagination sometimes fool unwary buyers. Gothic guild flagons over 2 feet high and bulbous measures marked Bush and

Perkins are two such imaginative pieces that have found places in established collections.

In the 1920's and 30's there were no restrictions to prevent a maker from adding a copy of an earlier makers mark to reproduction pewter. Such false attributions are now illegal in Britain. Some modern reproductions do carry the name of earlier makers. For example the James Yates range made in Birmingham. James Yates is the legal trade name of this range of reproductions, made by the successors of the actual company owned by James Yates.

1282. A page from a late nineteenth century pewterers' catalogue showing the range of goods still being made around 1880—1900. These are neither fakes nor reproductions but items still made at that time for daily use. (Courtesy of Robin Bellamy Ltd).

1283

1284

1283, 1284, 1285, & 1286. Pages from a reproduction catalogue circa 1926 showing some of the things being made at that time. (Courtesy of Robin Bellamy Ltd).

1286

1285

1287. Collecting in England was given its first impetus in 1904 with an Exhibition of pewter at Lincoln Inn. This is a previously unpublished photograph of this exhibition. (Courtesy of Robin Bellamy Ltd).

The trade in reproduction pewter is currently growing with many excellent copies being created in all parts of the world, most clearly marked with their origin.

There are no simple rules to help identify fakes. Scepticism and a keen sense of observation are perhaps the two most important qualities to try to develop.

The Care of Pewter

Pewter can be found in superb condition, its surface unblemished by dents or cracks and with no signs of oxide. Such rare examples need no more than an occasional rub with a cloth to keep them in immaculate condition.

Most pewter will show some signs of use, ranging from a few dents and scratches to substantial corrosion.

What should be done with these objects?

Two different enemies can attack pewter. The first is the damage that we can create through our carelessness; the dents and scratches of everyday use and the more serious damage caused by dropping pieces or leaving them too close to heat.

The second enemy is oxide. There are certain theoretical conditions under which pewter can decay. This type of damage can occur following long exposure to cold and has been termed "tin-pest". This is not what has attacked such a large proportion of pewter. The unsightly patches of dark metal errupting on the surface are caused by the alloy oxiding or rusting. All the elements in pewter will suffer such damage on the surface as they come into contact with the air. It is through this process that pewter attains its colour. The surface of a corroded pewter plate may contain as much as 60% of one or other of the tin oxides.

The mixture of metals within pewter is never wholly even. Small pockets of individual elements normally form. As each metal has its own speed of oxidation, these patches or pockets will oxide differently from the other elements around them and it is in this way that we get the pits and craters that appear on the surface of pewter.

We keep unblemished pewter in its fine condition by simply rubbing away the newly formed very thin coat of oxide with a cloth but to remove the heavy accretions of time is a more difficult task.

This takes us into the area of taste. Many people, especially in parts of Europe and Britain, like the gray colour which we associate with pewter. They term this lightish coat of oxide "patina" and prize it. In other areas, like Belgium and the United States, collectors abhor this discolouration which they view as dirt.

Thus British collectors seldom attempt to remove the oxide unless it is so bad as to give the

371

1288. & 1289. Heavy lifted oxide can be very unsightly.
(Courtesy of Robin Bellamy Ltd).

piece a very unsightly appearance whilst in the United States collectors usually clean their pewter.

This conflict has long raged. To clean or not to clean. In the end it is essentially a matter of opinion or taste.

But the consequences of whatever action is taken can remain with the piece forever.

If nothing is done then the surface will slowly and inevitably become darker and the pits and holes of oxide deeper and more serious. If it is cleaned then the whole surface will have to be rebuffed and the holes created by cleaning the oxide out of the pits, filled.

One of the consequences of cleaning pewter by immersing it in an acid or alkali dip is that the surface now exposed to the air is not that originally exposed when it was first finished. Pewter treated in this way needs to be resurfaced and this is usually done by buffing on a wheel.

Acid or alkali treatment means that where there are small pits or holes the caustic material works its way into them and creates small deeper holes. Its attack is not easy to control and can go further than the collector originally wished.

This form of cleaning also removes many of the traces of age that can be so useful in dating pewter, particularly if it is cleaned over its whole area. In Britain, where pewter has to be cleaned it is common practice to leave the underside of plates and dishes or the inside of bases of tankards and the like untreated. Thus while the obvious exterior surface is clean some of the original finish is retained.

If pewter is to be cleaned there are alternatives to acid or alkali treatment but they involve more effort. The surface can be rubbed by very fine glass or emery papers. This has the merit of leaving some of the original surface but does not create as even or as clean an appearance as some collectors require. The newly cleaned surface can then be polished by hand to a good soft colour.

The first decision then is whether to clean pewter or not. Having taken this step, if it is to clean, to decide by which method it should be done.

The other aspect of the care of pewter relates to repairs.

Should damage be made good?

The answer probably depends on two factors; the owners' attitude and the extent of the damage.

Some collectors can not abide any imperfection, others are hardly concerned with minor damage, seeing it as evidence of age.

If the damage is significant, as for example where a hinge is broken or a candlestick is nearly in two parts, there is a great impetus to take some steps to see that the damage does not worsen. Leave such repairs undone and inevitably, at some future time, the damage will worsen.

Many collectors feel that they have an obligation to prevent such further deterioration.

However repairing pewter is a difficult art and there are few professional restorers to whom to turn. Pewter melts at a low temperature and unskilled use of a soldering iron can do terrible damage. Avoid handing over important objects to someone who is learning his trade or does not normally handle pewter. It is best to seek help from the few skilled restorers that do exist.

There is no doubt that fine undamaged examples are more popular among collectors and are, as a consequence, more likely to increase in value. There was a period in the 1970's when the difference in auction price between a faultless and a damaged item was between 10 to 20%, whereas in recent sales this differential has risen to as much as 50%.

1290. Small bubbles of oxide, caused by original poor
mixing of the alloy. Such damage can continue to grow and
each bubble may one day become a small hole. (Courtesy of
Robin Bellamy Ltd).

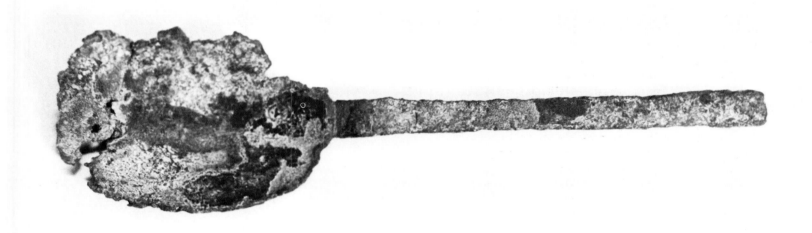

1291. Remnants of an excavated spoon. English mid-seven-
teenth century. Restoration of an object so damaged would
be very difficult and the best that might be accomplished
would be to complete the missing part of the bowl with
acrylic. (Courtesy of Robin Bellamy Ltd).

Bibliography

A complete bibliography of works on pewter would contain several hundred books many now out of print and some out of date as a consequence of modern research.

Such an extended bibliography, whilst impressive in size would be of little practical help.

A large proportion of works are in the language of the author and there are few studies on European pewter in English for the non-linguist.

Apart from books there has been a great deal published on pewter in learned journals, in Museum catalogues and Collectors journals such as the Bulletin of the Pewter Collectors Club of America.

A selection of important works is presented here, by language groups. Most of these books include detailed bibliographies and will lead on in turn to further books and articles of specialised or national interest.

English
Brett, V. *Pewter*. London: 1980.
Cotterell, H.H. *Old Pewter; Its Makers and Marks*. London: 1929. ***
 With Vetter, R.M. *Pewter Down the Ages*. London: 1938.
 With Riff, A. and Vetter, R.M. *National Types of Old Pewter*. Princetown: 1972.
Hatcher, J. and Barker, T.C. *A History of British Pewter*. Aberdeen: 1974.
Homer, R. *Five Centuries of Base Metal Spoons*. London: 1975.
Ingleby Wood, L. *Scottish Pewterware and Pewterers*. Edinburgh: 1905.
Jacobs, C. *Guide to American Pewter*. New York: 1957.
Laughlin, L. *Pewter in America. Its Makers and Their Marks*. Boston: 1940; Barre: 1972. ***
Masse. Edited Michaelis, R.F. *The Pewter Collector*. London: 1971.
Michaelis, R.F. *Antique Pewter of the British Isles*. London: 1955.
 ——————— *British Pewter*. London: 1969.
Montgomery. *A History of American Pewter*. New York: 1973.
Peal, C.A. *British Pewter and Britannia Metal for Pleasure and Investment*. London: 1971.
Peal, C. *More Pewter Marks*. Norwich: 1976.
Scott, J.L. *Pewter Wares from Sheffield*. Baltimore: 1980.
Verster, A.J.G. *Old European Pewter*. London: 1957.
Weiner, P. *Old Pewter in Hungarian Collections*. Budapest: 1971.
Woolmer, S. and Arkwright, C. *Pewter of the Channel Islands*. Edinburgh: 1973.
Dutch
Dubbe, B. *Tin en Tinnegieters in Nederland*. Lochem: 1978.
Verster, A.J.G. *Oud Tin*. Amsterdam: 1924.
 ——————— *Tin Door De Eeuwen*. Amsterdam: 1954.

French

Bidault, P. *Etains Religieux*. Paris: 1971.
 with Lepart, J. *Etains Medicaux et Pharmeceutiques*. Paris: 1978.
Boucaud, C. *Les Pichet d'Etains*. Paris: 1959.
Boucaud, P. with Fregnac, C. *Les Etains*. Fribourg: 1978.
Douroff, B.A. *Etains Francais*. Paris: 1960.
 with Tardy. *Les Etains Parisiens*. Paris: 1963.
Tardy. *Les Etains Francais*. Paris: 1959.

German

Aichele, F. *Zinn*. Munich: 1977.
Bossard, G. *Die Zinngiesser. Der Schweiz und ihr Werk*. Osnabruck: 1978.
Haedeke, H.U. *Altes Zinn*. Leipsig: 1969.
 ——————— *Zinn*. Brunswick: 1973.
Hintze, E. *Die Deutschen Zinngiesser und ihr marken*. Germany: 1921—31.
Mory, L. *Schonnes Zinn*. Munich: 1972.

Scandinavian
Languages

Andren, E. *Gammelt Snenski Tenn*. Vasteras: 1972.
Bruzelli, B. *Tenngjutare I Svenga*. Stockholm: 1967.***
Hals, A.S. *Gammelt Norsk Tinn*. Oslo: 1978.
Uldall, K. *Gammelt Tin*. Copenhagen: 1950.

Glossary

Alloy A mixture of metals to form a useful combination or alloy.

Ampulla A small flask used to hold holy water often brought back by pilgrims.

Antimony A silvery-white metal used in pewter.

Apprentice A young man or woman serving as a trainee to an established craftsman, usually for several years.

Assay A test to determine the quality of pewter, undertaken by the guilds.

Bismuth Reddish-white metal used with tin in pewter.

Booge That part of a plate, dish or bowl between the rim and the base or bottom.

Boss A rounded, domed centre to a plate or dish. Sometimes termed a "bumpy-bottom".

Britannia Metal Several definitions exist, based on the alloy used, the styles of objects made or the method of manufacture. The latter is more correct as britannia metal is essentially a technique; the spinning of pewter.

Bronze An alloy of copper and tin.

Burette A small jug used for holy oils or wine.

Capstan A type of salt so called because of its similarity to a dockside Capstan.

Charger A dish over 18 inches in diameter.

Costrel A container, usually in leather, used to carry water.

Crenulation The lip added on British and American tankards as a decorative feature, also termed "serrated".

Flatware Name given for pewter such as plates and dishes, to distinguish it from "hollow-ware".

Gadroon A type of decoration based on curves.

Garnish A complete set of pewter tableware.

Hallmarks False silver marks used as makers' marks on pewter.

Hammermen Craftsmen who use the hammer as their principal tool.

Hollow-ware Vessels made in complex molds such as tankards and flagons as distinct from "flat" articles.

Journeyman An employee working for a "master", after completing his apprenticeship.

Imperial Standard Standard of Capacity introduced in Britain in 1826.

Knop A knob or finial found on the lids of tankards flagons.

Latten An early name for brass; an alloy of copper and zinc.

Master A craftsman working at a trade.

Mull Another name for a snuff box.

Pap Boat A small vessel used to feed soft "pap" foods to children or the sick.

Prunt Small "pearl" like decoration, added by hammering the surface of pewter.

Reeding Cast or engraved lines on the rim of pewter plates and dishes.

Repousse Hammered decoration, worked from the reverse of the principal surface.

Rush Light A type of lighting device used with rushes soaked in animal fat.

Sadware Another term for flatware.

Tazza A plate standing on a foot or on feet.

Thumbpiece A small lever found on tankards and flagons to ease the raising of the lid.

Treen Wooden objects.

Trifle Pewter of little significance in contrast with flat- and hollow-ware.

Vessel Term for any hollow container.

Wall Sconce A fitting to hold candles, fastened to the wall.

Wrigglework Type of engraving in which the line is broken or not continuous.

Index

Computer software by Studley Computer Services Ltd.